The Traffic in Culture

The Traffic in Culture

Refiguring Art and Anthropology

EDITED BY

George E. Marcus and Fred R. Myers

UNIVERSITY OF CALIFORNIA PRESS

Berkeley Los Angeles London

University of California Press
Berkeley and Los Angeles, California

University of California Press, Ltd.
London, England

For our children—Samantha, Rachel, and Avery

ILLUSTRATIONS

The Traffic in Art and Culture: An Introduction

George E. Marcus and Fred R. Myers

This volume collects a set of essays[1] that signal a new relationship of anthropology to the study of art, one in which the historical boundaries and affinities between these domains are recognized. In contrast to a previous paradigmatic anthropology of art that was concerned principally with mediating non-Western objects and aesthetics to Western audiences, the work here engages Western art worlds themselves, casting a critical light on mediation itself, and proposes a renegotiation of the relationship between art and anthropology. The need for such a renegotiation is clear, given some obvious mutualities: on the one hand, so much of the traditional anthropological concern with "art" has focused in one way or another on whether a separate domain of aesthetic objects (or practices) exists in different cultures (see, for example, Coote and Shelton 1992; Gell 1992); on the other hand, Western critics also have been deeply involved in challenging the universality and essentialism of the category of art, drawing not infrequently on anthropological studies to make their points. More recently, in contemporary cultural life, art has come to occupy a space long associated with anthropology, becoming one of the main sites for tracking, representing, and performing the effects of difference in contemporary life. From this perspective, the two arenas in which culture is examined are in a more complex and overlapping relationship to one another than ever before.

A critical anthropology of art is distinguished from earlier efforts and from other disciplinary approaches by acknowledging that anthropology itself is implicated with the very subject matter that it wants to make its object of study: art worlds. Our perspective differs, for example, from most sociological studies of art, in which a very specific, historically situated subject is assimilated to a generalizing and abstracting conceptual discourse of objectivity and neutrality.[2] Howard Becker's classic study, *Art Worlds* (1982), is undeniably brilliant in its ethnographic acuity about art institutions and subcultures; however, the potential of the work to

be an engaged form of cultural criticism—an engagement that depends on a *work-ing identity*, a sort of recognition of parallel roles, between the critical ethnographer and the art critics—is suppressed by a greater concern with constructing general social theory. There is a distinctive and telling irony here about the production of objectivities. Becker is himself a talented participant in art worlds (musician, pho-tographer, dramatist) who knows these worlds intimately in practice. Yet, in writ-ing microsociology in dialogue with a mainstream discipline, Becker seems to keep his own artistic side at a distance.[3]

In the anthropology of art, as with other contemporary locations of ethno-graphic research, it is no longer possible for anthropologists to address subjects "cleanly"—that is, as subjects in relation to whom they, or their discipline of study, do not already have a history of relations. Indeed, such a history, no matter how submerged, must become an integral part of any contemporary research, and this seems nowhere more important than in the cases of those art practices in which anthropological conceptions of "culture" and "difference" have been so heavily entangled with the practices of museums, collectors, and markets.

The critical circumstance to which we refer has recently surfaced with increased theoretical force, but it has a particularly long history and a hidden presence in anthropology's complex identification with its subjects and its cultural authority, between concerns about ethnocentrism and sustaining the "native's point of view," on the one hand, and its determination to classify and compare different cultures, on the other. Our subjects, typically, have been people who were marginal, colo-nized, or otherwise peripheral to the standard narratives of world histories pro-duced in the West. As a consequence of this historical location, what might be called the "critical ambivalence" toward subjects creates a tension between a desire for the creation of distanced, objective knowledge of independently constituted subjects of study and an awareness of existing relationships (of power and histories) which make anthropology itself already a part of such subjects of study.[4] The essays in this volume make a significant contribution to extending and developing the insights from this legacy.

Our interest in casting a critical focus upon contemporary art worlds them-selves arose not from any a priori determination, but rather from our own experi-ences of following trails in which delimited ethnographic objects of study suddenly expanded and transformed themselves. We each began with projects of ethno-graphic research that originally had no obvious relationship to art. In a study of contemporary American dynastic fortunes and families, Marcus (1992) found that he was regularly being led to art collections and museum endowments; indeed, his tracing of dynastic legacies led not so much to particular family members or heirs as to art institutions themselves. Similarly, after years of theoretically innov-ative but methodologically traditional ethnographic research with Pintupi-speaking Australian Aborigines (Myers 1986a), Myers found himself amidst the world of art critics, dealers, and museum curators where much international interest had devel-oped in the acrylic paintings of the Pintupi and other Aboriginal people.

One of the most satisfying and exciting aspects, indeed requirements, of doing long-term ethnographic research today is the discovery of such unanticipated connections. However, for our purposes here, the discovery was not only of the connection of our specific subjects (members of capitalist dynasties and Aboriginal Australians) to a common frame—the international art world—but also of the affinities between our own discipline's modes of thinking and those of the art world. Thus, the idea for this volume originated with the unusual difficulty we encountered in constituting art worlds and their discursive fields as conventional, distanced objects of ethnographic study in a way that had been possible with dynasts and Aboriginals. This productive difficulty is at the heart of most of the essays in this volume, as they generate views of the art world from their own implicated relations, both personal and disciplinary.

We should state at the outset that, in thinking through the relationship between anthropology and modern art worlds, we have in mind a very specific historically situated art world: namely, the contemporary, Western-centered tradition of fine arts that began with the birth of modernism and a transformed art market out of the previously dominant Academy system in nineteenth-century France. This is a world still defined, even with its postmodern attempts at transformation, by the creation of aesthetic experience through the disinterested contemplation of objects as *art* objects removed from instrumental associations.[5] Further, the principal situation of our studies reflects the current conditions of the international modern art world and market, widely labeled "postmodern," with painting and its modernist alternatives as the main line of development, and with New York as its center since World War II. This point of reference derives from our particular research experiences as anthropologists with art worlds: Myers through dealers, critics, and museum curators in Sydney and New York; Marcus focusing more on the fine arts world from the perspective of his research and year at the Getty Center for the History of Arts and Humanities in Los Angeles. Nonetheless, if we couch our introductory rhetoric more generally, we do so to demonstrate how what we and the other authors in this volume have to say about a specific, dominant art world might have wider application and relevance. Some of the papers—such as Steven Feld's on world beat music or Judith Goldstein's on makeover advertising—also suggest that the same issues we raise apply to communities, industries, or markets based on other expressive cultural forms.

One significance of this volume and its historical location, therefore, is to challenge such certainties of distinctive, bounded communities—the boundary between observers and observed—that academic practices have tended to produce. A concurrent development to keep in mind is the current blurring of traditional boundaries and the segmentation of art worlds by media and markets. The sweep of the postmodern debate has among other things engendered new and rather unpredictable sites of interchange between artists of different sorts and between artists and intellectuals, scholars, journalists, and their patrons (see Marcus's essay). Our writing both reflects and is part of this emergence, as anthropol-

ogy and its traditional subjects are increasingly involved in the production of art and the institutions on which art production depends.[6]

ANTHROPOLOGY, THE ARTS, AND THE IDEA OF CULTURE

With this background, our starting point must be an exploration of the changing historical and contemporary relationship between anthropology and modern art worlds. The traditional anthropology of art, which considers art traditions and aesthetics cross-culturally (e.g., Anderson 1989; Jopling 1971), has been developed within the categories and practices of Western art worlds themselves. This development has varied, of course, depending on the nature of the medium (music, visual art, photography, film) and the real relationships particular anthropologists (such as Gene Weltfish, Edmund Carpenter, Robert Armstrong, Ruth Bunzel, Jean Rouch, and Gregory Bateson) have had with different artistic avant-gardes. Although anthropologists produced a diverse body of work, and exemplified a range of critical perspectives in practice, most of the traditional anthropology of art has been either *critical* of Western categories, by showing the difficulty of translating Western concepts cross-culturally, or it has *appropriated* art's own categories to valorize activities and cultures in its terms (e.g., by representing a non-Western culture as "civilized" or having "aesthetics"). In this respect, the existing anthropology of art has rarely been more than a complement to Western art institutions. As the impact of French ethnographers on Surrealists (Clifford 1988) illustrates, the anthropology of art has been particularly important in providing stimulation to avant-gardes.[7]

The essays collected here present a different relationship between anthropology and art, its discourses and institutions; but the importance of recognizing the change is not to claim credit for seeing what others have failed to see. We should ask, instead, what are the current conditions that make possible anthropological attention to *Western* art practices themselves? The phenomenon which probably most generated our interest in putting together this book has been the recent fascination of the art world with the "appropriation" of value-producing activity on an international scale, with the assimilation of the "art" of the Third and Fourth World societies anthropologists have traditionally studied. Such work is not only circulating more noticeably in Western high culture venues; it has also become of theoretical significance for critical debates within the art world concerning aesthetics and cultural politics (see, for example, Foster 1983, 1985, 1987).

Anthropological writing not infrequently figures in these discussions as problematic. It is attacked for its objectivity and as an "othering" discourse by new criticism developed in relation to the art world's concern with the "exotic"—a criticism posed oppositionally and rooted partly in avant-gardism's long-standing orientation of critique in relation to the academy (see, for example, Marks 1992; Trinh 1989). Anthropology's investment in the importance of detailed ethnographic context for understanding human activity and products (see Coote and

Shelton 1992; Gell 1992) is also challenged—by avant-gardist emphases on "unmediated" experience, the thing itself, as bearing the potential for delivering the unsettling "shock of the new" on which avant-gardes have depended (Feld, Kirshenblatt-Gimblett, Myers, this volume). Finally, anthropology's claim to be able to represent "others" at all has sustained a withering critique in recent years from domains of theory which have, at the same time, been inspirations for intersecting avant-gardes in the worlds of art and the academic humanities (see Clifford 1988; Derrida 1977; Foucault 1971, 1973; Said 1978; Trinh 1989; Torgovnick 1990). For their part, anthropologists find it especially difficult to accept avant-garde sensibilities that give centrality to "strangeness," shock effects, and unbridgeable difference (see Kirshenblatt-Gimblett, this volume).[8] As Diane Losche (1993) has recently argued in considering the problem of rendering Abelam aesthetic concerns within the framework of Western art discourses: "The recent issues of multiculturalism, primitivism and postmodernity are making apparent what may have been the case for a long time, the fact that in some ways apparently neighboring discourses within the same cultural context are as foreign and 'orientalized' to one another as foreign and not very friendly countries." Anthropology's "re-placement" within art-world discussions also reflects a change in the nature of contemporary transnational cultural flows in which what might have once been considered ethnographic artifacts enter immediately into Western art-market discourse of aesthetic judgment (see Appadurai 1990; Appadurai and Breckenridge 1988; Marcus and Fischer 1986; Price 1989). Navigating the translation between art-world discourse and that of anthropology, therefore, is particularly challenging, demanding a genuinely dialogical stance and a recognition that the boundary between "art" and "anthropology" has never been very clear.[9]

A more radically critical view of Western art practices has arisen among anthropologists with a burgeoning interest in the study of museums for both ethnographic and art objects, and the historic shift in the classification of non-Western objects particularly from artifacts to *objets d'art* (Clifford 1988; Price 1989; Karp and Lavine 1991). This interest is clearly part of the broader critique of representation and discourse that has generally affected the human sciences, and particularly so in the case of anthropology (Clifford and Marcus 1986). In this respect, these studies of the way that anthropological subjects and knowledge have historically been appropriated by art worlds signal a new direction in anthropology's relation to art. From our perspective, however, such representation-oriented studies are very partial and only coincidentally address art worlds *themselves*—their institutional, discursive, and value-producing complexities—as historic and contemporary spheres of activity. Mullin's essay (this volume) on the creation of the Southwest Indian Art Market emphasizes just these spheres of activity, exploring the institutions of patronage that linked American national culture after World War I, anthropological representations, Indian crafts, and the assignment of new forms of aesthetic value to objects.

There is an affinity between art and anthropology as discursive arenas for com-

prehending or evaluating cultural activity. Art and anthropology are rooted in a common tradition, both situated in a critical stance toward the "modernity" of which we are both a part (see also Miller 1991:57). The central issue for modern art has been the relationship or boundary between "art" and "not art." Since Kant's (1951) philosophical demarcation of an autonomous aesthetic domain of human judgment that was separate from both the means-end calculations of utilitarian practical reason and from the imperatives of moral judgment, the culturally constructed boundaries between aesthetics and the rest of culture have been neither stable nor neutral. If modern art has been preoccupied with the problem of, or the debates about, art's autonomy and the occupation of a *separate* cultural domain, anthropology has insisted on a *holism* whereby no dimension of cultural life is naturally to be considered in isolation from others. With a common heritage of cultural theory, participants in the two fields of disciplinary activity often speak a similar language, and yet—as with the cliché about the British and the American—are divided, or disjoined, by it.

From this perspective, for most anthropologists, the commonsense category of "art"—transcendent, referring to a sphere of "beauty" external to utilitarian interests, and signifying principally painting, sculpture, and music[10]—would not be universally applicable to human aesthetic activity. Rather, the concept would be "subject to the critique of relativism," as the anthropologist Dan Miller puts it, "in that it stems from an essentialist foundation . . . but has become an established perspective through particular cultural and historical conditions" (1991:50). By virtue of cross-cultural training and experience, most anthropologists encounter the category of "art," internal to our own culture, with a suspicion and a sense of its strangeness. Yet, in this suspicion, anthropologists have also tended to reify the category and to simplify the complex internal dynamics of conflict within art worlds over the issue of autonomy. Thus, anthropologists' critical sensibilities, out of relativism, have largely failed even to recognize modern art's own internal "assault on tradition" and challenge of boundaries.

For their part, social historians of art have begun to understand the transformations of European life that led to the condition for our particular (Western) experience of an "aesthetic dimension" (see, e.g., Baxandall 1972; Burke 1978; Eagleton 1990). Following a line of analysis pioneered by Weber, they all stress the general context of institutional separation of distinct and abstract areas of interest—of kinship, politics, religion, economics—taking place in the wake of capitalism's development, or with the rise of the nation-state (Eagleton 1990).[11] There may not be much agreement about the timing of such developments or about the definitive characterizations of the separation (see Clark 1982). But most theorists agree that there is an important difference between art and these other domains, in that—as Miller writes of the aesthetic practices of Western "fine art"—"art appears to have been given, as its brief, the challenge of confronting the nature of modernity itself, and providing both moral commentary and alternative perspectives on the problem" (Miller 1991:52). Ironically, the very category of "art"—as

opposed to "the arts"—goes unexamined in its own hierarchies of sense, so that various forms of popular performance, in which disinterested contemplation does not necessarily reign supreme, are excluded.

Our point is that this discursive separation of art from culture created a part of culture that, like anthropology itself, had culture as its object. This discussion of "separation" is not meant as a new contribution to art historical readings of modernism; instead, we are taking an anthropological approach to common academic and popular understandings of modernism because that is what influenced the development of the disciplines. Indeed, one must come to terms with the central problem of cultural theory in the recognition that the different arguments about this separation are themselves signifying practices—narratives—that struggle to define, essentially, what "culture" is.

Moreover, the very separation of an acultural aesthetic dimension and of the arts by sense intersected with modes of defining populations (class, race, gender, and culture) within nation-states. Implicitly or explicitly, aesthetic judgments and discernments of artistic value—a mode of interrogating cultural activity—thus had much to do with social distinctions of political substance. The critic Clement Greenberg, for instance, ([1939] 1961) founded his understanding of "art" in opposition to the kitsch of mass culture.[12] Or, to take another example, Adorno's well-known discussions of the autonomy of aesthetics that arose with the bourgeoisie argues dialectically that "What is social about art is its intrinsic movement against society, not its manifest statement. . . . Insofar as a social function can be ascribed to art, it is its functionlessness" (Adorno 1970:336, quoted in Bürger 1984:10). Against the domination of exchange value, which threatens to reduce all quality to quantitative equivalence, therefore, Adorno conceives the function of art as "a social realm that is set apart from the means-end rationality of daily bourgeois existence. Precisely for this reason, it can criticize such an existence" (Bürger 1984:10).

Despite long-standing debates and challenges to the problem and ideal of art's autonomy in the West, for many people engaged with the arts the category of "art" remains a resolutely commonsense one, associated with essential value in relation to a generalized human capacity for spirituality or creativity. Why else the interest among art historians in the rock paintings of Europe's Upper Paleolithic? Anthropology *has* long resisted the most obvious dimensions of an autonomous art perspective, and indeed all boundary making, evaluative perspectives that attempted to delineate Arnoldian (or avant-garde) high cultures from baser ones. This has been especially true when such a perspective was extended to evaluate the visual forms produced in the non-Western societies (see Forge 1973; Biebuyck 1969) anthropologists studied. Although relativism's work of "recognizing difference" and rejecting ethnocentrism was accomplished here, no investigation of the very hegemonic cultural process that anthropologists were themselves resisting recommended itself. Despite some resistance to the extension of the idea of an autonomous art beyond the boundaries of Western culture, anthropologists did

not, apparently, recognize this essentializing autonomous sphere of art as something itself to be studied (rather than sometimes resisted). Sally Price's *Primitive Art in Civilized Places* (1989) has provided an important step in this direction by questioning the ethnocentrism through which Western art categories and practices of evaluation have excluded non-Western objects. Steiner's study (this volume) of the African art trader's manipulation and brokerage between cultural traditions places particular forms of boundary maintenance and negotiation within a specific historical and institutional context. From a more subversive angle, Goldstein (this volume) critically examines the (male) postmodern construction of a boundary between high culture and the so-called mass culture of women's fashion and makeup advertising, the "female aesthetic community," which establishes its own forms of judgment and disinterested gaze.

With their long-held sympathy for outsiders, for cultural relativism, and for life as lived, anthropologists have not until quite recently really given these "boundaries" much direct consideration. There have been two interesting consequences of this. First, in the academic division of labor between the study of "primitive," small-scale societies and complex contemporary Western ones, the enterprise of studying artistic practices was left to art historians and "cultural critics" (i.e., the "natives"). The resulting unintentionally constructed boundaries between "pure" cultures were consequently left unexamined (see Clifford 1988). These critical practices and their positioning therefore became forms of cultural production insofar as they contributed to *other* kinds of stereotyping and representation of those beyond the pale of art history. Certainly, neither critics nor anthropologists imagined the specific boundaries for translation of the contemporary situation. Anthropologists now are less often "defending primitive cultures" against the colonialist or racist charges of possessing "inferior" culture than they are concerned to define the recognizable boundaries involved in an existing *market* for art objects that translates the products of "others" into its terms and values.

The second consequence involves a similar sort of cultural alliance in the name of theory. In the critique of "ethnocentrism," anthropologists have generally allied with what sometimes appears to be a rather casual dismissal of "high" culture (see Price 1989; Stevens 1990:31). It seems fair to say that anthropologists are not very comfortable with the idea of "high" culture (possibly because they are still uncomfortable about elites), and such discomfort leads them to find support from art critics and others who attack the "high" culture pretension. While criticism of evaluative practices that distinguish "high" from "low" or "middle-brow" culture is quite varied, of course, many such critics perceive little content or value in such practices other than those of exclusionary "distinction" for those with taste (Bourdieu 1984; Crow 1987). Others emphasize what they perceive as modernism's politics of ideological exclusion in an essentially heterogeneous cultural world (see Lippard 1991), a view with obvious attractions for anthropologists working on cultural "peripheries." Here one finds both a radically reductive and relativistic political critique of *anything* that might pass as "high" or "dominant," as well as a critique interested in inclusion

of the "low," the "other," and so on, as a current avant-garde means of destabiliz-ing prior dominant hierarchies of value and the authorities of the past (see, e.g., Foster 1985; Krauss 1984; Owens 1983).[13] Although these latter critiques offer a complex consideration of boundary-marking practices, their attempt to embed art socially is still concerned with art-world issues that differ significantly from anthro-pology's consideration of cultural heterogeneities.

Such challenges to boundaries between high and low, high art and mass cul-ture, have circulated as a major challenge to art theory as well (see Danto 1986) since Pop Art resurrected the Dadaist questionings of Duchamp and others. In the recent development of this theory, both artists and critics have drawn on (and produced) a range of current ideas about "power," "multiculturalism," "male domination," and so on, to inscribe challenges to boundaries of distinction and exclusion. Indeed, for anthropologists, "boundaries" should themselves be subject to consideration.

The underlying tension in the debates that participants find difficult to acknowl-edge is the necessary survival of the category and institution of "art" for its own cri-tiques. Why, after all, be "an artist"? Why not just be done with the whole busi-ness? This is a question of genuine anthropological interest. As the essays in this volume show, the position through which anthropologists interrogate "difference" diverges from the art critical procedures that depend on oppositional or critical postures. To be an anthropologist is not merely to pass claims to intrinsic or tran-scendent value for artistic productions through the lens of other cultural construc-tions in order to recognize their nonuniversality (and therefore cultural particu-larity). The trope of such comparisons has, indeed, long been in use both by anthropologists and by critics within the art world, with relativism providing a form of critique that effectively decenters taken-for-granted authority. To be sure, the usual course of anthropological study—participant observation—accomplishes this. But in doing so through a *living subject*, such methods have meant learning to "go native" in a sense (see Kirshenblatt-Gimblett, this volume), which implies more than a conventional positioning as a cultural critic in opposition. Goldstein's and Steiner's essays in this volume provide exemplary cases of the value of under-standing something of their subjects' conceptions of things, how they use them, in what contexts, and so on. Thus, ethnographic practice is both suspicious of any essentialisms of "cultural difference" and also wary of presenting *its* knowledge as challenging the *absolute* truth claims of participants. Ethnography, a research process "in which the anthropologist observes, records, and engages in the daily life of another culture . . . and then writes accounts of this culture, emphasizing descriptive detail" (Marcus and Fischer 1986:18), has considerable power in dis-cerning the significant features of cultural worlds that must be recognized through the veil of multiple representations (see Myers 1988b) and in discerning the capac-ity of acting subjects to comprehend the world(s) in which they live.

Not only does this approach militate against judging the value of practices in schemes external to them and against accepting intrinsic claims to truth, but it

also turns attention to the question of how such practices and products are *made* to have meanings or are signified. Again, to take an example from this volume of what close readings can illuminate about hegemonic processes, the creation of the Indian Art Market was not the simple, inexorable development of an American national imaginary,[14] but was, as Mullin's essay shows, the product of a complexly located group of upper-class women whose interests, concerns, and dreams neither match nor reflect those of profiteers or politicos. The essays in this book are not concerned to castigate art-world processes as ethnocentric, but rather to understand them as one would a domain of value production in any society. We are interested in how discourse(s) about "art" and "art making" circulate broadly within society—within the art world proper as well as within the other institutions, such as primary schools, universities, and government funding programs, that might be considered its auxiliaries.[15]

Readers will recognize that such a position obviously shares space with the considerable postmodern criticism of the universalizing and essentializing narratives of "art" (see Foster 1983:261, for example). Perhaps one of the most challenging properties of art culture as a field for theory is the extent to which the arts recognize the significance of culture as an arena of contest.[16] Here, of course, many of *our* analytic models may be indebted to the very art-world debates we now propose to "study." However, once ethnography makes art criticism itself an object of study inseparable from the production of the art on which it purports to comment, then the key issue of the integrity of such criticism is foregrounded. Far from being a devastating question, this issue of criticism from within that nonetheless continually reproduces the value of autonomy provides a key stimulus to probing the multiple valorizations of the idea of culture in the West.

Anthropological writing on art worlds, while it may come to have close similarities with the positions of art criticism, is significantly different from those positions in that it is not normative or prescriptive about the production of art itself. We do not challenge the claims of those, for example, who inscribe art practices as "spiritually redemptive," but treat these formulations as signifying practices linked to others. Our writing is not, at the moment, concerned with defining "art" but with understanding how these practices are put to work in producing culture. Nonetheless, the anthropologist's situation is not simply one of "wonderment" before this strange phenomenon because—as these essays make clear—art criticism and other art practices attempt to position anthropology itself as part of art's own legitimate concern with "all" of culture, within the discourses of art.[17]

THE TRAFFIC BETWEEN ART AND ANTHROPOLOGY

Why is the refiguring of the relationships between art and anthropology important? The significance of this project for anthropology rests in the fact that discussions in the West of cultural difference, homogenization, and heterogeneity have been prominently developed in the art world (see Foster 1983, 1985; Lippard 1991;

Owens 1983; Trinh 1989). Anthropologists have been prepared by the frameworks of modernism elaborated in the art world to undertake our very consideration of these problems. This has been the case, we suggest, since the rise of modernism in step with industrial capitalism in Europe and colonialism elsewhere. If anthropologists have tried, in recent years, to come to terms with these changing conditions (e.g., of cultural homogenization, mass consumption) as problems, the art world remains one of the primary arenas in which discourses about cultural values are being produced. To put this differently, how we feel about or judge "change," assimilation to Western patterns, and so on, has been determined by terms established within modernist discourses about art. Art continues to be the space in which difference, identity, and cultural value are being produced and contested.

Influence of Art on Anthropology

The influence of art discourses on anthropological theories and frameworks about culture is part of an internal history of the field yet to be written. If this is a subterranean and spotty history of influence, there are nonetheless some visible outlines. The clearest presence to be discerned is the long-standing (and unsurprising) reliance within anthropology on understandings of cultural production elaborated within the Western tradition of art and philosophy. This is perhaps most obvious in, but not limited to,[18] American anthropology, whose cultural theory has its roots in the very matrix of aesthetics and Romanticism from which modern art sprang.

In early Boasian anthropology, the inspiration of aesthetic theories was important, especially the neo-Kantian revival in German historical writing.[19] German historical writing and its attendant methodological claims for the need to understand actions from within their own historical context (a concern with "knowing from within") were significant in the formulation of such theories of culture and central to nineteenth-century debates in Germany that delineated differences between the "human sciences" and the "natural sciences." The very distinction of "idiographic" and "nomothetic," around which considerable anthropological debate has revolved (see Geertz 1973; M. Harris 1968; Kroeber 1952; Rabinow and Sullivan 1984), was earlier inscribed in the rise of Romanticism, emphasizing the subject and its body (the senses and emotions) as well as critiques of "scientism" and reason, and in the formulation of a philosophical basis for the new nation-states—precisely the same space occupied by the rise of aesthetics, concerned with the senses and the body (see Eagleton 1990).[20] The German historicists—Dilthey, Windelbrand, Rickert—had no small impact on the formation of anthropological conceptions of culture in the work of Boas, Kroeber, Lowie, and Sapir. Stocking traces Boas's recognition of a holism in culture—as "an integrated spiritual totality which somehow conditioned the form of its elements" (Stocking 1968:215)[21]—to Boas's contact with the German Romantic idealist and historicist traditions.

The influence of modernist art doctrines is clearer in Boas's work on "primitive art" (1927), which seeks to demonstrate that primitives may be "creative" and "individualist"—the very terms valorized by modernist understandings of culture-making.[22] Thus, the producers of Alaskan Eskimo needle cases (Boas [1908] 1940) were not passive recipients of tradition, as were Beaux Arts salon artists whom Manet and his compatriots sought to define as "academic artists." Instead Boas saw them as innovators. They thus bore a striking—and humanizing—resemblance to the individualistic avant-garde which addressed its art to the changing experiences of modernity or challenged the institution of art itself.

An association with aesthetic theories and historiographic concerns is perhaps most marked in Kroeber's work (1923, 1944, 1952), which regards "style" and "pattern" as fundamental to the organization of value culture.[23] Drawing on a sense of culture as a set of organizing principles, intrinsically patterned, Kroeber's writings coincided with the development of neo-Kantian gestalt perspectives in psychology that emphasized the role of configuration in the significance of particular elements, and with the beginning of the modernist appreciation of "form" as distinct from referential content.

Kroeber had significant differences with Edward Sapir, as embodied in the debate about the superorganic nature of culture (see Kroeber 1917; Sapir 1917), but Sapir, Mead, and Benedict all seem to have drawn heavily on the framework of "patterning" that Kroeber first elucidated. Sapir and Benedict especially turned in a direction more explicitly linked to art theory, in their concern with the aesthetic and temperamental "fit" between an individual and his or her culture (see Benedict's last chapter in *Patterns of Culture* [1934]). In his brilliant essays "Culture, Genuine and Spurious," and "The Meaning of Religion," Sapir (1970) began to establish a critical stance on "culture" that not only evoked a very modernist questioning of received traditions in favor of "self-expression," but also articulated the centrality of "authenticity" and "creativity" in considering the ordinary activities of culture. These terms are precisely those formulated within the discourses of early twentieth-century art. A genuine culture, Sapir says:

> is the expression of a richly varied and yet somehow unified and consistent attitude toward life, an attitude which sees the significance of any one element of civilization in its relation to all others. It is, ideally speaking, a culture in which nothing is spiritually meaningless, in which no important part of the general functioning brings with it a sense of frustration, of misdirected or unsympathetic effort. . . . (Sapir 1970:90)

Similar themes drawing on Dilthey's work, gestalt psychology, and Nietzsche are developed in Ruth Benedict's famous *Patterns of Culture* (1934), with its nostalgia for aesthetic integration within harmonious patterns of cultural life. Nonetheless, Benedict's work also shows the ambivalent, critical stance toward some of the central categories of Western modernity (and the contradictions of avant-gardism) that anthropological work on "the primitive" offered, especially with regard to the individual/society opposition:

There is no proper antagonism between the role of society and that of the individual. One of the most misleading misconceptions due to this nineteenth century dualism was the idea that what was subtracted from society was added to the individual and what was subtracted from the individual was added to society. Philosophies of freedom, political creeds of *laissez faire*, revolutions that have unseated dynasties, have been built on this dualism. . . . In reality, society and the individual are not antagonists. (Benedict 1934:251)

Lévi-Strauss recognizes his debt to earlier notions of "patterning" in his self-proclaimed affinity to the Boasian tradition (1971), and in his study of Northwest Coast masks (1982). James Boon, however, suggests another pattern of interchange as significant in Lévi-Strauss's structuralism, which he understands as drawing significantly on ideas developed in French Symbolism (see Boon 1972). Indeed, Lévi-Strauss's presentation of the ordering processes of "savage (undomesticated) thought" in *The Savage Mind* (Lévi-Strauss 1966), the well-known "Science of the Concrete," assimilates the cultural production of Aboriginal Australians to recognizable processes of twentieth-century art. Both are opposed, as well, to an abstracting Reason/Science. Specifically, Lévi-Strauss's analysis is indebted to principles of collage developed by Surrealism.

The borrowings are clearer still after World War II, when modernist understandings come to have a prominent place in anthropological cultural theory, especially within forms of symbolic analysis. One thinks of Geertz's (1973) borrowings of the concept of "significant form" from Langer (1942, 1953), who developed it specifically to justify aesthetics as a way of knowing in contrast to logical reason; of Turner's (1969) interest in ritually-produced *communitas* as a means of transcending the fragmented (or divided) condition imposed by the categories of everyday life; and of the universalization of the "problem of meaning" (see Asad 1983) in an existentialism-based symbolic anthropology. Surely, the meaning-seeking person postulated in Geertz's "Religion as a Cultural System" (1973) owes some inspiration to Joyce's modernist artistic hero, Stephen Daedalus, as well as to those existentialist theologians of a fractured modernity—Nietzsche (1967), Kierkegaard (1945), Bultmann (1958), Tillich (1952)—who figured so heavily in midcentury European literary work.

The recent[24] anthropological uses of Russian Formalism—itself a movement of the 1920s and 1930s and a key component of the avant-gardes—have a similar, even more definitive, debt. In Jakobson's (1960) model of communication, language can speak (referentially) about the world, but "poetry" is defined by its relative embodiment of the *aesthetic function*, a function in which linguistic signs come to be valued not for what they transparently refer to (their signifieds), but for their combination as material, palpable entities. As for painting, in which the representational function is displaced by the painterly (see Greenberg 1965; Greenberg is also a figure who came of age in the 1930s), so in poetry the organization of the sound quality of the signifier becomes a central concern. What is interesting about these borrowings is that while Western anthropologists use such theorizing

unproblematically as bases for interpreting other traditions, they often do not recognize that the categories they so deploy have been contested in their own culture's historic debates about art and the aesthetic.

The Influence of Anthropology on Art: The "Primitive"

The history of the relationship between art and anthropology in the other direction is perhaps more important for us here—namely, the appropriation of anthropological interests by the art world in producing art, in writing about it, in marketing and creating a taste for it. This relationship is most traceable in the intimate connection between the development of modern art and the figure of the "primitive."

The "primitive" has been a token of "otherness," and thereby an image from which projects of cultural criticism could be developed. Once the central province of anthropology's identity and scholarly location, the "primitive" has also been a central figure in modernist art practice. In so doing it has partially replaced the figure of "otherness" embodied by classical antiquity for the Renaissance and by medieval Europe for the "arts and crafts movement."[25] The European tradition of such "primitivist" yearning for unbroken community has been a long one (for example, the work of historian Henri Baudet 1965 and of anthropologist Jonathan Friedman 1983). If both art and anthropology have continued to retain their locations as arenas of cultural criticism, however, the concept of the primitive is no longer stable for either discursive community. What is of interest at the moment, therefore, is its changed significance.

While it was hardly central in an explicit way to anthropological *analyses,* the figure of the "primitive" was frequently offered by anthropologists to represent themselves to diverse publics at home. This is a connection that has been the subject of much retrospective attention in artwriting (as in the flurry of criticism of the MoMA's now extremely well-known show, *"Primitivism" in 20th Century Art: The Affinity Between the Tribal and the Modern*)[26] as well as a primary focus of the cross-disciplinary concern with museums and issues of representation (see Clifford 1988; Karp and Lavine 1991; Price 1989). Moreover, the manner in which the visual products of non-Western peoples have provided inspiration for "art" developed in the "modern" West has been the subject of a substantial literature and criticism.[27] Scholars have noted, for example, that the work of "primitives" has provided new and "different ways of seeing," highly valued by an avant-garde concerned not only to challenge existing *visual conventions* as limitations on perception and imagination, but also in search of new ways to attack the status quo—whether with urinals or with "primitive art"—and in pursuit of alternatives to fragmented *modes of being* where art and aesthetics are divided from life as defined by rationality, mass production, capitalism, and the commodity.[28]

Historians disagree considerably in their understanding of the emergence of such a set of discursive practices. Baudelaire's ([1846] 1982) concern with the "heroism of modern life" and its lack of comfortable certainties is conventionally

regarded as a turning point that coincides, roughly, with (1) Manet's move away from academic formal conventions and toward a genuine art market that underwrote art's turn toward its own properties, and follows on (2) Courbet's development, after the revolution of 1848, of an oppositional art that questioned art's own status in society (see Clark 1982; Blake and Frascina 1993). Others regard the development of alternative technologies of representation (for example, photography) as either freeing painting from its historical limits or as forcing it to find a new mission in its placement(s) vis-à-vis the social world (Danto 1986).

A common view is that transcendence of the fragmented, dislocated nature of contemporary life in the industrial era is a central concern of high art (see Miller 1991:52). In this analysis, "primitivism" is essential to the contemporary category of "art." The "primitive" other (and its represented reality)—as evidence of the existence of forms of humanity which are integral, cohesive, working as a totality— functions not merely as the critical opposite to such an experienced world, but also permits the very characterization of the "modern" *as* fragmented. Likewise it enables contemporary mass culture to be experienced as "spurious" and somehow "inauthentic."[29]

The trope of the "primitive" continues to exercise considerable rhetorical power in the present, and not simply in New Age frameworks, as demonstrated by the much publicized Parisian exhibition, *Magiciens de la terre* (see Buchloh 1989), by the continuing boom in the sale of "genuine" African art that has not been in touch with the contaminating hand of the West or the market (Steiner, this volume), and by the critical responses to Aboriginal acrylic painting discussed by Myers (this volume). Thus, the critic Robert Hughes's review (in *Time*) of an exhibition of Aboriginal acrylic paintings in New York is not surprising; he indulges in a form of nostalgic primitivism—as opposed to a rebellious, iconoclastic embrace of primitivism—suggesting that the paintings offer a glimpse of the spiritual wholeness lost, variously, to "Western art," "Western man," or "modernity":

> Tribal art is never free and does not want to be. The ancestors do not give one drop of goanna spit for "creativity." It is not a world, to put it mildly, that has much in common with a contemporary American's—or even a white Australian's. But it raises painful questions about the irreversible drainage from our own culture of spirituality, awe, and connection to nature. (Hughes 1988:80)

For us, the important points in this historic relationship are three: First, the concerns of anthropology have been one primary source of innovation for the creation of avant-garde work in the modern art world, a key source of difference on which the engine that powers "art of the new," "creativity," aesthetics, social critique, taste, respectability, desire, and so on, has run. Second, the assimilation and placing of anthropological discourse within art's own field has always been one of the operations of art discourse (in other words, that anthropological concerns have always been perhaps more of a motivated part of art world concerns than vice versa, or than anthropologists have tended to be aware). Third, this use of anthro-

pology by the art world has depended upon the authority and concepts that have constructed anthropological knowledge about "the primitive" having a certain stability. This stability has assisted modern avant-garde artists in their production of the art world through "shocks of the new." Thus, by defining "difference," figures such as the "primitive," the "exotic," or the "tribal," albeit decoupled from any sense of culture as the context that shapes them as a different form of life, served to disrupt dominant conventions during several moments in the history of modern art.

Yet, for the "primitive," however decontextualized or disembodied, to serve this function of defining a more or less stable, critical view of the modern in contrast to what went before in European civilization—that is, to stand for difference—it was necessary for a very stable source of alterity or difference to exist. This was established by anthropology's project of studying non-Western peoples. The stability of this source of "difference," however, is very much in doubt as a further example from Myers's paper (this volume) illustrates: If, in Hughes's estimation of Aboriginal painting, their "otherness" (spirituality, closeness to nature) occupies a world without much in common with ours, other accounts of this very same show illuminate the unstable quality of the "primitive" sign. One critic represents the paintings themselves as a fall from authentic primitive otherness (Schjeldahl 1988), while others attack the production of such a "spectacular primitive" (Fry and Willis 1989).

The essays in this volume analyze quite distinctive historical and cultural sites for the production of value for the "primitive" and, correspondingly, offer serious criticism for any claims for art's autonomy from other cultural processes. Mullin's essay, for example, provides insight into the underlying linkage between the recognition of the aesthetic worth of the exotic tribal and the construction of gendered, regional, national—and even global—identities. In writing of the development of the Indian Art Market in the Southwest U.S., Mullin shows it to have been valorized both in the economic development of the Southwest as a tourist destination, and in the context of providing, through the agency of upper-class, educated, East Coast women after World War I, a critical alternative to a European-derived aesthetic and cultural capital. The Indian Art Market was to be a basis for a distinctive and independent American national culture and identity (a pursuit of national cultural identity that was later achieved, in a different mode, by Abstract Expressionism in New York [see Guilbaut 1983]). In considering how traders fashion and market images of Africa and African art, Steiner (this volume) demonstrates the importance of the continued production of "the primitive"—whether conceived to be in the past or in some remote present areas—as a concomitant of the practices of brokerage in and the spatial organization of the African art market itself. His paper shows how the coexisting "primitive" and "modern" participants are brought together, bounded, and reproduced by art traders who "construct a product from raw materials and conceptual tools which are limited and predetermined by elements outside [their] immediate control."

Such coexistence of "primitive" and "modern" undoubtedly has taken many forms, one sort being articulated in the history of travel, tourism, and world fairs (see Breckenridge 1989; Kirshenblatt-Gimblett 1991a; Mitchell 1989; Stocking 1987), and possibly including the relationship between the "naif" painter Henri Rousseau, peasants, and folk art and modernist art. A particularly well-known case, certainly, is the anthropologically famous one of Bali, in which Western understandings of the intrinsically "artistic" Balinese emerged from the writings of a rich mix of avant-garde artists, anthropologists, and other visitors, who were cosojourners in this mythically enchanted isle (see Boon 1986).

For anthropologists, too, especially those in the American tradition, the "primitive" historically provided a critical distance on Western practices and ethnocentrism, an alter/native to what existed as seemingly natural and inevitable in our own societies (see Marcus and Fischer 1986:134). There is a long tradition of such a critical romance with the "primitive"—dating most significantly from Rousseau's *Discourse on the Origins of Inequality* ([1767] 1992) and its well-known construction of "man in the state of nature." Critical discussions of the nostalgia or longing for a simpler, more direct, and unmediated experience of social life have become something of a cottage industry (Stewart 1984; Torgovnick 1990), but it is clear that anthropologists have not ceased entirely to portray these cultures as "on the wane" and that this sense of impending loss is still poignant in ethnographic writing (see Stocking 1989).

One might acknowledge the force and significance of many of these critiques of anthropological "nostalgia" and yet still wish to part company with their monochromatic vision of the romance. While it has insisted on the relevance of understanding such "others" for any self-understanding, anthropology's stance in relation to the romance of the "primitive" has been complex (Stocking 1989). For example, Durkheim (who had written on Rousseau himself) clearly viewed the emergence of modernity and individualism's attendant anomie in light of a presumed loss both of community bonds and of a sense of a transcendental sacred ([1884] 1984, 1915). In the hands of Lévy-Bruhl, similar concerns led to several works on "primitive mentality" (1923, 1984). Perhaps such modernist speculations about a Being grounded in something beyond the individual are rooted in the response to the terrors of the French Revolution (see Dumont 1983; Tocqueville 1955). The significance of such concerns for French cultural theory (mediated, it would seem, through Mauss) is continued in the theoretical speculations of Bataille (1988), Artaud (1958, 1976), and finally Lévi-Strauss (1966, 1971). Derrida's (1977) critique of the suppressive dimensions of representations of the primitive linked to such a critical position has a powerful presence in cultural studies and the art world as a critique of "anthropology," with little awareness of Lévi-Strauss's own cultural specificity or of the different national academic traditions that have shaped anthropology's stance toward the "primitive."

Anthropology's position toward this "primitive" is, in fact, very mixed, responding more powerfully and situationally against representations of "primitive" oth-

erness as *inferiority* that denied them fully human status, as in the work of the twentieth-century pioneers, Boas and Malinowski. Both men criticized as deeply ethnocentric the characterizations of non-Western peoples as *essentially* different in virtue of their "primitivity"—that is, as group-oriented, uncreative beings. Rejecting the evolutionism that gave the concept of "primitive" a position on the developmental line preceding the rise of Western civilization (Locke's view that, "In the beginning, all the world was America"), Boas and Malinowski allowed the concept of "primitive" no *specific* content: People everywhere had histories, conventions, and cultures of their own; they were individuals; and they pursued individual strategies.[30]

Indeed, in most studies of non-Western, small-scale societies, the concept of the "primitive" was hardly central to analysis of how the society itself worked. However, the contrast continued to have an importance for anthropologists in a public relations context, so to speak, one that involved relating anthropological knowledge to the commonsense categories of middle-class readers and students. Not only did anthropologists continue to use the term to characterize their difference as scholars from those who studied other sorts of societies, but they drew easily on the romantic trope *in the service of* addressing constituencies in their own culture, rhetorically stitching together for the latter explanations arguing that such cultures had a recognizable value. Anthropologists did draw the line, however, at one dimension of modernism's construction of "the primitive": they rejected the ethnocentrism of Modernist artists' attributions of meaning to "primitive" African and Oceanic art, especially when the artists resorted to a language that verged on racism itself ("the genius of the race") in an effort to place these images as an expressive challenge to conventional rationality. Nonetheless, in some cases, anthropologists may have appreciated the artists' "respect" for these works as something more than (as yet) undeveloped forms of Western art (Firth 1992). Clifford (1988) suggests as much in his discussion of the shared enterprise of cultural critique in the intersection of French Surrealism and ethnology in the 1930s.

Despite these rather obvious contradictions within the practice of anthropology, the category of "the primitive," like that of the Orient (Said 1978), remained relatively stable or unproblematic for anthropologists until the historical relations between us (anthropologists, Westerners) and them (non-Westerners) became impossible to ignore, either in critiques of colonialism (Asad 1973; Hymes 1974; Wolf 1982) or in more deconstructive critiques of anthropological writing. Thus, the construction of "primitives" and "others" as outside history, in a timeless present that is not really contemporary with us, has been persuasively criticized by Fabian (1983) and others. Derrida's (1977) critique of Lévi-Strauss's romantic representation of precontact Amazonian Indians is, as noted above, also well-circulated as an example of the cultural (primitivist) fashioning of such constructions as functions of "our" own imaginations. With our consciousness of the world becoming more global and historical (through travel, communications, and so on), these resources within anthropology no longer have the critical, reflective appeal they

once did. To invoke another culture now is to locate it in a time and space contemporaneous with our own, and thus to see it as part of our world, rather than as a mirror or alternative to ourselves, arising from a totally alien origin.[31] Swamped with automobiles, televisions, popular music, and Western clothes, those once formulated as "primitives" who inhabited a different world, so to speak, will no longer work as a trope of "difference" from which a credible imaginative grasp of "our world" can occur.

THE POSTMODERN DESTABILIZATION OF THE RELATIONSHIP BETWEEN MODERN ART AND ANTHROPOLOGY

In the last two decades, there has been a severe disruption of those relationships between the modern art world and the subject of anthropology that we have just sketched. This disruption includes changes in the way disciplines define their subjects of study as well as in the subject/object they once studied. Such changing relationships are part and parcel of the debates about postmodernism, which—while particularly generic to art and architecture—have occurred across the entire range of the human sciences. To some degree, the sharing by both anthropology and art of a "problematic of postmodernism" (certainly not exactly the same problematic, but with resemblances nonetheless) has made their historic relationship more explicit and obvious. The conjuncture has created the opportunity to address a shared history and to reassess it, as we are doing here. Because the possibility of a new relationship between anthropology and art rests on the consequences of the disruptions wrought by a fundamental shift in the history of modernism—known as postmodernism—we should examine the character of these disruptions.

Postmodernism, together with a variety of intellectual influences (for example, the dissemination of French poststructuralist thought) and social causes (for example, the decline of the welfare state and post-World War II liberal optimism), has effectively undermined the institutional authority that has underwritten intellectual practices and standards in a number of disciplines. It has done this primarily by generating a powerful skepticism toward various kinds of rhetoric and practices of representation in language and other media. In turn, such effects have radically destabilized the categories which secured the relationship we have described between modern art and anthropology. The key disruption for anthropology and modern art was an undermining of the categories that made difference systematic, interpretable, and ultimately meaningful as a mode of cultural critique, a function that empowered much of twentieth-century anthropology (the "primitive" as a utopian or merely bizarre alternative to Western routine and common sense) as well as much of twentieth-century avant-garde art. The latter has been preoccupied with the question of art's autonomy: it has displayed cycles of moving away from—for example, Surrealism—or toward—for example, Abstract Expressionism—sustaining the boundaries between art and the experience of the everyday.

What became destabilized were the discursive practices for constructing difference, alterity, or otherness, practices in which both anthropology and art had a deep interest (although in different ways) and on which their mutual relationship depended. The strong bond between anthropology and art still resides in this mode of constructing cultural value by positing or evoking difference. And now it is just this relationship that—under the influence of postmodern disruption—must be renegotiated. For anthropology, this means undertaking critical ethnographic studies of the art world, for which the papers gathered in this volume stand, a world which is, we have suggested, a distorted mirror image of anthropology's own history and concerns.

"AN ETHNOGRAPHIC AVANT-GARDE"

In this brief section, we take up a powerful irony in the traffic between art and anthropology. For anthropology, in particular, postmodernism has meant the delegitimation of the "primitive" as an appropriate category or emblem with which to present itself to its publics, including the art world. This delegitimation has come about by absorbing some of the aesthetics of classic avant-garde modernism (such as techniques of pastiche or the concern with "performance"). For what one might call an "ethnographic avant-garde," instead of "whole" cultures of extreme difference in the contemporary world, whose codes and structures might be subject to perfect translation and interpretation, anthropology is faced now with the interpenetration of cultures, borders, hybrids, fragments, and the intractability of cultural difference to such authoritative interpretation (see Abu-Lughod 1993; Appadurai and Breckenridge 1988; Clifford 1988; Marcus and Fischer 1986; Myers 1988a; Rosaldo 1989; Taussig 1987). Heterogeneity has replaced pluralism. Anthropology, now aestheticized by modernism's conventions, can no longer provide a stable foundation for art's attempts to destabilize the West. This should mean, of course, that the art world ought no longer to count on *its* conventional notions, guaranteed by anthropology, of cross-cultural alterity. Nonetheless, for a variety of reasons, the art world has largely gone on constructing "the primitive" even in its own postmodern dislocations. At least part of the appeal of Aboriginal acrylic paintings, as we have noted (Myers, this volume), continues to rely on the sense of Aborigines as "primitives." What is appealing about the avant-garde use of the "other" in the LA Arts Festival, in Kirshenblatt-Gimblett's account (this volume), is the effect of incomprehensibility itself.

The ethnographic avant-garde, often labeled "postmodernist"[32] by anthropologists, is still in the minority of practitioners of anthropological research. Yet it has clearly struck a nerve about the sorts of problems that confront an anthropology of a contemporary world in which past conceptions of its subject matter are inadequate. For some, the conundrum has called for a Nietzschean skepticism (see Tyler 1986, 1987). For others, the response has been a call for anthropology to reconfigure its objects and projects of study in so-called postmodernity through an

ethnographic attention (as always) to local situations, traditions, and discursive practices but one which pursues a more demanding project of cultural critique (Marcus and Fischer 1986). In such a critical project, earlier "us-them," "primitive-modern" dualisms are to be superseded by ways of thinking, rhetorics, and realities that struggle with essentializing formulations of difference. The key initial task for the project remains one of refiguring the relation of anthropology itself to its objects of knowledge and to fields with which it has been historically related, such as the study and production of art.

THE POSTMODERN ART WORLD

Postmodernity has crystallized as a reflexive issue for the art world not by a natural progression of logic, but by two significant social conditions of art's production: recent inflationary markets and the censorship issue. Each inflects constructions of art's autonomy—or boundaries—in challenging ways that contest the meaning of artistic activity.

Art and Money

For the art world, the condition which has most signaled the currency of postmodernism has been the inflationary art markets of recent years. Such inflationary markets have focused obsessive attention, both in the general public and among participants in the art world themselves, on the intimate association of art with money in every respect. In so doing, they have destroyed any illusion, perhaps crucial to the historic formation in modern times of the category of art itself, that its discourse on cultural aesthetic value could be autonomous (see Sullivan, this volume). Postmodernism, with its emphases on loss of previous premises of authority, has arisen in the art world from the forced realization that aesthetics and money are intricately entwined (see, for example, Baldessari et al. 1990; Gast 1988; Princenthal and Drier 1988; Ratcliff 1988).

Indeed, as we discussed earlier, the whole history of art as institution and cultural operator might be understood as a debate about its autonomy or the possibility thereof, about the "problem" of autonomy. There are many narratives of these developments in European social life that led to the central concern with the separation of an autonomous, separate, "aesthetic dimension." Most narratives trace the elaboration of such a doctrine of art's autonomy to Kant's *Critique of Judgment* (1951) and his argument that aesthetics was a universal category of human experience that was irreducible to utilitarian principles and exchange-value. However one understands the social conditions for the emergence of this split, the significance of claims about art's autonomy and separation from the mundane dimensions of social life has been wide-ranging. It has ranged from the eighteenth-century philosophical concern to construct a basis for bourgeois citizenship in a domain that transcended narrow, sectarian interests (see Eagleton 1990); to

Courbet's "oppositional" art (Clark 1982); to claims by Modernist theorists that Manet's painting constitutes a rejection of art's conformity either to the formal dictates of the salon or to its reduction as a medium for communicating other moral values; to Impressionism's (and then Fauvism and Cubism's) further detachments from representation as painting became, increasingly, "about painting" rather than about the world; and finally to the historic avant-garde's embrace of an "oppositional," critical stance to the *institution* of art, the separation of its values from those of ordinary life (see Bürger 1984). These moves are frequently identified with the doctrine of "Modernism" that, in Clement Greenberg's famous formulation, strips away everything "nonessential" to an artistic medium.[33] Thus, we have Jakobson's (1960) concept of an "aesthetic function" in which signs come to be valued not for what they refer to (as signifieds) but for their combination as material, palpable entities. Postmodern writers have criticized such a Modernist doctrine— one that emphasizes the "self-sufficiency" of aesthetics and the art form's "self-designating" absorption with itself—for failing to recognize its own communication and relations to the world, to history, and to the cultural values or social context which underpins it.

One significant insight of postmodernists has been that formalist definitions are projected and circulated partly as defensive responses to a surrounding context— to the threat to "art," for example, of theatricality, entertainment, kitsch, and mass culture—threats specifically addressed in the formulations offered by Clement Greenberg ([1939] 1961), Michael Fried (1967), and Theodor Adorno (1983). Critically-oriented postmodern theorists, such as Rosalind Krauss, Hal Foster, Craig Owens, and others of the *October* group, as well as more straightforward sociological critics such as Pierre Bourdieu (1984), see art's defensive strategy of self-definition not as a neutral fact, but as a form of cultural production, an exclusionary, boundary-maintaining activity, a hegemonic exercise of power through knowledge (see also Crow 1987).[34] They approach the disputed boundaries of "art" and "non-art" (or "painting" and "theatre") as products of power, questioning the power and taste-making capacities invested in institutions and canonical traditions (see DiMaggio 1982). In the work of these critics, the focus on the "aesthetic" as a time-less principle is challenged, although their own very critical activities seem to presuppose, dialectically, a category of "art" and "aesthetic" that defines the domain of their practice. In their attacks on the industry and institutions of art, these and other avant-garde critics attempt to confront the fetishization of art making as a special principle of human activity. This fetishization is partly captured in the concept of a transformation of art-for-use-with-beauty into art-for-beauty, which transformation Joseph Alsop (1982) insists is the regular concomitant of art collecting and an independent art market.

The issue of the autonomy of art—its metaposition to create critical cultural value, a higher aesthetics—has been debated in a variety of ways, and the avant-garde has always vacillated between formalism and reinforcing this autonomy, on the one hand, and radically trying to collapse, or explore, the relationship between

art and life, on the other. In modernity, whatever the issue on autonomy, art has had a privileged position in social and cultural critique.[35] A strong sense of the autonomy of art in modernity, on which its authority depended even for avant-garde experiments and social criticism, could be preserved as long as no one participating in the art world looked at their own conditions of production and relationship to structures of capitalist society like market dynamics (see particularly the papers by Feld, Marcus, and Sullivan, this volume). Even those who wanted to collapse the relationship between art and life subtly depended, through their mere participation in given art institutions, on this autonomy. As long as the possibility of autonomy remained an inherent part not only of art discourse but also of art production, the art world itself would be very limited in its reflexive critical ability.

While it is indeed one of the key features of modernist aesthetics that art practices call attention to their medium's material properties, and even though the efforts of previous avant-gardes could sometimes be seen as an effort to alter the institutionalized commerce with art, the art world's potential for radical critique was undercut until the prolonged and unprecedented inflationary growth in the art market. As the nervous discussions in art journals throughout the booming 1980s suggest, this inflation—seeming to stimulate the production of differences and production value for a market—has radically undermined ideas about autonomy or of being in control of one's visions. This development was also central to the rise of "performance art," "conceptual art," and other refusals to produce a "commodity"—although these moves were not necessarily successful (see Marcus, this volume). In a sense, the postmodern art market has made the attack on autonomy much more personal for art-world people. It is not just that art is *implicated;* the fact of money value as fundamental or as inextricably entwined with aesthetic value is more apparent and undeniable than it ever has been (see Ratcliff 1988; Solomon-Godeau 1988). Judging from recent issues of the principal art journals, it has become impossible to talk of aesthetics without talking of money.

The question, then, is what is the art world going to do about it? There are all sorts of transgressive gestures in contemporary art—of self-conscious fragmenting, the pairing of high and low, the merging of high art with kitsch, of repeating Duchampian experiments—but what is interesting is the extended process of art production itself in this era of inflated values. If art is no longer conceivably separate from life (not everyday life as such but the commerce of hypermodern life—as the inflationary markets make apparent) now that the boundaries which sustained art's separation, if not autonomy, have been powerfully breached, what are artists and other makers of artistic value (dealers, curators, etc.) to do?

The responses are complex and varied, and not (to be sure) without self-awareness. Many artists are both knowledgeable about the circumstance and infatuated by the possibilities of fame, fortune, and fashion—a situation endlessly presented in discussions of Julian Schnabel, Jeff Koons and others in the 1980s (Sullivan, this volume). Cynical despair is, perhaps, the closest pairing to this development, or else waiting nervously for the end of the inflationary cycle (as has begun to occur in the

'90s). On the other hand, there are also those who have organized politically against such an assimilation of art to fashion and commerce; examples of such alternative responses include the Guerrilla Girls, the Studio Museum of Harlem, and MOCHA (Museum of Contemporary Hispanic Art). Artists like Lichtenstein, Warhol, and Kruger consciously move the critique of money and art *into* their work.

Clearly, a creative response to accepting the corruption of money and the loss of autonomy is difficult. We think one such response lies in a different sort of engagement—a renegotiation of relationship—with allied fields, such as anthropology, on which art has always relied for certain sorts of inspiration. It requires accepting the loss of autonomy and making something positive of it—redefining the boundaries and modes of assimilating influence in order to produce art. This is what the critical ethnographic study of art can proffer from its side.

Postmodern Art and Politics

The other major condition which has given rise to postmodernism as defining the contemporary art world—also linked, significantly, to questions of money or patronage—is the cultural and political right wing's assault on art funding (see Vance's essays, this volume). There is the "culture war" marked most overtly in the controversy over Robert Mapplethorpe's photography and over NEA grants and policy, but also—from the other side, as it were—with considerable, if not equal, political force by feminist, postmodern, and marginalized communities' critiques of Modernist aesthetics as complicit with cultural hegemony. Thus, art is political in ways that the progressive-minded historic avant-garde did not perhaps foresee: the social construction of the arts has become a celebrated issue in the national politics of the United States. The "arts community," as it has come to be named, regards itself as embattled within the larger polity as the nature and significance of artistic production are contested. These processes are only comprehensible if one follows the logic of ethnographic inquiry and starts with the terms of debate of the relevant social actors.

The contest extends far beyond the comfortable and relatively academic confines of recent considerations about the boundaries between high and low culture, such as those explored in the MoMA show curated by Kirk Varnedoe and Adam Gopnik (1990). The conflicting critical responses (for example, Kramer 1990; Kruger 1990; Stevens 1990) to the cultural and political location of "high art" in this show—an exhibition which is itself only the latest and relatively mild provocation in a process that Harold Rosenberg (1972) described, negatively, as the "de-definition of art"—now appear as a vanguard precursor to deeper cultural struggles.[36] Federal support for avant-garde art's traditional transgressive activities and doctrines of "artistic freedom" have been coming under attack from the New Right's expanding agenda of cultural reform—most notoriously in the case of the Robert Mapplethorpe exhibition and the exclusion of Karen Finley and others from funding on account of "obscenity" (Vance, this volume; see also Hughes

1992; Carr 1990; Hess 1989; Bolton 1992). Senatorial attacks on a revisionist exhibition that reexamined artistic representations of American westward expansion—"How the West Was Won"—received substantial coverage in newspapers and it was withdrawn from its planned circuit to other venues (Deitcher 1991). And, perhaps more humorously, in the 1992 election former Vice President Dan Quayle attempted to link the censorship of a transgressive critical culture to conservative concerns about more mainstream media representations generally by challenging an unnamed "cultural elite" who (he alleged) has no respect for moral values.

There is an irony, here, of considerable proportion, and perhaps reason to question the recent proclamations about (postmodern) art's easy insertion into the political culture (see Werckmeister 1991). The boundaries of art and culture are being breached on both sides. Many artists and critics have been insisting on the intrinsically political dimensions of artistic practice, celebrating its provocative, challenging dimensions and criticizing the arbitrary boundaries that an earlier high art discourse (for example, of Greenberg and Adorno) had established between fine arts and popular culture, between politics and art.[37] Do these critics simply follow in the longer history of challenging, upholding, and redrawing the boundaries, of challenging the "institution" of art (see Bürger 1984)? What is at stake, therefore, and what is of interest in the destabilizing of boundaries?

Considered as an emerging pattern, we take these debates to be illustrative of a complex situation in the contemporary art world (especially the American one), illuminating a range of discourses within which the arts are "made meaningful." Such a moment of contested significations, of ideological struggle, is all the more interesting when the arena of cultural production is one whose field of commentary is cultural value itself. Although these kinds of encounters reflect a fluidity in disciplinary and cultural boundaries that is itself a sociocultural phenomenon noted in writings about "postmodernity" (see Connor 1989:8–10, 61), in which the entangled boundaries between critical and sociocultural spheres are being redefined, we approach this condition not from a theoretical position but from an *ethnographic* one.

A significant intersection between art and politics is nothing new. The critical potential of inflationary art markets in particular, however, is that they undermine any possibility of sustaining the illusion of autonomy, even in its most subtle forms. What is left is criticism of the art institution itself. But as this comes from people who also now wish to sustain the autonomy of art in the face of controversies over government support for the arts, there is a bind: their strategy for sustaining a critical art requires government support or private philanthropy—that is, a nonprofit world in which to operate. With significant challenges being made to the bases in which art had once been included as a public good—either in the WPA period of the 1930s or in the Cold War battles of the '50s and '60s—such claims for support demand discursive developments, the imagination of forms of civic life in which "art" and its interventions might continue to have a place.

Politically, these recent developments have changed the notion of the "arts

community" in fundamental ways. The concerted attack on the NEA represents a challenge to such a community in ways that reveal its impotence, a tendency toward political posturing, and a potential lack of courage, which makes members of this community very uneasy. Contrastingly, it also enhances its sense of community and, perhaps, a sense of its own importance. At heart, the attack affects a very basic way in which the art world creates preferred images of itself—a liberating avant-garde against the repressive bourgeoisie, for example—and perhaps forces the sorts of changes we are suggesting: a radicalizing of the possibilities for internal critique.

SIMILARITIES THAT REMAIN AND DIFFERENCES THAT ARE ACCENTED BY THE CONDITION OF POSTMODERNISM

Despite the different effects of postmodernism, art and anthropology remain identified by fundamentally overlapping discourse fields concerned with culture and the value-making that is implied by defining culture. Indeed, with the explicit influence of aesthetic modernism on the ethnographic avant-garde, the historic relationship and overlapping discourses of art and anthropology have been made even more explicit. As in anthropology, postmodernism in the art world has led to visions of a thoroughly international world of operations that is radically transcultural. This is the vision of an operative space freed from past authorities, be they disciplines, markets, or nation-states. Whether such a vision is really emergent, already here, or just a form of utopian, hopeful thinking is unclear. It is, however, an aspect of change in vision that in some way (potentially) reunites the art world and anthropology through their own experiences of a postmodern change that has disrupted the nature of their relationship (see Feld's essay, this volume).

One major difference that has been highlighted by postmodernism is that art, as a field of knowledge or value-creation *about* culture, is situated very differently than is anthropology. This has been demonstrated to art-world participants and others by a combination of the inflationary art markets and the efforts to censor art through control of art funding. That is, art discourse and art production are very close to significant instrumentalities—large vectors of power and money—from which anthropology is relatively distant. The consequences of certain positions in art are much more substantive and immediate than the consequences of taking similar positions in anthropology. Art's proximity to power and money, as it were, comprises both a critique of art discourse and also its critical potential. Such an important difference between art and anthropology in their relative placement and embedding in substantive institutions of power and money is also, perhaps, a key to the renegotiating of their historic relationship.

Under these circumstances of the destabilized relationship between anthropology as a discipline and art as a producer of value in the interests of a particular cultural tradition, we now want to consider the renegotiation of this relationship for which this volume argues. From anthropology's side, the opening bid in such a

renegotiation would be critical ethnographic studies of contemporary art worlds. In such studies, the latter's practices and potential for cultural critique, as a common historical project connecting art to anthropology, would be one of the major interests of investigation. However, it is important first to take account of the character of art's powerful discursive field into which any such ethnographic studies would be received.

ARTWRITING

Artwriting—a term coined by Carrier (1987) to discuss a certain range of modern art criticism—is a useful means of representing a complex field of discursive practices that constitute the modern art world. This field includes not only the writing of art critics and scholars of various sorts (art historians, curators, literary critics), but also of artists about their own work, and occasionally of collectors and others. As Myers (this volume) recorded in an interview with a practicing artist, "We all need a good scholar to write about our work—art and words, that's what you need." This sense of the importance of context has been reflexively absorbed within the work of art producers themselves: As Marcus argues in his essay (this volume), the verbal images of contemporary artists who participate in artwriting are often much stronger than the material forms they create. In any case, the production of art has been accompanied by an increasingly complex field of interrelated writing on art that parallels and even creates the scene for event-making occurrences in the art world. Thus, newspaper and journal reviews often focus more upon catalogs and their essays than on relatively unmediated responses to objects, performances, and so on. These are clear indications that objects (or performances) only accumulate cultural value to the extent that they are inscribed in "histories."

This should give us, as a number of critics have recognized, a more encompassing analytic perspective on debates about the conception(s) of artistic activity and the category of art that have been so much a part of art history. Thus, neither the early debates about the avant-garde and modernism nor more recent framings of artistic activity in postmodern terms are *external* commentaries. They are neither part of a scholarly framework to be settled nor outside the production of art in which the boundaries between the "discipline" and its "object" are distinct. Rather, such debates comprise much of artwriting itself; they are quintessentially part of art's own constitutive narrative(s) and signifying practices, particularly enabling art to have a "history" (see Danto 1986, 1989, 1990). And history, or the narrative of art history, is central to the evaluation of paintings and other objects, whose importance is established by their place in a privileged story of culture and civilization. Hence, the power of museums lies not simply in their acquisitions and exhibitions, but also in the focus of attention among artists and other communities of interest (dealers, collectors, scholars) on the "evaluations" of museums and the complex narratives in which these are constructed.

The narratives of art history, however, are also inescapably a major part of market processes. Imagine, for example, a painter such as Frida Kahlo, who is reevaluated after her death, in contrast to the previously more celebrated Diego Rivera. Her paintings, valued at $30,000 ten years ago, are now worth over $1 million. Her work—which emphasizes gender, informality, and the body— becomes significant in the light of current theoretical trends. And, although Rivera's work is far more concerned with the Mexican state, as soon as Kahlo became important outside Mexico, her work acquired *national* value exceeding Rivera's. In this case, as with others, once people begin to appreciate a different art outside the dominant story, it finds its own genealogy in the past. Or consider the Chilean painter, Matta, who lived a long time. The investors began to worry because his style changed at age fifty or so, and they didn't like his later work. The changes raised questions about his place and the place of his work in some "story."[38]

Artwriting, therefore, appears to us as the discursive space that is a significant barrier or challenge to independent perspectives or discourses coming from anthropology, such as the critical ethnography of art worlds which we propose. As we noted, with its interest in culture and cultural value, anthropological discourse already shares a "family resemblance" with artwriting. This would not be so consequential were it not that artwriting, particularly critical avant-gardist artwriting, recognizes these resemblances (see Kirshenblatt-Gimblett, this volume). In its own ambitious interests, such artwriting practices are in competitive relationship to anthropological writing, with a considerable capacity to position and subsume it or to repudiate it. (Myers's essay begins with a discovery of his appropriation in art discourse.)

Art worlds "make art," as Becker (1982) showed,[39] and there is no doubt that artwriting practices are part of this institution (see Sullivan, this volume). One can view this cynically (as artists and dealers have been prone to do), or matter-of-factly (like Becker) as the sociological functions of particular institutions. It is also clear that the processes of "making art" require the establishing of a sensibility, a way of appreciating different forms of cultural activity (Myers 1994). This is what the critic Clement Greenberg did for abstract art—focusing on "universal" aesthetic principles as an attempt to sustain modern art within "Western tradition"—and what Lucy Lippard (1973) did for conceptual art (see also Crane 1987). With its constant anticipation of the next movement, style, or fashion, art criticism is partly in the business of producing such styles and differences; action/reaction is what structures the whole history of avant-garde movements. Although criticized itself for such promotional/self-promotional celebration of certain trends and movements to the exclusion of the actual diversity of art (Alloway 1984), as well as for its involvement in marketing, art criticism plays a significant role (somewhat similar to that of anthropology) in this process of producing "difference" and rendering it intelligible.

There is no doubt that a distinctive feature of artwriting is its effort to establish autonomy from, and to occupy a metaposition with regard to, all other related

critical discourses. This desire is parallel to (and might be contested along with) the issue of art's autonomy from social life around which modernist and postmodernist debates have revolved. Commentary about avant-garde art, the contemporary art-in-the-making, as contrasted with fine-arts writing (about art that has already been well-assimilated and legitimated as art) has a distinctive feel. A characteristic of such artwriting is its facility and fluidity: it incorporates and registers all positions by positioning them in turn; it acknowledges all ideas of difference and arranges them in relation to each other, through ingenuity of argument: the new wrinkle, the new phrase. Indeed, the appropriation of Baudrillard's writing within the art world (Baudrillard 1968, 1972, 1975; see Hughes 1992) both recognizes and instantiates the (sometimes reluctant) resemblances between the arts and consumerist late capitalism. There is a fascination in artwriting with a competitive aesthetics of discourse, with hipness, with one-upsmanship, with showing the exclusivity of one's own position, inaccessible to another. In this volume, analysis of the characteristics of the discursive field of the contemporary art world is most developed by Nancy Sullivan (who unlike us, the editors, came to anthropology from that world rather than vice versa). Essentially, "beautiful" theories and commentaries are not engaged as arguments (as in a scholarly field) but are merely juxtaposed and evaluated by a "poetics of attitude"—an aesthetics of novelty and hipness (see Buchloh 1987).

What role could anthropological writing, such as that deriving from the sorts of studies we are advocating and presenting here, play in this discursive field? In the past and present, very little. By the voracious assimilation of difference and similar discourses, artwriting has already made an identifiable place for anthropology (within its hierarchies of virtuous or worn-out sources of influence on art). Hal Foster's insightful essay (this volume) on the appropriation of the "ethnographic" in contemporary art and artwriting cogently identifies this assimilative tendency or desire as it identifies the ethnographic avant-garde's modeling of itself on the arts. Artwriting has created its own channels of appropriating anthropology's constructions of distinctive difference as a source of cultural value and critique. We have argued that contemporary art and artwriting have rejected anthropology as a way to "know" the "primitive" or "the other," by explicitly positioning anthropology, or sociology, or some other field of scholarship as flawed and limited, as "not art" (see Kirshenblatt-Gimblett, this volume).

In the future? Who can tell? The traditional relationships and ways of constituting the discursive space of artwriting are in transformation. Through various kinds of crossovers and mixtures of discursive spaces, postmodernism is making the assimilative function of artwriting less predictable and less efficient. Merely by constructing and recognizing artwriting as a peculiar sort of *doppelgänger* barrier for anthropology to cross in establishing its own perspective on art worlds, we think that an important provocation toward the domain of artwriting is made. At the same time, it opens up an important arena of cultural production within the U.S. and elsewhere to more straightforward anthropological consideration.

One of the functions of an ethnographic critique that pays close attention to art's discursive practices is to make apparent how these discourses seek to make themselves exclusive or totalizing by setting themselves up as the one cultural sphere which is genuinely open to all difference and which creates value on this basis. This occurs blatantly in the ways Western culture produces itself—as the "primitivism" debates have shown—by the interpretation and critical normative evaluation of other cultures,[40] debates in which anthropology, too, is implicated. Our analysis of such normal operations in the art world comes from our involvement with a changing dynamics of cultural production in many parts of the world, the new traffic in art and culture. And this critical analysis involves *relativizing* the embedded claims to precedence and universalism as those made by the contemporary art world. In its apparent inclusiveness and openness to possibility and critical sense, we argue, in fact it draws exclusionary boundaries. A critical ethnography of the art world, partly exemplified in this volume, would track these processes, including the ways in which they are part of the critical consciousness of participants within the art world, while using anthropological method to bring distancing to bear on specific (Western) cultural practices.

As the essays in this volume demonstrate, such a relativization of Western art discourse and practice is also coming about through the global circulation of objects and capital and the movements of people which are changing the modern traditions that have shaped art institutions. Anthropologists are well-positioned to make the provocation of relativizing Western art discourse because, as noted, the figure of the "primitive"—for whose stability anthropology has been responsible and which has occupied such an important place in the constitution of the discursive field of artwriting—has become so destabilized. Such a critical stance, aware of complex mutualities as well as differences, is the basis on which anthropology should move into a different relationship with the discursive practices of art worlds, with an identity that is not as implicated in the place made for it by such practices. To engage in an anthropological metaphor, the renegotiation we imagine is one of "exchange" in which the kind of critical ethnography in this volume might be seen as opening up a new dialogue. As with all exchange, the renegotiation involves possibilities of reciprocity as well as of contestation.

CRITICAL ETHNOGRAPHIC STUDIES OF THE POSTMODERN ART WORLD

Anthropology and modern art have always shared, in very different ways, a function of cultural critique in relation to forms of Western modern life. One important and shared concern has been to critique the tendency in the West to regard various spheres of life as autonomous from, rather than embedded in, a larger social context. For anthropology, however, postmodernism has meant that the task of undermining such conceptions of autonomy can no longer continue simply to use the virtue of social alternatives elsewhere as a critical handle on "us." With dis-

ruption of the category field, because cultures are "deterritorialized," circulate, and are thoroughly embedded in world-system institutions, challenges to Western cultural constructions must be deployed in different ways. For the art mode of critique, postmodernism's consequences are different; its demonstration of the loss of the art world's autonomy in the intimate and undeniable association of art with money and markets is more radical. Aesthetics cannot be considered independently of the social and of the intimately associated manifestation of the social, i.e., the postmodern art market itself. In the future, then, the critical functions of art and anthropology, once more or less closely aligned, are certain to become more divergent. In this divergence arises the possibility of a connected but distanced ethnographic perspective on art that has, at the same time, dialectic possibilities for reflecting back on anthropology's own positioning.

There are two projects we can delineate for the purposes of developing a critical ethnography. One task is to assess sites, positions, and levels of critical insight within cultural formations. It is ironic that we are looking at this question in a cultural formation—the art world—that principally sees itself as producing authoritative critical insights.[41] The second project is an ethnography of the social processes in which central cultural values are produced, and particularly as such processes are now defined on an unprecedentedly fluid global scale.

Ethnographies like those in this book would examine the insights and limits of critical consciousness expressed by the variously situated participants in the art world's terrains and processes. One discernible segmentation that should be recognized as generative of different positions is that between (1) the contemporary art world/market and the avant-garde that is continually being created from the reserve army of artists being generated these days by art schools (see Tomkins 1988; Rose 1988) and (2) the market for classic or fine art of different periods, which is (as Feldstein 1991 notes) of a different character. These zones—the former a zone of speculation, the latter of legitimation—have different characteristics. The crucial point of intersection, or interzone, is where particular contemporary artists and works of art move from the location of speculation and recognition, registered by a small world of dealers, gallery owners, curators, collectors (private and corporate), and artwriters (journalist critics, scholars), into the legitimated art world which is the world of art history. Here, museums and curators can be important legitimators of movement into the interzone. It is the function of time, art history, and collectors of fine arts to make an eventual place for what was once contemporary art, subject to a very speculative art market.

PENETRATION AND LIMITATIONS OF CRITICAL INSIGHT WITHIN THE ORGANIZATION OF THE POSTMODERN ART WORLD

Our conception of critical ethnography draws from the notion that social actors have a critical consciousness of their own and broader conditions of life, but one that is imperfect—partial, potential, or minimal (Willis 1977:119). Beyond the ques-

tion of "structure" and "agency," critical consciousness, and the potential for political engagement are problems central to recent ethnographic treatments of the knowledge social actors have of their worlds (for example, Ginsburg 1989; Nash 1979; Ong 1987).[42] Far from being exempt, it is precisely the variable capacity for critique within a site of ethnographic investigation that suggests the key focus for an *external* cultural critique such as anthropology might provide for the art world.

We are interested in how the embedded location of a subject's agency serves as the basis for one project of critical ethnography: namely, that of understanding the different levels and contents of critical consciousness that participants in the postmodern art world display about their own conditions of production. For example, Marcus's essay in this volume suggests that the recognized, shown, and collected avant-garde artists themselves—the cultural and literal current capital at any point in time of the art world—occupy a self-defeating position of contextual cultural criticism. This "limitation" to their critical consciousness, as Paul Willis (1977) might call it, is quite different from that of the working class "lads" the latter studied in a British school: the "lads" are stuck in a hopeless situation, but the critics get a payoff for not really rocking the boat. Other possibilities lead to other relevant explorations of position and function in the organization of the art world. Artwriters of various sorts, for example, are often in keen competition to be radically critical in novel ways, to "one-up" each other's insights and sensibilities in the creation of an aesthetic discourse. In this complex discursive field, however, given artwriting's extraordinary capacity to assimilate difference and interventions, one wonders whether such writers can develop a deeper critical consciousness of their own conditions in a way that has consequence. The ethnographic "sounding" of critical sensibility and form within the art world, an intervention from a neighboring and related discursive space, might provide this challenge.

Points of "knowing cynicism" comprise another sort of site at which to locate the "partial penetrations" of which Willis speaks (1977:119). Such positions are occupied by dealers, who most directly mediate market factors and cultural value. Other positions at which one might look include the following: corporate collectors; the key collectors who are relied on to "make" artists by their purchases; or museum curators, who provide the key legitimating context which moves speculative, promising art in the current, collectible art market into respectability and ultimately into the domain of art history (Sullivan, this volume). On the one hand, each site of participation is embedded in a set of social relations and has discursive practices associated with it that could be explored for their salience as cultural critique. On the other hand, beyond this "sounding" and the artworld's own suspicions of "hypocrisy" and "mystification," ethnography has the capacity to consider the larger process in which these distinctive positions of cultural production negotiate with each other in the workings of that field of activity we call the "art world."

The obstacle to overcome in this kind of critical study is the illusion that art (artwriting, art production) can absorb all difference while granting those differences integrity. And, in consequence, the aim is to look at the current predica-

ments to which this realization would lead.[43] A challenge to the hegemony of this illusion would significantly, if not fundamentally, transform the historic basis on which Western art worlds form their self-identity and radically change their relationships with the social and the cross-cultural.

THE RADICAL RELATIVIZATION OF ART WORLD PRACTICES OF CONSUMING DIFFERENCE

In this respect, a critical ethnography of the art world has a double vision of it. An ethnographer must, after all, understand his or her subjects; at the same time, he or she need not necessarily accept their truth-claims. Indeed, as a competing discourse within the same culture, this means that ethnography is likely to contest the key self-positioning of the art world which sees its participants as occupying a privileged "metaposition," one that is capable of absorbing everything else, all difference, within it. In this regard, the very specific anthropological critique would concern the art world's *manner* of assimilating, incorporating, or making its own cross-cultural difference. The goal would be to relativize art-world practices by showing effectively the broader contexts of activity in which the art world's appropriations are located. This technique of critique by relativization is a classic one in anthropology, but it requires some innovations since the decline of a mode of thought that operated in terms of whole cultures and their dualistic us-them comparison. The trope of "the West and the rest" no longer provides credible grounds on which to challenge the essentializing authority of art worlds. We suggest, therefore, three simple categories of analysis that might provide new grounds by which such a critical ethnography can proceed with its enduring task of relativization: appropriation, boundary, and circulation.

Appropriation

This concerns the art world's ideology, discursive practices, or microtechnologies for assimilating difference (other cultural materials) in varying ways. Such an assimilation of difference is generally accomplished by stripping cultural materials of original context, or using representations of an original context in such a way as to allow for an embedding of this influence within the activities and interests of producing art. In this volume, the essays by Feld, Hart, Kirshenblatt-Gimblett, Marcus, Mullin, and Steiner are particularly revealing about such processes of appropriation.

Boundary

Boundary questions are related to appropriation and deal with the resistance to and ambiguities of appropriation as seen by people both within the art world and those appropriated by it. Mark Stevens's (1990) review, arguing that it is the boundary between high and low that makes art meaningful, and thus provides a

reason for retaining the notion of art's autonomy, raises exactly these questions. How art sustains its boundaries—which issues sustain them—is a salient question posed especially by feminist studies, as in Goldstein's and Mullin's essays in this volume, and as Foster's essay shows, it is a major concern of the art world itself.

Circulation

The analytic category of "circulation" puts the appropriation-boundary functions in the broadest landscape and panoramic view in terms of what anthropologists (as opposed to art-world people) see, or at least care most about. This provides perspective on the "social life of things" (Appadurai 1986), by putting objects and their identities in motion and showing their broadest paths of circulation through a diversity of contexts. It is the juxtaposing of diverse contexts suggested by tracings of circulation that give scope and an edge to the critique of more parochial, embedded "truths" about the cross-cultural that might be produced in art worlds, which view themselves as the most cosmopolitan of institutions. At this point, anthropological knowledge might intervene in the art world's own appropriation of cross-cultural things, even contextualizing the art world itself as a site of production in the new traffic in art and culture. Such ethnographic work would not only show the circulation, but might also examine the whole complex—the larger, perhaps transnational system—which constitutes it, beginning with the local producers (for example, Pintupi artists [Myers, this volume] and Kumaoni women [Hart, this volume]). This does not mean that the art world cannot appropriate things cross-culturally for its own purposes, but such relativizations make the task more complicated and less imperial than they have sometimes been (as those undertaken in the name of some ideal or prestige of autonomous art, itself a contradiction to the need for appropriation). Instead, the appropriations require different negotiations of boundaries that take into account complex paths of circulation—of objects, money, ideas, and people—that were either previously not seen, ignored, or devalued by the art world.

Critical ethnography would argue, in this regard, that such devaluation is no longer possible to sustain. Behind the argument that art must operate explicitly on the basis of its own deep intuition—now exposed—that it is not autonomous is the idea that appropriations must involve a Bakhtinian notion of the dialogic. That is, you carry with you into your own realm of meaning and art production more than just the object. You also carry its whole context of local culture and of circulation (for an elaboration, see the conclusions to Marcus's essay, this volume).

CONCLUSION

In the past, the anthropological study of art has been essentially a marginal occupation. This should no longer be the case. In contemporary cultural life, art is becoming one of the main sites of cultural production for transforming difference

into discourse, for making it meaningful for action and thought. Especially because anthropology has also seen this as its role in the production of cultural knowledge, we argue that critical understanding and a new relationship between art and anthropology are required. The question of why anyone would be interested in Native American artifacts as "art" leads to significant vectors of cultural production: making the "primitive" part of the modernist art project may be, for example, part of a larger project of nation-building. "Aesthetic" recognitions may be autonomous discoveries, but they are also forms of power complexly linked to nationalism, commercial expansion, and gender politics. As we see increasingly with indigenous peoples around the world, traditionally the subject of anthropology's quest, the tropes available for the formulation of their identities are those formulated in the (distant) art world. In this arena, not only are particular judgments of cultural value enunciated on ranges of human enterprise, but the very frameworks in which cultural activity is to be evaluated—authenticity, continuity, and so on—have been and are developed, contested, and reformulated within the increasingly diverse, overlapping spheres of participants in both art worlds and anthropology.

THE PAPERS: A NOTE

The following essays represent significant examples that reflect the orientations of the preceding introduction. For the most part, prepared for other contexts rather than part of a collective effort, they do not, of course, register or encompass all of the issues raised in this introduction, nor does the latter completely map all of the issues addressed in the papers. In presenting these papers as a set, we think it makes sense to group them in terms of the two kinds of critical ethnographic studies of the art world that we did discuss.

The papers by Feld, Hart, Mullin, Myers, and Steiner all focally concern the relativization of the contemporary art world by its spatial placement in a more complex field of relations, especially with reference to questions of appropriation, boundary making, and circulation. Further, all of these papers develop through a refiguring of the specific historic inspiration within the art world for which anthropology has provided the ground: in each of these papers, the "primitive" is destabilized in terms of how the cultural values of particular, contemporary Third and Fourth World peoples are appropriated by the Western art world in a broader context defined by the paths of circulation of art objects.

The second set of papers, by Foster, Kirshenblatt-Gimblett, Marcus, Sullivan, Goldstein, and Vance, take up the ethnographic probing of the variant expressions of critical consciousness or capacity within the contemporary art world itself. More specifically, they are concerned with the making of avant-gardes and the key question of the autonomy of art from other spheres of social life, under various sources of stress such as inflationary art markets, attempts at censorship, and the assertive existence of alternative aesthetic communities.

NOTES

We would like to thank Debbora Battaglia, Barbara Kirshenblatt-Gimblett, Steve Feld, Faye Ginsburg, and Judith Goldstein for their immensely helpful and illuminating comments on this essay and on related issues. They are not responsible, of course, for the problems that remain.

1. Some of these have already been published elsewhere; others are published here for the first time.

2. The sociology of art that exists (Becker 1982; Levine 1988; Moulin 1987; DiMaggio 1986, 1988; N. Harris 1990; Wolff 1981, 1983; Zolberg 1990; and Bourdieu 1984, 1990) has impressively mapped and theorized the operations of art worlds as institutions and subcultures, certainly. But this literature typically casts the sociological gaze *from a distance* and from within the concepts and frameworks of sociology as a discipline with a history quite separate from the art world. With some interesting variations in reflexive awareness (see Bourdieu and Wacquant 1992), it does not or, for the most part, is not able to recognize an intimate, already-existing relationship between its own objectifying discourse and the discursive interests and practices of the domain which is its object.

3. In thinking of how anthropologists have also patrolled these boundaries, one should consider the typical resentment many of us have felt in the face of performers' (visual artists', musicians', etc.) claims to "knowledge" about the practices of people we study. Victor Turner (1986) was unusual in his willingness to take the plunge in considering more the rather dangerous possibilities of "transcultural" perceptions, perceptions based on recognitions of virtuosity within a recognizable medium.

4. The writing about anthropology's relationships with colonialism and imperialism (e.g., Asad 1973; Hymes 1974) as well as later critical concerns with the politics and poetics of representation (Clifford and Marcus 1986; Fabian 1983; Tyler 1987; Crapanzano 1980, 1992; Taussig 1987) all carried forward a long-time dialectical stance toward analytic categories as embedded in the observers' own cultural and social locations.

5. In making this statement, we want to draw attention to the general exclusion of vernacular aesthetic forms from recognition as legitimate aesthetic activity. Indeed, as Barbara Kirshenblatt-Gimblett has made clear (personal communication, 1993), current talk about "participation" and "collaboration" with publics and communities still insists on the primacy of the "artist" and the artist's consciousness—as if gardens or street performances did not embody an aesthetic consciousness.

6. For a discussion of the general cultural conditions that have challenged the boundaries between analysis or criticism and cultural objects, see Connor 1989.

7. Closer historical study should reveal experimentations, disruptions, and flows that should have been challenging both for Western categories of art and anthropological understandings. But if there is, as it appears, a submerged history within anthropology of attempts to create liberatory spaces for anthropologists as artists

and their complex work to mediate different forms of knowledge, then we should not congratulate ourselves for seeing what others failed to see.

8. It is interesting to note that these are sensibilities for which the anthropologist Stephen Tyler (1987) has been criticized.

9. Barbara Kirshenblatt-Gimblett (1993: personal communication) suggests that there is a triangulated critique: Anthropology offers the basis for a critique of such conservative academic modernism as the art history of the MoMA exhibition; that debate turns back on anthropology, however, which gets critiqued in turn by an antiacademic (anti–art academy, anti–intellectual academy) avant-garde that rejects both anthropology and academic art history approaches. Examples of this latter critique would be those in the mold of Artaud ("no more masterpieces") (1958, 1976) or of Peter Sellars, as described by Kirshenblatt-Gimblett, this volume.

10. There is, one must recognize, also a hierarchy of "the arts," and the application of the special category of "art" and its accompanying high culture legitimacy and value differentiates among them partly in relationship to the senses they prioritize.

11. See also Bürger (1984) for further discussion along these lines.

12. For an extended discussion of kitsch, bad taste, and the changing historical location of the relations between taste, culture, and style, see Kirshenblatt-Gimblett (1991b).

13. The work cited in reference to the critique of ideological exclusion, it should be said, does not represent a simple-minded rejection of the "high," but is instead engaged to produce a liberatory space for other forms of expression. There is, however, a more fully populist range of writings that do attack this boundary in functionalist terms (see Bourdieu 1984; Varnedoe and Gopnik 1990). For an earlier tradition, see MacDonald 1953.

14. I am borrowing this usage from Annette Hamilton (1990).

15. An example of this topic is Vera Zolberg's book on the Art Institute of Chicago (in preparation).

16. The recognition of culture as contested has multiple origins in anthropology, including the Manchester School, Bakhtin's contributions to dialogical views, Foucauldian "resistance," and Gramscian notions of hegemony among others.

17. Thus, in Kirshenblatt-Gimblett's essay (this volume), Peter Sellars is reported to oppose the "ethnographic" dimension of performances brought to the LA Arts Festival from overseas, and Myers (this volume) describes how anthropology is castigated for its mediation of Aboriginal paintings. Here lies the parallax side of juxtaposition.

18. Robert Thornton (1993) argues for the influence of Nietzsche's aesthetics on Malinowski's work generally but particularly in his rejection of history—as what we would now recognize as an "appeal to origins."

19. This would certainly include the reliance on Dilthey that Marvin Harris (1968:268–277) criticized.

20. The linkage of Romantic ideas—developed in opposition to the Enlight-

enment ideals of Universal Reason and Progress in the context of nation-building in Europe—to the specificity and particularity of historical periods (*Geist*, or "spirit," and thus *Geisteswissenschaften* or "human sciences") was ready-made to turn toward distinctive cultural styles. What is less well appreciated is that the development of these understandings of "culture" was so closely tied to the formulation of "aesthetics" as a discourse (see Eagleton 1990). Eagleton argues that with the fall of absolutist monarchies and the rise of the bourgeoisie, political cohesion and legitimacy had to be founded on something other than either Pure Reason or Utility, and the task of this cohesion (apparent even in Rousseau's interest in sentimental education) fell to the "senses."

21. Stocking recognizes resonances from German Romantic thought, especially from Herder's conception of history in terms of the embodiment of the human spirit in organismic ethnic or national forms. Indeed, the phrase even recalls traditions of nineteenth-century racial thought to which Boas' work was in quite explicit opposition. But if this seems paradoxical, it is in fact appropriate. Many of the roots of racial thought can be traced to the organismic diversitarianism of Herder. Boas' thinking on ethnic diversity was rooted in the same soil. Furthermore, his problem as a critic of racial thought was in a sense to define 'the genius of a people' in other terms than racial heredity. His answer, ultimately, was the anthropological idea of culture. (Stocking 1968:214)

22. Firth (1992) makes it clear in his own case how Western modernist views of form, and exhibitions of "primitive art," influenced his understanding of Maori sculpture and plastic arts. A similar case for the influence of the artistic avant-garde on appreciation of "primitive art" is made by Robert Goldwater's famous book (1938) and Rubin (1984).

23. It is worth remembering how influential this work was, in turn, on art historian George Kubler (1962).

24. By "recent" here, we refer to the introduction of these works to an English-speaking audience.

25. For a longer and deeper history of European interest in the exotic, see Hodgen (1964).

26. Among the publications relevant to this particular controversy are Clifford (1985), McEvilley (1984), Manning (1985), Rubin (1984), Varnedoe (1985), Bois (1985).

27. The debate over the MoMA exhibition on primitivism and modernism brought many long-brewing arguments in cultural theory to the fore, and effectively ushered in the current concern about representing the "other" in the arts.

28. Among the relevant works on the avant-garde, shock of the new, and the social location of such practices, see Poggioli (1968), and Bürger's (1984) response to Horkheimer and Adorno (1982).

29. The signifying locations of the "primitive" obviously vary with the particular narrative of "loss" presumed to have occurred with modern life. In a certain sense, the supposed traditionalism of the "primitive"—which violates avant-garde requirements for originality and self-creation—has had to be repressed by avant-garde appropriations to capture the organic opposite for modern fragmentation.

30. For a recent reenactment of this position, see Beidelman's review (1992) of Maybury-Lewis's *Millennium* (1992).

31. For discussions of this in contemporary ethnography, see Clifford and Marcus 1986; Marcus and Fischer 1986; Myers 1986b, 1988a, 1988b; and Taussig 1987. A significant body of writing on the mutual implication of representation and alterity, especially the work on the relation between "savagery" and "civilization," draws for its inspiration on Foucault (1973), and here anthropology and art world theory conjoin. A particularly good example is Lattas (1987).

32. This is certainly a technical misnomer, but in anthropology these practitioners certainly stand for the general critical orientation that postmodernism has wrought within a variety of disciplines.

33. For the distinction between "modernism" and "Modernism," see Blake and Frascina (1993).

34. The extent to which Greenberg's work was part of the formulation of a hegemonic structure (and what hegemony looks like) is illustrated by Barbara Rose's reminiscences about the sense of cultural coherence during her days at the journal *Artforum* in an article by Janet Malcolm (1986):

> "The magazine had coherence, which the culture had at that point, too." In this same vein, she discussed the impact Greenberg's ideas had on Fried and others: "They were converted immediately . . . because it offered a coherent way of looking at art. Nothing else did." And on the subject of popular culture, she said: "We were literary people. We didn't watch television. . . . And we didn't like junk. There wasn't this horrible leveling where everything is as important as everything else. There was a sense of the hierarchy of values. We felt we had to make a distinction between Mickey Mouse and Henry James." (Malcolm 1986, part 1:60, quoted by Collins 1987)

35. See, for example, Lewis Hyde's (1983) strenuous redemption of art as the modern "Gift."

36. Actually, the exhibition was far from radical, attempting only to identify "low" sources for "high" art—reflecting a somewhat conservative art historical preoccupation with provenance as the central approach. There was no low *art*, just low sources for high art.

37. Much of this debate is entirely internal to the "art world," with considerations of vernacular aesthetics or popular participation still reliant on authorized legitimate artists—leading one to suspect that if Clement Greenberg had not existed, postmodern theorists would have had to invent him. On this point, see also Crow (1987). For a more complex reading of Greenberg's sense of the relationship between art and the rest of culture and what has been made of him by postmodern theorists, see Tillim (1987).

38. We are indebted to Claudio Lomnitz (personal communication, 1993) for this example.

39. The concept of "art world" in this sense originated with Arthur Danto (1964), particularly in his argument that the meaning and value of works are produced in such an institutional matrix rather than inhering simply in the works themselves.

40. For this phrasing, we are indebted to discussion with Terry Turner (personal communication, December 4, 1993).

41. What we delineate may look like critical theory's classical concern with "liberation," which was caught up in its authoritative conditions of enunciation that never had a practice. We do not approach this critical function through "negative dialectic."

42. These questions of "structure" and "agency"—as they are often labeled in contemporary anthropological theory—are most carefully developed in ethnographic considerations of political action and ideology. The tradition in which such melding of critical theory and ethnography was formulated in order to challenge tendencies to reify "culture" and "ideology" began with Gramsci's work on hegemony and was picked up by Raymond Williams's (1977) considerations of "practical consciousness." It was deployed in British cultural studies (Hebdige 1979; Willis 1977), by the theorists Giddens (1979) and Bourdieu (1977), as well as in the various critiques of a pure political economy approach in American anthropology that attempted to allow for the social actor's ability to act on his/her world. We use Willis here largely because of the clarity of his formulation.

43. We might anticipate here the objection that even though we are talking about art, nowhere do we say much about the objects themselves. While recognizing that there is a history of debate over what kind of writing is needed (see Sontag 1966), perhaps this is what differentiates anthropological (or sociological) writing from artwriting; the latter must in some way derive its discourse from at least looking at the objects. We do offer a second-order commentary in this regard, but one of our radical points is that, at least in present artwriting, there is a decreased attention to objects as well, even though this remains its rhetorical mode. The power of artwriting is actually derived from elsewhere—from theory, from general social observations, etc. This is a "militant" answer to the anticipated question of what all this has to do with "art." We are not deeply involved in the enterprise of interpreting the art itself, but are involved, instead, in the discursive practices around the art in which we participate to some extent as provocateurs in an indirect manner.

It seems to us that this point about discourse's relation to the making of art is one of the key issues for actor-generated cultural critique. But it is always limited by the need to be looking at the objects (just as anthropologists are limited by their practice-defining rhetoric of always speaking from the intimate site of "being there," in the field). Such framings in art and anthropology are both a limitation and a source of empowerment in engaging in cultural critique.

REFERENCES

Abu-Lughod, Lila
 1993 *Writing Women's Worlds: Bedouin Stories.* Berkeley: University of California Press.
Adorno, Theodor W.
 1983 *Aesthetic Theory.* London: Routledge.

Alloway, Lawrence
1984 *Network: Art and the Complex Present.* Ann Arbor: UMI Research Press.
Alsop, Joseph
1982 *The Rare Art Traditions: The History of Art Collecting and Its Linked Phenomena Wherever These Have Appeared.* New York: Harper and Row.
Anderson, Richard
1989 *Art in Small-Scale Societies.* 2d ed. Englewood Cliffs, N.J.: Prentice-Hall.
Appadurai, Arjun
1990 "Disjuncture and Difference in the Global Cultural Economy." *Public Culture* 2(2):1–24.
———, ed.
1986 *The Social Life of Things: Commodities in Cultural Perspective.* Cambridge: Cambridge University Press.
Appadurai, Arjun, and Carol Breckenridge
1988 "Why Public Culture?" *Public Culture* 1(1):5–9.
Artaud, Antonin
1958 *The Theater and Its Double.* Trans. M. C. Richards. New York: Grove Press.
1976 *Selected Writings.* Ed. Susan Sontag, trans. H. Weaver. New York: Farrar, Straus, and Giroux.
Asad, Talal
1973 *Anthropology and the Colonial Encounter.* New York: Humanities Press.
1983 "Anthropological Conceptions of Religion: Reflections on Geertz." *Man* 18(2):237–259.
Baldessari, John, et al.
1990 "Making Art, Making Money: Thirteen Artists Comment." *Art in America* 78(July):133–141, 178.
Bataille, Georges
1985 *Visions of Excess: Selected Writings, 1927–1939.* Minneapolis: University of Minnesota Press.
1988 *The Accursed Share: An Essay on General Economy.* Trans. R. Hurley. New York: Zone Books.
Baudelaire, Charles
[1846] 1982 "The Salon of 1846: On the Heroism of Modern Life." Trans. J. Mayne. In Francis Frascina and Charles Harrison, eds., *Modern Art and Modernism: A Critical Anthology,* pp. 17–18. New York: Harper and Row.
Baudet, Henri
1965 *Paradise on Earth: Some Thoughts on European Images of Non-European Man.* Trans. Elizabeth Wentholt. New Haven: Yale University Press.
Baudrillard, Jean
1968 *Le Système des Objets.* Paris: Gallimard.
1972 *For a Political Economy of the Sign.* Trans. Charles Levin. St. Louis, Mo.: Telos Press.
1975 *The Mirror of Production.* Trans. M. Poster. St. Louis, Mo.: Telos Press.
Baxandall, Michael
1972 *Painting and Experience in Fifteenth Century Italy: A Primer in the Social History of Pictorial Style.* Oxford: Clarendon Press.

Becker, Howard
 1982 *Art Worlds*. Berkeley: University of California Press.
Beidelman, T. O.
 1992 "Millennium." *Cultural Anthropology* 7:508–515.
Benedict, Ruth
 1934 *Patterns of Culture*. New York: Houghton Mifflin.
Biebuyck, Daniel, ed.
 1969 *Tradition and Creativity in Tribal Art*. Berkeley: University of California
 Press.
Blake, Nigel, and Francis Frascina
 1993 "Modern Practices of Art and Modernity." In Francis Frascina, Nigel
 Blake, B. Fer, T. Garb, and Charles Harrison, eds., *Modernity and Mod-
 ernism: French Painting in the Nineteenth Century*, pp. 50–140. New Haven and
 London: Yale University Press in Association with the Open University.
Boas, Franz
 [1908] 1940 "Decorative Designs of Alaskan Needlecases: A Study in the History of
 Conventional Design." In *Race, Language and Culture*, pp. 564–592. New
 York: Macmillan.
 1927 *Primitive Art*. New York: Dover.
Bois, Yve-Alain
 1985 "La Pensée Sauvage." *Art in America* 73(April):178–189.
Bolton, Richard, ed.
 1992 *Culture Wars: Documents from the Recent Controversies in the Arts*. New York:
 New Press.
Boon, James
 1972 *From Symbolism to Structuralism*. New York: Harper and Row.
 1986 "Between-the-Wars Bali: Rereading the Relics." In G. Stocking, Jr., ed.,
 Malinowski, Rivers, Benedict and Others: Culture and Personality, pp. 218–247.
 Vol. 4 of *History of Anthropology*. Madison: University of Wisconsin Press.
Bourdieu, Pierre
 1977 *Outline of a Theory of Practice*. Trans. R. Nice. New York: Cambridge
 University Press.
 1984 *Distinction: A Social Critique of the Judgement of Taste*. Cambridge, Mass.:
 Harvard University Press.
 1990 *The Love of Art: European Art Museums and Their Public*. Stanford: Stanford
 University Press.
Bourdieu, Pierre, and Loic J. D. Wacquant
 1992 *Invitation to Reflexive Sociology*. Chicago: University of Chicago Press.
Breckenridge, Carol
 1989 "The Aesthetics and Politics of Colonial Collecting: India at World
 Fairs." *Comparative Studies in Society and History* 31:195–216.
Buchloh, Benjamin H. D.
 1987 "Periodizing Critics." In Hal Foster, ed., *Discussions in Contemporary Culture*,
 2, pp. 65–70. Seattle: Bay Press.
 1989 "The Whole Earth Show: An Interview with Jean-Hubert Martin." *Art in
 America* 77(May):150–159, 211, 213.

Bultmann, Rudolf
 1958 *Jesus Christ and Mythology*. New York: Scribner.
Bürger, Peter
 1984 *Theory of the Avant-Garde*. Trans. Michael Shaw. Minneapolis: University
 of Minnesota Press.
Burke, Peter
 1978 *Popular Culture in Early Modern Europe*. London: Temple Smith.
Carr, C.
 1990 "War on Art." *Village Voice*, Jan. 5, 25–30.
Carrier, David
 1987 *Artwriting*. Amherst: University of Massachusetts Press.
Clark, T. J.
 1982 *Image of the People: Gustave Courbet and the 1848 Revolution*. Princeton, N.J.:
 Princeton University Press.
Clifford, James
 1985 "Histories of the Tribal and the Modern." *Art in America* 73(April):
 164–177, 215.
 1988 *The Predicament of Culture: Twentieth-Century Ethnography, Literature, and Art*.
 Cambridge, Mass.: Harvard University Press.
Clifford, James, and George E. Marcus, eds.
 1986 *Writing Culture: The Poetics and Politics of Ethnography*. Berkeley: University of
 California Press.
Collins, Bradford R.
 1987 "Clement Greenberg and the Search for Abstract Expressionism's Suc-
 cessor: A Study in the Manipulation of Avant-Garde Consciousness."
 Arts Magazine: 61(9)36–43.
Connor, Steven
 1989 *Postmodernist Culture: An Introduction to Theories of the Contemporary*. Oxford:
 Basil Blackwell.
Coote, Jeremy, and Anthony Shelton, eds.
 1992 *Anthropology, Art, and Aesthetics*. Oxford: Oxford University Press.
Crane, Diana
 1987 *The Transformation of the Avant-Garde: The New York Art World, 1940–1985*.
 Chicago: University of Chicago Press.
Crapanzano, Vincent
 1980 *Tuhami. Portrait of a Moroccan*. Chicago: University of Chicago Press.
 1992 *Hermes' Dilemma and Hamlet's Desire: On the Epistemology of Interpretation*.
 Cambridge, Mass.: Harvard University Press.
Crow, Thomas
 1987 "These Collectors, They Talk about Baudrillard Now." In Hal Foster,
 ed., *Discussions in Contemporary Culture, 2*, pp. 1–8. Seattle: Bay Press.
Danto, Arthur
 1964 "The Artworld." *Journal of Philosophy* 61:571–184.
 1986 *The Philosophical Disenfranchisement of Art*. New York: Columbia University
 Press.
 1989 "Critical Reflections." *Artforum* 28(Sept.):132–133.
 1990 "The State of the Art World: The Nineties Begin." *Nation*, July 9, 65–68.

Deitcher, David
 1991 "A Newer Frontier." *Village Voice,* June 25, 39–40.
Derrida, Jacques
 1977 *Of Grammatology.* Trans. G. Spivak. Baltimore: Johns Hopkins University Press.
DiMaggio, Paul
 1982 "Cultural Entrepreneurship in Nineteenth-Century Boston: The Creation of an Organizational Base for High Culture in America." *Media, Culture and Society* 4:33–50.
 1986 *Nonprofit Enterprise in the Arts: Studies in Mission and Constraint.* New York: Oxford University Press.
 1988 *Managers of the Arts: Careers and Opinions of Senior Administrators of U.S. Art Museums, Symphony Orchestras, Resident Theatres, and Local Arts Agencies.* Washington, D.C.: Seven Locks Press.
Dumont, Louis
 1983 *Essais sur l'individualisme: Une perspective anthropologique sur l'idéologie moderne.* Paris: Editions du Seuil.
Durkheim, Emile
 [1884] 1984 *The Division of Labor in Society.* New York: Free Press.
 1915 *The Elementary Forms of the Religious Life.* Trans. J. Swain. New York: Macmillan.
Eagleton, Terry
 1990 *The Ideology of the Aesthetic.* Cambridge: Basil Blackwell.
Fabian, Johannes
 1983 *Time and the Other: How Anthropology Makes its Object.* New York: Columbia University Press.
Feldstein, Martin, ed.
 1991 *The Economics of Art Museums.* Chicago: University of Chicago Press.
Forge, Anthony, ed.
 1973 *Primitive Art and Society.* London: Oxford University Press.
Foster, Hal
 1985 *Recodings: Art, Spectacle, Cultural Politics.* Port Townsend, Wash.: Bay Press.
Foster, Hal, ed.
 1983 *The Anti-Aesthetic: Essays on Postmodern Culture.* Port Townsend, Wash.: Bay Press.
 1987 *Discussions in Contemporary Culture, 1.* Seattle: Bay Press.
Foucault, Michel
 1971 *The Order of Things: An Archaeology of the Human Sciences.* New York: Pantheon Books.
 1973 *Madness and Civilization: A History of Insanity in the Age of Reason.* Trans. R. Howard. New York: Vintage.
Fried, Michael
 1967 "Art and Objecthood." *Artforum* 5(summer):12–23.
Friedman, Jonathan
 1983 "Civilisational Cycles and the History of Primitivism." *Social Analysis* 14:14–52.

Fry, Tony, and Anne-Marie Willis
 1989 "Aboriginal Art: Symptom or Success?" *Art in America* 77(July):108–117,
 159–160, 163.
Gast, Dwight V.
 1988 "Pricing New York Galleries." *Art in America* 76(July):86–87.
Geertz, Clifford
 1973 *The Interpretation of Cultures: Selected Essays.* New York: Basic Books.
Gell, Alfred
 1992 "The Technology of Enchantment and the Enchantment of Technol-
 ogy." In Jeremy Coote and Anthony Shelton, eds., *Anthropology, Art, and
 Aesthetics,* pp. 40–66. Oxford: Oxford University Press.
Giddens, Anthony
 1979 *Central Problems in Social Theory: Action, Structure and Contradiction in Social
 Analysis.* Berkeley: University of California Press.
Ginsburg, Faye
 1989 *Contested Lives: The Abortion Debate in an American Community.* Berkeley: Uni-
 versity of California Press.
Goldwater, Robert J.
 1938 *Primitivism in Modern Painting.* New York: Harper and Row.
Greenberg, Clement
 [1939] 1961 "Avant-Garde and Kitsch." In *Art and Culture: Critical Essays,* pp. 3–21.
 Boston: Beacon Press.
 1965 "Modernist Painting." *Art and Literature* 4(spring):193–201.
Guilbaut, Serge
 1983 *How New York Stole the Idea of Modern Art: Abstract Expressionism, Freedom and
 the Cold War.* Trans. A. Goldhammer. Chicago: University of Chicago
 Press.
Hamilton, Annette
 1990 "Fear and Desire: Aborigines, Asians and the National Imaginary."
 Australian Cultural History 9(July):14–35.
Harris, Marvin
 1968 *The Rise of Anthropological Theory.* New York: Thomas Crowell.
Harris, Neil
 1990 *Cultural Excursions: Marketing Appetites and Cultural Tastes in Modern America.*
 Chicago: University of Chicago Press.
Hebdige, Dick
 1979 *Subculture: The Meaning of Style.* London: Methuen.
Hess, Elizabeth
 1989 "New York to Helms: Drop Dead." *Village Voice,* Oct. 24, 95.
Hodgen, Margaret
 1964 *Early Anthropology in the Sixteenth and Seventeenth Centuries.* Philadelphia:
 University of Pennsylvania Press.
Horkheimer, Max, and Theodor Adorno
 1982 *Dialectic of Enlightenment.* Trans. J. Cumming. New York: Continuum.
Hughes, Robert
 1988 "Evoking the Spirit Ancestors." *Time,* Oct. 31, 79–80.
 1992 "Art, Morals, and Politics." *New York Review of Books* April 23, 21–27.

Hyde, Lewis
 1983 *The Gift: Imagination and the Erotic Life of Property.* New York: Random
 House.
Hymes, Dell, ed.
 1974 *Reinventing Anthropology.* New York: Vintage.
Jakobson, Roman
 1960 "Closing Statement: Linguistics and Poetics." In Thomas A. Sebeok, ed.,
 Style in Language, pp. 350–377. Cambridge, Mass.: MIT Press.
Jameson, Frederic
 1984 "Postmodernism: or, The Cultural Logic of Late Capital." *New Left
 Review* 146:53–92.
Jopling, Carol, ed.
 1971 *Art and Aesthetics in Primitive Societies: A Critical Anthology.* New York: E. P.
 Dutton.
Kant, Immanuel
 1951 *Critique of Judgment.* Trans. J. H. Bernard. New York: Hafner Publishing.
Karp, Ivan, and Stephen D. Lavine, eds.
 1991 *Exhibiting Cultures: The Poetics and Politics of Museum Display.* Washington,
 D.C.: Smithsonian Institution Press.
Kierkegaard, Soren
 1945 *Fear and Trembling: A Dialectical Lyric.* Trans. W. Lowrie. Princeton, N.J.:
 Princeton University Press.
Kirshenblatt-Gimblett, Barbara
 1991a "Objects of Ethnography." In Ivan Karp and Stephen D. Lavine, eds.,
 Exhibiting Cultures: The Poetics and Politics of Museum Display, pp. 386–443.
 Washington, D.C.: Smithsonian Institution Press.
 1991b "Who's Bad? Accounting for Taste." *Artforum* 30(Nov.):119–125.
Kramer, Hilton
 1990 "The Varnedoe Debacle: MoMA's New Low." *New Criterion* 9(Dec.):5–8.
Krauss, Rosalind
 1984 "The Originality of the Avant-Garde: A Postmodern Repetition." In
 Brian Wallis, ed., *Art After Modernism: Rethinking Representation,* pp. 13–29.
 New York: New Museum of Contemporary Art.
Kroeber, Alfred L.
 1917 "The Superorganic." *American Anthropologist* 19:163–213.
 1923 *Anthropology.* New York: Harcourt Brace.
 1944 *Configurations of Culture Growth.* Berkeley: University of California Press.
 1952 *The Nature of Culture.* Chicago: University of Chicago Press.
Kruger, Barbara
 1990 "What's High, What's Low—and Who Cares." *New York Times,* Sept. 9,
 section 2, p. 43.
Kubler, George
 1962 *The Shape of Time: Remarks on the History of Things.* New Haven: Yale Uni-
 versity Press.

Langer, Susanne
> 1942 *Philosophy in a New Key: A Study in the Symbolism of Reason, Rite and Art.* Cambridge, Mass.: Harvard University Press.
> 1953 *Feeling and Form: A Theory of Art.* New York: Scribner.

Lattas, Andrew
> 1987 "Savagery and Civilisation: Towards a Genealogy of Racism." *Social Analysis* 21:39–58.

Levine, Lawrence W.
> 1988 *Highbrow/Lowbrow: The Emergence of Cultural Hierarchy in America.* Cambridge, Mass.: Harvard University Press.

Lévi-Strauss, Claude
> 1966 *The Savage Mind.* Chicago: University of Chicago Press.
> 1971 *Tristes Tropiques.* Trans. J. Russell. New York: Atheneum.
> 1982 *The Way of the Masks.* Trans. S. Modelski. Seattle: University of Washington Press.

Lévy-Bruhl, Lucien
> 1923 *Primitive Mentality.* Trans. L. Clare. New York: Macmillan.
> 1984 *How Natives Think.* Trans. L. Clare. Princeton: Princeton University Press.

Lippard, Lucy
> 1973 *Six Years: The Dematerialization of the Art Object from 1966 to 1972.* New York: Praeger.
> 1991 *Mixed Blessings: New Art in a Multicultural America.* New York: Pantheon Books.

Losche, Diane
> 1993 "The Sepik Gaze: Iconographic Interpretation of Abelam Form." Paper presented at the American Ethnological Society Meetings, Santa Fe, New Mexico. April 1993.

MacDonald, Dwight
> 1953 "A Theory of Mass Culture." *Diogenes* 3:1–17.

Malcolm, Janet
> 1986 "Profiles: A Girl of the Zeitgeist—part I." *New Yorker,* Oct. 20, 49–89.

Manning, Patrick
> 1985 "Primitive Art and Modern Times." *Radical History Review* 33:165–181.

Marcus, George E. (with Peter Dobkin Hall)
> 1992 *Lives in Trust: The Fortunes of Dynastic Families in Late Twentieth-Century America.* Boulder: Westview Press.

Marcus, George E., and Michael M. J. Fischer
> 1986 *Anthropology as Cultural Critique: An Experimental Moment in the Human Sciences.* Chicago: University of Chicago Press.

Marks, Laura
> 1992 "White People in the Native Camera: Subverting Anthropology." *Afterimage* 19(10):18–19.

Maybury-Lewis, David
> 1992 *Millennium: Tribal Wisdom and the Modern World.* New York: Viking.

McEvilley, Thomas
 1984 "Doctor, Lawyer, Indian, Chief: 'Primitivism' in 20th Century Art at
 The Museum of Modern Art in 1984." *Artforum* 23(Nov.):54–60.
Miller, Daniel
 1991 "The Necessity of Primitive in Modern Art." In Susan Hiller, ed., *The
 Myth of Primitivism: Perspectives on Art*, pp. 50–71. London and New York:
 Routledge.
Mitchell, Timothy
 1989 "The World as Exhibition." *Comparative Studies in Society and History*
 31:217–236.
Moulin, Raymonde
 [1967] 1987 *The French Art Market: A Sociological View*. New Brunswick: Rutgers Univer-
 sity Press.
Myers, Fred R.
 1986a *Pintupi Country, Pintupi Self: Sentiment, Place, and Politics among Western Desert
 Aborigines*. Washington, D.C.: Smithsonian Institution Press, and Can-
 berra: Aboriginal Studies Press.
 1986b "The Politics of Representation: Anthropological Discourse and Aus-
 tralian Aborigines." *American Ethnologist* 13:138–153.
 1988a "Critical Trends in Hunter-Gatherer Studies." *Annual Review of Anthropol-
 ogy* 17:261–282.
 1988b "Locating Ethnographic Practice: Romance, Reality and Politics in the
 Outback." *American Ethnologist* 15:609–624.
 1994 "Beyond the Intentional Fallacy: Art Criticism and the Ethnography of
 Aboriginal Acrylic Painting." *Visual Anthropology Review* 10(1)(spring):10–43.
Nash, June
 1979 *We Eat the Mines and the Mines Eat Us: Dependency and Exploitation in Bolivian
 Tin Mines*. New York: Columbia University Press.
Nietzsche, Friedrich
 1967 *On the Genealogy of Morals*. Trans. W. Kaufmann and R. J. Hollingdale.
 New York: Vintage Books.
Ong, Aihwa
 1987 *Spirits of Resistance and Capitalist Discipline: Factory Women in Malaysia*.
 Albany: SUNY Press.
Owens, Craig
 1983 "The Discourse of Others: Feminists and Postmodernism." In Hal
 Foster, ed., *The Anti-Aesthetic: Essays on Postmodern Culture*, pp. 57–82. Port
 Townsend, Wash.: Bay Press.
Poggioli, Renato
 1968 *The Theory of the Avant-Garde*. Trans. Gerald Fitzgerald. Cambridge, Mass.:
 Belknap Press of Harvard University Press.
Price, Sally
 1989 *Primitive Art in Civilized Places*. Chicago: University of Chicago Press.
Princenthal, Nancy, and Deborah Drier
 1988 "Critics and the Marketplace." *Art in America* 76(July):104–111.
Rabinow, Paul, and William Sullivan, eds.
 1984 *Interpretive Social Science: A Reader*. Berkeley: University of California Press.

Ratcliff, Carter
 1988 "The Marriage of Art and Money." *Art in America* 76(July):76–84, 145–147.

Rosaldo, Renato
 1989 *Culture and Truth: The Remaking of Social Analysis.* Boston: Beacon Press.

Rose, Barbara
 1988 *Autocritique: Essays on Art and Anti-Art, 1963–1987.* New York: Weidenfeld and Nicolson.

Rosenberg, Harold
 1972 *The De-definition of Art: Action Art to Pop to Earthworks.* New York: Horizon Press.

Rousseau, Jean-Jacques
 1992 *Discourse on the Origins of Inequality.* Trans. J. R. Bush. Hanover, N.H.: University Press of New England.

Rubin, William
 1984 "Modernist Primitivism: An Introduction." In William Rubin, ed., *"Primitivism" in 20th Century Art: Affinity of the Tribal and the Modern,* pp. 1–84. New York: Museum of Modern Art.

Said, Edward
 1978 *Orientalism.* New York: Pantheon Books.

Sapir, Edward
 1917 "Do We Need a 'Superorganic'?" *American Anthropologist* 19:441–447.
 1970 *Selected Writings of Edward Sapir in Language, Culture, and Personality.* Ed. David Mandelbaum. Berkeley: University of California Press.

Schjeldahl, Peter
 1988 "Patronizing Primitives." *Seven Days,* Nov. 16.

Solomon-Godeau, Abigail
 1988 "Living with Contradictions: Critical Practices in the Age of Supply-Side Aesthetics." In Andrew Ross, ed., *Universal Abandon? The Politics of Postmodernism,* pp. 191–213. Minneapolis: University of Minnesota Press.

Sontag, Susan
 1966 *Against Interpretation, and Other Essays.* New York: Dell.

Stevens, Mark
 1990 "Low and Behold." *New Republic,* Dec. 24, 27–33.

Stewart, Susan
 1984 *On Longing: Narratives of the Miniature, the Gigantic, the Souvenir, the Collection.* Baltimore: Johns Hopkins University Press.

Stocking, George W., Jr.
 1968 *Race, Culture, and Evolution.* New York: Free Press.
 1987 *Victorian Anthropology.* New York: Free Press.
 1989 *Romantic Motives: Essays on Anthropological Sensibility.* Madison: University of Wisconsin Press.

Taussig, Michael
 1987 *Shamanism, Colonialism and the Wild Man.* Chicago: University of Chicago Press.

Thornton, Robert, ed.
 1993 *The Early Writings of Bronislaw Malinowski.* Cambridge: Cambridge University Press.

Tillich, Paul
 1952 *The Courage to Be.* New Haven: Yale University Press.
Tillim, Sidney
 1987 "Criticism and Culture, or Greenberg's Doubt." *Art in America* 75(May):
 122–127, 201.
Tocqueville, Alexis de
 1955 *The Old Regime and the French Revolution.* Trans. S. Gilbert. Garden City:
 Doubleday.
Tomkins, Calvin
 1988 *Post- to Neo-: The Art World of the 1980s.* New York: H. Holt.
Torgovnick, Marianna
 1990 *Gone Primitive: Savage Intellects, Modern Lives.* Chicago: University of
 Chicago Press.
Trinh, T. Minh-Ha
 1989 *Woman, Native, Other: Writing Postcoloniality and Feminism.* Bloomington:
 Indiana University Press.
Turner, Victor
 1969 *The Ritual Process: Structure and Anti-Structure.* Chicago: Aldine Publishing.
 1986 *The Anthropology of Performance.* New York: PAJ Publications.
Tyler, Stephen A.
 1978 *The Said and the Unsaid: Mind, Meaning, and Culture.* New York: Academic
 Press.
 1986 "Post-modern Ethnography: From Document of the Occult to Occult
 Document." In James Clifford and George E. Marcus, eds., *Writing Cul-*
 ture: The Poetics and Politics of Ethnography. Berkeley: University of California
 Press.
 1987 *The Unspeakable: Discourse, Dialogue, and Rhetoric in the Postmodern World.*
 Madison: University of Wisconsin Press.
Varnedoe, Kirk
 1985 "On the Claims and Critics of the Primitivism Show." *Art in America*
 73(May):11–13, 21.
Varnedoe, Kirk, and Adam Gopnik
 1990 *High & Low: Modern Art and Popular Culture.* New York: Museum of
 Modern Art.
Werckmeister, Otto
 1991 *Citadel Culture.* Chicago: University of Chicago Press.
White, Hayden
 1978 *The Historical Text as Literary Artifact. Tropics of Discourse: Essays in Cultural*
 Criticism, pp. 81–100. Baltimore: Johns Hopkins University Press.
Williams, Raymond
 1977 *Marxism and Literature.* Oxford: Oxford University Press.
Willis, Paul
 1977 *Learning to Labour: How Working Class Kids Get Working Class Jobs.* New
 York: Columbia University Press.
Wolf, Eric
 1982 *Europe and the Peoples without History.* Berkeley: University of California
 Press.

Wolff, Janet
 1981 *The Social Production of Art.* New York: St. Martin's Press.
 1983 *Aesthetics and the Sociology of Art.* Boston: Allen and Unwin.
Zolberg, Vera
 1990 *Constructing a Sociology of the Arts.* Cambridge: Cambridge University Press.
 n.d. Art Institute of Chicago. In preparation.

PART 1

Relativizing the Art World

Representing Culture:
The Production of Discourse(s)
for Aboriginal Acrylic Paintings

Fred R. Myers

*To see something as art requires something the eye cannot descry—an atmosphere of artistic
theory, a knowledge of the history of art: an artworld.*
ARTHUR DANTO (1964)

When I was returning to Central Australia in July 1988, I noticed an unusual
woman on the plane from Sydney to Alice Springs, the heart of Australia's "Out-
back" where the clothing tends to range from tourist sweat suits and reeboks, to
country western style outfits with R. M. Williams stockman's boots, to hippie-trav-
eler casual. Compared to most of the passengers, this woman was dramatically
overdressed—wearing fine gold-colored Italian leather sandals, scarlet nailpolish,
and a kaftan-style designer jacket and trousers made of dark silk. She was accom-
panied by a man with long black hair drawn back in a pony tail, a black goatee
and moustache and a long black duster coat—the combined effect evoked a late-
nineteenth-century studio artist from the École des Beaux Arts in Paris. Leaving
the plane, I wondered what these people, who seemed ready for a gallery party in
Sydney, could be doing in the frontier town of Alice Springs, particularly since
they seemed to know their way around.

An hour later, dressed in my uniform of choice, a denim shirt and jeans, I
stopped in to greet old friends at the shop of the Papunya Tula Artists company,
where I was introduced to the mystery woman. She was Gabrielle Pizzi, the Mel-
bourne art dealer who is the principal distributor of the acrylic paintings produced
by the Aboriginal people with whom I have been working since 1973. Our different
ideas about attire for meeting Aboriginal artists in the Outback emphasized our
differences. Ironically, my discomfort with *their* entry into a domain I had consid-
ered refreshingly remote from the pretensions of our own society's high culture
led me to examine the world from which *they* came.

Back in New York, in May 1989 the John Weber Gallery in Soho had a show of
Papunya Tula Artists' work, and as I waited there one afternoon to interview the
gallery owner, I was jarred by hearing a visitor to the gallery talk with familiarity of

Simon Tjakamarra's "colorism" and the decline of Clifford Possum's recent paintings. These are Aboriginal men I know from my fieldwork, where I was once threatened for merely having asked the name of a man's country!

Such cultural incongruity appears even when the emphasis is on the "Aboriginality," or distinctiveness, of their paintings. I find it dislocating to hear them repeatedly represented as "painters" or "artists." In Weber's gallery, the acrylics are hung to emphasize that role as defined by the West.[1] No information is presented about specific content: only the name of painter, the date, and title are given, although an accompanying catalog traces some of the general historical tradition related to the production of these images.

In short, the people whom the *Guinness Book of Records* inscribed as having the simplest material culture of any people on earth (the "Bindibu"[2]), representatives of a people regarded disparagingly by the dominant white majority in Australia, are now accorded international appreciation as producers of "high art," an appreciation rarely granted to Australia's white art producers.

A sign of the definitive success of Australian Aboriginal acrylic paintings in the U.S. was the exhibition at the Asia Society Galleries in New York City in late 1988. Entitled "Dreamings: The Art of Aboriginal Australia," this show drew the largest attendance (27,000 visitors) of any exhibit ever held at the Asia Society. Viewers came to see a display of 103 objects, of five types and from four different "cultural areas" in Australia. There were wood sculptures (from Cape York Peninsula), bark paintings (from Arnhem Land), acrylic paintings on canvas and shields (Central Australia), and small carved pieces known as *toas* or message sticks (from the Lake Eyre region) (see Sutton 1988).

For the Aborigines of Central Australia, the acrylic paintings on canvas (as well as the paintings on bark) are a *new* form, objects made for sale and not for their own ritual or practical use. They are attempting, nonetheless, to define these products in terms meaningful to them. While bark and acrylic paintings are produced as commodities for commercial sale to outsiders (see Bardon 1979; Kimber 1977; Megaw 1982; Morphy 1983, 1992; Myers 1989; Sutton 1988; N. Williams 1976), both artistic traditions draw largely on designs and stories embedded in indigenous religious activities and this constitutes—for Aborigines and probably for whites (although differently)—a major part of their value. Yet the significance of these objects and their activities—the meaning of their meanings, as it were—is not controlled by the Aboriginal painters as they move into the wider cultural arena in which they are displayed and sold.

Nobody in 1973 or 1974 would have expected to read about Papunya paintings in the *New York Times*, as we do (occasionally) now. Yet, from the beginning, their existence was defined in three differentiated cultural arenas: local, state, and art circles. Specifically, their production has provoked growing self-consciousness among the Aboriginal producers for whom the sales have had economic and cultural importance,[3] responses from those formulating "cultural policies" in the agencies of the Australian state—such as the government-funded Aboriginal Arts

Board of the Australia Council and the Department of Aboriginal Affairs (see Alt-
man 1988:52–53; Altman, McGuigan, and Yu 1989)—and, increasingly, evalua-
tions from the art markets.

The movement of the acrylic paintings into the "international art scene" has
generated rising prices[4] and an inventory of articles and reviews from the art crit-
ical world. What is challenging for anthropologists about the presentation of Abo-
riginal art in the Asia Society exhibition—or in events like this exhibition in which
images are exchanged internationally—is not just that ethnographic representa-
tions of Aboriginal culture play a visible part in the "constitution" of these objects;
these anthropological representations, drawn from our own discourse, are con-
tested by other representations as well.

My point in this paper is to show that the production, circulation, and con-
sumption of these objects constitutes an important dimension of self-production
of Aboriginal people and of the processes of "representing culture" significant in
what Appadurai and Breckenridge (1988:1) have described as the "global cultural
ecumene" of the contemporary world. The task is to understand how these paint-
ings have come to represent "Aboriginal culture" through a variety of practices
and discourses. This is a hybrid process of cultural production, bringing together
the Aboriginal painters, art critics, and ethnographers, in addition to curators, col-
lectors and dealers: in short, an "artworld" (Becker 1982). I am particularly con-
cerned with the attempts by critics to situate these art forms in cosmopolitan art
circles. Such a situation places anthropologists in an unfamiliar relationship to
their stock-in-trade—knowledge rooted in *local* constructions.

It seems to me, drawing upon my own experience, that anthropologists have
been largely concerned to defend their own interpretations or to make them intel-
ligible within the shadow of what they *take* to be the prevailing, culturally hege-
monic notions of "art." In so doing, we have tended to reify our own culture's con-
cepts into a more stable form than they actually have, and we fail to consider
empirically (and critically) the processes in which we (and the art critics) are
engaged as ethnographically important processes of cultural representation. This is
ironic, I think, because the point of the struggle is almost entirely a question of
how to represent others. Thus, if these antagonistic encounters (and I must admit
to being a willing participant) about the imposition of Western art historical con-
cepts often seem to be only so much turf warfare, they can also be conceived of as
themselves forms of the social and cultural practices of representation. In recon-
ceptualizing the relationship between art criticism and anthropology in this way, it
may be possible to articulate more cogently the processes through which differ-
ence can be rendered intelligible.

To be sure, such ethnocentrism persists, despite the interventions of anthro-
pologists and art critics. However, the discourse of art critics (and art historians) is
not a univocal one, and cases like those discussed by Price (1989) represent what is
now only a portion of the Western discourse of art. This discourse is as unsettled
and multiple as our own. What I want to outline here is the "engagement" (is it a

military metaphor or a romantic one?) between anthropological and indigenous accountings of Australian Aboriginal acrylic paintings and those of art critics. In part, the choice of subject is accidental, owing much to my personal circumstances and history.

DISJUNCTIONS (1)

My sense of disjunction in examining the representation of Aboriginal painting is both personal and professional. Since I began research with Western Desert—Pintupi-speaking—Aboriginal people, this work association has taken me to a number of local communities west of Alice Springs.[5] Although nearly all were living in more or less permanent settlements by 1973, many of them had been still living as hunter-gatherers until the 1960s (and one family until 1984). On government settlements in the 1960s, these Aboriginal people lived largely in conditions of administered welfare colonialism and began to exercise a significant degree of local self-determination with the election of Gough Whitlam's Labour Government in 1972—shortly before I arrived. The development of acrylic painting began at the settlement of Papunya in 1971 under the sponsorship of art teacher Geoff Bardon, whose own book (1979) chronicles the transformation of indigenous forms of graphic representation—signs and designs deployed in ceremony, body decoration, cave paintings, and sand stories—into paintings on masonite and canvas board for sale.

Even in communities as remote as Warlungurru, 250 miles west of Alice Springs in the Northern Territory, the Aboriginal producers of these paintings live in a world complexly related not only to the Australian state (through welfare payments and other forms of services) but also to an international world of images (films, videos, television), sounds (country western music, rock and roll, gospel), and clothing (especially, for men the cowboy/stockman attire of jeans, boots and Western shirts). Evangelical activity competes with religious movements of cultural revival and intensification, but indigenous meanings continue to dominate local discourse. Such intermingling of culturally heterogeneous forms is, of course, one of the principal problems for contemporary cultural theory. A decade and a half after painting was first adopted as an activity, then, is it a means through which Central Desert people add their voices to the cultural discourses of the world? Or is it more evidence of "cultural homogenization"? What is to be understood by Aboriginal claims that these very new forms are "authentic" and "traditional"—that is, that they are "from the Dreaming," "true," or "from the beginning"?

DISJUNCTIONS (2)

To an anthropologist who has long been used to working his interpretations of a distant culture in some obscurity, one of the most important dimensions of the flurry of interest in Australian Aboriginal acrylic paintings is the very cultural pro-

duction occasioned by these objects and their makers. There are many stories—told both by Aboriginal people and others—involved in placing these objects meaningfully in a cultural order. Certainly, it should not be surprising to anthropologists either that new objects might require stories to place them in a cultural order or that different stories might contest each other's accounts. Rarely, however, do we regard our accounts and their competitors from such a disengaged analytical perspective, but that is what I argue we should be doing.

These interpretive activities are of ethnographic interest for two reasons: first, because through them the acrylic paintings are being used to signify something about Aboriginal culture. Second, the way these representations contest each other provides an entry both into the disjunctions of local and global process, into the question of authoritative ethnographic representation, and into the relationship between anthropological knowledge and art criticism.

My experience suggests that the disjunction between these arenas in which meanings are produced and circulate is more complex than commodification. There is not only the sense of spatial and cultural incongruity that accompanies the globalization of cultural processes, when people in New York City discuss, debate, and evaluate the meanings of objects produced in small Aboriginal communities and the intentions and lives of its producers. There is also the disjoined relationship between the discourses of the art world and those of Aboriginal painters, the gap between how the producers account for their paintings and what significance they are made to have in other venues.

In all the interpretive activity devoted to Aboriginal paintings, Meyer Rubinstein's insightful review seems best to have grasped the elusive situation that I am labeling disjunction:

> But for now, as our two worlds meet upon the site of these paintings, we and the Aborigines are in similar positions: neither knowing quite what to think. For both societies the appearance of these paintings is relatively recent and their nature and role is still being discovered. They are in limbo between two homes, sharing their functions and sense of belonging with both, but not fully explicable in either's language. They are, like those ancestral beings whose journeys they depict, traversing a featureless region and giving it form. In the words of an Aboriginal man trying to explain Dreamings to an anthropologist, "You listen! Something is there; we do not know what; *something.*" (Rubinstein 1989:47)[6]

We cannot understand these processes by attempting to transcend the gap. Rubinstein's discussion is important not merely because it draws attention so dramatically to the disjunction, however. While Rubinstein recognizes the incongruities, his statement conceives of the engagement of critical discourses with their subject as more than the encounter between reified, hypostasized cultural categories ("art" and "Dreaming"/*tjukurrpa*). He conceives of it, rather, as human *activity* that should be examined.[7] Aboriginal objects are not simply or necessarily excluded by Western art critical categories; they may in fact contribute to or challenge these dis-

courses for the interpretation of cultural activity in productive ways. They can hardly do so, however, if anthropological interpretation accepts a stable category of "art" as its horizon of translation.

There are several distinctive (discursive) levels involved in the social construction of the objects, ranging from the indigenous accountings to government cultural policies, art dealers, and art critics. The stories are numerous and each individually interesting, but I cannot discuss all of them here. They include, for example, the humanizing representation of Aboriginal culture as "artistic," of acrylic paintings as "cultural renewal," of their message as "spiritual wholeness" in contrast to a desolate modernity, and so on—representations all situated in the changing sociopolitical context of Aborigines in a settler society. In this paper, I restrict my discussion principally to the constructions of anthropology and art critical reception.

INDIGENOUS DISCOURSE AS CULTURAL PRODUCTION

Before turning to the critical response(s) to the Asia Society exhibition as constructive and deconstructive activities involved in defining the significance of Aboriginal painting, I want to discuss the accountings provided most directly by the Aboriginal producers (see fig. 2.1). I am concerned with the disjunction between ethnographic/local accountings and those issuing from venues of cultural production at a greater distance.

The evaluation of Aboriginal practices is not a simple interpretation of "some facts" existing out there. In such constructive activities, rather, one discerns the properties of intertextuality or of what Bakhtin called the "dialogical," in which one "word" is addressed to, assumes, or is aware of other interpretations. Before the appearance of these reviews, for example, I was brought in most often as a translator and was asked to explain what these paintings "mean" to the Aborigines, as the way in which viewers might learn how to look at them, how to interpret their significance. This practice always tacitly assumed other readings, usually "ethnocentric" ones, that needed to be countered, but I rarely considered those worthy of analytic or ethnographic attention.

Anthropologists have tried—extending our role as translators—to stretch ourselves into a function usually allocated to critics, that is, to tell people what they should see in the paintings. This may be simply a promulgation of Aboriginal statements, but it does constitute a position—as authority, if you will—within the definition of meaning. This is where we have been challenged by others with a different understanding of what there is to know about a surface, with different questions to engage, and often with a more developed and critical vocabulary for discussing visual phenomena and their production. Moreover, the evaluation of Aboriginal image production is not based on a static Western notion of "art," since the tradition of cultural criticism in which art practices are themselves embedded has been questioning precisely what this category is and should be.

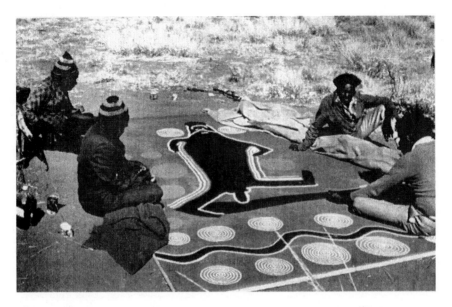

Fig. 2.1. Uta Uta Jangala and the painting of *Yumari* at Papunya, N.T., Australia. July 1981.

Be this as it may, "Aboriginal art" could not exist without Aboriginal culture(s), Aboriginal persons and traditions of body painting, sand painting, and so on. We begin, therefore, with the practices through which Aboriginal producers assign significance to their productions. Nancy Munn's study of *Walbiri Iconography* (1973) and Howard Morphy's *Ancestral Connections* (1992) are well-known for articulating the processes of producing and exchanging images in ritual in Central Australia and Arnhem Land respectively. Even though the acrylic images are not themselves produced for local consumption, these processes and coordinate social and cosmic identities represent the first level of organization and the basis for most Aboriginal evaluations of the objects. Nonetheless, most commentators gain access to these meanings not in the experience of daily life, but through some textualization.

My Textualization of Pintupi Practice

Let me begin with my understanding of Pintupi explanations and practices. What the Pintupi painters continually stress is (1) that their paintings are "stories" *(turlku)*, representations of the events in the mythological past of the Dreaming, and (2) that they are "true" *(mularrpa)*, that they are not made up. Like all the other Central and Western Desert people who do acrylics, the Pintupi have a rich ceremonial and ritual life in which songs, myths, and elaborate, complex body decora-

tions as well as constructed objects are combined in performances which reenact the somewhat mysterious events known as "the Dreaming" *(tjukurrpa)* which gave their world its form and order. The significance of the paintings in their own eyes is bound up with their ideas about the relationship between this world and the Dreaming. All paintings represent stories from one of many cycles that concern traveling, mythical ancestral beings (Dreamings), and Pintupi country is laced by the paths of their travels. The value of the Dreaming lies in the fact that the world as it now exists is conceived to be the result of the actions of these beings. Persons, customs, geographical features are all said to have originated in the Dreaming, or as Pintupi people regularly say, *tjukurrtjanu, mularrarringu* ("from the Dreaming, it became real"). Access to knowledge of these events, the right to tell the stories, and the right to reenact the events and reproduce the designs and objects in ceremony are restricted, and transmitted through a variety of kinship links. Instruction in the most important details of esoteric knowledge takes place in ceremonies in which men (and women in their own ritual activities) reenact the stories of the Dreaming, constructing ritual objects and decorating the actors in designs said to be "from the Dreaming." These designs—which it is often forbidden for men or women to see if produced by the opposite sex—are in some ways iconic representations of the event and the landscape which records it, but they are also said to come (indexically) from the Dreaming and to have been "revealed" *(yutinu)*.

Finally, like the rituals of which they are considered to be a part, the story-song-design complexes are "owned" by various groups of persons, and the rights to "show" them are in the hands of the owners of the place, especially those whose own "spirits" come from that Dreaming. The particular formulations of ownership vary throughout Aboriginal Australia, but the overall features of these relations of image production are fairly consistent at least in Central Australia. Thus, Pintupi continue to think of their commercial paintings as related to and derived from their ceremonial designs and rock paintings, associated with important myths, and therefore possessing value other than that merely established in the marketplace (see figs. 2.2 and 2.3).

I want to point out that no single significance is entailed by the account above. What is critical to recognize, I believe, is that the display of ritual knowledge is a revelation both of something "from the Dreaming" and of one's rights to a place, but it is also a performance of a central component of the identities of those who produce the display. Nonetheless, the further movement of these objects through the world suggests that instead of regarding these discourses for image production as intrinsically the *meaning* of the paintings, we should consider how these (or other) discourses are drawn on by painters in *accounts* of their acrylic images.

Other Textualizations

Aboriginal people increasingly have the opportunity to deploy their meanings directly, and their versions circulate fairly widely now in the press and in exhibition

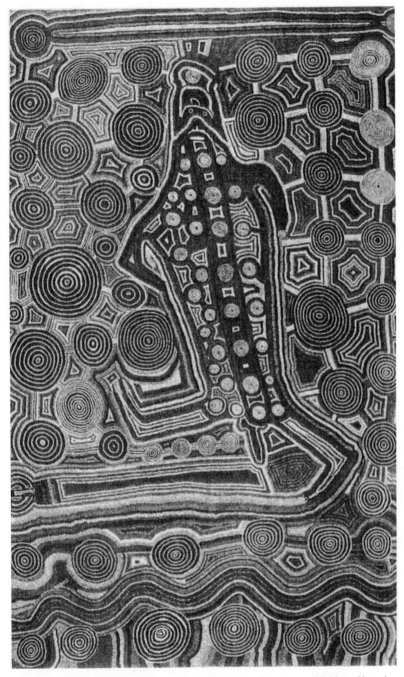

Fig. 2.2. Papunya Tula painting at the Asia Society *Dreamings* exhibition. *Yumari,* 1981. Uta Uta Jangala. Acrylic on canvas, 244 × 366 cm.

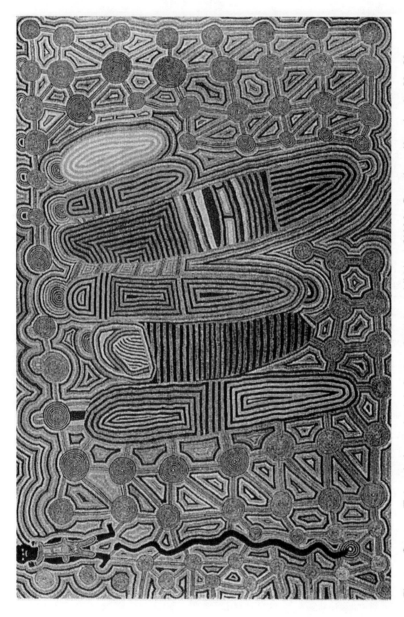

Fig. 2.3. Papunya Tula painting at the Asia Society *Dreamings* exhibition. *Old Man Dreaming at Yumari*, 1983. Uta Uta Jangala. Acrylic on canvas, 242 × 362 cm.

catalogs (where they are partly mediated by interpretive accounts of "the Dreaming" like mine above). I will make my point from these self-presentations.

Consider, for example, how one woman painter—in New York for the first time and on stage at the Asia Society for a symposium in which Aboriginal paintings were being discussed (October 22, 1988)—defined her production. Dolly Granites spoke in Warlpiri; her words were translated into English by the anthropologist Françoise Dussart. Dussart reported: "Dolly says that she holds the Dreaming from her father. She holds the Dreaming from her father's father, and she holds many Dreamings in her country. She also holds the Dreaming from her mother. She holds the Dreaming from her father's father and from her father's mother." This was what an Aboriginal painter thought needed to be explained. No background or interpretive framework was offered beforehand.[8] Indeed, the anthropologists and art adviser present on stage felt obliged to provide such a context in their comments.

An article in the *Sydney Morning Herald* (Kent 1987), on the occasion of a show at the Hogarth Gallery there, reports how Aboriginal painters in the Napperby Station community (northwest of Alice Springs) see their painting. "This dreaming," a painter named Cassidy says,

> is about the place where I was born. . . . This waterhole and this emu track are part of my Dreaming. It takes me two weeks to make. *One day my painting will make Napperby number one.* . . . I show the young fellas what we Aboriginal people can do for ourselves. (Kent 1987:48, my emphasis)

Like Dolly, Cassidy's comments combine a reference to the Aboriginal worldview[9] which is usually said to be embodied in the paintings—the Dreaming, as described above—with themes that are commonly part of Aboriginal thinking: usually the right to portray the designs of one's dreaming (that is, the ancestral/mythological being whose spirit animated one).

A good ethnographer might press further as to what it could mean for Napperby to be "number one." At some level the quotation must generally be held to signify increasing self-esteem through external recognition—a form of self-production that is precisely what, one might argue, Aboriginal people typically accomplish in their traditional practices of "owning," producing and exchanging representations of the Dreaming (see Myers 1986, 1989).

The newspaper article, however, gave more prominence to another set of themes articulated by other Aboriginal painters in the Napperby community: about money, respect, self-esteem and dignity. As Rita Nungala, a woman painter, put it:

> We have no grog here, on this station, because we don't want fights. We make that decision ourselves. We do have this painting, though, and it gives us something to do. It is good that the youngsters see that, that they work and they get paid. (Rita Nungala in Kent 1987:48)

The painters made it clear that while money is a principal reason for painting, they regard the canvases as more than mere commodities.[10] Rita's statement of the positive effect the painting has on everyone reflects—in addition to the influence of government training programs on Aboriginal views of labor—an appreciation of how painting represents a cultural effect, an act of autonomy, self-esteem, and cultural reproduction. While her statement might seem more accessible than Dolly's, it too draws on a presumed context, in this case, the recent history of Australian government policies for what has been called "Aboriginal self-determination" (see Beckett 1985), which I discuss below.

Constructions similar to those delineated briefly above are commonly offered in public presentations by painters.[11] What these examples make clear is that these interpretations, those of the natives and others, are all accountings—constructions—each presuming a set of taken-for-granted givens which they also reproduce. The painters *presume* their own cultural discourses: they expect that those who see the paintings will recognize in them the assertion or demonstration of the ontological link between the painter, his/her Dreaming, the design, and the place represented. They also (tend to) presume the function these links will have. When Dolly Granites was at the Metropolitan Museum in New York, upon finding out that the Degas paintings were not "from the Dreaming," she classified them as "rubbish" (of no significance).

Clearly, the available meanings to Aborigines for this activity are many. To summarize briefly, they include painting as a source of income, painting as a source of cultural respect, painting as a meaningful activity defined by its relationship to indigenous values (in the context of "self-determination"), and also painting as an assertion of personal and sociopolitical identity expressed in rights to place.

CONSTRUCTION: ABORIGINAL CULTURE AS ART

In this section, I want to explore how the representations of the acrylic paintings offered by whites, while basing themselves on remarks such as those I have described, have primarily constructed a *permissible* Aboriginal culture, that is, a representation that meets the approval of the dominant white society's notions of "common humanity." The reasons for this are complex and not possible to consider here,[12] but let me start with the initial framing devices. Most of the Western constructions of acrylic paintings interpret them within the rubric of "art." This occurs at two levels: (1) the assertion or demonstration that Aboriginal people have "art," value it, and that the tradition is very old (implying that Aboriginal people are able to preserve things of value) and that therefore their culture is vital and worthy of respect; and (2) that this "art" contributes something important—something different or challenging—to the world of art. It will be clear that much of the "construction" of Aboriginal activities as art draws heavily on a variety of themes in modernist discourse, ranging from visual invention to human creativity

and the loss of spirituality with development. These constructions, then, can be seen as a kind of cultural production.

The presentation of the objects at the exhibition itself drew partly on such "humanistic" representations. According to the publicity circulated, the exhibition of these varied objects shows

> the extraordinary vitality of Aboriginal art. It is the oldest continuous art tradition in the world, and is flourishing with new energy and creativity in contemporary media. The works in the exhibition represent the "Dreamings," the spiritual foundation of Aboriginal life.

There are many significations in this theme, but one bears immediate tracing. The scientifically reported thirty-thousand-year history of visual culture on the Australian continent has considerable salience for contemporary urban Aboriginal people, who treat this history in much the same way that the French conceive of their prehistoric cave paintings. The appearance of "art" in the Australian archaeological record precedes that of the Ice Age in Europe, for example, the art of Lascaux, so often regarded popularly as the first evidence of civilization. This representation offers an image of cultivated Aboriginal ancestors while Europe still lacked aesthetic vision. Moreover, in stressing that this tradition of visual culture is continuous, the museum publicity can attest to the survival, renewal ("flourishing"), and contemporary creative potential ("extraordinary vitality," "creative energy") of Aboriginal culture. The roots of this potential lie in the Dreamings, identified as the "spiritual foundation of Aboriginal life."

The Spiritual Is Political

> Ordinary Australians, who may have had trouble dealing with the poverty, customs, and appearance of Aborigines, have finally been able to respect their artform. For Westerners, beautiful artifacts are the accepted currency of cultural accomplishment. (Pekarik 1988:52)

This construction is a step toward the synecdochic representation of Aboriginal culture itself by one form of its practice. Indeed, the significance or place of Aboriginal "art" in the representation of Aboriginal culture and identity owes much to motivations that are political, in the hope of improving the condition of Aboriginal people in Australia by gaining appreciation of their achievements.

The themes of Jane Cazdow's (1987a) article in the 1987 *Australian Weekend Magazine*, reporting on the art boom, are illustrative of the stories in which the paintings are embedded. She emphasizes three themes: (1) the financial and morale-boosting benefits to Aboriginal communities, (2) the controversy about the loss of "authentic" Aboriginal art as "the number of Aboriginals raised in traditional tribal societies is dwindling" (p. 15), according to one collector,[13] and (3) the significance of the art's success for black-white relations.

Cazdow (1987a:15) reports that the (then) Minister for Aboriginal Affairs, C. Holding, believed that the boom in Aboriginal art was important in gaining respect for Aboriginal culture, "in creating bridges of understanding between Aboriginal and white Australia" (an important goal of the DAA's cultural policies, see above). According to Holding,

> Many Australians have been taught that Aboriginal people have no traditions, no culture. . . . When they come to understand the depth of tradition and skill that's involved in this area, it's a very significant factor in changing attitudes. (Cazdow 1987a:15)

The capacity of the success of these paintings to signify for black-white relations depends largely on art's standing for the generically (good) human.

Although largely a stranger himself to Australian shores, the director of the Asia Society Galleries, Andrew Pekarik—who brought the show to New York—recognized a similar dimension and articulated (more self-consciously) some of its subtler political twists in the statement that begins this section (above). Many writers have drawn on explicit Aboriginal constructions about the political significance of their representation of places. The Australian fiction writer Thomas Keneally certainly drew on such statements and a wealth of anthropological material for his *New York Times* piece to place the paintings in a meaningful context for viewers. Keneally asked rhetorically what these men and women were "praising" in their work. This is something "we are entitled to ask," he wrote. The answer he offered—that "every stretch of land belongs to someone," that this is not art for art's sake (1988:52)—framed this work in the politics of Australia, the concern with land rights and the development of a movement of return to traditional homelands, and the need for money.

Visual Invention

I like the way they move the paint around. (John Weber, personal communication, 1989)

Another important story, more recognizably "modernist," has been that the Aboriginal paintings are "good" art, describable in the conventions of contemporary Western visual aesthetics. Art critic Kay Larson (1988), in *New York Magazine*, wrote:

> Modernism has allowed us to comprehend the Aboriginal point of view. . . . Aboriginal art at its best is as powerful as any abstract painting I can think of. I kept remembering Jackson Pollock, who also spread the emotional weight of thought and action throughout the empty spaces of his canvas. (Larson 1988)

Others, like John Weber, the Soho gallery dealer, also thought it was "good art" (Wallach 1989; Sutton 1988; but see Michaels 1988).

But, as the art critic Nicolas Baume (1989:112) notes, the Aboriginal paintings do not simply repeat the familiar for Larson. They assert their *differences*, their challenge to contemporary norms.

Roberta Smith (1988) builds a different story, deriving from features of this same discourse. In her review in the *New York Times*, Smith judges that the exhibition "can unsettle one's usual habits of viewing," presenting a "constantly shifting ratio of alien and familiar aspects, undermining the efficacy of designating any art outside the mainstream." But her judgment is that "this is not work that overwhelms you with its visual power or with its rage for power; it all seems *familiar* and *manageable*" (emphasis added).[14] Smith recognizes that the paintings are based on narratives and motifs handed down through generations, but for her,

> The more you read, the better things look, but they never look good enough. The accompanying material also suggests that these same motifs are more convincing in their original states. (Smith 1988)

Thus, Smith is open to the possibility of this art but falls back on formalist conventions in weighing the enduring problem of "context" in relation to "art."

While critics disagree, the important point is their assimilation of these forms to a historically and culturally specific discourse that focuses on creative invention and the way a painting, essentially self-designating, organizes color and other values on a two-dimensional surface.[15] In some sense, the conventions of modernism suggest that the visual demonstrations of art can stand alone but that artifacts need contexts.[16]

"Artistry" and Human Creativity

Some critics have focused on whether these works challenge Western conventions of the artist as individual producer either by their communal production, a feature stressed in several accounts (Cazdow 1987a; Michaels 1988), or notions of artistic specialty by virtue of the fact that "traditionally, all people in the Aboriginal community are artists" (Stretton 1987:32; see also Isaacs 1987).

With his usual acerbic eye, Eric Michaels caught this ideologically transparent combination of Romantic and Modernist conceit in a newspaper account (Cazdow 1987b) of the journey of the curators of the Asia Society exhibition to the Aboriginal community of Yuendumu:

> These clever sorts managed to discover a whole tribe of Picassos in the desert, presumably a mysterious result of spontaneous cultural combustion. We're told of the curator's astonishment at finding more painters per capita of population than in Manhattan's Soho! (Michaels 1988:62)

Spirituality and Modernity

Other evaluations suggest that the acrylics offer a glimpse of the spiritual wholeness lost, variously, to "Western art," to "Western man," or to "modernity." Robert

Hughes's (1988) glowing review of the Asia Society exhibition in *Time* draws precisely on this opposition:

> Tribal art is never free and does not want to be. The ancestors do not give one drop
> of goanna spit for "creativity." It is not a world, to put it mildly, that has much in
> common with a contemporary American's—or even a white Australian's. But it
> raises painful questions about the irreversible drainage from our own culture of spirituality, awe, and connection to nature. (Hughes 1988:80)

In Hughes's estimation—and he is an Australian expatriate in New York—their "otherness" occupies a world without much in common with ours; the artistic values of individual creativity and freedom are not relevant. But this otherness is itself meaningful for us. Another line of evaluation asks if they can be viewed as a conceptual return to our lost ("primitive") selves, as suggested in Amei Wallach's subtitle: "Aboriginal art as a kind of cosmic road map to the primeval" (Wallach 1989).[17] Many of the visitors to the Asia Society certainly embraced this sort of New Age spiritualism.

Creativity as Cultural Renewal

Within the context of Australia more specifically, the significance of artistic activity among Aboriginal people is often embedded in a slightly different narrative of self-realization through aesthetic production—although still formulating potentially universalist meanings. Addressing conceptions of Aboriginal culture as inevitably on the course of assimilation, Westernization, or corruption, many observers ask whether these paintings are not evidence of cultural renewal, creativity, resistance, and survival (Isaacs 1987; Myers 1989; Sutton 1988; Warlukurlangu Artists 1987), whether they should be seen as an assertion of indigenous meanings rather than as homogenization.

Writing about an exhibition at the Blaxland Gallery in Sydney, for example, Jennifer Isaacs (1987) embraces the pluralism compatible with postmodern art theory[18] in emphasizing that the admixture of European materials and venues for Western Desert visual culture (that is, canvas, acrylics, and exhibitions instead of bodies, ochres, and ceremonies) is not a loss of *authenticity* or a cultural subordination (which means a product that is not an expression of inner spirit). The hybridization, she argues, represents an explosion of creativity even breaking the bounds of the wrongheaded (to her mind) restraints for cultural "purity" urged by some advisers in the use of traditional ochre colors only. Such policies—which she characterizes as "bureaucratic"—are reminiscent, in her construction, of earlier policies for Aborigines that advocated separate development and postulated an unchanging Aboriginal culture.

The rhetoric of Isaacs's article is of "cultural explosion" as creativity and strength in opposition to "purity" as governmental and bureaucratic restraint. Isaacs's construction also must be seen as an interpretation that implicitly counters commonly held views of "the Aboriginal" as tradition-bound, incapable of change

and innovation (as Strehlow 1947 emphasized), unable to enter into the twentieth century, doomed to extinction.

The representation of Aboriginal paintings appears to be defined in relation to the political discourse of "nationalism" on the one hand, and the spiritual and aesthetic ones of "modernism" on the other. Moreover, as we shall see, these concerns are often related.

CONTEXTS

Aborigine as Sign

These discourses that develop around Aboriginal acrylic painting intersect some of the recent theorizing about "national imaginaries" (Anderson 1983), especially because of the Australian concern to create a national identity in which, increasingly, Aboriginal people or culture have figured. Reflecting on the significance of "Aborigines" and "Asians" in Australia, Annette Hamilton (1990) has tried to specify the process historically: she suggests that a concern with "others" emerges most clearly at the same time as the sense of national identity is most threatened by emergent trends of internationalization and new forms of internal cleavage.[19] Hamilton's analysis maintains that recent developments in Australia manifest not a rejection but an appropriation of—an identification with—certain features of the "Aborigine" as image.[20] The significance of the "Aboriginal" as a sign is established by its placement in these historical contexts, with Aboriginality participating in multiple circuits of meaning.

If Aborigines were no longer a threat to national development, as Native Americans were in a vital period in the formulation of their image in the American national identity, the "Aboriginal problem" was a central concern for the Labour Government that took office in 1972 and was addressed through welfare subsidies and policies promoting "Aboriginal self-determination" and "multiculturalism" (see Beckett 1985, 1988). "Self-determination" is the principal discourse underwriting cultural policies, anticipating that local control and autonomy will have beneficent effects on people's confidence, self-esteem and success in acting on the world.[21] The support of and recognition for Aboriginal art, for example, was seen by most of its promoters at this time as a way to promote appreciation for the accomplishments of Aboriginal culture. Such appreciation, it was believed, would not only provide a basis for self-esteem for a long-disenfranchised racial minority but would also support recognition for the value of Aboriginal culture in a context of increasing struggle with interests opposed to Aboriginal land rights, a struggle evidenced in the mounting campaigns by the mining companies in Western Australia.

There was an important combination of interests here involved in promoting appreciation for Aboriginal "artistry" and "spirituality." Many white Australian artists who opposed the dominant rationalistic and materialistic Euro-Australian

culture were attracted to Aboriginality as an indigenous, local form expressive of their opposition. Elkin's (1977) *Aboriginal Men of High Degree* was republished, for example, and its representation of Aboriginal mysticism met with considerable popular enthusiasm among those who were also attempting to establish Australia's regional identification with Southeast Asia in opposition to the cultural domination of Europe and America. Another intersection between the identities of a "spiritual" and "natural" Aboriginality (that was seen as "respecting" the land) and oppositional Australian culture was forged in the environmental movement opposed to uranium mining in Arnhem Land and hydroelectric development in Tasmania. These economic developments were decried by some as serving primarily the interest of foreign national economic exploiters, by others as expressive of the continued devastation of environmental relations by a mechanico-rationalistic culture, and so on.

Through such significations, the mysterious interior of Australia, a place long resistant to the purposes of (white) man[22] in Australian lore, comes to stand for Australian identity as a spiritual/Aboriginal center on which to define an identity opposed to foreign, industrial control. Various meanings of Aboriginality are constituted in such processes of political incorporation. Hamilton's account is illuminating in that it shows that such significations draw on images of Aborigines constructed in earlier historical experience (see Hamilton 1990), especially the dichotomizing ambivalent respect for the "wild bush black" and contempt for the "detribalized fringe campers," "mission blacks," and "half-castes." The "wildness" of the bush Aboriginal—an image focused on the bush, nature, mystic power, and "tribalism"—while it "held a threat to the normal functioning of station life . . . also marked Aborigines as somehow able to transcend everything which European civilization (itself a fragile flower on the frontier) was able to offer" (Hamilton 1990:25). Recent constructions draw on these previous images, manifesting a particular form of desire, according to Hamilton: "the wish to move into the mystic space and spiritual power which has been retained from the earlier construction of 'good' Aboriginality, and to somehow 'become' the good Aborigine" (1990:25).

With an emphasis on "self-determination" through land rights and ultimately an ideology of "self-realization" in culture, these were bases for the inclusion of Aboriginal themes in the creation of a specifically Australian identity. Finally, the "difference" of Aborigines later allowed them to be figured as a symbol of exoticism and wildness (Morton 1991) to be sought out and consumed by a growing tourist industry, attempting to market the "true heart" of Australia.[23]

Aboriginal Painting

Modernist art narratives need not imply that Aboriginal paintings are simply the equivalents of Western forms. Critical discourse, modernist or not, is not so simpleminded. The question is whether this placement of the acrylics "into the exist-

ing structures of popular art theory" (Weber 1989) is appropriate or whether, as the New York dealer John Weber holds, "a new vision demands a new system of critical thought" (ibid.).

Most writers on the art recognize it to be decoratively pleasing and fitting comfortably enough within the visual expectations of Western tastes for the kinds of formalism of the 1960s and 70s and busy surfaced acrylic work of the 80s.[24] Thus, it not only suits the development of national identity but also fits without discomfort on corporate walls and in the preexisting collections filled with such Western works.

John Weber—who is known for supporting Conceptual and Minimal art and who exhibits the work of site-specific artists like Richard Long and political artists like Hans Haacke—is the first significant gallery owner in New York to have taken on the work. He attempts to show that the work's entry into the art market demands a *rupture* in critical constructions, as something more than 1970s formalism. He talks of the need for "an art dialogue sympathetic to the intent of this work . . . to engender a deeper understanding and appreciation of what the viewer sees and subsequently feels and thinks" (ibid.).[25] If a new art critical theory is necessary to elucidate this new art, Weber's discussion suggests it should engage four central features: (1) the vitality and compositional complexity of the paintings, (2) their site-specific quality, (3) their political message, and (4) their narrative subject matter.

Weber's comments are also revealing of the accommodations it takes for these paintings to enter into the "fine art" market. Referring to the appearance of fly-by-night dealers and galleries[26] and inflating prices, he argues that the current "commercial onslaught" in the marketing of the acrylic paintings threatens the continued existence of the acrylic art movement. This is another institutional problem, in that, "as Australia has not previously generated an art movement of international significance, the art power structure is at a loss to deal professionally with the fast emerging Aboriginal scene" (Weber 1989). Only one commercial gallery— Gabrielle Pizzi's, which has exclusive rights to Papunya Tula Artists—has what he considers to be a "well thought out program of group and one person shows of this work" (ibid.).

There are more narratives for the paintings, but I want to turn my attention now to what are essentially responses to these initial constructions.

DISJUNCTION AS DISCURSIVE INCONGRUITY

While anthropologists and Aboriginal painters have been inclined to emphasize the continuities between the paintings and indigenous Aboriginal *traditions*, emphasizing their *authenticity* as expressions of a particular worldview, these very terms— and their meanings—are among the most hotly contested in art critical circles. This discursive incongruity is a point that Eric Michaels and others embracing a postmodern position grasped immediately (and enthusiastically):

Traditionalism and authenticity are now completely false judgments to assign to contemporary Aboriginal painting practices. . . . The situation I worked in at Yuendumu demonstrated unequivocally that the Warlpiri painting I saw, even if it accepts the label "traditional" as a marketing strategy, in fact arises out of conditions of historical struggle and expresses the contradictions of its production. . . . To make any other claims is to cheat this work of its position in the modernist tradition as well as to misappropriate it and misunderstand its context. (Michaels 1988:62)

From here, it seems possible to go on to discuss the practices of cultural appropriation by the West, the impact of the West's "gaze" in defining the "other." Indeed, there has been much critical writing that has explored and deplored such "representational practices."

DECONSTRUCTION

The "appreciation" of Aboriginal acrylic paintings and their placement comfortably *in* the art world are problematic for critical-pluralist postmodernism like that embodied in James Clifford's (1988b) criticism of the much publicized 1984 exhibition at the Museum of Modern Art that was called *"Primitivism" in 20th Century Art: Affinity of the Tribal and the Modern.*[27] Clifford (1988b) and others (for example, Moore and Muecke 1984) argue that the sort of humanism deployed in such representations makes the culturally different too familiar, when it should challenge the universality and natural status of Western categories.[28] Clifford writes, "We need exhibitions that question the boundaries of art and the art world, an influx of truly indigestible 'outside' artifacts" (1988b:213). From this position, the acrylic paintings—as they are inserted in the art scene and gathered for exhibitions as "fine art"—are seen as confirming the power of the former colonial masters to determine what matters.

The postmodern critique of "humanism," which points out the loose ends (that is, deconstructing) of attempts to make "them" look more like "us," locates a common weakness in projects of "imagining" difference, one with which anthropologists are familiar (see Marcus and Fischer 1986).[29] Is it any wonder, therefore, that some anthropologists who have been engaged in the construction of Aboriginal culture have been surprised by the ferocity of the critique of *our* rhetoric (see Michaels 1988; Sutton 1988; von Sturmer 1989; Fry and Willis 1989)?

The generic critique of the "humanistic" does not comprise the full range of deconstruction's attack. In more specific and limited ways, the construction of the paintings as "art" has been undermined variously by "revealing" the essentially "economic motivation" of Aboriginal painting and the contrast between the supposed spirituality of the art and the destruction of its civilization by white settlement. Faced with other popular representations of Aboriginal people as drunks, as lazy, or as a morally dispirited remnant, many are critical of hopeful, poetic, and romantic representations of Aboriginal cultural and spiritual renewal such as that offered by Isaacs (see above).

THE LOSS OF THE "OTHER"

Peter Schjeldahl's (1988) review in *Seven Days* finds the acrylic paintings to be not "other" enough, too accessible, and thereby essentially representative of the domination and destruction of Aborigines by whites. He contrasts a visit he once made to Alice Springs—remembering the challenge that an Aboriginal presence (although brief and insubstantial) offered to his sense of the universal and real— with the show, attacking its basic constructions of art as somehow redeeming of Aboriginal subordination: "The paintings are seen as a means to build independent wealth and self-esteem for a people gravely lacking both." Sadly, he writes, "In problem-solving terms the idea is impeccable. But the paintings are no good." The domination is unfortunate, he says, and it is probably praiseworthy to attempt to show good benefits for Aboriginal people, but this liberal solution will not wash: the paintings exhibit the final domination of Western categories. Indeed, their very recognition of Schjeldahl's realities (manifest in the materials and the straight lines of the canvas) appears to undermine their ability to challenge them. So, "Don't go looking for that power of strangeness at the Asia Society."

Once upon a time, the mere interest in things Aboriginal in a metropolitan center like New York would have been seen as a triumph over ethnocentrism. Yet Australian critics Fry and Willis (1989:159) criticize the emphasis on representing Aboriginal culture as the "spectacular primitive" because it diminishes "Aboriginals to a silenced and exoticized spectacle." They decry as "ethnocide" the manufacture of "Aboriginal culture" in the process through which "experts" who "trade in the knowledge of 'the other' " make their own careers (1989:159–60).[30] And, if anthropologists once railed against art critics for the imposition of Western aesthetic categories on objects produced in other cultural contexts, some critics (Rankin-Reid 1989) attack anthropologists and curators for their emphasis on the "ethnographic," for focusing on the narrative and "mythological" content of the acrylic paintings. Such an approach, they contend, is a primitivizing device that precludes appreciation of the "patently visual accomplishments of the work."[31] In the artists' home communities or traveling with the painters in New York, these positions seem terribly distant. They are artworld battles.

How is one to compare Schjeldahl's criticism with the self-esteem expressed in comments made to me by Michael Nelson, the Warlpiri painter, when he visited New York for the Asia Society show? The latter believes people are really interested in his work and the work of other "traditional" people. "They want to see paintings from the Centre," he said, contrasting this with the lack of white interest in the work of urban Aboriginal artists. This contrast makes sense to him in his own culture's terms in which religious knowledge is the basis for recognition: "Urban Aboriginal people, *ngurrpaya nyinanyi* (unknowing, without knowledge— they sit down). I feel sorry for them. We're lucky. We still have our Law [religious traditions], everything" (Nelson, personal communication, 1989).[32]

Andrew Pekarik's reading of the relative popularity of the acrylic paintings (in

comparison to the work of urban Aboriginal artists) follows this implicit contrast in another way, suggesting that the popularity of work like Nelson's owes much to a certain preservation of the cultural boundaries of the audience:

> What people like is a safe way to incorporate an element of Aboriginality. They won't be as interested in what the urban [Aboriginal] artists do. There is too much pain. People don't like "accusatory art." They want something they can feel more positive about, they can feel good about. They see buying the paintings as helping to preserve these existing cultures. . . . This "traditional" Aboriginal art allows Australians to feel good about themselves. (Pekarik, personal communication, 1990)

That is, the "traditional" acrylics are not understood by audiences as challenging them where they live, so to speak, drawing the audience's accountability into the frame of the exchange. To follow Hamilton's (1990) terms, the acrylics of "traditional" people represent the "good" Aborigine—a spirituality, respect for land, and so on of people at a distance (see Fabian 1983) rather than people who are seen as contemporaries competing for the same life-space—which viewers or buyers can incorporate. In a sense, this incorporation of "difference" is possible by virtue of the very self-contained confidence of artists like Michael Nelson and Dolly Granites, men and women who still remain relatively secure in their own cultural traditions.

Despite *their* assurance, however, Aboriginal people's expectations that knowledge of their culture's foundation in the Dreaming will result in recognition of their rights are not entirely fulfilled. The answer to such a question rests not so much on the qualities of the object, or even in the structural relations between cultural groups, as in the capacity to make one or another set of meanings prevail or even visible.

CRITICAL PRACTICE: "ORIGINS" AND DESTINATIONS

Fry and Willis maintain a suspicious and deconstructive stance toward an emphasis they see on Aboriginal painters as "all traditional people who have little experience of cities" (1989:159–160). They find the same emphasis on the theme of the "spectacular primitive" at *Magiciens de la terre,* the display of artists and their work from all over the world in Paris in spring 1989, where Warlpiri men from Yuendumu made a ground painting. However, while Schjeldahl is disappointed and angered at the domination of the authentic in the new medium and its recontextualization, they take an opposing position with respect to that theme:

> The marketing of contemporary Aboriginal art can be seen as a form of soft-neocolonialism, through which Aboriginal people are incorporated into commodity production (with the attendant reorganization of social relations). One result is that traditional beliefs and practices have to be reconfigured according to the relative success or failure of the commodity. There is thus no continuity of tradition, no 40,000 yearold culture, no "time before time." There are only objects produced by a range of

fragmented cultures with varying connections to tradition and economic necessity, posed against the homogenized readings of these objects according to the meaning systems of the culture of dominance. (Fry and Willis 1989:116)

At issue is the question of what one sees in these cultural productions, and Fry and Willis are concerned principally with the claim of the new art's "continuity" with (and renewal) of Aboriginal culture. Drawing on a "poststructuralist" approach which is highly critical of presumed essences and continuities, for Fry and Willis, "in Australia, the romantic recovery of the past as a pre-colonial life is impossible. . . . The return to the old culture is therefore really a new culture built upon the signs of the past" (Fry and Willis 1989:160).

For these critics, displays of art as indigenous culture cannot be the basis for Aboriginal self-identity, being oriented largely "for the gaze of the colonizer and on terms and conditions set by the dominant culture" (ibid.). Rather than providing forms for the development of Aboriginal self-determination, "in the appropriation of Aboriginal culture, careers in 'white' society are being made." In this social field, moreover, the career advancement of these white experts depends upon the reproduction of "the primitive." Far from being a token of authenticity,

> In this process, "Aboriginal culture" is something manufactured within the parameters of the professional norms of the careerists; it becomes a culture from which Aboriginal people are excluded either literally or by having to assume subject positions made available only by "the oppressor." (ibid.:159)

Not surprisingly, therefore, Fry and Willis claim that they have no authority to speak on behalf of what Aboriginal people mean. This position has the appearance of being politically more satisfactory in the avoidance of submitting "their" meanings to "our" categories, yet to hold such a position is still to assume that one knows the impact of colonial practices on these subjects.[33] For all their perspicacity, here are the outsiders who know more than the participants, outsiders whose representational practices directly thwart the representations of Aboriginal painters.

As we saw in the Schjehldahl and Smith reviews,[34] Fry and Willis are not alone in showing little interest in finding out what the Aboriginal people are doing, saying, or understanding in these events which are addressed partly to us. They presume, following Eric Michaels (1988), for instance, that "looking"—as in attending a Warlpiri ceremony—is the privilege of domination. However, this is not necessarily or simply so in Aboriginal cultures where the revelation of forms to the sight of the uninitiated is a gift that carries responsibilities. In showing their paintings, Aboriginal people may require that to have seen something is to be responsible for understanding it in their terms.

Nonetheless, the point of such criticism is that the terms and conditions for the display of indigenous culture are always set by the dominant culture and that the exchange will be massively unequal. Is this, as Fry and Willis claim, "ethnocide," a cultural erasure accomplished by "obliging them to transform themselves to the

point of total identification, if possible, with the model proposed to or upon them" (Clastres 1974, in Fry and Willis 1989:116)? What do such discourses mean for Aborigines? It appears that Aborigines have to establish themselves within or against these defining terms—or do they?

CONTROVERSY

My concern in this paper is not so much to resolve the controversy about the acrylic paintings—to go beyond it in some way—but rather to present and understand it ethnographically as a form of cultural production.

Andrew Pekarik, the director of the Asia Society Galleries during the show and a specialist in Asian art, sees the show as a success *because* of the controversy, but not just because any publicity is good. He explained this to a small group of collectors convened by the New Museum of Contemporary Art in February 1990, which I later asked him to articulate: "This is a good thing. One of the worst things would be if people said, 'Yes, that's cute.' If there is no controversy, that means nobody is thinking about it" (Personal communication, 1990).

What Pekarik said about the controversy offers a curator's more concrete appreciation of education. He suggested that

> the real significance of the acrylic movement is its ability to be a point of cultural communication. There hasn't been a language in terms of which these two sides [that is, white and Aboriginal] could communicate. They are so far apart that they can't help but misunderstand each other. And in these misunderstandings, the Aboriginal side has had the worst of it. These paintings are the first occasion for cross-cultural communication. For Aborigines they represent a way of dealing with the majority world. For outsiders, they represent a way of trying to hear what the other side is saying, because it is in a language that is not threatening. . . .
>
> Roy Wagner says that cargo cults are a kind of New Guinea anthropology, their way of understanding what they are seeing on the outside. That's what is taking place in the paintings. Outsiders have to make an *effort* to try to understand. Obviously [given the controversy and disagreements], they are working on it. (Pekarik, personal communication, 1990)

Pekarik's analysis reflects an art world insider's understanding of its processes—processes in which artists, gallery dealers, museums, collectors, and critics are a kind of network, "all in it together." They produce meaning for objects and construct their place(s) in an overarching theory. The production of culture is a social process: the ideal-typical career course is for an artist to be taken up by a gallery, who shows his or her work and gets it placed with select collectors, gradually encouraging and establishing recognition of its sensibilities and gaining a reputation for it with reviews. After a series of exhibitions, the next step would usually be placement with collectors and then with museums. In the case of the Asia Society show, evidently, the initial establishing exhibition was a more *official* recognition or certification of the objects' worth than that of a dealer's gallery. The reviews of

a show in New York were significant in drawing attention to the work, here and in Australia, in legitimating it, "putting it on the map."[35] Despite this flurry of attention, potential dealers for the acrylics in the U.S. realize that more shows are necessary to demonstrate the stability of the art as an object of interest. This is where the artworld network functions again: dealers need museums to show the paintings regularly in order to remind people such art is there.

Art worlds "make art," as Becker (1982) showed, and while one can view this cynically (as artists and dealers have been prone to do recently) or institutionally (as Becker did), it is also clear that the processes of "making art" require the establishing of a sensibility, a way of appreciating different forms of cultural activity. This is what the critic Clement Greenberg did for abstract art—focusing on "universal" aesthetic principles as an attempt to sustain modern art within a tradition, as not representing a radical break from the "Western tradition"—and what Lucy Lippard did for conceptual art (see Crane 1987). As an artist friend told me, "We all need a good scholar to write about our work: art and words, that's what you need." And art criticism—with its constant anticipation of the next movement, style or fashion—is partly in the business of producing such styles and differences. Although criticized itself for such promotional and self-promotional celebration of certain trends and movements to the exclusion of the actual diversity of art (Alloway 1984), art criticism plays a significant role in this process of producing "difference" and rendering it intelligible.

From an outsider's vantage point, this is where the ambivalence and energetic responses of the art world seem to lie. Art critics produce their stories and sensibilities as part of larger, ideological concerns about art and the world: chiefly, it would appear, against the threat of "mass culture," "kitsch," "the market," and "commodification." Yet the work of critics is deeply embedded in a capitalist marketplace, fueled by novelty and "difference" to offer buyers.[36] In this sense—and this is the chief irony with which many artists contend—despite its claims to the contrary, the art world may itself reflect rather than transcend the "placelessness" of late capitalism (Jameson 1984; Lash and Urry 1987). Thus, within the art world, artists and critics struggle with the recognition that new differences—the regional, the local, the challenging—are too easily drawn into the common, "international culture" that subverts the initial differences and incongruities:

> The way [global culture] works now is by diversifying. It has to work by making regional differences active, making them recognisable but not really disturbing. It has to keep the structures in play and change the details. So regionality is really absolutely essential news for global capital at the moment, absolutely essential. (Artist Terry Smith, quoted in Nairne et al. 1987:212)

CONCLUSION

It is clear that the "acrylic movement" may not only compete with modern art on its own level, but can just as easily defeat it in those same terms. This apparent victory

for Aboriginal art may, however, turn out to be pyrrhic. If our pseudo-humility before Aboriginal art is based on its confirmation of our own aesthetic values and spiritual aspirations, it will simply be subsumed by the reactive processes of cross-cultural projection. Instead of confining our understanding to the illusory tradition created by visual association, we might seek out the unseen differences. Interpretations that reduce art to a literal content and a structural grammar only tame it, make it comfortable. What Aboriginal acrylics may offer, unlike most recent art, is precisely their potential to make us nervous. (Baume 1989:120)

Anthropology has been long concerned with the problem of interpreting or translating between the indigenous concepts and practices of other cultural orders and those of our own society. But we are not alone in our engagement in such interpretive activity. The easy authority of our interpretations has been questioned in frequently cited works. The best known of these, surely, is that of Clifford (1988a, 1988b), representing the general pluralist positions delineated by the band of cultural theory known as "postmodernism."

A significant domain in which the question of such interpretation has regularly been of interest is that of "art." This is a concept about which most scholars are now self-conscious. "Art" has long been recognized as a *cultural* domain in the West, one not necessarily shared or similar in all societies, and one which has been convincingly historicized (R. Williams 1977). This is a problem on which anthropologists have fought the "good fight." Indeed, a good deal of self-satisfied writing by anthropologists has focused on this problem, criticizing the imposition of Western categories on the practices of other peoples.[37]

These categorizations of "art," "creativity," or "humanity" matter in more than merely academic ways insofar as they can imply differing representations of cultures. To say that Aborigines do not have "art," however qualified by insisting that the category is a distinctively historical one in the West, without hierarchical and evaluative significance, can easily be read as "racism."[38] Any anthropologist with the experience of trying to explain this issue to nonspecialists should recognize the practical problem.

Anthropological translations may founder as much in their transparencies with respect to cultural boundaries as in their opacities. In an important sense, what Aboriginal producers say about their work—their own discourse for its interpretation—draws primarily on an indigenous tradition of *accounting,* and it is this discourse (frequently) that anthropologists have sought to present as the authentic meaning. But as one must learn from the appearance of the acrylic paintings in New York and elsewhere, this knowledge of the Aboriginal culture, persons, and traditions of image-making—knowledge of what Aboriginal painters say about their work—does not necessarily recognize the potential and significance of these forms to engage interest from those concerned with visual images in our own culture.

One asks, therefore, whether the engagement with art criticism as a competing practice of interpretation offers anything for anthropological understanding? Art

theory's concern with the boundaries between "art" and "not art," both as a modernist evaluative process (that is, is it art?) or as a postmodernist critically problematized and oppositional practice (that is, what does it mean to define such boundaries?) is a critical part of the processes through which Aboriginal people are producing themselves in the contemporary world. Thus, the reception of the paintings raises the broader question of the capacity of indigenous people to objectify *their* meanings into the discourses for their reception.[39]

Can there genuinely be a dialogue between their conventions and those of the art world? The examples I have presented suggest that Aborigines are triangulated by a series of discourses—which might represent positive benevolence, political support, sympathy, or renewed racism[40]—discourses in which Aborigines are central but usually absent. Aboriginal accounts enter more explicitly into that Derridean world in which all signification exists in a context of other representations, in which there is no transcendental signified outside of representation.[41] Are Aboriginal actors able to make their practices have just the meanings they claim?

To review briefly, I have delineated differences with three sets of critics.

1. There is Roberta Smith, who says we must hold these paintings up to the standards of our own culture since they circulate in it now. In those terms, she says, "Too bad, they represent second rate neo-Expressionism." She rejects the paintings in terms of the Western art world.
2. Another set of critics, exemplified by Peter Schjeldahl, want the lost romance, and reject these paintings in terms of the West's nostalgia for some "other" that the Aboriginal paintings cannot represent by virtue of their "contamination" by Western forms.
3. The third set, Fry and Willis, treat the paintings in terms of commodity circulation and the inevitable corruption it entails. They reject the paintings, supposedly from an Aboriginal perspective.

Such criticisms are part of the discursive practices that define "high art." The very existence of the debates has validated the acrylic paintings as objects worthy of broader consideration. This is exactly what John Weber desires in his plea for a "new art critical theory." He is, after all, a dealer and what he does is find paintings and transform them into "art" by selling them. The acrylic paintings not only have a meaning, they are being made to have a meaning about the nature of human creative activity, and made into saleable "fine art."

These discourses fail to explain the meaning of the acrylic paintings at the Aboriginal level. At best, the Aborigines are considered to have been co-opted; at worst, they are not considered at all. It should be clear that my association with the painters makes it difficult for me to accept at face value criticisms of the acrylic movement which disparage the local focus on the "continuity" and "authenticity" themes as a "constructed primordialism," to borrow a term from Arjun Appadurai (1990). Most Pintupi and Warlpiri painters have not constructed primordial iden-

tities, "origins," principally in opposition to wholly external "others," as in various nationalisms—not, that is, as an ethnic discourse of "Aboriginality."

Aboriginal people's primordialisms are constructed, of course, but they are frequently constructed and sustained in relation to processes different from colonial and contemporary Western ones. They are constructed in complex systems of similarity and difference—"totemisms" if you will—in which larger collective identities are only temporary objectifications, shared identities produced for the moment (see Myers 1986; Sansom 1980). "Country," as most Aborigines would call the places represented in acrylic paintings, the token of the painter's identities, represents the basis for objectifications of shared identity through time.

A critical art theory struggles with the local message because of its own preoccupation with the global processes that suffocate it, threatening to make all the world the same, all processes and forms substitutable for each other. It is just such a fear of "cultural homogenization" at work—the incorporation of Aboriginal products into European fine art—that underlies much art critical writing. Such one-way narratives deny any "indigenization," despite the fact that the potential for such "indigenization" is what is ultimately of interest in Aboriginal paintings.[42] The identities that many acrylic painters produce on their canvases are not uprooted or deterritorialized; this is their very claim.[43] It is surely ironic that, as art theorists Deleuze and Guattari (1987) place their bets on "nomadology" as a way of finding a path through this placeless rhyzomic world, so did the late Bruce Chatwin, a refugee from the art world on a romantic search for the "nomad" representing some imagined version of a ceaseless human urge for wandering, seek out Australian Aborigines (see Chatwin 1987).[44] However, Aboriginal Australians are precisely those who insist on not being *displaced*.

The situation of Fourth World people should not be so loosely compared with other postcolonial circumstances that currently inform cultural theory. Pintupi—or Warlpiri or Anmatjira—claims that the paintings are "from the Dreaming" or that they are expressive of an ontology in which human beings gain their identity from associations with place *do* express a historical struggle, but initially at least they have done so in their own right, not simply in recognition of a colonizing threat from outside. To see these claims—their identities—as "our" product (as from colonialism) is to colonize doubly by denying them their own histories.

If art theory fails to grasp what the activity means to the painters, their critical responses so far only skirt the question of its appeal. I want to conclude by considering what this appeal might be and what it suggests about the contribution Aboriginal acrylics might be making as "art." The appeal of the paintings is not, I suggest, as ineffable as the best critics suggest.

Ironically, the paintings have significance in art theory and for the buyer because of their local meanings for Aboriginal people, the association they represent for buyers between an artist and a place. As forms acceptable to the art world, Aboriginal acrylics offer a powerful link to particular locations in a world which is said—according to most postmodern theorists—to have "no sense of place" (see

Meyrowitz 1985). What the acrylics represent to their makers resists this sort of commodification: all places are *not* the same. Painters can only produce images from their own local area, all conceived of as different.

In Warlpiri artist Michael Nelson's explication of the meaning of the paintings, one traces the "original meanings" in the emergence of something that is new: an "Aboriginality" that is also becoming defined in opposition to "Europeans":

> White people don't really fully appreciate these dreamings that we paint. These dreamings are part of this country that we all live in. Europeans don't understand this sacred ground and the law that constrains our interaction with it. We've been trying to explain it to them, to explain what it means to us. For the sake of all Australians, we try to show them that this is our land. We try to show them our dreamings which are part of this country that we all live in. But white people don't even recognize our ownership of it. We paint all these pictures and they still can't understand. They want them as souvenirs to hang on their walls but they don't realise that these paintings represent the country, all of this vast land.
>
> In other countries, they're all right; the land belongs to them, it's their country. We belong to this country; that's why we keep saying that we want our land back. (Michael Nelson at the Sydney Biennale 1986, quoted in Nairne et al. 1987:221)

Michael Nelson continues to deploy here the same principal discourses that an anthropologist is most likely to encounter. His statement reminds us that these discourses are not some intrinsic bottom line but that they take shape in the context of contemporary politics in Australia: but their goal, their intent, is not displaced.

I do not mean to say that the "place-meaning" of acrylic paintings is the totality of their signification or that the signification of this meaning is the same for all consumers. Given the regular association of purchasing the paintings with travel to the area in which they are produced and located, for instance, I suspect some particular thrill accompanies knowing the place that is represented in such utterly "other" (that is, unfamiliar) graphic signs which hold a different meaning for "others." For Westerners, this both valorizes the travel—to a place that is genuinely different—and the painting as a sign of that difference.

Moreover, what is at stake in a "sense of place" in Australia is different from what it is for consumers from overseas. In Australia, for some, the places of Aboriginal people are places before history, a place in the Outback often coded as more primeval—a frontier in which Australians are fascinated to know that some *real* "stone age" hunting and gathering people still live (see Myers 1988). This primordial spirituality at the heart of Australia, especially at Ayers Rock but also (in a way) in each painting,[45] provides links with tourism and travel away from the solid domesticity of suburban homes and rational order of "white science" (see Fiske, Hodge, and Turner 1987:119–130 for a discussion of these themes). The Aboriginal and the Outback are, increasingly, the source of Australia's self-marketing for the international tourist industry, the "difference" they have to offer. These constitute an important dialectical dimension of emerging formulations of Australian national identity: something essential outside and before the nation that

lies also at its heart, central to its identity,[46] these significations give Aboriginal representations of place a particular value. The painting represents this mystery, in a way, by being the token of what the place or country is prior to or outside its appropriation into the uses and purposes of white society. Australians, therefore, can obtain such tokens and display them as representations of some part of themselves on their wall.

The appeal of the acrylics is the sense of their rootedness in the world—although this "rootedness," the sense of place, appears to some critics to be undermined by the apparent cosmopolitanism of the painters and the circulation of their products. It is not that Western art critics understand the specific information or details of the Dreaming places that are usually the subject of the paintings, but rather that the fact of these relations fulfills a real or nostalgic sense of the loss of attachment to place among Westerners. The specific understanding of a story is not as important as the fact that it signifies so rich, complex, and unself-conscious a sense of connection.

It is not accidental that this sense is what informs postmodernism so strongly. There is a great irony of historical accident in this: the paintings make their way into the art market by virtue of their strong formal similarity to abstract expressionism, a movement defined by its detachment from specificity and location! Postmodernism looks to the margins of a dominant culture and to minority voices not only for a critique of oppression, but also out of a genuine concern to reroot high culture to sources of the sensory and the intellectual delight in everyday life. This is what can be found in the descriptions of the "creative process" in Aboriginal communities—a sense of the "cottage industry" with painters sitting out in the sun, making images without the European's requisite sturm and drang.

Postscript

Because I would develop a more dialectical conception of knowledge, I seek to question both the increasingly popular identifications of ethnographic knowledge as merely domination of our objects and the defensive reaction, by many anthropologists, to the revelation of our project's placement within history. Recognition of the social and cultural place of interpretive projects—positioning ethnography, reflexively, within its own frame of consideration—is an essential step for contemporary anthropology to gain insight into the multiple circuits in which the representation of culture operates. In writing this paper, I hope to help place anthropological practices of interpretation more adequately—more ethnographically—within our (limited) perspectives as acting subjects and within the larger historical perspectives which define us.

NOTES

A much truncated version of this paper was originally given at the Annual Meeting for the Society for Cultural Anthropology in Santa Monica, Calif., May 18–19,

1990. For their direct help in understanding the process of Aboriginal art's movements, I want to thank Michael Nelson, Billy Stockman, Peter Sutton, Chris Anderson, Richard Kimber, Andrew Pekarik, Françoise Dussart, Felicity Wright, and Daphne Williams. This paper has benefited from many conversations, readings, and criticisms, but most especially it would never have been written without the encouragement and imaginative engagement of Faye Ginsburg. For comments and criticisms on the paper and general discussion, I thank Don Brenneis, Sandro Duranti, Faye Ginsburg, Annette Hamilton, Barbara Kirshenblatt-Gimblett, George Marcus, Bambi Schieffelin, Toby Volkman, and Annette Weiner.

1. A trainee at the gallery told me that presenting the paintings in this minimal way allows "connoisseurs" to feel good about their knowledge.

2. This is the name that the anthropologist Donald Thomson gave to Pintupi-speaking people when he encountered them in the 1950s; "Bindibu" is the term Warlpiri-speakers (who were Thomson's guides) often used.

3. In 1988, for example, the artists in the Pintupi community at Warlungurru were receiving around $30,000 per month from their art cooperative, Papunya Tula Artists. For more details about the economic dimensions of acrylics in Western Desert communities, see Anderson and Dussart (1988), Megaw (1982), Myers (1989).

4. Reportedly, an important painting of Clifford Possum was sold by the collector Margaret Carnegie to the National Gallery of Victoria for $140,000. While entirely exceptional, the prices of the acrylics have created a boom market for speculators. For a discussion of the changing price structure, see Benjamin (1990).

5. For a fuller account of this research and of Pintupi social life, see Myers (1986). Field research with Pintupi people—at Yayayi, Northern Territory (1973–75), at Yayayi and Yinyilingki (1979), and at New Bore and Papunya, Northern Territory (1980–81)—was supported by a National Science Foundation Doctoral Dissertation Improvement Grant, a National Institute of Mental Health Fellowship, and research grants from the Australian Institute of Aboriginal Studies. Short visits with Pintupi in Kiwirrkura, Western Australia, and Warlungurru, Northern Territory (in 1983 and 1984), were undertaken under the auspices of the Central Land Council. A longer stay in 1988 was supported by the Australian Institute of Aboriginal Studies, National Geographic Society, and the John Simon Guggenheim Memorial Foundation. The bulk of this study and this paper were done while I was a Fellow of the Guggenheim Foundation and of the National Endowment for the Humanities in 1988 and 1989.

6. More recently, Baume (1989, see especially page 120) has made a similarly cogent argument about the issue of critical disjunction. I draw on his discussion more fully in the conclusion of this paper.

7. For the conception of aesthetic theory as an activity, see also Becker (1982:131–137).

8. Dolly Granites was not the only Aboriginal painter speaking, and the remarks of the Arnhem Land painters—Jimmy Wululu and David Malangi—were very similar. Unfortunately, space prevents me from considering them all here.

9. This worldview, usually delineated in the concept of the Dreaming in Aboriginal English, has been extensively discussed in anthropological and other representations of Aboriginal cultures. The analysis below will address many of the issues, but for an entry into these descriptions, see also Myers (1986), Stanner (1956), Sutton (1988).

10. But this construction is not solely that of the article's writer nor a product of recent conditions of Aboriginal life. The function of image production in mediating Aboriginal autonomy, especially in ritual, is of long standing (see Myers 1988).

11. When Billy Stockman, an Anmatjira painter from Papunya, was visiting New York in conjunction with the Asia Society exhibition and was interviewed by the producer of the MacNeil/Lehrer News Hour segment on the paintings, he explained all of this quite clearly—but they had not yet set up for videotaping. When the TV crew arrived in the hotel room, they tried to create a little rapport and communication, asking the men where they had learned to speak English. Billy Stockman, at that point, actually told them most of what they would have wanted in an interview.

He said that he hadn't learned to speak English in school but at stock camps. Before any of that, however, he had to learn ceremony, their own Law, from his father's Law—in the bush: "I didn't go to school . . . went to Aboriginal school, ceremony. Learned Aboriginal Law. Sort of Aboriginal high school, you know? Not white people's school. Learned ceremony, painting, there." Later, he learned white people's ways. Of course, this was not on camera, and it did not seem to me that the two women saw how much they were being informed about the value or priority of "Aboriginal high school," of learning "our Law," which is what Billy sees as the significance of his painting.

12. In a hyperbolic and nasty but inspired comment on the repression that stands as an obstacle to grasping the internal life of Aboriginal people, the anthropologist John von Sturmer points to the problem of such tranquil notions of humanity:

> One senses that there is something of the same destructiveness [as that of the narrator of Dostoevsky's *Village of Stepanchikovo*, who in the name of certain ideals would destroy the whole household] directed at Aboriginal societies, that they too can only be treated as spectacle, as tableau. Is it because they lie beyond the possibility of a truly lived engagement? It is still the case, as it has been from the very beginning, that they do not live according to "civilised" notions of society, refinement, propriety, group welfare or personal well-being. They fight too much, they drink too much, fuck too much, they are too demanding, they waste their money and destroy property. But a lack of restraint, caution, or calculation is not necessarily an absence or a failing. It can be a superfluity. A refusal: a refusal to accept the repressive principle. (von Sturmer 1989:139)

13. This theme, which I do not have time to elaborate here, is of relevance particularly to concerns of collectors. For them, the fact that there is a limited supply of "authentic" Aboriginal art—and that soon there will be none—is critically important in establishing the value of their collections.

14. In other words, the paintings do not "challenge" Western conventions of the visual imagination. As "outsider" art, Smith sees the work in the Aboriginal

show as "for the most part quite weak," pale versions of 1970s Neo-Expressionist abstraction. Without question, most critics regard the formal resemblances between the acrylic paintings and recent art production in the West as a central condition for their acceptance. Critics have, nonetheless, different positions on this apparent resemblance.

15. These modernist conceptions of painting as an art form are usually seen as developed most cogently by Clement Greenberg. The debates between "modernism" and "postmodernism" in the art world constitute one important background for the reception of Aboriginal acrylic paintings. These debates concern not only the nature of "art" as a category of understanding in our culture—that is, they are attempts to define what should be included as "art" and what should be excluded as peripheral to its "essential" function—but also the applicability and/or criticism of such a concept as a "universal" one.

The positions are complex and I cannot describe them here; they will emerge more fully in the discussion of particular critiques, but I want to alert the reader to the relevance of these internal art debates for the reception of the acrylic paintings. I do think it is important to recognize that two classic positions in anthropology—the universalizing and the particularizing (interpretive)—intersect the art critical discourses of modernism and postmodernism in important ways that generate different stances.

16. See Kirshenblatt-Gimblett (1991) for a discussion of these issues with respect to museums. It is also important to recognize that Clement Greenberg's oft-discussed preference for the visual in its own right, for looking at the object, did not really presume an experience entirely innocent of or uneducated in context in the sense of art history (see Tillim 1987).

17. The conventions of their differences have also been seen as morally instructive about some of our own associations, especially of our materialism. In his travels to Australia during the planning of the exhibition, Andrew Pekarik (director of the Asia Society Gallery) is reported to have said, "These people with practically zero material culture have one of the most complex social and intellectual cultures of any society" (in Cazdow 1987b:9). In this Romantic construction, a critique of Modernity, the paintings may represent the worthiness of Aboriginal survival and, consequently, the dilemma and indictment of modern Australia's history and treatment of their forbears as less than human (Hughes 1988; Keneally 1988).

18. Ironically, few anthropologists who have stressed the vitality of the local to engage and assimilate the forces of Westernization, colonialism, or capitalism have seen the compatibility of their argument with postmodern theory. The anthropological discourse reflects, instead, an emphasis on the defining capacity of culture.

19. In writing about the National Imaginary, Hamilton writes as follows:

> I suggest that under world conditions of the past two hundred or so years, and more so recently, the problem of distinguishing a national self has moved to the forefront precisely as it is challenged by social economic and political mechanisms which undercut the prior senses of national, ethnic, local, class or trade-specific identities. (Hamilton 1990:16)

20. More precisely, she writes:

Although there is a fear of something in the heart and outside the boundaries, there is also a lure and fascination, which can be neutralised not by retreat, but by appropriation. This is not an appropriation of the "real", but an appropriation of commodified images which permit the Australian national imaginary to claim certain critical and valuable aspects of 'the Other' as essentially part of itself, and thereby claim both a mythological and spiritual continuity of identity which is otherwise lacking. (Hamilton 1990:19)

21. In a far-ranging critique, Morris (1988) discusses the hegemony of the state's domestication of social and cultural differences in policies of cultural pluralism that are limited and partial insofar as they seek to subordinate expressions of identity to the universal structures of the dominant society. For some explorations of the cultural dimensions of the discourse of self-determination as revealed in the perspectives of remote area Aborigines and their function in the larger system, see Beckett (1988), Hamilton (1987), Myers (1985), Peterson (1985), Rowse (1988).

22. The masculine reference is meant to be specific here.

23. A number of writers have pointed out that tourists to Central Australia place a high value on the possibility of coming into contact with Aboriginal culture.

24. A friend asked one New York artist how he or she would place the paintings in terms of current art movements, if a gallery received a box of these paintings and was told they had been done in the last thirty years by a European or American artist. The answer: "Pattern painting of the late 1960s and early 1970s— the stuff Holly Solomon used to deal. Dots, stripes, ribbons. Value, not chroma, painting."

25. Weber clearly understands the role of aesthetic theory in legitimating or justifying inclusion of work in an art world, what Becker (1982) refers to as the institutional theory of art. The philosopher and critic Arthur Danto (1964) stated the problem succinctly in the well-known citation beginning this paper.

26. There were at least three different shows of "acrylic paintings" in Soho in 1989.

27. This particular exhibition and critiques of it provide a model for the reception of many quite different attempts at cross-cultural presentations. In itself, I think, this shows something of the cultural significance of presentations and reviews in New York.

28. Moore and Muecke (1984) criticized the growing pluralist representation of Aboriginal culture in terms of "art" as one which

allows for the acceptance of Aboriginal art, dance, language, etc. whilst simultaneously screening out aspects like extended family forms, aspects of Aboriginal law, "undesirable social habits," "unhealthy environments," and economic independence within a rigid harmony. In this sense, the notion of "common humanity" should be seen as a ruse.

29. Any attempt to represent similarities between cultures, whether these be the "affinities" between "primitive art" and "modernism" decried by Clifford for its ethnocentrism or the apparent "similarities" in "kinship systems" similarly critiqued by the anthropologist David Schneider (1970), seems destined to fall short,

to be attempts "to reconcile the irreconcilable" whose loose ends will show, as Fry and Willis (1989:113) judged Kay Larson's review of the Asia Society show. In this respect, Clifford (1988b)—more fully recognizing the dialectical nature of knowledge than most who embrace postmodernist positions—recommends a complement of "surrealist" subversion, challenge, and disruption of categories to balance the familiarizing comparisons of "humanistic" representations.

30. They criticize particularly a passage in Peter Sutton's catalog for the Asia Society show in which Sutton talks about the development of a field of Aboriginal art scholarship (Sutton 1988:213–214). Fry and Willis claim that not only is such "un-selfconscious prioritizing of conventional academic knowledge . . . ethnocide in action" (1989:160) but so also is the creation of what they call the "spectacular primitive" through the art establishment's management of the discourses of art (ibid.).

31. Thus Rankin-Reid writes:

With all the hype about the "dreaming" in these and other Aboriginal artists' acrylic paintings, it was hard for viewers to look at these works of art without the textual references served up by self-styled field experts. . . . The point is . . . that the glamorisation and recontextualisation is beginning to have a negative effect and the Aboriginal work of art is being muffled by the very act of trying to raise it from its "earthy" origins into the "sophisticated" art world. For the viewer, the literal equations that claim to provide access to meaning in Aboriginal painting are sheer entrapment, perpetuating the myth of the narrative as the *raison d'etre* of the Aboriginal work of art. . . .

The likelihood that some Aboriginal artists possess talent beyond the telling of dreamings in their paintings is an idea that anthropologists, government art agencies, shopkeepers and self-styled international representatives of Aboriginal art have yet to convey officially. In their enthusiasm to promote the saleability of Aboriginal acrylic paintings, the mediocre is given the same billing as the sublime. (Rankin-Reid 1989:12)

32. A more extensive explanation of Michael Nelson's perception is textualized in the following comments reported for him in a discussion of the Sydney Biennale of 1986:

You must appreciate that we, my generation, were brought up in the bush, in our own country in the desert. We were instructed by the old people. We did go to school and learned something of the European way, but only to a limited extent. We were primarily brought up within our own Law. We became well versed in our own culture. Our culture was very much alive. We had our dreaming places, our sacred sites, our song cycles and traditional dances and ceremonial regalia, like shields and so on.

We hadn't lost all of that; not like those people living here in Sydney. They've lost all their culture, they just follow the European way. But we still hold fast to our culture. North of us, south of us, west of us, our language and culture is still intact, right there in the middle of the desert, among the spinifex and the sand dunes. I still remember when we lived in bush shelters and travelled constantly, from Ngangaritja to Papunya and Yuendumu and then back again.

The designs I had learned from corroborees and from traditional ceremonial regalia I had been taught by my uncle, my father, and my grandfather. All of us—the young, the old and the middle-aged—we all knew this way. The designs were also painted on shields, usually little shields, sometimes big ones. The designs were derived from those we created in the sand. Now that we paint these designs on canvas, white people and other Aboriginal people can see them and appreciate them. They can be seen all the time, whereas the traditional forms of our art could only be seen at ceremonies. Those shields that we painted, we only used them at certain

times; for corroborees or related rituals. The designs we made in the sand were also only seen occasionally. We use these designs still in corroborees and other ritual practices. *I still participate in ceremonies. It's embedded in my heart. Others may have lost it all but at Kintore, Papunya and Yuendumu, we still retain our culture. We cherish our traditions.* (my emphasis)

I cite this explanation at length here because such textualizations of Aboriginal commentary are not only rare but are also much drawn upon by art critics—who usually lack extensive first-person experience of Aboriginal language, culture, and daily life. In that sense, given the art world's reliance on the textual, one might see how such textualized representations have an even greater potential for alienation than is the case with ordinary ethnographic representations. Thus, in this quotation, which does not appear to be entirely in the English that Michael Nelson would ordinarily use, we do not know what language Nelson was speaking or how it was translated.

33. See also Roger Benjamin's (1990:71) response to the Fry and Willis discussion, in which he considers how "their argument deprives Aboriginal culture of the dynamic capacity for adaptation and change which distinguishes it in the harsh environment of interaction with First World culture."

34. The same can be said of Paul Taylor's (1989) article about the show at the John Weber Gallery in May 1989.

35. The art magazines—in which most reviews are published and circulate—are heavily supported by dealers and collectors. Here lies part of the material basis of representational practice: the organizers of the Asia Society show worked long and hard not only to obtain financial support to put on the show, but to gain timely publicity and reviews.

36. The following statement represents a widely held position:

The market system works to make art "rare" (more original, more authentic) and to keep prices at the highest level. Maximum return is generally produced in a field of low technology . . . by controlling the supply and working to create an excess of demand. The art market trades on exciting a desire for the "touch" of the original hand. The glamorous aspects of the art world, the auctions featured in fashion magazines, the siting of art galleries among prestigious shops, the exclusivity of the opening or "private view" are features of the system. . . . Yet it is the market . . . that takes chances in bringing forward new work to wider public attention; much of that work is selected later by public museums and galleries. (Nairne et al. 1987: 14)

37. An important recent example of this intervention—and a step toward capturing the cultural formation of our own artistic values—is the work of Price (1989), who examines the barriers to the entry of Suriname Maroon patchwork cloth into the domain of "fine art."

38. Such themes prevail in the recent debate in the Australian cultural journal, *Meanjin,* between art historians Donald Brooks and Bernard Smith.

39. In a book expanding upon this paper, I will discuss several levels in the production and circulation of the paintings that I cannot consider here—such as the art advisers, the changing relationship of the Australian welfare state toward Aborigines and toward cultural issues, the support of community craft centers by government agencies pursuing a variety of cultural policies, and the practices of art dealers. Their practices all contribute to the fashioning of meaning for the paintings.

40. The continuation of racist rhetoric is sufficiently documented in a particularly offensive remark by Auberon Waugh, cited by Hughes (1988).

41. In another publication I hope to take up more directly the significance of these critical positions in terms of theoretical questions about empiricism, deconstruction, and representation. Here I only mention that Derrida's *Of Grammatology* (1977), and his general criticisms of ethnology, have had a central influence on the critics' response to the language of "authenticity" and "origins."

42. To capture such complex processes, in which the metropolis is no longer simply the center, Appadurai suggests that we

> begin to think of configuration of cultural forms in today's world as fundamentally fractal, that is, as possessing no Euclidean boundaries, structures or regularities. Second, [he] would suggest that these cultural forms . . . are also overlapping. (1990:21)

43. And this is how, perhaps, they speak to what is said to be a

> central problematic of cultural processes in today's world . . . : The world we live in now seems rhizomic (Deleuze and Guattari 1987), even schizophrenic, calling for theories of rootlessness, alienation and psychological distance between individuals and groups, on the one hand, and fantasies (or nightmares) of electronic propinquity on the other. (Appadurai 1990:2–3)

44. Before becoming a famous travel writer, Chatwin worked for Sotheby's art auction house.

45. And also in the interest in Asia—and its mystical spirituality—among Australia's young. These themes are represented in Australian films like *Picnic at Hanging Rock, Walkabout, The Year of Living Dangerously,* and *The Last Wave.*

46. I do not have the time or expertise to go into Australian notions of the land in any depth, but the literature on the harshness of the interior—its resistance to white/human efforts—is well known. So also do most Australians know from school that Aborigines knew and understood the land (C. Strachan, personal communication, 1990; see Keneally 1988).

REFERENCES

Alloway, Lawrence
 1984 *Network: Art and the Complex Present.* Ann Arbor: UMI Research Press.
Altman, Jon
 1988 "The Economic Basis for Cultural Reproduction." In M. West, ed., *The Inspired Dream: Life as Art in Aboriginal Australia.* pp. 48–55. Brisbane: Queensland Art Gallery.
Altman, Jon, Chris McGuigan, and P. Yu
 1989 *The Aboriginal Arts and Crafts Industry. Report of the Review Committee.* Department of Aboriginal Affairs. Canberra: Australian Government Publishing Service.
Anderson, Benedict
 1983 *Imagined Communities: Reflections on the Origin and Spread of Nationalism.* Rev. and expanded ed. London: Verso.
Anderson, Christopher, and Françoise Dussart
 1988 "Dreaming in Acrylic: Western Desert Art." In Peter Sutton, ed., *Dream-*

ings: The Art of Aboriginal Australia, pp. 89–142. New York: George Braziller/Asia Society Galleries.

Appadurai, Arjun
1990 "Disjuncture and Difference in the Global Cultural Economy." *Public Culture* 2(2):1–24.

Appadurai, Arjun, and Carol Breckenridge
1988 "Why Public Culture?" *Public Culture* 1 (1):5–9.

Bardon, Geoffrey
1979 *Aboriginal Art of the Western Desert*. Sydney: Rigby.

Baume, Nicholas
1989 "The Interpretation of Dreamings: The Australian Aboriginal Acrylic Movement." *Art and Text* 33:110–120.

Becker, Howard
1982 *Art Worlds*. Berkeley: University of California Press.

Beckett, Jeremy
1985 "Colonialism in a Welfare State: The Case of the Australian Aborigines." In Carmel Schrire and Robert Gordon, eds., *The Future of Former Foragers*, pp. 7–24. Cambridge, England: Cultural Survival.
1988 "Aboriginality, Citizenship and Nation State." *Social Analysis* 24:3–18. Special issue: *Aborigines and the State in Australia*.

Benjamin, R.
1990 "Aboriginal Art: Exploitation or Empowerment?" *Art in America* 78(July):73–81.

Cazdow, Jane
1987a "The Art Boom of Dreamtime." *Australian Weekend Magazine*, Mar. 14–15, 1–2.
1987b "The Art of Desert Dreaming." *Australian Weekend Magazine*, Aug. 8–9, 6.

Chatwin, Bruce
1987 *The Songlines*. New York: Viking.

Clifford, James
1988a "On Ethnographic Authority." In *The Predicament of Culture: Twentieth-Century Ethnography, Literature, and Art*. pp. 21–54. Cambridge, Mass.: Harvard University Press.
1988b "Histories of the Tribal and the Modern." In *The Predicament of Culture: Twentieth-Century Ethnography, Literature, and Art*, pp. 189–214. Cambridge, Mass.: Harvard University Press.

Crane, Diana
1987 *The Transformation of the Avant-Garde: The New York Art World, 1940–1985*. Chicago: University of Chicago Press.

Danto, Arthur
1964 "The Artworld." *Journal of Philosophy* 61:571–584.

Deleuze, Gilles, and Felix Guattari
1987 *A Thousand Plateaus: Capitalism and Schizophrenia*. Trans. B. Massumi. Minneapolis: University of Minnesota Press.

Derrida, Jacques
1977 *Of Grammatology*. Trans. G. Spivak. Baltimore: Johns Hopkins University Press.

Elkin, A. P.
 1977 *Aboriginal Men of High Degree*. 2d ed. St. Lucia, Queensland: University of
 Queensland Press. Originally published in 1945.

Fabian, Johannes
 1983 *Time and the Other: How Anthropology Makes its Object*. New York: Columbia
 University Press.

Fiske, John, Bob Hodge, and Graeme Turner
 1987 *Myths of Oz: Reading Australian Popular Culture*. Boston: Allen and Unwin.

Fry, Tony, and Ann-Marie Willis
 1989 "Aboriginal Art: Symptom or Success?" *Art in America* 77(July):108–117,
 159–160, 163.

Hamilton, Annette
 1987 "Equal to Whom? Visions of Destiny and the Aboriginal Aristocracy."
 Mankind 17:129–139.
 1990 "Fear and Desire: Aborigines, Asians and the National Imaginary." *Aus-
 tralian Cultural History* 9(July):14–35.

Hughes, Robert
 1988 "Evoking the Spirit Ancestors." *Time*, Oct. 31, 79–80.

Isaacs, Jennifer
 1987 "Waiting for the Mob from Balgo." *Australian and International Art Monthly*,
 June, 20–22.

Jameson, Frederic
 1984 "Postmodernism: or, The Cultural Logic of Late Capital." *New Left
 Review* 146:53–92.

Keneally, Thomas
 1988 "Dreamscapes: Acrylics Lend New Life to an Ancient Art of Australian
 Desert." *New York Times Sunday Magazine*, Nov. 13, p. 52+.

Kent, Susan
 1987 "A Burst of Colour in the Western Desert." *Sydney Morning Herald.* July 11,
 48.

Kimber, Richard
 1977 "Mosaics You Can Move." *Hemisphere* 21(1):2–7, 29–30.

Kirshenblatt-Gimblett, Barbara
 1991 "Objects of Ethnography." In Ivan Karp and Stephen D. Lavine, eds.,
 Exhibiting Culture: The Poetics and Politics of Museum Display, pp. 386–443.
 Washington, D.C.: Smithsonian Institution Press.

Larson, Kaye
 1988 "Their Brilliant Careers." *New York Magazine*, Oct. 4, 148–150.

Lash, Scott, and John Urry
 1987 *The End of Organized Capitalism*. Madison: University of Wisconsin Press.

Marcus, George E., and Michael M. J. Fischer
 1986 *Anthropology as Cultural Critique: An Experimental Moment in the Human Sciences*.
 Chicago: University of Chicago Press.

Megaw, Vincent
 1982 "Western Desert Acrylic Painting—Artefact or Art?" *Art History*
 5:205–218.

Meyrowitz, Joshua
 1985 *No Sense of Place: The Impact of Electronic Media on Social Behavior.* New York: Oxford University Press.
Michaels, Eric
 1988 "Bad Aboriginal Art." *Art and Text* 28:59–73.
Moore, Catriona, and Stephen Muecke
 1984 "Racism, Aborigines and Film." *Australian Journal of Cultural Studies* 2(1):36–53.
Morphy, Howard
 1983 " 'Now You Understand'—An Analysis of the Way Yolngu Have Used Sacred Knowledge to Retain their Autonomy." In Nicolas Peterson and Marcia Langton, eds., *Aborigines, Land and Land Rights,* pp. 110–133. Canberra: Australian Institute of Aboriginal Studies.
 1992 *Ancestral Connections: Art and an Aboriginal System of Knowledge.* Chicago: University of Chicago Press.
Morris, Barry
 1988 "The Politics of Identity: From Aborigines to the First Australian." In Jeremy Beckett, ed., *Past and Present: The Construction of Aboriginality,* pp. 63–86. Canberra: Australian Institute of Aboriginal Studies.
Morton, John
 1991 "Black and White Totemism: Conservation, Animal Symbolism and Human Identification in Australia." In David Croft, ed., *Australian People and Animals in Today's Dreamtime,* pp. 21–52. New York: Praeger.
Munn, Nancy
 1973 *Walbiri Iconography.* Ithaca, N.Y.: Cornell University Press.
Myers, Fred R.
 1985 "Illusion and Reality: Aboriginal Self-Determination in Central Australia." In Carmel Schrire and Robert Gordon, eds., *The Future of Former Foragers,* pp. 109–122. Cambridge, England: Cultural Survival.
 1986 *Pintupi Country, Pintupi Self: Sentiment, Place, and Politics among Western Desert Aborigines.* Washington, D.C. and Canberra: Smithsonian Institution Press and Aboriginal Studies Press.
 1988 "Locating Ethnographic Practice: Romance, Reality and Politics in the Outback." *American Ethnologist* 15:609–624.
 1989 "Truth, Beauty and Pintupi Painting." *Visual Anthropology* 2:163–195.
Nairne, Sandy, in collaboration with Geoff Dunlop and John Wyver
 1987 *State of the Art.* London: Chatto and Windus Ltd.
Pekarik, Andrew
 1988 "Journeys in the Dreamtime." *World Archaeology* 41 Nov.–Dec.:46–52.
Peterson, Nicolas
 1985 "Capitalism, Culture, and Land Rights." *Social Analysis* 18:85–101.
Price, Sally
 1989 *Primitive Art in Civilized Places.* Chicago: University of Chicago Press.
Rankin-Reid, Jane
 1989 "Colonial Foreplay." *Artscribe International,* Sept.–Oct., 12–13.
Rowse, Tim
 1988 "Paternalism's Changing Reputation." *Mankind* 18:57–73.

Rubinstein, Meyer R.
1989 "Outstations of the Postmodern: Aboriginal Acrylic Paintings of the Australian Western Desert." *Arts Magazine*, March, 40–47.

Sansom, Basil
1980 *The Camp at Wallaby Cross.* Canberra: Australian Institute of Aboriginal Studies.

Schjeldahl, Peter
1988 "Patronizing Primitives." *Seven Days*, Nov. 16.

Schneider, David
1970 "What Is Kinship All About?" In Priscilla Reining, ed., *Kinship Studies in the Morgan Centennial Year*, pp. 32–63. Washington, D.C.: Anthropological Society of Washington.

Smith, Roberta
1988 "From Alien to Familiar." *New York Times*, Dec. 16, C32.

Stanner, W. E. H.
1956 The Dreaming. In T. A. G. Hungerford, ed., *Australian Signpost*, pp. 51–65. Melbourne: F. W. Cheshire.

Strehlow, T. G. H.
1947 *Aranda Traditions.* Melbourne: Melbourne University Press.

Stretton, Roberta
1987 "Aboriginal Art on the Move." *Weekend Australian*, Sept. 5–6, 32.

Sutton, Peter, ed.
1988 *Dreamings: The Art of Aboriginal Australia.* New York: George Braziller/Asia Society Galleries.

Taylor, Paul
1989 "Primitive Dreams Are Hitting the Big Time." *New York Times*, May 21, H31, 35.

Tillim, Sidney
1987 "Criticism and Culture, or Greenberg's Doubt." *Art in America* 75(May):122–127, 201.

von Sturmer, John
1989 "Aborigines, Representation, Necrophilia." *Art and Text* 32:127–139.

Wallach, Amei
1989 "Beautiful Dreamings." *Ms.*, Mar., 60–64.

Warlukurlangu Artists
1987 *Yuendumu Doors: Kuruwarri.* Canberra: Aboriginal Studies Press.

Weber, John
1989 "Papunya Tula: Contemporary Paintings from Australia's Western Desert." In *Papunya Tula*, catalog for show at John Weber Gallery, May 25–June 17, 1989.

Williams, Nancy
1976 "Australian Aboriginal Art at Yirrkala: Introduction and Development of Marketing." In Nelson Graburn, ed., *Ethnic and Tourist Arts*, pp. 266–284. Berkeley: University of California Press.

Williams, Raymond
1977 *Marxism and Literature.* Oxford: Oxford University Press.

From Schizophonia to Schismogenesis: The Discourses and Practices of World Music and World Beat

Steven Feld

Struggles over musical propriety are themselves political struggles over whose music, whose images of pleasure or beauty, whose rules of order shall prevail.
SUSAN MCCLARY, *Feminine Endings*

This essay concerns struggles over musical propriety in the discourses and commodification practices that surround the contemporary global traffic of "world music" and "world beat." In the first of the paper's two sections I focus on a complex layering of representations emanating from voices that are differentially positioned—as academics, journalists, fans, musicians, critics, music industry insiders, and consumers. The juxtaposition of their perspectives indicates a play of shared and contested assumptions about who speaks authoritatively, and what outcomes are at stake for world musical production and creativity. These discourse positions are constructed, asserted, circulated, and implicitly understood as signposts of an array of artistic and political investments. I employ and explore the trope of "schizophonia to schismogenesis" to demystify these discourses, to suggest that they are fundamentally about the mutualism of splitting and escalation. This is to argue that the postmodern world music commodification scene is dominated by surfaces, neon signs of musical heterogeneity that glow in the ever-present shadows of an expanding musical homogeneity. By focusing on the dialectic of this contradiction, I look for a way out of the modernist predicament that can only write and critique world musical interactions in terms of a far less complexly nuanced thematic: "interesting art even if lousy politics," alternated with, "interesting politics even if lousy art."

Following this overview of discursive practices, an overview accomplished through the tactics of critical reading and textual juxtaposition, the paper's second section reframes these issues through a more personal and experiential attempt to come to terms with one kind of world music commodification. Here I review my own involvement with rock star Mickey Hart to produce a commercial CD of a remote music culture and environment in Papua New Guinea. While

this reframing in part responds to contemporary expectations that ethnographers be more fully accountable for their representations, it is also a way to clarify how the larger schizophonia to schismogenesis trope is not merely a diffuse abstraction about a global ecumene (Hannerz 1989) of discursive elsewheres. For although it is true that cultural interactions are increasingly characterized by complex and anonymous exchanges, through flows of technology, money, media, and ideology (Appadurai 1990), transcultural record productions also tell site-specific stories about authorship and agency, about the workings of capital, control, and compromise. My participation in activities of mediating and commodifying music locates me directly in this arena, and I am concerned to use that experimental position to interrogate the critical alternatives for discourse and practice.

To emphasize this destabilized boundary between anthropological and art-world positions and predicaments, the paper's two sections experiment with traversing and linking participatory spaces. In the first section I write both as a reader, analyst, and critic of academic and pop writing, and as a consumer of music who spends an equal amount of time in music shops, nightclubs, concert halls, and listening to a stereo or radio. In the second section I write as an ethnographer and ethnomusicologist who has become a record producer and cultural survival advocate at a historical moment when amplified musical diversity resists, in a rather literal way, the dramatic silencing or muting of indigenous voices by transnational development interests. The continuities and clashes between the two sections, and the multiple, overlapping voices that speak them, reveal how my interpretative politics are inseparable from my mediation and commodification practices.

"Schizophonia refers to the split between an original sound and its electro-acoustical transmission or reproduction," writes Canadian composer Murray Schafer, introducing his terminology of soundscape research and acoustic ecology in *The Tuning of the World* (1977:90). While the tone of a term like "schizophonia" codes Schafer's suspiciously anxious view of the impact of technology on musical practices and sound environments, it resonates equally with the familiar devolutionary ring of mass culture criticism. Schafer laments a drop in world acoustic ecology from hi-fi to lo-fi soundscapes marked by the proliferation of noise, a proliferation corresponding to the increasing split of sounds from sources since the invention of phonographic recording a little more than one hundred years ago. His scheme is straightforward: Sounds once were linked more indexically to their time and place, their sources, their moment of enunciation, their human and instrumental mechanisms. Early technology for acoustic capture and reproduction fueled a preexisting fascination with acoustic dislocations and respatialization. Territorial expansion, imperialistic ambition, and audio technology as agent and indicator increasingly came together, culminating in the invention of the loudspeaker. Then came public address systems, radio expansion, and—after World War II—the tape recorder, which made possible a new and unprecedented level of

editing via splicing manipulation such that sounds could be endlessly altered or rearranged yet made to have the illusion of seamless, unbroken spatial and temporal contiguity. Summarizing his concept Schafer writes:

> I coined the term schizophonia in *The New Soundscape* [1969] intending it to be a nervous word. Related to schizophrenia, I wanted it to convey the same sense of aberration and drama. Indeed, the overkill of hi-fi gadgetry not only contributes generously to the lo-fi problem, but it creates a synthetic soundscape in which natural sounds are becoming increasingly unnatural while machine-made substitutes are providing the operative signals directing modern life. (Schafer 1977:91)

No doubt if Schafer were writing his book now, he would see digital sampling, CD-ROM, and the new ability to record, edit, reorganize, and own any sound from any source, as the final stage of schizophonia, namely, the total portability, transportability, and transmutability of any and all sonic environments. But for the moment forget the "after the deluge" rhetoric here and some of the many social complexities Schafer ignores, such as the fact that musical technology has been occasionally hijacked to empower certain traditionally very powerless people and as a result has strengthened their local musical bases. Rather, focus in and think about the sense of nervousness that Schafer's lovely and precise schiz-word means to announce: mediated music, commodified grooves, sounds split from sources, products for consumption with fewer if any contextual linkages to processes, practices, or forms of participation that endow their meanings in local communities. Here Schafer's schizophonia idea recalls Walter Benjamin's celebrated essay of forty years earlier, "The Work of Art in the Age of Mechanical Reproduction" (1968). Although Benjamin's concern with the transformation from unique to plural existences centered upon visual-material art objects, his critical interest in "aura," that which is lost from an original once it is reproduced, first raised the assumption that anchors Schafer too, that "the work of art reproduced becomes the work of art designed for reproducibility" (1968:224). This view, where social relations are announced in the codes of aesthetic inscription, has been most strongly enunciated for music in Jacques Attali's *Noise: The Political Economy of Music* (1985), which argues that "repeating," the transformation from representation to reproduction in music, creates a new network for social organization:

> In this network, each spectator has a solitary relation with a material object; the consumption of music is individualized, a simulacrum of ritual sacrifice, a blind spectacle. The network is no longer a form of sociality, an opportunity for spectators to meet and communicate, but rather a tool making the individualized stockpiling of music possible on a large scale. Here again, the new network first appears in music as the herald of a new stage in the organization of capitalism, that of the repetitive mass production of all social relations. (Attali 1985:32)

Like Benjamin's "aura," or again, in the visual mode, Baudrillard's "signature" (1975, 1981), Attali's "repeating" (1985:87–132) and Schafer's "schizophonia" help focus our critical awareness not just on the process of splitting, but on the conse-

quent status of the copy and the contestation of its authenticity as it seeks to partake of the legitimacy granted to an original. The jeopardy to primal originality posed by reproductive technologies, once more a centerpiece of elite and high culture critical discourses on the vulgarity of popular culture, is now more substantially situated in the discourses of cultural analysis, mediation, or commodification. Schizophonia thus needs to be imagined processually, not as a monolithic move in the history of technology, but as varied practices located in the situations, flows, phases, and circulation patterns that characterize particular cultural objects moving in and out of short and long commodity states, being transformed with the experiential and material situation of producers, exchangers, and consumers (Appadurai 1986), located in historically specific national and global positions vis-à-vis late capitalism and development (Castoriadis 1985), cultural domination (Schiller 1976), modernity and postmodernity (Berman 1983; Harvey 1989).

In the world of popular musical traffic, such issues are centrally and critically grounded in the international ascendancy of the recording industries. In "The Industrialization of Popular Music" (1988), Simon Frith's typically broad strokes help to reposition Schafer's "schizophonia" in the larger techno-economic arena of the pop music business. He writes: "The contrast between music-as-expression and music-as-commodity defines twentieth-century pop experience and means that however much we may use and enjoy its products, we retain a sense that the music industry is a bad thing—bad for music, bad for us. Read any pop history and you'll find in outline the same sorry tale" (Frith 1988:11). Frith's own outline of this sorry tale of the devolutionary shift from active music-making to passive pop consumption (Frith 1981, 1986) rises forcefully to the defense of technology to argue for the importance of rock as a mediated art form, and defends consumer tastes and choices to counter elitist assumptions about standardization and the passivity of pop music consumption. But Frith also retreats to more stable ideological and rock critic turf:

> Pop is a classic case of what Marx called alienation: Something human is taken from us and returned in the form of a commodity. Songs and singers are fetishized, made magical, and we can only reclaim them through possession, via a cash transaction in the market place. In the language of rock criticism, what's at issue here is the *truth* of music—truth to the people who created it, truth to our experience. What's bad about the music industry is the layer of deceit and hype and exploitation it places between us and our creativity. (Frith 1988:12)

These defenses of technology and of the rock consumer speak to cultural studies preoccupations with refiguring Adorno and Frankfurt School dogmas on production, standardization, consumption, and passivity that typified much of the earlier academic pop music literature. But to move into the world arena it is necessary to move past two general problems with this overall angle on the industrialization of music. Frith constantly uses the word "pop" when what he more typically means is "rock," specifically the internationally marketed but American- and Western Euro-

pean-derived rock of the last thirty-five years. Generalizations about "pop" involve some other, specific complexities when one attempts to account for the larger *world* popular musical picture beyond rock with regard to industrialization. Similarly, Frith's notion of a popular music "colonized by commerce" takes on different vicissitudes when we move beyond rock to concretely observe Third and Fourth World musical realities, ones where the people and music really have been colonized, and not only by commerce. What is crucial here is a view of world music industrialization in which global power relations are visualized as forces shaping productions of musical style and icons of cultural identity.

Like Schafer's "sounds split from sources," Frith's notion of "truth to the people who created it" has particular consequences when the sounds, sources, and creators are truly exotic to the overwhelming majority of their potential consumers. This is because enormous genres of sonic otherness from the reservations beyond Western European-derived art and popular musics are unlike other mediated popular musics and specifically unlike rock in major ways. First, in the bush, at the outposts and edges of empire, grassroots musical styles and distribution have long sung undulating melodies of resistance and accommodation to the hegemonic rhythms of international copyright law and the practices of record companies. Additionally, exotic world musics will always be financially and aesthetically remote from the historical locus of the international recording consolidation. That consolidation currently concentrates control and ownership of approximately 93 percent of the world musical sales market among six Euro-North Amero-Japanese companies: Time-Warner, CBS-Sony, MCA, Thorn-EMI, BMG/RCA, Philips-Polygram (Pareles 1990; Robinson et al. 1991). The vertical and horizontal integration of music production and publishing industries, an alignment of technology ownership and production control, has been closely linked to the power centers of technological invention in the West and, more recently, Japan (Boyer 1988). Western art, rock, and pop stars have shared in that market and growth considerably in the last twenty-five years in ways that are generally unknown and almost unbelievable outside the West, even in the context of a non-Western star of the stature of Ravi Shankar.

Jon Pareles, in his regular *New York Times* (March 19, 1990) Pop View column, has considered this "larger means fewer" world of the music business consolidation as a power move vis-à-vis promotion, investment, distribution, and overall control. He writes: "As the record business enters the 1990's it has developed a two-tiered system. Independent labels handle specialized styles and new performers—they have almost taken over scouting for talent and test marketing it—while the majors grab proven contenders." Effectively, this describes a market strategy in the realm of world music where Frith's "colonized by commerce" is particularly colonial. Consolidation leads to the search for huge single hits rather than broad profitability on various projects or broad dissemination of myriad musics. Huge hits inevitably come from a small group of pop stars, all of whom hold major label

contracts, and receive industry support and promotion commensurate with their sales histories and potential.

Schizophonia gets intensively schizy here because of the ways splitting sounds from sources simultaneously implicates matters relating to music, money, place, time, ethnicity, race, and social class. But many researchers and writers counter by stressing the optimistic dimensions of world musical contact and industrialization. Simon Frith, for example, in his introduction to a collection of early 1980s International Association for the Study of Popular Music conference papers entitled *World Music, Politics, and Social Change* (1989), writes, "The essays here celebrate, then, the richness of local music scenes, and document the remarkable skill, vigour and imagination with which local musicians and fans and entrepreneurs take over 'hegemonic' pop forms for themselves. Popular music, even in the era of Sony-CBS, MTV-Europe, and Michael Jackson as global Pepsi salesman, is still a progressive, empowering, democratic force" (1989:5). Likewise, Andrew Goodwin and Joe Gore, writing about the debate over world beat and cultural imperialism in *Socialist Review,* conclude: "Although World Beat is itself largely an effect of . . . cultural imperialism . . . the complexity of the results of such practices [is] demonstrated in . . . transculturation" (1990:77). Here more critical and political stances blend with more mainstream ethnomusicological views, like Bruno Nettl's (1985) evocation of a world of unprecedented musical diversity, or sociological ones, like Krister Malm and Roger Wallis's work on media and musical circulation (Malm and Wallis 1992; Wallis and Malm 1984). All these viewpoints, academic and popular, draw on a normative conceptualization of a world in creolization (Hannerz 1987), a trend that has the positive effect of balancing the discourses of cultural imperialism (Laing 1986; Tomlinson 1991) with the complexities of cultural exchange and transculturation (Malm 1993). But such readings also risk confusing the flow of musical content and musical expansion with the flow of power relations. For even when local musicians take control in remote locales, and even when dramatic and aesthetically compelling new musical syntheses emerge, how progressive can the world of popular music be when transnational culture industry practices steadfastly reproduce the forms and forces of legal and technological controls that overwhelmingly stabilize outsiders at the influence and labor stage of pop?

Some of the answers lie in the complexities of the recent commodity intensification of world musics in the international marketplace. The 1980s, the moment in capital and commodity flows when all musics once very "other" moved steadily into zones of the familiar, was also the moment of major discursive shifts, a moment when the academic monopoly in authoritative discourse on obscure musics was thoroughly devalorized. Thus in his 1982 review of the first WOMAD (World of Music Arts and Dance) *Music and Rhythm* double LP, a compilation juxtaposing pop stars Peter Gabriel, David Byrne, Jon Hassell, and Pete Townshend with African, Jamaican, Balinese, and Indian artists and styles, John Szwed introduced the word "ethnomusicology" to readers of New York's *Village Voice,* only to

quickly dissolve its modernist purism this way: "Who needs a Ph.D. when there are
enough record stores stocked with product in New York, Tokyo, Miami, London,
and Paris to give you permanent culture shock?" By the end of the decade
ethnopop had taken over ethnomusic, the other was the world, and academic
irreverence (from voices inside and outside the academy) was the dominant tone of
radio and popular press discourses, even becoming smug and self-congratulatory
in the alternative music press, like in this 1990 piece in *Option* magazine:

> Bored with the music you're listening to? Why not invite a Kenyan wedding band or
> a turbaned troupe of gypsies from the villages of the Nile into your living room?
> Musical treasures from the world's far-flung regions abound in record stores these
> days. And most of the credit for that goes to a few intrepid souls within the fringes of
> the pop music establishment, people who have devoted years to the thorny proposi-
> tion of bringing state-of-the-art world music recordings to a mass culture. Ten years
> ago the international bin was populated with high-priced French imports and muffled
> recordings on labels like Folkways, Nonesuch Explorer and Lyrichord—most of these
> licensed for a song from hungry ethnomusicologists out to cash in on their fieldwork.
> These releases tended to be academic, with sliced-up three minute selections, abrupt
> beginnings and endings, and didactic liner notes, stiff with classifications and musi-
> cological jargon. Not anymore. Aside from international pop, which has become an
> industry unto itself, traditional music veterans like Nonesuch Explorer and Lyrichord
> are forging into the CD market. But now they are being overtaken by more savvy
> and ambitious explorers, most notably Globestyle Records, the brainchild of restless
> musician and field recorder Ben Mandelson; Rykodisc's World Series, masterminded
> by Grateful Dead drummer Mickey Hart; and Real World Records, a project steered
> by Peter Gabriel in collaboration with WOMAD (World of Music Arts and Dance).
> These three new forces have no hangups about what is classical, traditional, folk, or
> pop. They are guided by a belief that the world's great music, presented right, can be
> commercially successful. (Eyre 1990:75)

So by the 1990s elite pop stars were setting the pace for the marketing of what
their record companies now called "world music," bypassing folkies, academics,
and previous generations of collectors, advocates, and promoters like Moses Asch,
Alan Lomax, and others who fought the early uphill battles to record, publish,
and promote the world's musics. Alongside the populist discourses and practices of
rock stars that developed through the 1980s, an elite version circulated within the
art music avant-garde with artists like Terry Riley, Steve Reich, Philip Glass, or
the Kronos Quartet strongly promoting Asian and African musics through com-
positional experimentation, performance, and collaboration. Likewise, prestigious
entrepreneurial organizations like the New Music America Festival introduced
Inuit throat-game vocalists or tango accordionists alongside the West's minimalists,
experimentalists, and improvisers.

And in the stores, where headings labeled "Africa" or even "Europe" formerly
housed a small hodgepodge of recordings, one could increasingly find entire sec-
tions and subsections and sub-subsections on the world music shelves, with multi-

ple divisions and numerous recordings. Style terms like cajun, zydeco, polka, salsa, *soukous, ska,* tango, Afro-beat, *jùjú,* highlife, township, conjunto, or klezmer emerged to demarcate substantially diversifying and enlarging genre sections. These quickly intermingled with more established geographical style regions and more familiar pop genres like reggae or blues.

With those schizophonic notes in hand we can momentarily zoom out to the land of the Iatmul in the Middle Sepik of Papua New Guinea, where—forty years before Schafer entered the fray of schizo-suffixing—Gregory Bateson coined the term "schismogenesis" to discuss patterns of progressive differentiation through cumulative interaction and reaction (Bateson 1958:171–197, 1972:61–87, 107–127). Schismogenesis, in Bateson's more formal language, refers to "classes of regenerative or vicious circles . . . such that A's acts [are] stimuli for B's acts, which in turn [become] stimuli for more intense action on the part of A, and so on" (Bateson 1972:109). Bateson identified two related patterns of schismogenesis, symmetrical and complementary; the second, complementary schismogenesis, is what concerns me here. This pattern involves cycles "where the mutually promoting actions are essentially dissimilar but mutually appropriate, e.g., in cases of dominance-submission, succoring-dependence, exhibitionism-spectatorship and the like" (ibid.). In the complementary mode the progressive differentiation involves a mutually escalating reactivity whose continuance leads to the closer symbiotic interdependence of the parties. Simultaneously, however, anxiety, paranoia, and increasing distortions make the mutualism destructive and progressively impervious to forms of self-correction. Unless, of course, the two unite in opposition to an outside force, or mutually reduce the escalating distortions by attaining new forms of self-consciousness about their predicament. Bateson identifies three other possible endpoints for such cycles: fusion of the parties, elimination of one or both, or the persistence of both in a dynamic equilibrium (Bateson 1958:184). Bateson's view of the limits of stability in large-scale systems goes considerably beyond seeing cumulative and interactive escalation as a one-way path to explosive destruction; instead, he continually focused on forces of self-regulation, correction, and feedback in a variety of social formations.

Juxtaposing Bateson's schiz-word to Schafer's might be useful in thinking about some of the material and discursive developments related to the intensified commodification of world music. Following increasing splits from their sources and the subsequent explosion in world musical products and marketing over the last ten or so years, we are in the throes of a major trend, where musical activities and the emergent discourse in this world music arena exhibit a complementary schismogenetic pattern. The opposition or mutual differentiation scenario of this pattern rhetorically contrasts claims to "truth," "tradition," "roots," and "authenticity," all under the cover term "world music" (or, in the lingo of its more zealous promoters, "real world music") versus the practices of mixing, of syncretic hybrids, blends, fusings, creoles, collaborations, all under the cover term "world beat" (or, in the lingo of its more zealous promoters, "planet groove").

What world music signifies for many is, quite simply and innocently, musical diversity. The idea is that musics originate from all world regions, cultures, and historical formations. World music thus circulates most broadly in a liberal field of discourse. In a somewhat more specific way it has also become an academic designation, the curricular antidote to a tacit synonymy of "music" with Western European Art Music. In this latter sense the term is potentially more political, contesting the dominance of "common practice" European music—"the canon"—and opposing it with a plural, multicultural world founded on the concept of musical diversity. But it is as a commercial marketing label that "world music" is now most commonly placed. In this context the term has come to refer to any commercially available music of non-Western origin and circulation, as well as to all musics of dominated ethnic minorities within the Western world; music *of* the world to be sold *around* the world. Indeed, by 1990, *Billboard*, the major recording industry journal, validated the term by adding "World Music" as a sales and airplay tracking category.

But by this time as well, "world music" had begun to discursively overlap with "world beat," and one heard the terms used synonymously to refer to (and market) the best known commercial and popular varieties of world musical styles, like reggae, blues, zydeco, conjunto, or salsa. Calling attention to the dialectics of isolation and hegemony, resistance and accommodation, this discursive merger of world music and world beat through the 1980s drew out an expanding world of blurred boundaries between the exotic and the familiar, an intertwined local and global product commodified in transnational popular culture.

The "world beat" label also developed more specific connotations. Introduced by Austin, Texas musician and radio personality Dan Del Santo in the 1980s, the name was picked up rapidly by the radio and music industry to denote all ethnic-pop mixings, fusion dance musics, and emerging populist musical fusions from all over the world, particularly its urban centers. What rhetorically set world beat apart was often the assertion of a new, thoroughly postmodern species of authenticity, one constituted not in isolation or difference but in hybridity proper, an authenticity precisely guaranteed by obvious blendings. This openness to synthesis and resynthesis, to transrootedness, contributes to an instant appeal: "world beat" becomes populist dance music that invites participation irrespective of any knowledge of its (often non-English) lyrics or cultural background.

But notice the marked word in the phrase: "beat." That also implicitly reminds Westerners that it is "others" who have rhythm, who make music of and for the body, music for dance, music unambiguously for bodily pleasure. Inevitably tied to a long history of essentializing and racializing other bodies as possessing a "natural sense of rhythm," the invention of world beat also reproduces some of the Western gaze toward the exotic and erotic dancing body, particularly one with darker skin. These other "beats" thus provide the pulse and groove for Western bodies to throw off their inhibitions and get down on the dance floor. "World beat," then, is a much more marked term than "world music." Critically disparaged by some as

other people's (or oppressed people's) party music, now commercially fashioned or newly appropriated for white folks to dance to, world beat is equally championed by others as the only new, populist, honest, commercially viable form of dialogue or potential equalization between musics and musicians of different cultural spaces.

The escalating discourse of differentiation surrounding the notions of world music and world beat is located both in vernacular and academic forms. The vernacular form, particularly popular with musicians and with journalists who like to side sympathetically with musicians, argues that market expansion, global stylistic contact, and the recognition of global musical diversity are inevitably accompanied by circulatory problems. Here commodification and promotion take a toll, one that greys out, vulgarizes, distorts, or maligns those who are supposedly benefiting from increased exposure. Expansion and advance in the musical style arena are thus often seen as the positive face of a process which inevitably involves contraction and mastication. The perception among culture producers and creators is often that banality is part of the price one pays for exposure. This perception dictates that outsider musics and musicians must yield to and depend upon Western pop market tastes, Western pop stars, and the Western pop recording industry when it comes to participating in a musical synthesis. World beat may be created from and inspired by outsider grooves, but the creators are led to understand that it is not exotic grooves that sell the music but rather the status and entrepreneurial role of pop stars and their specific ability to access the support systems of major record companies that do so.

An example: Jon Pareles, again, in his (August 28, 1988) *New York Times* column entitled "Pop Passports—At a Price." His anxiety is well illustrated in the following paragraph: "When Paul Simon, Peter Gabriel and Talking Heads sell millions of records using Jamaican reggae and South African *mbaqanga*, their sources deserve a piece of the action. But to reach the world audience, how much will those regional musicians have to change—and for better or worse?" The piece continues in this vein and then about-faces toward a more tempered balance.

> It's not fair to simply cry "Sellout!" . . . local and outside influences have been tangled for decades, maybe centuries. As the musicians see more of the world they're bound to incorporate the ideas and rhythms they now live with. Beyond that, most popular music means to be hospitable, and one way to make listeners feel at home is to give them something they're familiar with. . . . It would be a double standard to suggest that Paul Simon and Sting can borrow whatever they want while their sources have to stick to local or national styles—as if the colonies could only provide raw material for the empire's factories.

And finally, speaking of the specific non-Western musicians involved in world beat projects, Pareles concludes that "it will be up to them whether they're remembered as stateless pop bands or national standard-bearers." Pareles here both sides with and puts the heat on the musicians, imagining that they have a degree of con-

trol that they surely don't. At the same time he tends to ignore the larger social and economic dimensions of the culture industries which continually do force musicians to "provide raw material" for the empire.

But to point out how Pareles's anxiety about "world beat" is balanced by his enthusiasm for "world music," turn to another of his columns, written a few months later (November 6, 1988), on the "roots move." Here Pareles praises Panamanian politician and salsero Rubén Blades and the Los Angeles-based rock group Los Lobos, who were just enjoying fame for their remake of the song "La Bamba." Why this praise? Because they were "telling listeners across the hemisphere that success in America is possible without cutting off roots, without jettisoning their own language and music, without assimilating and Americanizing. While slick, mainstream American pop blankets the world, they insist, with plinking harps and time-honored salsa rhythms, that diversity should not be lost." To some that last sentence reads like the pledge of allegiance for real world music pop patriotism. To others it is more notable for the degree to which it ignores the multilayered syncretic dynamism underlying the music of both Rubén Blades and Los Lobos.

Moving over into the academic sphere, I'll take my nervous self as a token of equal anxiety about the scene. My review (Feld 1988b) of the politics of Paul Simon's appropriative mixing and copyrighting practices for his *Graceland* album is perhaps more loudmouthed than Pareles's, but the anxiety is similar (also see Meintjes 1990; Hamm 1988; the exchange between Hamm 1989 and Laing 1990; and Erlmann 1989, 1990 for a broader view locating the academic politics and aesthetics of *Graceland*). It is an anxiety about an increasingly focused and intensified set of interactions whose consequences seem to grow in magnitude, not just from the reproduction of asymmetrical power to control technologies, but within a space marked by a heightened symbolism of race and/or ethnicity.

> Musical appropriation sings a double line with one voice. It is a melody of admiration, even homage and respect; a fundamental source of connectedness, creativity and innovation. This we locate in a discourse of "roots," of reproducing and expanding the tradition. Yet this voice is harmonized by a counter-melody of power, control or domination; a fundamental source of maintaining asymmetries in ownership and commodification of musical works. This we locate in a discourse of "rip-offs," of reproducing the hegemonic. Appropriation means that the issue of "whose music?" is submerged, supplanted, and subverted by the assertion of "our music." (Feld 1988b:31)

When James Brown breaks down complex African polyrhythms and incorporates them into dense funk/soul dance tracks, we don't speak of a powerful Afro-American star moving in on African musical turf. Ten years later, when Fela Anikulapo Kuti seizes the essence of the James Brown scratch guitar technique and makes it the centerpiece of his Afro-Beat, we don't speak of a powerful African star moving in on Afro-American turf. The economic stakes in this traffic are small, and the circulation has the revitalization dynamic, of roots. But when the Talking Heads move in on both James Brown and Fela Anikulapo Kuti and use scratch, funk, Afro-Beat and

jùjú rhythm as the basic grooves for *Remain in Light,* something else happens. The economic stakes—however much attention is drawn to the originators as a result—are indeed different, the gap between the lion's share and the originator's share enlarged, and the discourse of race and rip-offs immediate and heated. (ibid.:37)

Arjun Appadurai has recently characterized the intensification in global interaction that has created such spaces: "The world we live in now seems rhizomic, even schizophrenic, calling for theories of rootlessness, alienation and psychological distance between individuals and groups, on the one hand, and fantasies (or nightmares) of electronic propinquity on the other" (1990:2–3). And a few pages later: "The central problem of today's global interaction is the tension between cultural homogenization and cultural heterogenization" (ibid.:5). Yet contrary to the pessimism of Jameson's vision of postmodern schizophrenia (1990) as a pastiche of detemporalized surfaces, ahistorical dispersal, decontextualized stylistic diversity, authorial erasure, and the habit of being about itself, Appadurai sees more crucial space for struggles and creative contestations marking this schizophrenic condition. Music becomes a particularly poignant locale for understanding roots versus rootlessness, homogenization versus heterogenization, because, to state the case most strongly, as Attali does: "Music is prophecy. Its styles and economic organization are ahead of the rest of society because it explores, much faster than material reality can, the entire range of possibilities in a given code" (Attali 1985:11). But even if one finds such a privileging of music suspicious, there is a more fundamental reason for music's centrality to this rhizomic moment: music is the most highly stylized of social forms iconically linked to the broader cultural production of local identity, and indexically linked to contexts and occasions of community participation.

These journalistic and academic discourses for musical worlds versus world beats are marked by the way they sense, anticipate, or feel the presence of escalation—a progressive, cumulative, interactive, pattern differentiation from intertwined mutuality, namely, complementary schismogenesis. If schizophonia, the splitting of sounds from sources, is the antecedent fact of life in today's global and transnational world of music, then schismogenesis is a way to describe something of the resultant state of progressive mutual differentiation that is playing out in at least four clear ways, as (a) an escalating dominance-submission pattern of ownership among the majors and independents, paralleled by a similar relationship between Western pop stars and non-Western musicians; (b) an escalating succoring-dependence pattern of world beat and world music; (c) an escalating exhibitionism-spectatorship pattern between Third and Fourth World creators and First World fans; (d) an escalating homogenization-heterogenization struggle in the realm of musical style. Added together, these practices of and discourses on world music and world beat are in an increasingly politicized and polemicized zone in which the key struggles are over authenticities—the rights and means to verify what Frith called "the truth of the music"—and the dynamics of appropriation, centering around the rights and means to claim musical ownership.

If authenticity and appropriation are the struggle zones, how is complementary schismogenesis located in the current practices of producing world music and world beat? One place we can look for an answer is in the construction of signs of collaboration. Promoters and fans of world beat point to ways it is a genre of synthesis, and more importantly a sign of international cooperative collaboration. Musicians like Sting, David Byrne, Peter Gabriel, and Paul Simon have said such things in interviews and most of their fans and many of the critics have no trouble presenting them in a positive and progressive political light as a result. Further, there can be little question that many promoters, musicians, and media people are invested in world beat as a politically progressive and artistically avant-garde movement. One way in which that progressive agenda is articulated is through patronage, and specifically by the promotional and curatorial involvement of these stars with real world music and the careers of its makers. This process has the positive effect of validating musicians and musics which have been historically marginalized. Simultaneously, it has the much less positive effect of reproducing the institutions of patronage and their attendant rights of validation, as well as their connection to long-standing patterns of cultivation central to elite avant-gardism. This situation locates musical practices close to visual ones, discussed vigorously in recent analyses of how locally "primitive" "crafts" are transformed into aesthetically and commercially significant ethno-"arts" through the rhetoric, sponsorship, and connoisseurship of Western artists, dealers, academics, collectors, and museums (Clifford 1988:189–251; Myers 1991; Price 1989:23–99; Torgovnick 1990:119–137).

One pattern for establishing merit and significance, and for expressing the nature of patronage and valorization in the realm of musical recording, emerges in historical compilation projects, projects where the documentation of emergent traditions is mixed with the promotion of contemporary musics. These are good examples of safe genre statements of authenticity; they show a concern for roots and express the desire to validate historically dynamic and evolving traditions. These practices are closely linked to the recent emergence of scholarly analyses of international pop genres. Good academic examples, where professional ethnomusicologists have studied particular popular musical histories, are Christopher Waterman and Veit Erlmann's successful compilation of *jùjú* and *mbube* roots for Rounder Records, documenting the rise of major Nigerian and South African musical syntheses over the last sixty years (Waterman 1985, 1990; Erlmann 1987, 1991). With those sorts of things as models it is obviously complicated to criticize the more high-tone commercial compilations produced in parallel by major pop stars, like David Byrne's volumes of Brazilian samba classics and Cuban musics.

Likewise, what critical stance can one take given the extraordinary care taken to record the Gyuto Monks, Dzintars, Hamza el Din, Zakir Hussain, or Babatunde Olatunji with state-of-the-art technology in Mickey Hart's Rykodisc CD series, The World? Why not join the sentiments of Kyle Kevorkian, who in a *Mother Jones* article entitled "Evolution's Top Forty" (1990) says of Hart's series: "*The World*

isn't 'world beat'—it's the real thing, unadulterated." Why be cynical about Peter Gabriel's Real World Studios and Real World Records and WOMAD Talking Book projects, projects that have produced neglected or important records of recent years, like the music of Tabu Ley Rochereau and Remmy Ongala, or the extraordinary voice of Youssou N'Dour, or the *qawwali* music of Nusrat Fateh Ali Khan? Why imagine that Gabriel isn't utterly sincere when he says "we're trying to make these other artists as well-known as we are" (Cheyney 1990). Indeed, expressing his optimism about collaborations with Gabriel, we have Nusrat Fateh Ali Khan telling interviewers that "the West should understand our music and culture, and vice-versa. With such collaboration, artistes [*sic*] can come closer to each other and come to know each other" (Khan 1991). And Youssou N'Dour concludes the liner notes to his popular 1989 CD *The Lion* with: "Special thanks to my friend Peter Gabriel for all that he has done for me and for music in general. Africa thanks him for being the biggest promoter of music without frontiers."

With the same pop stars increasingly involved in the curatorial, promotional, and collaborative roles, as well as their more marked entrepreneurial and appropriative roles, the critical arena surrounding world beat features assertions of "altruism" and "generosity" as frequently as it does accusations of "cannibalism" and "colonialism." But to view matters more structurally, the same mixing of curatorial, promotional, and appropriative roles also means that genre lines between real "world music" and "world beat" are becoming increasingly vague and blurred. So while fans and critics rhetorically debate how politically well-intentioned artists might be, or what implications their style fusings have for the end of old traditions or the genesis of new ones, record companies profit considerably through market saturation and greater audience familiarity. In other words, escalating a blurred genre market means that sales of world beat promote sales of world music and vice versa. This leads to a situation where Peter Gabriel and Real World might make almost as much money from the sound track recording to *The Last Temptation of Christ* as from the *Passion Sources* compilation (the source material from which his sound track is drawn)—a compilation that consists of extended selections from the sound track's source material, including Pakistani *qawwali*, Moroccan wedding music, Armenian *duduk*, Zairian *soukous*, Cuban *son-chanqui*, plus Indian, Tanzanian and Nile pieces as well. And of course this presentation spectrum helps advertise, sell, and link specific artists, the Real World network, and the image of these musics and artists as aesthetically, politically, and commercially unified. Patterns similar to the WOMAD/Real World Studios vision could be explored in Mickey Hart's own *Planet Drum* (winner of the first World Music Grammy, in 1992) and his productions for the World Series, or Ben Mandelson's own band, Three Mustaphas Three, and his Globestyle Records projects, or David Byrne's compilation activities in Cuban and Brazilian music, and his *Rei Momo* project.

Such patterns also have begun to extend outward and link up with the print media, such as Mickey Hart's books *Drumming at the Edge of Magic* (1990) and *Planet*

Drum (1991), and with television. The view of Brazilian trance rituals in David Byrne's TV *candomblé* film *Ilé Aiyé* provides another angle on the process of dissolving oppositional mutuality through genre blurring. Very arty and stylish, yet very much in the artistic mold of PBS documentary—syrupy narration featuring nuggets of other peoples' ancient wisdom, plenty of sunsets, and gyrating bodies— the film predictably has no time or place for locating *candomblé* in local politics, economy, or society. Byrne the curator is so busy transporting us into a world of "purely musical being" that the question of musical control, as Amy Taubin (1989) pointed out in a typically acute *Village Voice* column, only surfaces in small print credit titles at the very end: "Original score by David Byrne, performed by . . . (long list of Brazilian musicians)."

As these varieties of homogenization-heterogenization dialectics intensify, one form of dynamic equilibrium that emerges in the escalating complementary schismogenesis of world music and world beat takes the following form: as the discourse of authenticity becomes more militant and nativistic, more complicated, and more particularized to suit specific interest and taste groups, the activities of appropriation get more overt and outrageous, as well as more subtle, legally sanctioned, accepted, and taken-for-granted. By placing the same pop stars, record companies, and extended media conglomerates at the center of the action, holding both the curatorial roles, as keepers of "truth" and "authenticity," and the entrepreneurial roles, as keepers of ownership and appropriative means, there is a fusion of the parties for mutual business gain and unification against competing genres and business operations.

What looks like imperial transnational adaptation, or self-regulatory anticipation, here seems to be packaged, unfortunately simultaneously, with a mechanism of "cultural greyout" (Lomax 1977). But such greyout and the devolutionary assumption that anchors it need not rule. The promotion of world beat has undoubtedly led to a much greater interest in and concern for the promotion and circulation of world music than ever existed before. Greater exposure and market power have improved the survival prospects and development situation of local musics in unexpected ways. Additionally, as the increasing development of a world-beat blur, a more and more generic ethnopop music, can also be accompanied by marked, intensified, and highly dramatic assertions of resistance-tinged local musics. Reggae is a prime example of this tension between genericization and stylistic markedness in the international arena. Its perception by indigenous peoples outside the Caribbean as an oppositional roots ethnopop form has led to its local adoption by migrants and indigenes in places as diverse as Europe, Hawaii, Native North America, Aboriginal Australia, Papua New Guinea, South Africa, and Southeast Asia. At the same time, the form has come to take on generic connotations that are often nonpolitical.

To bring matters back home, the position of rap in the black-white pop music scene is a more locally American example of many of these dynamics. Rap is now a genre much more marked and oppositional than soul, rhythm and blues, or

other black styles long since appropriated or crossed-over. Rap's markedness derives from the ways it disrupts the assignment of the label "artistry" to only those musical forms which participate in a particular discourse of originality. Digital sampling, the recording empire's own high-technology cyber-fetish, is subversively used here to resist and refuse to participate in Euroworld conventions of literary authenticity, to oppose them with an oral aesthetic of citation. In particular, this interferes with practices naturalized by Western legal codes of copyright and ownership. Rap thus *re*covers an oral tradition long covered by outsiders. This inversion—the reappropriation by black artists of black and white musical material through sampling and digital manipulation—talks back to a whole history of white appropriation of black musical forms and styles (see Chapple and Garofalo 1977).

If, as writers and critics as diverse as Amiri Baraka and Robert Christgau rhetorically claim, black music today is still a reverberation of the rape of African rhythm by European harmony in slavery's brothels, then Public Enemy's 1990 "Fear of a Black Planet" rap should be listened to not just as a response to the rhetoric of "race mixing," but as an allegory of musical contact as schismogenesis. In this rap, a second voice emerges in counterpoint to the dominant verbal rhyme. Speaking deliberately, almost monotonically, with all the hip smugness of high performance art, the voice calmly delivers these lines:

black man . . . black woman . . . black baby
white man . . . white woman . . . white baby
white man . . . black woman . . . black baby
black man . . . white woman . . . black baby.

More than a vernacular promotional jingle for Afrocentricity, such lines confront stereotype through style, and ask:

white music capital . . . white pop stars . . . black roots grooves . . . white music?
or, black music?

Rap, now routinely seen as a site of struggle or contestation involving roots and gender, race and ethnicity, identity and authority, marks a particular locale of expressive intensification. It is a powerful local example of the same schizophonia to schismogenesis dynamic now increasingly mapping world popular musical discourses.

> *Music . . . makes audible what is essential in the contradictions of developed societies: an anxiety-ridden quest for lost difference, following a logic from which difference is banished.*
> JACQUES ATTALI, *Noise: The Political Economy of Music*

To explore now in a more experiential space how these concerns over schizophonia and the "world music"—"world beat" schismogenesis dynamic enter into the mediation and commodification practices of anthropologists and ethnomusicologists, I will discuss the "anxiety-ridden quest for lost difference" in *Voices of the Rainforest*, my CD/cassette recording of music and environmental sounds of the Kaluli people

from Bosavi, Papua New Guinea, commercially released by Rykodisc in April 1991. To do this I ask how participation in the traffic of commercial world music evokes the problematics of "imperialist nostalgia" (Rosaldo 1989), situations where highly positioned parties lament, indeed, may feel anger about the passing of what they themselves have helped to transform. Clarifying the nature of professional complicity in schizophonia is also essential to a critique of ethnomusicology's practice of making and circulating recordings, and specifically of these recordings' representational tendencies toward the construction of transparent, realist samples of "traditional music." Although most of the effort to unmask conventions of ethnographic representation has concerned print, literary, visual, or filmic genres (for example, in Marcus and Fischer 1986; Clifford and Marcus 1986; Clifford 1988), the "writing" of culture, of "inscribing" otherness, is also located in methods of auditorally "recording," "magnetizing," "engraining," "digitizing," and "modulating" it.

Surely it is a sign of the postmodern moment that the substantial disjunctions embedded in the production of *Voices of the Rainforest* emerge with little sense of surprise or improbability. For example, there is the disjunction of recording in Papua New Guinea, where people of the highland interior have come into contact with outsiders only in the last fifty years, and making a commercial ultrahigh-tech CD with portable state-of-the-art equipment and experimental, even pioneering, field and studio recording techniques. And there is the disjunction of recording the sounds of birds and music among a small group of isolated people, the Kaluli, whose rainforest environment and cultural future are now threatened by—in addition to twenty years of evangelical missionization—mineral and timber exploitation that will yield multimillion dollar profits for American, British, Australian, and Japanese companies, as well as for the government of Papua New Guinea. Then there is the disjunction of an academic—me—who has studied Kaluli language, music, and culture since the mid-1970s, working with a rock-and-roll drummer, Mickey Hart of the Grateful Dead, active, in addition to his recordings, in world music books, concert promotion (the Gyuto Monks' tours of America), and educational funding. And the disjunction in products: academic recordings are usually published by relatively small, noncommercial, or commercially marginal companies, while Mickey produces a successful and well-known series, The World, for Rykodisc, a major independent label whose catalog includes diverse popular artists, from the more esoteric (Frank Zappa) to the more glittery (David Bowie).

Once the recording was produced, parallel disjunctions emerged in the realm of promotion too. For example, the events that launched *Voices of the Rainforest* in 1991 were extraordinary when compared to those typically surrounding the release of an academic product. The Earth Day weekend opening gala for the recording began in the Northern California Mountains at the very plush and very private high-technology screening room of George (Star Wars) Lucas's Skywalker Ranch, where Randy Hayes, Executive Director of Rainforest Action Network, and Mickey Hart spoke about rainforest survival and musical survival, and I presented a megawatt surround-sound CD preview and synchronous computerized slide

show for invited members of the audio, radio, and record industry. The next evening the three of us presented the show again at San Francisco's Greens Restaurant and hosted a $100-a-plate fund-raiser to benefit the Bosavi People's Fund, the trust Mickey and I had established to receive royalties from *Voices of the Rainforest,* and Rainforest Action Network's campaign against logging and rainforest destruction in Papua New Guinea. Then during the next two months I traveled across the U.S.A. with the slide-show preview to venues ranging from classrooms to zoos to nightclubs to malls. Free presentations were coordinated with radio and popular press interviews, release parties, and appearances at book and record shops; when concert schedules permitted, Mickey participated too. The scale of these activities underscores a major, indeed outrageous, contrast to the material wealth of the few thousand Kaluli people in Bosavi.

To review how this all came about, I should say that *Voices of the Rainforest* originated in a powerful confrontation some years ago, one related to a number of the disjunctions mentioned above. During the course of several periods of field research on Kaluli music and rainforest ecology, I enthusiastically produced two recordings (Feld 1982, 1985). Both appeared in prestigious academic series, but distribution was minimal: each sold just a few hundred copies, and neither recording was much reviewed in scholarly journals, much less heard over the airwaves. Most of the people who read my Kaluli ethnographic work never heard these recordings. Then, in 1984, I produced a radio program, *Voices in the Forest,* for National Public Radio. In thirty minutes, it featured a representation of a twenty-four-hour soundscape of the Bosavi rainforest, and was an instant popular success. Millions of people heard the program, and it continues to be rebroadcast on several continents. As a result of these experiences, popular radio seemed a much more interesting media approach for sharing the audio riches of my Papua New Guinea research. I had no desire to make another record.

Then I met Mickey Hart. He called one day to talk with me about Papua New Guinea drums, and ended up coming by to listen to that recently completed tape. When the half-hour soundscape of a day in a Kaluli village was over, he looked at me and said, "That's incredible . . . and it's much too important to be kept an academic secret." I defensively offered something about how this wasn't an "academic secret" but was intended for National Public Radio. He said, "Highbrow, man," then offered to play it during intermission at that night's Grateful Dead concert!

If I was stunned by the offer it was mostly because Mickey was so completely casual about his populist vision of a new world order of musical consumption. And this created a vantage point from which I could imagine that a shift from making academic records to National Public Radio wasn't a radical shift at all, both kinds of production being circumscribed within securely respectable and politely bourgeois institutions and consumption locales. I gulped: "You want to play *this* at a Grateful Dead show?" Mickey smiled devilishly: "Of course! Twenty thousand Deadheads will turn into tree-climbing monkeys about two minutes after I crank up the volume!" I knew he was pushing buttons, but I felt embarrassed that I

hadn't thought of this music as something that could appeal to a large audience, something that many others could enjoy as I had. Then I felt equally embarrassed by the idea of participating in a grand commercial production to make the music heard that way, suspicious that I would be contributing to a terrible escalation of audio voyeurism and exoticism.

After years of that kind of ambivalence, I decided to work with Mickey in 1989, once his series, The World, took off on Rykodisc. The decision led me to confront how *Voices of the Rainforest,* our project, would encode multiple significances, from more benign to more suspicious. As the very first compact disc completely devoted to indigenous music from Papua New Guinea, *Voices of the Rainforest* signifies an effort to validate a specific culture and musical region otherwise generically submerged in American record stores in a bin labeled "Pacific." That idea, and the access to superb audio recording and reproduction of the vibrant musical and natural sounds of Bosavi, instantly appealed to me. But I was unsure what it meant that *Voices of the Rainforest* was not to be a research document but an unabashedly commercial product meant to attract as large a listening audience as possible.

Part of the problem was that I was resisting the idea that the sounds of what people do everyday can make a popular commercial record. But that's what *Voices of the Rainforest* is—a day in the life of the Kaluli and the Bosavi environment in one continuous hour. The soundscape begins before dawn with a section featuring the overlapping voices of birds waking up a Kaluli village. A segment of morning sago-making follows; women sing as they scrape and beat sago starch and their voices overlap with those of children, some responding to the song with whistled imitations of the bird calls heard in the distance. Another morning work activity follows: groups of men sing, whoop, and yodel in echoed polyphony as they clear trees for a banana garden. After the trees are down women clear the brush with machetes, singing as they go. This morning work section is followed by two midday leisure tracks: first a series of bamboo jew's-harp duets with bird calls and cicada rhythms, then a woman singing at, with, and about a waterfall. A return to ambient sounds follows, chronicling the transition from afternoon bird volleys to the dense electronic-sounding interplay of insects, and frogs of dusk. This leads into an evening rainstorm, with interspersed voices of frogs, insects, and bats, and then a ceremonial sequence, first with a group of drummers, and then a ritual song performance that moves an audience member to tears. The recording closes with a final ambient segment, where voices of frogs, owls, kingfishers, and night insects pulse through misting winds into the hours toward dawn. In total, Bosavi is presented as a coordinated world of continuously overlapping sound clocks: ambient rhythms and cycles intermeshed with human musical invention, performance, and spontaneous interactions. The listener enters and subjectively experiences what Kaluli call *dulugu ganalan,* "lift-up-over sounding" (Feld 1988a). This is the idea Kaluli invoke about the overlapping, interlocking, alternating nature of all sounds, ambient and human, as well as the textural density and organization in their vocal and instrumental genres.

By creating this structure, *Voices of the Rainforest* departs from the typically com-
mercial world music CD to take a major risk: while conventionally numbered as
cue bands, all the recordings are fused and continuous, and they represent equally
the natural environmental sounds and local musical expression found in Bosavi.
All these sounds, ambient and musical, are edited together to produce one fluid
sixty-minute soundscape, a metacomposition that sensually evokes, through my
technological mediation, ways Kaluli experience and express the music of nature
as the nature of music. In work, leisure, and ceremonial contexts, Kaluli musical
invention is suffused with the sounds of birds or waterways or the pulses of frogs
and crickets. The vocal and instrumental tracks on the disc are inspired both son-
ically and textually by natural sounds, and the editing practices I employed make
it possible for a listener to experience how Kaluli appropriate these into their texts,
melodies, and rhythms, merging with the musical ecology of their place.

Understanding the politics and aesthetics of this representational structure, par-
ticularly its radical departure from the scholarly ethnomusicological recording
genre, launches us into complex questions about cultural production. These ques-
tions link the representation of local aesthetics and rainforest acoustic ecology to
the techno-cultural history of audio avant-gardism, particularly the international
postwar avant-gardism of radio, musique concrète, art rock, and soundscape com-
position. For while the dense overlapping of "lift-up-over sounding" sounds incred-
ibly local to Kaluli, people who hear it in the U.S. and Europe can find subtle res-
onances with well-known modernist avant-garde techniques. For example, the
compositional emphasis on interlocking textures, on timbre over melody and
rhythm, on figure-ground mosaics, and on rupturing boundaries between humanly
produced and ambient sounds are frequently found in the early experimentalism
made well-known in the U.S. from the 1930s by Henry Cowell and John Cage.
The Fluxus group, the electro-acoustic "shingling" sound art of Edgar Varèse, the
acousmonium of Pierre Schaeffer and the Groupe de Recherches Musicales, and
the work of researchers at the Cologne Radio Studios extensively developed all
these techniques, as did a later generation of techno-rockers, synthesis and com-
puter musicians, and radio sound artists.

In different ways Mickey and I were quite aware of this legacy, he from com-
posing and performing high-tech rock, I from composing and performing experi-
mental electro-acoustic music. This shaped our roles as technological intermedi-
aries, particularly our emphasis on innovative approaches to field recording. Given
both the unreliability of portable digital recording technology in the humidity of
the rainforest, and the tendency for digital to thin out the critical high frequencies
that we wanted to be as warm and saturated as possible in recordings of birds,
insects, and water sounds, we both felt fully committed to analog recording.
Mickey provided the best analog technology available: a modified stereo Nagra,
with a Bryston portable Dolby SR noise reduction unit, a custom preamp and
state-of-the-art microphones. The portable Dolby noise reduction system, which
had not yet been used in a remote rainforest locale, plunged the noise floor of the

analog system, and with the remarkable sensitivity of the Aerco preamp and AKG microphones, allowed me to record critically soft ambient sounds with no appreciable increase in noise.

Microphones are to ears what camera lenses are to eyes, reduction technologies that imitate the human sensory apparatus by performing specific ranges of limited functions from which perceivers recreate fuller perceptual cues. Using two cardioid capsules in an XY configuration (i.e., crisscrossed one on top of the other) images the broadest stereo sound field in the density of the forest. But without multiple microphones and portable mixing capabilities, it is impossible to simultaneously record, with full spatial dimensionality, the height and depth of the ambient rainforest environment, either alone or in the context of its musical backdrop to other sounds. So instead of imagining that any single real-time two-track stereo recording could produce a full audio image I decided to break down and record the forest's various height and depth zones separately, and then to add them back together at Mickey's Studio X using multitrack recording technology. This usually meant mixing two or three sets of stereo tracks to recreate the full audio atmosphere of any particular time of day or musical occasion. Obviously such practices violate the spatial and temporal integrity of any given recorded moment or event, but in return they offer the possibility of optimizing the full surround of sound once these layers are added together and the environment thereby reconstituted.

These field and studio practices were not simply a case of technical audio experimentation or trompe l'oreille. They were occasioned by a desire to transcend the technical limitations of microphones and live two-track recording, but they were also stimulated by the nature of the Kaluli sound world. I had always wondered if the local idea of "lift-up-over sounding" in fact indicated how the temporality of sound was imagined by Kaluli as spatialized height arching outward. Having component audio tracks in the field meant that I could experiment informally and attempt to further understand the Kaluli "lift-up-over sounding" aesthetic of sonic density. Simultaneously playing back transfers of component tracks on two cassette recorders, I asked Kaluli assistants to adjust volume controls on the two machines until the composite sounded good to them. When the tracks combined musical performances with environmental surround sounds, Kaluli tended to amplify the surround tracks, particularly of the middle and upper forest canopy. Comments made to me in the context of these events embellished ones I had heard on many other occasions, to the effect that even in the presence of musical performance the sounds of the forest heights are equally copresent and significant. This sort of bush premixing studio put Kaluli in a more directly dialogic editorial role in the project, extending my earlier experiments with dialogic editing (Feld 1987, 1990). Back at Studio X, where I worked for four months with engineer Jeff Sterling to edit and mix the one-hour master from eighteen hours of original recordings, I was able to incorporate these Kaluli ideas into the editing and mixing, thereby more openly pursuing and acknowledging the socially negotiated and constructed ethnoaesthetics of the production.

Other studio practices similarly violated basic tenets of documentary realism and replaced them with a hyperrealism which I again found justified by both technoaesthetic and ethnoaesthetic ideals. To enhance our ability to highlight the textural density of "lift-up-over sounding," we digitally sampled seventy-five bird, frog, and insect sounds from my close-up recordings. Then, using real-time guide tracks that I had made in the field on cassette, we recorded the samples onto the multitrack master for more controlled spatial and temporal location in the mix of forest height and depth. While in Bosavi I frequently recorded birds close-up from blinds, perches, or tree houses, without parabolic reflectors. By quickly playing back the bird's call I was often able to get birds to excitedly come closer and to repeat their calls, and in some cases, after a few days or weeks, I often had enough control to record them almost as close-up as Kaluli singers. In the studio we utilized the clarity of the digital samples of these recordings to optimize the lucidity of the bird and human mix, and thus were more able to create an ambience where the listener experiences, as one does in the rainforest, the strong sense of avian audio-presence in the height and depth layers of the canopy. Because birds inspire Kaluli music, are considered singers in their own right, and are also *ane mama,* "gone reflections," the "spirits" of Kaluli dead, their presence is quite experientially intensified for listeners in the forest. Our studio editing and mixing practices underscored this intensity through spatial imaging techniques that subtly bring the birds into the audio foreground, as they have been in Kaluli imagination and experience.

Apart from the adventurous side of *Voices of the Rainforest*'s experimental audio practices, one must scrutinize the potential for techno-aesthetics to mask vulgar techno-fetishism. Mass culture criticism often opens this line of attack and surely it is a significant one, raising the issue of how these projects fulfill the economic and social needs of their makers and reproduce their positions of privileged access and ability to define just what kind of adventure may be had. But it is equally important now to explore the retributive potential for techno-aesthetics to create cultural respect and musical empowerment. For many years indigenous peoples have taken a second-class ride on cheap recording equipment as part of a process of "othered" record production. The dignified and masking term for this tradition is "noncommercial" recording. Minimal audio quality is often matched in this realm by a lack of concern for circulation and a generally tacit assumption that there will be no royalties to speak of, much less to return to the musicians or community where the music was recorded. Such practices have been central to the rhetorical traffic and actual commodity circulation of musical diversity. Lack of circulation, like lack of royalties, came to be inextricably linked to claims of "authenticity." This is precisely how my earlier recordings could be praised as serious scholarship and documentation yet remain virtually inaudible to the great majority of my readers. This taught me concretely how marginality in the commodity marketplace was an indexical scholarly sign that one had produced "real" "authentic" "ethno" music. This emphasis on purity, boundedness, separation, and autonomy

went right along with elitist academic discourses that equated popularity with vulgarity, with a loss of "authenticity."

Whatever respect the products of these practices once engendered for musical diversity, they are equally interpretable now as signs of the reproduction of musical colonialism, of the redistribution of its bounty in the form of recordings whose exotic content is indexically signaled by muffled grooves. Mickey Hart's postmodern alternative, in which I am complicit, surely embodies its own complications of empire. It insists that the best equipment, engineers, budgets, and distribution networks can and should be shared past the world of symphony orchestras and high-tech rock 'n' roll. No doubt this is complicated to decode: the move simultaneously strikes back toward equity and empowerment while substantially reproducing the entrepreneurial and curatorial positions of the already empowered. Apart from the potential contradictions here, there is no denying that by foregrounding the importance of technological mediation and populist circulation, Mickey's strategy directly contaminates and derails the modernist authenticity that once dominated ethnomusicology recordings.

Apart from these mediation issues, I was also concerned with challenging the conventions of authoritative liner notes. So I wrote an imaginary letter to Mickey from the rainforest, speaking in a vernacular voice and emphasizing the immediate listening experience. In addition to descriptions of contents and contexts of the recordings, the notes acknowledge the anxious predicament embodied in the disc: just as the music receives international recognition as a volume in The World series, Kaluli songs, along with most other cultural practices, are quickly changing or vanishing as the environment of the Great Papuan Plateau is now threatened by oil pipelines, roads, and logging. Drawing attention to the relationship between cultural and ecological destruction in rainforests, the notes use the term "endangered music," intending the listener to imagine how the ravages of artistic loss are suffered by indigenous people just as species thinout is suffered by their local flora and fauna, and degradation of their waters and lands.

Here, again without academic framing, *Voices of the Rainforest* is thrown into anthropology's representational politics. At a historical moment when cultural diversity is both increasingly commodified and becoming a more scarce commodity, anthropological discourse is increasingly engaged with criticism of state-indigene relations. And as the chaos so recklessly visited upon the others they care to chronicle escalates, anthropologists are increasingly engaged with giving voice to people whose validity, indeed, humanity, is denied or silenced by the dominant. Because the practices of anthropology are increasingly located within discourses of postcolonialism, of cultural survival, of difference, the field's intellectual products— talk, books, articles, recordings, films, etc.—are correspondingly subjected to intensified scrutiny both from the community that actually undertakes the research and from the community that is its subject (Fabian 1983; Hymes 1974; Karp and Lavine 1991; Said 1989; Trinh 1989).

How then might one further scrutinize the representational politics of *Voices of*

the Rainforest simultaneously as commercially avant-garde cultural production, and as world music? One way to do this is to acknowledge that *Voices of the Rainforest* presents a unique soundscape day in Bosavi, one without the motor sounds of tractors cutting the lawn at the mission airstrip, without the whirring rhythms of the mission station generator, washing machine, or sawmill. Without the airplanes taking off and landing, without the mission station or village church bells, Bible readings, prayers, and hymns. Without the voices of teachers and students at an airstrip English-only school, or the few local radios straining to tune into Radio Southern Highlands, or cassette players with run-down batteries grinding through well-worn tapes of string bands from Central Province or Rabaul. Without the voices of young men singing *Tok Pisin* songs while strumming an occasional guitar or ukulele at the local airstrip store. And without the recently intensified and almost daily overhead buzz of helicopters and light planes on runs to and from oil drilling areas ranging over thirty miles to the northeast.

For some this might mean that *Voices of the Rainforest* is a falsely idealized portrait of Bosavi's current acoustic ecology, romantic at best, deceptive at worst. An honest response can only accept those concerns and acknowledge the currency of their politics. After all, *Voices of the Rainforest* transparently embodies the highest of postmodern ironies: it presents for us a world uncontaminated by technology, but one that is hearable only because it has been brought to us courtesy of the most high-tech audio field and studio techniques currently available. But it is also important to add that the recording is a highly specific portrayal, one of an increasingly submerged and subverted world of the Bosavi soundscape. Clearly, it is a soundscape world that some Kaluli care little about, a world that other Kaluli momentarily choose to forget, a world about which some Kaluli are increasingly nostalgic and uneasy, a world that other Kaluli are still living and creating and listening to. It is a sound world that increasingly fewer Kaluli will actively know and value, but one that increasingly more Kaluli will hear on cassette and sentimentally wonder about.

Lest it seem that there is still some hedging here, the stakes can be stated more bluntly and personally. The sound world in Bosavi is one that I hear as powerful and unsettling, and, more importantly, one that can still be heard. Because my role in *Voices* is equal parts researcher and sound artist, I feel a need to make that world more hearable, to amplify it unashamedly in the hope that its audition might inspire and move others as it has inspired and moved me. *Voices of the Rainforest* then is no illusory denial that both nature and culture in Bosavi are increasingly drowned out by "development," the apologist euphemism for extraction and erasure. Rather it is an affirmative counterdrowning of "development" noise with an aggressive assertion of a coevolved sonic ecology and aesthetics. As a celebration that is also an alarm, my representational re-erasing is motivated equally by affection and by outrage, indicating both the memory of florescence and the sense of escalating loss that characterize Kaluli life today. *Voices of the Rainforest* speaks to remembrance at a moment of forgetting, talking back from my feelings of revul-

sion over the way a mission and government rhetoric of development and a better future have meant more vulnerability, less autonomy, and diminished integrity for Bosavi people today.

The notions of "endangered music" and "endangered culture" demand equal scrutiny. The problems with circulating such terms are obvious: by equating music and culture with animal and plant species the impression may be conveyed that the project means to promote protectionist purism, cultural zoos, reservations, and conservation parks. Preservation agendas often have very conservative political slants, and invocation of the "endangered" label also tends to dredge up fears of control, of the desire to freeze time and place. And in addition to this problematic, the "endangered" label is potentially or actually deeply insulting to indigenous peoples in the context of their own struggles to control the terminology and imagery of how their interests and identities are represented.

On the other side, aligning the notion of "endangered music" or culture to that of "endangered species" encourages a potentially important intellectual and political alliance. Every instance of the thinout of planetary biodiversity is currently connected to the real or potential thinout of cultural, linguistic, and artistic diversity. Environmentalists and ecologists are increasingly aware of the important interactions between humans and plants and animals that not only shape processes of adaptation but define the very nature of regions and communities. Linking the struggles for rainforest environments with the future of the people indigenous to them is an essential aspect of promoting the integrity of people and place, of local rights and survival. Besides, anthropologists have virtually let the environmental movement freely create the illusion that the only thing at stake in eco-destruction is cute and cuddly animals and the plants that Western pharmacy needs to cure cancer. To the contrary, we must insist that the struggle for these places is the struggle for the survival of people whose knowledge of the animals and plants is critical both to balanced management and to future deployment for global medical betterment.

Obviously, intersecting issues such as these, the editorial politics and aesthetics of *Voices* are dense and complicated. So are the consumption concerns that extend from them. So far nobody has confused the recording with the New Age meditation tapes whose titles, while similar, indulge and seduce with promised echoes of the audio-idyllic. But in popular culture subordinate social formations are always the source of fantasy and relaxation for the dominant classes or societies (Fiske 1989). For this reason *Voices of the Rainforest* undeniably contributes to both enhanced Western primitivist fantasy and to voyeurism, allowing a listener to enjoy an hour of yuppie green politics, or audio-leisure tourism, perhaps even while feeling righteous about wealth trickle-down. "Release" from the modern world and into the "awesomeness" of nature is central to the nostalgia promulgated by the New Age movement, refashioning prior romanticisms and recreating them as quasi-spiritual experiences that connect "us" to "them." Does any of this neutralize my intentions, or neutralize the recording's potential to work against the grain of popular culture?

Once a recording is in the marketplace, one has little control over how it is consumed. Notes and other contextual material, as well as interviews and other media interventions, may be acts that indicate serious desire to take responsibility for representation; but they can't control what happens once the decision to commodify has been made. Quite significantly, that goes for "merely academic" recordings too (see Seeger 1991a, 1991b), even ones framed by obscure jargonized notes, musical transcriptions, or specific invocations. For example, when recordings of Aboriginal Australian or Sepik (PNG) music carry the explicit label "Do not play this recording in the presence of any females or uninitiated male members of the ——— society," do they in any way claim to be able to control just who does and doesn't hear the music? Does discharge of ethical duty by a cover sticker guarantee compliance any more than notes on meaning and intention guarantee forms of "proper" reception and consumption?

An additional problem here is that much anthropological and political debate on the control of and responsibility for representation is circumscribed in almost entirely realist and literalist terms. The most typical criticism addressed to *Voices of the Rainforest* is framed this way, as an insistence that destruction and domination be treated in more overt, "serious" terms. That critique strikes me as equal parts sincerity and naiveté. There is only one response, and a rather old one at that: artistic projects are, for some of us, equally overt and "serious" however much more risk their subtleties bring to the realm of cultural politics.

Mickey and I obviously decided to throw ourselves behind a particular hope: that devotion to state-of-the-art audio techniques and to a combined artistic and political vision would ensure that the recording was not only the best audio document it could be, but that it would dramatize the current environmental and cultural survival issues in Bosavi, evoking both the florescence and loss of rainforest musical ecology. In a world where fifteen to twenty thousand species of plants and animals are destroyed each year by the logging, ranching, and mining that escalates rainforest destruction (Caufield 1984; Collins 1990), *Voices in the Rainforest* was meant as an assertion that we must be equally mindful of the precarious ecology of songs, myths, words, and ideas in these megadiversity zones. Massive wisdom, variations on human imagination in the form of knowledge in and of place, these are cocasualties in the eco-catastrophe. Eco-thinout may proceed at a rate much slower than cultural rubout, but accomplishment of the latter is a particularly effective way to accelerate the former. The politics of rainforest ecological and aesthetic coevolution and codevolution are one, and Mickey's initial reaction to hearing the Bosavi rainforest couldn't have turned out to be more eerie in the larger political economy of musical and cultural destruction: this *is* too important to be kept in the zone of academic secrets.

These representational issues, embodied in the recording, editing, rhetoric, and royalty distribution of *Voices of the Rainforest,* are closely situated in the larger process I've called schizophonia to schismogenesis. Once sounds like these are split from their sources, that splitting is dynamically connected to escalating cycles of dis-

torted mutuality, and that mutuality to polarizing interpretations of meaning and value. The process of movement from schizophonia to schismogenesis, concretely located in the creation and circulation of world music for consumption, thus provides an example in the more generalized social experience central to this historical, discursive, and cultural moment. Just as "tradition" was once constructed as the nostalgia of modernity, so its more vague cousin, "memory," is ongoingly inserted as the nostalgia of postmodernity. In that context it is certainly necessary to acknowledge that my passion for sharing what I've been privileged to experience in knowing and hearing others cannot mask complicity with institutions and practices of domination central to commodifying otherness. But my participation in constructing the soundscape world of *Voices of the Rainforest* can't so easily be reduced to "imperialist nostalgia" any more than it can be reduced to modernist chicken and egg clichés about whether aesthetics must serve politics or vice versa. For in the end the recording is an openly nonacademic and nondanceteria hybrid genre, a synthesis of skills, a mixture of cultural sensibilities, a "lift-up-over sounding" of voices and practices linking extraordinarily varied aesthetics and histories. And one of its hopeful potentials is to sensually smudge or obliterate, as nonreferential grooves do so well, some of the us and them, insider and outsider rigidity that has so thoroughly paralyzed modernist engagement between anthropology and artworlds.

NOTE

Portions of the first part of this paper were previously published in *Working Papers and Proceedings of the Center for Psychosocial Studies* 53, 1992. Portions of the second part previously appeared in *Public Culture* 4(1), 1991; and *Arena* 99/100, 1992. A different version of the whole essay appears in Charles Keil and Steven Feld, *Music Grooves,* University of Chicago Press, 1994. I thank Fred Myers for his critical help with shaping this version, and dedicate it to the memory of Frank Zappa (1940–1993), whose kick-ass anarcho "my guitar wants to kill your mama" back-talk to music industry ignorance, censorship, and corruption has long been a source of inspiration to me.

REFERENCES

Appadurai, Arjun
 1986 "Introduction: Commodities and the Politics of Value." In Arjun
 Appadurai, ed., *The Social Life of Things: Commodities in Cultural Perspective,*
 pp. 3–63. Cambridge: Cambridge University Press.
 1990 "Disjuncture and Difference in the Global Cultural Economy." *Public*
 Culture 2(2):1–24.
Attali, Jacques
 1985 *Noise: The Political Economy of Music.* Minneapolis: University of Minnesota
 Press.

Bateson, Gregory
[1936] 1958 *Naven.* Stanford: Stanford University Press.
1972 *Steps to an Ecology of Mind.* New York: Ballantine.

Baudrillard, Jean
1975 *The Mirror of Production.* Trans. M. Poster. St. Louis, Mo.: Telos Press.
1981 *For a Critique of the Political Economy of the Sign.* St. Louis, Mo.: Telos Press.

Benjamin, Walter
1968 *Illuminations: Essays and Reflections,* ed. Hannah Arendt, trans. Harry Zohn. New York: Schocken Books.

Berman, Morris
1983 *All That Is Solid Melts Into Air: The Experience of Modernity.* London: Verso.

Boyer, Peter
1988 "What a Romance! Sony and CBS Records." *New York Times Magazine,* Sept. 18, 34–49.

Castoriadis, Cornelius
1985 "Reflections on 'Rationality' and 'Development.'" *Thesis Eleven* 10/11:18–36.

Caufield, Catherine
1984 *In the Rainforest: Report from a Strange, Beautiful, Imperiled World.* Chicago: University of Chicago Press.

Chapple, Steve, and Reebee Garofalo
1977 *Rock and Roll Is Here to Pay.* Chicago: Nelson-Hall.

Cheyney, Tom
1990 "The Real World of Peter Gabriel." *The Beat* 9(2):22–25.

Clifford, James
1988 *The Predicament of Culture: Twentieth-Century Ethnography, Literature, and Art.* Cambridge, Mass.: Harvard University Press.

Clifford, James, and George E. Marcus, eds.
1986 *Writing Culture: The Poetics and Politics of Ethnography.* Berkeley: University of California Press.

Collins, Mark, ed.
1990 *The Last Rainforests: A World Conservation Atlas.* New York: Oxford University Press.

Erlmann, Veit
1987 *Mbube Roots: Zulu Choral Music from South Africa, 1930s–1960s.* [LP] Cambridge, Mass.: Rounder Records.
1989 "A Conversation with Joseph Shabalala of Ladysmith Black Mambazo: Aspects of African Performers' Lifestories." *World of Music* 31/1:31–58.
1990 "Migration and Performance: Zulu Migrant Workers' *Isicathamiya* Performance in South Africa, 1890–1950." *Ethnomusicology* 34(2):199–220.
1991 *African Stars: Studies in Black South African Performance.* Chicago: University of Chicago Press.

Eyre, Banning
1990 "Bringing It All Back Home: Three Takes on Producing World Music." *Option,* Nov. 75–81.

Fabian, Johannes
 1983 *Time and the Other: How Anthropology Makes its Object.* New York: Columbia University Press.

Feld, Steven
 1982 *Music of the Kaluli.* [LP] Boroko: Institute of Papua New Guinea Studies.
 1985 *The Kaluli of Papua Niugini: Weeping and Song.* [LP] Kassel: Bärenreiter Musicaphon.
 1987 "Dialogic Editing: Interpreting How Kaluli Read Sound and Sentiment." *Cultural Anthropology* 2(2):190–210.
 1988a "Aesthetics as Iconicity of Style, or, 'Lift-up-over Sounding': Getting into the Kaluli Groove." *Yearbook for Traditional Music* 20:74–113.
 1988b "Notes on World Beat." *Public Culture* 1(1):31–37.
 1990 *Sound and Sentiment: Birds, Weeping, Poetics and Song in Kaluli Expression.* 2d ed. Philadelphia: University of Pennsylvania Press.
 1991 *Voices of the Rainforest.* [CD] Salem, Mass.: Rykodisc.

Fiske, John
 1989 *Understanding Popular Culture.* Cambridge, England: Unwin Hyman.

Frith, Simon
 1981 *Sound Effects.* New York: Pantheon.
 1986 "Art vs. Technology: The Strange Case of Popular Music." *Media, Culture and Society* 8:263–279.
 1988 *Music for Pleasure.* London: Routledge.
———, ed.
 1989 *World Music, Politics, and Social Change.* Manchester: Manchester University Press.

Goodwin, Andrew, and Joe Gore
 1990 "World Beat and the Cultural Imperialism Debate." *Socialist Review* 20(3):63–80.

Hamm, Charles
 1988 *Afro-American Music, South Africa, and Apartheid.* Brooklyn: Institute for Studies of American Music.
 1989 "Graceland Revisited." *Popular Music* 8(3):299–304.

Hannerz, Ulf
 1987 "The World in Creolisation." *Africa* 57(4):546–559.
 1989 "Notes on the Global Ecumene." *Public Culture* 1(2):66–75.

Hart, Mickey, with Jay Stevens
 1990 *Drumming at the Edge of Magic.* San Francisco: Harper Collins.

Hart, Mickey, with Fredric Lieberman
 1991 *Planet Drum.* San Francisco: Harper Collins.

Harvey, David
 1989 *The Condition of Postmodernity.* Oxford: Basil Blackwell.

Hymes, Dell, ed.
 1974 *Reinventing Anthropology.* New York: Vintage.

Jameson, Fredric
 1990 "Postmodernism and Consumer Society." In A. Kaplan, ed., *Postmodernism and its Discontents: Theories, Practices,* pp. 13–29. New York: Verso.

Karp, Ivan, and Stephen D. Lavine, eds.
 1991 *Exhibiting Cultures: The Poetics and Politics of Museum Display.* Washington,
 D.C.: Smithsonian Institution Press.

Kevorkian, Kyle
 1990 "Evolution's Top Forty." *Mother Jones,* April/May.

Khan, Zeman
 1991 "Classical Music Is Not Against Islam": an Interview with Nusrat Fateh
 Ali Khan. *Herald,* Mar., 117–120.

Laing, Dave
 1986 "The Music Industry and the 'Cultural Imperialism' Thesis." *Media, Cul-*
 ture and Society 8:331–341.
 1990 "Call and Response." *Popular Music* 9(1):137–138.

Lomax, Alan
 1977 "Appeal for Cultural Equity." *Journal of Communication* 27(2):125–139.

Malm, Krister
 1993 "Music on the Move: Traditions and Mass Media." *Ethnomusicology*
 37(3):339–352.

Malm, Krister, and Roger Wallis
 1992 *Media Policy and Music Activity.* London: Routledge.

Marcus, George E., and Michael M. J. Fischer
 1986 *Anthropology as Cultural Critique: An Experimental Moment in the Human Sciences.*
 Chicago: University of Chicago Press.

Meintjes, Louise
 1990 "Paul Simon's *Graceland,* South Africa, and the Mediation of Musical
 Meaning." *Ethnomusicology* 34(1):37–73.

Myers, Fred R.
 1991 "Representing Culture: The Production of Discourse(s) for Aboriginal
 Acrylic Paintings." *Cultural Anthropology* 6(1):26–62.

Nettl, Bruno
 1985 *The Western Impact on World Music: Change, Adaptation, and Survival.* New
 York: Shirmer Books.

Pareles, Jon
 1988a "Pop Passports—At a Price." *New York Times,* Aug. 28.
 1988b "Cross Over and Cross Back: You Can Go Home Again." *New York*
 Times, Nov. 6.
 1990 "When the Business of Music Becomes Even Bigger." *New York Times,*
 Mar. 19.

Price, Sally
 1989 *Primitive Art in Civilized Places.* Chicago: University of Chicago Press.

Robinson, Deanna C., Elizabeth Buck, and Marlene Cuthbert, eds.
 1991 *Music at the Margins: Popular Music and Global Cultural Diversity.* Newbury
 Park, N.J.: Sage.

Rosaldo, Renato
 1989 "Imperialist Nostalgia." *Representations* 26:107–122.

Said, Edward
 1989 "Representing the Colonized: Anthropology's Interlocutors." *Critical*
 Inquiry 15:205–225.

Schafer, R. Murray
 1977 *The Tuning of the World*. New York: Alfred A. Knopf.
Schiller, Herbert
 1976 *Communication and Cultural Domination*. New York: M. E. Sharpe
Seeger, Anthony
 1991a "Creating and Confronting Cultures: Issues of Editing and Selection in
 Records and Videotapes of Musical Performances." In Max Peter Bau-
 man, ed., *Music in the Dialogue of Cultures: Traditional Music and Cultural Pol-*
 icy, pp. 290–301. Berlin: International Institute for Comparative Music
 Studies and Documentation, International Music Studies 2.
 1991b "Singing Other People's Songs." *Cultural Survival Quarterly* 15(3):36–39.
Szwed, John
 1982 "The Sun Never Sets on Music and Rhythm." *Village Voice,* Sept. 7.
Taubin, Amy
 1989 "Songs of Innocence and Experience." *Village Voice,* July 11.
Tomlinson, John
 1991 *Cultural Imperialism*. Baltimore: Johns Hopkins Press.
Torgovnick, Marianna
 1990 *Gone Primitive: Savage Intellects, Modern Lives*. Chicago: University of
 Chicago Press.
Trinh, T. Minh-Ha
 1989 *Woman, Native, Other: Writing Postcoloniality and Feminism*. Bloomington:
 Indiana University Press.
Wallis, Roger, and Krister Malm
 1984 *Big Sounds from Small Peoples: The Music Industry in Small Countries*. New
 York: Pendragon Press.
Waterman, Christopher A.
 1985 *Jùjú Roots: 1930's–1950's*. [LP] Cambridge, Mass.: Rounder Records.
 1990 *Jùjú: A Social History and Ethnography of an African Popular Music*. Chicago:
 University of Chicago Press.

Three Walls: Regional Aesthetics and the International Art World

Lynn M. Hart

The steady increase in the West's commodification of non-Western art forms has caused tremendous interest, and some alarm, to anthropologists, museum and art gallery curators, art educators, art historians and others who are sensitive to the cultural origins of such art forms and to the points of view of the people who produce them (Buchloh 1989; Chalmers 1985; Clifford 1988; Karp and Lavine 1991; Myers 1991; Steiner 1990). The meaning of indigenous, traditional art changes when local forms are commodified and brought into the Western-dominated international art world. Such transformations in meaning are becoming increasingly common in the "global cultural ecumene" (Appadurai and Breckenridge 1988:1) of which the contemporary art world is an important part. The constant delivery of novelty from the non-Western world to the art market is part of a larger global change in which "vital, independent cultures of socially subordinated groups are constantly mined for new ideas with which to energize the jaded and restless mainstream of a political and economic system based on the circulation of commodities" (Ferguson 1990:11). Although the art world has not generally acknowledged its role in this global issue, this state of affairs is changing:

> In these last few years of the 20th century, there is emerging a significant shift in the sensibilities and outlooks of critics and artists. In fact, I would go so far as to claim that a new kind of cultural worker is in the making, associated with a new politics of difference. These new forms of intellectual consciousness advance reconceptions of the vocation of critic and artist, attempting to undermine the prevailing disciplinary divisions of labor in the academy, museum, mass media and gallery networks, while preserving modes of critique within the ubiquitous commodification of culture in the global village. (West 1990:19)

In spite of this upsurge in commodification, relatively little is known about the processes involved in the transformations in meaning of objects as they move from

one cultural context to another. The shift from the local, regional domain to the global, international arena involves a series of disjunctions, to use Fred Myers's term. In a discussion of Australian aboriginal painting, Myers points to the disturbing character of "the disjoined relationship between the discourses of the art world and those of Australian aboriginal painters—the gap between how the producers account for their paintings and what significance they are made to have in other venues" (Myers 1991:30). Because of the disjunctions caused by using inappropriate Western terminology when writing about non-Western traditional art, in this paper I try to avoid using it whenever possible. For want of a better alternative, I will use the term "producer" or "producer of visual images" instead of "artist," and "visual image" or "image" instead of "art" as far as possible.

This paper traces three steps in the transformative journey of a form of local, indigenous, traditional image production, Hindu women's ritual art, from a religious patterning of the wall of a traditional house in India to an object produced for sale and displayed on the wall of a middle-class house in an Indian, European, or North American city, and finally to a celebrity object, a work of fine art, on the wall of a major international art gallery or museum of contemporary art located in an urban Western artistic center.

WALL ONE: IN A TRADITIONAL HINDU HOUSEHOLD

The house in question is in the center of Almora, a small city in the Himalayan region of Kumaon, in the North Indian state of Uttar Pradesh where I conducted twenty months of field research during 1981 and 1982. Śrīmatī Sāvitrī Devī Sāh, a Hindu woman of the Sāh or merchant caste, is working at a huge, brilliantly colored painting, roughly fifteen feet wide by nine feet high, that covers the entire wall of the main room on the third floor of her house (fig. 4.1). She stops working as we come into the room and explains that with the help of other women, she is preparing the wall for the marriage of one of her children, an event that will take place in a few months. A party of women led by her will work for about a month until the image is ready. The central part of the painting, called a *jyonti*, measuring some four by five feet, consists of a depiction of three forms of the Mother Goddess, the elephant-headed god Gaṇeś who is the guarantor of auspicious beginnings, the Lakṣmī-Nārāyaṇ, symbol of the divine couple Lakṣmī and Viṣṇu, the sun and the moon, a pair of parakeets which symbolize love and passion, and the symbol of the newly married couple's hearth, the heart of their new household. The rest of the wall is filled with intricate geometric symbols called *bār būnd*, "lines and dots."

This kind of painting is an example of one form of ritual art; other forms are practiced by Hindu women both in Kumaon (Upreti 1972) and in regional systems throughout South Asia (Hart 1990; Kilambi 1985; Kramrisch 1985). Ritual art varies systematically by region in terms of content, materials, techniques, styles, and the occasions for which images are produced. Women's ritual art in Kumaon

is referred to by the general Kumaoni term *aipaṇ* or *alpanā* in Hindi. In each of these regional systems visual images are an intrinsic and necessary part of the observance of auspicious occasions: the life cycle ceremonies called *sanskārs*, the hundreds of annual festivals, monthly and weekly observances, and daily worship in the house temple. It is necessary, more specifically, to make the inhabited space suitably beautiful and appropriately patterned for the presence of a divine being. Many of the images, such as that depicted in Figure 4.1, are made directly on the wall or the floor and so become part of the house itself. Depending on the ritual occasion, the work is produced either by one woman alone in her house temple (a room or part of a room in the house set aside for worship) or collectively by groups of women from the same family and/or community. Before beginning to make an image, the women purify themselves ritually and physically by bathing, often in the early morning before dawn. They then seat themselves on the floor in front of the space where they will make the image and enter into a state of meditation through the recitation of mantras and softly chanted prayers. Ideally the meditational, devotional state of mind is maintained throughout the production of the image, especially for smaller images. The production of large images starts with purification and a meditational state, but this is replaced by a relaxed atmosphere of camaraderie among the women who gather to do the painting together; as described to me, "We get together to do this in preparation for a joyous occasion, we enjoy ourselves, we eat, we talk, sometimes we sing" (Śrīmatī Sāvitrī Devī Sāh, personal communication, 1981). At the end of the ritual for which it was produced, the image is destroyed or allowed to fade away, and new ones are produced for each occasion. The images and patterns themselves are based on religious, ritual, and mythic themes and derive their meaning—and their power—from the religious contexts of their production and use.

What is being expressed here? The painting on this wall consists of a series of images of two types. Most of the painting is made up of complex sets of different geometric *bār būnd* patterns, organized and selected by the women making the image. But in the middle of the wall is the ritual image, *jyonti*, that must contain the specific symbolic elements described above, including the Mother Goddesses and Gaṇeś. Each of the graphic elements carries a specific meaning for the people who take part in the ritual: each is expected, each is evocative, and together they constitute an essential part of the transformation of two human beings through marriage into "one body," as Hindus in many parts of India put it (Inden and Nicholas 1977). The specific elements used in the marriage *jyonti* both echo and transform the images used in *jyontis* and other kinds of painting for earlier life-cycle rituals; the whole series of *jyontis* and other images used for the ceremonies throughout a Hindu person's life becomes more and more elaborate as the developing person becomes more complete. This marriage *jyonti*, then, condenses a whole stereotypical, ideal personal history, while also linking the family and the marrying couple with the gods, with the patterns of time represented by the sun and moon, and with the future development of the couple and the lineage represented by the para-

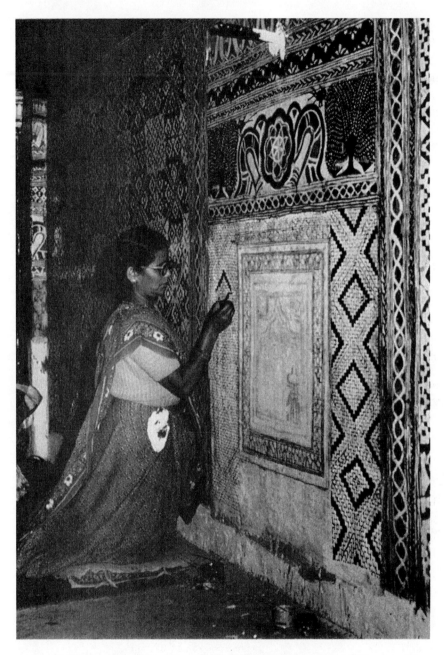

Fig. 4.1. *Jyonti*, a wall painting produced by upper-caste Hindu women of Kumaon, Uttar Pradesh, for the marriage ceremonies of members of their families. Here Śrīmatī Sāvitrī Devī Sāh is working on the image on a wall of her house in Almora, Kumaon. Photo: Lynn M. Hart.

keets, symbols of love. For the participants in the ritual, all this history and cosmology is just there, it is an already known part of their lives. The marriage *jyonti* is one of a number of focusing mechanisms, bringing common knowledge and shared memories to bear on the ritual at hand.

This ritual imagery operates according to a regional Kumaoni aesthetics which is different from standard Western aesthetics (Hart 1991a). Excellence of *aipan* is seen to lie in the closeness of the central symbol's approximation to an ideal image, with special attention paid to the style, technique, and materials used. It is important to re-present the symbols in an adequate way, not to improve upon them, though at the same time the image on the wall should be as beautiful and pleasing as possible. The central symbols play an essential role in the ceremony, often as seats for the deities so the latter can be invoked to inhabit the images during the ceremony: an observance accompanied by symbols that are not accurate and technically beautiful will not only be ineffective in producing the desired ends but will offend the deity who is said, for instance, to refuse to settle on an incorrectly made seat. This would, of course, thwart the entire ceremony. If the image and the ceremony are produced correctly, the participants are blessed by the deity's visible presence (*darśan*; see Eck 1981).

The explicit and elaborate criteria for properly producing an image thus constitute an aesthetic system in themselves, a set of standards and objectives which members of the culture use and understand, and which are quite distinct from Western aesthetic canons.

WALL TWO: IN A NORTH AMERICAN HOUSE

This house is in a middle-class neighborhood in a North American city. On the dining-room wall is a large, brightly colored, clearly non-Western painting of human figures, measuring about three feet high and over ten feet long (fig. 4.2). It is framed and protected with plexiglass. The painting is one of several, including watercolors and oils, some prints, and some sculptures. It was painted by a member of a cooperative of women painters in the Mithila region of the eastern Indian state of Bihar. Its present (Western) owners found it rolled up in a bin with other Mithila paintings at a "handicrafts village" located to the south of New Delhi near the Qutub Minar, where people live and produce their work for sale in the "village" crafts shop. People from other parts of India also send their work to this location to be sold. For generations, women in Mithila have been making wall paintings for ritual purposes, a tradition that seems to function very much like the Kumaoni one. But in addition to this living tradition, for several decades now they have also been producing paintings on paper for sale (Mishra and Owens 1978).

These commodified paintings differ from the traditional wall paintings in a number of ways that affect their meaning. Unlike the wall paintings, the painting on paper is signed, usually by one woman who is thus designated the "artist," even though others shared in its production. Often the "artist" does the basic drawing

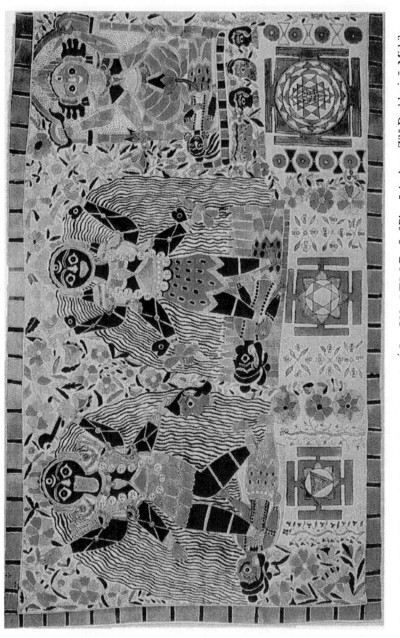

Fig. 4.2. *Das Mahāvidyā*, detail of a painting on paper by Śrīmatī Ugrā Tārā Devī of Bhayā Andpur, Zilā Darbhaṅgā, Mithila, Bihar, produced for the Cooperative of Women Painters of Mithila. Collection: Lynn M. Hart and John Leavitt, Montreal. Photo: Uzi Witkowski.

and decides on the colors, then her husband and/or other women and girls in the family help add the color. Commodification got men involved in the production of a women's art form because it proved to be more lucrative for the family than other work that men might do. The only information about the painting and its producer(s) is given in seven lines written in Devanagari script on the back of the painting:

> *Das Mahāvidyā*
> *Śrīmatī Ugrā Tārā Devī*
> *Śrī Kumār Kalyāṇ Jhā*
> *Grām Post Sibrām*
> *Bhayā Andpur*
> *Ẕilā Darbhangā*
> *Bihār*

The Western purchaser who wants to make the effort to translate this information finds that the image is entitled "The Ten Great Wisdoms" and that it was painted by Mrs. Ugrā Tārā Devī; also given is her address in the village with a man's name, Mr. Kumār Kalyāṇ Jhā (her husband?) indicated as part of the address, as well as the district and state, Bihar.

By requiring the designation of an individual artist to fit Western expectations of authenticity and authorial responsibility, the commodification process has created the category of artist within Mithila villages, a category that was previously neither meaningful nor particularly important in image production. It is well documented that many non-Western producers of visual images, like Kumaoni women, do not use the terminology "artist" when referring to themselves or "art" in reference to what they are doing and making (Anderson 1979; Forge 1973; Hart 1991a; Layton 1991; MacGaffey 1993). Kumaonis use the term *lekhan*, "writing," to describe the activity of image production, an activity they consider to be an integral part of their everyday lives. As Fred Myers notes in reference to Aboriginal men who produce images, "I find it dislocating to hear them repeatedly represented as 'painters' or 'artists' " (Myers 1991:27). Because of the Mithila cooperative's need to designate one person as "the artist" for each painting, the identities of the additional people (other than the woman's husband) who clearly did a significant amount of work on this enormous image have disappeared.

In addition to changes in the identities of the people producing non-Western images, there are changes in the meaning of the images themselves. However, the title of the image, *Das Mahāvidyā*, even when translated as "The Ten Great Wisdoms," leaves the Western viewer with only the vaguest notion about the content of the painting. If the viewer did some research into Hindu mythology and contemporary Hindu religious practice, he or she would discover that the painting represents ten forms of the great Goddess, each form having its own myth, characteristics, personality, and accompanying tantric symbol beneath it. Unfortunately few Westerners make the effort to do the necessary research for something

they have picked up at a "handicrafts village." More often they consider them-
selves fortunate to get the name of the producer of the image and a little informa-
tion about the subject matter, even though, as is the case with the *Das Mahāvidyā*
image, it may be written in a language they can't read.

The painting on the second wall has thus been transformed from ritual image
to tourist art, relatively cheap and accessible to anyone wishing to purchase it. The
transformed object has been launched into a public, international sphere of activ-
ity (Clifford 1988; Graburn 1976). No longer in its ritual context, no longer an
intrinsic part of the wall of the house, and no longer ephemeral, it can and is
meant to become a permanent but portable object hung on the wall of another
house. No longer ritual art, to urban Westerners it has become a "representation"
of a ritual object (Steiner 1990), carrying connotations of its original context, the
mysterious yet somehow simpler and more authentic way of life of village India.

Thus while the original ritual meaning of the object has been lost, new mean-
ings have been added. Purchasers usually have little knowledge of the meaning
and use of the image in its context of production; the information available is often
scant, written in a foreign language, inaccurate, or absent by the time the painting
reaches the dining-room wall. Instead they bring to it what art-critical knowledge
they have acquired, viewing it the way they view Western art. They respond to its
formal qualities, such as composition and color, and might have some personal
emotional feeling for it (Hart 1991a). They can only imagine what religious or mag-
ical meaning the image might have had. It is a conversation piece, a provoker of
reverie, at worst a curio.

Besides the two kinds of meaning I have mentioned—ethnographic and art-
critical—there is a third kind of meaning conveyed by the very presence of this
non-Western, "primitive"-looking painting on a Western middle-class wall. Own-
ership and display of the piece carry the message that its owners are interesting
people, curious about other parts of the world, sophisticated, and well-traveled.
While this third kind of message tells us nothing about the meaning of images in
their South Asian ritual context, it does tell us a lot about what we might call the
ritual display of identifying objects as markers of class, style, and personal identity
in the modern West (cf. Csikszentmihalyi and Rochberg-Halton 1981). What
would the occupants of this house be telling visitors—and themselves—about
themselves if instead of this exotic painting they had a framed reproduction of
"Washington Crossing the Delaware" or the Sacred Heart of Jesus?

The message here is just as clear and culturally specific as that conveyed by the
image on the village wall in India. But here the painting is answering to the pro-
found but standardized Western concern with individual distinctiveness and iden-
tity in a way typical of one segment of the middle class. Of course such messages
are conveyed not only by paintings on walls but also by exotic objects such as jew-
elry, ethnic clothing, and so forth. To put it bluntly, as Jane and Michael Stern
do in their article "Unicorns and Rainbows" in *The Encyclopedia of Bad Taste*

(1990:305), "the fact is that so many people like to see themselves as different in exactly the same way, they're the same."

In Kumaon, where no one has thought seriously of setting up a painting cooperative, women told me that selling their paintings would be improper, and that they would never think of doing so. One wonders whether Mithila women once felt the same way, and whether some of them still do. While there has been a loss of meaning and of sacred power in the process of commodification, the community as a whole has been revitalized by the presence of the cooperative (Mishra and Owens 1978). Some women have been able to make good incomes and improve the standard of living for themselves and their families in this particularly poor region of India. Moreover, production for sale does not seem to have displaced the production of the ritual art required for Hindu ceremonies. In fact, two art systems seem to be flourishing in tandem, one for ritual and the other for commercial purposes, each with its own meanings and logic, both drawing on a common fund of style and imagery. The two systems seem to require different kinds of identity for the producer of the images: in one system she is a Hindu mother of the household producing images as an intrinsic part of ongoing religious ritual, while in the other she is an "artist" selling her paintings through a cooperative.

WALL THREE: IN A MUSEUM

On a wall in a major art museum in Paris, one of the world's main artistic centers, is a framed painting of figures in brilliant colors (fig. 4.3). It is clearly a Mithila painting like the image on the second wall, similar in style and representational content to ritual paintings on the walls of village houses in India and, once put on paper and sold, on middle-class urban and suburban domestic walls in India, Europe, and North America. But this time the image is part of the 1989 exhibition *Magiciens de la terre*, which was translated into English as "The Whole Earth Show" (Buchloh 1989). This is the first attempt at a giant, worldwide ecumenical survey of contemporary art in a major art museum, the Musée d'Art Moderne, Centre Georges Pompidou, in Paris.

The label next to the painting provides the viewer with basic information. Since the point of the exhibition is to represent works from all over the world, the artist's country of origin—in this case, India—is indicated with a dot on a schematic world map. The label gives information about the artist and the painting: the artist's name, Bowa Devi; her date of birth, 1942; her village, region, state, and country: the village of Jitwarpur, Mithila Region, State of Bihar, India; her nationality, Indian; the title of the painting, *Naginis, Femmes serpents*; the materials, natural pigments and gum arabic on paper; and the size of the painting, 56 × 78 cm.

This is the kind of minimal information that is normally given in Western-style art galleries. In addition there is a short text with the name Yves Véquaud under it. Yves Véquaud, a writer and lecturer, is the author of one of the few books on

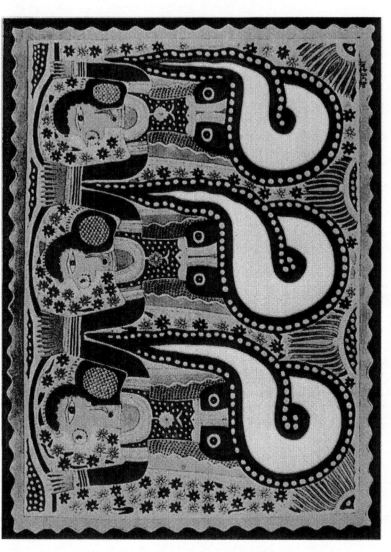

Fig. 4.3. *Nāginis: Femmes serpents*, a painting on paper by Bowa Devi, of Jitwarpur, Madhubani, Mithila, Bihar, for the Cooperative of Women Painters of Mithila, and subsequently exhibited in *Magiciens de la terre*, Musée d'Art Moderne, Centre Georges Pompidou, Paris. Collection: Yves Véquaud, Paris. Photo: Uzi Witkowski.

Mithila women's art, *The Women Painters of Mithila* (1977). Véquaud's short text gives no information about the specific meaning of Bowa Devi's images of serpent women and goddesses. In fact most of the text was written over a decade before the exhibition and can be found in Véquaud's book. Little or no attempt has been made to adapt it to explain the paintings shown in 1989. Other parts of Véquaud's book actually contain some brief but helpful information about "Snake Goddess" paintings, information which applies to the paintings in the 1989 exhibition, but which is not included.

Magiciens de la terre showed the work of fifty artists from Western artistic centers and that of fifty artists from non-Western countries. The aim was to present all the work on equal terms, as aesthetic objects in and of themselves, without concern for the cultural origins of the artists. Like the other non-Western pieces in the exhibition, the Mithila painting was chosen by the curator, Jean-Hubert Martin, using the following criteria: "Since we are dealing with visual and sensual experience, let's really look at [these objects] from the perspective of our own culture. I want to play the role of someone who uses artistic intuition alone to select these objects which come from totally different cultures. . . . I intend to select these objects from various cultures according to my own history and my own sensibility" (quoted in Buchloh 1989:152–153). In the context of the museum and the discourse of the art world in which it participates, the Mithila ritual painting has now been transformed into a piece of "fine art," selected through the same process as the Western art works in the exhibition and presented on an equal footing with the works of major contemporary Western artists, such as Nancy Spero and Anselm Kiefer, included therein. At least that was the purpose of the exhibition. The amount of information provided for the viewer about the producer of the image and about the image itself is one index of the work's transformation into "fine art." Sally Price (1989:86) describes this phenomenon as follows:

> During the past several decades, with less concern about the status of anthropology as a science, the prestige of particular pieces is more frequently upgraded through a *reduction* in the label copy; ethnographic artifacts become masterpieces of world art at the point where they shed their anthropological contextualization and are judged capable of standing purely on their own aesthetic merit.

What has happened to the local and ritual meaning of the image through this shedding of context and its transformation into fine art? As far as the curator and the viewing public are concerned, the ritual meaning of the painting does not exist with any specificity at all. The label copy for the painting by Bowa Devi is minimal, though some effort has been made to provide information about Mithila painting in general.

On the other hand, now that it has been displayed on the museum wall a whole new set of cultural meanings has invaded the piece. While it may be the same kind of picture or "representation" (Steiner 1990) of Mithila women's ritual art framed and under glass as the one we saw on the dining-room wall, the fact that it is dis-

played on the wall of a museum changes it into an "original painting" by a creative artist with a "name" (and some fame), invested with all the semispiritual magic and glamour that surrounds high art and the genius artist in the modern West. All this derives from its ultimate commodification: now a very expensive commodity, or hopefully soon to be one, no longer a curio object of easy exchange but an intensely fetishized object of occasional exchange and high seriousness. The object of elegant auctions and elegant connoisseurship, it has gained an altogether new market and new respect.

The ritual object and the object's maker have both undergone real transformations through an increasingly intense process of commodification. This transformation has involved economy, meaning, and identity. First, an object of aesthetic and ritual use value has been given a price and produced for sale, in some cases reaching the status of an expensive aesthetic object in the West. Second, the initial meaning of the object has been erased and replaced by new meanings involving personal identity and the status of Art with a capital A. Finally, the object's maker has gone from being a participant in a collective ritual process to a named and isolated bearer of the mystical spark of artistic creativity.

THE DEBATE OVER MEANING AND REPRESENTATION

The story of the transformations that Hindu women's ritual art has undergone on its journey from the first wall in the traditional Hindu house to the third wall in the Western art museum is not only becoming increasingly common but is at the source of a debate over the politics of representation. The debate primarily concerns art historians, museum curators and directors, art educators, anthropologists, and folklorists (Buchloh 1989; Karp and Lavine 1991; Getty Center for Education in the Arts 1989; Myers 1991; Price 1989; Vogel 1988). Part of the conflict in this debate centers on tensions between two approaches to the representation of non-Western images in art museums. According to one approach, the contextual information provided by anthropological knowledge is fundamentally important (Buchloh 1989; Clifford 1988; Kurin 1991). Others feel that all art, including non-Western art, should be treated primarily as a visual experience without the burden of too much additional contextual information (Alpers 1991). This sentiment is shared by many curators in major art museums, including William Rubin (1984), the curator of the *Primitivism* show at the Museum of Modern Art, New York. Rubin, as Michelle Wallace (1990:47) puts it, "would have us think that Modernism is the culmination of universal aesthetic values and standards."

These differing approaches can be illustrated by considering two cases that exemplify them.[1] One is a set of exhibitions that was part of the Smithsonian Institution's *Festival of India,* in which the indigenous context was taken seriously, and the other is the exhibition *Magiciens de la terre,* in which context was minimized. *Magiciens de la terre* was highly controversial, in part because there was little or no contextual information provided about the non-Western works it presented. The

problems raised by its treatment of non-Western objects were great enough to war-
rant lengthy debate in two issues of *Art in America* (Buchloh 1989; Clifford et al.
1989; Heartney 1989). As the art historian Benjamin Buchloh (1989:152, 157) put it
in an interview with Jean-Hubert Martin, "You don't seem to mind that this
approach re-introduces the most traditional conception of the privileged subject
and the original object into a cultural context that might not even know these
Western concepts, and that it excludes from the beginning such notions as anony-
mous production and collective creation?"

In contrast, Richard Kurin (1991), a cultural anthropologist and acting director
of the Office of Folklife Programs at the Smithsonian Institution in 1985, makes a
convincing case for the importance of contextual information. He played a key
role in organizing two highly successful India folklife exhibitions, *Aditi: A Celebration
of Life* and *Mela! An Indian Fair*, which were part of the Smithsonian Institution's
Festival of India in 1985. Artists and performers came from India for these events
and produced their work in settings that were built as far as possible from con-
struction materials brought from India. Among the many activities at the exhibi-
tion, Hindu women spent hours every day producing ritual images in replicas of
Indian house interiors. These are part of the same kind of ritual art system that
we saw on the first wall, traditional imagery produced all over South Asia by
Hindu women. Visitors to the exhibition were able to watch and ask questions
while the women worked. The women explained what they were doing, and they
answered the viewers' questions in the house setting while actually involved in the
activity, approximating the experience of an interested visitor learning about ritual
art in a Hindu woman's house in India. The production of visual images was fur-
ther contextualized by other events representing aspects of life in India such as
Hindu religious worship, *pūjā*, and a realistic functioning bazaar with street per-
formers and lots of audience interaction.[2] In contrast to *Magiciens de la terre*, the
Smithsonian exhibitions allowed the viewer to become engaged, to some extent,
with the producer of the image and with the process of production itself, to enter
into something like the physical space of image production, to get a feel for the
ritual art and the context in which it is done. The exhibition at the Musée d'Art
Moderne, by presenting the finished work with minimal contextual information
along with Western pieces, rather than engaging the viewer and producer of the
image, encouraged viewers to look at non-Western art within the same art-histor-
ical framework that they use to look at Western art.

At the root of this debate are value-laden oppositions set up within Western
ideology. Fundamental in the debate is the Western opposition of art and craft
(Clifford 1988; Parker and Pollock 1981; Pellizzi 1989), with art valorized and dis-
played in the art museum while craft, shown in the ethnographic museum, is
devalorized. Several other key oppositions match up with the art versus craft
dichotomy: the notion of the great, genius artist versus the anonymous producer;
the notion of the uniqueness of the artistic image versus the repetition and collec-
tive nature of the craft image; the notion of reflexivity in the creative process ver-

sus the nonreflexive, nonthinking, automatic nature of craft production (Hart 1991b). Clearly the first characteristic in each opposition is valorized while the second is devalorized. Each of these oppositions has been present either implicitly or explicitly throughout my discussion of the images on the three walls and the current debate over the politics of representation.

The goal of this examination of Western ideological oppositions goes beyond merely trying to reverse the pattern of valorization so that the devalorized characteristics become valorized. Both sides of each opposition are rooted in Western ideology and can be thought of as two sides of the same coin. Thus in this ideology the anonymous producer is the opposite of the individual genius artist with a famous name. This is a convenient way to dismiss the non-Western producer; after all, what monetary value is there in anonymity? If, for a moment, the viewer tries to put aside this Western coin and adopt the point of view of a non-Western producer, something quite different becomes apparent: the Western notions of fame and anonymity have little or nothing to do with the way many non-Western producers think about their image production. Instead, we often find a complex world of image production that operates according to its own categories with its own regional aesthetics and its own point of view (Hart 1991a; Leavitt and Hart 1990), including its own aesthetic ideas and creative process. Western curators and viewers need to stand back and try to understand their own ideological polarities and the power these have over Western perceptions and attitudes toward non-Western images and their producers. We can begin this process by looking at the three oppositions noted above, showing how each affects the way in which the images on the three walls have been presented and viewed.

Identity: Genius Artist versus Anonymous Producer

One of the basic ideas built into Western art history and theory is the importance of the role or the authority of the individual producer (Alpers 1977:7). In contrast, many non-Western producers of traditional images, as well as the people who view and use these images in ritual contexts, do not consider the individuality of the producer to be of central importance. This is the case both with the local, ritual production of images in a traditional context and with much commodified production, a separate activity often performed by the same person for the tourist market. The commodified pieces sometimes wend their way into personal art collections or art galleries and museums where they frequently end up being labeled "anonymous" (Price 1989; Steiner 1990). Because of this, Western scholars often conclude that the non-Western traditional producer must be anonymous, nameless. The notion of the anonymity of the non-Western producer of images is problematic. Sally Price (1989:60) believes that "a case can be made that the 'anonymity' of Primitive Art owes much to the needs of Western observers to feel that their society represents a uniquely superior achievement in the history of

humanity." This presents an interesting problem. The fact that the individuality of the producer is not of central importance does not mean that the producer is anonymous *within* his or her culture. In Kumaon, for instance, everyone in the producer's family, neighborhood, and even the village, knows who made a specific image, and some women are acknowledged, praised, and respected for their expertise and the quality of their work. The producer is not actually anonymous at all in the cultural context in which the work is done. But this does not necessarily mean, as in the modern West, that her personal distinctiveness is felt to be the most important aspect of her work.

The transformations we saw on the second and third walls included changes in the perceived identities of the people who had produced the images, changes rooted in Western ideology about the individuality of the artist. The producer of the image on the second wall was transformed from a woman living in a village in India who makes images as an integral part of her everyday life and religious worship, a context in which signing her work would be absurd, to an individual "artist," producing and signing images commercially in the context of a village painting cooperative. It is noteworthy that the name of the "artist," as well as other information about the image, was covered up by the cardboard backing of the frame, since that information was written on the back of the paper. Once framed, the image looks as though the producer(s) is (are) anonymous. The identity of the producer of the image on the third wall went through two stages of transformation; first, from a woman doing everyday ritual art in a Hindu village to an "artist" in the cooperative, and second, from an "artist" in the cooperative to an individual "celebrity artist" whose work was selected on its aesthetic merits by a Western curator to be shown in an international art exhibition in a highly prestigious art museum. Down the road she might become a great, genius artist, provided that curators continue to display her work and critics to promote it. This is an excellent illustration of Mihaly Csikszentmihalyi's argument for a systems view of creativity (1988). Csikszentmihalyi found that social factors play a significant role in determining who is designated as a great artist, possessing creativity and talent. The creativity and giftedness of the artist are necessary but not sufficient conditions to ensure a place in the galleries and in art history. In fact, a producer of images cannot be said to be creative until he or she has first earned approval, and along with it the label of "artist," from the art world's social network of art critics, art historians, and curators. Only then is the person considered worthy of a place in art history.

In *Magiciens de la terre*, this process, rather than clarifying the identity of the producer of the image, creates misunderstanding and confusion about who that producer is. The exhibition's curator attempted to identify Bowa Devi as an individual artist in India, but failed to do so for lack of knowledge about North Indian naming and kinship. In the exhibition and catalog, the producer of the image was identified as "Bowa Devi" just the same way as they identified a Western artist as "Nancy Spero" or "Neil Dawson" (Martin 1989:13). The assumption is that Devi is

her family name, like Spero or Dawson. But there is a problem here: In a number of regions of North India, including Mithila, every adult Hindu woman is called "Devi," which translates as "Goddess." "Devi" is a respectful marker of femaleness in the names of millions of Indian women and has nothing to do with either the family name or the artist as an identifiable individual. Bowa is the producer's personal name, in a way that is similar to but still different from the way in which Nancy is Nancy Spero's personal name, since very few people would ever refer to her simply as "Bowa," but rather as "Bowa Devi." She undoubtedly has a clan name, somewhat comparable to a Western family name, which she shares with other members of her extended patrilineage. But this has been omitted here, and is often simply assumed in India rather than used. Had ethnographic information about naming in India been of interest to the curator, Bowa Devi's full name could have been included in the catalog and exhibition. The misunderstanding about her name highlights Western ignorance, and it is almost amusing when she is identified as "B. Devi" in the catalog on the diagrammatic floor plan of the museum (Martin 1989:13), for this makes her indistinguishable from the millions of Hindu women whose names begin with a "B." Although the use of "Bowa Devi" is perfectly appropriate in the Indian village context, its use in the exhibition and catalog fails to identify her as an individual artist, distinct from other individuals, whose work has been singled out as unique and different from that of other artists—thus failing to fulfill one of the aims of the exhibition.

Unique versus Collective Images

In addition to the individuality of the artist, the uniqueness of the individual work is one of the underlying assumptions of Western art historical scholarship (Alpers 1977:7), with original imagery being produced through the personal creativity, inspiration, and special artistic vision of the artist.[3] The text in the *Magiciens de la terre* catalog tells the reader that "drawing on this [Mithila] tradition, during the past ten years Bowa Devi has developed a personal art, inventing a style, symbols, and compositions of her own" (Martin 1989:129; my translation).

In this passage the viewer is told that Bowa Devi has developed a personal art by *inventing her own* unique artistic style and her own symbols. This is an excellent example of the disjunction of the relationship between the discourses of the art world as seen in the exhibition and the catalog and an anthropological knowledge which seeks to include the discourses of the image producers themselves. Rather than being invented by Bowa Devi, the images, symbols, and compositions in her work, including those exhibited in Paris, are produced by many women in the village community in which Bowa Devi lives, are based on universally-known Hindu myths, and play an important role in rituals practiced in the majority of middle- and upper-caste Hindu households in Mithila. Although Bowa Devi may have certain images she prefers to paint for the commercial market, these are by no means her own images in the sense of a Western artist's personal imagery, and she would

probably not think of her artistic activity in these terms. But there is a twist here—
given the Western requirements of commodified art production in the coopera-
tive with its need for a marketable, personal style, it is possible and even likely that
Bowa Devi has deliberately begun to do work that intensifies its personally dis-
tinctive aspects. The problem of personal style is an interesting one, because every
woman who produces ritual images in India can be said to have her own personal
style. For example, the images made by Kumaoni women are essentially collective
images. Even so, women in Kumaon know perfectly well who did a particular
painting and, if required, can easily identify an image from the "personal style"
of its producer—every woman has a way of drawing a line, representing facial fea-
tures and so on, that is slightly different from other women's; indeed such identifi-
cation on the basis of style was often made for me when I asked who did a certain
(always unsigned) image so I could talk to her about it. Kumaoni women's cen-
tral concern is not personal style, but rather the production of beautiful images
that include the symbolic elements required to make a ritual event or ceremony
effective (Hart 1991a:148). It is interesting that the curator of *Magiciens de la terre* felt
compelled to discuss personal style in the exhibition and in the catalog. We have to
ask whether Bowa Devi's work would have been less valid to the curator and view-
ers if her "personal style" had not been raised as an issue in the catalog. Indeed,
was her personal style mentioned simply as a justification for including her work in
the exhibition?

If Western viewers do not think of these images as original and unique, their
significance is diminished in their eyes, as they feel that "art" must be made up of
"personal imagery." For the original producers and consumers, however, the
images are part of an art system that valorizes aspects of image production differ-
ent from those valued in the West. These images, compositions, and styles are
based on regional, caste, and family distinctions that have been passed on from
one generation to the next for centuries, not only in Mithila but in women's ritual
art practiced all over South Asia. Bowa Devi's art is part of a great living tradi-
tion (Ecker 1990), practiced and continuously changing and developing through
the centuries. This does not mean that the images made by one woman are indis-
tinguishable from those made by others; it just means that the individual differ-
ences in the images are not necessarily their most interesting or important aspect
for the people who produce them. But it is this aspect, the uniqueness and indi-
vidual differences in the images, and the notion of the role or authority of the indi-
vidual creator, that the Western art world finds interesting and valuable.

Reflexivity in the Creative Process

Linked to the notion of anonymity and to assumptions about repetition in collec-
tive images—the same image produced by many women for the same ritual on
the same day in the same village—is the idea that while contemporary Western
artistic production is a reflexive activity, traditional non-Western image production

is not. For example, Jean-Jacques Simard (1988:51) considers reflexivity to be a characteristic of contemporary music production, suggesting that "the artist is conscious of his or her role in the creative process . . . traditional Hungarian dances give us Brahms or Bartók." An equivalent example in the visual arts can be found in the catalog (Rubin 1984) for the *Primitivism* show at the Museum of Modern Art, New York, in 1984, in which Picasso is assumed to have consciously incorporated elements of traditional African masks in the process of creating his modern paintings. Accompanying such an assumption, prevalent in much Western writing about traditional and non-Western forms of expression, is the suggestion that there is an absence of reflexivity in such activities as the production of African masks and traditional Hungarian dance. The traditional producer is represented as mindlessly repeating traditional dance music or carving a wooden mask without being conscious of his or her role in the process of creation.

During a discussion of aesthetic pluralism in a recent comparative literature seminar at the Université de Montréal on the "Culture and the Institution of the Museum," a sophisticated, well-read graduate student commented on traditional non-Western image production in general, saying, "But it can't be considered art and doesn't belong in an art museum; the people simply make these images automatically and they all make the same images, just as visual hex marks in Haiti are dashed off quickly without thinking, not unlike the way bees automatically make hives." I would argue, on the contrary, that no one who has observed and participated in the production of non-Western traditional imagery could possibly say that it is an unconscious, nonreflexive activity. Take for example the film of the Northwest Coast sculptor Joe David (Hodge and Lund 1982), in which he shows his experience of the creative process by sculpting a ceremonial wolf mask and explains both what he is doing and thinking. That many Westerners think that modern, Western artistic production is a self-reflexive, conscious process while much of traditional and non-Western image production is not recalls Sally Price's (1989:60) observation, discussed earlier, of the Western need to believe in "the 'anonymity' of Primitive Art in order to feel that Western society is a unique and superior achievement."

Rather than the presence or absence of reflexivity in visual production being the issue, perhaps the quality of explicit ideological self-consciousness should be considered instead. The Western producer of a painting destined (he or she hopes) for the wall of an art gallery and possibly for the wall of a great art museum is conscious of him- or herself as an "artist" making an object that is contrived, posed, set apart from everyday life, just as the short stories and novels of contemporary fiction are contrived, posed, and separate from everyday life. These products proclaim, "Look at me, I'm art!" The producer of ritual images in a Hindu village is not conscious of herself in this particular way. She is producing an image that derives its meaning from the part it plays in life, rather than as a contrived, posed object. She is intensely conscious of a whole series of aesthetic criteria: she *must*

make reflective aesthetic judgments for her work to have its intended effect. She is also conscious that the image she is making is for a specific event, with specific symbols; she is intensely aware of being in communication with the gods through the use of the image, and knows that in this way she is consciously affecting and influencing her own life and the lives of members of her family. However, there is indeed a difference between this kind of reflection and that typical of Western art production, which bears on the object and goals of reflection. Instead of saying "Look at me, I'm art!," the Hindu woman's production says, "Look at me, gods, and inhabit me. Look at me, new bride and groom, and be transformed into a new stage of life, into a new, complete and perfect person!"

Rather than an anonymous and nonreflexive process, the production of Hindu ritual art is an intensely personal, conscious process during which the producer of the image is acutely aware of just what she is making and how and why she is doing it. A woman, a mother, lovingly creates beautiful, emotion-filled, auspicious, important images for her own children for the purpose of helping them, of supporting them so they can succeed and be happy in the next stage of their lives.

CONCLUSION

Due to its increasing involvement in the debate over the politics of representation, the international art world may be starting to accept the necessity of including, or even basing the display of non-Western images upon, the point of view and knowledge of the people who produce these images. Without explicit information about the regional meanings and aesthetics of non-Western images, the Western viewer can only appreciate their formal characteristics and bring his or her own emotional response to them, missing out on the incredible richness that contextualizing knowledge could bring to the experience. The absence of otherness in contemporary art exhibitions will begin to be rectified, as George Marcus (1991) puts it in a discussion of an American art exhibition, when critical Western artists not only

> recognize . . . other cultures or [a Western] reality that is culturally plural (although this is important) but . . . self-conscious of their own elitist surroundings, they might explore in their own art and in juxtaposition to themselves the conditions and practices of other contemporaneous art traditions, especially those among people who are not considered to be producing art until they are assimilated by the high-culture art tradition. (Marcus 1991:152)

The changes in representational practice that this implies are highly complex. As Michel Côté of the Musée de la Civilisation in Quebec City has pointed out, the museum must take into account differing points of view and interpretations since the same object is "viewed differently by the person who makes it or uses it, the artisan or artist, the anthropologist, the art historian, and the dealer" (Côté 1992:5; my translation). The representation of the object, especially the non-Western

image, is never neutral; it is always problematic, with multiple points of view to be taken into consideration. The problems and issues discussed here pose an immediate challenge to the international art world as the demand grows for contextual knowledge to be incorporated into museum displays with information about regional aesthetics, transformations in meaning and identity, and awareness of the ideological assumptions that affect the way Westerners display and view non-Western images.

NOTES

This work is based on a shorter paper, "Regional Aesthetics and the International Art World: Hindu Women's Ritual Art on Three Walls," presented at the Annual Meeting of the American Anthropological Association, Chicago, November 1991. I owe a great debt of thanks to many people in Kumaon for helping me understand Kumaoni ritual art: Shanti Budhalakoti, Nilima Das, Indra Singh Negi, Shekhar Pathak, Sāvitrī Devī Sāh, Vishvambar Nath Sah "Sakha," I. C. Vidyasagar Sah, Ajay Singh Rawat, Y. D. Vaishnava, and especially Rajendra Lal Sah, Sheela Devī Sah, members of their family, and the Sharda Sangh Association, Nainital. I am grateful for John Leavitt's suggestions and conversations exploring the ideas in this chapter. For comments and general discussion, I thank Mihaly Csikszentmihalyi, Richard Kurin, Wyatt MacGaffey, Fernand Ouellet, and Barbara Tedlock. Research on which this article is based was funded by grants from the Social Sciences and Humanities Research Council of Canada (1979–81) and the American Institute of Indian Studies (1980–81).

1. Parts of this chapter, including discussion of the two cases, are based on: my paper, "Multicultural Aesthetics and Art Criticism: Understanding Non-Western Points of View," presented in the symposium "Beyond the Traditional in Art: Facing a Pluralistic Society," Conference of the United States Society for Education through Art, Columbus, Ohio, 1991; and an article, "The Role of Cultural Context in Multicultural Aesthetics," *Journal of Multicultural and Cross-Cultural Research in Art Education* (1992–93) 10/11: 5–19.

2. On the problem of how to include contextual information in exhibitions also see B. N. Goswamy (1991:76) who, in a discussion of two exhibitions of Indian classical art that he organized with his colleagues, talks about how they "tried to approximate the original intention and context." These exhibitions were *Rasa: les neuf visages de l'art indien*, Grand Palais, Paris, 1986, and *Essence of Indian Art*, Asian Art Museum, San Francisco, 1986.

3. In Hart 1991a:146–149, I address the problem of applying Western art historical categories and concepts from Western art criticism to non-Western images. The lack of information about the meaning of a non-Western work often stemming from a lack of desire for such information—means that the Western viewer must fall back on familiar formalist categories and a romantic, personal response to the non-Western image.

REFERENCES

Alpers, Svetlana
1977 "Is Art History?" *Daedalus* 106:1–14.
1991 "The Museum as a Way of Seeing." In Ivan Karp and Stephen D.
 Lavine, eds., *Exhibiting Cultures: The Poetics and Politics of Museum Display*,
 pp. 25–32. Washington, D.C.: Smithsonian Institution Press.

Anderson, Richard L.
1979 *Art in Primitive Societies*. Englewood Cliffs, N.J.: Prentice Hall.

Appadurai, Arjun, and Carol Breckenridge
1988 "Why Public Culture?" *Public Culture* 1(1):5–9.

Buchloh, Benjamin
1989 "The Whole Earth Show: An Interview with Jean-Hubert Martin." *Art in
 America* 77(May):150–159, 211, 213.

Chalmers, F. G.
1985 "Art as a Social Study: Theory into Practice." *Bulletin of the Caucus on
 Social Theory and Art Education* 5:40–50.

Clifford, James
1988 *The Predicament of Culture: Twentieth Century Ethnography, Literature, and Art*.
 Cambridge, Mass.: Harvard University Press.

Clifford, James, B. Groys, Craig Owens, Martha Rosler, Robert Storr, and Michele
 Wallace
1989 "The Global Issue: A Symposium." *Art in America* 77(July):86–89, 152–153.

Côté, Michel
1992 "Mi-vrai mi-faux." *Vice Versa: Magazine transculturel* 37:5.

Csikszentmihalyi, Mihaly
1988 "Society, Culture, and Person: A Systems View of Creativity." In R. J.
 Sternberg, ed., *The Nature of Creativity: Contemporary Psychological Perspectives*,
 pp. 325–339. Cambridge: Cambridge University Press.

Csikszentmihalyi, Mihaly, and Eugene Rochberg-Halton
1981 *The Meaning of Things: Domestic Symbols and the Self*. Cambridge: Cambridge
 University Press.

Eck, Diana L.
1981 *Darśan: Seeing the Divine Image in India*. Chambersburg, Pa.: Anima
 Books.

Ecker, David
1990 "Cultural Identity, Artistic Empowerment, and the Future of Art in the
 Schools." *Design for Arts in Education*, January/February, 14–20.

Ferguson, Russell
1990 "Introduction: Invisible Center." In Russell Ferguson, M. Gever, T. T.
 Minh-ha, and C. West, eds., *Out There: Marginalization and Contemporary
 Cultures*, pp. 9–14. Cambridge, Mass.: MIT Press.

Forge, Anthony, ed.
1973 *Primitive Art and Society*. London: Oxford University Press.

Getty Center for Education in the Arts
1989 "New Voices on Multicultural Concerns." In *Inheriting the Theory: New*

Voices and Multiple Perspectives on DBAE, pp. 23–40. Los Angeles: J. Paul Getty Trust.

Goswamy, B. N.
 1991 "Another Past, Another Context: Exhibiting Indian Art Abroad." In Ivan Karp and Stephen D. Lavine, eds., *Exhibiting Cultures: The Poetics and Politics of Museum Display,* pp. 68–78. Washington, D.C.: Smithsonian Institution Press.

Graburn, Nelson H., ed.
 1976 *Ethnic and Tourist Arts: Cultural Expressions from the Fourth World.* Berkeley: University of California Press.

Hart, Lynn M.
 1990 "South Asian Women's Ritual Art: A Living Tradition." In B. White and Lynn M. Hart, eds., *Living Traditions in Art: Papers from the First International Symposium,* pp. 101–111. Montreal: Canadian Association for the Study of Living Traditions in the Arts.
 1991a "Aesthetic Pluralism and Multicultural Art Education." *Studies in Art Education* 32(3):145–159.
 1991b "Pluralisme esthétique et enseignement des arts au Québec." In F. Ouellet and M. Pagé, eds., *Pluriethnicité, éducation et société: Constuire un espace commun,* pp. 371–398. Montreal: Institut Québecois de Recherche sur la Culture.

Heartney, Eleanor
 1989 "The Whole Earth Show: Part II." *Art in America* 77(July):90–97.

Hodge, Jennifer, and Robert Lund
 1982 *Joe David: Spirit of the Mask.* [Film] Producer: Seawolf Films. Kensington Communications.

Inden, Ronald B., and Ralph W. Nicholas
 1977 *Kinship in Bengali Culture.* Chicago: University of Chicago Press.

Karp, Ivan, and Stephen D. Lavine, eds.
 1991 *Exhibiting Cultures: The Poetics and Politics of Museum Display.* Washington, D.C.: Smithsonian Institution Press.

Kilambi, J. S.
 1985 "Toward an Understanding of the *Muggu:* Threshold Drawings in Hyderabad." *Res: Anthropology and Aesthetics* 10:71–102.

Kramrisch, Stella
 1985 "The Ritual Arts of India." In R. Sethi, ed., *Aditi: The Living Arts of India,* pp. 247–269. Washington, D.C.: Smithsonian Institution Press.

Kurin, Richard
 1991 "Cultural Conservation through Representation: Festival of India Folklife Exhibitions at the Smithsonian Institution." In Ivan Karp and Stephen D. Lavine, eds., *Exhibiting Cultures: The Poetics and Politics of Museum Display,* pp. 315–343. Washington, D.C.: Smithsonian Institution Press.

Layton, Robert
 1991 *The Anthropology of Art.* 2d ed. Cambridge: Cambridge University Press.

Leavitt, John and Lynn M. Hart
1990 "Critique de la 'raison' sensorielle. L'élaboration esthétique des sens dans une société himalayenne." *Anthropologie et Sociétés* 14(2):77–98.
MacGaffey, Wyatt
1993 " 'Magic, or as We Usually Say Art': A Framework for Comparing European and African Art." Paper presented in Department of Anthropology Seminar Series, Université de Montréal.
Marcus, George E.
1991 "The Power of Contemporary Work in an American Art Tradition to Illuminate Its Own Power Relations." In H. T. Day, ed., *Power: Its Myths and Mores in American Art, 1961–1991*, pp. 141–154. Bloomington: Indiana University Press.
Martin, Jean-Hubert
1989 *Magiciens de la terre.* Paris: Centre Georges Pompidou.
Mishra, G., and R. Owens
1978 *Mithila Folk Paintings.* Austin: Huntington Gallery, University of Texas.
Myers, Fred R.
1991 "Representing Culture: The Production of Discourse(s) for Aboriginal Acrylic Paintings." *Cultural Anthropology* 6(1):26–62.
Parker, Rozsika, and Griselda Pollock
1981 *Old Mistresses: Women, Art and Ideology.* New York: Pantheon Books.
Pellizzi, Francisco
1989 "Mésaventures de l'art: Premières impressions des Magiciens de la Terre." *Res: Anthropology and Aesthetics* 17/18:199–207.
Price, Sally
1989 *Primitive Art in Civilized Places.* Chicago: University of Chicago Press.
Rubin, William, ed.
1984 *"Primitivism" in 20th Century Art: Affinity of the Tribal and the Modern.* New York: Museum of Modern Art.
Simard, Jean-Jacques
1988 "La révolution pluraliste: une mutation des rapports de l'homme au monde." In F. Ouellet, ed., *Pluralisme et école. Jalons pour une approche critique de la formation interculturelle des éducateurs,* pp. 23–55. Quebec: Institut Québécois de Recherche sur la Culture.
Steiner, Christopher B.
1990 "Worlds Together, Worlds Apart: The Mediation of Knowledge by Traders in African Art." *Society for Visual Anthropology Review* 6(1):45–49.
Stern, Jane, and Michael Stern
1990 *The Encyclopaedia of Bad Taste.* New York: Harper Collins.
Upreti, N. R.
1972 *Folk Art of Kumaon.* Census of India 1961, Vol. 1, Part VII-A, Monograph 5. New Delhi: Government of India.
Véquaud, Yves
1977 *The Women Painters of Mithila.* London: Thames and Hudson.
Vogel, Susan
1988 "Introduction." In Arthur Danto, R. M. Gramly, Mary Lou Hultgren, Enid Schildkrout, and Jeanne Zeidler, with an introduction by Susan

Vogel, *ART/artifact: African Art in Anthropology Collections,* pp. 11–17. New York: Center for African Art and Prestel Verlag.

Wallace, Michelle

1990 "Modernism, Postmodernism and the Problem of the Visual in Afro-American Culture." In Russell Ferguson, M. Gever, T. T. Minh-ha, and C. West, eds., *Out There: Marginalization and Contemporary Cultures,* pp. 39–50. Cambridge, Mass.: MIT Press.

West, Cornell

1990 "The New Cultural Politics of Difference." In Russell Ferguson, M. Gever, T. T. Minh-ha, and C. West, eds., *Out There: Marginalization and Contemporary Cultures,* pp. 19–36. Cambridge, Mass.: MIT Press.

The Art of the Trade:
On the Creation of Value and Authenticity
in the African Art Market

Christopher B. Steiner

Early in the spring of 1985, amidst the economic flamboyance of the 1980s and a dizzying trail of skyrocketing prices in the international art scene, there appeared in a French magazine a full-page advertisement for Jean-François Gobbi's Galerie d'Art. A dramatic black-and-white photograph depicts Monsieur Gobbi, dressed in a dark suit and sporting an oversized cigar, surrounded by some of his master-works of European art. The text below the photograph reads as follows:

> The world's largest museums and collectors await your valuable paintings. . . . The problem, however, is that you don't know where they are—these museums and col-lectors who are ready to pay good money for your works of art. Jean-François Gobbi, *he* knows where they are: they are all his clients. Today, the demand for masterpieces is so great that museums and collectors don't even discuss price. . . . Now if you think you will some day come in contact with a big museum or an important collector will-ing to pay top dollar for your masterpiece, don't call Jean-François Gobbi. Otherwise dial 266–50–80. (*Galerie des Arts* no. 227, 1985: inside front cover)

In the art world, as in the world of all big business, the success of the middleman depends upon the separation of buyers from sellers. Social, legal, and bureaucratic barriers are erected at every level of the economic system to maintain the distance between the primary suppliers of art and their ultimate consumers. "The produc-ers and consumers of the art," Bennetta Jules-Rosette has written with regard to the African tourist art industry, "live in quite different cultural worlds that achieve a rapprochement only through the immediacy of the artistic exchange" (1984:8). Art dealers earn their livelihoods as go-betweens—moving objects and artifacts across institutional obstacles which often they themselves have constructed in order to restrict direct contact or trade.

 The market for African art and artifacts is characterized by precisely this sort of network of relations, in which a host of both African and non-African middlemen

forge temporary links in a transnational chain of supply and demand. Art objects and cultural artifacts enter the market in two ways. Either they are bought from village inhabitants who are motivated by financial or personal reasons to sell family heirlooms and ritual paraphernalia, or they are purchased from artists who produce directly for the export trade. Both used and made-for-sale materials are collected by professional African traders who travel through rural communities in search of whatever they believe can be resold (cf. Ravenhill 1980a). Most of the suppliers have little or no idea where these objects are destined, why they are sought after, and for what price they will ultimately be bought.

After being collected in villages or workshops, objects are moved from town to town until they are eventually sold to a dealer who has direct contact with European or American clients. These dealers, most of whom are Hausa, Mande, or Wolof, are based in Abidjan, the chief economic port of Côte d'Ivoire, as well as in the larger towns of Man, Korhogo, Bouaké, and Yamoussoukro. Because their primary network of relations extend outward—i.e., into the world of Western buyers rather than inward into the world of local village suppliers—urban dealers are dependent upon village-level traders for their supply of goods. They themselves never buy art directly in villages (fig. 5.1).

Through their interactions with Western buyers, dealers have partial understanding of the world into which African art objects are being moved. Their experience enables them to discern certain criteria underlying Western definitions of authenticity. They know, through trial and error, which items are easiest to sell, and they can predict which objects will fetch the highest market price. Using this refractured knowledge of Western taste, traders manipulate objects in order to meet perceived demand. In this essay, I will illustrate three ways in which African art objects are manipulated by African traders: the presentation of objects, the description of objects, and the alteration of objects. My remarks are based on eighteen months of field research from 1987 to 1991 conducted among African art traders in rural and urban Côte d'Ivoire.

PRESENTATION OF OBJECTS

The presentation of an art object for sale is not something that is carried out in a haphazard manner. Careful preparations are made before an object is shown to a prospective buyer. The context in which an object is placed and the circumstances surrounding its putative discovery weigh heavily in the buyer's assessment of quality, value, and authenticity. Presentation is always a key element in the success of a sale. If an object is uncovered by the buyer in what is thought to be its original or "natural" setting it is presumed to be closer to the context of its creation or use and therefore less likely to be inauthentic or fake.

The very process and act of discovery generally confirms the collector's sense of good taste. There is a long-standing tradition in travel writing that involves an author's arduous exploration for genuine cultural objects—the more difficult the

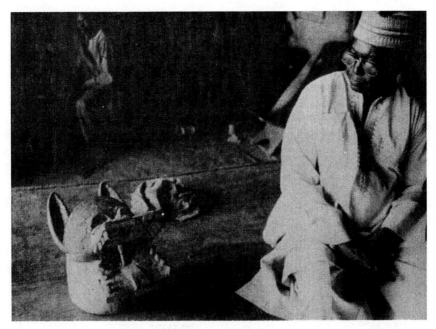

Fig. 5.1. African art trader with Senufo mask. Korhogo, Côte d'Ivoire, June 1991. Photo: Christopher B. Steiner.

search the more authentic the find. In his 1914 memoir, *The Sport of Collecting*, Sir Martin Conway recounts his search for ancient Egyptian artifacts: "I had spent two or three evenings in the *dark* native houses of Luxor, finding nothing but the ordinary poor rubbish that came to the surface everywhere in Egypt. At last I was taken . . . into the an *inner* room within the compound of a *specially secluded* house, and there, to my astonishment, they showed me a few quite extraordinary treasures" (1914:77, emphasis added). More recently, in a travelogue narration of a voyage to Côte d'Ivoire in the 1970s, an African art collector described his visit to the northern town of Korhogo in the following words: "While my travel companions were all taking naps, I *ventured* into the *obscurity* of a hut, which was *lost* somewhere in the heart of a labyrinth of identical alleys, where I saw a magnificent Senufo hunter's tunic covered with talismans: fetish horns, leather pouches, feline teeth, and small bones" (Lehuard 1977:28, emphasis added). And, in a subsequent article describing his travels through Burkina Faso, the same author provides his readers with the following piece of advice: "For those who collect antiques, but cannot afford the cost, or do not possess the training, to *'hunt'* for objects in the bush, it is always possible to *excavate* through the stock of the urban traders who are set up alongside the Hotel Ran in Ouagadougou. Although there is a preponderance of modern sculptures here, it is sometimes possible to *ferret out* a rare gem" (1979:19, emphasis added).

The manipulation of context through the calculated emplacement of objects is a widespread practice among art dealers around the world. One of the classic tricks of the French antique market, for example, was to plant reproduction furniture in old homes. In the autobiography of André Mailfert (1968), a cabinetmaker who produced reproduction antique furniture in Orléans from 1908 to 1930, the author unveils the so-called *coup du meuble "planqué."* A dresser was made to fit the specifications of a dealer who knew he could sell such a piece to a client who was soon scheduled to arrive from abroad. Once completed, the dresser was taken to the home of an elderly woman who lived on the outskirts of Paris. A wall in the front hall was thoroughly cleaned, the dresser was placed in front of it, and, with the help of an air compressor, dust was sprayed on the wall so as to leave a noticeable mark around the edge of where the dresser now stood. The dresser was scratched in appropriate places, the drawers were filled with odds and ends taken from the woman's closet, an accumulation of decades of floor wax was quickly applied to the brass rim of the dresser legs, and a yellowed envelope which dated from thirty years earlier was casually tucked under the marble top to support a corner which had been made to warp. The customer was told that an old woman needed to sell an antique dresser in order to pay her taxes. He was taken to the woman's home whereupon, after scrupulous inspection and words of encouragement from his dealer *expert*, the client bought the dresser for 12,000 francs. For the use of her home the woman received 1,000 francs, the cabinetmaker was paid for the price of the reproduction dresser, and the dealer kept the rest. "There is of course a question of conscience," Mailfert concludes, "but it's all so amusing that even the most virtuous among us could hardly resist such a wicked temptation" (1968:57).

In Côte d'Ivoire, as in France before World War I, one of the key factors in the presentation of an art object is to create an illusion of discovery. Because of the barriers, which I noted earlier, that separate art consumers from art suppliers, the Western buyer almost never has the opportunity to uncover an object by chance or recognize its potential value *before* it enters the market or *before* it becomes a commodity. Yet, part of the collector's quest, I would argue, is to discover what has previously gone unremarked. As one European art critic put it, "the charm [of an art object] is bound up with the accident of its discovery" (Rheims 1961:212). From the perspective of the Western collector, African traders are perceived as mere suppliers of raw materials. It is the gifted connoisseur, not the African middleman, who first "sees" the aesthetic quality of a piece and thereby "transforms" a neglected artifact into an object of art (cf. Price 1989).

African art dealers are acutely aware of the discovery element in Western taste. Depending on the circumstance, traders will sometimes feign ignorance or pretend not to know much about the goods they sell in order to let the buyers believe that they are getting something the true value or significance of which the seller does not recognize. In fact, the principal art market in Abidjan, known as the Plateau marketplace, is constructed in such a fashion as to facilitate this illusion

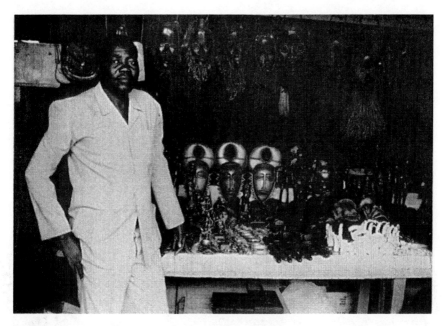

Fig. 5.2. African art trader at his stall in the front of the Plateau marketplace. Abidjan, Côte d'Ivoire, November 1988. Photo: Christopher B. Steiner.

of discovery. The front of the marketplace consists of a series of adjoining stalls, with layered shelves on which are displayed quantities of identical items. These objects are marketed largely as contemporary souvenirs made for the tourist trade (fig. 5.2). In the back of the marketplace, which can only be accessed through a series of dark and narrow paths, there are a number of large wooden trunks in which some of the traders store their goods (fig. 5.3). Many of the objects kept in the back of the marketplace are identical to those displayed in the front. The difference, however, is that they are *presented* to the buyer as unique and rare items.

Drawing on the dramaturgical idiom in the sociology of Erving Goffman, Dean MacCannell has noted the interplay between front and back regions in the construction of authenticity. "Just having a back region," writes MacCannell, "generates the belief that there is something more than meets the eye; even where no secrets are actually kept, back regions are still the places where it is popularly believed the secrets are" (1976:93). "Entry into this space," he concludes further on in the text, "allows adults to recapture virginal sensations of discovery" (1976:99). By permitting the buyer to penetrate the back region of the marketplace, the African art trader thus underscores the value and authenticity of the object he is showing.

Like their counterparts in the French antique market, African traders also plant objects in remote and ingenious settings. An elderly Malian art trader recounted

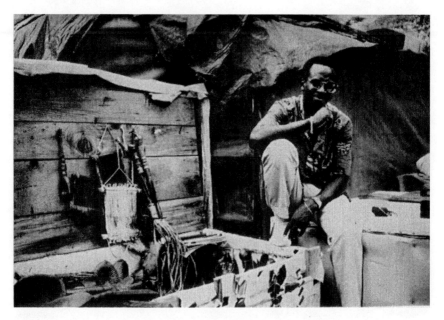

Fig. 5.3. African art trader with wooden storage trunk in the back section of the Plateau marketplace. Abidjan, Côte d'Ivoire, May 1988. Photo: Christopher B. Steiner.

an instance in which he tried to sell a mask to an American buyer. The buyer carefully examined the mask but refused to purchase it, telling the trader that he doubted it was very "old" or "real." Several months later the buyer returned to Abidjan. The trader planted the very same mask (which had not yet been sold) in a village located not far from the urban capital. The buyer was brought to the village and taken with great circumstance into the house where the mask had been placed. The object was examined, as best it could, in the dim light of the house. This time the customer bought the piece and, in the trader's words, was delighted with his "find."

DESCRIPTION OF OBJECTS

Verbal cues affect judgment of authenticity and success of sale in ways similar to object emplacement. That is to say, what we are told about a work of art conditions what we see. In Europe, for example, the title of a painting is sometimes changed to fit the current taste of the market. In the 1950s, when macabre themes in art were apparently more difficult to sell than lighthearted and amusing works, the title of van Gogh's painting described in earlier references as *The Cemetery* was changed in an auction catalog to the more cheerful *Church under Snow* (Rheims 1961:209).

In Africa, traders communicate through verbal means two types of information about the objects they sell. On the one hand, traders convey to Western collectors and dealers specific information relating to an object's market history (i.e., when it was collected, how it was acquired, where it originates from, and so on). To foreign tourists, on the other hand, traders provide general information regarding an object's cultural meaning and traditional use. Both types of information are constructed to satisfy perceived Western taste and are intended to increase the likelihood of sale. In the language of mediation studies, one might say that the trader's description of an object is phrased at the level of metacommunication or "communication about communication." The sender's messages, to borrow Bateson's phrase, are "tailored to fit" according to his ideas about the receiver, and they include instructions on how the receiver should interpret their content (1951:210).

African art objects in the West are sometimes sold with a documented "pedigree" which consists of a list of previous owners. A quick glimpse at auction prices would indicate that a mask once owned by a Picasso or Rockefeller is worth far more money than an identical mask from the collection of an unknown patron (cf. Price 1989). Before an object leaves the African continent, however, its true pedigree is carefully hidden from prospective buyers. African traders are well aware that the Western collector is concerned with neither the identity of the artist nor a history of local ownership and exchange. Indeed, an object is generally worth far more if it is perceived by the buyer to have been created by a long departed and unknown artist and to have come directly out of a remote village community.

As a result of the economic structure of the market most European and American purchasers of African art are not the first Westerners to have seen a particular object. Since art objects do not have a fixed monetary worth, traders often test an object's value by bargaining with different potential clients. In some instances, pieces are even tested in the markets of Europe and America before they are returned to Africa and sold to local expatriate collectors. In an attempt to hide the true channels of trade through which art objects are moved, traders will always tell their clients that they are the first Westerner to have an opportunity to buy a given piece. Even though most traders who have direct contact with Westerners are not the ones collecting art at the village level, they will always indicate that they themselves have just arrived from purchasing objects in a village. The mystique of "direct" contact thereby elevates the value and authenticity of the piece.

Malam Yaaro, a Hausa dealer specializing in the art of Ghana, recently shipped to New York City twenty-six Asante stools (fig. 5.4). Upon arrival, an African colleague asked Yaaro to select six stools from the lot in order to show them to one of his clients. After the six stools were picked out, Yaaro contacted one of his regular clients, a New York gallery owner, who purchased all twenty of the remaining stools. A few days later, the trader who had taken the six stools returned with the merchandise, informing Yaaro that his client did not want to buy the stools. Yaaro immediately contacted the gallery owner who had bought

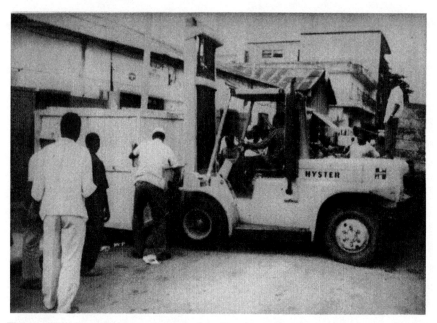

Fig. 5.4. Shipment of African art destined for New York City. Treichville quarter, Abidjan, Côte d'Ivoire, June 1991. Photo: Christopher B. Steiner.

the original lot and told him that a smaller shipment of six very fine stools had just been sent to New York by an old Dioula woman. The true itinerary of the objects was kept hidden from the prospective buyer for several reasons. First, the seller did not want to anger a regular client by revealing that six of the finest stools had been removed from the original lot. Second, the seller did not want the buyer to know that the six stools had already been rejected by another Western buyer. And third, the seller wanted to create the illusion that the goods had been freshly brought from Africa and had not yet even been seen by other Western eyes. In fact, by saying that an old woman had transported the objects, he was further communicating to the buyer that not even another African art trader had yet seen the stools.

While collectors are interested in learning the path of objects from village to market, tourists in Africa are concerned with learning the traditional meaning and function of African art. Traders provide tourists not only with objects to take back home, but also with the knowledge of what the objects mean in their traditional contexts (cf. Spooner 1986:198). Indeed, it could be argued that for many tourists, their experience in the marketplace would not be complete unless the traders told them something "interesting" about the objects they wanted to buy. Jonathan Culler's remarks about tourist *sites* could easily be applied to an analysis of tourist *arts*. "To be fully satisfying," he writes, "the site needs to be certified as authentic.

It must have markers of authenticity attached to it. Without those markers, it could not be experienced as authentic. . . . The paradox, the dilemma of authenticity, is that to be experienced as authentic it must be marked as authentic, but when it is marked as authentic it is mediated, a sign of itself, and hence not authentic in the sense of unspoiled" (1981:137). Traders are caught in the webs of this "paradox of authenticity." On the one hand, by offering authenticity markers, traders satisfy tourist demand for "ethnographic" knowledge. Yet, on the other hand, their role as middlemen and economic intermediaries denies the tourist direct access to the "genuine" cultural encounters which they seek to achieve.

Most of the descriptions that traders use to embellish the objects they sell are derived from marketplace lore—stories that are passed from one trader to another, or that are simply overheard in the banter of marketplace discourse. Many of the stories that are circulated among traders have nothing to do with "traditional" object interpretation or usage—they are simply anecdotes invented to entertain prospective buyers. Among the common items sold in the art market are small wooden masks—palm-size replicas of larger forms. Most of these masks are carved in the style of the Dan of western Côte d'Ivoire; however, miniature masks carved in the styles of several other ethnic groups have also cropped up in recent years. In their original context, miniature masks were integrated into a system of belief in which they functioned as spiritual guides and personal protectors (Fischer and Himmelheber 1984:107). In the market, however, they are known as "passport" masks. Asan Diop, a Wolof trader in one of the art marketplaces of Abidjan, explains the function of "passport" masks to a captive audience of European tourists: "Before the whiteman brought paper and pen to Africa, these small masks were the only form of identification that we Africans could carry with us. Each person owned a carving of himself and each tribe had its own kind of masks. This is the only way people could cross the frontier between tribal groups." The tourists were all amused by the trader's story, and one asked rhetorically, "But where did they put the rubber stamp?" Collapsing the conventional categories of tradition and bureaucracy, the trader's explanation of the mask is phrased in terms which tourists easily can assimilate. It mocks the true meaning of the masks, reaffirms the tourist's sense of technical and cultural superiority, and provides an entertaining tale with which to return home.

ALTERATION OF OBJECTS

Together with presentation and description, traders satisfy Western demand through the material alteration of objects. These activities include the removal of parts, restoration of fractures and erosions, and artificial transformation of surface material and patina. The simplest kind of material alteration consists of removing an object from its mount. Objects from local private collections and galleries are sometimes put back on the market in the hands of African traders. Gallery owners who are having trouble selling certain pieces may choose to liquidate a portion of

their stock by consigning objects to an African trader. The moment the trader receives the art he removes and discards any base on which the dealer may have mounted the object. I questioned a trader as to why he should remove the mount from a piece that was so unbalanced it could not otherwise stand. He told me that his clients would never buy something from him which had been mounted. The presence of the base, it could be argued, indicated that the object had already been "discovered" by another collector and that its "purity" had somehow been compromised by Western contact. Its removal reaffirmed the dominant image of traders collecting art directly from village sources.

To satisfy Western demand for strong evidence of age and ritual use, traders replicate the shiny, worn patina which results from years of object handling. They reproduce surface accumulation of smoke, soil, and dust. And they imitate the encrustation of blood, feathers, and kola nuts which results from repeated sacrificial offerings. Because it is inexpensive and easy, traders tend to spew chewed kola nuts on a wide variety of objects. The process is undertaken on pieces that might normally receive such a treatment, such as wooden face masks, but the principle is also extended to objects that would never receive kola sacrifice—such as wooden hair combs.

During the early eighteenth century in Paris, French collectors of Oriental art were offended by the nakedness of certain Chinese porcelain figures. In hopes of fetching higher prices, Parisian dealers responded to their clients' prudishness by dressing up the figures in French clothes (Rheims 1961:167). In a parallel (but inverted) case, African art traders involved directly with European buyers have remarked that their clients are more likely to buy *naked* Baule statues than those whose waist has been covered by a carved wooden loincloth. Collectors prefer to buy Baule statues that have no loincloth or those with loin protectors made of actual fabric which is affixed to the surface of the wooden sculpture. These type of Baule figures are thought by collectors to predate those that have loincloths carved into the sculptural form itself. Traders have responded to this preference among collectors by systematically removing, with the use of a chisel or knife, the wooden loincloths which cover certain Baule figures. The unstained wood which is left as a result of this process is restained with an appropriate dye, and an old piece of fabric is tied around the figure's waist to cover the damage. I have witnessed some collectors, who are now aware of this practice, peeking under a statue's loincloth to see if its nakedness is genuine or spurious.

Finally, a poignant example of object alteration can be found in one of the recent trends in the Ivoirian art market, namely in the sale of so-called "colonial" statues. Wooden carvings of colonial figures (representing either Europeans or Africans in Western attire) are found in societies throughout West Africa (Lips 1937). Though bearing elements of European design (clothing, posture, and various accoutrements) these statues were not originally conceived for the market but for indigenous use. Among the Baule, according to research conducted by Philip Ravenhill, statues in fashionable dress were used in the same manner as other

wooden statues to represent a person's "spirit mate" in the other world. "A Baule statue in modern garb," he writes, "is neither a replica of a European nor the expression of a wish for a European other-world lover, but rather a desire that the 'Baule' other-world lover exhibit signs of success or status that characterize a White-oriented or -dominated world" (1980b:10).

During the colonial period, modern polychrome statues, such as Baule spirit mates clothed in European dress, were not generally sold in the African art market. A Wolof trader, who has been selling African art in central Côte d'Ivoire for over forty years, recounts the following:

> My father began as an art dealer in Senegal in 1940. In 1945 we moved to Côte d'Ivoire and set ourselves up in the town of Bouaké. At the time, colonial [*colon*] statues had no value whatsoever in the art market. In the region of Bouaké, where there were many such carvings, we called them 'painted wood' and would give them as gifts to customers who purchased large quantities of other merchandise. . . . But some clients even refused to take them for free. (quoted in Werewere-Liking 1987:15)

During the late 1950s, toward the end of French colonial rule in Côte d'Ivoire, foreign administrators, civil servants, soldiers, and other colonial expatriates began commissioning portraits of themselves—as souvenirs to take back home. This gave rise to a whole new genre of "tourist" art which grew out of an indigenous tradition of representing Africans in Western attitudes or attire.

The colonial style of carving has reached new heights of popularity during the past several years. Following a series of well-publicized auctions held recently in London and Paris—where colonial figures sold for significantly more money than they ever had before—the value of colonial statues in Côte d'Ivoire has been inflated dramatically and the production of replicas has swelled. In addition, Werewere-Liking's publication of *Statues colons* in 1987, a photographic guide to "colonial" figures that was widely distributed in Abidjan bookstores and hotel shops, has further increased the demand for such carvings by European expatriates and tourists alike.

Although the tradition of "colonial" figures dates to the advent of European exploration in Africa, most of the pieces on the market today were recently manufactured for the export trade. Traders have noticed, however, that buyers like to believe that the statues were made during the colonial era. When "colonial" carvings are purchased from workshop artists, they are always painted in lustrous enamel colors (fig. 5.5). Traders have found, however, that brightly painted objects do not sell as well as faded, older-looking ones—that is, buyers enjoy the fact that the paint has eroded naturally through time. Thus, when a trader purchases a colonial figure from a workshop, he will invariably remove a layer of paint with sandpaper (fig. 5.6). The object will then be stained with potassium permanganate or similar dye. This treatment of the object produces a darkened surface, with flaked paint, which can often be marketed as antique. The process of artificial aging underscores the separation of art suppliers from art traders. Most of the

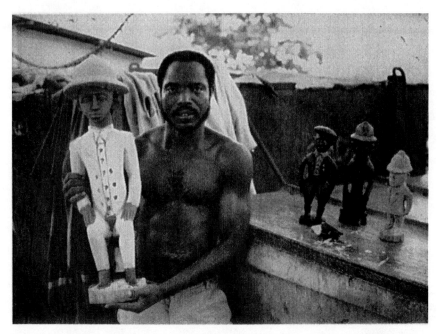

Fig. 5.5. Guinean workshop artist with "colonial" figures. Port de Carena, Abidjan, Côte d'Ivoire, June 1988. Photo: Christopher B. Steiner.

artists producing colonial statues for the market have no idea that their works are being transformed by traders, and furthermore, I believe, they would not really understand why such a transformation would add value to the piece.

CONCLUSION

African art traders are links in a long chain of distribution over which they control neither the supply nor the demand. They can neither create a stock of objects necessary to satisfy the market to which they cater, nor can they create a market for the objects they have in stock. The two principal components of a market system—supply and demand—are controlled by forces external to the trader's world. Supply is dependent on the availability of objects from village sources and on the skills and production potential of contemporary artists. Demand is largely set by Western publications, museum exhibitions, auction records, and the tourist industry.

Like the *bricolage* of Lévi-Strauss's famous mythmaker, the African art trader constructs a product from raw materials and conceptual tools which are limited and predetermined by elements outside his immediate control. The best the trader can do is manipulate the perception of the objects he has with him in order to

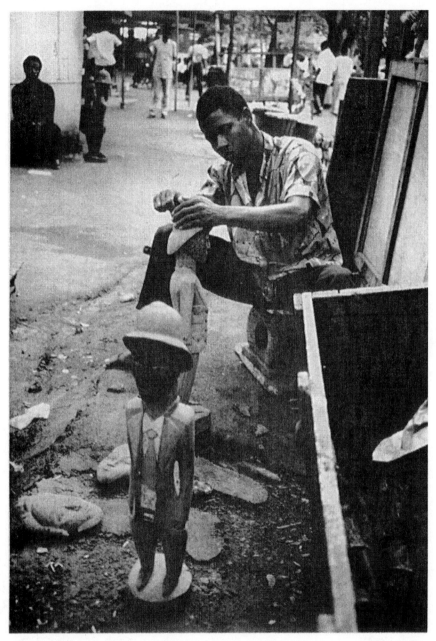

Fig. 5.6. African art trader sanding down the paint from newly arrived "colonial" statues. Abidjan, Côte d'Ivoire, June 1988. Photo: Christopher B. Steiner.

meet what he believes are the tastes and demands of the Western buyer. The "art of the trade," in this sense, does not involve the manufacturing of any product, but consists rather in the symbolic structuring and engineering of what is already at hand.

Although I respect and espouse E. P. Thompson's (1966) assertion (*contra* Althusser) that historical subjects are as much determining as determined in shaping the(ir) world through lived experience, I also believe that the intentionality of historical life is not without limitations. That is to say, culture must be understood as something that offers not only a range of possibilities but also something which presents a limit on the possible (cf. Ulin 1984:148–153). Thus, although African art traders fashion and market images of Africa and African art, these images are constrained by the buyer's a priori assumptions about what is being bought—that is, the images are constructed to *satisfy* demand rather than to *create* demand.

Separated by oceans of geographic distance and worlds of cultural differences, African traders and Western consumers are brought together in a fleeting moment of economic exchange. From this brief transaction, buyers and sellers leave with vastly different impressions of their encounter. The buyers, on the one hand, depart with the artifacts of seemingly remote and distant cultures that will become integrated into a world of meaning and value comprehensible only through Western eyes. The sellers, on the other hand, walk away with renewed impressions of Western tastes and desires that will become part of their store of knowledge of how tourists and collectors perceive Africa and its art.

NOTES

This essay is a slightly revised version of an article that first appeared in 1990 under the title "Worlds Together, Worlds Apart: The Mediation of Knowledge by Traders in African Art" in a special issue of *Visual Anthropology Review* 6:1 devoted to "The Image of Africa" guest edited by Lucien Taylor. It is reproduced here by permission of the Society for Visual Anthropology and the American Anthropological Association. A more extensive treatment of the ideas presented in this essay may be found in my book *African Art in Transit* (Cambridge University Press, 1994), where full acknowledgements also appear.

All translations from the French in this article are by the author.

REFERENCES

Bateson, Gregory
 1951 "Conventions of Communication: Where Validity Depends upon
 Belief." In Jurgen Reusch and Gregory Bateson, eds., *Communication: The
 Social Matrix of Psychiatry*, pp. 212–227. New York: W. W. Norton.
Conway, Sir Martin
 1914 *The Sport of Collecting*. London: Fisher Unwin.

Culler, Jonathan
 1981 "Semiotics of Tourism." *American Journal of Semiotics* 1(1–2):127–140.
Fischer, Eberhard, and Hans Himmelheber
 1984 *The Arts of the Dan in West Africa.* Zurich: Museum Rietberg.
Jules-Rosette, Bennetta
 1984 *The Messages of Tourist Art: An African Semiotic System in Comparative Perspectives.* New York: Plenum Press.
Lehuard, Raoul
 1977 "Un voyage en Côte d'Ivoire." *Arts d'Afrique Noire* 23:26–33.
 1979 "Un voyage en Haute-Volta." *Arts d'Afrique Noire* 31:11–19.
Lips, Julius E.
 1937 *The Savage Hits Back.* Reissued 1966. New Hyde Park, N.Y.: University Books.
MacCannell, Dean
 1976 *The Tourist: A New Theory of the Leisure Class.* New York: Schocken Books.
Mailfert, André
 1968 *Au pays des antiquaires: confidences d'un "maquilleur" professionnel.* Paris: Flammarion.
Price, Sally
 1989 *Primitive Art in Civilized Places.* Chicago: University of Chicago Press.
Ravenhill, Philip L.
 1980a "Art." Ivory Coast Supplement to the *Financial Times* (London), Dec. 9, 19.
 1980b *Baule Statuary Art: Meaning and Modernization.* Working Papers in the Traditional Arts, vol. 5. Philadelphia: Institute for the Study of Human Issues.
Rheims, Maurice
 1961 *The Strange Life of Objects.* New York: Atheneum.
Spooner, Brian
 1986 "Weavers and Dealers: The Authenticity of an Oriental Carpet." In Arjun Appadurai, ed., *The Social Life of Things: Commodities in Cultural Perspective,* pp. 195–235. Cambridge: Cambridge University Press.
Steiner, Christopher B.
 1994 *African Art in Transit.* Cambridge: Cambridge University Press.
Thompson, E. P.
 1966 *The Making of the English Working Class.* New York: Vintage Books.
Ulin, Robert C.
 1984 *Understanding Cultures: Perspectives in Anthropology and Social Theory.* Austin: University of Texas Press.
Werewere-Liking
 1987 *Statues colons.* Paris: Les Nouvelles Editions Africaines.

The Patronage of Difference: Making Indian Art "Art, Not Ethnology"

Molly H. Mullin

The art of the Indians, so eloquent of this land, is American art and of the most important kind. A hundred years ago, men could not have realized this. Art was then a thing to be seen in the Vatican or in the Louvre.
WALTER PACH (1931)

When the Exposition of Indian Tribal Arts opened at Grand Central Art Galleries in Manhattan in 1931, critics announced the "first truly American art exposition." The Exposition brochure described the event as the first exhibition of "Indian art as art, *not* ethnology," and quoted one critic's statement that "the cry for 'American' art has been answered." According to John Sloan, the New York-based painter and one of the key organizers of the Exposition, "spreading the consciousness of Indian art in America affords [a] means by which American artists and patrons of art can contribute to the culture of their own continent, to enrich the product and keep it American" (SAR, AEWC, a). Such statements suggest connections between a popular acceptance of relativist notions of culture associated with anthropology and attempts to use art—an honorific category intimately related to class-structured distinctions[1]—and taste as a way of reimagining American national and regional identities. These newly imagined identities celebrated cultural pluralism, particularly as expressed through commodities validated as art.

In this article I explore how such a utopian affirmation of cultural difference—an early, more colonial version of *multiculturalism*—reflected elite responses to the rise of consumer capitalism. The 1920s and 1930s were a period of heightened concern with representations of the national identity as well as with the implications of mass consumption (C. Alexander 1980; Susman 1973, 1984). For patrons of Indian art, including those who sponsored the 1931 Exposition, commodity consumption represented both problem and solution in matters of identity; part of the solution involved recasting carefully selected commodities, produced by ethnic and racial others, as art.[2]

Relationships between art, national identity, and class-related distinctions have been neglected in some of the more influential examinations of Primitivism and the taste for the objects of colonial others. Works such as those of Clifford (1988),

Price (1989), and Torgovnick (1990) have provocatively critiqued oppositions between primitive and modern, self and other, but in a way that sometimes tends, inadvertently, to reproduce such binary structures of thought. "How do 'we' relate to 'them'?" is the fundamental question posed. The self, however, is as much a social fiction as the other and glosses an infinite number of alternative boundaries of difference. By considering examples of early attempts to promote American Indian art, I hope to draw attention to ways in which a consideration of distinctions typically falling outside the category of *culture* may complicate the self-other dichotomy. Concern with *otherness* and its metonymic objects occurs in specific historical contexts, contexts that may be obscured by analyses of a more global nature and by such broad terms as *Primitivism* and *Orientalism*.

In addition to suggesting ways in which discourses centering on culture may be illuminated by a consideration of class, my aim is also to emphasize the importance of considering theories of taste, value, and evaluation—as explored by Bourdieu (1984), Thompson (1979), and Smith (1988)—in relation to race, ethnicity, and change. *Distinction* (Bourdieu 1984) is, after all, a markedly historical analysis with little consideration for racial, ethnic, or geographical differences. By showing, however, that even the most avant-garde of tastes may serve to legitimate and reproduce inequalities, and by blurring the boundaries between culture and power, Bourdieu suggests complications for ideals of cultural pluralism. His analysis, for example, places anthropologists in a particularly awkward relation to markets in art produced by anthropology's historical subjects, where the work of anthropologists and related scholars plays an important role in constructing the value of objects. The role of anthropologists in these markets becomes even more politically ambiguous as colonial others increasingly adopt the often useful strategy of what Brian Wallis has termed, in an article on recent national cultural festivals, a "Self-Orientalizing mode" (1991:88). In lieu of simple answers to the questions arising from this encounter between art and anthropology, it may be worth considering its historical precedents.

The context in which American Indian art was promoted during the first half of the twentieth century was a formative one for anthropology as a discipline, a period when anthropologists were securing their place in the academy while constructing their most marketable conceptual tools—notions of culture and cultures that could be described authoritatively by the professional ethnographer. Interest in cultures was not, however, confined to anthropologists, who both influenced, and were influenced by, widespread social and intellectual trends.[3] Discussing the 1930s in America, historian Warren Susman has argued that the period was one marked by the widespread "discovery" of the concept of culture (1984:153–154, 1973:2–8), a concept already of central importance to anthropologists and many other intellectuals. Not only were works by anthropologists like Mead and Benedict reaching wide popular audiences, but other prominent intellectuals, like popular author Stuart Chase, were using ideas and research derived explicitly from the work of cultural anthropologists. The examples I discuss here are suggestive of

some of the ways in which the idea of cultures resonated outside the academy and how this new division of peoples accommodated a search for national consensus and drew attention away from other sorts of categories, particularly that of class.

The notions of culture supported by anthropology were, no doubt, effectively employed as persuasive critiques of many sorts of intolerance. It is also certainly the case that, during the period in question, anthropologists debated various theories of culture and its relation to history, individual variation, and political-economic processes. But regardless of academic theorizing, the basic idea that peoples of the world belonged to different cultures, each worthy in its own way, was a powerful one, generally supported by anthropology, and a concept that promised a solution to perennial concerns about America's relationship to culture. As Russell Lynes wrote in his 1949 study, *The Tastemakers* (a study that makes for a useful contrast to *Distinction* in its unrelenting emphasis on contested standards of taste and the continual possibility of resistance and change), "Through the story of the history of our taste has run a constant theme—if America is to be great, America must have culture" (1949:7), a difficult demand to meet when culture was equated with elite European art forms and institutions that a former colony could only emulate.

While the slogan adopted by the "Exposition of Indian Tribal Arts, Inc." suggested an antagonistic relationship between *art* and *ethnology*—the one approach revolving more around aesthetic appreciation and the other emphasizing the pursuit of scientific knowledge—in fact, the Exposition grew out of a rather congenial coalition, fairly typical of the period, of artists, art patrons, and anthropologists who saw themselves as united in their tastes as well as in their politics against forces of assimilation and intolerance.[4] The Exposition's accompanying booklet, "Introduction to American Indian Art," was jointly authored by John Sloan and Oliver La Farge, an indicative collaboration of painter and anthropologist-turned-novelist (La Farge, in fact, had just won the Pulitzer prize for his 1929 novel of Navajo romance, *Laughing Boy*). Book orders were taken at the Exposition, and the catalog of available literature included works by poets, novelists, and folklorists, along with those by anthropologists and archaeologists. Although the "art, not ethnology" slogan did indicate a slight shift of emphasis in the discourse of evaluation—from *authenticity* to *quality*—there was no radical challenge to anthropological authority, just as anthropological notions of culture, especially in their popular applications, were not so very incompatible with the more Arnoldian notion of culture as "the best which has been thought and said" (Arnold 1925:6).[5]

SEARCHING FOR AMERICAN PLACES
AND DISCOVERING CULTURES

Although the Exposition of Indian Tribal Arts attempted to include Native artists from various regions of the United States, its emphasis was on the Southwest. Its organizers belonged to a generation of eastern Anglo-American intellectuals,

artists, and art patrons who began settling in southwestern regions, particularly northern New Mexico, in increasing numbers after World War I. Rejecting tastes that mimicked the European aristocracy—the tastes underlying, for example, the gilded Vanderbilt mansion in Newport, Rhode Island, built by craftsmen imported from France—these travelers and settlers in the Southwest sought instead a humble authenticity, a reverse form of conspicuous consumption. They quickly discovered, in the words of one Indian art patron, "the value of Indian culture and art" (Dietrich 1934:100). In so doing, they reacted against the coercive, assimilationist policies of the federal government, and of Christian missionaries, as well as against a more pervasive contempt for those characterized as primitive. While they fought the government's efforts to make Indians "American," they joined a campaign to reconfigure the national identity and began to promote Indians as "the first Americans" and as the creators of "original American culture" (e.g., Hewett 1922).[6] The preservation and the national appropriation of Indian cultures apparently were not seen as contradictory aims.

The Southwest, where American cultural nationalists were most apt to encounter Indians, held especially promising possibilities for remapping the geography and aesthetics of American identity—away from Europe and from colonial New England—by virtue of monuments of comparable antiquity and landscapes, commodities, and people appearing startlingly unique. In addition to American Indian and Spanish Colonial art, and dramatic open spaces, the Southwest offered antique furniture at least as old as could be found in New England, inexpensive land and labor, and architecture, which, like pottery, weaving, and handmade silver jewelry, could be praised as a "true product of America" and a "purely indigenous art" (Sims 1922:103). There was no risk of pretentiously imitating Europe in, as Waldo Frank described them in 1919, "these squat, straw-grained homes with their bright blue shutters and their crimson flowers." When Frank, a Yale-educated man of letters and a determined cultural nationalist, traveled briefly through the Southwest by "motor-bus," he discovered in its Hispanic and Indian inhabitants material for a new vision of what he called "Our America." Protesting what he called "the hegemony of New England," Frank proposed that "America is a land with a shrieking rhythm"; praising Indian aesthetics, he claimed that "Indian art is classic, if any art is classic" (Frank 1919: 5, 75, 95, 114).

Frank was among the more intellectual and well-published admirers of the Southwest, but his concern with the region remained superficial. (Frank, in fact, like a number of Manhattan intellectuals of the period, saw little hope for projects of cultural preservation and was not completely unappreciative of such emblems of modernity as machines, skyscrapers, and factories.[7]) There were, however, countless other such "discoveries" of Southwestern virtues and their relevance to the project of reworking the national identity, particularly in terms of the nation's relation to culture; many authors of such visions, unlike Frank, moved from celebrating the region's national significance to a practical commitment as advocates for the region's ethnic and racial others. Several such authors eventually became

involved in the network of Indian arts enthusiasts at least peripherally behind the 1931 Exposition.

Elizabeth Sergeant, for example, who first visited the Southwest in 1916 at the urging of Willa Cather (Sergeant 1953:141), returned after World War I to write utopian descriptions of northern New Mexico such as those found in her widely read "Journal of a Mud House," which appeared in *Harper's* in 1922. Here Sergeant attempted to answer the question of "why a woman who might live in France 'should go and bury herself in the desert.' "[8] By the time her *Harper's* pieces were published, Sergeant had become actively involved in fighting to protect Pueblo land, religious freedom, and art (along with becoming an independent student of anthropology)—although she parted company with the key sponsors of the Exposition in the early 1920s after a disagreement concerning political strategies in the fight to protect Indian land rights. Mary Austin, Witter Bynner, Alice Corbin Henderson, and Mabel Dodge Luhan similarly promoted southwestern Indian art while authoring oppositional, southwestward-leaning constructions of the national identity.[9]

As they rejected identities oriented toward Europe and the Northeast, American cultural nationalists of the 1920s and 1930s found inspiration in Mexico, as well as in the southwestern United States (Stocking 1989:229). In her autobiography, Mary Austin connected her decision to settle in New Mexico and encourage Indian and Spanish Colonial art to the Mexican revolution. Developments in Mexico, Austin claimed, made her optimistic about "the possibility of the reinstatement of the hand-craft culture and of the folk drama" (Austin 1932:336). Austin recalled that when she saw Diego Rivera's murals and spoke with him, she found support for her efforts to document "the American Rhythm," the title of her 1923 book on "Amerindian" verse, as an element of a new national culture (1932:365).

Many other American intellectuals were similarly inspired by travels in Mexico and encounters with Mexican revolutionaries and artists. An apt example of the importance of Mexico in attempts to reimagine the identity of the United States— also an example of the popular influence of anthropology—can be found in Stuart Chase's best-seller, *Mexico: A Study of Two Americas* (1931),[10] illustrated by Diego Rivera, in which Chase compared Tepotzlán and "Middletown," the "machine age" and the "handicraft age," and found Tepotzlán by far the more authentically *American* place, largely because of its Indian inhabitants and their crafts ("in race as well as in culture, Tepotzlán is almost pure American, while [Middletown] is an omelette of English, French, Poles, Italians, Czechs, Russians, Negroes" [1931:15]). "Why," Chase asked, recalling a visit to a "timeless" pyramid, "should we arrogate to ourselves the name 'America' at all?" (S. Chase 1931:7).

Chase, like other intellectuals of his generation, was especially attracted to Indian cultures and handicrafts because they were thought to illustrate nonalienated labor, a merging of the utilitarian and the creative, art and community, undivided by class and the distinctions of taste ensuing from mass consumption. Indian

art—in New Mexico and "Old"—was also important because it could so easily be seen as embodying regional character (although there was, of course, the constant matter of whose Indian art? whose definition of regional character?). It was perceived as truly distinctive—each piece "one of a kind"—and as inseparable from the natural landscape ("our soil," according to art critic Walter Pach [1931]). Even more important for cultural nationalists, perhaps, it seemed to possess an integrity resulting from obliviousness about what might be the fashion in other places. Indian art expressed, for its enthusiasts, an utter self-confidence in its isolation. Its seeming self-sufficiency stood in opposition to the trend toward global political and economic integration and the hegemony of center over periphery.

Indian art was also able to satisfy increasingly popular demands for connection to an American past, something cultural forms associated with Europe and the genteel tradition were seen as lacking. While American intellectuals, following Whitman, struggled to resolve the question of how the nation could develop an independent national artistic tradition (C. Alexander 1980), Indian art promised connection to a distinctly American time (as well as an American race). Eventually this attachment to national and regional history, place, and race would impede the extent to which Indian art could be admitted to fine-art circles—particularly after World War II, when, as Charles Alexander argues (1980), American cultural nationalism in the arts gave way to a more universalistic high modernism—but it especially helped the efforts of philanthropists who, during the 1920s and 1930s, sought to develop new, more prestigious, and profitable markets on behalf of Indian artists. As the nation emerged from World War I with greater political and economic power, Americans were more prepared than before to embrace a confident national identity, represented by art.[11] But, although cultural nationalism would seem to stress the unity of the nation, it also hinged on regionalism and an acute awareness of the uniqueness of particular places.

In addition to an insecurity about the definition of the nation, the demand for regionalism was driven by a perception of the imminent disappearance of distinctive regional character. As David Harvey has explicated so clearly in *The Condition of Postmodernity* (1989), the greater the mobility of capital, the stronger the nostalgia for place-specific identity (though, of course, nostalgia is not equally distributed). From the early twentieth century in Santa Fe, migrating art enthusiasts from the East shunned bungalows in favor of adobes (see, e.g., Weigle and Fiore 1982; Wilson 1990). And while the eastern transplants were decorating their adobes with Indian and Spanish Colonial art, in Appalachia, patrons of similar (mostly New England, upper-middle class) backgrounds were promoting the revival of mountain folk arts (Whisnant 1983; and Becker 1992). In 1931, the year the Exposition of Indian Tribal Arts opened in Manhattan, Abby Aldrich Rockefeller, a supporter of the Exposition, was beginning to purchase folk art from throughout the country— the collection that in 1939 would be her gift to Colonial Williamsburg and a showpiece of the national identity.[12]

However, the struggle to capture national and regional character was spurred

on not only by fears of creeping uniformity, but was also imbued with more class-specific visions of the nation being engulfed by cheaper, commercial, and inauthentic tastes. Indeed, while tourism was becoming a national pastime—the development of highways and the mass production of automobiles giving new meaning to the slogan "See America First" (which southwestern travel writer Charles Lummis [1925] claims credit for coining before the turn of the century)—celebrities were emerging with the rise of the mass media and the commodification of leisure. This emergence contributed to a sense that identities could be entirely self-made, requiring only ambition and personal success, independent of any inherited status or even of more bourgeois forms of cultural capital. As Warren Susman has argued, the national economy was shifting from an emphasis on production to one centered on increasing consumption, and along with that, working-class and middle-class consumers were taking on new measures of cultural authority, an authority disturbing to intellectuals of diverse political allegiances (Susman 1973, 1984).

In 1922, Nathalie Curtis, a classical musician and a dedicated collector of southwestern Indian music, wrote of an emerging Indian-focused southwestern literature, and revealed some important connections between anxieties about the proliferation of commodities and the loss of regional character, while offering a vision of the redemptive possibilities of art. Curtis claimed that

> although New Mexico is so foreign to the character of much of our country that visitors have been known to talk of going back to New York as "returning to America," it is nevertheless, a very real part of these United States, with a distinct utterance of its own. A land lives through its artists, even after the people themselves have perished. That type of Americanization which is largely a matter of mail order house clothes and crockery, of chewing gum and "movies" will soon wipe its erasing hand across the Southwest like a well-meaning but ignorant servant who zealously "setting to rights" an artist's studio, dusts off his pastels. One can not sufficiently praise this growing literature of the Southwest which reminds us of the worth and beauty of a section of America that is still free from machinery and—marvelous to relate—free from bill boards as well. (Curtis 1922:99)

The anxieties Curtis had about Americanization were expressed not only as passive laments (nor was her servant metaphor insignificant). The ideology and institutions of art provided a means by which patrons could actively attempt to influence the public taste, expressions of cultural and regional difference, and, ultimately, the national identity.[13] The Exposition of Indian Tribal Arts, which toured major cities of the East and Midwest for two years, with a side trip to Venice, is but one example of attempts to draw on newly popular notions of cultures as relatively stable, harmonious, consensual wholes, while also—if unintentionally—supporting the notion of culture as the province of an elite.[14]

Although John Sloan served as president of the Exposition of Indian Tribal Arts, his title was mostly an honorary one and intended to draw public attention; the driving force behind the show was actually a newspaper heiress and turn-of-the-century Bryn Mawr graduate from Manhattan, Amelia Elizabeth White.[15]

White had long been interested in American Indians, and as early as 1915 had begun consulting archaeologist F. W. Hodge, of the Heye Foundation, about her library of ethnographic literature (Hodge 1915)—just as from the early 1920s on, she regularly consulted such authorities as John Sloan and Walter Pach concerning her library devoted to modern art (SAR, AEWC, b). A Republican, like many other women of the era who became powerful advocates of Indian rights and patrons of Indian arts, White had global travel experience, was influenced by the early-twentieth-century settlement house movement, and had learned political organizing skills in the movement for women's suffrage. White, like her close friend Margretta Stewart Dietrich—a prominent Republican suffragist, Main Line Philadelphian, and fellow Bryn Mawr alumna—became enchanted with Santa Fe in the early 1920s and, encouraged by her friend Elizabeth Sergeant's "Journal of a Mud House," bought up large tracts of land while joining the battle for Indian legal rights.[16] Both White and Dietrich, along with an extensive network of other wealthy arts patrons and less wealthy artists and anthropologists, began to amass substantial collections of Indian art and threw themselves into a decades-long campaign to promote "authentic" Indian art and to institutionalize standards of evaluating it.

By naming the 1931 event an *exposition*, the sponsors were appropriating a term from what they saw as opposing forces. Since the late nineteenth century, American Indians and their wares had been put on display at world's fairs, often called expositions—one of the most influential being the 1893 World's Columbian Exposition in Chicago—events which Curtis Hinsley has aptly termed "carnivals of the industrial age" (1991:344). The Indians on display at such events were used as a foil for industrial progress and treated as exotic objects of curiosity. The sponsors of the Exposition of Indian Tribal Arts sought instead to ally Indians with the romantic discourse of art rather than commerce, with the museum rather than the carnival, the elite rather than the crowd.[17] As Dolly Sloan wrote to Amelia Elizabeth White concerning the possibility of loaning materials to the 1939 World's Fair, "I agree with you that we must not go into the World's Fair unless they will show the collection as Art and I do not feel that they will" (SAR, AEWC, c).

The cultural nationalism emphasized in the Exposition literature, although sincere, was partly a means of gaining public attention and support during years when it must have been difficult, especially in New York, to draw concern away from breadlines, Hoovervilles, and massive unemployment. While their motivations were clearly complex, Indian arts patrons perceived their actions as pure philanthropy. By placing Indian handicrafts in the category of fine art, they aimed to make art production a more economically profitable, pleasant, and respectable activity for southwestern Indians, a means of livelihood which would enable Indians to remain in their rural homelands and to continue to follow the rhythms of tribal calendars, observing important occasions with ceremonial dances, at which arts patrons were frequent and appreciative guests. Encouraging arts production was also a way of avoiding sharp divisions between the domestic and public econ-

omy; many of the artists promoted were women, often elderly, with strong ties to home and family, who created their art in their backyards or in their kitchens, with the help of husbands and relatives. To establish Indian art as art—not a simple task because its forms were associated with the domestic and utilitarian, not to mention primitive—the philanthropists recognized that their aim must be twofold: to encourage Indians to make pieces in accord with elite tastes (tastes that, in Indian art, were influenced by many Indians as well as by anthropologists and took older Indian artwork as their standard of excellence), and to educate potential buyers.

Of course, one of the most direct and elementary means for patrons to exercise authority in the Indian art market was to purchase what they liked (for themselves and for others) and at higher prices than most tourists and traders were willing to pay. One of Amelia Elizabeth White's initial steps to promote Indian art was to open an Indian art gallery on Madison Avenue in Manhattan, one of the first of its kind, called "Ishauu" (later the "Gallery of American Indian Art," on Lexington), which she operated at a loss for more than a decade (SAR, AEWC, d). Figure 6.1 displays a similar establishment and suggests that consumers, depicted here as upper-middle class women in fur coats, were uncertain how to classify and evaluate the items for sale. Patron-philanthropists such as White sought to establish Indian art as a clearly identifiable category, with reassuring standards for evaluation. In 1922, just shortly after White returned from working with the Red Cross in Belgium and Paris during the war, she wrote of her intentions to Mabel Dodge Luhan, who had recently moved to Taos: "My idea is to show people here in the East the very best things the Indians make and to pay the Indians a fair price for the *best*. I hope in time the Indians will stop making the trashy stuff that is sold as 'Indian art' along the Santa Fe road" (White 1922).[18]

The Exposition was a project designed even more specifically to influence the tastes of potential buyers. To ensure this influence, White, Sloan, and their colleagues used all their contacts and authority: in addition to obtaining additional financial backing (including $5,000 from the Carnegie Corporation), the official endorsement of the College Art Association, and nominal sponsorship by the Secretary of the Interior and the Commissioner of Indian Affairs, they enlisted the support of newspapers, prominent art critics like Walter Pach, archaeologists like F. W. Hodge, and well-known collectors of Indian art, including Abby Rockefeller and Lou Henry Hoover. Press releases listed the elite sources of the artwork on exhibit: from the private collections of, for example, Amelia Elizabeth White, Mary Cabot Wheelwright, Mrs. Herbert Hoover, and Mrs. John D. Rockefeller, Jr. For its part, the Junior League of New York City staged a fashion show featuring Indian silver jewelry (the Associated Press reporting that "Miss Challis Walker, a prominent debutante, wore a gown of sheer black velvet with a jet and turquoise necklace, and a silver belt . . . all made by Navajo Indians"). White, meanwhile, distributed photographs of Indian art used as decor for her Manhattan apartment and of Pueblo pottery displayed in her garden in Santa Fe, photographs that were

◿METROPOLITAN ◿MOVIES

Trade Mark Reg. U. S. Pat. Off.

"Isn't it cute—for a present, I mean"

Fig. 6.1. Cartoon from the *New York World*, 1929.

used to illustrate articles in newspapers and in magazines like *House and Garden* and *House Beautiful* (e.g., "If You Would Decorate Your Home *Earliest* American"). As Dolly Sloan wrote to Amelia Elizabeth White concerning the importance of such publicity, "We must let people know that some people are collecting Indian art" (SAR, AEWC, d). The success of the Exposition, at least in gaining public attention, may be indicated by the fact that their exhibition openings began to be accompanied, not entirely to the sponsors' satisfaction, by Indian displays in department stores like Macy's and Bloomingdale's. (In 1932, Dolly Sloan wrote to Amelia Elizabeth White: "After seeing our show in New York and Springfield, I never thought Indian art could look as rotten as it does at Bloomingdale's" [SAR, AEWC, e].)

In making celebrities of some of the Indian artists whose work was included in the exhibition, newspapers played up a connection—or an opposition—between the artists' geographically limited backgrounds and their aesthetic genius. Repeatedly, syndicated newspaper articles quoted Pueblo painter Alfonso Roybal's response to the question of how he liked New York: "Have you ever seen Santa Fe?" (SAR, AEWC, f). Describing the opening of the Exposition, one journalist remarked on "designs so dashingly modern that one can scarcely believe they were woven into a blanket by an Indian woman who never heard of Paris" (Seinfel 1931:E2). Similarly, in articles praising Tonita Peña, a painter whose work was purchased by Margretta Dietrich, Amelia Elizabeth White, Abby Rockefeller, and the Whitney Museum, journalists played up a contrast between Peña's geographical naiveté and her aesthetic sophistication (in addition to praising her work as "racially authentic"): "Tonita Peña's paintings," reported an article entitled "She Learned from the Corn, the Rain and the Buffalo," "have travelled far more than she, for this Indian woman, mother of six children, seldom journeys from the Cochiti Pueblo in New Mexico" (*Providence Sunday Journal* 1933). Such comments suggest the sensationalism and appeal of the idea that there might be systems of aesthetic value existing independently of the core of the modern world system and the historic capitals of fashion.

INSTITUTIONALIZING THE EVALUATION OF DIFFERENCE

Miss White said the big question now was: how to combat the tourist trade. The Indians can sell much more of the junky type of pottery than the good. Some means must be found to improve the pottery.

SRCA, SWAIAC, a

The Exposition claimed to present works "chosen entirely with consideration of aesthetic value." Although the break with more ethnological approaches to such objects was not at all complete, the Exposition organizers sincerely sought to break down distinctions between objects valued as ethnology and those valued as fine art. Certainly they did not consider Indian art the exclusive province of museums

of natural history, and felt Indian arts should be represented in museums like the Whitney (which opened in 1931), the Metropolitan Museum of Art, and the many museums then springing up throughout the country devoted to modern art and fine art. In fact, an explicit purpose of the Exposition was to challenge the ethnocentricity of notions that only art linked to a European or Euro-American tradition was worthy of the name. And in an attempt to counteract the anonymity of artists in ethnological exhibitions, the Exposition was also intended as a way to obtain public recognition for individual Indian artists.

The assumption, however, that aesthetic value could be adequately judged by those possessing sufficient knowledge and "good taste," enabled Indian arts patrons to attempt to influence Anglo and Indian tastes and identities, and to exercise a form of cultural authority that could attempt to compete with that of tourists seeking trinkets.[19] In the Exposition's "Introduction to American Indian Art," Sloan and La Farge end their discussion of beadwork by mentioning that the cultural authenticity of designs is increasingly difficult to determine, offering as example the fact that Indian beadworkers "began depicting horses and American flags long ago"; it is difficult, therefore, to "draw the line between what is, and what is not, truly Indian." Their solution to the dilemma is revealing in its vagueness:

> The criterion has to be largely one of taste, and of the Indian feeling. They turn out many silly things, such as ornamented rabbits' feet or poorly conceived designs slapped onto factory made moccasins, but there are many of them today who prefer the old, rich masses of decoration, containing still the vigour and brilliance of their ancient warriors. (La Farge and Sloan 1931:25)

Similarly, in a display of open-mindedness, La Farge and Sloan praise the new bright colors of Hopi and Jicarilla basketry—which they claim ethnologists frown upon—asserting that certainly Indian art cannot be expected to remain unchanged; but then they admit that many "white buyers" have led basket makers astray in encouraging the use of "fancy pseudo symbols" (La Farge and Sloan 1931:11). The assumption behind their swift flips between authenticity and good taste, of course, is that these are really two sides of the same coin. Their fellow patron, the poet Witter Bynner, who lent his collection of silver jewelry to the Exposition, was even more willing than they to dispense with ethnologists as the primary authorities of evaluation and to rely on his own, supposedly innate, good taste. Discussing his collection of Indian silver, Bynner stated frankly that he knew

> nothing of the history of silver-work among Indians, nothing of the origin or significance of the designs they use. For me that is not the point. I can only wheeze with other amateurs that I know what I like. But at the same time I can instinctively and instantly reject the false design, the design which means nothing to its maker except foreign instruction or intended sale. (Bynner [1936]1979:337)

While projects such as White's Manhattan gallery and the 1931 Exposition were meant to influence Easterners' perceptions of Indians and their arts, local activities allowed Indian arts patrons to have a more direct influence on the artists them-

selves (among whom, patrons felt, there had been too much foreign instruction and catering to the vulgar, uneducated tastes of tourists). In 1922, the School of American Research had begun to sponsor annual "Indian fairs" in Santa Fe, including exhibitions of Indian art at which cash prizes and ribbons were awarded for the best pieces. The exhibitions were organized by anthropologist (and, one might argue, professional cultural nationalist) Edgar Lee Hewett, whose academic credentials were rather dubious, but who had managed nonetheless to position himself as one of the more influential anthropologists in the region (Stocking 1982). Typical of the division of funding and expertise in local Indian arts patronage (where women were most often patrons and men authorities), prizes for the fairs were funded by a "Miss Rose Dougan, of Richmond, Indiana . . . who has become deeply interested in the life of the Pueblo Indians and has given unsparingly . . . in an effort to raise the standard of their native arts and handicrafts" (*El Palacio* 1922a). The early exhibitions were held in conjunction with Santa Fe's Annual Fiesta, a pageant and three-day event billed as celebrating "the culture of a thousand years and more," which invited audiences "to live over a cycle of American culture history that has been rescued from oblivion" in a setting filled with "picturesque landmarks" and "stupendous mountain scenery," with nearby remains of cliff dwellings that "housed a great culture in the days when Europe was still in the shadow of the Dark Ages" (*El Palacio* 1922b).

Edgar Hewett, who coordinated the early fiestas much like a circus ringmaster, was rather too accommodating of tourists (and probably too lax in his standards of authenticity) to suit the tastes of the artists, art patrons, and sophisticated anthropologists who gradually gained control over the events.[20] In 1927, the Indian Fair aspect of the Fiesta was taken over from Hewett and the School of American Research by a committee of volunteers, among them Margretta Dietrich and Amelia Elizabeth White;[21] in addition to continuing to award prizes at the big annual spectacle in Santa Fe, they also began to hold fairs at the various northern pueblos where experts—including anthropologists, modernist artists, and collectors—would award ribbons and cash prizes to Indian artists. Some of the items displayed and sold at the Exposition of Indian Tribal Arts were, in fact, acquired through fairs held during the summer of 1931 (LA, KCC, a). Although judge Kenneth Chapman reported sadly to the committee, after a fair held at Cochiti Pueblo in 1935, that the quality of art was so "disgracefully poor" that reprimands were given instead of prizes, more often the artists were at least deemed worthy of encouragement (LA, KCC, b).

Despite the blatant paternalism, relations between artists and their patrons were typically congenial, with artists and the Pueblo political leadership usually in support of an arrangement that promised to bring at least some of their members economic rewards and prestige, prestige within their communities as well as outside them. In addition to the more long-term benefits of artist status, Indian artists welcomed the opportunities patrons provided them to sell their work directly to the

public, bypassing traders. Moreover, many of the artists approved of the evaluative distinctions made by patrons, especially when they concurred with their own preferences. Although individually expressed resentments were common (when, for example, an artist was offended by an award going to another artist), there were only occasional efforts to resist the overall patterns of patronage.

In the 1930s, the pueblo of Tesuque became an exception to the more general trend toward embracing the opportunities that patronage offered. When members of the New Mexico Association on Indian Affairs tried to bring Tesuque potters to a fair in Santa Fe, they reported that the potters were reluctant to participate because they did not want to compete with one another for prizes. The potters, it was reported, said they feared Tesuque would become divided into "good" potters and "those who make the poorer painted type" and suffer the sort of factionalism that had occurred at nearby San Ildefonso (SRCA, SWAIAC, b),[22] where potter Maria Martinez was becoming something of a national celebrity and where a number of other potters and painters had begun to establish significant reputations and to command high prices for their work.[23] Although Association members seem to have been remarkably unconcerned about the potters' anxieties, that same year one erstwhile member, Elizabeth Sergeant, did write a harshly critical analysis of the social consequences of patronage at San Ildefonso, arguing that patronage, inevitably selective and arbitrary, encouraged rivalry, political and economic inequality, and divisiveness among the pueblos (Sergeant 1935).

More often than resistance to the overall system, there were tensions among individual artists and judges of the fairs, the judges placing ribbons on the various pieces as the producers sat beside them. Marjorie Lambert, an archaeologist who judged pottery at the Indian fairs during the 1930s and 1940s, recalls that one of the most well-known potters, Rose Gonzales, who was also her friend, refused to speak to her after Lambert awarded a ribbon to another potter (personal interview, 1991). Hard feelings about the prizes were not merely a matter of personal pride, but a consequence of the direct economic impact of the awards. By the early 1940s, judges at Santa Fe Indian fairs were trailed by collectors, who sought to buy the prizewinning pieces and were willing to pay considerably more for them.[24]

The standards of evaluation instituted by patrons did, of course, vary over the years, in response to artists' initiatives as well as the changing tastes of patrons. But there was little in the way of serious disagreement among judges of the Indian fairs, some of whom were archaeologists, others serious collectors, some artists who were collectors, but none of them Indian. According to the regulations of the Fair, distributed months in advance every year:

> All articles in order to compete for prizes must be strictly Indian in material, handicrafts, and decoration. For instance, pottery should not be made in the shape of non-Indian dishes or other utensils; and blankets, textiles, beadwork, and other articles should not contain flags, lodge emblems or other non-Indian designs. (*El Palacio* 1926:205–206)

Additionally, artists were rewarded for keeping the designs of each pueblo as distinct as possible, and the borrowing of designs was considered a departure from authenticity: Zuni pieces, for example, needed to be recognizably Zuni, and made by a Zuni. In addition to following guidelines derived from anthropology, the emphasis on clear-cut tribal styles fitted in with the demand for an intimate relation between place and object. Although such standards reflected the preferences of patrons, it is likely that they also grew out of the aim to develop a more exclusive market for Indian art, the patrons recognizing that a wealthier, more educated clientele would be willing to pay more for objects that were backed by institutions like museums and universities and that demanded the exercise of institutionally sanctioned knowledge and taste in the labor of consumption. (Of course, links to museums and universities also help to reproduce the value of objects, allowing buyers to justify their expenditures as an investment—although that is more a concern in the contemporary market than it was in the 1930s.)

Following the Indian Fair in 1930, Margretta Dietrich, chairwoman of the Southwest Indian Fair Committee, reported on its high standards—standards influenced by anthropologists, but not completely dependent upon them: "Nothing," she claimed, "was accepted for the Fair which did not show good workmanship, correct materials and fine design" (Dietrich 1930). Although fine design was generally considered synonymous with traditional, later Dietrich recalled that exceptions were made for "particularly fine innovations" (SRCA, SWAIAC, c).

In addition to holding the fairs in Santa Fe, members of the Committee volunteered to judge exhibits at events held throughout northern New Mexico, such as the Gallup Inter-Tribal Ceremonial and the Shiprock Fair. These competitions were similar to those held in Santa Fe, but were organized largely by traders and federal Indian agents, who were considered by Santa Fe patrons to lack the taste and expertise to award prizes appropriately. As Oliver La Farge wrote in 1933:

> It has been painfully brought out at the Shiprock Fair and other such events that no prize list is good without good judges. . . . At Gallup, . . . through our Committee on Judges, judges of what we may call "our group" have been secured. . . . What we want is to have the entire judging of Arts and Crafts at such Fairs turned over to us. (SAR, AEWC, g)

Although La Farge and friends were not entirely successful in their grasp for hegemony, by 1936 Margretta Dietrich reported that she, La Farge, and their colleagues had been particularly successful in influencing the exhibits at Gallup, where, to her horror, a prize had once been given to "a reproduction of an oriental rug" woven by a Navajo, and by 1938, she was pleased to report the "increasingly Indian character" of the work on display (SRCA, SWAIAC, d).

The Santa Fe patrons designed numerous other projects to influence Indian artists. In the early 1930s, for example, the New England-based Eastern Association on Indian Affairs, including Mary Cabot Wheelwright, her cousin Lucy

Cabot, and Amelia Elizabeth White, campaigned to revive older styles of Navajo weaving. Disapproving of the loud colors produced with chemical dyes and new designs, which they felt showed the influence of Anglo traders and tourists, the Association encouraged a return to the more subtle hues of vegetable dyes and the weaving of designs without borders. In addition to working with chemical companies to develop inexpensive, packaged vegetable dyes (including one mixture called "Old Navajo"), Association members traveled the Navajo Reservation, distributing photographs of old Navajo blankets among their own collections and encouraging weavers to use them as examples (SAR, AEWC, h). Similarly, it became a common practice (one continuing today) to encourage Indian artists to study the collections in museums in Santa Fe, collections which were used as a standard by which new works were judged, thereby strengthening a sense of tradition and aiding artists in the route to authenticity and institutionally sanctioned taste. This was a route that many of the more ambitious artists were quick to pursue on their own (in many cases, of course, departing from as much as reproducing the older designs).

Other local activities were aimed at educating tourists, encouraging them to purchase "articles of real worth, not Indian curios" (Dietrich 1936). As head of the New Mexico Association on Indian Affairs, Dietrich reported in 1935 that, in addition to continuing the Indian fairs, members of the Association would also sponsor a series of lectures in order to educate "the public to an appreciation of Indian Art, for Art's sake and for the sake of creating markets for Indian goods" (SRCA, SWAIAC, e). In 1936, the Association published a series of articles, officially approved by the Laboratory of Anthropology, that attempted to educate potential buyers.[25] During the same year, Association members decided to return to holding the Indian fairs in Santa Fe's central plaza, rather than at the more remote pueblos as they had been doing for several years, since "naturally the number of strangers attending and being educated unconsciously is limited" (SRCA, SWA-IAC, e). During these events, educational tactics took a more direct turn, and placards were placed around the exhibition area explaining to potential buyers how to identify the "best" pieces. Objects that were considered acceptable were marked with stickers: "Approved by the NMAIA" (SRCA, SWAIAC, f). The same patrons worked to establish permanent collections of Indian art in Santa Fe, which could serve as a standard by which other works could be judged (in addition to serving as a source of study for artists).[26] Later in the 1930s, some of the Indian arts professionals and patrons in Santa Fe worked with the Roosevelt administration's Indian Arts and Crafts Board (although some patrons—Amelia Elizabeth White, for example—tried to have little to do with anything related to the Democratic New Deal). Among other activities, the Board developed official government standards for Indian silver work and placed official stamps on approved pieces (stamps designed to reward artists and to educate buyers). Pieces were rejected if, for example, they used stereotypical but inauthentic designs, such as arrows, thunderbirds, or horses, or if the workmanship was considered careless.[27]

THE SPECTER OF THE "GARISH AND RESTLESS"

Throughout these attempts to serve as tastemakers, a role they sought to play quite deliberately, patrons lamented that their influence—over artists, but especially over tourists—was limited. As Witter Bynner protested in 1936:

> The fact is that many Americans, with their creative minds destroyed by the effect of factory products, can come even into this mountain country whose clear air should clear their taste, and prefer Indian jewelry made wholesale in factories at Denver or Albuquerque or in the petty factories set up by white traders. . . . An unimaginative and tinny jewelry is being imposed upon credulous and tasteless buyers in the name of Indians who, left alone, let me repeat and repeat, can create for themselves and through themselves for us, decorative belongings as distinguished and personal and aesthetically important as the decorative belongings which for centuries have graced the Orient. (Bynner [1936] 1979:338)[28]

In addition to Bynner's attempt to appropriate the discourse of Orientalism, one should note that there is more than one sort of other discernible here. Bynner's moral fervor concerning the slippery slope of standards of quality was common. After one of the first Indian fairs, Kenneth Chapman—one of the leading quasi-anthropological local authorities on Pueblo pottery—had written optimistically of the effect they would have on the tourist, who, Chapman complained, instead of seeking "honest quality," chose "the trivial, the gaudy, and the cheap" and was "heedless of the part he was playing in the demoralization of Indian crafts" (Chapman 1924:215–216). But despite Chapman's optimism, eighteen years later, Margretta Dietrich complained similarly of the obstinacy of popular tastes. In addition to helping the Indians sell their work, Dietrich explained that the Indian fairs—by then renamed Indian markets, after one of the Association members sought to replicate village markets in "Old Mexico"—were designed to "educate the buying public." She had to doubt their educational effectiveness, however, when faced with "the enthusiasm of the tourist over the poorest articles" (Annual Report of the Chairman 1938; SRCA, SWAIAC, g).

Indian artists, Dietrich observed, found it easy enough to sell pieces that had been rejected by the Indian Market authorities outside the official boundaries, in the central plaza, in nearby hotels, in restaurants, and on side streets (a practice continuing to plague authorities in the 1990s). Despite the placards on display at the fairs that alerted buyers to the qualities of "good" Indian art, Dietrich reported that "tourists, even if they had read the placards, bought pottery which had designs painted on with show-card colors, after firing, which perhaps fortunately wash off" (SRCA, SWAIAC, h). And in a *New Mexico Magazine* article, which was part of the series of articles reprinted and sold to tourists in the hope of educating them, Dietrich summed up her attitude toward authenticity and Indian arts, an attitude shared by many of her associates: "It is impossible to give a recipe for good taste," she admitted (despite the fact that so many of her and her colleagues' efforts centered on trying to do just that), "but the Indian, uninfluenced by the white man,

had taste of such universal appeal that his work is treasured by people of all lands. . . . It is only when ideas of an alien race, our own, are imposed on the Indian that the patterns and colors become garish and restless" (Dietrich 1936:27). Committed to upholding an abstract notion of culture and tradition—not altogether separate from race—Dietrich and her colleagues did not see their own efforts as imposing alien influence, but rather as encouraging the authenticity which others had undervalued.

Although it is easy to dismiss such evaluative judgments as old-fashioned, racist paternalism (or, perhaps, maternalism), it is less easy to dismiss the fact that the efforts of patrons like Dietrich did pay off in a more lucrative market for Indian artists—the approved ones benefiting more, of course, than the "garish and restless." But one can argue that most Indian artists in the long run benefited, economically at least, however indirectly. The officially approved market in Indian "art" still fueled the market in less expensive "junk," just as the popular acceptance of the practice of hanging original paintings on walls encourages sales of less expensive posters. In the contemporary market for Indian art, tourists and newcomers are often shocked by the prices, prices that seem to many to be legitimate only once they have become familiar with Indian art exhibitions, scholarship, and museums—including a web of public and private, professionally staffed institutions vastly expanded since the 1930s. These provide terminology, frameworks, and classificatory schemes for making distinctions between objects and artists, art and trash—at least as much, nowadays, using indices of quality as of authenticity—and stress the labor-intensiveness of the art's production and its connections with culture, tradition, and regional history. Many buyers of Indian art, as with any art, would simply not buy—unless, of course, items were quite cheap—if they did not have curators, writers, and exhibition judges to help them be discerning in their purchases.[29]

Nor should the quaintly prudish tone of evaluative statements like those of Dietrich and Bynner obscure their kinship with a more academic anthropological sensibility. Historically, anthropologists, by and large, have often tended to assume tacitly, like Dietrich, that there are objective standards of quality and aesthetic value, at least among Western cultural forms, and they have also tended to draw the line of authentic culture at the border of consumer capitalism—whether more explicitly, as in Sapir's (1924) article, "Culture, Genuine and Spurious," or implicitly, by excluding mass consumption from ethnographies and assuming it is not of importance to the student of culture. In the contradictory popular merging of Arnoldian notions of culture with anthropological ones, there are still some people left without culture.

Although on the surface Margretta Dietrich's statements, and those of her colleagues quoted here, concerning Indian art are about differences between cultures, they can also be read usefully as statements about class and the way in which identities are constructed (and evaluated) in relation to commodities. *Garish* and *restless, gaudy,* and *cheap,* are heavily class-laden terms. In the same article quoted

above, Dietrich explained that she and her colleagues felt that Indians made "better artists than mechanics or houseworkers"—*mechanics,* a period term for proletarians. Although it is easy to sympathize with the patrons' belief that producing art is more fulfilling than wage labor, in their patronage of specific visions of cultural difference Indian art patrons were implicitly crusading against other forms of difference, differences that to them were more threatening than those posed by Indians (who were generally being offered cultural preservation, and some political and economic power, but little cultural authority—that is, the power to determine classifications and hierarchies of value). In the equation of oppositions, Indians (authentic ones, that is) and others thought of as primitive were authentic particularly in opposition to the largely white working and middle class (not in relation to the soft-spoken descendants of New England settlers, as Amelia Elizabeth White was described in newspaper accounts of the 1931 Exposition [e.g., Seinfel 1931]).

Similarly, art was opposed to mass culture or to the mass-produced commodity. Whereas in the world of mass-produced goods, patrons were only consumers with relatively more money to spend, in the world of art they could be authorities and institution-builders. In one of the volumes of her biography, Mabel Dodge Luhan recalled that when she sailed home to America after her pre-World War I years living in an Italian villa, she wept at the thought of returning to "a world of dull, grubby men and women, street cars, cigar stores, electric signs and baseball games" (Luhan 1935:447)—a world perceived as quite masculine and unlike that of art, one where Luhan could have little influence. She instructed her son, "Remember, it is ugly in America . . . we have left everything worth while behind us. America is all machinery and money-making and factories . . . ugly, ugly, ugly" (1935:435). Mabel Luhan, of course, found a place for herself in the midst of all this American ugliness as a patron of modern art, and then later in Taos, as a patron of Indian and Spanish Colonial arts. Recounting her arrival in Taos, in a telling passage, Luhan admired the haggard faces of "Mexicans." Although their faces showed the effects of hard labor in a harsh climate, Luhan felt that "they were not deprived of their essence, as seemed the few lower-class Americans I had seen [in New Mexico]. The faces of *these* were often depraved and dead; it did not seem to agree with them to live in this wide state" (Luhan [1937]1987:34).

The ugliness of commodity-dependent masses is the implicit threat looming on the horizon in the discourse of Indian arts patrons in the 1920s and 1930s, as well as much other discourse of the period concerning culture. In the Indian art market, the threat came primarily from tourists, who were seen as degrading Indian art because of their low standards, their acceptance of misleading stereotypes of Indians, and their desire for cheap souvenirs. Tourism, though, was just part of a larger transformation. There were also concerns that Indians themselves might be drawn into the ranks of the masses, particularly as they increasingly produced handmade wares for sale and purchased mass-produced commodities for their own use. When Elizabeth Sergeant wrote in the *New Republic* in support of Indian religious freedom, she employed the threat of mass culture to inspire Americans to appreciate

Indian religious differences; when the government-suppressed Indian dances were finally eradicated, she warned, "Then will every Indian surely prefer . . . the movies to the Deer Dance," resulting in "Death to [America's] Golden Age" (1923:357).

Misgivings about consumer capitalism were not, of course, limited to Indian arts patrons. In 1935, a writer for the Communist *New Masses* argued the importance of encouraging "a healthy and progressive culture to take root in the masses of people," and railed against "the manufacturer" who "is interested primarily in profits, not in elevating the level of public taste and standards of design" (S. Alexander 1935:21). It was also at this time that Frankfurt School and other critics were beginning to debate the ideological and aesthetic implications of mass culture, debates that continue into the present.[30] In an essay typical of the contradictions embraced by popular concerns with culture, Clement Greenberg, the modernist art critic, pondered how "a painting by Braque and a *Saturday Evening Post* cover" could be "part of the same culture" ([1939]1957:98), and warned that *kitsch* (ersatz culture) was taking over everywhere: "It has gone on a triumphal tour of the world, crowding out and defacing native cultures in one colonial country after another" (Greenberg [1939]1957:103). Similarly, Stuart Chase, who admitted frankly that, in comparison with Indians, he did "not like white Mexicans so well, not the cities they live in, nor their taste in interior decoration" (S. Chase 1931:304), concluded his comparison of Mexico and the United States by stating that his "gravest misgivings" with regard to the Mexican future concerned the appeal of commodities mass-produced in the United States. "Will the machine roll Latin America flat, trampling down the last vestige of authentic American culture?" Chase asked (1931:306). In his chapter "Advice from a Parvenu Cousin," Chase outlined what he felt was Mexico's "chief menace from the machine age" and, more specifically, from "the Yankee invasion." His chief concern, he explained— in the typically 1930s fashion of manically listing proliferating things—was that of "cultural penetration in the form of American sports, radios, jazz, words, habits, subdivisions, billboards, Rotary clubs, plus-fours, Arrow collars" (1931:315).[31]

Such misgivings are partly an example of cosmopolitans wanting to preserve the differences that make cosmopolitanism possible. As Hannerz notes, "There can be no cosmopolitans without locals" (1990:250). But what is perhaps stronger in this discourse than the desire to preserve difference is an apocalyptic sense that difference is getting out of control—particularly out of the control of elites (including the anthropologists). Critics like Stuart Chase confronted the rapidly expanding range of goods available for purchase, such as the "100,000 items, and 36,000 different kinds of things" offered by the Sears Roebuck mail-order catalog (S. Chase 1929:276), and questioned whether the problem of modernity was really one of "standardization." Similarly, those who sought to express distinctive national and regional character, and turned toward anthropology for guidance, were hindered by their less geographically concerned neighbors who were apt to erect, as Mary Austin put it, "any imaginable style of architecture except one native to the soil" ([1929]1933:122). Travelers to remote parts, once exceptional,

were being joined by tourists—as in Chase's warning that Mexico would soon be visited by "clouds of Buicks, swarms of Dodges, shoals of Chevrolets" (S. Chase 1931:187)—hordes uninformed about, even uninterested in, standards of authenticity and good taste as constructed by either anthropologists or art patrons.

CONCLUSION

In response to recent public controversies surrounding the hot potato of multiculturalism, as well as the continuing popular appeal of culture as a way of representing human differences (a mode of representing difference far more marketable and seemingly more innocent than other available abstractions such as race or class), it is useful to historicize notions of culture, with all their contradictions and confusion. This project of historicizing the category of culture should not be restricted to analysis of academic writings or the lives of well-known anthropologists. Practices revolving around notions of cultural pluralism, such as those discussed here, are no less important because of their distance from academic canons. This essay has attempted to take the historical study of the idea of culture, and what Virginia Dominguez has aptly termed "the culturalization of difference" (1994:249), into realms of local practice.

The related movements to foster widespread appreciation for native cultures and American culture arose during a key moment in the development of consumer capitalism. Not surprisingly, then, the discourse surrounding culture, although superficially departing from more elitist uses of the term, centered largely on commodities and their division into art, artifacts, and trash. As Michael Thompson (among others) has argued (1979), the ability to make such distinctions with any degree of legitimacy is dependent upon power and control over time and space (even if there are always limits to the acceptance and awareness of such distinctions). Thus, although we should continue to question, as Sally Price and other critics of Primitivism have argued, the assumption that Western peoples have art, and others have artifacts, the processes by which artifacts become art offer no refuge from inequality.

NOTES

A version of this article was presented at the annual meeting of the American Ethnological Society in Charleston, South Carolina, March 15, 1991. Research was funded by a Woodrow Wilson Fellowship in Rural Policy and a Leslie White Award from the Central States Anthropological Society. The School of American Research (SAR), Santa Fe, New Mexico, generously provided access to archival materials, working space, and helpful colleagues. I would also like to thank the staff of the other institutions whose archival collections are cited here.

1. As Barbara Herrnstein Smith notes in her study of theories of value and evaluation, "The labels 'art' and 'literature' are, of course, commonly signs of

membership in distinctly honorific categories" (1988:43). Relationships between taste, classification, and social stratification have also been explored in detail by Bourdieu (1984) and Thompson (1979).

2. Friedman has argued that the codes of consuming are so inescapable a feature of the modern world that no cultural or political movement can choose not to participate in them: any movement is itself a consumer—"or at least must define itself in relation to the world of goods as a non-consumer" (1990:314).

Although there are important differences, the movement discussed here bears resemblance to a slightly earlier movement to encourage the production of American handicrafts, as studied by Lears (1981), among others. Lears argues that the Arts and Crafts Movement was also a response to a "crisis of cultural authority" perceived by the late Victorian bourgeoisie in relation to mass production and consumption. His description of Victorian and turn-of-the-century antimodernism would also apply to the movement discussed here: "it was meanspirited and largehearted, suffused with upper-class forebodings and utopian aspirations" (1981:60).

3. A number of recent studies have explored connections between modernism, romanticism, and anthropology by looking at some of the most influential anthropologists like Mead and Benedict. See, for example, Handler (1991) on Benedict, and Stocking (1989). My focus here is on relatively unknown anthropologists and the use of anthropological ideas by intellectuals outside the academy.

4. The journal *Art and Archaeology* is an interesting, slightly earlier, example of collaboration between artists, anthropologists, and archaeologists. The journal was started in 1914 by the Archaeological Society of Washington and proclaimed itself dedicated to contributing to "the higher culture of the country by encouraging every form of archaeology, history, and artistic endeavor." In 1924 the journal included an article suggestive of the challenges posed to anthropology by the emergence of mass culture. Entitled "Movie Realism and Archaeological Fact," the article protested that the movies have only displayed a *semblance of authenticity* with the use of fake archaeological ruins and artifacts (Bryan 1924).

On the general compatibility of views among anthropologists and artists during the 1920s and 1930s in Santa Fe, see Weigle and Fiore (1982). According to Elizabeth Sergeant, "In this unindustrialized New Mexico, even science is largely the science of archaeologist, ethnologist, anthropologist—the sort of science that unconsciously feeds the novelist, the poet" (1934).

5. Raymond Williams describes culture as one of the most complicated words in the English language because of the tacking back and forth between two contradictory senses of the term: the one connoting moral superiority, the other referring to an entire way of life, obscuring power, internal division, or hierarchy (Williams 1973:10, 76–79).

6. For an overview of early-twentieth-century struggles for the reform of government Indian policies, see Lawrence Kelly's (1983) study of John Collier and the Indian New Deal.

7. Although Frank was impressed by Indian art, he was scornful of Indian art-

collecting Anglo artists gathering in Santa Fe and Taos, whom he dismissed as "seekers of the 'picturesque' " and as "mere truants from reality" (1919:116). Although Rodriguez's study (1989) of the Taos art colony generally supports Frank's negative view of the artists, Frank and many other Manhattan intellectuals were harshly pessimistic about the future of Indians, who, Frank blithely asserted, "will be destroyed" (1919:116). An especially interesting—though exaggerated—example of a Manhattan Marxist's skepticism of attempts at cultural preservation through the revival of handicrafts is Michael Gold's article on "Mabel Luhan's Slums" (1936).

8. Experiences during World War I heightened many American intellectuals' interests in "rediscovering" America. Sergeant, who was a war correspondent for the *New Republic*, read a draft of her friend Cather's *My Antonia* while recovering from a serious grenade injury in a Paris hospital, and thought romantically of the peripheral regions of her country and of the visit Cather had inspired her to take to the Southwest: "The luminous light that burns on the Arizona desert, out of long miles of untouched sage and sand. Yes, that's where I want to be, on an observation car travelling swiftly into the Southwest. Losing myself in a shimmer of fine dust, passing the bold, red ramparts of a land beloved of pioneers, and large enough to carry Europe in its pocket" (1920:205).

9. For information on the community of writers that formed in Santa Fe and Taos in the 1920s and 1930s, see Weigle and Fiore (1982), who provide many useful extracts of their writings. See also Rudnick's biography of Mabel Dodge Luhan (1984); Dauber (1993); and Dilworth (1992).

10. Stuart Chase's earlier book, *Men and Machines* (1929), is also a particularly interesting example of anthropology used as social criticism, as well as of ideas about regionalism, national identity, and consumer capitalism. In the chapter "One Dead Level," in which Chase considers whether modern life is more standardized than primitive life, he uses Mead's *Coming of Age in Samoa* to compare the lives of a "White Plains Clerk," a "Samoan," and a "Park Avenue Banker" (1929:283–285)—a prelude to his comparison of "Middletown" and Tepotzlán.

11. Of course, there had long been resistance among Americans to the category of art as one invested with a great deal of importance and entrusted with representing collective identity. Lynes (1949) discusses many interesting examples of struggles to gain the widespread acceptance of art as a hallowed social space and target of philanthropy.

12. According to a biographer:

No undertaking of Abby Aldrich Rockefeller more clearly demonstrates her pride in America and in its cultural history than her collection of folk art which now hangs in the Ludwell-Paradise House in Colonial Williamsburg. . . . it records those years in American history when, after the baffling problems of a new world had been solved by the colonists and after the War of the Revolution had finally shattered an earlier dependence upon the culture and learning of England, a new American people began for the first time to stand alone, to work out its own destiny as a nation. (M. Chase 1950:147–148)

13. Somewhat of an analogy can be found in Marquis's argument that in the

1930s the organizers of the Museum of Modern Art waged a campaign against *kitsch* by redefining the boundaries of art:

> By broadening the definition of art to include a mass of intrinsically valueless items—movies, photographs, advertisements, packages, furniture, articles of daily use—the museum . . . taught the public that it could exercise connoisseurship in a purchase as humble as a potato masher or a soup plate. (Marquis 1986:184; see also chapter 4, ". . . But is it Art?")

Marquis also provides a general discussion of controversies during the 1930s surrounding the relationship between culture and mass culture.

14. For a much more reactionary construction of culture as the province of the upper-middle class serving particular economic interests (and quite opposed to any cultural nationalism), see Debora Silverman's study of connections between Bloomingdale's, the Metropolitan Museum, and the Reagan White House (1986).

15. For additional information on White and the Exposition of Indian Tribal Arts, see Swenson (1983).

16. Though their paths to New Mexico were largely independent of one another, it is worth noting that Elizabeth Sergeant, who for a time collaborated with Dietrich and White in promoting Indian art, was also a Bryn Mawr graduate—like Margretta Dietrich, in fact, a member of the class of 1903. Women's colleges of the period, especially Bryn Mawr, encouraged their students to see themselves as crusaders and advocates: "Bryn Mawrters," according to Sergeant (1953).

17. In addition to those in the world's fairs, there were many other representations of Indians with which patrons felt they must compete, particularly in the thriving tourist industry and, increasingly, in the motion pictures. On the importance of Indians to the tourist industry in the Southwest during this period, see Weigle (1989) and Dauber (1993).

18. In 1932, White had an intriguing exchange of letters with Dorothy Deane, who was trying to use handicrafts as an economic development strategy among Chippewa women. Deane sent White examples of the work the women were making in the hope that White might sell them in her shop. In reply, White wrote:

> I am sorry but the things you sent on to my shop were not in the class of material that is sold there. Have you anything of their own design and workmanship? It is the truly Indian work that appeals to the class of people here. I am sorry that I am not very familiar with the Chippewa work so cannot tell just what you might have.
>
> I am very much interested in what you are doing as it seems to me the real way to help the economic difficulties of the Indians. (SAC, AEWC, i)

Deane wrote back, asserting that the work was authentic, since it was handmade by Chippewa women. But, she explained:

> they have in some cases copied southwest designs because those who are not familiar with Chippewa workmanship often find them more attractive. I am trying, however, to keep them to their own traditional designs as much as possible. (SAR, AEWC, j)

19. Anthropologists had long been troubled by the lack of concern for authenticity in the Indian souvenir trade. W. H. Holmes, for example, in the *American Anthropologist* in 1889, denounced the clay figurines being made among the Pueblos. Holmes alarmingly announced that

the country is being flooded with cheap and, *scientifically speaking,* worthless earthenware made by
the Pueblo Indians to supply the tourist trade. . . . Only those who happen to be familiar with
the refined and artistic wares of the ancient Pueblos can appreciate the debasement brought
about by contact with the whites. (Holmes 1889:320, emphasis added)

Babcock et al. (1986) provide information about how the figurines in question
eventually became accepted as a legitimate(d) folk art.

20. Hewett seems to have envisioned the fiestas as a mini-World's Fair—a type
of event he had previous experience with as director of exhibits for the 1915
Panama-California Exposition in San Diego (which celebrated the completion of
the Panama Canal). On Hewett and his role in the Fiesta and the San Diego Expo-
sition, see Chauvenet (1983), who touches on differences between Hewett and other
Indian art patrons in Santa Fe. Also, on the early history of Indian fairs in the
Southwest, including a number of projects not covered here, such as the Hopi
Craftsman Show, see Wade (1985). Wade analyzes the fairs as an element of strug-
gle for power in the Indian art market between factions composed of philanthropists
and traders. As I argue here, though, many philanthropists saw tourists and other
uneducated consumers as a more important threat than traders, among whom they
sometimes found allies. Stocking (1982) provides additional information about
Hewett and his relationship to other anthropologists and patrons of anthropology.

21. In 1934, the Southwest Indian Fair Committee was absorbed into the New
Mexico Association on Indian Affairs (NMAIA), an organization formed in Santa
Fe in 1922 to protect Indian land rights and religious freedom as well as to improve
health and economic conditions among nearby Indians. The NMAIA today is
known as the Southwestern Association on Indian Arts (SWAIA). The sponsor of
Santa Fe's annual Indian Market, it now focuses exclusively on promoting Indian
arts. Its membership is still predominately Anglo, though in recent decades its
board members have included Indians.

22. In 1936, it seems that Santa Clara Indians took quite the opposite approach
and asked Santa Fe patrons, including Amelia Elizabeth White, if they would serve
as judges for their fair and provide prize money (SAR, AEWC, k).

23. In his 1924 article promoting the Indian Fair, Chapman mentioned that
one potter at San Ildefonso, presumably Maria Martinez, was "capable" of earn-
ing $300 per month from pottery, whereas the cash return on farm products for
the entire pueblo during the previous year was only $3,300 (Chapman 1924:224).
Chapman remained unconcerned about the social consequences of such individual
success.

24. This information concerning the immediate impact of awards on collec-
tors was mentioned in personal interviews conducted in 1990 and 1991 with Mar-
jorie Lambert, Letta Wofford, and Sallie Wagner, who served as judges during
Indian markets of the 1930s and 1940s. Although in the contemporary Indian Mar-
ket, entries are judged before they can be exhibited and sold, many buyers espe-
cially seek to buy award-winning pieces (which often are sold for greatly increased
prices as a result of having won an award).

25. Maria Chabot, who was hired to edit the series of articles which was partly funded by Amelia Elizabeth White, wrote to White in 1936: "We all feel that anything we can do to make the thunder-bird and other such imported articles 'bad taste' in tourist articles will be to the good" (SAR, AEWC, 1).

26. For a history of the Indian Arts Fund, which was funded partly by John D. Rockefeller, Jr., see Dauber (1990, 1993); Stocking (1982) also discusses the Indian Arts Fund and Rockefeller's role as an important patron of anthropology in the region.

27. In a letter to Mary-Russell Colton at the Museum of Northern Arizona, Kenneth Chapman, who was a special consultant to the Indian Arts and Crafts Board (IACB), explained that such designs were not accepted, "since the prevailing opinion is that all these [designs] have been suggested by traders or by other whites" (LA, KCC, c). In addition to their concern about protecting Indian arts as an important source of Indian income, the IACB made it clear that they were concerned about "these products as art, and as part of the art heritage of the American people as well as of the Indian" (LA, KCC, d). On the history and policies of the IACB, see Schrader (1983).

28. Although Bynner was especially interested in the Orient as a scholar of Chinese, analogies between the Southwest and the Orient are common elements of the discourse (many interesting examples can be found in Sergeant [1922, 1923]). Examining similar analogies, Barbara Babcock has argued that "the Southwest *is* America's Orient" (1990:406). Complicating the equation, however, Susan Kenneson has suggested that allusions to the Orient, particularly to the Middle East, were not merely an attempt to exoticize and dominate the Southwest; in her discussion of a slightly earlier group of "local colorist" writers, Kenneson argues that these writers "recognized Old World standards as the ultimate arbiters of culture and color but were determined to prove that the New World could and had beaten the Old World at its own game" (Kenneson 1978:262)—that is, the United States also had its exotic peripheries and sources of antiquities. East Coast intellectuals like Bynner and Sergeant must have felt a need to justify their sudden devotion to what many of their contemporaries would have thought a provincial backwater of little interest; one way of doing that was to compare the region to Greece, Rome, and the Middle East, at that time the more accepted territory of the cosmopolitan traveler and seeker of spiritual inspiration. They also used this strategy to gain national political support for the pueblos (e.g., Sergeant 1923).

29. A common reaction to the sort of hothouse flowering of tradition presented here is to praise the more avant-garde of Indian artists (see, e.g., Wade 1985), those who stress innovation and experiment with European traditions, those who speak the language of art schools, as if these were *really* the authentic and creative artists. But what of the many traditional artists who say they have never felt forced in their traditionalism (despite all the awards for it), who are proud of their culture, and heritage, however profitable it may be? As Myers (1991) suggests in his examination of discourses surrounding Aboriginal painting, scorning aspirations to tra-

ditionalism is not necessarily a morally or politically preferable position. As Bourdieu (1984) and many other analysts of taste have shown, there is as much mystification in Western art traditions.

30. For an overview of debates concerning mass culture—or, more sympathetically, popular culture—see Brantlinger (1990). Barnard (1995) examines such debates among intellectuals in the context of the 1930s.

31. Chase's 1929 book is filled with similar lists, as in his discussion of whether to consider modernity a process of homogenization or diversification:

> Look at the fads which follow one after another in crazy procession—bicycle riding, ping pong, golf, bridge, mahjong, jazz, crossword puzzles, bobbed hair, antiques, prohibition cocktails. (1929:271)

On the practice of listing senselessly diverse commodities in 1930s literature, see Barnard (1995), who also provides a relevant discussion of Nathanael West's use of Indians in his critique of consumer capitalism (1995:279–285).

REFERENCES

Alexander, Charles C.
 1980 *Here the Country Lies: Nationalism and the Arts in Twentieth-Century America.*
 Bloomington: Indiana University Press.
Alexander, Stephen
 1935 "Design for a Parasite Class." *New Masses,* Jan. 8, 21.
Arnold, Matthew
 1925 *Culture and Anarchy.* William S. Knickerbocker, ed. New York: MacMillan.
Austin, Mary
 [1923] 1970 *The American Rhythm.* New York: Cooper Square Publishers.
 [1929] 1933 "Regional Culture in the Southwest." In T. M. Pearce and T. Hendon, eds., *America in the Southwest: A Regional Anthology,* pp. 119–123. Albuquerque, N. Mex.: University of New Mexico Press.
 1932 *Earth Horizon.* Boston: Houghton Mifflin.
Babcock, Barbara A.
 1990 " 'A New Mexican Rebecca': Imaging Pueblo Women." *Journal of the Southwest* 32(4):400–437.
Babcock, Barbara A., Guy Monthan, and Doris Monthan
 1988 *The Pueblo Storyteller: Development of a Figurative Ceramic Tradition.* Tucson: University of Arizona Press.
Barnard, Rita
 1995 *The Great Depression and the Culture of Abundance: Kenneth Fearing, Nathanael West and Mass Culture in the 1930s.* New York: Cambridge University Press.
Becker, Jane S.
 1992 "Selling Tradition: The Domestication of Southern Appalachian Culture in 1930s America." Ph.D. diss., Boston University.

Bourdieu, Pierre
1984 *Distinction: A Social Critique of the Judgement of Taste.* Trans. Richard Nice.
 Cambridge, Mass.: Harvard University Press.
Brantlinger, Patrick
1990 *Crusoe's Footprints: Cultural Studies in Britain and America.* New York: Rout-
 ledge.
Bryan, Bruce
1924 "Movie Realism and Archaeological Fact." *Art and Archaeology*
 18(4):131–144.
Bynner, Witter
[1936] 1979 "Designs for Beauty." In James Kraft, ed., *The Works of Witter Bynner,* pp.
 336–342. New York: Farrer, Strauss, and Giroux.
Chapman, Kenneth
1924 "The Indian Fair." *Art and Archaeology* 18(5–6):215–224.
Chase, Mary Ellen
1950 *Abby Aldrich Rockefeller.* New York: Macmillan.
Chase, Stuart
1929 *Men and Machines.* New York: Macmillan.
1931 *Mexico: A Study of Two Americas.* New York: Macmillan.
Chauvenet, Beatrice
1983 *Hewett and Friends: A Biography of Santa Fe's Vibrant Era.* Santa Fe, N. Mex.:
 Museum of New Mexico Press.
Clifford, James
1988 *The Predicament of Culture: Twentieth-Century Ethnography, Literature, and Art.*
 Cambridge, Mass.: Harvard University Press.
Curtis, Nathalie
1922 "Pueblo Poetry." *El Palacio* 12(7):95–99.
Dauber, Kenneth
1990 "Pueblo Pottery and the Politics of Regional Identity." *Journal of the South-
 west* 32(4):576–596.
1993 "Shaping the Clay: Pueblo Pottery, Cultural Sponsorship and Regional
 Identity in New Mexico." Ph.D. diss., University of Arizona.
Dietrich, Margretta
1930 "The Indian Fair." *El Palacio* 29(3):103–105.
1934 "Nebraska Recollections." Unpublished ms., New Mexico State Library.
1936 "Old Art in New Forms." *New Mexico Magazine* 14(9):26–27, 56.
Dilworth, Leah
1992 "Imagining the Primitive: Representations of Native Americans in the
 Southwest, 1880–1930." Ph.D. diss., Yale University.
Domínguez, Virginia
1994 "Invoking Culture: The Messy Side of 'Cultural Politics.' " In Marianna
 Torgovnick, ed., *Eloquent Obsessions: Writing Cultural Criticism,* pp. 237–259.
 Durham and London: Duke University Press.
El Palacio
1922a "Prizes for Indian Handicraft." 12(6):81.

1922b "The Santa Fe Fiesta and Centenary of the Santa Fe Trail." 13(2):15–17.
1926 "Southwest Indian Fair." 20(10):204–212.

Frank, Waldo
1919 *Our America.* New York: Boni and Liveright.

Friedman, Jonathan
1990 "Being in the World: Globalization and Localization." In Mike Feather-
 stone, ed., *Global Culture: Nationalism, Globalization, and Modernity,* pp.
 311–328. London: Sage.

Gold, Michael
1936 "Mabel Luhan's Slums." *New Masses,* Sept. 1, 11–13.

Greenberg, Clement
[1939] 1957 "Avant-Garde and Kitsch." In Bernard Rosenberg and David Manning
 White, eds., *Mass Culture: The Popular Arts in America,* pp. 98–111. Glencoe,
 Ill.: Free Press.

Handler, Richard
1991 "Ruth Benedict and the Modernist Sensibility." In Marc Manganaro,
 ed., *Modernist Anthropology: From Fieldwork to Text,* pp. 163–180. Princeton,
 N.J.: Princeton University Press.

Hannerz, Ulf
1990 "Cosmopolitans and Locals in World Culture." In Mike Featherstone,
 ed., *Global Culture: Nationalism, Globalization, and Modernity,* pp. 237–251.
 London: Sage.

Harvey, David
1989 *The Condition of Postmodernity: An Enquiry into the Origins of Cultural Change.*
 Oxford: Basil Blackwell.

Hewett, Edgar Lee
1922 "The Art of the Earliest Americans." *El Palacio* 13(1).

Hinsley, Curtis M.
1991 "The World as Marketplace: Commodification of the Exotic at the
 World's Columbian Exposition, Chicago, 1893." In Ivan Karp and
 Stephen D. Lavine, eds., *Exhibiting Cultures: The Poetics and Politics of
 Museum Display,* pp. 344–365. Washington, D.C.: Smithsonian Institution
 Press.

Holmes, W. H.
1889 "Debasement of Pueblo Art." *American Anthropologist* 2:320.

Kelly, Lawrence C.
1983 *The Assault on Assimilation: John Collier and the Origins of Indian Policy Reform.*
 Albuquerque, N. Mex.: University of New Mexico Press.

Kenneson, Susan
1978 "Through the Looking-Glass: A History of Anglo-American Attitudes
 Towards the Spanish-Americans and Indians of New Mexico." Ph.D.
 diss., Yale University.

La Farge, Oliver
1929 *Laughing Boy.* Boston: Houghton Mifflin.

La Farge, Oliver, and John Sloan
1931 *Introduction to American Indian Art. Exposition of Indian Tribal Arts, Inc.* Glori-
 eta, N. Mex.: Rio Grande Press.

Lears, T. J. Jackson
1981 *No Place of Grace: Antimodernism and the Transformation of American Culture,
 1880–1920.* New York: Pantheon.
Luhan, Mabel Dodge
1935 *European Experiences.* Vol. 2 of *Intimate Memories.* New York: Harcourt,
 Brace.
[1937] 1987 *Edge of Taos Desert: An Escape to Reality.* Albuquerque, N. Mex.: University
 of New Mexico Press.
Lummis, Charles F.
1925 *Mesa, Cañon and Pueblo.* New York: Century Co.
Lynes, Russell
1949 *The Tastemakers.* New York: Grosset and Dunlap.
Marquis, Alice G.
1986 *Hopes and Ashes: The Birth of Modern Times, 1929–1939.* New York: Free
 Press.
Myers, Fred R.
1991 "Representing Culture: The Production of Discourse(s) for Aboriginal
 Acrylic Paintings." *Cultural Anthropology* 6(1):26–62.
Pach, Walter
1931 "The Indian Tribal Arts: A Critic's View of a Unique American Asset."
 New York Times, Nov. 22, section 8, p. 13.
Price, Sally
1989 *Primitive Art in Civilized Places.* Chicago: University of Chicago Press.
Providence Sunday Journal
1933 "She Learned from the Corn, the Rain and the Buffalo." Aug. 27.
Rodriguez, Sylvia
1989 "Art, Tourism, and Race Relations in Taos: Toward a Sociology of the
 Art Colony." *Journal of Anthropological Research* 45(1):77–97.
Rudnick, Lois
1984 *Mabel Dodge Luhan: New Woman, New Worlds.* Albuquerque, N. Mex.: Uni-
 versity of New Mexico Press.
Sapir, Edward
1924 "Culture, Genuine and Spurious." *Journal of American Sociology* 29:401–429.
Schrader, Robert F.
1983 *The Indian Arts and Crafts Board: An Aspect of New Deal Indian Policy.* Albu-
 querque, N. Mex.: University of New Mexico Press.
Seinfel, Ruth
1931 "Indian Art Exposition Aided by Woman's Intelligence." *New York
 Evening Post,* Dec. 1, E2.
Sergeant, Elizabeth Shepley
1920 *Shadow-Shapes: The Journal of a Wounded Woman.* Boston: Houghton
 Mifflin.
1922 "The Journal of a Mud House." *Harper's,* Mar., 409–422; Apr., 585–598;
 May, 774–782; June, 56–67.
1923 "Death to the Golden Age." *New Republic,* Aug. 22, 354–357.
1934 "The Santa Fe Group." *Saturday Review of Literature,* Dec. 8, 351–354.

1935 "Notes on a Changing Culture, as Affected by Indian Art." Unpublished
 ms., John Collier Papers, Yale University.
1953 *Willa Cather: A Memoir*. Philadelphia: Lippincott.
Silverman, Debora
1986 *Selling Culture: Bloomingdale's, Diana Vreeland, and the New Aristocracy of Taste in
 Reagan's America*. New York: Pantheon.
Sims, Alida F.
1922 "Pueblo: A Native American Architecture." *El Palacio* 12(8):103–106.
Smith, Barbara Herrnstein
1988 *Contingencies of Value: Alternative Perspectives for Critical Theory*. Cambridge,
 Mass.: Harvard University Press.
Stocking, George W., Jr.
1982 "The Santa Fe Style in American Anthropology: Regional Interest, Aca-
 demic Initiative, and Philanthropic Policy in the First Two Decades of
 the Laboratory of Anthropology, Inc." *Journal of the History of the Behavioral
 Sciences* 18:3–19.
1989 "The Ethnographic Sensibility of the 1920s and the Dualism of the
 Anthropological Tradition." In George W. Stocking, Jr., ed., *Romantic
 Motives: Essays on Anthropological Sensibility*, pp. 208–276. Madison: Univer-
 sity of Wisconsin Press.
Susman, Warren
1984 *Culture as History: The Transformation of American Society in the Twentieth Cen-
 tury*. New York: Pantheon.
————, ed.
1973 *Culture and Commitment, 1929–1945*. New York: George Braziller.
Swenson, Sonja
1983 "Miss Amelia Elizabeth White's Patronage of Native American Art."
 M.A. thesis, Arizona State University.
Thompson, Michael
1979 *Rubbish Theory: The Creation and Destruction of Value*. Oxford: Oxford Uni-
 versity Press.
Torgovnick, Marianna
1990 *Gone Primitive: Savage Intellects, Modern Lives*. Chicago: University of
 Chicago Press.
Wade, Edwin L.
1985 "The Ethnic Art Market in the American Southwest, 1880–1980." In
 George W. Stocking, Jr., ed., *Objects and Others: Essays on Museums and
 Material Culture*, pp. 167–191. Madison: University of Wisconsin Press.
Wallis, Brian
1991 "Selling Nations." *Art in America* 79(Sept.):84–92.
Weigle, Marta
1989 "From Desert to Disney World: The Santa Fe Railway and the Fred
 Harvey Company Display the Indian Southwest." *Journal of Anthropological
 Research* 45(1):115–137.
Weigle, Marta, and Kyle Fiore
1982 *Santa Fe and Taos: The Writer's Era, 1916–1941*. Santa Fe, N. Mex.: Ancient
 City Press.

Whisnant, David
 1983 *All That Is Native and Fine: The Politics of Culture in an American Region.*
 Chapel Hill: University of North Carolina Press.

Williams, Raymond
 1973 *Keywords: A Vocabulary of Culture and Society.* London: Croom Helm.

Wilson, Chris
 1990 "New Mexico in the Age of Romantic Reaction." In Nicholas C.
 Markovich, ed., *Pueblo Style and Regional Architecture,* pp. 175–194. New
 York: Van Nostrand Reinhold.

Archives and Manuscript Collections

Hodge, F. W.
 1915 Letter to A. E. White. Indian Arts Research Center (IARC), Amelia Eliz-
 abeth White Collection (AEWC), School of American Research (SAR),
 Santa Fe, New Mexico.

Laboratory of Anthropology (LA), Kenneth Chapman Collection (KCC), Santa Fe, New
 Mexico.
 a McKittrick, Margaret
 1931 Letter to Pueblo Governors. June 6, file KC0.026.
 b Chapman, Kenneth
 1935 Letter to Faith Meem. July 18, file KC0.030.
 c 1938 Letter to Mary-Russell Colton. September 26, file 89KC0.005.
 d 1934 Report from the Committee on Indian Arts and Crafts to Harold Ickes.
 September, file KC0.020.

School of American Research (SAR), Amelia Elizabeth White Collection (AEWC), Santa
 Fe, New Mexico.
 a Sloan, John
 1931 Brochure, Exposition of Indian Tribal Arts, box 1.
 b White, A. E.
 n.d. General Correspondence, box 2.
 c Sloan, Dolly
 1938 Letter to A. E. White. February 2, box 2.
 d Files, bills, and general correspondence devoted to A. E. White's gallery, "Ishauu,"
 box 13.
 e Sloan, Dolly
 1932 Letter to A. E. White. March 10, box 1.
 f Eads, Jane
 1931 Indians Have Sense of Humor that Confuses Reporters. Associated
 Press, December 15, box 1.
 g La Farge, Oliver
 1933 Letter to John Meem. October 5, box 2.
 h McKittrick, Margaret
 1931 Correspondence with A. E. White, box 9.
 i White, A. E.
 1932 Letter to Dorothy Deane. April 18, box 13.

j Deane, Dorothy
 1932 Letter to A. E. White. April 30, box 13.

k Aberle, Sophie
 1936 Letter to A. E. White. July 15, "misc."

l Chabot, Maria
 1936 Letter to A. E. White. March 23, box 12.

State Records Center and Archives (SRCA), Southwestern Association on Indian Affairs
 Collection (SWAIAC), Santa Fe, New Mexico.

a 1935 Meeting minutes of NMAIA. September 27, folder 38.

b 1935 Meeting minutes of NMAIA. July 1, folder 38.

c Dietrich, M. S.
 n.d. "The History of the Indian Market," p. 8, folder 106.

d 1938 NMAIA Annual Report. November 20, folder 38.

e 1935 NMAIA Annual Report, folder 38.

f n.d. "History of the Indian Market," p. 6, folder 106.

g 1938 Annual Report of the Chairman, NMAIA. November 20, folder 38.

h 1935 Meeting minutes of NMAIA. September 27, folder 106.

White, A. E.
 1922 Letter to Mable Dodge Luhan. September 12. Beinecke Rare Book and
 Manuscript Library (BL), Yale University, Mabel Dodge Luhan Collec-
 tion (MDLC), New Haven.

Critical Consciousness in the Art World

The Power of Contemporary Work in an American Art Tradition to Illuminate Its Own Power Relations

George E. Marcus

In this essay, I focus on the younger artists in *Power* (Indianapolis Museum of Art, Sept. 5–Nov. 3, 1991), who were born after World War II and who came to prominence in the American high-culture art world during the 1970s and 1980s: Dennis Adams, Ashley Bickerton, Chris Burden, Nancy Burson, Michael Clegg and Martin Guttmann, Peter Halley, Jenny Holzer, Jeff Koons, Barbara Kruger, Stephen Laub, Louise Lawler, Robert Longo, Richard Prince, Cindy Sherman, Lorna Simpson, Haim Steinbach, Tony Tassett, and Krzysztof Wodiczko. As a group they are distinguished by their ambivalence about the various twentieth-century modernisms and avant-gardes that preceded them. In visual imagination and artistic form they are thoroughly within the tradition of modernism, and, at least for some, the patronage of older artists identified with Minimalism and Conceptualism has been crucial to their success in Soho galleries.[1] Yet these artists, committed to the defining oppositional and critical impulses of classic avant-gardes but unable to find a neutral or untainted ground on which to stand, are keenly aware of the failures of their post–World War II predecessors as critics of power and privilege. Mostly university-educated during the period of youth countercultures in the 1960s and familiar with art history and social theory since then, they are influenced by such works as Serge Guilbaut's *How New York Stole the Idea of Modern Art* (1983), which recounts the eventual use of Abstract Expressionism as an ideological weapon in the cold war struggle. (Such a work of scholarship in academia is a powerful source of gossip and attitude formation in the art world.) Even the resumption of explicit social and cultural critical concerns by such artists as Andy Warhol, Frank Stella, Roy Lichtenstein, and Richard Serra, among the older artists represented in *Power*, failed to block the rapid assimilation of their work by corporations seeking logos, governments seeking public sculpture, and the media seeking attractive and entertaining design images.[2]

The younger artists have indeed created less assimilable and more definitely

oppositional work than their immediate Minimalist and Conceptualist predecessors, but they are also more reflective about and cognizant of their immersion within a distinctive elite system of power and wealth, the by-now mythical interconnected art world of New York, Chicago, and Los Angeles.[3] The only possible avant-garde is now the "avant-garde" that is produced institutionally within this system.

Deeply influenced in their thinking and writing by the contemporary intellectual current—variously tagged as postmodernism, poststructuralism, or a crisis of representation—that has focused debates across academic disciplines of the humanities in the 1970s and 1980s, these artists have produced work that challenges conventions of representation of all kinds. But they do so in a world where conventions—the basic everyday culture of signs, commodities, and images that has supported structures for accumulating power and wealth—have generally been called into question in what Jurgen Habermas has termed the legitimation crisis.[4] So, how powerful in its critical effect can such art be when there is no longer an "innocent" bourgeoisie or a general public to "épater"? The implication is that this art is as likely to express much about the cynical, self-parodying sensibility of those who are privileged and powerful (the archetype being the winning self-parodying, winking style of our recent actor-president) as to see beyond or outside such a sensibility. More importantly, how successfully can such art address the particular power relations that produce the high-culture world that gives it special recognition, status, and support? Thus the predicament for the younger artists, clearly articulated in their published interviews and writings, is how to equal in their material and visual creations *the precision and passion they achieve in their commentaries* on the power relations in which they as celebrities and their art as collectibles are immersed.[5]

After recent exhibitions such as *Damaged Goods* (1986), *Endgame* (1986), *Avant-Garde in the Eighties* (1987), *American Art of the Late 80s* (1988), *A Forest of Signs* (1989), and *Media World* (1990), which have examined contemporary artists from the perspective of the complex theories of modern and postmodern culture that inform their work, it is refreshing finally simply to ask what several of these artists have to express about power in American society, since it is indeed such a basic concept of social thought as power that any critical project tries to explore. In the last two decades the attention to power as the relatively unsubtle exercise of coercion and influence in mass society by political, economic, and cultural institutions of recognized authority (the kind of writing archetypically associated with C. Wright Mills's *The Power Elite* of 1956) has given way to theories of how power is deeply embedded in cultural and linguistic processes. The main currents for these theories derive from the translation and exegesis in English of the work of Antonio Gramsci on the concept of cultural hegemony, of Louis Althusser elaborating the operation of ideology within Marxist theory, and of Michel Foucault on the association of power with the microproduction of knowledge and its transformation into institutional practices as well as everyday life routines.

With their predominant interest in processes of commodification, consumption, desire, advertising, and media images, the artists in *Power* are clearly most influenced by those European-derived approaches to the study of relations of power, but some (for example, Adams, Burden, and Wodiczko) also refer more directly to "power elites"—the so-called military-industrial complex. The salience of much of this art in telling us something about power in American society that the poststructuralists or power-elite theorists have not, depends on the artists' ability to address the specificity of power relations that affect them most, those they live every day, professionally and institutionally.

To measure their achievement we must first extricate the artists from the identity the art world has made for them, in which they are imbued with an avant-garde aura as individual talents, if not geniuses, and as unique valuables, so as to place them in broader intellectual and cultural currents in American society. This important reframing is indeed suggested by the comments of several of these artists, who while accepting celebrity art-world identities, attempt to resist or at least distance themselves from the positions of aura in which they find themselves. These comments bespeak other theoretical and social identifications presumably truer to their art.

OF WHAT BROADER CONTEMPORARY INTELLECTUAL FORMATION ARE THE YOUNGER ARTISTS IN *POWER* A PART?

For me, the work of the younger artists in *Power* is distinctly intellectual. That is, I found a depth of appreciation of and engagement with their work only on the basis of certain social-theoretical references I already shared with it or only after I had read the critical commentary on it, which is generated not only by professional art critics and historians, but also by the artists themselves. This, then, is art whose visual power is markedly enhanced by the theoretical discourse concerning how it means and what it is intended to mean. Certainly, from the perspective of their concern with the social criticism of power, these artists would be in a bind without an investment in such commentary: the mere selection of the work, which is non-realist and thus at least partly inaccessible to a broad public, for elitist collection and display is itself an act of power over society, defining what is culturally "important" for the general public. Only by breaking down this category of the "general public," by denying its existence in contemporary society, or by targeting much more precisely the intent of and kinds of spectators for their art can the artists offset their collusion with the sort of overt "power elite" that most of them intend to critique in their work.

This strong investment in interpretation by the artists themselves is a distinctive feature of their work. For example, none of them display an indifference in their interviews to what their work might mean; with critics, they forcefully discuss and elaborate on what they intend. They fully cooperate in explaining their work in the framework of contemporary theories of social and cultural criticism that they share

almost seamlessly with critics of their generation. This kind of unity between the art, artist, and critic in the discourse that surrounds and affects the work seems markedly different from the way Abstract Expressionists or Minimalists related to critics, or from the interest Abstract Expressionists or Minimalists had in elaborately interpreting their work in terms of then-current social theory and intellectual discussion.

The especially strong alliance between artists and critics suggests a shared intellectual horizon broader than merely the art world. The artists and critics are unified by having read or been influenced by the same social thinkers, such as Foucault, Jean Baudrillard, and Jacques Derrida, albeit the channels of influence and uses of such theory may be deployed differently in the work of artist and critic. The source of this unity is the current cultural studies movement. This movement began during the 1970s in the United States with the diffusion through literary studies of poststructuralist social theories. It is academically based (often in interdisciplinary centers and institutes in the interstices of traditional humanities departments), and is oriented to discussing the state of contemporary culture in terms of a debate about the nature of postmodernity (or postmodernism).

The complex story of this movement over the past two decades is only now being told with any clarity.[6] Certain fields, such as feminism and literature, have gained a more central critical role in this movement, while others, such as architecture, though important initially, are less so now. Still others have more recently become relevant, such as anthropology. In any case, these disciplines share strong common interests in the state of late capitalism, semiotic analysis, the media, advertising, processes of commodification, consumption, forms of social and cultural authority, and the nature and politics of representation, inscription, narrative, and the making of texts out of everyday social life.

The younger artists (and their critics, among whom they include themselves) in *Power* are certainly a clearly identifiable part of this movement. Indeed, commentators on the development of postmodernism as an intellectual formation often refer to several of the artists to show postmodernism's scope and spread (Cindy Sherman is a favorite referent).[7] While the artists in their writings and interviews rarely if ever use the term *postmodern* and do not seem interested in the cultural studies movement as a movement (as the academic commentators are), the terms of their discourse and, more importantly, the references of their art are wholly captured by this domain of theory and debate. Thus, the current "avant-garde" in the American high-culture art world can be understood to have as clear an identity in the postmodern intellectual formation as in the art world itself. At least in its art, any social or cultural critical reference that the "avant-garde" has developed can be easily derived from the discussions, debates, and scholarship within postmodernism.

Finally, although their discourse is distinctive of the world they inhabit, their art is less so. At its best, the art seems to me, with some exceptions, to be creative and parodic visual or performed representations of the insights generated by the

discourse within the cultural studies movement about postmodern conditions. That is, its "statement" about power in society is familiar, predictable from the theory that influences it, and too general. The power of this art, when detached from the commentary, which *is* distinctive, is attenuated by the recognition that its message originates elsewhere, with other thinkers. The art is most effective in a derivative sense then and is therefore not very powerful on its own as a vehicle of social or cultural critique.

The social thought that the artists have produced has a much different and more original relation to the broader intellectual formation to which it refers than does the art itself. This thought is about commodification, gender, power, and related issues within the specific locale of the art world itself. Much of the art, on the other hand, makes general statements about society or culture rather than about the conditions of its own production or the particular social coordinates that have given rise to the broader intellectual formation of the postmodern.

WHAT ARE THE GENERATIONAL, CLASS, AND PSYCHOCULTURAL CHARACTERISTICS OF THESE ARTISTS IN CONTEMPORARY AMERICAN SOCIETY?

Having located the artists within a broader contemporary intellectual context, we might now ask about their social grounding, one explicit dimension of specificity that their art might address. In such reflexivity and particularity, as I will argue in the next section, lies the possibility of this work developing as yet unachieved transformative and critical power. The effort to offer a sociological grounding for the current intellectual postmodernism crosscutting academia and the arts has been most cogently developed by Fred Pfeil, who is worth quoting at length.

> Specifically, I will be arguing that postmodernism is preeminently the "expressive form" of the "social and material" designated as the "baby boom" and the "professional-managerial class" or PMC. The classic definition of the PMC's place in the relations of production of contemporary capitalism is, of course, the Ehrenreichs': situated "between labor and capital," the PMC consists of "salaried mental workers who do not own the means of production and whose major function in the social division of labor may be described broadly as the reproduction of capitalist culture and capitalist class relations."
>
> Such a site has no clear borderlines on either side. Those placed in the top income brackets of what the U.S. Bureau of the Census calls "managerial and professional specialty occupations," for example, may be politically as fully recuperated by capital as nurses or elementary and secondary teachers, at the bottom of this salariat, are recuperable by labor. Yet it includes all those responsible for administering, rehabilitating, ameliorating, mediating—in short, of reproducing the capital-labor relation, from the point of production, where the industrial engineer is deployed, to the dizzy, whirling realms of distribution and realization, where the ad men and marketing people live with all their retinues, from the provinces of social service workers, those colorless halls in which the "safety nets" are spread out for

those qualified to be caught up in them, to those most apparently abstracted and autonomous realms of "cultural production" from MGM in L.A. to Mary Boone in Soho to New Haven's Yale.

What binds these obviously gelatinous and heterogeneous "middle strata" together as a class, though, is more than the external, functional description; it is also constituted by a class ethos which includes as one of its leading elements an internal set of norms, values, and attitudes towards work—both the work we do, and the work of our parents and peers in the old middle and working class. *This "mind-set" towards work is overdetermined and accentuated by generational difference, but is nonetheless fundamentally enabled by the peculiar nature of PMC work processes themselves, dependent as they are for their proper functioning on some combination of the internalization of bureaucratized norms (academic and/or legal regulations, company policy, etc.), specialized discourses and behaviors ("being a professional"), and not least, an almost guildlike sense of individual autonomy and ability within the more-or-less horizontally perceived company of one's peers, with whom one not only works but "networks" for the final satisfaction of each and all.* Such requirements and values (for which the way is laid, as we have seen, by education) differ markedly both from those of traditional middle-class and/or petit bourgeois sectors (that is, from both the "organization man" and the small-scale entrepreneur), and from traditional working-class notions of solidarity and cohesion in the face of direct pressures and controls applied from above.

For the PMC, by contrast, Foucault's otherwise rather dubious ontology of power is experientially true. His view that power, "permanent, repetitious, inert, and self-reproducing," has no definable or limitable sources, "comes from everywhere," has been met with such acclaim by PMC intellectuals here precisely because the mixture of canniness and befuddlement it contains and effects expresses the perspective of an entire class, an entire way of life.[8]

In his precis of Peter Sloterdijk's *The Critique of Cynical Reason,* Andreas Huyssen adds a psychological dimension to the "mind-set" Pfeil describes:

Sloterdijk perceives a universal, diffuse cynicism as the predominant mind-set of the post-1960s era, and he takes the cynic not as the exception but rather as an average social character, fundamentally asocial, but fully integrated into the work-a-day world. Psychologically he defines him as a borderline melancholic able to channel the flow of depressive symptoms and to continue functioning in society despite constant nagging doubts about his pursuits. I suspect that Sloterdijk's criticism is less widespread than he might want to claim. But as an analysis of the prevailing mind-set of a generation of middle-aged professionals and intellectuals, now in their late thirties to mid-forties and in increasingly influential positions, Sloterdijk's observations are perceptive and to the point. One of the consequences of Sloterdijk's concern with the subjective effects of cynical reason is that he attempts to address the creeping political disillusionment of the post-1960s era on an existential, subjective level rather than disembodying it into the realm of universal norms or agonistic, free-floating language games without subjects. From an American perspective one might say that Sloterdijk offers a sustained polemical reflection on a modernity gone sour and a postmodernity unable to stand on its feet without constant groping back to what it ostensibly opposes.[9]

Whether one agrees fully with Pfeil's heavily Marxist-inflected analysis or not, it has the great virtue of grounding the postmodern, including the artists within it, in the social. The irony is that while these artists seem to stand apart culturally, they are in fact part of a mainstream deeply implicated in processes of power and image creation that sustain high, popular, and everyday culture. Does the "avant-garde" artist qualify as a professional specialty occupation? Do these artists have the mind-set described above, for which Foucault (and other key theoreticians such as Baudrillard) have a special affinity? If they do, are they critical or merely expressive (and reinforcing) of the power base and position of their broad social class? If merely expressive, how might their work become more critical, more revealing, and more subversive of the PMC of which they are full members? This would require, as I noted, a more reflexive and particularistic art than now exists, one that equals but develops free of dependence upon the commentaries that surround it, one whose installations, objects, and images can address more strongly the specific institutional (art world), intellectual (the postmodern movement), and social (PMC) affiliations in which it is embedded. This would be a more personal and explicitly sociological (or from the perspective of anthropology, ethnographic) art, and certainly an art more in line with what the commentary on it intends it to be.

Further, it is clear from the interviews with and commentaries by these artists that they are rooted in the kind of cynical mind-set that Huyssen, discussing Sloterdijk, describes for contemporary artists and intellectuals. However, their hopes for their art—hopes that are moderated by their constant nagging awareness of the appropriation of their work by centers of wealth and power as the condition of its success—are also rooted in Sloterdijk's rather utopian faith in the trickster, the master of parody. Parody—humor with serious intent—is after all the major mode of this art (and postmodernist genres generally). The problem is that it expresses few historical or sociological specificities to protect it from appropriation as mere entertainment by its targets among the wealthy and powerful within the PMC and beyond. Finding more precise and personal subjects in the world in which this art is produced, collected, and circulates would finally make of its predominant parodic mode an unambiguous critical weapon, one that would not only evoke processes of power and wealth but would also provoke the sorts of responses that would test the limits of prevailing cynicism among the powerful and among their intended critics, the artists themselves.

THE COMMON PREDICAMENT OF CONTEMPORARY ART AND ANTHROPOLOGY

A major advantage of having established the identity of contemporary "avant-garde" art within the broader currents of postmodernism is that this encourages comparisons between the practices and conditions of high-culture artists and those of other kinds of intellectuals and scholars affected by the same sorts of theories and issues—comparisons that might not have seemed as natural had contempo-

rary art remained isolated in its own high-culture context. Here, I want to query further the critical power of the work by younger artists in the exhibition to probe the nature of power relations in contemporary America from the perspective of cultural anthropology, a discipline whose practices of knowledge creation have been open to strong critiques during the 1980s, derived from the general questioning of forms of representation and authority associated with debates about postmodernism. A similar though more wide-ranging commentary on the social critical power of contemporary art could be offered from the vantage point of feminist theory.[10] But I have been more personally involved in the debate about the representation of society and culture in anthropology, and it was this disciplinary situation that constantly came to mind as I reviewed the work in this exhibition.

Twentieth-century anthropology has been defined by a distinctive method of inquiry and kind of writing: careers are initiated and then developed through a long period of participation and study within the realm of another culture (classically, so-called primitive, exotic others, but now, almost any human subjects, often in Europe and the United States), followed by the writing of descriptive and interpretive texts—ethnographies—that attempt to represent experience, everyday life, modes of thought and cognition, and social processes in that realm as a cultural system. While there have been many ways to write ethnography, including a good deal of literary allusion, the task has largely been understood by anthropologists as conducted according to scientific and objective standards. Stimulated by certain historic events especially affecting anthropology, such as decolonization, and by others crosscutting the humanities and human sciences, such as the cultural studies movement and postmodernism, the critique of ethnographic writing from the mid-1980s brought issues about power, ethics, and the nature of anthropological knowledge to central attention in the discipline.[11] In part, the very same concerns that are being raised about contemporary "avant-garde" art in this exhibition have also been at stake in the critique of ethnography in anthropology—concerns about the implication of the production of knowledge (which could cover both the work of socially minded artists in the exhibition as well as that of ethnographers) within relations of power and of the power of such knowledge, once its authority and ability to securely represent other ways of life have been questioned, to provide critical insight into processes of domination, control, and the creation of value in a particular society.

Three aspects of ethnography that have been of central importance in its recent critique seem relevant to an assessment of the critical power of the art in *Power:* reflexivity, particularity, and the self-other dialectic. I will briefly define these aspects in the frame of ethnography before discussing to what extent they are evident in the work and thought of the younger artists in the exhibition.

Reflexivity requires attention to the conditions and relations of the production of knowledge as an essential part of producing that knowledge. It personalizes the process of inquiry, but not primarily for the purpose of self-understanding. Rather,

closing the distance between observer and observed, the subject and the object, the writer and his or her referent in social life, through a keen sensitivity to how one is always in a very definite and complex social relationship to an object of knowledge, raises immediately the dimension of differential power involved in the manifest claims of clinical disinterest, rationality, and scientific objectivity for an activity of research such as fieldwork in anthropology (and also, I would argue, such as creating art, which impersonally produces insight about society and culture). Reflexivity ultimately suggests changes in these relations between observer and observed that constitute knowledge production, as well as changes about what is to count as knowledge in different spheres such as ethnography and art.

Particularity is traditionally at the heart of ethnography. Knowledge comes from finely observed and sifted detail. General concepts are made less abstract by having a specific location and subject in social life. In ethnography high value is placed on translating general categories of activity about social processes into the particular everyday life conditions of a group. Knowledge is built from such situated and local knowledges. The more particular a knowledge is and the more it is directed toward and accessible to one's subjects as well as to a broader readership, the more powerfully illuminating it is. In the postmodern debate there is indeed a general suspicion of metaframeworks, authoritative abstractions, and the inflexible bounding of culture by rules and system metaphors. Consequently, I perceived the postmodern moment as potentially an ethnographic moment, with the highlight on exploring the particular in an increasingly global, interconnected world.[12] How to represent the particular, probed reflexively, becomes a matter for experimentation in the production of ethnographic work, which is now ongoing.

The construct of otherness has been an essential aspect of the construction of the object of reference and study in anthropology. It is also the source of its critical sensibility. The differentiation of self and other in anthropological research requires a process of translation that inevitably transgresses boundaries between cultures. It calls into question the absolute boundedness of any cultural domain as an ideological statement and assertion of power. Through the older doctrine of cultural relativism, and more recently through an understanding that all cultural systems in an increasingly mobile world of time-space compression are composed of intercultural references and fragments, anthropology has regularly transgressed the power of cultures to define their own identities in a controlled manner. This transgression is enacted in every case of fieldwork, which, while trying to define others, fundamentally calls into question the anthropologist's own culture of reference. American culture never looks quite the same or as coherent after fieldwork. The critical sensibility of anthropology is founded on this kind of bifocality or stereoscopy. Never being able to fully constitute a homogeneous, distanced other in its representations is a seeming limitation of ethnography that is also the source of its most important critical perspective.

REFLEXIVITY, PARTICULARITY, AND OTHERNESS IN THE WORK
OF THE YOUNGER ARTISTS IN *POWER*

Reflexivity and particularity together suggest a more focused and targeted explo-
ration of power, one that the artists know best as autoethnographers of a sphere in
which they are deeply involved but from which they are also alienated—the high-
culture art world itself as a distinctive elite institution of American society.
Processes of commodification, the desire for luxury goods, and the mass repro-
duction of images preoccupy a number of artists in *Power.* Yet the art, in contrast to
the discourse of these artists, lacks particularity and reflexive consciousness other
than on its margins or in occasional gestures. Now thoroughly theorized and under
investigation by academic humanists and social scientists, the representation of
commodification in self-consciously avant-garde art seems less compelling as a
general condition of society than in its specific institutional and subcultural condi-
tions for people differently situated and with varied involvements in the exchange,
circulation, and consumption of signs and objects. More can and should be com-
municated about the particular than the general at the moment. This requires a
more personal and precise positioning of a critical art concerned with the politics
of producing and giving aura to certain images and objects over others within the
framework of economic exchange and value creation.

In contrast to the overly general and abstract statement that much of this art is
making as an extension of largely academic theory, the thinking of these artists,
manifested in interviews and essays,[13] is fresher and more engaged with the man-
ifestations of power that affect them most specifically. For example, the following
extended excerpt from a brief article by Clegg and Guttmann is an eloquent state-
ment about and reflection upon the predicament of the contemporary artist who
would engage in social and cultural criticism.

> Our generation however lost the belief in the existence of an omnipotent and
> omnipresent system. What we see around us are decaying powers. A collection of
> power configurations without a common goal or method. And, as a consequence,
> we lost the belief in the possibility and usefulness of finding an Archimedian point
> outside the system.
>
> So where does it leave us if we are not only tolerated by the system, but actually
> encouraged to critique it by some strange and self-destructive force? *What if critique
> itself were a desirable commodity, not in spite of its content, but because of it?*
>
> Perhaps the deeper reason for this radical doubt is that we feel more than before
> the effects of the processes of privitization of experience, and hence we are called to
> redefine the relationship art has with its public.
>
> Earlier conceptual artists conceived of their art as representing its public or even
> being able to constitute a public from their viewers. Such a process presupposes a
> complex and engaged interaction between the art and its public; a process which
> attempts to change the viewer.
>
> This model is exactly what is challenged by the "private" conception of art which
> prevails now, according to which the viewer is presented as a consumer and the art as

the product consumed. The opposition is clear—for one thing, consumption presupposes initial acceptance, and hence preempts provocation and resistance. In addition, consumption is a solitary activity. A group of consumers never makes a public of consumers.

The present condition, then, is of doubting whether art could function as a critical tool directed at a public when what we see around us is a collection of consumers. This doubt calls for a suspense of any assumption about the public. It defines the public negatively—via de-privatization—the emptying out of anything private. And the result, when interpreted as a continuation of the tradition of conceptual art, is art which analyzes the conditions of production and reception of meaning under the pressure of privatized experience. More specifically, we feel a necessity to shift from a preoccupation with content—Art as Critique—to experimentation with new modes of communication and reception. Without those, content and meaning cannot be trusted any longer.[14]

Indeed, I found that the most critically astute and effective of the younger artists are those most concerned with who their publics are, with what and how extensive the reception to their work is. These are the artists who intervene in and recontextualize through installations actual social events, everyday activities, and settings, the artists whose examinations of social forms of power get fully enacted in their work, which depends precisely on a very context-specific and reflexive monitoring of how the work is received. They include Dennis Adams and Krzysztof Wodiczko (and, most obviously, Hans Haacke, had he been included in this exhibition). Adams and Wodiczko are not as reflexively concerned as Haacke with the art world in which they have acquired recognition, but their work is distinguished by its sensitivity to its social location and reception. It depends considerably on the anticipated and actual reception in specific, mostly public places. Escaping the gallery, museum, and private residence (or reconfiguring these settings when they are represented), these artists are able to enact in their art the complexity of the issues about the contemporary possibilities of critical art that Clegg and Guttmann discuss with such clarity. As Mary Anne Staniszewski comments on the work of Dennis Adams:

So much of Adams's works takes place on city streets—his bus shelters, his street signs, his pedestrian tunnels. He has said that his pieces, in general, are situated at "thresholds, entrances, exits," places he considers "marginal, transitional, sites that catch the viewer off guard." These marginal, "threshold" locations are appropriate sites for revealing the ellipses of collective memory, or what I've been describing as the political unconscious of a location.[15]

Wodiczko also has a keen concern for how his work intervenes in public spaces and the sorts of responses these interventions elicit. Such interventions are indeed dramatic acts of or bids for power, analogous to those of the socially powerful people (represented, for example, in architecture) which his art is meant to illuminate. The following excerpts from an interview with Roger Gilroy about Wodiczko's nighttime projections on Washington museum buildings provides a sense of his critical project.

KW: Listen, isn't it true that the cultural value of all symbolic structures in the city—whether they are statues or buildings (historic or contemporary), whether they were intentional or unintentional—depends on the city dwellers' ability and opportunity to project and juxtapose new meanings on these structures? That is, doesn't their value depend upon the ability to place them in present situations, confront them mentally with the contemporary social context, and imagine, for example, what those monuments "see" (or do not see) when they "look" at the homeless people on their steps? What kind of meaning or appearance can these monuments assume—monuments on the federal (not city) territory of the Washington, D.C. Mall—when they "look" at the current presidential election campaign?

 Now, the problem is how much we artists and intellectuals of different kinds—activists, urban geographers, ethnographers, community workers—how much can we activate those symbolic sites to help them to operate as places of critical discourse . . .

RG: Do you think there is any way your pieces could become authoritarian given their mass spectacle qualities? . . .

KW: . . . Bear in mind that the public is subjected daily, by billboards and advertisements, as well as political propaganda, to an enormous amount of manipulative material. In light of these facts, I am skeptical about discussing my work as being somehow "authoritarian," or as having an effect similar to that of an orchestrated mass spectacle. People might be particularly sensitive to specific images or parts of images because of individual experiences. I was hoping the Smith and Wesson revolver would not evoke the memory of the Vietnam War; unfortunately, this was the case with one viewer. . . . *I would like to be sure that my work is coherent enough to protect itself from such selected and extreme readings, and I'm always very sensitive about the possibility of making a mistake by not predicting readings that contradict the intention of the work.*

 . . . I can't believe that my work can successfully alter the way things develop. All that the work can do is help those people and groups and institutions, and also larger sections of critical society, to retain a level of criticism and understanding of what's happening. *It is a very small contribution. So, to talk about my authority and power in relation to the power and authority addressed by the work is quite inappropriate because that would really suggest too much for the power of the artist as an interventional, temporary, public speaker. As soon as my work reaches the level of power of the forces I question, I will turn my projectors against themselves. At the same time, one must be willing to exercise some power in order to gain access. The fear of gaining access to power is generated by the dominant system, of power itself; it is an ideological trap of that system. Those who want to retain total control of the dominant power structure support a kind of religious fear of power. One should not normalize this power, or confront it passively, but try to gain access to it to voice a critical position.*[16]

Even though Wodiczko's claims for the transforming potential of his art's social critique are quite modest, his work, along with Adams's, comes closest among the artists in *Power* to being a political art. If its subject were the power relations in the production of art itself, Wodiczko need not have been so modest about its potential contribution to changing such relations.

 Finally, the artists, at least those selected for this exhibition, are disturbingly silent about the self-other dialectic, especially as it concerns art worlds outside the

official aura of the high-culture art world and beyond the present culturally homogenizing state of the PMC. With the exception of gender—treated in the feminist strains of the work by Holzer, Kruger, Lawler, Sherman, and Simpson (but, interestingly, largely absent in work by the male artists)—important fault lines of inequality such as race, ethnicity, and culture, in which scenes of domination and resistance are played out in contemporary American life, are completely missing in this exhibition. From an anthropological perspective, it is hard to practice effective criticism without dealing sensitively with the extraordinary heterogeneity of American society through which power is diversely exercised and just as diversely resisted. Introducing the contemplation of the salient dimensions of otherness, requiring the kind of bifocal translation previously discussed in ethnographic research, would radically enhance these artists' work, too encompassed as it is by the largely white male conditions of the baby-boom PMC. If artists within the aura of the current high-culture "avant-garde" were to address themselves explicitly not just to other cultural, racial, and, ethnic differences, but also to other, already existent, vibrant art worlds that have been created from the experience of such differences,[17] this alone would be a bracing subversion of the power relations in their own elitist art world, which fix the boundaries of value and taste.

PROVOCATIVE MUSINGS ABOUT THE SILENCE OF WEALTH IN THE HIGH-CULTURE ART WORLD: COLLECTING AND LENDING

The preceding discussion of reflexivity and particularity as qualities that might enhance contemporary art's pursuit of a critique of the exercise of power and the ways in which power, control, and domination are embodied in cultural forms in American society, suggests that the artists might turn their concerns back upon the institutions and power structures of the art world in which they are most deeply and personally implicated. Here, their more general treatments of authority, discipline, consumption, and commodification would be made powerfully specific, if not ethnographic. These artists' most passionate concerns about power relations, expressed in their interviews and writing, but backgrounded in their creations (or only indirectly addressed by artists such as Bickerton and Lawler, mainly with regard to the conventions of display), would now take center stage.

Whereas voice in the high-culture art world largely comes from the interpretive, critical writings of art critics, historians, and the artists themselves, all bound together by the intellectual and social class connections previously discussed, those constituting the most powerful sector of the art world—the institutional and private collectors, and their intermediaries, the dealers, advising academic and financial experts, etc.—are deafeningly silent. Artists might focus on the reception of their art by those who buy and collect it. Such a speculative or ethnographic endeavor might be the most illuminating, if not the most critically subversive, means of evoking the power correlates of cultural processes. In moving from the general view of, say, commodification, to the reflexive and particular, the art mar-

ket and collecting itself would become obvious concerns of artists who themselves are distinguished by their collectibility.

I have not done an ethnographic study of collectors, nor do I know of any extensive social science studies of this domain of the powerful and wealthy in the contemporary art world.[18] Yet, for the purpose of assessing the appropriateness of this particular power elite as a topic for reflexive, critical art, it is worth outlining its sociological contours and raising questions about the attitude of establishment collectors toward the putatively critical art in which they invest considerable money.

Purely for illustration, I have extracted information about private lenders to *Power*, and organized it into two tables (see tables 7.1 and 7.2). Methodologically, what I have done is seriously flawed, since this exhibition did not intend to examine the process of collecting work of the current "avant-garde." Hence the sample of collecting in the exhibition is not necessarily representative of such collecting in general. Yet I would like to think that what I have done in the table is similar to what Ashley Bickerton does in *Tormented Self-Portrait (Susie at Arles) #2*. As the logos is an iconic portrait of the self as consumer, so this table ironically creates a partial portrait of this exhibition on power as represented by the private owners, lenders, and sources of wealth that it quite circumstantially has brought together.

Nonetheless, certain features of the table are suggestive of the argument I have been making. The most important is that some of the collectors who would presumably be making highly personal choices about the art,[19] have derived their wealth from activities that are targets of the art itself. Given the real lack of information about the response of the collectors to the art they acquire, this might be a naive question in specific cases, but generally it is an important one to ask and an especially provocative one to ask of the artists themselves.

If the artists do not actually know, then how do they imagine that the collectors of their work, who have become wealthy from careers in the media, publishing, and advertising, respond to their critical parodies of corporate and advertising images, the exercise of power through signs, the corruption of commodification, and the like? The artists might think cynically about this—the joke is on the collectors. Or, perhaps out of embarrassment or uneasiness about the brute fact of this most direct form of their appropriation by elite wealth and power, they might exhibit a studied indifference—a shrug—concerning what meaning those who buy their work attach to it. Or, as in the case of the following quotation from an interview by Jeanne Siegel with Jeff Koons, the artist might think self-servingly and naively about such reaction:

J.: How do you think the art collector perceives the work?
JK: I think of my work as trophies—not only for my personal accomplishments, which is my art—but that the collector views the work as a trophy of their personal accomplishments. The reflective quality of these pieces gives them a sensation, that fast intoxication of achievement. Objects of luxury are reflective. They're about distortion—a confusion of thought patterns for the moment, which works as a drug. I

TABLE 7.1 Private Collectors Who Lent Works to *Power*

Lenders acknowledged as top U.S. collectors of contemporary art (from annual listing in *Art & Antiquities*, March 1989, 1990)

Collector	Work
Eli and Edythe L. Broad, and Eli and Edythe Broad Family Foundation, Santa Monica, CA	Cindy Sherman (3 untitled works) Jenny Holzer *(Laments)*
Jay Chiat, New York	Richard Artschwager *(OfficeScene)*
Edward R. Downe, Jr., New York	Louise Lawler *(Combien pour ce chapeau?)*
Gerald Elliott, Chicago	Ashley Bickerton *(Tormented Self-Portrait . . .)* Jeff Koons *(Louis [XIV])*
Raymond J. Learsy, New York	Louise Lawler *(Does Marilyn Monroe Make You Cry?)*
Paul and Camille Oliver-Hoffman, New York	Richard Prince *(Creative Evolution #3) (King Kong)*

Other private lenders who may be either (1) minor private collectors whose source of income is comparable to that of recognized major collectors listed in section I, or (2) minor private collectors who may also be dealers or gallery owners and who are lending their privately owned works, which are not for sale in their galleries

Collector	Work
Ruth and Jacob Bloom, Marina del Rey, CA	Chris Burden *(Warship)*
Judy and Stan Cohen, Atlanta	Barbara Kruger *(Untitled) (Who Is Bought and Sold?)*
Suzanne and Howard Feldman, New York	Louise Lawler *(Three Women / Three Chairs . . .)* Lorna Simpson *(Necklines)*
Gabriella de Ferrari, New York	Louise Lawler *(Does Andy Warhol Make You Cry?)*
Arthur and Carol Goldberg, New York	Stephen Laub *(Untitled)*
Mr. and Mrs. Ronald K. Greenberg, St. Louis	Donald Judd *(Untitled)*
Mr. and Mrs. Samuel J. Heyman, New York	Stephen Laub *(Untitled)*
Mr. and Mrs. Takao Ito, Tokyo	Frank Stella *(Mitered Squares)*
Susan Harris, New York	Richard Prince *(Untitled)*

(continued)

TABLE 7.1 *(continued)*

Collector	Work
Miani Johnson, New York	Lorna Simpson *(Untitled)*
Marvin and Alice Kosmin, New York	Clegg and Guttman *(Et in Arcadia Ego & Company)*
Rita Krauss, Roslyn, New York	Cindy Sherman *(Untitled)*
Sidney and Frances Lewis, Richmond, Virginia	Roy Lichtenstein *(Three Pyramids)* Robert Morris *(Untitled)*
Carol and Paul Meringoff, Old Westbury, NY	Stephen Laub *(Untitled)*
Gerd Metzdorff, Vancouver	Tony Tasset *(Bench Progression)*
Don and Mera Rubell, New York	Jeff Koons *(New Hoover Convertible)*
Michael H. Schwartz, New York	Cindy Sherman *(Untitled)* Peter Halley *(Power/Volume)*
Marty Sklar, New York	Haim Steinbach *(Pink Accent)*
Mr. and Mrs. Edward Strauss, Denver	Stephen Laub *(Untitled)*
Susan William, New York	Lorna Simpson *(You're Fine)*
Mr. and Mrs. Bagley Wright, Seattle	Robert Longo *(Black Palms)*
Donald and Shirley Young, Chicago	Ashley Bickerton *(KHKSHGK)*

TABLE 7.2 Private Collectors of Younger Artists in *Power* (drawn from table 7.1)

Artist	Collector
Bickerton	Elliott, Young
Burden	Bloom
Clegg and Guttman	Kosmin
Halley	Schwartz
Holzer	Broad
Koons	Elliott, Rubell
Kruger	Cohen
Laub	Goldberg, Heyman, Strauss, Meringoff
Lawler	Downe, Learsy, Feldman, de Ferrari
Longo	Wright
Prince	Oliver-Hoffman, Harris
Sherman	Broad, Krauss, Schwartz, William
Simpson	Feldman, Johnson
Steinbach	Sklar
Tasset	Metzdorff

imagine the collector will also feel somewhat threatened by the survival strength of the stainless steel.[20]

But what if the joke is on the artists? What if the owners find their parody entertaining or otherwise tolerable to their values, rather than subversive? In this sense, the work can even be understood to be expressive of values shared with owners/collectors. After all, amid the general legitimation crisis that Habermas discusses, cynicism and a sense of the insecurity of one's power are common psychological attributes of elites, and certainly would not be uncommon in the wealthy connoisseur of modernist art. Probing behind the silence of the powerful within the contemporary high-culture art world is thus one compelling topic for the art in this exhibition that would require the kind of reflexivity and particularity for which I have argued.

THE ABSENCE OF OTHERNESS IN THE ART IN *POWER*

I don't have in mind here merely that critical artists must recognize and treat other cultures or an American reality that is culturally plural (although this is important), but that, self-conscious of their own elitist surroundings, they might explore in their art and in juxtaposition to themselves the conditions and practices of other contemporaneous art traditions, especially those among people who are not considered to be producing art until they are discovered or officially assimilated by the high-culture art tradition. This would be a mode of subversion, rather than mere criticism, as it would transgress the boundaries that elite power imposes and depends upon to control its cultural identity of dominance. For some artists such a move would mean returning to their earlier experiences in public art[21]—a diverse world of artistic practices associated with movements, causes, and communities.

My suggestion may seem similar to the effort in postmodernism (as in past avant-gardes) to collapse high culture and popular (often culturally diverse) culture by borrowing from the latter, but this sort of effacement of elite boundaries and pretensions has already been well accomplished and is in the secure tradition of contemporary high-culture modernism. The difference in what I am suggesting is in recognizing the *autonomy* of these alternative sources of art when bringing them into the aura of high art. In the hands of the established artists, uneasy in their own co-optation, these other art worlds would remain foreign bodies, only partially digested—they would be more quoted from than borrowed by the recognized "avant-garde" as a way of initiating a dynamic self-other dialectic in their work. From the perspective of the critique of power, the point of this undigested treatment of other art practices would be to challenge the operation of power relations in constituting the high-culture art world—to bring within its discourse on images and objects other creations that this discourse does not, and as constituted cannot, recognize and value.

A recent interest of anthropology is an apt illustration of this suggested critical

strategy for contemporary artists. There has been much discussion of how during and since the era of Western colonialism and the history of modernism, ethnographic artifacts have moved from anthropology and natural history museums to art museums, galleries, and artist studios.[22] But what is at stake now in the late-twentieth-century circulation of tribal objects is very different from a mere modernist affinity for tribal "art," which through the entwined histories of modernism and colonialism has been enacted under an attitude of condescension and by unadorned acts of appropriation. Now, many such tribal, so-called "Fourth World," peoples have created their own distinct commodity-oriented domains of art production for tourist art markets as well as for high culture, "avant-garde" art markets. In an important recent paper on how Australian aboriginal acrylic paintings are being assimilated by the New York art market, Fred Myers remarked:

> Back in New York, in May of 1989 the John Weber Gallery in Soho had a show of Papunya Tula artists' work, and as I waited there one afternoon to interview the gallery owner, I was jarred by hearing a visitor to the gallery talk with familiarity of Simon Tjakamarra's "colorism" and the decline of Clifford Possum's recent paintings, Aboriginal men I knew from my fieldwork, where I was once threatened for merely asking the name of a man's country! In short, the people whom the *Guinness Book of Records* inscribed as having the simplest material culture of any people on earth, representatives of people regarded disparagingly by the dominant white majority in Australia, are now accorded international appreciation as producers of "high art," an appreciation rarely granted to Australia's white art producers.[23]

At the heart of this irony is the arrogance of power in the New York art world, assimilating what is culturally different but on its own terms, according market value to this difference in the form of an appeal to exoticism while keeping the conventions of its own world intact. Fortunately, the art dealer John Weber himself sees something more challenging in the entry of this art into the "avant-garde." As Myers writes:

> Most writers on art recognize it to be decoratively pleasing and fitting comfortably enough within the visual expectations of the Western tastes for Abstract Expressionism of the 60's and 70's and busy surfaced acrylic work of the 80's. Thus, it not only suits the development of national identity, but it fits without discomfort on corporate walls and in the preexisting collections filled with such works.
>
> The question is whether this placement of the acrylics "into the existing structures of popular art theory" (Weber 1989) is appropriate or whether, as the New York dealer John Weber holds, "A new vision demands a new system of critical thought." Weber—who exhibits the work of site-specific artists like Robert Longo and political artists like Hans Haacke—is the first significant gallery owner in New York to take on the work and he attempts to place the work's entry into the art market as demanding a *rupture* in critical constructions. He talks of the need for "an art dialogue sympathetic to the intent of this work . . . to engender a deeper understanding and appreciation of what the viewer sees and subsequently feels and thinks." If a new set of art critical theory is necessary to elucidate this new art, Weber's dis-

cussion suggests it should engage four central features, (1) the vitality and compositional complexity of the paintings, (2) their site specific quality, (3) their political message, and (4) their narrative subject matter.[24]

Following Weber, an explicit treatment of alternative art worlds (*not* other cultures unmediated), largely unrecognized by the New York art world, might be an enhancing, critically reflexive direction for some of the established "avant-garde" artists in this exhibition to explore. Confronting "otherness" in this open way would challenge from within the power of an elite art world to sustain the boundedness of its own identity (and in so doing, to sustain by implication a hierarchy of other artistic identities by tokens of recognition and nonrecognition), just as the self-other dialectic operates as a dynamic of cultural self-critique in ethnographic research. The case of the aboriginal acrylics is suggestive, but the aborigines do not have much power to control their process of assimilation into the world of high art. However, the established "avant-garde" potentially does have such power merely by making other art worlds, their relation to high art, commodification, and the like an explicit subject of its own art.

My main point then is that those artists who are interested in the critique of power relations within the high-culture art world might be interested in otherness, art marked by cultural, ethnic, and racial difference, or merely in art excluded and unrecognized within this world, as a possible means of transforming those power relations. Thus, challenging the homogenizing, institutionalizing tendencies in the creation of new trends in this elite art world by making statements about other art elsewhere (that already has its own definition and is not waiting to be discovered as "art" by an established high-art system constantly thirsting for the new at its edges) is a complex, ingenious strategy for artists who might be seeking more effective and engaged ways to treat the workings of power in late-twentieth-century American culture.

CONCLUSION

I have, with some injustice, downplayed the considerable diversity of visual imagination among the younger artists in *Power* as well as the pleasures that their work offers in its ingenuity, cleverness, and humor, in order to examine the premise that this is art that has something cogent and powerful to express (or desires to do so) about relations of power and domination in contemporary American society. In fact, what I found interesting in this art was not its critical acuity concerning power, but its fundamental ambivalence about it. Despite the salient awareness of forms of social and cultural domination in these artists' work, in contrast to that of their immediate forebears, their images and installations are still all too easily appropriated in different ways—as entertainment, as light but tolerable critique, even as celebrating power elites or certain media and culture industries—by those who are the very subjects, by implication, of the critiques of power relations that this art develops.

The variance between the rich diversity of what the artists have to say in interviews and writings about their everyday lives in a powerful and elitist art world and as members of the PMC, and the relative predictability and generality of what they depict in their art about contemporary culture and domination, suggests that the discursive eloquence and critical sophistication of the former should be more evident in the experiments with images and objects in the latter. In order to do this, the artists would ground their general insights about commodification, consumption, desire, discipline, and violence in their own specific positions and experience within the power-laden transactions of the market for their work. Once their work is opened to such a critical reflexivity, the result might be the beginning of a political art at the very center of high-culture power, wealth, and prestige that have been so vested in a series of post-World War II "avant-gardes."

NOTES

This paper has benefited immeasurably from the research assistance of Laura Brousseau, scholar of art and the media. Arguments presented here in my own idiom were forged in our discussions during the long, hot Houston summer of 1990.

1. Ridgeway 1989:75–86.

2. For example, from Shaun Caley's interview with Ashley Bickerton (1988:79): "In art history Stella marked an absolute point when he broke down the art process: the stretcher defined the image, the image defined the stretcher. What you saw was what you got, becoming an absolute, final endgame equation. What Stella left undone was the fact that this object was catalogued and indexed into art history—his paintings became logos essentially for the corporation. But he left out the backside, the placement, the value, the recognition and the objectness as it existed outside of the point of authentic/aesthetic reckoning on the gallery wall. I wanted to address this and take it to its logical, or illogical if you like, extreme: what that object is, how it operates, how one contemplates exactly what it is one is dealing with in all of its facets."

3. The artists themselves have even written the most cogent *sociological* accounts of the art world in which they are implicated. See, for example, Rosler 1979:10–25. My argument is that there is nothing as explicit or as critical in the art they produce about the structures of power in which they operate.

4. See Habermas 1975.

5. This contrast between the power of the critique in their discourse and in their work is illustrated in Caley's interview with Ashley Bickerton in *Flash Art*. Bickerton speaks with eloquence and originality about contemporary American culture and about the traps into which the art that has sought to critique this culture in the past has fallen. Yet, when it comes to dealing specifically with the appropriation of his own art within the power relations of the art world, his own resistance to it, as manifested in his art, is gestural and ingeniously clever, but not direct, powerful, or committed:

It was first realizing that all important art in the catalogue of art history is indexed by the time and place it was made and this is what gives it its value, status, and ultimately *because* of these factors, its meaning: i.e., a Picasso, 1928. So when I came up with the SUSIE logo (which came from another piece—the name "Susie" written in hideous, neon text and typeset across a white ground), I decided that artists are usually catalogued in the formal surname of the father. By choosing a phonetically casual, female first name, that whole agenda is thrown into some discursive light. In a sense it becomes the artist's name brand, but it also becomes *name brand*. It breaks down the individual creator and they are no more Bickertons than they are Susies. (p. 80)

By a tactic of resistance, a guerrilla maneuver, Bickerton hopes to call art-world practices into question, but it has none of the power of his direct verbal assault on the state of American culture. It is this verbal power of critique that needs to be transferred visually and materially to the SUSIE work during its creation through a critique of a particular location and set of lived and experienced power relations. This might make such a specifically targeted work itself powerful and transformative rather than merely gestural. Despite the message intended for SUSIE, it is Bickerton, and not *name brand*, that circulates in this exhibition and others. It is this level of art-world power processes that Bickerton's tactic cannot touch.

6. See especially Huyssen 1986; Harvey 1989; and Brantlinger 1990.

7. See Harvey 1989; and Pfeil 1990.

8. Pfeil 1990: 98, 105; emphasis added.

9. Huyssen, Forward to Sloterdijk 1987:xii–xiii.

10. See, for example, Nicholson 1990.

11. See Clifford and Marcus 1986; Marcus and Fischer 1986; and Clifford 1988.

12. See Marcus and Fischer 1986: chap. 4.

13. Probably the most theoretical and intellectual of the artists is Halley, who writes strongly analytic essays, similar to those produced by academics. His ideas and strategies for critique are original and interesting, but he fails, in my opinion, to target them to any particular reception classes or to make them accessible to a broader public for his art. For example, as he wrote in "The Crisis of Geometry" 1984:

Additionally, if we can still believe in the distinction between capital and labor, and manager and worker, it must be emphasized that while media signs are primarily aimed at the mass, at the consumer and the worker, it is geometric signs in the form of art, architecture, and statistical analyses that the managerial class reserves to communicate with itself. For artists to address that ideology is an act of self-criticism rather than condescension.

Here is an expressed sense of the need for reflexivity to address relations of power and an understanding of a class identity between artists and managers. Halley also establishes an interesting connection between geometric images and the ideology as well as the inscriptive practices of managers. The question is whether the formal exercises that constitute his art convey precisely and without considerable verbal elucidation the important connections he is making between certain sign preferences and the use of very rationalized forms of power.

14. Clegg and Guttmann 1988: 117. Emphasis added.

15. Staniszewski 1990:19.

16. Gilroy 1989:29–31. Emphasis added.

17. See, for example, Raven 1989.

18. However, while I was at the Getty Center for the History of Art and the Humanities in 1989, Raymonde Moulin, the foremost French sociologist of art, had been conducting systematic research on the art market in Los Angeles, especially for contemporary art, and she was deep into the world of dealers, galleries, and collectors, including private individuals, corporations, and museums.

19. This, of course, is not always the case—one can see them as purely financial investments. But once works are acquired, collectors are often called upon in public and private to display "taste" about the assets in which they have otherwise made a considerable financial investment.

20. Siegel 1986:68. What is notable in Koons's comment is that he believes his creations have such an overpowering effect as luxuries (based on the scale and materials used to produce them) that their parodic quality—his artistry—is lost on those who own and behold them. I hardly think that they are unmediated trophies of achievement, except maybe to Koons himself. His further comments on the meaning of luxury, whether his creations manage to convey this or not, are more complex and particularly self-revealing (p. 68):

JS: steel pieces and paintings?

JK: The theme of the show was "Luxury and Degradation." I wanted to show how luxury and abstraction are used to control social class structure. . . . I intended to have the viewer become very intoxicated, to show a heightening of abstraction and distortion through visual intoxication, to have the works hover right at the edge of the upper class—to show luxury is a form of degradation. It's something that will do you in. . . . The more luxurious something becomes, the more reflective generally it becomes—the grill of a Mercedes, the distortion of light through crystal. These are all very intoxicating experiences. One gets lost. . . . It's trying to show that in a society, directed by income level, you are lured into seeking a deceitful luxury.

21. See Raven 1989.

22. See Rubin 1984; and Clifford 1988.

23. Myers 1991:41.

24. Ibid.:50.

REFERENCES

Brantlinger, Patrick
 1990 *Crusoe's Footprints: Cultural Studies in Britain and America*. New York: Routledge.
Caley, Shaun
 1988 "Interview with Ashley Bickerton." *Flash Art* 142(Nov.–Dec.):77–88.
Clegg, Michael, and Martin Guttman
 1988 "On Conceptual Art's Tradition." *Flash Art* 143:115–119.
Clifford, James
 1988 *The Predicament of Culture: Twentieth-Century Ethnography, Literature, and Art*. Cambridge, Mass.: Harvard University Press.

Clifford, James, and George E. Marcus, ed.
 1986 *Writing Culture: The Poetics and Politics of Ethnography.* Berkeley: University of
 California Press.

Gilroy, Roger
 1989 "Projection as Intervention (Interview with Krzysztof Wodiczko)," *New
 Art Examiner* 16(6):29–31.

Habermas, Jurgen
 1975 *Legitimation Crisis.* Boston: Beacon Press.

Halley, Peter
 1984 "The Crisis of Geometry." *Arts Magazine* 58(10):8–14.

Harvey, David
 1989 *The Condition of Postmodernity.* Oxford: Blackwell.

Huyssen, Andreas
 1986 *After the Great Divide: Modernism, Mass Culture, Post-modernism.* Bloomington:
 Indiana University Press.
 1987 Foreword to *The Critique of Cynical Reason,* by Peter Sloterdijk. Minneapo-
 lis: University of Minnesota Press.

Marcus, George E., and Michael M. J. Fischer
 1986 *Anthropology as Cultural Critique: An Experimental Moment in the Human Sciences.*
 Chicago: University of Chicago Press.

Myers, Fred
 1991 "Representing Culture: The Production of Discourse(s) for Aboriginal
 Acrylic Paintings," *Cultural Anthropology* 6(1):41–67.

Nicholson, Linda J., ed.
 1990 *Feminism / Postmodernism.* New York: Routledge.

Pfeil, Fred
 1990 *Another Tale to Tell: Politics and Narrative in Postmodern Culture.* London:
 Verso.

Raven, Arlene, ed.
 1989 *Art in the Public Interest.* Ann Arbor: UMI Press.

Ridgeway, Sally
 1989 "Artist Groups: Patrons and Gate-Keepers." In Arnold W. Foster and
 Judith R. Blau, eds., *Art and Society: Readings in the Sociology of Art,* pp.
 75–86. Albany: SUNY Press.

Rosler, Martha
 1979 "Lookers, Buyers, Dealers, and Makers: Thoughts on Audience," *Expo-
 sure* 17(1):10–25.

Rubin, William, ed.
 1984 *Modern Art: Affinity of the Tribal and the Modern.* New York: Metropolitan
 Museum of Art.

Siegel, Jeanne
 1986 "Jeff Koons: Unachievable States of Being, Interview," *Arts Magazine*
 61(2):66–70.

Staniszewski, Mary Anne
 1990 Foreword to Dennis Adams, *The Architecture of Amnesia.* Kent: Kent Uni-
 versity Press.

Confusing Pleasures

Barbara Kirshenblatt-Gimblett

People [at the Los Angeles Festival of the Arts] had to look at stuff they did not know how to react to. That began to be an authentic experience. They simply had to react as human beings. They did not know [how to react]. They simply had to look.

PETER SELLARS (1991)

What are the preconditions for creating interest in what audiences do not understand? Or, more specifically, how has the avant-garde prepared us for watching and valuing what we don't know how to react to? The definition of authentic experience as one where audiences confront the incomprehensible is at the core of the 1990 Los Angeles Festival, which I see as a cultural form driven by an avant-garde sensibility. It might even be said that the 1990 Los Angeles Festival restaged the loci classici of avant-garde performance, among them those encounters with Chinese opera and Balinese performance in Moscow and Paris during the thirties that gave us Brecht's *Verfremdungseffekt* (1964) and Artaud's (1958, 1976) pure theatricality. This paper explores how the 1990 Los Angeles Festival, in staging work unfamiliar to its audiences, avoided "ethnographic" and "entertainment" approaches. The location of authenticity in a moment of aesthetic reception—rather than in the objects presented—gives to the Los Angeles Festival its special character.

I

The 1990 Los Angeles Festival, which took place from September 1–16, was an ambitious undertaking, given the number of events mounted in so compressed a period of time over so vast a space. In all, about 2,900 artists appeared in 550 events in 70 venues. They included, within the curated program of 150 events, some 1,400 artists—500 of them brought to Los Angeles from 21 Pacific Rim countries and various parts of the United States and 900 of them based in Southern California. Another 1,500 artists, also based in Southern California, presented their independently produced work in 400 events within the Open Festival that accompanied the curated program. This activity was spread across Greater Los Angeles, primarily in the downtown and mid-Wilshire areas, Hollywood, and Westwood, but also in East Los Angeles, Santa Monica, Pasadena, Long Beach, Van Nuys,

Hawthorne, San Pedro, and Huntington Park, among others. The venues included parks and gardens; museums, art galleries, and art centers; theaters, cinemas, and amphitheaters; community and cultural centers, temples, and churches; historic districts and ordinary streets, shop windows and storefronts; buses, a train station, a pier, an outdoor marketplace, and City Hall. The 1990 Festival events included not only formal performances (theater, dance, music) and performance events that fit no easy categorization, but also literature programs, film and video, and exhibitions. The budget was about six million dollars.

The 1990 Festival's grand opening ceremonies took place on the Labor Day weekend at Angel's Gate and Point Fermin Park, overlooking the Pacific. Centered around a great Korean Peace Bell, itself a marker of the 1976 Bicentennial, the proceedings were described in the program and ticket information booklet as follows:

> In the morning, the artists will gather at the Korean Bell for a blessing beginning with native American prayer. After a procession down the hill joined by Chinese, Hawaiian, Tongan, Japanese, Samoan and gospel musicians, all the groups will arrive at Port Fermin Park for an afternoon long gift exchange of song, dance and invocation—a gesture of welcome and respect traditional to many cultures. This is not really a sneak preview of performances in the Festival, but a spiritual jam session. In the evening, there will be social dancing to a hot local group, Rudy Regalado and Chevere Band, playing straight-ahead salsa. . . .
>
> Got the idea? Take a deep breath. Inhale the world.
>
> (Los Angeles Festival 1990:8)

That Sunday, Los Angelinos visiting the African Marketplace at the Rancho Cienega Park would find four stages featuring music (jazz, blues, rock, salsa, reggae, rhythm and blues, and gospel), parades of floats as well as costumed groups of dancers and drummers, and performances by the Woomera Mornington Island Culture Team (aborigines from Queensland, Australia), performers from the Polynesian islands of Wallis and Fatuna, and Japanese American *taiko* drummers. Those who went to Olvera Street and Union Station could see the Ikooc (indigenous musicians from Oaxaca) and the Jemez Pueblo Matachines from New Mexico perform near the oldest church in the city, Iglesia Nuestra de Los Angeles. They were joined by the Bread and Puppet Theater. On the next day, the Moon Festival in Chinatown was incorporated into the Festival, which seems to have revived it after a ten-year hiatus. That afternoon shamans from the Chindo Islands in Korea performed "their euphoric, electrifying dances in the courtyard of Pasadena's Pacific Asia Museum. Accompanied by an ensemble of musicians, these ritual healers from Korea's Chindo Islands will offer a special blessing to Los Angeles—an event sure to startle and amaze" (Los Angeles Festival 1990:8).

In the days that followed an extraordinary lineup of artists appeared in locations far and wide, from the Children of Bali (twenty-two musicians and dancers aged nine to fifteen) and the Court Performers from the Yogyakarta Palace of Java to the Los Angeles Poverty Department (a performance group built from a work-

shop for homeless people directed by John Malpede) and the mixed-media installation Living With AIDS. Rather than the modular approach of so many international festivals, with formal national representation in dedicated pavilions or through official national performing troupes, the 1990 Festival sited itself in a city that Mayor Bradley declared was home to more Koreans and Cambodians than anywhere else except Korea and Cambodia. The world had already arrived and the task of the Festival was "to open up Los Angeles' neighborhoods to one another as never before, to introduce us to ourselves" (Bradley 1990:2). As constructed by the Festival, immigration was the international made local. Artists from abroad were "guests," rather than official state representatives.

In a recent interview, Claire Peeps, who has been with the Los Angeles Festival since 1988 and is now its Associate Artistic Director, shed light on its history. The Los Angeles Festival was founded as the successor to the 1984 Olympic Arts Festival that accompanied the Olympic games in Los Angeles. Incorporated in 1985 as a nonprofit organization (501c3), the Los Angeles Festival mounted its first festival in 1987. Though a new and different organization, the Los Angeles Festival drew several of its board members, including Maureen A. Kindel, who became the chair of its board, and Robert Fitzpatrick, who became its first director, from the Olympic Arts Festival's board and staff. It also retained some of the same patrons.

Both the 1984 Olympic Arts Festival and the 1987 Los Angeles Festival featured internationally recognized theater, music, and dance groups, most of them touring companies that worked within established Western genres on a proscenium stage. They performed within a few established venues in Los Angeles, with the exception of Peter Brook, whose *Mahabharata* was staged in the Raleigh Studios in Hollywood, which were especially prepared for it. While the Olympic Arts Festival was more international, in that more countries participated, the 1987 Los Angeles Festival concentrated on European artists.

During the 1987 Festival, Robert Fitzpatrick announced his resignation as director and his new role as president of Euro Disneyland Corporation, though he continued to serve on the 1990 Festival's board of directors.[1] During both festivals, he had been president of the California Arts Institute, which was founded as a training ground for Disney animation, eventually broadening its mandate. Several other key people also left the Festival for jobs with Disney. The Board initiated a search to fill the vacancy, invited Peter Sellars to direct the organization, and announced his appointment on the last day of the 1987 Festival.

Sellars became both the director of the Festival and the president of the board of directors. Sellars, who had established an international reputation as a brilliant theater artist, perhaps best known for his experimental staging of opera, first thought he would bring his own work and that of his colleagues to Los Angeles to form the core of the next Los Angeles Festival. He had been directing Mozart operas at PepsiCo SummerFare, near New York City, at the time. As he got to know the city and to make contacts at the University of California at Los Angeles,

particularly Judith Mitoma, director of the World Arts and Cultures Program, he realized that this plan "did not fit the Los Angeles landscape, literally or figuratively," in Peeps's words. Colleagues at UCLA had been thinking in terms of a Pacific Rim festival. The Los Angeles Festival picked up this theme and developed it in partnership with UCLA colleagues.

The first issue was to determine whether the Pacific Rim theme was more than a political expedient serving international trade, with Los Angeles at the center of a new global economy based in the Pacific and a burgeoning immigrant population from this region. Peeps recalls several questions that needed to be addressed: Was there a cultural theme here? Could this theme be "made real" in arts terms? What was the role of the arts in cultural survival?

Under Sellars's direction, the Los Angeles Festival as an institution changed its organizational structure, curatorial process, and artistic vision, experimented with the international arts festival as a form in its own right, and redefined the Festival's relationship to the city. Peeps explained that the Los Angeles Festival prior to Sellars's arrival had been more traditionally structured. Like many other presenting organizations for the performing arts, it had had a single artistic director whose taste defined the programming, an associate artistic director, a general manager, a business manager, production staff, and marketing staff. When Sellars became director, the impresario model was abandoned for a more collaborative one that involved a director (Sellars), executive director (Judith Luther), associate director (Norman Frisch), program director (Claire Peeps), and curator (Judith Mitoma). By the 1993 Festival, Sellars was director, Allison Samuels was executive director, and Peeps and Frisch were associate artistic directors.[2]

This arrangement expressly divided and shared responsibilities between executive and artistic directors. It was tailored to having a working artist as a director. The reason was as much pragmatic as ideological, because Sellars could not be there full-time to deal with the day-to-day operations and because he needed to focus on artistic issues. The organization also needed a director who had skills in public and community relations to operate not only in governmental, civic, and business spheres, but also within local communities, and to make a case for the arts and enlist support and cooperation. This structure produced neither the unified artistic vision of one person nor the consensus of a committee, but rather what Peeps characterizes as something between a democratic discussion and individual visions that are clearly discernable within the larger project. What the team shared was a concern for the role of the arts in everyday life and cultural survival. They were open to any work anywhere that dealt with such issues.

The organization continues to be deeply committed to an intensive curatorial process. For the 1990 Festival, an interdisciplinary and intercultural advisory committee participated in preliminary planning meetings. Several other curators and curatorial committees addressed particular communities and events. For example, Paul Apodaca orchestrated Native American participation in the opening ceremonies, while others prepared local Los Angeles communities over a six-month

period for the arrival of Japanese and Balinese performers. The 1993 Festival, which followed the uprising in Los Angeles, would engage local communities to a much greater degree. Both the 1990 and the 1993 festivals were followed by large conferences that evaluated the festival and were attended by scholars, artists, arts professionals, funders, educators, and community representatives. Proceedings of the 1990 Festival evaluation conference were issued.

This process is labor intensive. It requires more staff, which makes the organization administratively heavy. It demands more time, which is why there are several years between festivals. And, it consumes more resources, about half the organization's budget—$6 million for the 1990 event, which lasted sixteen days, and $4 million for the 1993 event. The budget for the 1993 Festival was considerably less than the $11 million for the 1984 Olympic Arts Festival, which ran ten weeks, and the $5.8 million for the 1987 Festival, which lasted three and a half weeks. The planning and evaluation process is as important to the organization as the outcome or product and reflects a mission that is larger than the festival as an event. The recording, transcription, and circulation of the proceedings of such meetings is itself a major undertaking. The Los Angeles Festival allocates its costs accordingly. It will put more money into the planning process or into preparing an outdoor venue, while saying no to big-ticket items like a symphony orchestra from abroad, whose costs can approach $500,000. But this approach is hard to sustain in tough financial times. Even under the best of circumstances, it is easier to raise money for events than for process. And it is easier to raise money for international stars and established genres familiar to Los Angeles patrons and established audiences for the performing arts than it is for emerging experimental artists or accomplished performers from the Pacific Rim and the United States.

The 1993 Festival made some significant changes in response to both artistic and financial considerations. While most of the events were still free, many more were sited indoors. Reeling from a statewide economic crisis and attempting to rebuild itself after the uprising, the city could no longer provide the pro bono services needed for events in outdoor public spaces—police, security, sanitation, and traffic control for several miles around the area, including the closing off of streets, parking, and a free shuttle from parking to the event. Even with a city subsidy, the organization would have needed $250,000 to outfit each park site with stages, sound systems, electricity, and toilets. Instead, the 1993 Festival featured master musicians and soloists whose work was perfectly matched in terms of scale, audience, and acoustics to such indoor venues as churches and temples. This was still not ticketed theater. Indeed, as Peeps explained, the organizations that hosted performances and exhibitions were progressive institutions that had broken the ground locally for precisely the kind of dialogue the Festival hoped to encourage. They had already been tackling hate crimes, advocating for immigrants, dealing with housing issues, and building bridges across communities. A major benefactor of the 1993 Los Angeles Festival was The Community Redevelopment Agency of the City of Los Angeles.

In the wake of the recent earthquake, plans for future activity are open and the organization, stripped to its bare bones, again rethinks the "festival" as a form and ways to experiment with the event, the process, and the institution. When he took on the 1990 Festival, Sellars made a commitment to the Los Angeles Festival as a "10-year project to introduce Los Angeles to itself and to reintroduce the world to Los Angeles" (Sellars 1990b:15). Increasingly, the organization is committed to the arts in advocacy terms and seeks to define their role in a civic agenda, not only for the intense weeks of the Festival proper, but also throughout the year. It is serving both as a presenting organization and as a catalyst and broker within the arts community of Los Angeles more generally. Other organizations, such as the Los Angeles Philharmonic, are encouraged to work more closely and effectively with local communities, not only on the model of the Los Angeles Festival, but with the help of Sellars in his capacity as their creative consultant.

This essay is based upon remarks that I delivered at the 1990 Festival evaluation conference, "New Geographies of Performance: Cultural Representation and Intercultural Exchange on the Edge of the Twenty-First Century." The conference took place on January 10–13, 1991. It was cosponsored by The Getty Center for the History of Art and the Humanities, the Los Angeles Festival, and the World Arts and Cultures Program at UCLA and funded by the Rockefeller Foundation, the Ford Foundation, AT&T, and the Getty Center for the History of Art and the Humanities, among others. Sellars and his colleagues have consistently sought serious engagement with their work. It was in this spirit that they received my remarks, which took issue with several aspects of the event, and then invited me to join the Program Steering Committee for the 1993 festival. I attended one of several national 1993 Los Angeles Festival Planning Conferences, entitled "Frontiers of a New Global Society: Los Angeles, Africa and the Middle East," on January 17–19, 1992, at the Hsi Lai Temple in Hacienda Heights—this temple, as described in the letter of invitation (November 18, 1991) from Sellars and Peeps, "is the largest Buddhist temple in the western hemisphere. . . . a vital gathering spot in the community and an extraordinary piece of architecture." I also participated in Program Steering Committee meetings during the 1991–92 academic year, while I was a Getty Scholar at the Getty Center for the History of Art and the Humanities in Santa Monica. Though I was not at the 1990 Los Angeles Festival, I did attend the 1993 event, which addressed many of the issues raised at the evaluation conference. My discussion of the 1990 Festival, which is the focus of this essay, draws upon interviews, internal documents, press coverage, video documentation, and the evaluation conference in which I participated.

The precise nature of the 1990 Festival, how it was conceived and received, will emerge in the discussion that follows. I will argue, first, that despite its departure from many conventions of international arts festivals, the 1990 event is deeply implicated in their history. It is, as mentioned, a successor to the Olympic Arts Festival. International art exhibitions are an essential feature of world's fairs, which began as truly international events in 1851, and of Olympic games. Inspired by

world's fairs, the first Olympic games as we know them today, that is, as large, international events, were appended to international expositions in the 1890s. They became an independent venture during the early years of the twentieth century (see MacAloon 1984). The arts elevated the status and enlarged the scope of events otherwise dedicated to industry, commerce, or physical skill. By the 1890s, massive international art exhibitions also became independent events. Some, like the Venice Biennale, which was established in 1895, took place at the same location on a regular basis. But even when an international event occurred only once in a given location, it could have lasting effects on the place that had hosted it. Many museums were formed on the basis of collections and buildings featured at world's fairs. Or, as is the case here, an arts festival created on the occasion of the Olympic games became a permanent institution.

Second, I will also explore how the 1990 Festival is implicated in the history of the avant-garde's relationship to that which lies outside accepted notions of art and culture. Key figures in the history of avant-garde performance have long used the performance traditions of Asia and other parts of the world, which they may have encountered only briefly in Europe, to mount their attack on the status quo. Artaud's exposure to Balinese theater was limited to what he saw in the Dutch Pavilion at the Paris Colonial Exposition in 1931 and Brecht's encounter with Chinese opera took place in 1935 when Mei Lan Fang toured Russia (see Artaud 1958; Brecht 1964). That such limited exposure could have such enormous impact offers an important key to the 1990 Festival's optimism in the value of brief encounters with work not necessarily understood. With regard to the relationship of the avant-garde to anthropology, we have tended to pay more attention to literature and the visual arts and their repositories, namely museums, than to the performing arts and their venues, which is the focus of this essay. The performing arts present particular challenges and possibilities, first among them the live presence of performers and the ephemerality of their activity.

This essay examines performance at the interface of cultural encounter. I begin by discussing two approaches that the 1990 Festival rejected outright—what the organizers characterized as the ethnographic approach and mainstream entertainment. I then relate the 1990 Festival to the values of the historical avant-garde. Finally, I examine the particular ways in which the 1990 Festival staged work unfamiliar to its audiences, why Sellars found it "thrilling beyond all expectations" to see "the genuine surprise of people who didn't understand what they were looking at and had no way of figuring it out. All they could do was look" (Braxton 1990). Central to this staging is the location of authenticity in a moment of aesthetic reception that resists conventional understanding, if it does not actually assault it.

II

When the organizers of the 1990 Los Angeles Festival of the Arts distanced themselves from the ethnographic—as they understood it—they were rejecting the

"labels" (primitive, ethnic, folk) and academic claims to authoritative knowledge. For Sellars, the will to explain and understand such performances as Bedhaya Court dance or Kogi-eso was misguided, because futile, as were attempts to demystify Kun Chinese Opera or Wayang Wong dance theater, to make these forms accessible and familiar. The trade-off—mystery for information—was suspect, for Sellars envisioned an aesthetic experience predicated on an unmediated encounter. By ensuring that the strange would stay that way, the 1990 Los Angeles Festival resisted efforts to reduce or otherwise dissipate the force of performances by explaining them away.

It was in this context that Sellars spoke disparagingly of "cultural baggage." As he spoke those words, I saw excess luggage. But the "cultural baggage" that he considered an impediment is precisely what ethnographers produce through the labors of fieldwork and bring into the festival and exhibition—ethnographic insight is a prerequisite, if not a requirement, for the deeper understanding we propose. While incomprehensibility may be a necessary way to begin a cultural encounter, intelligibility is the ethnographer's destination. "Cultural baggage," from an ethnographic perspective, is not a nuisance, but an opening. It can be a corrective for the unacknowledged and unexamined stereotypes that "humans" bring to cultural encounters. It can be even more.

A further clue to Sellars's objections may be found in the ways that anthropologists value shock and understanding. From an ethnographic perspective, culture shock, while an expected part of ethnographic fieldwork, appeals to the prurient interest of general audiences if not mitigated by empathetic understanding. This is the challenge posed by the brief intercultural encounters that museums, festivals, and tourism afford, even when produced by professional students of culture. But culture shock is more than an occupational hazard. It has historically been a defining experience in the making of anthropologists, and to some degree folklorists and ethnomusicologists—though perhaps less so, as we study ourselves. Making a virtue of necessity, we have learned to transvalue our lack of prior knowledge as an absence of preconception or bias. We attempt to avoid "ethnocentrism," or seeing the world in our own image. Trained to become virtual clean slates on which to write cultural logics beyond our own experience and imagination, we have often studied societies about which little has been published. Initial confusion, while valued, is not an end in itself. Rather, it anticipates a deeper and more empathetic understanding that requires extended immersion in the lives of those we study. Where hope of cracking the cultural code still prevails, fluency in that code is the objective—Come as a blank, leave as a native.

Shock, from this perspective, is a powerful prelude to intimate knowing. What at first seems odd, becomes just another way of being human. The strange is normalized. Eventually, I can imagine living the way of life that I am studying. At one extreme, then, empathetic knowing eventuates in "going native" or the desire to do so, whether temporarily through initiation and apprenticeship, or permanently. The dramatic structure of many fieldwork accounts arises from the process

by which intimate knowing happens. When this process precipitates an epistemo-logical crisis—when language and reason fail—the fieldworker may surrender to what Michael Jackson calls the embodied character of lived experience, a surren-der which requires kinesthetic, practical, and bodily engagement (Jackson 1983). Epistemological crisis is also a source of what James Clifford has characterized as "the surrealist moment in ethnography"—namely, "that moment in which the possibility of comparison exists in unmediated tension with sheer incongruity" (Clifford 1981:563).

At the other extreme, *not knowing* is an ethnographic subject in its own right. Indeed, the desire to render oneself blank—and the impossibility of ever really doing so—has given to the fieldwork account special importance as a genre of ethnographic writing. The dramatic structure of much of this writing arises pre-cisely from the author's struggle to transform him- or herself from novice field-worker at the beginning of the research to cultural connoisseur at the end of the project—and the incompleteness of that venture. Here the convulsions of culture shock intensify reflexivity by offering dramatic access to the ethnographer's own assumptions—not so as to empty oneself out, but so as to become visible to oneself. As the ethnographer becomes a native of what he or she is studying, he or she becomes a stranger to him- or herself. The double itinerary of culture shock thus leads simultaneously into and out of the ethnographer. To the degree that shock intensifies reflexivity, it also offers the possibility of critique. Ethnographic knowl-edge arises from an interpersonal encounter, and accounts of that encounter, whether written or filmed, are often attentive to the process of coming to know.

We not only publish and teach in academic settings, but also produce public displays of our knowledge in museum exhibitions, films, and festivals directed to general audiences. We have developed our own ways of determining what to bring to festivals of art and culture, how to site performances, and how to shape the encounter. Our distinctive display genres and performance values range from elab-orate mimetic re-creations reminiscent of the foreign villages at world's fairs during the late nineteenth century and dioramas of natural history museums to extremely spare presentations of a singer and her songs on a clear stage (see Cantwell 1993; Kirshenblatt-Gimblett 1991).

Using what might be called an ascetic approach to staging, the Smithsonian's Festival of American Folklife, for example, often presents performers without cos-tumes or sets on a bare platform in a tent on the Mall in Washington, D.C. Audi-ences sit on backless bleachers in a setting that is at once informal and respectful, reminiscent perhaps of county fairs and other rural and small town gatherings. Scholars "present" performers using a "talk show" format in order to prepare audiences for what they will see. State-of-the-art sound and recording equipment are prominent, for the performances are fully documented and the recordings archived. This plain style of presentation—the very absence of the theatricality we associate with folkloric troupes—is an "ethnographic" way of marking the authen-ticity of what appears on the stage. Many of the "performances" at folklife festivals

are nothing more than the arts of everyday life—conversational storytelling, ballad singing, cooking, and work skills. The very act of bracketing them for public presentation makes them "performances" of a special kind. They depend for their "reality effect" on a presentational mode low in theatricality and high in information. To avoid degenerating into casual exoticism, events like the Smithsonian's Festival of American Folklife place a premium on intelligibility and on reflecting the perspective of those who are performing. This Festival has its own ways of mediating the encounter consistent with its own ethos—what has been termed cultural equity and cultural conservation—and style (see Feintuch 1988; Baron and Spitzer 1992).

In his 1972 appeal for "cultural equity," Alan Lomax condemned the devastating effects on local music and culture of aesthetic imperialism and "centralized music industries, exploiting the star system and controlling the communication system" (Lomax 1972:3). As this statement suggests, ethnographic approaches to the display of performances from outside the official art world also carry a political load, one that both advocates for forms whose survival is precarious and criticizes the forces that undermine them. This is a position underpinned by a sense of social responsibility, expressed politically (as it was by the Federal Writers Project during the New Deal in the thirties), practically (as in the Settlement Houses and playground and pageant movements during the first half of this century), or intellectually within academic disciplines. We might situate this approach within a tradition of "ethnographic humanism," whose reigning values are cosmopolitan, progressive, and democratic, though its effects may not necessarily be consonant with its aims (Clifford 1981:558).

III

Sellars made it clear that he consciously avoided not only the didacticism of an ethnographic approach, but also the conservatism of "mainstream entertainment," what he characterized as "your typical Labor Day band/parade/barbeque fare" (Kleid 1990). He alerted audiences that the Los Angeles Festival would not be "the Festival of Fun Foods at your nearest mall" (Sellars 1990b:14). Nor would it be Edinburgh or Spoleto. In other words, the Festival would avoid the kitsch of high and low culture. It would skirt painfully good and painfully bad taste. The Los Angeles Festival was to be neither a series of illustrated lectures, nor yet another celebration of the accessible arts, whether classical or "ethnic."

The avant-garde understands well the artistic possibilities of bad taste and the transgressive potential of popular culture, with its love of anomaly and its panoply of genres for presenting the strange—the old anatomy and medical museums, the side show, Ripley's Believe It or Not, Barnum's dime museum, the Guinness Hall of Records, the *National Enquirer*, tourism (which also replicates older forms of ethnography), and world's fairs, among others. These too are loci classici of avant-garde performance. But, enthrallment with anomaly verges on prurient interest,

because it quickly attaches itself to the monstrous and grotesque for their own sakes. Anomaly in popular entertainment appeals to a fascination with that which defies explanation, with " 'curiosities,' 'freaks of nature,' 'rarities,' 'oddities,' 'eccentrics,' 'marvels,' 'nature's mistakes,' 'strange people,' 'prodigies,' 'monsters,' " and even ethnographic objects, to the extent that they are "exotic," "primitive," or "oriental" (Bogdan 1988:6). What such objects and acts might lack in fame, they make up for in strangeness, or so it would seem from the way they are produced and promoted as popular entertainment in restaurants, nightclubs, theme parks, cruise ships, and amusement parks. Events like the Smithsonian's Festival of American Folklife and the Los Angeles Festival try to achieve the exuberance and wide appeal of popular entertainment, without exoticizing performances unfamiliar to their audiences.

Sellars explained to the press how he tried to reach a wide audience: "It's about trying to remove as much of the starch as possible from a cultural experience. It's not a formal thing where you have to sit in row 36J for an entire evening and behave." What made the event so special, in his view, was siting "the greatest artists in the world in a completely alfresco environment where it's not a big deal, it's just living" (Kleid 1990:16). Maureen A. Kindel, chair of the Los Angeles Festival, reassured audiences that this festival was "casual, personal, intimate, and accessible. It is for everyone" (Kindel 1990:2). These statements are somewhat disingenuous because they are reassuring about experiences whose power, in many cases, lies precisely in their potential to disconcert: associate director Norman Frisch made just this point when he wrote in the program, "I can promise you that the cumulative experience will be disturbing, challenging, even at moments offensive: a slap in the face, a bucket of water, a stain on the sheets. It has been for me" (Frisch 1990:21). Whether reassuring or warning their audiences, the Festival organizers clearly signaled a rejection of the stiff discipline of the opera house, Broadway theater, symphony hall, and ballet, and the elitism expressed by their price of admission, clear separation of audience and performer, audience decorum, and highbrow status (see Levine 1988). Instead, the Los Angeles Festival used a wide variety of venues, many of them outdoors in parks and other open public spaces, where environmental, multifocus, multisensory, interactive events combined the casual accessibility of popular entertainment with the seriousness of "art."

The embrace of popular entertainment offered yet another position from which to attack the status quo, for the 1990 Los Angeles Festival seemed to say that art takes forms you have never seen before in places you would least suspect, and that you are not required to undergo an onerous regimen of preparation to enjoy them. Quite the contrary. The organizers took as a measure of success such statements as, "I didn't understand it, but I had fun." They depended not on the didacticism of ethnography to normalize the strange, not on popular entertainment's appeal to a prurient interest in the irreducibly weird, but on the power of art, as they conceived it, to create fascinating confusion. If audiences at the Los Angeles Festival

could enjoy what they did not understand, they might become more receptive to contemporary art more generally—one of the long-range objectives of the Festival. Their very naiveté was a virtue, for if properly approached, the uninitiated audience might prove even more open to a broader range of artistic expression than the institutionalized publics cultivated by the cultural establishment.

Given the draw of celebrity performers, one of the 1990 Festival's biggest challenges was to attract audiences to performers who were not superstars here, however famous they might be at home—indeed, according to Sellars, "Many of the performers in the Festival are not professional entertainers," which did not make them amateurs either (Sellars 1990b:15; Mitoma 1990:16). While the distinction was irrelevant, it presented a serious marketing problem because the media were less likely to pick up on the events. The organizers had to convince audiences who expected the assurance of star performers and familiar art forms that performances at the Los Angeles Festival from throughout the Pacific are "every bit as . . . sophisticated and legitimate as European culture. It's just *different,*" in the words of Rudy Garza, the Festival's public relations director (Snow 1990). The Festival organizers had to bring their audiences from fear of the unfamiliar to a love of the "just different," while preventing the just different from becoming really weird, on the one hand, or the Disney pap of "It's a Small World," on the other. The very audiences who until this point had resisted experimental art forms were a prime target for the Los Angeles Festival.

IV

Values derived from the historical avant-garde, before World War II, and from experimental performance during the postwar period, drive this festival. They offer keys to the special pleasures afforded by the incomprehensible and, beyond pleasure, to the importance of making audiences experience, rather than interpret, what they see. The historical avant-garde, by exposing the arbitrariness of the autonomous art object and the institutions that police the domain of art, challenged the status quo, the academy, bourgeois cultural institutions, and the culture industry (see Bürger 1984). So too did the Los Angeles Festival. It was surely no accident that the Festival did not shy away from controversy when it featured Rachel Rosenthal, the LAPD (Los Angeles Poverty Department), the Wooster Group, and David Wojnarowicz, one of several artists at the heart of a recent controversy regarding the public funding of art and the role of the NEA.

Radical artistic movements during the first half of this century dethroned the notion that the aesthetic is a hermetic realm set apart from daily life, and attempted to restore to art its social consequentiality (see Schulte-Sasse 1984). Without intending to collapse important differences between the various movements and their proponents, I would single out the following tactics. Avant-gardists subverted the high seriousness, compartmentalizations, and purities of bourgeois art forms. They questioned the illusionistic naturalism of proscenium drama, the

primacy of literature, and the subordination of the other arts to it. Some insisted on the sensuous presence of the object, its materials and formal properties, rather than on "content" located elsewhere. Others celebrated the trivial and banal, the obvious and commonplace, the low and the vulgar—in a word, that which lay outside received notions of art. Some rejected the notion of artistic genius and masterpieces. Some tried to recover the immediacy, physicality, and hybrid force of such popular forms as the circus, the fairground booth, variety theater, magic shows, puppet theater, folk plays, and street performance. Others were entranced by the pure theatricality of Asian forms, their quality of total performance—their success as *Gesamtkunstwerk*. Some aspired to the ecstatic, spiritual, and marvelous qualities of ritual and festival and saw here the possibilities for a physical theater, rather than one centered in language. Others alienated the audience from identification with the action to produce a critical reflexivity which might serve the cause of radical social change. Consistent with these values, the Los Angeles Festival is a *festival*, "a moment," in Sellars's words, "in which the world is turned upside down and we can rethink which end is up," that is, the festival acquires special significance in the history of avant-garde performance as a model for what theater, if not life itself, might be (Sellars 1990b:14).

A history remains to be written of the sources to which the historical avant-garde, midcentury experimentalists, and more recent postmodern performance artists have turned for their critique of the very art world within which they worked and against which they rebelled—the European peasantry, rural America, the tribal, the industrial, the quotidian, and in the case of the Los Angeles Festival, "multicultural artists" and "international performers." The following discussion places the 1990 Festival within a brief history of avant-garde encounters with such sources to better understand both the display traditions within which it is working and the distinctiveness of its approach.

The Arts and Crafts Movement in late nineteenth-century Europe and the United States turned for its antimodernist critique of the excesses of civilization and ills of industrialization to the European peasantry, rural and urban America, and to earlier periods of European art history, notably to the Gothic and Renaissance. Using these sources, and others farther afield, the Movement, led by William Morris, affirmed joy in labor, organic community, and the collapse of distinctions between art and craft. Repercussions of this Movement can be seen in the Bauhaus, architects such as Frank Lloyd Wright, and other proponents of form following function and truth to materials, as well as in folk festivals (see Becker and Franco 1988). In their search for a preindustrial past that might save European and American society from itself, followers of the Movement found the "folk" at two social margins: the countryside and immigrants in inner-city neighborhoods. By the end of World War I, as the gates to immigration were closing, Settlement Houses and sister organizations were staging exhibitions and folk festivals of the "homelands," an urban counterpart to their celebrations of rural life in such areas as Appalachia (see Eaton 1932; Whisnant 1983).

The last twenty-five years of immigration are not the first period of mass immigration that the United States has experienced, though this period differs from the influx between 1880 and 1924 in important ways. The predominance of Southern and Eastern Europeans at the turn of the century was new in relation to the Irish and German immigration of the mid-nineteenth century. Southern Italians and East Europeans, many of them Jews, so exotic at that time, can now celebrate their passage at Ellis Island, the Mayflower of mass immigration, while those who have arrived since 1965 from Asia, Latin America, the Caribbean, and Africa are the newest new immigrants. These two periods of mass immigration have yielded their own displays of diversity, their own ideologies of pluralism, their own ethos, and their own theorists (see Snow 1993; Kirshenblatt-Gimblett 1990). Such festivals, commemorations, and historical re-creations should be seen in relation to the efflorescence of holidays in America after the Civil War, the rise of world's fairs, the pageant movement, immigrant homelands exhibitions and festivals, folk festivals, and international arts festivals. Many of these events, prototypes for the "multicultural" events of our own day, offered a cosmopolitanized notion of the common man, made the quotidian a site of utopian intervention, and gave to the arts (which included craft) a redemptive role.

Just how widely the historical avant-garde was prepared to cast its net for fresh sources can be seen from Jindrich Honzl's account in 1940 of theatrical experimentation in interwar Czechoslovakia:

> Cubo-futuristic theatrical experiments turned our attention to stages and theaters other than those built for the tsarist ballet, the box displays of high society, or for the cultural activity of the small-town amateurs. Through these experiments we discovered the theatre of the street, we became fascinated by the theatricality of the sports field and admired the theatrical effects created by the movements of harbor cranes, and so on. Simultaneously, we discovered the stage of the primitive theatre, the performances of a barker, children's games, circus pantomimes, the tavern theatre of strolling players, the theatre of masked, celebrating villagers. The stage could arise anywhere—any place could lend itself to theatrical fantasy. (Honzl 1976:76)

From at least the Romantic period, the study of these forms in their own right by folklorists and ethnographers has proceeded in relation to contemporary artistic interest in them. This has produced in many cases a shared sensibility, to mention only the preoccupation of eighteenth-century British literati in the ballad and French surrealists' fascination with primitive art (see Stewart 1991; Clifford 1981). Sellars's attempt to distance the Los Angeles Festival from ethnography obscures the role of an "ethnographic attitude" in the formation of avant-garde sensibility and vice versa—as Clifford notes, "surrealist procedures are always present in ethnographic works, though seldom explicitly acknowledged" (1981:563).

New categories create new subjects out of old materials. Nowhere is this clearer than in the role of curators of modern art in constituting "folk art" as a subject (see Metcalf and Weatherford 1988). According to Holger Cahill, "Contemporary

interest in it [American folk sculpture] began with the modern artists who found in this folk expression a kinship with their own work" (Cahill 1931:18). That kinship is at the heart of the relationship between artistic movements and academic disciplines. During the thirties, the Newark Museum and New York's Museum of Modern Art showed "folk" and "popular" art "without apology or condescension," in the words of Alfred H. Barr ([1938] 1966:9). "Primitive paintings" and "folk sculpture" were valued precisely because these curators believed them to be "unschooled," unpretentious, and for these very reasons a "truer and more indigenous expression of the American artistic sense"—that is, for the curators of these shows they had little to do with "the fashionable art" of their time and were "never the product of art movements" (Cahill 1931:5). Thanks to a curatorial category, "folk" painting and sculpture became a "natural" resource for challenging the status quo, while affirming a uniquely "American" artistic sense (see Vlach 1985; Metcalf and Weatherford 1988).

"Primitivism" in 20th Century Art (1984) at the Museum of Modern Art in New York is a sequel to a series of exhibitions in the 1930s that had featured "folk art," "popular painting," and "modern primitives." Informed by the curatorial interests of Cahill, the MoMA mounted *American Folk Art: The Art of the Common Man* (1932) and *Masters of Popular Painting: Modern Primitives of Europe and America* (1938), which was the last in a trio of exhibitions that included *Cubism and Abstract Art* and *Fantastic Art, Dada and Surrealism,* both in 1936.

Five decades later, *"Primitivism" in 20th Century Art* would document a similar conjuncture in the various European avant-garde movements of the early twentieth century, this time in the form of "affinities" between the "tribal" and the modern—Picasso's *Guitar* and a Grebo mask, for example. More recently, MoMA's *High & Low: Modern Art, Popular Culture* (1990) explored how "high" artists—from Braque and Leger to Warhol and Holzer—appropriated the mass culture of industrialized cities, which the curators identified with such "low" sources as newspapers, advertising, billboards, comics, and graffiti. In a sense, the MoMA exhibitions of the thirties are closer in spirit to the Los Angeles Festival because they go beyond assertions of "kinship" between modern art and folk and popular forms— indeed, they exhibit the latter in their own right. In contrast, the two recent MoMA exhibitions are firmly wedded to "affinities," an approach that makes into a curatorial principle and exhibition strategy the primacy of "sources" in the study of art history. This principle is fully literalized in the installation of *High & Low,* where the walls were plastered with copies of the actual newspapers from which the Cubists clipped pieces for their collages. The "sources" have no independent life in this approach to exhibition. Rather, they serve to reinforce the division between high and low that legitimates the MoMA's corner on the high market.

In what seems like a global resurgence of interest in such juxtapositions, *Magiciens de la terre,* organized in 1989 by Jean-Hubert Martin at the Centre Pompidou and La Grande Halle de la Villette, used the rubric magical/spiritual to exhibit together artists as diverse as Barbara Kruger, the Yuendumu community of Alice

Springs, Anselm Kiefer, Tibetan monks, and Nam June Paik: "From the great Canadian North to the Australian desert, from Arizona to China and Japan, from Africa to Central and Latin America, a small team set forth to seek out the art of today, visiting studios set up in disused factories as well as villages which have scarcely discovered electricity. The first worldwide exhibition of contemporary art." Authenticity here was located in the "genuine outsider," which according to one reviewer was in short supply (Cardinal 1989–90).

The contemporaneous, that which is *in* the present, was elevated to the truly contemporary, that which is *of* the present (see Fabian 1983). Temporal elevation moved objects from the status of artifacts to that of (modern) art. The result is a disjuncture between the history of the category and the history of the objects. When presented in an art museum, the mandala made by three Tibetan monks using multicolored mineral powders—or the work of "outsider artists"—does not trace its history back to French Impressionism or Russian Formalism. The Tibetan mandala becomes contemporary by sharing the space of display, not by way of a common history of production. Despite elevation from the contemporaneous to the contemporary, it is the lack of a shared history that produces authenticity. The less history shared, the more genuine the outsider. This is how I read Cardinal, when he writes that the "genuine outsider" was in short supply. Paradoxically, however, *Magiciens de la terre* and the 1990 Los Angeles Festival attribute to the "genuine outsider" closer contact with the mythic origins of art itself. These are the terms in which a shared history for insiders and outsiders is formulated and a critique of the European art world mounted.

Postmodern choreographers such as Merce Cunningham (working with John Cage), Trisha Brown, and Yvonne Rainer and performance artists such as Linda Montano turn not to an earlier historical period or distant place or low cultural form but to the quotidian, the life world, ordinary movement, everyday talk—to the habitual and the mundane. Their embrace of the everyday is a refusal of such accepted performance values as spectacle, virtuosity, illusion, and glamour, as well as some of the more radical practices of experimental performance that with repetition had become somewhat predictable.

V

To what did the Los Angeles Festival turn? To performers from the "Pacific Rim," which the Festival organizers juxtaposed with artists from various parts of the United States, mainly Los Angeles. The result was an anthology of Cambodian court dance, Gospel choirs, Sellars's opera *Nixon in China,* Javanese shadow puppets, China's Kun Opera, Trash Lizards, Pacific Island Kava Ceremony, Mariachi bands, and Eugene O'Neill's *Hughie* in English and Chinese. In this respect, the Los Angeles Festival restaged the world as seen from an experimental performance perspective. This is not quite the synthesis and hybridity of a Peter Brook, Jerzy Grotowski, or Eugenio Barba—what Richard Schechner would call intercultural-

ism or what counted as *ethnosyncrétisme* in *Magiciens de la terre*. It is rather a restaging of their sources, so to speak, within a new masterwork, the FESTIVAL.

On display at the Los Angeles Festival were many values that derived from the historical avant-garde, prominent among them resistance to commodification and to the status quo, in both artistic and social terms. Many of those who worked on the Los Angeles Festival did so with a deep commitment to the project as something worth doing in its own right. Some gave up their salaries. Many gave of themselves far beyond the call of duty. Seventy percent of the Festival, according to Sellars, was free of charge. Commercial gain was not the primary consideration in determining what would be presented, and art forms that had resisted commercial exploitation, a quality that Sellars attributed to "much of non-Western culture," were accorded very high value, particularly since this was one of the reasons, in his view, that they had remained invisible to us (Sellars 1990a:75). Or it could be said that their invisibility is what had saved them until now. Festival organizers challenged audiences to encounter work they might otherwise ignore or reject, to rethink the boundaries of "art," to step outside the art world, to actively participate rather than passively spectate, and to venture into parts of Los Angeles they had never visited before.

These concerns bear on the central theme of these remarks, the pleasure of the unfamiliar and the incomprehensible. Consistent with avant-garde values, there is in the Los Angeles Festival a refusal to reduce art to something that can be explained. The test of a work's resonance is precisely its irreducibility, its resistance to interpretation. Aficionados of avant-garde and experimental performance can sit and watch something they don't "understand" because of what they have *unlearned*—namely, the expectations, attitudes, values, and sensibility associated with establishment art forms. This unlearning entails holding interpretation and judgment in abeyance. Such audiences know how to yield to "experience," to sensuous immediacy, to presence, energy, and actuality. They value abstraction, pure form, pure theatricality, pure performance. They are open to chance operations, indeterminacy, and improvisation. They enjoy the blurred boundaries between art and life and between performer and audience. A century of Dada cabarets, Futurist serata (theatrical evenings), Surrealist ballets, epic theater, agitprop, Bauhaus puppetry, theater of the absurd, happenings, environmental performance, postmodern dance, and performance art has cleared a space not only for radical artistic experimentation, but also for performance forms from other social and cultural worlds. Most important, these audiences have been trained to receive the latter *as if they had emanated from the avant-garde itself.*

Though the history of avant-garde and experimental performance has prepared its specialized audiences for this Festival, *the problem is not the boundaries, clear or blurred, between high culture and low culture or between Western and non-Western art forms, but the split between the art academy and the avant-garde.* Here the gate opens through which the rest of the world can enter, for once the avant-garde says that what counts as art is not for the academy to decide, everyone—well, almost everyone—can come

in. This is not quite what Lincoln Center did when Nathan Leventhal, president, told the *New York Times*, " 'I had the same prejudices about jazz that opera lovers or ballet lovers might have, . . . but I've learned a lot, and now I am a convert. There is as much richness and as much variety in Duke Ellington as there is in Mozart,' " because Mozart was the standard jazz had to meet if it was to be accepted by the artistic academy (January 10, 1991:A1). In allowing jazz to squeeze through the narrow aperture it had opened for a moment, Lincoln Center reaffirmed the values of the academy. When Sellars asserted, "We have opened a door that can't be closed again," not only was the door opened wider and permanently—at least in principle—but the conditions for admission had also changed, for the Los Angeles Festival challenged the academy itself. This was the avowed "hidden agenda" of the Festival, according to Norman Frisch: "the possibility of a deep and extensive re-examination of the role of the arts in our most public and most private lives" (Frisch 1990:21).

Many of the values of avant-garde and experimental performance were mapped directly onto the arts featured at the Los Angeles Festival, first and foremost a reclassification of activities as "art," however they were understood in their home settings, and second, an affirmation that in many of the societies represented at the Festival "the working definitions of 'traditional' and 'contemporary' are not mutually exclusive" (Sellars 1990b:15). According to the literature that was distributed to the press and the public, the performers come from communities that do not think of what they do as art, art and life are one, everyone's an artist, and they do not distinguish between high and low art. These are vital and spiritual communities; they are in tune with nature. Their arts illustrate the spiritual origin of art; they are about survival, not decoration; they heal. These arts are egalitarian, collective, and communally produced; they are participatory; they resist commodification. They're spontaneous and improvisatory; they are synthetic, combining music, dance, theater, and oratory; they are all form. They range from the loftiest spirituality to the bawdiest humor; they meld the old and the new. They are repositories of ancient wisdom passed down through the generations. They celebrate the kinship of all people. As Judith Mitoma, curator of the 1990 Los Angeles Festival, explained: "Performance in these cultures occurs in the streets, in the temple, in the public square—contexts that democratize the arts to a great extent since access is assured for all levels of the community" (Mitoma 1990:18). The credibility of these claims does not concern me here. What matters is that they inform the ethos of the Los Angeles Festival.

Indeed, they tell us much more about the Festival organizers than they do about the performances, for embedded in these affirmations of arts brought from afar—not only from other countries, but also from the margins of the American art world—is a critique of American commercial theater, academic art forms, and the culture industry. Read back on themselves, these affirmations are a plea for the arts to regain their emancipatory power in American life. Sellars saw the Festival as an answer to the decorativeness of European high culture and the vacu-

ousness of mass culture: "Western civilization has produced a neurotic, afflicted, hyperextended society where psychoanalysis has replaced culture and Big Entertainment has replaced everything" (Sellars 1990a:3). The Festival was an antidote to "mall culture," to the cult of the superstar and the blockbuster, to the safety of conventional theater, though the Festival publications made these points on pages facing advertisements for Hollywood films, cosmetics, alcohol, banks, luxury hotels, cars, airlines, tourism, realtors, and television. Someone had to pay for the Festival.

The Pacific Rim, broadly conceived, offered the producers of the Los Angeles Festival yet another area for staging an attack on the status quo and for affirming the oppositional values of the avant-garde, values that they attached to the King Island Inupiat Singers and Dancers, Wallis and Fatuna, Children of Bali, and so many others. As Judith Mitoma stated, "We are also being challenged to recognize the value of their perspective on the world, to ask ourselves if their insights might enhance the quality of our lives" (Mitoma 1990:18). Hints of New Age spirituality may also be detected, as well as affinities with the antimodernism of the Arts and Crafts Movement earlier in this century. Sellars expressed the utopianism of the Los Angeles Festival thus: "Interculturalism is the basis for the survival of the species." In his view, the place to start is with visibility, with looking at each other, for "we live in a culture of exile," defined both by the massive immigration of the last three decades and by "an unnamed internal exile from our own selves. . . . our effort and our need to recover the lives of others is a need and a possibility to recover the missing pieces of our own lives." Looking would hopefully lead to talking, listening, and action (Sellars 1991:15).

With all these good intentions, the Festival organizers still had to deal with audiences unprepared for much of what they would see. What was to be done with audiences who were as yet neither inoculated with ethnographic information that might make performances from afar more accessible, nor initiated into the experimental art world and its values? Sellars's comment at the conference—"Nothing happens for hours and that's the beauty of it"—is of the essence, for it suggests how experimental performance trains audiences to watch almost anything. After hours of Philip Glass or Lucinda Childs or other postmodern performers, where "nothing happens for hours and that's the beauty of it," audiences are in a sense primed for Inuit drumming, Woomera Mornington Island dance, and Philippine kulintang. Los Angeles audiences had to be told that "Many of our presentations do not 'reach a climax' in the second act," an indication that they were still in training, so to speak (Sellars 1990b:15).

Sellars's refusal to supply Roland Barthes's missing term, a practice honed by avant-garde practice, takes on special significance here (Barthes 1977). It is one thing if the missing term is missing by design, if the signifier has been evacuated so it can float free—much experimental performance works in this way. In the Los Angeles Festival, it might be said that "ethnographic" performances offered a shortcut to this effect, substituting inaccessibility for evacuation. That is, perfor-

mances that are semantically dense for their home audiences acquire the desir-
able quality of free-floating signifiers when produced for avant-garde reception. I
do not mean to suggest that home audiences receive these performances in some
archaic literalist mode. Barthes's discussion of the third meaning, obtuse mean-
ing, may be helpful here.

Discussing the work of Sergei Eisenstein, Barthes locates the filmic—and by
extension, the performative—in "that which cannot be described," that is, where
"language and metalanguage end" (Barthes 1977:64). That place is also a site of
obtuse meaning. Techniques of defamiliarization override what Barthes calls gra-
tuitous meaning, whether by severing the expected relations between signifieds
and signifiers, refusing the logic of narrative, or emptying the sign of obvious
meaning. The Los Angeles Festival took a shortcut to Barthes's obtuse meaning: to
the extent that performances were presented as quotations, found objects, or
readymades, they were instantly obtuse by virtue of their foreignness to many Los
Angeles audiences. This is not to suggest that for their home audiences such per-
formances are totally intelligible or without Barthes's "third meaning," but only
that signifiers need not be evacuated for obtuse meaning to emerge. A mismatch of
performance and audience will suffice. The *unfamiliar*, rather than defamiliariza-
tion, becomes the route to obtuse meaning. Signifiers float free, not because some-
thing familiar has been made strange by virtue of formal operations in the work
itself, but because a disjunction between a performance and its audience has been
created and preserved. The organizers of the Los Angeles Festival "quoted" from
Japanese or Hawaiian culture, but in theory, if not in practice, withheld "transla-
tion" for the many Los Angeles audiences who were not speakers of those "lan-
guages." To some extent, this approach could be seen as a way of circumventing
"hollow" meaning—explanations of what the performance is "about" or what it
"means"—and maximizing the potential for obtuse meaning, which by definition
starts where language ends. The greater the absence of gratuitous meaning in
unfamiliar performances, the greater the temptation to supply it. The organizers of
the Los Angeles Festival studiously avoided this temptation.

By short-circuiting gratuitous meaning, audiences who have cut their teeth on
experimental performance get a passport to all the performance traditions of the
world: in principle, they need neither plot nor climax, neither special training nor
explanation, to enjoy what they see. Other cultures become their performance art
and even a measure of what is missing in their own lives. Would that our theater
was as vital as theirs! Would that our lives were as meaningful! Ethnographic
expertise was just not up to the task, for all it could do, from the Festival organiz-
ers' perspective, was to come between audience and performer with "information"
that, even at best, offered little chance of conveying all that audiences back home
could be expected to know. As Sellars remarked at the conference, "You're not
Samoan. You can't know." A few factoids delivered by experts cannot close the
gap. Nor should "information" create the illusion of instant communication. If, as
Sellars suggested, "People in those societies don't sit around explaining everything.

. . . What about societies where the highest point is in the performance, in the dance, not in talking about it afterwards?" then his audiences should simply deal with the performances themselves—who is to say that everyone back home understands what these performers are doing? Or that everyone can or should have access to everything? There is in these remarks a convergence between practical limitations on what audiences can be expected to know or learn and avant-garde principles of reception that, at least theoretically, require no preparation or expert foreknowledge and may even benefit from their absence.

Consistent with this position, 1990 Festival organizers were skittish about "experts" telling audiences what to think. Phyllis Chang, educational coordinator for the Festival, told the press, "We've eliminated the third person . . . or the specialist who gets up there and says: 'I have studied Latino culture, and here are my findings.' It is not academic at all" (Haithman 1990:F6). The Los Angeles Festival was not infotainment. But the very casting of expert knowledge in these terms—a bespectacled egghead comes to mind—suggests a missed opportunity and a somewhat naive view of ethnographic expertise, for there are many convergences in sensibility between the Festival's avant-garde approach and ethnography in its more experimental mode. These convergences could have served the Festival well, for ethnographers also destabilize the locus of "understanding" and they do so on the very ground on which we (the public as a whole) stand.

Sellars stated at the conference that "One of the aims of the Festival was to remove forever the concept of ethnomusicology and ethnic studies, which at its core is offensive, and to move to another level where we didn't have to have special parentheses around things. These were not 'primitive' artists or 'folk' artists. These were *artists*" (Sellars 1991:13). It could be said that the labels, and the categories associated with them, posed a challenge to the Festival's working concept of art and that the Festival organizers transformed this challenge into a provocation by *restaging the "ethnographic" as "art."* The Los Angeles Festival began precisely at the point where the ethnographic and the avant-garde converged and it forged its own path by undoing the ethnographic.

How was this undoing achieved? The Festival organizers systematically removed ethnographic labels, withheld explanation, asserted the primacy of experience over hermeneutics, demanded attention to form as content, and affirmed the power of art to transcend difference by constituting difference as "just different" and asking audiences to respond as just "humans." In the absence of "ethnographic labels," performances chanced upon in unfamiliar places became *objets trouvés*—an artistic operation celebrated by the historical avant-garde. Gathered together from the far reaches of the Pacific, performances of seemingly infinite number were dispersed across a sprawling megalopolis at the end of the second millennium in a maze-cum-menu of possibilities to be sampled, not grasped, in a decentered entirety. The compositional principle of the Festival, in Norman Frisch's words, was "blend and clash," the component parts retaining their identities (Frisch 1990:23). The "art" of such a festival arises from dislocation and juxta-

position, procedures that give to ethnography its surreal quality and to surrealism its ethnographic character. In both cases—and this is of the essence—we see how the elements in question *"continually proclaim their foreignness to the context of presentation,"* be that context the printed book, museum display case, record album, film, or festival stage (Clifford 1981:563).

I have colleagues who turn the sound off when watching film, who prefer to watch dance without the music. They refuse to read program notes, reviews, or synopses. They won't go to a preperformance lecture. They don't want anyone to explain to them what's going on. They prefer performances in a foreign language because they don't understand the words. Not "understanding" is precisely what makes it possible for them to ignore language, to attend to the purely performative. Not "understanding" is precisely what keeps them open to something entirely new. If anything, language gets in the way. As Sellars said at the conference, "Communication reaches the most satisfying level when we don't have to talk," a statement more likely to come from an avant-garde director than a conventional playwright. Language was the enemy because of its power to "assimilate Art into Thought, or (worse yet) Art into Culture," as Susan Sontag wrote in 1964 (Sontag 1966:13).

This approach to performance, which informed many aspects of the Los Angeles Festival, is encapsulated in a distinctive conceptualization of authenticity. I have in mind the comment that the most authentic moment occurs when the audience confronts what it doesn't understand, a notion rooted in an avant-garde sensibility—I cannot imagine this formulation coming from the Cahuilla Bird Singers or Halau O'Kekuhi. "Understanding" Chindo Ssitkim-Kut or the Wooster Group's St. Anthony, or requiring that they be "explained," interferes with the purity of the aesthetic experience, because from an avant-garde perspective, explanation mediates what should be a direct encounter. Audiences should come to performances open. They should be willing to experience what is immediately before them and make up their own minds about what they see. Artistic intention and curatorial guidance—not to mention what the critics have to say—are finally irrelevant. Nor does it matter what the performers think of this approach to their work, though clearly the Festival organizers were respectful to the performers and wanted them to be comfortable. What matters is the total event as the organizers produced it. Understanding was to be deferred. According to Sellars, "We hope that after looking, there will be talk, and that after listening, there will be action" (Sellars 1990b:15).

When Norman Frisch stated that "Ours is an 'appropriated' festival," he meant that many of the performances at the Los Angeles Festival were cultural quotations. Extrapolating from Barthes on the postmodern text, he characterized the Festival as a "tissue of quotations" that "blend and clash" without forming a neat totality (Frisch 1990:23). Consider for a moment the difference between works designed from the outset as theatrical events, however experimental and iconoclastic, and "heritage" performances excised from occasions and settings that have not been transplanted with them, an absence that the press, and even the program

booklet, attempted to redress by recreating in words what had been left at home. Hardja Susilo, Professor of Ethnomusicology at the University of Hawaii, explained in the program booklet, "Today . . . wayang kulit is performed in the context of weddings, celebrations of thanksgiving, national holidays, etc., in cities and villages everywhere. Such performances begin about 8:30 P.M. and end around 5:00 A.M. the following morning" (Susilo 1990:80).

Such accounts point up with special clarity the partiality of strict quotation and what a larger bite might afford. I am reminded of Petr Bogatyrev's account of peasant reception of folk plays in Czechoslovakia during the first half of this century. The same plays were performed year after year. Audiences did not constantly demand new ones, but knew the old ones almost by heart and watched them with great interest. Rather than novelty of plot, "the focal point of a folk theatre performance lies in the treatment of detail" (cited by Honzl 1976:80; see also Bogatyrev 1976). Other cases could be cited. But as long as we repeat the mode of reception taught to us by avant-garde practice, as long as we turn our cheek toward the slap, we will not know what it is like to revel in the "detail" of performance worlds new to us but familiar to their local audiences, who find the new in the repetition. A narrower opening, the detail requires a different grasp on the event, a different mode of reception. We need an orientation not to the performance as a self-contained artifact, but to the performance as a ramified event in which reception (not to be confused with interpretation) is integral. Such an approach would reveal to what degree the assumptions of an avant-garde approach to reception are culturally specific rather than offering a master key to art as a transcendent category.

VI

Cultural quotation is not ethnographic vivisection. It is not a cultural kidney on ice that is rushed to the festival body, readied for transplant, with the hope that the foreign organ will take. We are not dealing with a kind of ethnographic Théâtre Libre, which instead of slicing life quotes cultures. Nor, in the case of the many Los Angeles neighborhoods featured at the Festival—"Every two blocks it's a new world"—are we dealing with a bell jar that has been dropped over an ethnographic region of the city. The Festival does not bring a vitrine to the site, so that a neighborhood all of a sudden presents itself for viewing. The organizers were well aware that the Los Angeles Festival was the determining context for everything it presented. Indeed, the arts festival is in some cases the primary—if not the only—occasion for performance forms that have lost whatever "other" settings and contexts they once had. Even as some of these performances evoke an originary setting of the old days, they may in fact only be performed at festivals of the arts. One of the Festival organizers commented that a performer who had immigrated to Los Angeles from Thailand worked at Federal Express during the day—but surely not in the elaborate costume he wore for the Los Angeles Festival of

the Arts. Were audiences to assume that performers wore their "costumes" all the time? Or just for this occasion?

The arts festival may have become the safe and appropriate place to be different, to be "ethnic." As such, these festivals have long been the repository of imagined communities and invented traditions (see Anderson 1993; Hobsbawm and Ranger 1983). "Heritage" is not simply inherited. This is a claim that draws on a rhetoric of legitimation. Rather, "heritage" is constantly constituted and renewed. When Sellars aimed for a festival without labels, when he refused to identify the performers as ethnic, folk, or primitive, he was taking the ethnomusicologists, ethnographers, and folklorists to task, for these are in his view anthropological labels. But the Los Angeles Festival did use labels: "the Maoris," "the Koreans," "the Balinese," and so on. Why were those labels benign? I am not arguing for the other labels. I want only to shatter the illusion that there were no labels, that designations geopolitical or ethnic or cultural are unproblematic, and to draw attention to the implications of these labels, their singularity, as if those who performed could be defined in their entirety by a geopolitical designation. The ease with which such labels were used suggests that the only way that American "minorities" and Pacific peoples can appear is in their essential "ethnic" or "national" mode, that people are best known in the festival genre, that culture divides while art transcends, and that the only safe differences are aesthetic ones. The dizzying array of diversity, while motivated by an exuberant spirit of inclusiveness, also risked the danger of banalizing difference by rendering it inconsequential, particularly in the humanizing face of art, the master category.

Indeed the ethnographic survived as the hidden term in the Festival equation, where disavowal helped to create a lexical minefield. Having stripped the performances of ethnographic labels—it's all just art—the terminology dance began anew, only this time the preferred terms were tradition, heritage, and multicultural. These terms were offered by Susan Auerbach, former Folk Arts Coordinator for the Los Angeles Cultural Affairs Department and a thoughtful writer on her subject. Still, they are indicative of the dilemma, as is her statement in the program booklet: "Tradition encompasses change, and heritage-related arts range along a continuum from purist roots to hybrid and avant-garde offshoots, as the Festival amply shows" (Auerbach 1990:36). Roots are pure—folk arts programs "encourage cultural preservation"—and presumably they are purest at their putative source, whether removed in time or space or saved by immigration. Terms like fusion, blend, hybrid, evolving, and dynamism define the other end of the continuum.

When both ends meet at the Los Angeles Festival, the result is a "cross-cultural arts venture" that will make Los Angeles itself a "multicultural mecca." The delicacy of these terminological manoeuvres is particularly clear when Cambodian musician Chim Reap, an immigrant, is "multicultural" (a euphemism for not white), but a group like the Gujo Hachiman Bon Odori, who were brought from Japan, are "international" (a euphemism for not American). As surrogates for "for-

eign," both euphemisms occlude difference—and the asymmetries of power—by pluralizing (and otherwise splitting and reconstituting) the other. Why is Chim Reap multicultural? Who, by implication, is (mono)cultural? If The Friendly Islanders of Tonga are international, who is by implication national? Whether "multi," "cross," or "inter," the entities so designated stand in a special relationship to those who are not, for, it would seem, "they" are plural, "we" are one. Euphemisms take us only so far, particularly when the categories and assumptions they seem to challenge are still very much alive. After all, just who counts as different or as different enough or as different in the ways that matter? And who does not? Is the Bread and Puppet Theater, which is neither multicultural nor international, technically speaking, also "just different"? And if so, just different from what? The categories seem to be structurally intransigent and lexically fluid. Though the shifts in terminology do suggest some taxonomical give, they promise more than they deliver.

For another spin on the problem, consider Arlene Croce's dismay when Mark Morris was dropped from the Los Angeles Festival for financial reasons. In her *New Yorker* piece entitled "Multicultural Theatre," Croce champions Morris as "a genuine expression of world dance" and "a multicultural microcosm"—his dancers are of "every color and physical description" and his choreography is "a blend of styles Western and Eastern." Opining on multiculturalism, "the latest buzzword" created by the university, Croce celebrates the ecumenicism of dance and bashes the political correctness of academics:

> Multiculturalism exists and has always existed in American dance; there is scarcely an American choreographer of note who has not been influenced both by the pluralism of our society and the way that dance just naturally soaks it up. Pinning a label on a simple phenomenon like that is something only an academic would want to do. And only political academics would want to isolate the elements of pluralism in such a way as to aggrandize some and stigmatize others. (Croce 1990:84)

To at once trivialize the issues signaled by the term "multiculturalism" as a "simple phenomenon" that only academics would gussy up with a buzzword and then celebrate Morris as "a multicultural microcosm" only dramatizes the extent to which Croce herself has jumped on the bandwagon, but without having paid the price of admission.

What is so insidious about Croce's position? She equates appropriation with pluralism, an equation that naturalizes the process by which "the West" separates forms from their performers, converts those forms into "influences," brings the influences into the center, leaves the living sources on the margins, and pats itself on the back for being so cosmopolitan: "There may be a need to promote the accessibility of Asian, Hispanic, and African dance companies, many of which lead a marginal life, with few bookings. But the dance forms themselves are hardly inaccessible—they're part of every dance tradition the West knows. At their purest (assuming that one can find village and street festivals that are uninfected by tele-

vision and tourism), they still speak a rhythmic language intelligible to all" (1990:ibid.). To think otherwise is "divisive." Croce's affirmations of the purities of difference and her identification of the " 'other' (it's another buzzword)" with rhythm bear the traces of racist thinking.

Multiculturalism, in Croce's view—and she is not alone—is an invention of the intellectual academy and the enemy of the arts, for it presumes that ballet and modern dance are in decline and that "these other styles," kept outside by "mainstream prejudice," are the only hope for rejuvenation. On the contrary, she argues, "Morris speaks so many [dance] languages that it comes as a surprise, when from time to time, he creates a work that has no trace of an accent—that is just 'pure' movement" (1990:87). In other words, Babel is the path to the transcendent purity of artistic form, and even more important, to greatness as a dance company, for Morris's work exemplifies "a vision of the universe and the individual's place in it" (1990:84). Enlightenment values reassert themselves and political realities are obscured in the elision of anything—multiculturalism?—that might stand between the smallest unit (individual) and the largest (universe).

Yo! "After all, what is 'yo'? Only 'oy' spelled backward," a *New Yorker* cartoon at the time quipped. Step back a moment. What about "art"? Is that not a label? Who decided what to present at the Los Angeles Festival? The choices were not random. If, as Sellars stated, anthropological labels imply the superiority of Western art forms, then the label "art" is a way to elevate forms that have been so labeled. We dignify such forms by reclassifying them, by using categories we value, whether or not our categories bear any relation to those the performers use—as Mitoma noted, "Most of the international participants invited to the Festival do not consider themselves 'artists' in the general Western sense of the word" (Mitoma 1990:16).

I want to dispel the notion that when art mediates, it makes us all just human. I want to challenge the idea that art does not mediate. That it speaks directly. Or, that when art speaks it does so in a universal "nonlanguage." Phyllis Chang's assertion that "We've eliminated the third person" when we have eliminated the academic specialist and her explanations fosters the illusion that the Festival organizers did not mediate what they presented, that they simply let "art" speak for itself. Yet it is precisely the theatrical mediation effected by the Los Angeles Festival that distanced so many of the events from the ethnographic and bracketed them as art.

Consider Croce's comment at the end of her review of Mark Morris that "In dance, high art has always needed to be nourished by folk art, and folk art has always needed the mediation of the theatre. Without the theatre, dance isn't a medium; it's the preserve of anthropologists, not of artists" (1990:87). The diction is suggestive: in its role as nourishment, is "folk art" only food for the master, who "mediates" by digesting it? This reading exposes the *illusion* of reciprocity in Croce's statement, which promotes the fiction of a quid pro quo that equates nourishment with mediation. Though Croce's sensibility is very different from that of Sellars, her pronouncement points again to the power of theatrical mediation to remove

"folk art" from the "preserve of anthropologists"—and, inter alia, to the tensions between artists and those Croce calls anthropologists. The Los Angeles Festival is a spectacular case of theatrical mediation.

The mediation of theater, however well intended and successful, skirts the apologetics of inclusion—as noted earlier, Lincoln Center was unabashed on this score when it declared its plan "to elevate jazz to the same level as opera, ballet and symphony." Nathan Leventhal, president of Lincoln Center, predicted: "I think people will be very pleased about the fact that we're giving recognition to jazz, and that jazz has a place at Lincoln Center" (Pareles 1991), an assessment that would meet its true test when Lincoln Center went after funding. Money speaks loudly, even at the 1990 Los Angeles Festival, whose budget was considerably lower than those of its two predecessors. Were 70 percent of the events free of charge because they were hard to sell? Is "multicultural" a codeword for low budget? If money talks, what is it saying? It certainly speaks to asymmetries of power in the relationships that made the Los Angeles Festival possible and that has kept jazz out of Lincoln Center until now.

The press was often at a loss. Were the critics to review performances or to report on them? Some articles reverted to the encyclopedia entry, offering a somewhat ethnographic or historical treatise on a particular art form assumed to be unfamiliar to the reader. Others fell back on the human interest story and wrote about the performers. Some followed the conventions of travel writing to describe their encounters with those who had come from afar. Others observed Sontag's dictum to "supply a really accurate, sharp, loving description of a work of art" (Sontag 1966:13). Some wrote about the Los Angeles Festival as a total phenomenon. At bottom, reviewers seemed too unsure of themselves to write about performances from Asia and other parts of the Pacific the way they normally reviewed theater and dance in Los Angeles. Value judgments did not seem "politically correct" under the circumstances. While revealing a double standard—criticize art, describe the multicultural—their quandary also illustrates how limited are the ways the performing arts are usually reported in the press and suggests the need to experiment not only with performance and festivals, but also with the ways we write about them. The consumer reports quality of much performance criticism could do with a healthy dose of attentive description and critical analysis.

Like the press, what audiences experienced was the Los Angeles Festival itself—notwithstanding Sellars's comment that the Festival was a huge maze, everyone made their own festival, no one saw everything, and one cannot really speak of a "shared" experience. Indeed, the maze, like the alphabetical list of events and the calendric grid of their occurrence, was a way to avoid hierarchy by using disorientation, arbitrariness, and parataxis to advantage. The Los Angeles Festival, a product of the contemporary art world, the university, civic institutions, corporate philanthropy, city government, and big business, needs an ethnomusicologist, a folklorist, an anthropologist, if it is to be understood as a cultural phenomenon in its own right.

When a brochure entitled "The Los Angeles Festival Guide, 1991," issued by the Cultural Affairs Department, was captioned "Celebrating America's City of Festivals," the message was that Los Angeles is party time. It is a happy place. The brochure stated further that these festivals "tell a story of a City that is culturally alive." Read the newspaper for the unstated story of urban decay, urban problems, gangs, and all the other fixtures of American cities. At the Los Angeles Festival, the city of Los Angeles was the hero and the script, the stage and the producer, whatever else the event might have been about. The 1990 Los Angeles Festival, like the guide to all the festivals occurring in Los Angeles throughout the year, signified that Los Angeles is civilized, that Los Angeles has a civic and public sphere. People work for the common good. Los Angeles has the arts. Los Angeles is in the vanguard. Los Angeles will lead the future. Los Angeles is multicultural. Diverse people can work together. The city is vibrant, a center, a magnet. We can beat the sprawl. We can get off the freeway. We can park our cars. We can visit each other's neighborhoods. There is a there there. Thanks to the last twenty-five years of new immigration—and the airplane that brings performers from around the Pacific—we can really prove it. Just look at Little Tokyo, Chinatown, Olvera Street, Philippine Town, Koreatown, and other distinctive parts of the city. The Los Angeles Festival helped the city define itself in terms of those who have come to it from somewhere else and who assert hereness through thereness.

A key to the Los Angeles Festival is its location of authenticity in a moment of aesthetic reception, rather than in the objects presented. This move is informed by an avant-garde sensibility that, having challenged the category of art and admitted what the art academy excludes, gives to reception a constitutive role. While this sounds emancipatory, there are unexplored asymmetries here between performances that are coherent in their home contexts and the planned anarchy of their reception by Los Angeles audiences. Driving a wedge between ethnographic and artistic practice obscures the extent to which the two enterprises share procedures and values and the ways in which theatrical mediation "undoes" the ethnographic. The organizers of the Los Angeles Festival incorporated critiques such as this into their planning discussions for the 1993 Festival and continue to do so in their ongoing experimentation with the festival as a form.[3]

NOTES

1. He has since left Euro Disneyland Corporation.

2. Frisch has since moved on.

3. I would like to thank Norman Frisch, Judith Mitoma, Claire Peeps, and Peter Sellars for the opportunity to participate in the Los Angeles Festival and their openness in discussing it with me; Michelle Kiskliuk for her thoughtful reading of an earlier draft of this paper; and Karl Signell, editor of *ERD (Ethnomusicol-*

ogy Research Digest), for posting an electronic draft of this paper in 1992 and for the discussion that followed.

REFERENCES

Allen, Barbara, ed.
 1990 *Los Angeles Festival Program Book.* Los Angeles: McTaggart-Wolk.
Anderson, Benedict
 1993 *Imagined Communities: Reflections on the Origin and Spread of Nationalism.* Rev. and expanded ed. London: Verso.
Artaud, Antonin
 1958 *The Theatre and its Double.* Trans. Mary Caroline Richards. New York: Grove Press.
 1976 *Selected Writings.* Ed. Susan Sontag, trans. Helen Weaver. New York: Farrar, Straus, and Giroux.
Auerbach, Susan
 1990 "Against the Odds: Sustaining Traditional Arts in Los Angeles." In Barbara Allen, ed., *Los Angeles Festival Program Book,* pp. 33–37. Los Angeles: McTaggart-Wolk.
Baron, Robert, and Nicholas Spitzer, eds.
 1992 *Public Folklore.* Washington, D.C.: Smithsonian Institution Press.
Barr, Alfred H., Jr.
 [1938] 1966 Preface. In Holger Cahill, Maximilien Gauthier, Jean Cassou, and Dorothy C. Miller et al., *Masters of Popular Painting: Modern Primitives of Europe and America.* New York: Museum of Modern Art.
Barthes, Roland
 1977 "The Third Meaning: Research Notes on Some Eisenstein Stills." In Stephen Heath, comp. and ed., *Image—Music—Text,* pp. 52–68. New York: Hill and Wang.
Becker, Jane S., and Barbara Franco, eds.
 1988 *Folk Roots, New Roots: Folklore in American Life.* Lexington, Mass.: Museum of Our National Heritage.
Bogatyrev, Petr
 1976 "Semiotics in the Folk Theater." In Ladislav Matejka and Irwin R. Titunik, eds., *Semiotics of Art: Prague School Contributions,* pp. 33–50. Cambridge, Mass.: MIT Press.
Bogdan, Robert
 1988 *Freak Show: Presenting Human Oddities for Amusement and Profit.* Chicago: University of Chicago Press.
Bradley, Tom
 1990 "Official Invitation." In Barbara Allen, ed., *Los Angeles Festival Program Book,* p. 2. Los Angeles: McTaggart-Wolk.
Braxton, Greg
 1990 "The L.A. Festival: Thumbs Up or Down?" *Los Angeles Times,* 20 Sept., Calendar, F1, 10.

Brecht, Bertolt
 1964 *Brecht on Theatre.* Ed. and trans. John Willett, New York: Hill and Wang.
Bürger, Peter
 1984 *Theory of the Avant-Garde.* Trans. Michael Shaw. Minneapolis: University
 of Minnesota Press.
Cahill, Holger
 1931 *American Folk Sculpture: The Work of Eighteenth and Nineteenth Century Craftsmen,*
 Exhibited October 20, 1931 to January 31, 1932. Newark, N.J.: Newark
 Museum.
Cantwell, Robert
 1993 *Ethnomimesis: Folklife and the Representation of Culture.* Chapel Hill: University
 of North Carolina Press.
C[ardinal], R[oger]
 1989–90 "But Where Was the Magic." *Raw Vision: Outsider Art, Art Brut, Grassroots
 Art, Contemporary Folk Art, Visionary Art* 2(winter):55.
Clifford, James
 1981 "On Ethnographic Surrealism." *Comparative Studies in Society and History*
 23(4):539–564.
Croce, Arlene
 1990 "Dancing: Multicultural Theatre." *New Yorker*, 23 July, pp. 84–87.
Eaton, Allen H.
 1932 *Immigrant Gifts to American Life: Some Experiments in Appreciation of the Contribu-
 tions of Our Foreign-Born Citizens to American Culture.* New York: Russell Sage
 Foundation.
Fabian, Johannes
 1983 *Time and the Other: How Anthropology Makes its Object.* New York: Columbia
 University Press.
Feintuch, Burt, ed.
 1988 *The Conservation of Culture: Folklorists and the Public Sector.* Lexington, Ky.:
 University Press of Kentucky.
Frisch, Norman
 1990 "The Hidden Agenda." In Barbara Allen, ed., *Los Angeles Festival Program
 Book*, pp. 21–26. Los Angeles: McTaggart-Wolk.
Haithman, Diane
 1990 "UCLA Course on the L.A. Festival Takes to the Streets." *Los Angeles
 Times*, 3 Aug., F6.
Hobsbawm, Eric, and Terence Ranger, eds.
 1983 *The Invention of Tradition.* Cambridge: Cambridge University Press.
Honzl, Jindrich
 1976 "Dynamics of the Sign in the Theater." In Ladislav Matejka and Irwin
 R. Titunik, eds., *Semiotics of Art: Prague School Contributions*, pp. 74–93.
 Cambridge, Mass.: MIT Press.
Jackson, Michael
 1983 "Knowledge of the Body." *Man* 18:327–345.

Kindel, Maureen A.

1990 "Chair's Letter." In Barbara Allen, ed., *Los Angeles Festival Program Book*, p. 2. Los Angeles: McTaggart-Wolk.

Kirshenblatt-Gimblett, Barbara

1990 "Producing Ellis Island." *Artforum* 29(Dec.):17–19.

1991 "Objects of Ethnography." In Ivan Karp and Stephen D. Lavine, eds., *Exhibiting Cultures: The Poetics and Politics of Museum Display*, pp. 386–443. Washington, D.C.: Smithsonian Institution Press.

Kleid, Beth

1990 "Family Adventures." *Los Angeles Times*, 26 Aug., Calendar Part II: Festival '90, 16.

Levine, Lawrence W.

1988 *Highbrow/Lowbrow: The Emergence of Cultural Hierarchy in America*. Cambridge, Mass.: Harvard University Press.

Lomax, Alan

1972 "Appeal for Cultural Equity." *The World of Music* 14, pp. 3–4, 9.

Los Angeles Festival

1990 *Los Angeles Festival, September 1 thru 16, 1990, Program and Ticketing Information*. Los Angeles: Los Angeles Festival.

MacAloon, John J.

1984 *This Great Symbol: Pierre de Coubertin and the Origins of the Modern Olympic Games*. Chicago: University of Chicago Press.

Metcalf, Eugene W., Jr., and Claudine Weatherford

1988 "Modernism, Edith Halpert, Holger Cahill, and the Fine Art Meaning of American Folk Art." In Jane S. Becker and Barbara Franco, eds., *Folk Roots, New Roots: Folklore in American Life*, pp. 141–166. Lexington, Mass.: Museum of Our National Heritage.

Mitoma, Judith

1990 "Art and Spirit in Los Angeles." In Barbara Allen, ed., *Los Angeles Festival Program Book*, pp. 16, 18–19. Los Angeles: McTaggart-Wolk.

Pareles, Jon

1991 "Lincoln Center Is Adding Jazz to Its Repertory." *New York Times*, 10 Jan., section A, 1.

Schulte-Sasse, Jochen

1984 "Foreword: Theory of Modernism versus Theory of the Avant-Garde." In Peter Bürger, *Theory of the Avant-Garde*. Trans. Michael Shaw, pp. vii–xlvii. Minneapolis: University of Minnesota Press.

Sellars, Peter

1990a "Beginning to Notice What We Are." *Los Angeles Times*, 5 Feb., Calendar, 3, 75.

1990b "Welcome." In Barbara Allen, ed., *Los Angeles Festival Program Book*, pp. 14–15. Los Angeles: McTaggart-Wolk.

1991 "Artistic and Aesthetic Agendas." In *New Geographies of Performance: Cultural Representation and Intercultural Exchange on the Edge of the 21st Century, Summary Report*, pp. 9–17. Los Angeles: Getty Center for the History of Art and the Humanities, Los Angeles Festival, University of California, Los Angeles.

Snow, Shauna
 1990 "3 Out of 4 Unaware of L.A. Festival, Informal Survey Finds." *Los Angeles Times*, 1 Aug., Calendar, F4.

Snow, Steven
 1993 *Performing the Pilgrims: A Study in Ethnohistorical Role Playing at Plimoth Plantation.* Jackson: University Press of Mississippi.

Sontag, Susan
 1966 "Against Interpretation." In *Against Interpretation, and Other Essays*, pp. 3–14. New York: Dell.

Stewart, Susan
 1991 *Crimes of Writing: Problems in the Containment of Representation.* New York: Oxford University Press.

Susilo, Hardja
 1990 "The Royal Court of Yogyakarta Java." In Barbara Allen, ed., *Los Angeles Festival Program Book,* pp. 80–81. Los Angeles: McTaggart-Wolk.

Vlach, John M.
 1985 "Holger Cahill as Folklorist." *Journal of American Folklore* 98(388):148–162.

Whisnant, David
 1983 *All That Is Native and Fine: The Politics of Culture in an American Region.* Chapel Hill: University of North Carolina Press.

Inside Trading:
Postmodernism and the Social Drama
of *Sunflowers* in the 1980s Art World

Nancy Sullivan

INTRODUCTION

In 1988 I met a tour guide in the Tablelands of Queensland, Australia, who turned out to be a casual collector of American art. In fact, he owned pieces by artists I knew and exhibited with in New York's East Village. Athy was about thirty-five, wore blue work clothes, and spoke with typically Australian droll cynicism. Not only did he look like he had hardly visited Brisbane, but both his first and last names were attached to this rainforest region as local place names. Still—he collected cutting-edge American art. No doubt, he was just as surprised to find that this tourist was an East Village artist who, after an introductory exchange, could share with him the art-speak idiom peculiar to New York art magazines and a rumor mill based in lower Manhattan. The only friction, I recall, amounted to Athy's doubts about investing in art by women who, he said, predictably dropped out of the market to marry and have kids. It seemed that I had found a fellow art-speaker with surprisingly conservative views.

But Athy actually represented a different sector of the art-world community than I did, not merely by his remote location but, more to the point, by his status as collector. It was in fact far-flung, wealthy individuals like himself who invested in and thereby shaped the tighter circle of New York art makers to which I belonged—and whose gender (and culture and race)–biased prophesies were continually fulfilled by people like myself, unable to sell enough work to stay in the game and (at that point) ready to start another life far from New York. But I also remember that months later he sent me the catalog of a woman friend's work, a well-known Outback painter, for which he had written an Introduction. In his words, her vigorous Abstract Expressionism came from being a mother and living close to the land in far west Queensland, and not from any global aesthetic dis-

course. Nonetheless, her work was much like the work of Jean-Michel Basquiat or George Baseltiz, international "heavies" of the Neo-Expressionist eighties.

The question is, what is the art world that enveloped Athy, this artist, and myself? In this essay, I want to constitute this "world" as an object of study, and to examine recent events which influenced social relations within it.[1] My point is to make sense of the art world as a community whose complex, often mystifying, operations actually adhere to a logic.

The Art World as a Community

More than just a market, or a magazine readership, or even a professional sector, the art world is an "imagined community" (Anderson 1983) of tiered commercial, communicative, and social networks spread across the globe. However, it is the nucleated cluster of participants living in New York who, during the eighties, operated as the art world's power axis. The actions of this core community of art professionals commanded (and to some extent still commands) such centrifugal force upon global art practices that (I suspect) even the remote Australian painter held this community in her mind's eye as a principal spectator. It is the system of artists, dealers, critics, and collectors who stand behind the images in international art magazines and consciously shape the posterity of Western art.

What defines this community as a whole is its proximity to the auction market, which is itself based in New York auction houses. It is a community constituted of overlapping occupational and social relations, several strata of art discourse, and the commercial institutions that surround the auction market. Because the negotiations between dealers and collectors are always confidential, auctions are commonly viewed as the public reckoning of secretive decision-making processes, where economic and artistic "futures" are confirmed by the gavel (see Crane 1987:110–118). Contemporary Western art's mainstream flows toward the auctions, drawing off secondary markets around the world. But the New York art scene replicates this process as well, with several layers of art activity (many without commercial objectives) ascending toward a strong "secondary" market below the "blue chip" arena of art auctioneering. The community I refer to is composed of this secondary tier—where social relations are relatively fluid, and commercial transactions frequent—as well as its more stable and elite core of primary market players. These spheres of influence include several occupational groupings: critics and art theorists associated with New York–based international publications and publishing houses; auctioneers at Sotheby's and Christie's; a number of "high end" contemporary dealers (many associated with galleries in Europe as well); "bankable" artists whose works frequently sell at auction; private and public museum directors and curators; curators of corporate collections; and a range of "secondary" dealers and artists hovering just this side of the auction block.

In describing this community, this essay focuses on the contradictory relation-

ship between postmodern theory and art-world practices during the 1980s. This subject falls at the intersection of three critical trends in anthropological theory. The first is a movement away from traditional concepts of culture, as bounded in space and time, toward groupings of shared identities, and communities of "discourse" and the "practices" that constitute them (Abu-Lughod 1990, 1991:147–148; Gupta and Ferguson 1992; Myers 1991; Appadurai 1990, 1991; Reddy 1992). I would define the art world as a "discursive formation" constituted of particular social relations at a given time. It is not a cultural group, but a community of common interests governed by its own "political economy." This means that it differs from communities forged solely by the medium of communication, as for example television audiences, which may be viewed as communities in the "global village" with "no sense of place" (Meyrowitz 1985; Appadurai 1990). Imaginatively and actually New York is where this community is "placed."

 The constitution of an art world, as an object of study, also enters a broader discussion of the changing relationship between anthropology and art. Anthropologists and other scholars are concerned that, as non-Western individuals and groups are increasingly swept up in the art market, they become objectified in terms that are more patronizing than humane (Ames 1986; Clifford 1988; Fischer 1989; Geertz 1991; Martorella 1990; Messenger 1989; Myers 1991; Price 1989); and that these terms tend to stigmatize all that is "ethnographic" (Kirshenblatt-Gimblett 1991; Myers 1991). It appears that a strain of art criticism has been conceived in contradistinction to anthropology (see, e.g., Couacaud 1990; Fry and Willis 1989; Michaels 1988; see also Golub et al. 1991; Jaar et al. 1989; Rosler et al. 1989). Even so, ethnographic literature is woven throughout the art market: an anthropologist's text may be part of assaying objects as they enter a local art or tourist market, and then become present by erasure as these objects are catapulted into international markets (see Clifford 1988:189–214). However, a macroview of art circulation, as part of larger global culture and commodity flows, misses the political niceties of today's "postmodern" condition, including the social relations involved in transforming what is produced as "modern" on the periphery and yet grasped as "postmodern" at the center. Anthropology, rather than art theory, is best suited to describing these particulars.[2]

Postmodernism

"Postmodernism" has become a gloss for a whole range of theoretical developments in the humanities and social sciences. My use of the term covers this range, although it most often refers to art theory's grasp of the paradigm. Flax (1990), Reddy (1992) and Hutcheon (1989), for example, tell us that postmodernism declares the death of Man, of history's "Metanarrative," and of metaphysics. The following are what I perceive to be the broad epistemological constituents of this paradigm, which apply to art as well as anthropological theory: (1) a critique of

the philosophical bases of objectivity and subjectivity (Barthes 1984; Derrida 1967; Foucault 1966; Giddens 1979; Rorty 1979; Tyler 1986), (2) an awareness of the historical and contemporary power relations implicit between object and subject (Bourdieu 1984; Foucault 1977, 1980; Lyotard 1984; Marcus and Fischer 1986:7–16), (3) an end to the linear models of modernism which place postindustrial capitalism at the end point of history, and the center of the globe (Habermas 1983; Hannerz 1989; Huyssen 1981; Jameson 1984; Lyotard 1984), (4) a breakdown of the autonomous spheres of culture (art, science, morality) and the belief that these lie outside social and political history (Baudrillard 1987; Geertz 1980; Lyotard 1984; Morris 1990; White 1973), and (5) a critique of romantic modern myths involving the heroic individual and allegorizing the rise of private property and the conquest of free enterprise (over tradition-bound, uncritical thought and feudal exchange relations) (Clifford 1988; Foucault 1966; Sahlins 1976; Williams 1958; cf. Foster 1983; Kelly 1984; Krauss 1984).

In my examination of postmodernism's social and material aspects, I am informed by a third current of anthropological thought. This is the critique of ethnography's own postmodern "turn" originating within but not exclusive to (see Sangren 1988) feminist theory. Basically, the argument is that textual self-awareness and innovation are not the same as an actual redistribution of power, and may in fact underscore the status quo—between white men and everyone else within the academy and out in the field. However, for many reasons, textual adjustments do not necessarily alter the dimensions of power on social and institutional planes. As Mascia-Lees, Sharpe, and Cohen point out, "The new ethnography draws on postmodernist epistemology to accomplish its political ends, but much feminism derives its theory from a practice based in the material conditions of women's lives" (1989:23). Indeed, the strain of postmodernism that had the greatest currency in the eighties' art world was one that gave substance to a particular experience of contemporary culture—that is, the work of Baudrillard, Jameson, Debord, Lyotard and a number of others who (notwithstanding their range of ideas) somehow achieved admirable omniscience over a life of chronic consumption, especially in America. It is a critique of materialism run amok, with collapsed social and symbolic values. These thinkers' frustrations, their feelings of dislocation and repressed ecstasy, convinced art professionals that their traditional (modernist) pose of social alienation was an especially safe bunker during the aftermath of truth and beauty. On the other hand, not a few readers of these texts—within and without the art world—have failed to achieve the same identification with these authors. They have been left feeling, as Fred Pfeil so nicely puts it (1990:144), a little like Tonto, while Indians loom on the horizon, asking "What do you mean 'we' Kimosabe?" As someone who worked for fifteen years as an artist (and a sometimes-curator) on the margins of this "core" community, I have an engaged relationship to this material and a genuine interest in seeing things change.

BACKGROUND: FROM MODERN TO METAMODERN AND BACK

For the art world, as for the social sciences, postmodernism is both prospective and retrospective, in that it is a revolt against modernism as well as a program for its replacement. The "modernism" of art is a discursive formation within the broader ideological and social history of modernism—the contours of which are shaped by ideas of modern consciousness (from, e.g., Baudelaire, Flaubert, Wagner, Nietzsche, and Kierkegaard) and of modern material life (from, e.g., Durkheim, Mauss, Marx, Veblen, and Weber). Most of the postmodern art literature struggles with the closure of a narrow discourse on aesthetics. While critics and theorists are not ignorant of modernist art and theory's relationship to the broader socioeconomic and ideological formations of modernism, their occupational objectives are limited. However, for árt writers, the relatively rapid ascent of postmodern theory has presented problems. Postmodern theories do not themselves posit a break, sealing off modernism from present and future space. They tend to critique modernity's residual cultural formations. The texts that were most influential in formulating a modern aesthetic now seem trapped in a metaphysical time warp, suggesting that something has changed in the way we (art scholars included) view modernism. Their confident assertions of art's timeless and socially transcendent meanings today seem pious, even mystical. Modernism is commonly defined as a march of formal innovations that begin purposefully in the late nineteenth century (Gablik 1977; Gombrich 1963; Greenberg 1961; Wölfflin [1932] 1950), sealing itself off from other spheres of culture as a language of pure forms (Bell 1982; Clark 1982; Fry 1932; Greenberg 1961). Nonobjective images represent "a unique world of their own, as creations with a lawful organization of colors, variation of forms, and rhythm of motif," wrote critic Hilla Rebay in 1937. "These combinations when invented by a genius can bring the same joy . . . and animation of spiritual life as music" (Rebay 1937). Views of modern art from within—by art critics rather than, say, academics—are known to border on the theological (see Ratcliff 1980), full of unempirical statements of fact and rhetorically revealed truths.

Artist and critic Victor Burgin (1986:30–33) points out that the modern aesthetic is constituted of two post-Enlightenment viewpoints: the Ascent of Man-the-Individual humanism, and a concept Derrida calls "logocentrism," or the tendency to refer representations back to an originating presence (author, zeitgeist, history, etc.). What lifted the art of the Renaissance off walls and cathedrals and on to the seventeenth century easel was a combination of forces, as feudalism gave way to capitalism, and art's use-value shifted to a principle of exchange—an object's worth became intrinsic, inscribed within as a mark of the human mind. But the revolution of imagery that we commonly refer to as "modernism" did not occur until late in the nineteenth century. The compression of stylistic movements that bridged the nineteenth and twentieth centuries propelled the painted image in an abstract direction. Eschewing "mimesis," it remained for artists to explore nonob-

jective imagery as a system of color, line, composition of forms. Painting rose above sculpture and photography in a hierarchy of visual media as the most direct inscription of the human mind. It became all the more a genius occupation: ramified by cliques of theosophists, Bergsonians, and space-time investigators (Henderson 1983). In a sense, this apparently "apolitical" zone is where theories of art have since remained.

Modern art theory originates in the work of historian Heinrich Wölfflin, whose 1913 study of Renaissance art introduced the Hegelian notion that successive art styles respond to an internal dynamic (Fried 1982:117; Carrier 1987; see also Wölfflin [1932] 1950). This powerful idea has succeeded in holding more social and historical perspectives of art history at bay. But it was the postwar writings of critic-theorist Clement Greenberg that refocused the humanist-logocentrism of modernism for contemporary artists. For Greenberg, modern art embodied nothing less than the "intelligible continuity of taste and tradition."[3] Speaking from the seat of a new avant-garde, New York City, he put together all the self-important sensibilities of this time in a theory of modern art that placed American Abstract Expressionism at its summit. He also reanimated the identity of the artist as distinct from the scholar or laboratory technician, as a hero, bohemian, and social outcast. The site of a modernist struggle was the flat picture plane where, in Greenberg's view, a push-pull now existed between illusionism and the physical presence of a picture plane. Artist and critic Darby Bannard says that, "The consciousness and pressure of this simple idea is the basis of the stylistic revolution of modern art. It is the core of the modern 'mainstream,' which one way or another affects practically every artist" (1966:35).

During this postwar period, museum display conventions also "modernized." The New York Museum of Modern Art's first director, Alfred H. Barr, made physically manifest the idea that art is only interpretable by art: art works spaced regularly, on flat white walls, denoting unbroken lines of formal development, with placards supplying the barest historical information (see Schapiro 1978:187–188). This display form is still ubiquitous, as is the idea that the viewing experience should be unitary—one picture, one viewer—to facilitate the alignment of artist, subject, and viewer in an epiphanic agreement (cf. J. Berger 1972). Viewers are rarely informed about curatorial decision making or any of the stages in consecrating an object as art (Bourdieu 1980:263). Indeed, in keeping with mystical strains of modernism, the practical details of curation are (still, today) effaced, as if to suggest an act of intuition or, at least, historical inevitability (Ratcliff 1974, 1980).

Antiaesthetics

Virtually every one of art's palace rebellions of this century contains some kind of utopian rhetoric about returning to purer aesthetic values, some millenarian need to seek art's end. This iconoclasm predates the High Modernism of Abstract Expressionism as an integral component of the avant-garde (Crane 1987). Yet ever

since Abstract Expressionism, modernism has been trailing its apotheosis in a succession of small purges, attempting to rejuvenate the essence of modernism without overthrowing it. In "After Abstract Expressionism" (1962:30), Greenberg said, "The question now asked . . . is no longer what constitutes art or the art of painting, but what irreducibly constitutes *good* art as such." By the seventies, modern art was testing all its boundaries: rejecting the "object"; dismantling hierarchies of media that placed painting above (the more "present") sculpture and photography; even challenging the importance of exhibiting artistic "hand" as authorship. These erosions at the semiotic level—in art's image—were accompanied by serious doubts about art at the social and commonsensical level. Times had changed. There was an image problem with Western aesthetics in general—handmaiden of colonialism, hobby of privileged males (no more true than in the field of painting). This is when art writing first took to storming the warehouses of Western representation in search of some imperial code of aesthetics. An antiaesthetic impulse dominated the seventies art scene, and set about deconstructing that indigenously Western system of values which, over the course of time, had come to unite (conceptually and terminologically) modernism with colonialism, culture with material acquisition, and truth with the white man's burden.

During the seventies, artists gave up the exchangeable object in an act of resistance and purification. Performance artist Vito Acconci followed random members of the public in his 1969 *Following Piece*. In another, he masturbated beneath the gallery's entrance ramp. Robert Morris sold rooms full of felt scraps, transacting "certificates of the right to refabricate" his installations. Dennis Oppenheim seeded and harvested a wheat field in Holland; Gordon Matta-Clark buzz-sawed a house in half; Robert Smithson constructed his *Spiral Jetty* in Utah's Salt Lake. For all this anticommodification of art, museums and galleries in the seventies began to look like the front rooms in architectural firms, or city planning offices, with blueprints laid out for ambitious territorial claims by artists like Christo and Claus Oldenburg (see Battcock 1973; Sondheim 1977). Conceptual art created a surge in art publishing beyond the monograph and catalogue raisonné formats, as this sort of work was better documented in books than in photos tacked to gallery walls.

In 1971, Allan Kaprow published a series of articles advocating that art professionals escape from the pictorial paradigm, from semiology altogether, into—of all places—high technology (the last bastion of verisimilitude). Kaprow recommended, for example, NASA's Lunar Module over any modern sculpture; the broadcast exchanges between Apollo II and Houston, over contemporary poetry; and anthropological videos of ghetto families over underground film. He went on to claim, "the Southeast Asian theater of war in Vietnam, or the trial of the 'Chicago Eight,' while indefensible, is better than any play." His program for this "ritual escape from culture" held the chilling objective of establishing the ultimate gaze, global surveillance—to be achieved by a "network of simultaneously transmitting and receiving video arcades" (Kaprow 1971, as cited by Rosler 1987).[4] This

sort of program for art's dissolution into science and mass media (related to MacLuhan's sense that "The new media . . . are nature"), was an inversion of the Dadaist trick—whereby everyday objects were inserted into a field of art. Kaprow was responding to an implicit program for art's "vanishment" in late sixties' Minimal art—in which the object seemed to expand into culture at large, and foreclose on representation altogether.

Yet modernism was far from dead. Pop Art, Minimalism, and Conceptualism were responses to Greenberg's autocratic regulation of style; they were an attempt to press the modern paradigm beyond the edicts of Abstract Expressionism. But American society at large had also changed the system of distributing fine art. It was in the sixties that a communications explosion in general changed the way a public encountered art, and elaborated the system of points or "settings" by which an art work may be evaluated and, in so doing, accrue compound meanings. From studio to gallery to museum to collection, and on to other museums and collections: each change of venue elicits different meanings from differently positioned viewers. "Mediated" contexts proliferated with the growth of an art publishing industry and magazines dedicated to reviewing and critiquing contemporary art which contributed to an increase in semantic projections of and about art work. The business of distributing art grew in complexity and threatened to overwhelm the coherence of what had been, in the fifties, a simple structure with relatively fixed conditions of consumption.

One significant consequence of all this was the heightened awareness of art's twofold symbolic operation. At one level, most evident in direct viewing, an art work indicates autographic uniqueness, the artist's own signature on the object and the art historical past. At another level, which is more pronounced in photographic (including film and TV) reproduction, a work falls into a comparative field of quotidian media signs, connecting with advertisements, news, and other art reproductions. It loses a "surface" signature and becomes a composition of shapes and colors. In the past, when the occasions for viewing were restricted, so were the limits of possible interpretations. In the communications age, as Alloway noted in 1972, "The effect is, to quote Henry Lefebre, of an 'enormous amount of signifiers liberated or insufficiently attached to their corresponding signified' " (1972:29). Artists also perceived an increased alienation from their work which, in wider circulation, was rapidly distanced from authorial intent. The view of art as possessing a singular meaning, one which the "correct" reception identifies, became harder to sustain in the face of expanding viewing contexts and a general questioning, on the part of artists themselves, of the social centrality of art. The social movements of this period made artists wary of the commercial and communicative operations that confined them, and resulted in the first of a series of copyright protections: the Artist's Reserve Rights Transfer and Sale Agreement, which artists pressed collectors to sign so as to insure their continual remuneration in resales.

The distribution of art underwent greater change during the sixties than artistic production itself. In general, as the system expanded to incorporate new media

and forms of consumption, the artist lost more control over the meanings of his or her work. One subtle mechanism by which dealers and institutional curators came to reaffirm the importance of the correct viewing experience was the restriction of photographic images: in the sixties, the convention arose of circulating a single set of transparencies for an artist's work, so that catalogs, books, reviews, and even merchandised objects (posters, T-shirts) carried the same image of an original (Alloway 1972:31). Rapid image assimilation in the age of mechanical reproduction did not so much undermine the handmade quality of an original as challenge the system of producing exclusive interpretations. Art "handlers" received their wake-up call.

It was during the late sixties and seventies that art also became institutionally "normalized" in the academy, in state and federal arts programs, and in the market. Modern art museums, contemporary art galleries, national and state funding organs, private foundations, and corporate collections—all these critical infrastructural components of art (and their attendant bureaucracies) exploded in the U.S. during the period from roughly 1950 to 1980 (Crane 1987:2–11).[5] Experimentalism was increasingly sanctioned by federal funding (Cone 1989), while a growth of private interests fostered the emergence of contemporary investment art (Pears 1988). In the late sixties, with the stylistic closure of Abstract Expressionism, midcareer artists were transformed into living Great Masters for the first time in history, entering the hallowed chambers of art auctioneering (see Crane 1987:110–118). Whether older living artists got rich, or younger ones got teaching positions and government grants, in general artists in the seventies entered the leisured classes. This placed a strain on conventional relations between artists and their "brokers." Artists had more and more in common with their patrons, especially nouveaux riches ones, and had less and less need for interpreters. It is always an honor to be invited aboard Stavros Niarcho's yacht, but real friendships could now be forged while deep-sea fishing with CEOs and their families. It makes sense, then, that institutional curators were increasingly lured toward promotional literature and away from a tradition of catalog scholarship (Alloway 1972, 1975; cf. Crimp 1984).

Because critics were isolated from this social nexus, they sought inspiration from a wide range of theoretical sources. As new structuralist and semiotic approaches to literature eroded the "logocentrism" or "signature" logic of modernism, art critics rapidly articulated the aesthetic implications (Carrier 1987:108–134). The idea that deep subjective judgments are a conduit to absolute truths, in either artistic creation or appreciation, could no longer be supported. Critics turned away from the art object as their principal subject matter, incorporating more ideas from (nonsociological) culture studies, and art and criticism increasingly become collateral metalanguages in search of a single aesthetic. Whereas modernism had been, if nothing else, a generative theory that allowed critics to debate different genealogies in a single discursive mode, what immediately succeeded it was an absence of genre conventions and unrestricted blurring of art-writing forms. Overqualified, underpaid, and cramped by magazine deadlines, critics were pressed to invent

new guideposts to evaluating contemporary art. Finding enough raw data has never been artwriters' problem, but shaping one's interpretation with knowledge of particular production and distribution events was becoming very difficult; critics were less privy to decisions made by an influential elite. A once-stable and scholarly critical point of view dissolved into so many subjective positions informed by pretextual illuminations of Marxism, feminism, structuralism, and psychoanalysis. Criticism was at once more obscure and less definitive than before, a field of educated and singular points of view.

But criticism was still in the thrall of a pictorial paradigm: still consecrating the object for a specialized public, controlling the flood of variables to the context and interpretation of art; still exalting the "correct" reception in the form of an educated one, even as this no longer relied on insider information regarding artistic intent. Moreover, whatever the artist's intent, work was still enclosed by a system dedicated to the autonomy of art, its fundamental humanism, egocentrism, and self-referentiality. The seventies paintings of Brice Marden, for example, were touted by critics as emblems of a formalism shared by linguistics and art; in fact, they were central to the contemporary art market of that period (along with Robert Mangold's, Robert Ryman's, and Carl Andre's) and were actively promoted by Thomas Messer, the then director of the Guggenheim Museum, who scheduled a series of shows that favored select dealers and a vision of new painting as highly formal and continuous with Abstract Expressionism. Alloway noted at the time, "This is a conservative tactic to ditch Clement Greenberg, but hold on to the sort of painting that he liked or that has developed from his kind of painting" (1975:33).

Art made a retrenchment back from public to private spaces by the end of the seventies, when painting (which, in critical corners, was "dead" [Crimp 1981]) got reincarnated by artists themselves. Ugly associations of this form of representation with an elitist, mostly male, modernism were underplayed. Artist and critic Thomas Lawson urged colleagues to return to painting as an "act of faith" (Lawson 1981). By the mideighties, big "male" Abstract Expressionist painting was back (as Neoexpressionism: for example, the work of Salle, Fischl, Schnabel, Basquiat, and several Europeans), New York galleries had multiplied, and a new breed of collectors was willing to risk real money on artistic "futures." Where critics were reticent to stake their own careers on one or another coterie of artists, dealers and even a number of artists provided confidence-instilling promotions. Artist Julian Schnabel, for example, says, "My painting comes out of the continuum of art that has been. It is not antiart in any way" (Ratcliff et al. 1982:69). All of this signaled a return to a patriarchal principle in the reaffirmation of art's *presence*. As Burgin notes, "It is impossible not to suspect that such icons of masculine mastery now have more than a little to do with the symptoms of anxieties generated by the feminist politics of the 1970's" (1986:47).

The feeling of modernism's absolute closure—its ability to epistemologically dominate both art and society at large, to be "dead" and also alive—reached a culmination in the art of "Simulation," notably the refabricated household objects

of Haim Steinbach and the kitsch objets d'art of Jeff Koons. Simulation art was in fact the pièce de résistance in a broad trend toward "fraudulance" by young artists. These artists, like their Conceptual forefathers, would test the limits of what would sell. Mike Bidlo "faked" modernist masterpieces. Mark Kostabi (who once said his middle name was "et") ridiculed the collectors clamoring for his work—paintings signed by the artist but executed by minimum-wage assistants. Just to be sure no one misread him for a patsy, Kostabi liked to tell reviewers he worked only with the cheapest materials. He called one client, Sylvester Stallone, a sycophant.[6]

But the market favored literal representations of commodity value as metaphors of aesthetic value. Thus pictorial abstraction (a reference to modernism's most expensive products) and precious sculptural materials garnered the highest original and resale prices. Artist John Baldessari complained, "There are collectors who won't even look at a work unless it's priced above $100,000"—which explained a season of bronze sculptures by the painter Julian Schnabel. Baldessari's guess was that they cost $250,000 just to produce. "I don't even think the sculptures have anything to do with bronze, but bronze is a signal: it makes it real sculpture, real art and worth real money" (Baldessari et al. 1990:134).

Efforts by art professionals to disengage from the market, and from market analyses, were themselves fraught with symbolism. By the mideighties, artists and art professionals had become polarized by the idea that money was the driving force, even the focal idea, of an art system. Schnabel himself had been harbinger of growing cynicism within the community of New York artists: a transitional figure, appearing on the scene in the seventies as the reincarnation of Abstract Expressionism's heroic male, in hipper, more me-generation guise. He was the first to utter unspeakable things like "If I didn't do what I'm doing I might as well die, or become a stockbroker" (in Hirschberg 1987:76). And for several years bridging the seventies and eighties, he became an object of envy and scorn, the inaugural figure of a decade when such boasts would become commonplace (and its fastest rising star, Jeff Koons, did move from a Wall Street brockerage house to Soho).

By the mideighties, well-heeled dealers from around the world moved to Soho, bringing a select stable of artists. Galleries multiplied slowly, then exponentially. By 1989, the look of money was everywhere: hundreds of galleries had opened up; on Saturdays, West Broadway teemed with collectors and critics making their rounds, occasionally exchanging inside trade confidences; shows were selling out before they opened, before the artist's name could be remembered. Artists with no exhibition experience would sell everything they made right out of the studio. Art's "scene" experienced a sort of supernova explosion, cash surging in and rushing out in all directions. There was simply not enough art made for the money chasing it.

It is of course impossible to escape the fact that so-called ineffable aesthetics are embedded in a retail market (this alone can make interdisciplinary discussion of art disjointed.) Postmodern theory in general recast the way critics thought and wrote about art, so that the art-and-merchandise relationship was both admissible and sensible. From the 1970s forward, art catalogs, journals, and texts have fore-

grounded the "spectacle" in critiques of contemporary culture—the view of late-twentieth-century life as a sensational and unremitting parade of retail values. Although this imagery often refers directly to art, it is part of a complex new world-view, from which it has been expropriated by art discourse to serve new ends. A mixed Marxist-poststructural-semiotic canon of postmodernism comes to art from France, in the work of Debord, Bourdieu, Deleuze, Lyotard, Foucault, Baudrillard, and a few others. Critic Robert Hughes, proudly non-Francophile, calls the jargon employed by postmodernists in general, and Baudrillard in particular, "an impenetrable prophylactic against understanding" (Hughes 1989:29). In fact, for all its opacity, this Continental strain of postmodernism is often (in art journals) reduced to a view of Western values as imperiled by vulgar American merchandising: a world of virtual experience and funhouse signs, extreme symbolic, social, and psychological alienation. It is a critique of late capitalism that is vaguely nostalgic for the premodern world of use-value economies and unmediated signification. (The seminal work in this regard is Walter Benjamin's 1968 essay, "The Work of Art in the Age of Mechanical Reproduction".[7]) While on one level this indictment of contemporary culture denies art production any special place in the melting pot, at another level it acts as a password to even more exclusive clusters of art afficionados: those who are informed of the trends are better equipped to exploit them—those who bemoan postmodernism are destined to the poverty of art versus money.

The writings of both Frederick Jameson and Jean Baudrillard have been influential in art-critical circles for plotting the rise and fall of direct (unmediated, modernist) values during the late capitalist era. Jameson reports that everything is cultural, the individual has been dislocated by today's media such that there is no escape from the "system," no exterior position from which to critique it. In his essay "The Cultural Logic of Late Capitalism" (1984), he more or less concludes that we in the First World now move through a depthless depoliticized ether that throws up nothing but our own image, and art is but an especially dense symbol of late capital's spiritual vacuum.

Jean Baudrillard, on the other hand, is never too sure whether the end of "modernity" is near, presently upon us, or somehow reversible. He is much more excitable than Jameson, particularly about the power of capital to reproduce reality in a shell game with consumers. Art, for Baudrillard, provides the quintessential sign of an inverted late capitalist epistemology—one in which reality is modeled after representation, rather than vice versa (see Baudrillard 1988). His vision of "Gordian knots," "Moebian compulsions," and interchangeable "obscenities" and "banalities"—as sensorially numbing as romance fiction—was embraced by critics and catalog writers throughout the eighties, who recognized in it the perfect companion text/program for American art. For Baudrillard, the conflation of bourgeois ideology and the cultural sphere is nothing less than the end of ideology—a convenient disclaimer for art critics themselves. "Baudrillard's desperate howl was translated into the terms of American therapeutic culture as an ideology that

offered absolute license in the guise of total honesty" (Varnedoe and Gopnik 1990:392). In a backhanded way such cynicism also valorizes the work of art professionals, by vesting great perspicacity in the merchandising of images. But it also divests all players of responsibility, as enslaved minions of a new dark age. The suasive power of such prose lies in its threat—a vision of art's end, more extreme than the observation of retrograde trends. This bleak forecast was instrumental in art's economic inflation during the eighties.

But there were critics who began to articulate a political critique of postmodernism. Hal Foster (1983, 1985) postulated two postmodern practices, one reactionary, the other progressive and subversive. Others expanded the critique with their own take on postmodernity (for example, Craig Owens, Benjamin H. D. Buchloh, and Douglas Crimp, found in Foster's 1987 edited volume and Wallis's 1984 anthology). The binary logic of these positions in general borrows from Huyssen's (1981) distinction between academic (or "modernist") poststructuralism (e.g., Barthes) and its political counterpart (found in Foucault, Kristeva, and Baudrillard): the one being deconstructive, the other "oppositional." The shared premise in both Huyssen's and these art critics' works is that theory divorced from its object is quickly institutionalized, whereas to remain focused and critical (of art or theory) is to resist current structures of power. Still, it was difficult for art critics to seize their object from middle distance: not privy to many artist-dealer confidences, they were nonetheless confined by editorial policies that tend to respond to a magazine's leading advertisers. "Progressive" postmodernism became "ossified," as one critic describes it (Meyer 1992:68), by intertextual debates and the practice of challenging overarching structures of late capitalism rather than the individuals presumably caught in their grip (see, e.g., Hutcheon 1989). As I explain below, the fine-grained art-critical studies of the eighties were mainly focused on extraordinary art-market events. Critics who insisted on addressing commercially untested work found their best outlets in general publishers (e.g., Crimp 1988; Lippard 1991). In sum, the progression of an antiaesthetic impulse from late modern revisionism to postmodern "simulations" was shaped by the consolidation of social alliances at the top of the market, isolating the critic in an intellectual zone and undermining the intellectual functions of the curator.

POSTMODERNISM'S RECASTING OF MODERN ROLES

The Artist

Throughout the eighties, once avant-grade notions of "oppositionality" and "difference" remained banners of patriotism for the Left in general and art in particular. However, the consolidating art market compressed those divisions of class, race, gender, and ethnicity that crosscut so many American social movements of this decade and left artists either inside or outside the market: as within or without the "system," whatever one's personal politics might be. Indeed, much of the polit-

ical art of the eighties could not get beyond the suggestion that, like the idea that all difference is the same, all suffering is equal.[8]

The dominant strain of Neo-Expressionism, itself the dominant artistic style of the eighties, was steeped in philosophical despair. This work has been called "Apocalyptic" or "Endist" for its affinities to chiliastic literary and social theories. It is heroic in scale with a brooding broad-shouldered view of history. The best-known exponents may be Anselm Keifer, Enzo Cucchi, Julian Schnabel, and Per Kirkby—all of whom paint richly-textured, dark canvases, with various degrees of spatial illusion. Cavernous illusions of space are commonly "refuted" by over-drawings suspended on their surface, a stock modern technique for voiding the "window on the world" and calling attention to the artist's hand. Keifer's canvases are especially renowned for their emotional charge. One series represents vague retreating fields of German memory—Nazi battlegrounds and death-camp sites now overgrown but still haunted by the symbols and clustered figures of war. Other paintings layer references to successive ruined civilizations, from the Mesopotamian to the Third Reich. As with all these artists, Keifer's titles are integral to the work: *In the Time of Saturn, Twilight of the West, Melancholia,* for example. (Cucchi's can be more turgid: *In 1984 a Millennarian Transport Begins to Move through Prehistory,* and *When the Days Must Be Laid to Earth.*) In exhibition contexts or catalogs, these works are always accompanied by various forms of "terminal" exegesis—essays by Sontag (*Under the Sign of Saturn* really kicked this movement off), Baudrillard, Derrida ("the end of history, the end of the struggles of the classes, the end of philosophy, the Death of God . . . the end of the subject, the end of man, the end of the West, the end of Oedipus, the end of the earth, of the subject, *Apocalypse Now*" 1982:59, and so forth), Kristeva (who also likes titles, for example *The Black Sun, Depression and Melancholy* [1989]), loaded with references to Kant, Hegel, Marx, and Nietzsche.[9]

Practitioners of what might be called "Thanatos" art are very clearly American, German, Italian (or not). What binds them—their gender (male), their age (most born in the forties), their postwar perspective—may be as compelling as what divides them, but it is elaborated in distinctive national styles.[10] Hal Foster observes that the Germans (namely Baselitz, Penck, Immendorf, and Keifer) are less ironic than the Americans and less insouciant than the Italians (viz., Chia) regarding history; German artists, he says, have taken the look of an earlier Expressionism and transformed it into the sign of "a natural, essential category—a style with a special purchase on the human condition and a natural (i.e., mythical) relation to German culture" (1985:44). All these artists have mastered a form of postmodern self-mythification to disengage their work from the political but not the discursive present tense.[11]

The Curator

Curation is the pivotal linchpin of an art system, the site where new ideas become corporeal, and where a nonutilitarian object (or act) is invested with historical sig-

nificance. Were it not for curators, critics would lose their primary source material, artists would have no one's favors to curry, and business would lose a friend on the ground floor. It was the curator of the Metropolitan's 1986 show, *Van Gogh in Saint-Remy and Auvers,* who jacked up the value of the *Irises* beyond that of *Sunflowers* by giving it a central position at the exhibition's entrance, and reproducing it in the show's poster. And it was the curators of a 1991 Museum of Modern Art show *(High & Low, Modern Art and Popular Culture)* who, by highlighting Robert Rauschenberg's 1955 piece, *Rebus,* helped bolster a faltering 1991 market and stay Swedish collector Hans Thulin's bankruptcy—when the latter chose to cash in on show publicity and auction his property in the middle of the show (Tully 1991:1).

Curation varies horizontally across the art world, as decisions about what to represent are made close to the working bases of different institutions, from publishing houses to museums. It also coheres along a vertical axis as a hierarchy of display decisions along the course of an art work's rise from obscurity to international acclaim. The titled profession of curator represents only a fragment of art-world curatorial responsibilities (mainly museum display), when in fact there is a pyramid of exhibition venues rising from a noncommercial base through the secondary market and the blue-chip level which are all governed by "curators" of one sort or another. In the secondary market dealers and gallery owners "curate" their stable of artists and invite freelance curators to compose theme shows. Dealers have small businesses at stake in their selection, freelance curators are building personal reputations (in galleries, government-funded art spaces, and small museums). At this level, art is culled from an open field of what is "out there"—primarily what is available for inspection in New York, and middle-class collectors can enter the market by befriending curators and less-established dealers who act as informal advisors on their collections.

Above this level there are more exclusive galleries which draw from secondary dealers and act as gatekeepers to a variety of intermediate players: corporate curators who rarely invest in unknown (unmarketed) artists, institutional curators who assemble theme shows and acquire for their permanent collections, and an elite number of freelance curators associated with international biennials and "blockbuster" shows. The apex of this system is art's highest social echelon, no less than a subsection of America and Europe's most privileged classes. In this strata the distinctive roles of patron and client are often dissolved by wealth and a sense of coeval social power between artists, collectors, and dealers. Lawrence Alloway recognized this emergent "peerage" in 1975 and suggested that, at that time, artists, collectors, and dealers were making puppets out of museum curators. Museum curators are close to but not the same thing as museum directors. "They constitute a stratum *under* the director/trustee level. . . . Close to the top, but not at it, they take their lead where they can find it, in the artist-dealer-collector alliance" (Alloway 1975:34). Moreover, their work with contemporary art—their professional prestige and continued access to important pieces—depends upon the cooperation of artists and dealers:

This is easy to get while artists are in the initial stages of their careers but it gets harder as they become more prominent. What happens is that artists, dealers, and collectors have a shared taste and a common interest. The center of their attention is the work of art: it is a product of the artist, the commodity of the dealer, and the possession of the collector. The three types represent an alliance for the purpose of furthering the work both as a cultural sign and as an object on the market. (Alloway 1975:32)[12]

Throughout the transformations of the sixties to the eighties, there have remained two levels of mystification surrounding curation. The first and most general is an illusion cast by modernist discourse of curation's noncommercial and apolitical identity—or at least an illusion that curation intersects with realpolitik only in the presence of "masterpieces." This is the case despite common awareness of postwar American art's constitutive role in the art market: when, during the Cold War, art's value as an emblem of free enterprise led directly to the development of a contemporary auction market (M. Berger 1989; Mattick 1991). Related to this myth is the veil curators themselves draw across their decision-making practices in order to cast the illusion of art's "immaculate conception." Modernist theory and its essentializing logic rest on curatorial self-effacement, wherein those people who actually determine which objects get seen also assert the historical inevitability of their production. They imply a kind of isomorphic relationship between what we see and what is produced in a given era. The mere reproduction of Alfred Barr's early modern conventions of white walls and text-free viewing environments amounts to such an assertion and, during the eighties, contributed to the symbolic collapse of commercial and aesthetic values as natural, inevitable, and correct. That is to say that, encased in familiar modernist curation, postmodernism barely had a chance. At best, new imagery was vested with irony, in a frustrating recension that came to define a 1980s postmodern aesthetic.

It was hard for curators, even low-profile ones, to balance the competing demands of their careers, their colleagues, the exhibition venues, and new art theory. The kind of catalog research and interpretation that had made the reputations of modern art curators was no longer a requisite to postmodern curation—indeed, it became problematic. Alfred Barr of the MoMA had set the standard in the forties for this particular brand of scholarship, in summarizing catalogs that were rich with biographical, stylistic, and comparative information on an artist. MoMA curators William Seitz and William Rubin (later director) maintained this tradition, and the 1990 show curated by director Kirk Varnedoe and critic Adam Gopnik, *High & Low: Modern Art and Popular Culture,* was accompanied by an anthology of essays and an exhaustively researched and illustrated catalog which, in effect, asserted the museum's continuing commitment to the curator-as-scholar (see Varnedoe and Gopnik 1990). However, this show—as a case in point—aggressively repudiated the idea of a postmodern paradigm. Texts and exhibition together situated very contemporary art in the context of one art historical thesis regarding the use of popular cultural imagery as a vehicle for high cultural expres-

sion. The "postmodern" notions that high and low cultural barriers are now meaningless, and that the visual arts are but a form of luxury commodity (incorporating its own ad copy), were thoroughly and authoritatively denounced—in a manner more catholic than but still reminiscent of Greenberg's famous polemic, "Avant-Garde and Kitsch" ([1939] 1961). Systematically, even exasperatingly, the show proved to viewers that not only can a narrative of modern art still cohere but (following Habermas) that modernism is far from over. Whether we track its consistencies through overlord-underbelly dialectics, or modern-primitive ones, the stratification of cultural form continues.

Elsewhere, the practice of *not* dismantling modernism was more discreet. Ever-rising insurance costs for borrowing and exhibiting eliminated important comparisons and discouraged curators from formulating "lineages" of influence in their catalogs. But shallow historical perspectives do not necessarily lend substance to the idea that modernism is over. Despite appearances, postmodernism more often reproduced than routed the modern paradigm. A commercially successful "postmodern" show might cohere in all its parts, from catalog text to the art itself, be presold to a collector, and generate reviews that lambast the market but not the art, its makers, or handlers. Artist, critic, and museum curator act as unwitting servants to the dealer's cultivation of a client: insuring the viability of a "hot" investment without claiming responsibility for its "commodity" appeal. The work itself accrues value as part of a postmodern juggernaut, no less inevitable, autonomous, or erudite than a modern masterpiece. Thus, almost anything done with Jeff Koons's bronze elfs, Haim Steinbach's lava lamps, or Louise Lawler's photo-forged old masters, for example, became unassailable in the eighties. With or without catalog citations to parareality theorists, such shows were addressed to a public of potential consumers by what one might call art's brokers of junk bonds.

Thus, in a few short years, the parody of modernism became its protraction, just as the simulation of consumerism became its franchise. Dealers also curated revival movements that peeled styles apart from their historical contexts to lend "masterpiece" cache to the present. Neo-Geo painter Peter Schuyff frequently cited Tanguy, Matta, Albers, and others as his modernist influences (representing a spectrum of form and content), yet his "look," a Hanna-Barbera brand surrealism, was pitched to a young flush buying public of the early eighties (members of what some have called postmodernism's "Professional Managerial Class" [Ehrenreich and Ehrenreich 1979; Pfeil 1990]) by the savvy gallery owner and curator, Pat Hearn. It was Hearn who "brokered"—that is, not only supplied, but created the demand for—an art that speaks to the baby boom's affair with its past while satisfying the terms of a quality market. Schuyff was subsequently picked up by more powerful dealers in the United States and Europe (including Leo Castelli, Larry Gagosian, and Paul Maenz) and collected by and curated in museums as the central player of a Neo-Geo movement. Hearn has since closed shop. Whatever puerilisms critics initially attached to his work have since faded to a patina of

historical importance—as this work likely hangs beside Tanguy and Albers in old money collections.

As the ideas of "opposition" and "difference" became mixed up with dated notions of avant-gardism and social condescension, they lost their political charge and, ironically, came to infer cynical resistance to art's *noncommercial* status. Yet, as inevitable as this market-driven aesthetic appeared, Gramsci (1971:177–178) reminds us that such organic movements are always engineered—that there lies a level of reality which is willed, contingent, and decidedly unnatural, where individuals are detached from the smooth operations provided by any such totalizing logic. Artists grappled to remain identified with their objects and still be transported by flows of capital, while curators were attracted to postmodern theory but pulled back by the undertow of unreflexive display conventions to a familiar posture of self-effacement. Their alienation from art's power axis enabled a conflation of mercantile and modernist distribution practices, such that the logic of art circulation was caught up in its own orbit—and out of sync with a relatively unchanged (modernist) production logic. The effect was that postmodern art looked similar to— but was (for the most part) purveyed as different from—the art of the past.

CRITICS AND THE AUCTION MARKET

The elite alliance between artists, collectors, and dealers that Alloway noted in 1975 was not only a product of the consolidation of a contemporary market, but also a sign of the rising importance of auctions in this system. Before the seventies, auctions had been the province of antiquarians and historical (mainly European) collectors. In their expansion to incorporate living artists, they moved from being a recuperative apparatus vis-à-vis the closed circuit of dealers and collectors to a position similar to that of private dealers. Auctions stabilized the latter's speculative determinations of art's long-term worth by fixing public price tags. These sometimes undercut, sometimes vindicated, the back-room confidences of dealers and their clients. Initially, contemporary auctions posed no great threat to such intimacies: in the sixties, a handful of American collectors collaborated with a system of dealer pricing that was grossly inflated and subject to elaborately negotiated discounting (Alloway 1972:31). But the remarkable aspect of an eighties art world was the dissembling of such private conventions in the face of large sums of money. As prices escalated, experienced collectors were more inclined to eliminate dealers' fees and shop at auction. In a sense, auction houses usurped dealers' power to "curate" long-term and international clusters of art (as discussed in the next sections). What had been extremely relaxed relations between elite dealers grew frictional and competitive in the scramble to retain patrons; and most remarkably, their judgments were either mediated or subverted by the apparent objectivity of auctioneers as art works went to the gavel more frequently.

In general, critics of the eighties did not closely identify with the artists they

boosted, as had been the case from the forties through the seventies. By the 1980s art writing had also fanned out into a spectrum of discourses, from philosophical speculation to more pedestrian industry reportage (Carrier 1987: 108–114). Art criticism included everything from business reports to florid hosannas of a new age. The idea that artists were capitulating to market forces, and that aesthetic and economic values had collapsed under the weight of new money entering the system was very soon the professional party line, although its archness sometimes merely concealed base snobbery. Of special interest to many critics was the high drama of auctioneering: the single-mindedness of dealers and collectors, and the collegial manner with which careers were made and destroyed on the auction block. Both theorists and commentators were riveted by a succession of very celebrated sales in the middle of the decade which had an overall vortex effect on the market, and eventually turned the head of the general media as well.

Critics also (more or less politely) picked apart each other's critiques of the auction block. Craig Owens masterfully unraveled the 1987 *New York Times* coverage by Robert Hughes of a van Gogh *Sunflowers* sale (Owens 1987). His point was simply to reveal where Hughes had misread the social and cultural significance of this sale, blinded as he was by outdated notions of art's audience. Hughes, Owens said, had chosen to bemoan the purchase of this piece by a Japanese insurance firm (at "38.9 million dollars, roughly the budget of a *Star Wars*, or, perhaps more appropriately, *The Empire Strikes Back*") as yet another marriage of art and money—overlooking subtler relations between art and the flow of global capital including, most importantly, what this sale said about Japanese penetration of U.S. and European markets. Hughes, who was traveling in the United States when he filed his review, on an "Art and Money" lecture circuit ($3,500 a shot, according to Owens),

> denounced the *Sunflowers* as a monument to "the new vulgarity" of "a new entrepreneurial class that has fixated on 'masterpieces.' " *Masterpieces* appears in quotation marks because, in Hughes' opinion, the painting's aesthetic value—what we might call its Hughes value—has been compromised by popular appeal. (1987:16)

Owens mercilessly recast Hughes's words so that they quivered with fear for a Western patrimony and oozed with distaste for the nouveau riche. Hughes would trump the Japanese at their own game, noting that the *Sunflowers* had yellowed or "gone off" over time. Of course, as Owens pointed out, "Hughes doesn't appear to appreciate the irony that the world's most expensive work of art should be a gold painting" (1987:16). Hughes was punished for not getting his facts straight: calling this a matter of private interests pitted against the public hardly constituted a close analysis (indeed, in an age when most major shows have corporate sponsors, readers may have wondered whether Hughes was receiving all his press materials). Moreover, Owens said, Hughes appeared to *fetishize* this Impressionist painting (he "attributes living or animate properties to it" [1987: 16]). But in fact, Hughes had attributed Western cultural values to it, precisely the investment he assumed the Japanese to be making.

Certainly the fact that museums in 1987 were unable to compete for master-pieces with the yen or a Fortune 500 dollar was less than newsworthy at the time (Grampp 1989; Brenson 1990; Grimes 1990; Heller 1990a, 1990b; Danziger 1990; Martorella 1990). Owens, by contrast, assured his readers that a Western patri-mony was not at stake. The *Sunflowers* buyer, Yasuda Fire and Marine Insurance, he said, had widely publicized its intentions to hang this painting where an earlier *Sunflowers* had been, before it was destroyed of all things by fire (in fact, the first painting went up in flames during the bombing of Yokohama[13]). The company simply wanted to express its "gratitude to the Japanese people" (1987: 16). Thus, we learned our trade competitors were not arrivistes after all and had enlisted this international market in service to an indigenous form of gift-giving. These ironies brought home the "unreality of the stakes and the omnipotence of manipulation" (Baudrillard 1984:268). But still more ironically, this sale released van Gogh's painting from a relatively obscure New England museum to have it splattered across the press and finally showcased before an appreciative audience. Owens was no doubt justified in dissembling Hughes's jingo-snob aesthetics, and yet the mercilessness of his critique was really a form of professional hazing in a diffuse and confusing field of postmodern theorizing.

Nineteen eighty-seven was a watershed year for art criticism. That year *Sun-flowers* went to auction along with three other van Goghs, in what has been called the "Quadruple Crown" of art auctioneering (Zemel 1988). They tipped the scales of cultural worth when it comes to art, and sent critics and reviewers into a tailspin over issues of national identity and the ascendancy of private interests. The firms of Sotheby's and Christie's appeared to siphon off the cultural authority of major corporations, powerful individual collectors, and reputable art dealers, concen-trating all of this in the rapid moves of a gavel. This site of what has traditionally been perceived to be financial "objectivity" virtually exploded in a frenzy of inter-national currencies—every auction another episode of "masterpiece theater." The earth moved beneath the market's short- and long-term growth principles.[14] In the late eighties, wish lists, rumors, and panicky questions of "what's the best?" all circulated around a compressed demand for a limited number of masterpieces (as explained in the next section), creating an especially jumpy market. Owens's essay was only one of many attempts to make sense of these extraordinary events (cf. Davies 1988; Ratcliff 1988).

The four extremely "dense" van Goghs auctioned that year were released from either private collections or small museums, and all but *Sunflowers* slipped into the greater seclusion of individual collections (where insurance costs have made it very difficult to display art publicly). Of the four, *Sunflowers* and *Irises* fetched the highest sums. The more industrial-looking (we might say "modern") *Bridge at Trinquetaille*, and the more pensive, personal *Portrait of Adeline Ravoux* came in at millions less, and to modest publicity. Significantly, the most popularly beloved and reproduced piece went to the Japanese, while the other three were ushered behind the screen of anonymity that auction houses reserve for their best clients. That left the Japan-

ese alone as fall guys to art-critical anxieties over Western patrimony and cultural worth (which is more or less where they remain today; see, e.g., Danziger 1990; Heller 1990a:49).

But in the battle of culture over commerce, the Japanese proved difficult to pin down—not for the reasons Owens detailed, but because they didn't spend the most money at auction. The *Irises* eventually went for $53.9 million, making it easier to "dematerialize" on its way from a national treasure in a small public institution to a sign of unspecified proportions in a private vault somewhere. The *Washington Post* called this "marketing pictures right into obscurity" (1987:A24), and a French critic sneered that, "Only a newcomer, without an art collector's experience, could pay such a price" (Geraldine Norman, quoted in Zemel 1988:92). When in 1989, Australian beer magnate Alan Bond began to liquidate under bankruptcy, it was confirmed that he had been the buyer of *Irises*.

Thus, the immediate reactions to the scramble for van Goghs ranged from frank chauvinism (following the line that the Japanese took the "simple" piece, while a German no doubt bought *Bridge*, the thinking man's van Gogh, etc.) to fears of Western culture's "privatization." In the drama of national interests and filthy lucre, the fact that the general press echoed the first impulsive cries from critics and art scholars says something about the fundamental public importance of art: that, for all its social intimidation, it remains an "inalienable possession" of mixed metaphysical and practical worth to both national and supranational communities (cf. Weiner 1992). Almost as soon as these sentiments had surfaced, they were checked by interesting revelations concerning the "art of the deal." It seems that Sotheby's had virtually given away *Irises* in a deal so favorable to the buyer (extending their own credit to Bond), that the $53.9 million only represented how eager they were to make this sale, and not Australia's urgent need for a masterpiece. Sotheby's had constructed the illusion of a sale to bolster a wavering market right after the October 1987 market crash (see Heller 1990a). Suddenly it was no longer a question of new money or old, rightful and illegitimate ownership (although Australian expatriate Robert Hughes may have been stumped by the events). It was a matter of high-profile "singeing" and auction-house ethics. Too much easing of credit in an overheated market had not only caused further overheating—it had prompted auctioneers to let go the stops. Whereas generally auctions bring out extremes at both ends (in bargains and treasures), by the close of 1987 it was all too clear that they had created grotesque distortion at the high end. Art publications wisely refrained from caricatures of Bond, allowing magazines like *Vanity Fair* to thrash the philistine millionaire (by itemizing his more dubious art credentials, such as slicing a Renaissance painting in two to frame a doorway [Seabrook 1990]).

THE RISE OF MUSEUM DIRECTORS

The art press needed to get a handle on what now appeared to be auction-house omnipotence, and to distinguish itself from what now seemed old guard national-

ist instincts. Early on, the *Washington Post* had editorialized about the *Sunflowers'* "comparable cultural worth," equating it to the cost of two F-16 fighter planes, a mile of interstate highway, and roughly the price of the Seattle Mariners (1987:A24).[15] The art world's response to this was defensive; as artist Ellsworth Kelly put it, "The van Gogh really earned it. They make those fighter planes at the drop of a hat" (McGill 1987a:C36). But production value could hardly explain these and later auction events. It was critic Milton Esterow who, early on, seized the right approach to the van Gogh sales, one flexible enough to endure future developments. He reprinted the transcript of bidding over *Sunflowers* and *Irises* (Esterow 1988) so as to highlight all those mysterious quips and 'phone bids, the decolletage and Americans with British accents that made up this furious four-minute drama. The title of his piece, "Now Joan, Don't Be Stingy," actually refers to dealer Carmen Messemore's coaxing of a reluctant Joan Whitney Payson into her purchase of *Irises* in 1947 (for the unprecedented sum of $84,000). The point here was that auctions have always been alarming, and Impressionists expensive. Esterow went even further, by urging readers to consider the unreality of the stakes here as integral to the work itself, not simply an acquired meaning. He suggested that its "currency value" was inscribed in the work by the artist—that relentless self-promoter van Gogh.[16]

Unbelievably, the eighties market had yet to peak. On May 15, 1990, the night it finally went through the roof, critic Godfrey Barker tells us:

> the art market had about it the feeling of immortality. To gasps from the thousand amazed bidders jammed into Christie's New York, Vincent van Gogh's portrait of his doctor, Paul Ferdinand Gachet, was sold for the sum of $82.5 million—topping by more than 50 percent the world record for a work of art. Three-quarters of the audience climbed to its feet applauding. "Back to reality," proclaimed auctioneer Christopher Burge some minutes later, but few were disposed to follow him. . . . Two nights later at Sotheby's, the woman by the rostrum who bid $78.1 million for Renoir's *Au Moulin de la Galette*, acting for the same buyer, Japanese dealer Ryoei Saito, burst into tears as the painting was knocked down to her. It was a wholly sane response to a night of madness. As the glitterati went home and Sotheby's opened ten cases of champagne, excited analysis was on the tongues of those present: they had attended, in just 48 hours, the two most expensive auctions ever staged . . . : seen the world record for a painting twice broken; and learned that at least three people were prepared to pay $77 million for a masterpiece of art. . . . Was there now any limit to what art was worth? (1992:75–76)

The answer to this question was fully apparent just a few months later. The May auctions had hit the limit, the stratospheric end point to a decade's inflation. Auction prices for Impressionist, modern, and contemporary art plummeted by 92 percent during 1990, settling back at 1986–88 levels when all the air was released from this bubble. There had been warning signs even in May. After the *Dr. Gachet* sale, Christie's managing director estimated that, minus this work, the rest of the evening's sales had not matched levels of six months earlier (Barker 1992:76).

Within a month, bank-credit squeezes, oil at $40 a barrel, war looming in the Gulf, failing corporate profits, and numerous other factors dogging high finance in general, finally put a brake on the vendors' frenzy.

Stunned, art journals reported a falling market rather matter-of-factly for a few months. Perhaps the most important revelations of an eighties market, after the coldhearted fact that auction "truths" are more apparent than real, concerned the most powerful players. Few, it appeared, were actually aficionados of art; fewer still had any historical perspective on collecting. They were primarily financiers, of many (and compound) nationalities. These tycoons and industrialists were not statesmen of an old regime but governors of the "global ecumene" (Hannerz 1989). Yet, in an O'Henry twist, it seemed they had also been manipulated by the most serious of collectors, the auction houses themselves (which, when the dust settled, were left with vast holdings of art consigned by bankrupt clients). Thus, in a game of winners and losers, the traditional connoisseurs apparently came out on top— but not without "burning" off short-term value from their most prized commodities: Impressionist, early and late modern, and (a handful of) contemporary masterpieces.

By 1991 art journals rebounded with a body count. Big American and Japanese buyers were gone from the primary market; they had taken a beating. Now they could also take the blame: as one critic noted (Barker 1992:77), "There was a general agreement that with the absence of Japanese and other speculators who had previously bought third- and fourth-rate pictures, the market was now a 'serious market'." In a sense, the circle had closed: criticism had come around to its original position regarding the "inalienability" of Western masterpieces (if not exactly to a position of national inalienability) and converged again with the comforting lay ideas regarding social and cultural entitlement to art. The 1991 *ARTnews200*, the annual review of collectors, listed new European names for every absentee American and Japanese one.[17] Critics seized the available optimism to produce a number of cover stories on new European, Pacific Rim, Latin American and (even) Californian markets.[18]

In the course of roughly five years the art "system" had been turned inside out and left deflated by economic forces beyond its control. Masterpieces had washed up on the shores of global capital flows. In the process, a number of critics had entertained ideas concerning money's constitutive role in art signification, at present and in the past, in an attempt to normalize the extraordinary and synchronize artistic intent with its net results. Whether auction events tended to confirm the millenarian strain of postmodern theory, or vindicate old-guard idealists who had always been suspicious of money, the status of art's autonomy from other cultural spheres was no longer in doubt. Just as trends can be manipulated on the ground floor, an overarching aesthetic is shaped by large-scale investors. In fact, inflation had a crystallizing effect upon the current aesthetic that, in some ways, countered the influence of postmodern theory. As the components of the art world moved like iron filings toward big money, art's highly arbitrary bases were exposed,

prompting renewed calls for "faith" and standards of excellence: precisely the terms of Greenberg's High Modernism. Hence, auction events actually recalibrated the modern era along the lines of a High Modern aesthetic, and projected this ideal into a contemporary market. Thus, the interest in van Gogh, which was stimulated by various national and serendipitous factors, tended to align masterpieces historically and by cost according to a progression of styles from Impressionism to Abstract Expressionism. Impressionism registered sensationally at auction, but (as will be shown) a succession of post-Impressionist styles also increased in value during this period. In this way, the market was able to punctuate modernism in a manner which theory could not, by bounding off a corpus of work as masterpieces.

What happens when a generative paradigm (modernism) ceases to generate new ideas? Just when Abstract Expressionism was perceived as exhausted, it still maintained absolute hegemony over the practices of young artists. In the eighties, postmodernism nowhere offered an explicit program for paintings; it was a deconstructive rather than constructive paradigm. The auction block confirmed modernism's aesthetic death at the same time that it inflated its economic importance, thereby signaling to living artists that certain styles, certain image citations, were more marketable than others.

In the wake of a bull market, museums had the unfortunate responsibility of reconstituting modernism according to their limited acquisitions budgets. During the full swing of the boom, they scrambled to deaccession newly-valuable properties: responding to collectors' stimulated appetites by opening their vaults, sometimes auctioning what interested observers would call pivotal elements of an art-historical narrative. Whole "lots" of Impressionist, early Expressionist, Futurist, Fauvist, Dadaist and Cubist (you name it) works were released from institutions whose original acquisition mandates may have been built on them. If ever there were a commercial analogue to the notion of postmodernity's "depthlessness" it was this rapid reshuffling of collections, so that historical depth might give way to "breadth" and/or "clarity." Beyond the surface of this lay important financial considerations, such as the fact that collectors were no longer able to donate works to museums at full market value. Institutions were left with an urgent need to liquidate—so as to continue acquiring. They were fighting for their own longevity, which in fact lent each of their purchases contradictory significance: each work must be considered in terms of its potential resale value and its symbolic "inalienability." Whereas cashiered works were once commonly referred to as "not of museum quality," new terms like "inappropriate" and "redundant" to the collection gained currency out of respect for the works' resale values. Such subtle language blunted drastic streamlining and contributed to the overall institutional image of art in the eighties, as a streamlined evolution of signs. As auctions effectively postdated High Modernism to run through the present, museums discreetly predated postmodernity as a subtext to the modern era. They did not forsake their function as warehouses of tradition, but were compelled to subordinate the terms of tradition to the exigencies of the present.

All this indicated a concentration of responsibility and power in the hands of an institution's board or, in many cases, its director. In the words of one critic, "Museums have increasingly become memorials to present-day judgments. Deaccessioning appeals to an ahistorical, self-mythologizing strain in culture that is as American as the Fortune 500 and the Jolly Green Giant" (Weiss 1990:125). The major narrative was now subject to fits and starts, with movements rebracketed after major purchases, and—as with baseball's corporate transformation—once-key players sent to the outfield or traded with no clear explanation for the public. Modernism in particular was rocked: its contested genealogies (reflecting each museum's primary benefactors' collecting preferences) expanded and contracted according to the auctions' magnetic force. Thus, if a museum were lucky enough to own a Manet (a van Gogh predecessor), it might cash in on its rising value to acquire several late modern works; or, it might highlight this asset and divest itself of unrelated nineteenth-century works. The most active works in trade and curation were of recent late modern movements: from Minimalism and Pop Art through Conceptualism. These were relatively affordable and aesthetically speculative works that allowed curators a certain degree of flexibility in periodizing modernism. Big modern art museums were direct beneficiaries of such reconfiguration, with the most to sell and more parts to reassemble. But generalized institutions (and collectors) bought and sold wisely, often focusing on liminal modern movements (like Constructivism or Op art) in anticipation of future worth. In this way, museums were absorbed by the logic of private enterprise and entered a dialectical relationship with private entities (dealerships, publishing houses, artists, and collectors) in the construction of an overall postmodern aesthetic.

Thus the pitilessness, ruthlessness, and abstraction of the market were both fueled and harnessed by savvy museum directors. A single good sale might bring solvency, publicity, and a whole new curatorial direction for museums, facilitating future deals and ambitious exhibition calendars. Such a deal would be largely planned and executed by the director, whose accountability to an institutional board was, for a time, unscripted. Philipe de Montebello of the Metropolitan put it nicely just after the *Sunflowers* sale, which garnered $3 million in commissions alone for that museum (more than its entire purchasing budget that year) when he said, "I feel like a fossil awakening from another era" (McGill 1987b:C23). It is difficult not to see the resonances, if not similarities, with the transformations taking place in the larger economic sphere, when bond brokers and stock traders were becoming cultural heroes in their own right.

In 1989 the Art Institute of Chicago auctioned six paintings, including a Bonnard and a Monet some saw as critical to the museum's reputation. In turn, the Institute acquired a $12 million Brancusi sculpture. At the same auction, the Guggenheim cashed in a Chagall, a Modigliani, and a Kandinsky, to build funds for acquiring Count Guiseppe Panza di Buimo's large collection (more than two hundred works) of Minimal and Conceptual art. Before this auction, Guggenheim director Thomas Krens had been careful not to characterize the works he would

sell as "lesser" or unimportant; afterwards, however, he was jubilant about what
his collection would gain:

> I think that the artists we've acquired in the Panza collection will be among the most
> important artists of the 20th century. . . . I believe that half of what we've acquired
> [Serras, Judds, Rymans, Morris's, Mardens and others] are masterpieces. . . . I
> believe these are classical works of the 20th century, and they deal with the funda-
> mental issue of the 20th century, which is the notion of abstraction. (Weiss 1990:130)

The museum's former director, Thomas Messer, also defended the swap, saying
that for a museum to stay alive today, "It must not only feed itself, it must excrete,
if you don't mind the metaphor" (Weiss 1990:131).

When the Metropolitan Museum tried one of these swaps in 1972, exchanging
two Gris, a Picasso, a Bonnard, a Modigliani, and a Renoir for one David Smith
sculpture and a Diebenkorn painting, there was a mild outcry. First, because it
had not been done before; and second, because director Thomas Hoving tried to
make the switch in private. Nothing in any institutional bylaws or legislation pre-
vented him from doing so, but the New York State Attorney General's Office got
on the case immediately, pressing for "sunshine" laws for cultural institutions. The
Museum of Modern Art, for one, protested, announcing the following: "We
respectfully submit that the Attorney General's Office cannot and should not
attempt, by itself or through proxy, to assume the functions of the professionals
and specialists in the field of modern art" (Weiss 1990:127).

MoMA board member Richard Zeisler believes the public and media calls for
public accounting of these deals are fundamentally misplaced, saying there are
matters MoMA's administration will not even discuss with him. "After all," he
says, "we are not a public institution" (Weiss 1990:128). Whatever sunshine ele-
ments apply to museum disposition procedures would be overwhelmed by auc-
tion-house etiquette, which bluntly masks certain dealings (such as reserve-fixing)
and ingeniously circumvents provisions for "openness" (such as coding a work's
selling history and disclosing other details in illegibly fine print in the catalog) (see
Heller 1990a). The object is to preserve an illusion of "virginity"—its unsinged his-
tory—before and during a work's sale, in deference to seller, prospective buyer,
and the work itself. (It would be ludicrous, however, for a collector to make such a
purchase without knowledge of a work's complete sales resume—hence the mis-
nomer of any auction being "public.")

Still, the Guggenheim sale did raise a few eyebrows. There were two main
objections to it: first, that it involved crucial works from the existing collection
(those assayed as most valuable); and second, that it amounted to a period-for-
period swap which set the entire collection off-kilter. Kirk Varnedoe of the MoMA
called it a dangerous precedent, and one of his board members declared that, "If
every museum followed this policy, the *Demoiselles d'Avignon* would be on sale
tomorrow" (Weiss 1990:130). This apparently was not the case when, during the
same year, Varnedoe pulled from the MoMA vaults two Picassos, a Mondrian, a

Monet, a Renoir, and a de Chirico, to ready them for trade with a van Gogh portrait, in a deal so complicated, "and announced in [such] an opaque manner that was so condescending to the public that the museum was forced to backtrack" (Weiss 1990:127). But Varnedoe did make the deal. In an interview with Philip Weiss afterward, he narrated a tale of secret flights to Switzerland, dealers playing one side off the other, windows of opportunity, weeks of suspense, and (best of all) an 8×10 color transparency of the piece passed from one trustee to another. As Weiss wrote: "Varnedoe seems more like the author of a novel of international intrigue than a serious historian whose most recent book, *A Fine Disregard*, just happened to be displayed at the edge of his desk as we talked" (1990:128).

Varnedoe would not be atypical of museum directors today, many of whom see the art of the deal as their long-sought opportunity to put a signature on art history. Others are strictly businessmen, and have moved laterally into directorship (Krens, of the Guggenheim, has an MBA and background in business; see Zorpette 1991). Either type is likely to alienate a minority of board members or trustees by violating convention or the institution's vision of the past. New York University professor and MoMA board member Robert Rosenblum cast a dissenting opinion on the van Gogh purchase, because he questioned its place in the "story of modern art that the museum wanted to tell" (Weiss 1990:128).

When the van Gogh was unveiled, a press release circulated with a statement by MoMA chairman David Rockefeller extolling its contribution to "our local and national patrimony"—without naming the particular works now lost to the same. (One of the reasons why this portrait had been considered a steal, at $45–50 million, was because a Japanese industrialist had just bought another van Gogh portrait for $82.5 million.) Varnedoe noted in the press release the "severity of the iconic frontal pose" in this work (Weiss 1990:128). He nonetheless expressed some concern over how the publicity might effect viewers' perception of this work, worrying "that they look at the picture and all they see is money."

These museum directors, with a growing sense of their own art-historical importance, are as firmly committed to the inviolability of aesthetic standards as they are to a public that deserves the best. The irony of their assertions is manifest not only in the deals they make, and the effects upon public collection, but also in the influence they wield over international sales. Museums are the OPEC of art, their leaders capable of fixing prices on a global scale even while they aver the fiercest of tribal loyalties—they have a stake, they say, in tradition. But, in a flat-footed translation of postmodern theory, collector Ben Heller reports that prominent dealers acknowledge the fact that "auctions are a form of shell game whose so-called truths are *more apparent than real*" (Heller 1990a:51). Museum reshuffling may not have signified, as Varnedoe implies, the pursuit of sublime truths, or even a conscious liberation from art history; but it did represent a wave of opportunism producing irrevocable changes in the historical record and questionable postures toward the past. "Invariably, the art works that are dumped by one generation are scrambled after by the next," writes Philip Weiss (1990:125). Robert Rosen-

blum says, "Museums now have the mind-set of private collections. They're wildly competitive; they don't think like public institutions anymore" (Weiss 1990:128).[19]

At a time when contemporary curators were turning from historical analysis to apocalyptic theory, their institutional superiors were busy revamping the permanent collection to support a view of art as ontologically shallow—one might even say cryptic. Indeed, the seventies' curatorial "dim-out" had become an eighties black out in the deaccessioning wave: the job of reinterpreting a historical record through inventive selections of work was now in the hands of MBA-qualified museum directors and board trustees with (sometimes) contradictory convictions about a museum's mission. Moreover, if the curator's temporary installations are relatively accessible to a public's questions of dealer-collector influence, the permanent collection is hardly penetrable by deconstruction. A public never sees the entire permanent collection at once. To assess one show of early Moderns for its holes, or one of Minimalists for its emphases, requires more than casual knowledge of acquisition events.

The general compression of history toward the present provided an excellent institutional backdrop to the new masters of contemporary art: Neo-Expressionism's citations of Abstract Expressionism, and Simulationism's resemblances to Conceptualism and Dadaism, were thereby grounded in strong institutional representation of these historical movements. In fact, these past and present look-alikes became eminently collectible at the same time, by the same rush on late modern art. Only keen market observers might decipher the fiduciary rationale behind temporary installations. For example, the MoMA's *High & Low* show prominently featured the works of American constructivist Stuart Davis, Pop artist Claus Oldenburg, and contemporary sculptor Jeff Koons, their relationships to current popular cultural trends being well established in the catalog text. (Indeed, this was a throwback to modernist curation for its strong catalog scholarship.) But some viewers may have suspected more behind the showcasing of the relatively obscure Davis—perhaps a presale promotion of the museum's Davis holdings, or a postacquisition justification of Constructivism. The other two artists were easier to read. Koons, a former commodities broker whose pre-Boesky move to art sustained his image as cultural hero, was positioned to be viewed as a Pop Art impersonator. His stainless steel rendition of a Woolworth's blowup bunny was the right choice for a centerpiece to the show's contemporary art section because it (and only it) could lend seminal importance to the soft sculptures of the MoMA's favorite Pop artist, Clause Oldenburg, who happens to be the general director's brother.

CONCLUSION: THE END OF THE END OF ART

Blue-chip contemporary artists are commonly promoted as state treasures. Neo-Expressionist painters have even incorporated nationalist imagery in their work. Some of this politicking is to be expected in a contemporary market that was grafted on to a trade in historical masterpieces, and some of it is unique to postwar

exhibition structures. Since the sixties several countries have hosted annual or biennial surveys of international art in which artists have been invited to represent their nation. What is interesting is the effect that the artists' changing socioeconomic status has had on the demographics behind producing national treasures: just after World War I, Europeans flocked to New York to work under the banner of American art, eventually congealing in the politically influential movement of Abstract Expressionism. Gradually, the pattern has been reversing itself: wealthy American artists are increasingly exhibiting, installing, and fabricating their work in Europe, often residing where it is convenient. Although New York has remained art's production and distribution metropole, financial success has liberated many artists from the costs and conventions of American craftsmen during production. But among the international fraternity of "quality" artists there has always been a remarkable homogeneity of race and gender, a sense of collective Euro-American patrimony that swells up from the annals of art history. The late capitalist expansion of markets has simply exported what are now cramped ideas about the avant-garde individual. This should surprise no one versed in the laws of monopoly capital, but it serves as a reminder that a market-driven aesthetic has no mechanisms to accommodate multiculturalism—any more than it has a materialist self-critique or a means of surpassing the econo-speak of business cycles and "invisible hands."

Many alternative spaces and museums put up multicultural shows during the eighties that purported to explore the breadth and depth of Western hegemony by showcasing some of its worst victims. Terms like "folk" and "naive" were removed from exhibition texts to make way for sometimes bizarre cross-cultural affinities. But it is beyond the means of most curators to indicate the political niceties behind a varied selection of art works. One might imagine the difficulties of reconciling Sherrie Levine's "multiple originals" (imitating famous moderns), or Mike Bidlo's fakes, with the similar images of Senegalese painter Saint Mor Faye. (Is one more authentic than the other—or are they both "slaving" the master narrative? Is it enough to suggest as much in the catalog?) Heaven help the curator who hangs a Mike Kelly thrift-store banner next to its earnest Third World look-alike (possibly the height of bad taste). The Czech sculptor Milan Knizak makes fairy-tale figurines that look like Jeff Koons's parodies. But his are political caricatures, whereas Koons's are *ur*-tchotchkes. Can curating the two together be its own sick joke?

Such tricky questions are not unrelated to the problems facing ethnological curators today, and in fact constitute the point at which these different zones of object distribution converge.[20] In fact, there have been noteworthy political gaffes in curating modernism. One that made history was the 1984 Museum of Modern Art *Primitivism* show, curated by then-director William Rubin (assisted by Kirk Varnedoe, who would come to replace him). The political embarrassment this show sparked (initially with Thomas McEvilley in *Artforum*, and sustained in that magazine by letters to the editor from Rubin, Varnedoe, and then McEvilley[21]), still serves warning to anyone willing to put together a show under the rubric of

cultural relativism (see Clifford 1985). Rubin was taken to task for his "etic" presentation of tribal art, construed by the industry as a belated tribute both to modernism and to his own institution's acclaimed collection. His catalog essay squeaked with High Modern rhetoric, and the momentary effect was to make all art scholars look colonial (see Myers, this volume).

Artists themselves today talk about supralocal ideas, and some are justifiably suspicious of national identities being attached to their work. American Leon Golub, for one, struggles to defy the heroic claims identified with postwar American art (Golub et al. 1991:124); Ouattara, an Ivory Coast artist living in New York, says, "National identities are not important; for the artist, inspiration comes from the sorcery of the cosmos and of the earth. Because it is always with you, it does not matter where you go" (Golub et al. 1991:130). The modern notion of artistic freedom was forged early in midcentury by the ideology of an American marketplace; as the art market was inscribed within global markets, so was its prevailing idea of artistic freedom as a form of "free enterprise" (Mattick 1991). Artists themselves variously enhance this image with essentialist notions of genius and inspiration.

Today, in a nineties market, as the masterpiece trade is being transformed by regional interests, the economic frames by which art professionals have come to interpret market phenomena may become relaxed and revised. Perhaps there will be a time when an international artistic identity rests upon more than Euro-American patrimony; when the Latin American or African artist who has climbed the ranks of strengthened regional markets, negotiating a regional aesthetic, can command the same price as a Julian Schnabel or Georg Baselitz. Until then, however, the art world must address the structural impact of its eighties inflation. The political rhetoric and consciousness of this system were thrown out of sync with the actual locations of participants, such that rearguard social interests were served by art's "liberal and progressive" plank and noncommercial producers were aligned with regressive modern romantics. Before a decentralized global aesthetic can succeed the eighties, and before regional markets can represent to the system anything more than raw material or provincialism, art professionals need to rethink their roles and, in doing so, to open up art discourse to material and social self-awareness. They need to entertain "ethnographic" information, if not embrace it.

Most of all, the art-world community must overcome its aversion to money's constitutive role in aesthetics, whether this acceptance can be called "postmodern" or something else. Such an adjustment would suit what now appears to be an expanding art-world "base"—really a decentralization of the masterpiece market, with Sotheby's and Christie's opening branches in Eastern Europe, Latin America, and possibly elsewhere, and with regional shows, institutions, collections, and periodicals drawing art and attention away from the old eighties' style extravaganzas that proported to represent so many national treasures as part of one (variously interpreted) postmodern aesthetic.

To review, my argument has been as follows:

In the eighties, *critics* were cast adrift from an alliance of collectors, dealers, and

artists and from the backroom information about art making that shaped modernist criticism. They redefined their role as art interpreters by availing of new theories of signification in general. *Artists* became wealthy and had greater affinities with both middle-class and upper-class collectors, as well as prominent dealers. The most successful were able to lavishly produce images vaguely deconstructive of modernism that also satisfied luxury commodity standards. *Dealers* lost their paramount control over market events at the height of inflation, when auctioneers supplanted them as liaisons between artists and collectors, exchanging quasi-objective valuations for dealers' subjective intuitions of aesthetic importance. *Curators* lost their scholarly responsibilities and moved closer to critical approaches of the period; they remained largely uncritical of the connections between self-effacing and context-suppressing display conventions and modernist aesthetics. *Museum directors* usurped the role of historical interpreter from curators (and other scholars, including those on their boards of trustees) and entered the margins of a collector-artist-dealer alliance through active participation at auctions. Their power over contemporary aesthetics rivaled that of major dealers as they revamped the historical and institutional stage for current trends.

These changes did not originate in postmodern theory but in the social relations of a postmodern discourse within the art community. Without questioning the validity and astuteness of postmodern theories, it is possible to evaluate their significance to particular fields of scholarship in terms of their social and political effects upon a community of professionals (as Mascia-Lees, Sharpe, and Cohen [1989] and others have done for anthropology). In this case, the complex of material and discursive functions that constitute art production and distribution have been deeply affected by postmodernism's basic concept of a dislocation between signifier and signified in contemporary culture. Following this assumption, critics have asserted the nonauthoritarian nature of any single art interpretation (with no less authority than in the past). But in a process unparalleled in any academic field, other art professionals have exploited the aesthetic instability postmodernism implies and scrambled for the social and economic power unleashed by a shift in paradigms. In the eighties, as more money entered the system and this power expanded exponentially, the relatively fluid social and aesthetic boundaries of the seventies constricted: suddenly the possibility of anything *but* "postmodernism" disappeared—and the regime that insured this resembled a modernist's nightmare: the world's most influential businessmen bonding with its most successful artists under the aegis of socially-outside avant-gardism. Indeed, just when the seventies' "normalization" of American art had given birth to a generation of women and nonwhite artists—just when the humanities and social sciences had begun to talk about multicultural canons—the art world not only claimed that there could be no authoritative readings of art, but it turned this claim into the new password for an old white men's society of occult, modernist aesthetics. That is, the persistence of modernist ideas fueled the art world's millenarian frenzy and produced a doppelgänger of modernism at its most influential core.

NOTES

1. I am indebted to Fred Myers for his help and encouragement with several drafts of this paper, and to George Marcus for his suggestions on an early version of it.

2. Unfortunately, the scope of this paper does not permit discussion of politically conscious and historically astute shows and texts that challenge a dominant postmodern ideology from beyond the magnetism of an auction market: shows like the 1986 *Damaged Goods* at New York's New Museum and *The Decade Show* in 1990 at the New Museum, The Studio Museum in Harlem, and the New Museum of Contemporary Hispanic Art; and a text such as Lucy Lippard's 1991 *Mixed Blessings,* about otherwise unreported Caribbean and North, Central and Latin American artists. Such events and works are produced all the time, and many cross over into investment art zones when they involve successful artists.

3. However hard Greenberg worked to suppress art's topicality, he could not innoculate it against political "effect"—particularly during the Cold War. As Victor Burgin puts it, "Ideology abhors a vacuum; the exclusion of all trace of the 'political' from the signifieds of a work may merely deliver it into complicity with the status quo" (1986:24). And Greenberg was its deliverer. By championing American art's "freedom of expression" as against "official culture" elsewhere (Mattick 1991:22; Schapiro [1937] 1978, 1957), at a time when the art market was evolving into a sphere of investment, Greenberg effectively inserted the American avantgarde into a dominant postwar "alliance for progress" of politics, business, and culture (Mattick 1991). "Some day it will have to be told," Greenberg wrote in 1957, "how 'anti-Stalinism,' which started out more or less as 'Trotskyism' [referring to Russian Formalism], turned into art for art's sake, and thereby cleared the way, heroically, for what was to come" (cited in Burgin 1986:23). He was commended in the fifties by Congressman Dondero for his active anti-communism, just before a Cold War thaw "released a flood of American art upon the world," as Victor Burgin puts it (1986:24). What had previously been considered subversive, "because it offended the philistinism of conservative politicians" came to "connote not 'Bolshevism' but, by virtue of the *difference* it established in opposition to official Soviet socialist realism, 'freedom of expression' (Eco [1975] has described the mechanism of such inversions of ideological evaluation in terms of *code switching)."* The net result of Greenberg's rhetoric can be assayed in light of America's cultural imperialism in the latter half of this century, and measured more accurately in terms of art auction records. Thus, Ben Heller, a private New York dealer and collector, puts today's market spin on Greenberg's heroic subject: "Interestingly," he says (1990a:51), "the art that now seems to be in greatest demand, post-World-War-II painting, is also in shortest supply."

4. See also Krauss (1976), "Notes on the Index: Seventies Art in America"; and Lippard (1973), *Six Years: The Dematerialization of the Art Object.* Certain dematerial gestures, recycled in a 1990 Paris show, have taken on souvenir appeal; as critic

Jackie Dunn notes (1990:36), thus "Robert Morris' *Statement of Aesthetic* [*sic*] *Withdrawal*, a directive sent to his gallery [in the seventies] to remove 'all aesthetic qualities and content' from the attached metal painting *Litanies*, after two decades becomes exactly that which it was meant to deny." Hapgood (1990) has an excellent discussion of refabricated conceptual works from the seventies and the legal, ethical, financial and of course "conceptual" questions these raise.

5. Crane, citing sources that include the *Guide to Corporate Living in the Arts* and the *American Art Directory*, notes that 67 percent of U.S. art museums and 93 percent of corporate collections were created between 1940 and 1980; NEH funding (established in 1965) increased from $1.8 million in 1966 to $131 million in 1983; in the period 1966–1981 corporate investments rose from $22 million to $436 million; and, from 1966 to 1982, foundation support rose from $38 million to $349 million. During this period, spanning the late sixties to early eighties, Crane adds, the arts acquired a political constituency with municipal lobbies in Washington and state arts organizations around the country, constituting a "bureaucracy of art" (1987:7).

6. A certain stigma has always haunted Kostabi's work. It was and still is associated with an early eighties market phenomenon that came and went almost overnight. This was the proliferation throughout the United States and Europe of cheap art secondary markets, most renowned of which was New York's East Village. The East Village in its heyday was called a "Neo-Frontier" (Levin 1983), a "New Territory" (Glueck 1983), a unique blend of poverty, drugs, and untapped resources—a perfect simulation of bohemia. These were labels East Village players themselves coined. "It's the law of the jungle and the fittest survive . . . ultimately quality prevails" wrote artist-critic Nicholas Moufarrege (see also Deutsche and Ryan 1984:107). By 1987 these galleries had been wiped out by an escalating real estate market.

7. Art criticism has a tradition of invoking antipopulist theories of culture, whether they be concepts of "mass deception" (e.g., Horkheimer and Adorno 1972) or early "unreality" theories (e.g., Boorstin 1962). Modernism in general has been conceptualized as a threat to high culture and democratic thought, undermining standards of quality and intelligence (e.g. Kristol 1960). What art writers have not developed, by contrast, is a perspective found in Benjamin (1968), which is also common to J. Berger (1972) and others like Bourdieu (1984), that is suspicious of art's role in the program of modernity: a view that diminishes art's "aura" by likening it to low cultural production, as a political tool, or a function of class-bound tastes.

8. Not until Jesse Helms's moral purge of the arts did artists animate a collective identity in defense of artistic liberty that crosscut the economic strata of this era (see Cembalest 1990). And only at the turn of the nineties did AIDS activism mobilize artists into both semiotic and practical resistance, outside the market and its dominant aesthetic (see Crimp 1988; Meyer 1992; Robinson 1991).

9. The whole *fin-de-siecle/fin-d'art* wave picked up steam from a 1982 German

blockbuster show called *Zeitgeist*, and played itself out through the eighties with a series of redundant shows, on both sides of the Atlantic, with titles like *The End of the World: Contemporary Visions of the Apocalypse, Apocalypse + Utopia, Artists Under Saturn, Melancholy and Macabre,* and so forth (see Plant 1991). Then, in 1987, two art-historical texts with compatible messages refueled this vision: Arthur C. Danto's "Approaching the End of Art" and Hans Belting's *The End of the History of Art?*

10. Artists of this stature are exhibited and collected together, and share a social milieu comprised of international artists and dealers. Julian Schnabel and Georg Baselitz, for example, are as much cohorts as they are distinct national culture heroes. Their self-mythologizing is interesting: A personal friend of Schnabel's explains, "He married Jacqueline [his French ex-wife] because he thought he was Picasso. Then he moved to Long Island and started painting out on the ground without a shirt on, thinking he was Pollock. Then he took over the role [of contributing editor] at *Interview* because he had become Andy [Warhol]. Now he's thinking of making a movie about the suffering artist, so he must see movies as the Sistine Chapel—the big screen. So he must think he's Michelangelo" (cited by Kazanjian 1992:432). Baselitz, who lives in a German castle and, like Schnabel, avidly collects art of all periods, has an extensive collection of African art (like Picasso) and is very unsympathetic to East German artists who did not, like himself, escape to the West for the sake of artistic freedom. Both these men are widely represented by the popular press, especially in women's magazines—where, in *Mirabella*, Baselitz recently said, "As long as this is a patriarchal society there cannot be a female artist" (De Ferrari 1992:61).

11. The career trajectory of one of these "melancholic" painters, the American Robert Morris, provides an excellent illustration of how style (i.e., "sign") can serve multiple worldviews and how the individual may raise personal history to the level of myth. Morris's career spans the "authoritarian abstraction" of late-sixties Minimalism (Kuspit 1978) and the Neo-Expressionism of the late eighties. Because Morris has moved, chameleonlike, through successive styles, he has been called a "dandy" and a "prisoner of modernism" (Carter Ratcliff); targeted for "shameless borrowings" (Roberta Smith), for being "a one-man synthesizer of contemporary art" (David Bourdon). One critic called his work "pretentious to a really incredible degree" (Peter Schjeldahl; all three cited in Patton 1983:87–88). In 1970 he withdrew his own "retrospective" (a parody of the form, for the young artist) from the Whitney Museum of American Art, in response to the American invasion of Cambodia and to the tragic Kent State killings (M. Berger 1989:88). Then in 1974, the same year that a member of his cohort, Linda Benglis, appeared nude, wielding a huge dildo, in a full-page *Artforum* statement about what makes art sell, Morris presented himself in a poster for his Leo Castelli exhibition in full Nazi leather-and-chains regalia. (Go figure.) But in the eighties his "derivativeness" found its mark, miraculously transformed into "innovation" of the second power— the quintessential stylistic "bricolage." Morris's mideighties paintings and sculp-

tures placed him squarely in the foreground of American Neo-Expressionism: spectacularly ghoulish and meticulously fabricated cenotaphs, tombstones, bombs, skulls and human fragments, with titles like *The Natural History of Los Alamos, Hypnerotomachia* and *Psychomachia*. Flaming wall-sized canvases were encased by baroque frames composed of blackened human bones and body parts. This look of the gilded social conscience, with its lush surfaces and macabre subject matter, coupled with Morris's personal diffidence, even his looks, have all prompted the occasional critic to call him "the J. Robert Oppenheimer of modern art" (Kuspit 1986; Patton 1983). Artistic identity is once again greater than the moral stratagems of a particular age: one can imagine Robert Morris in White Sands Desert, humbled, transfixed, and reciting the *Bhagavad-Gita*. In response to an interviewer's remarks about nuclear annihilation, Morris mused, "It's out there, the possibility . . . I am fascinated by all that power. It goes back to Xerxes, the raw power to create an empire" (Patton 1983:90).

12. Alloway talks about then-recent museum shows (from 1969 to 1975) that were evidently mounted as market campaigns by prominent dealers; others that suffered from their deference to artists' decisions; and one show (in 1963), curated by himself, that, under threat by the artist's estate and dealer, had a small item in its catalog text revised to protect the work's market value. None of these cases seem remarkable twenty years later. Excellent critiques of museum curation and acquisition can be found in Duncan and Wallach 1978, 1980; Crimp 1984; Frascina 1985; M. Berger 1989; and Wallis 1991. As the job of museum curator has grown less scholarly, critics and sometimes artists now serve as guest curators; in turn, scholarly curators move to academia and art criticism. The curator of the Pasadena Art Museum, John Coplans, moved over to edit *Artforum*. The rare example of a curator who has been able to exploit recent trends and consolidate his authority is Henry Geldzahler of the Metropolitan Museum's contemporary department. Early on, with dealers Richard Bellamy and Ivan Karp, he took the lead in cultivating marketable careers from the gallery to the museum, and has become something of a cult figure himself (see Tomkins 1971; Alloway 1972:29).

13. Carol Zemel (1988:91) writes: "The fact that [Yasuda's] picture was painted in 1988, the same year the company was founded, that it replaces a version of the *Sunflowers* lost in the bombing of Yokohama . . . and that van Gogh considered Japan the site of a utopian culture and society 'naturalizes' the purchase and its price." James Clifford also notes (in Foster 1987:147), "I just saw the van Gogh at the Met and was again struck by the presence of Japan in his work."

14. See Heller 1990a:51, on Graham's value principles, which, he says, "have been at work for some time in the art world. So established are they that what was first only a perception—that safety and substantial growth were greatest in art works of the highest quality—has become a market slogan."

15. *The Christian Science Monitor* calculated the worth of *Sunflowers* against Reagan's inauguration costs ($16 million), and a grant to establish a program on ethics at the Harvard Business School ($30 million) (Zemel 1988:90).

16. This curious form of historical revisionism has been taken up by other critics, such as Carter Ratcliff, who explains its logic as follows:

> If we are to live in our historical moment, we have to look at *Irises* (or a reproduction of it) with a full sense of the price it fetched and try to see that outrageous number as part of what the painting means now. Maybe we can't do that. If we cannot, the painting will go unseen in its fullness. We will see in its place an image lacking that aspect we call "intention," for van Gogh himself intended this painting to sell, and it has, ten times since his death. (1988:147)

Compare this to sentiments expressed by van Gogh in an 1885 letter to his long-suffering brother Theo: "I hope to make such progress that you will be able to show myself boldly without compromising yourself" (cited in Davies 1988:19). Also note an item mentioned in a 1991 *ARTnews* article on the growth of Hollywood collectors (Curtis 1991:106): "Kirk Douglas put most of his Impressionist and modern art up for sale at Christie's New York branch last year, saying his 1956 role as Vincent van Gogh in *Lust for Life* inspired him to collect more work by living artists."

17. What had also happened in early 1991 was the revelation of a high-finance scandal involving Japanese industrialists-dealers-collectors. Apparently those indigenous forms of gift-giving in Japan were less esoteric than they first appeared. In Japan the gift of art had been a useful financial tool(s). As the late 1980s Tokyo stock market faltered, and interest rates rose, European masterpieces became integral to hazier and hazier schemes for transferring money, evading taxes, and sharking consumer loans. When interest rates hit 36 percent, companies wanting higher returns simply sold paintings to clients at inflated (or current market) prices. Thus the masterpiece market was sustained by the very mechanisms that kept Japan's economy afloat—until a series of scandals broke. These were dutifully and sometimes wittily recorded in all art journals (e.g., Berman 1991:41–42; *Journal of Art* 1991:8; Robinson 1991:25–26; Barker 1992).

Once again, the Japanese took a fall. Those businessmen who did not commit suicide in the ensuing scandals faced new perils. The European news media found an appalling item: just after Ryoei Saito brought home his van Gogh and Renoir paintings, he apparently said to someone in public, "Put those paintings in my coffin to be cremated with me." *Le Figaro* splashed "SCANDAL" over its front page. The Swiss daily, *Tribune de Genève*, reported "Masterpieces in Peril—The Yellow Peril," and illustrated this with a cartoon of a bucktoothed Asian tossing paintings into an open coffin. The director of French museums huffed that "even the most pharaohesque of pharaohs took care of the art works that were buried with them." Later, to *Newsweek*, Saito explained, "What I really wanted to [express] was my wish to preserve the paintings forever," and added he would think about donating them to a museum (*Newsweek* 1991:35).

18. See, for example, *ARTnews* October 1990 ("The Latin American Issue"); *ARTnews* November 1990 ("Inside Europe"); *ARTnews* December 1990 ("The Los Angeles Issue"); *Art in America* September 1991 ("Art and National Identity"); *ARTnews* October 1991 ("Latin America: Global Outreach"); *ARTnews* November 1991

("Hollywood Collectors"); and *ARTnews* Summer 1992 ("Pacific Rim: An Art World Blooms").

19. In a more sympathetic vein, Ben Heller acknowledges that soaring art prices have severely limited museums' ability to function as they have in the past. He notes that many purchases are out of their reach now, that loans are also harder to obtain (although Sotheby's and Christie's continue to offer bridge-financing for clients), and that loan exhibitions are harder to fund.

> While this combination of unhappy circumstances may paradoxically enhance the fortunes of the contemporary art world by forcing institutions to expend their activity in this still affordable area at the expense of other interests, the situation also makes it increasingly difficult for museums to perform their more classical functions in any meaningful way. (1990a:51)

20. A testament to how muddy things have become is the July 1989 issue ("The Global Issue") of *Art in America*. In one article, Australia's Tony Fry and Anne-Marie Willis implicate all the agents involved in merchandizing Aboriginal art for a Western public. Just as Derrida reminds us that the Nambikwara face extinction as Lévi-Strauss enters the French Academy, so Fry and Willis point out how little cultural remuneration Aborigines receive from our interest in dot painting. Another piece, by Eleanor Heartney, reviews the Paris Centre Pompidou show, *Magiciens de la terre*, which effectively leveled today's folk, fine, primitive, and primitivist art in a world's fair of spirituality. Heartney's conclusion: "It leaves an odd aftertaste. For all its celebration of the exotic and different, it remains oddly familiar, reminding us that to seek the Other in a reflection of our idealized self is never to leave home after all" (1989:96). Then, at the back of the issue, there is an interesting series of statements by artists. One is from the artist Lawrence Weiner who, with the curator of the *Magiciens* show, traveled to the Sepik River of Papua New Guinea in search of material for that exhibit. "I went there to collaborate with another artist," Weiner explains, "but it became impossible because I would then in fact become a teacher." Apparently he tried to persuade villagers to abandon their trade in artifacts to tourists and dealers and make art for themselves; to his dismay, he found that "generally they saw the idea of doing something for themselves as having no value, because there was no market for it" (quoted in Jaar et al. 1989:134–135).

21. See Rubin (1984), McEvilley (1984), and Letters of the Editor of *Artforum*, February and May 1985.

REFERENCES

Abu-Lughod, Lila

1990 "Can There Be a Feminist Ethnography?" *Women and Performance: A Journal of Feminist Theory* 5:7–27.

1991 "Writing Against Culture." In Richard G. Fox, ed., *Recapturing Anthropology: Working in the Present*, pp. 137–162. Santa Fe, N. Mex.: School of American Research.

Alloway, Lawrence
 1972 "Network: The Art World Described as a System." *Artforum*
 11(Sept.):27–31.
 1975 "The Great Curatorial Dim-out." *Artforum* 13(May):32–34.
Ames, Michael
 1986 *Museums, the Public and Anthropology: A Study in the Anthropology of Anthropology.*
 Vancouver: University of British Columbia Press.
Anderson, Benedict
 1983 *Imagined Communities: Reflections on the Origin and Spread of Nationalism.* London: Verso.
Appadurai, Arjun
 1990 "Disjuncture and Difference in the Global Cultural Economy." *Public
 Culture* 2(2):1–24.
 1991 "Global Ethnoscapes: Notes and Queries for a Transnational Anthropol-
 ogy." In Richard G. Fox, ed., *Recapturing Anthropology: Working in the Present*,
 pp. 191–210. Santa Fe, N. Mex.: School of American Research.
Baldessari, John, et al.
 1990 "Making Art, Making Money: Thirteen Artists Comment." *Art in America*
 78(July):133–141, 178.
Bannard, Darby
 1966 "Present-day Art and Ready-made Styles." *Artforum* 5(May):30–35.
Barker, Goddfrey
 1992 "New Faces in the Crowd." *ARTnews*, Jan., 75–78.
Barthes, Roland
 1984 "From Work to Text." In Brian Wallis, ed., *Art After Modernism: Rethinking
 Representation*, pp. 169–174. New York: New Museum of Contemporary
 Art.
Battcock, Gregory, ed.
 1973 *Idea Art.* New York: E. P. Dutton.
Baudrillard, Jean
 1984 "The Precession of Simulacra." In Brian Wallis, ed., *Art After Modernism:
 Rethinking Representation*, pp. 253–282. New York: New Museum of Con-
 temporary Art.
 1987 *The Ecstasy of Communication.* Trans. Bernard and Caroline Schutz. New
 York: Foreign Agents Series.
 1988 "Beyond the Vanishing Point of Art." In Paul Taylor, ed., *Post-Pop Art.*
 New York: Flash Art Books, MIT Press.
Bell, Clive
 1982 "The Aesthetic Hypothesis." In Francis Frascina and Charles Harrison,
 eds., *Modern Art and Modernism: A Critical Anthology*, pp. 67–74. New York:
 Harper and Row.
Benjamin, Walter
 1968 "The Work of Art in the Age of Mechanical Reproduction." In *Illumina-
 tions: Essays and Reflections*, ed. Hannah Arendt, trans. Harry Zohn, pp.
 217–251. New York: Schocken Books.
Berger, John
 1972 *Ways of Seeing.* London: British Broadcasting Corporation.

Berger, Maurice
 1989 "Of Cold Wars and Curators." *Artforum* 27(Feb.):86–92.
Berman, Ann
 1991 "Mixed Messages." *ARTnews* 90(summer):41–42.
Boorstin, Daniel J.
 1962 *The Image: A Guide to Pseudo-events in American Life.* New York: Atheneum.
Bourdieu, Pierre
 1980 "The Production of Belief: Contribution to an Economy of Symbolic
 Goods." *Media, Culture and Society* 2:3:263.
 1984 *Distinction: A Social Critique of the Judgement of Taste.* Trans. Richard Nice.
 Cambridge, Mass.: Harvard University Press.
Brenson, Michael
 1990 "Why Curators Turn to the Art of the Deal." *New York Times,* Mar. 4,
 section 2, pp. 1,38.
Burgin, Victor
 1986 *The End of Art Theory.* Atlantic Highlands, N.J.: Humanities Press Interna-
 tional.
Carrier, David
 1987 *Artwriting.* Amherst: University of Massachusetts Press.
Cembalest, Robin
 1990 "Obscenity Trial: How They Voted to Acquit." *ARTnews*
 89(Dec.):136–141.
Clark, T. J.
 1982 "On the Social History of Art." In Francis Frascina and Charles Harri-
 son, eds., *Modern Art and Modernism: A Critical Anthology,* pp. 249–258. New
 York: Harper and Row.
Clifford, James
 1985 "Histories of the Tribal and the Modern." *Art in America*
 72(April):164–177, 215.
 1988 *The Predicament of Culture: Twentieth-Century Ethnography, Literature, and Art.*
 Cambridge, Mass.: Harvard University Press.
Cone, Timothy
 1989 "Limited Partnership: The NEA and the Arts." *ARTS,* Nov., 13–14.
Couacaud, Sally
 1990 *Paraculture.* Sydney: Artspace.
Crane, Diana
 1987 *The Transformation of the Avant-Garde: The New York Art World, 1940–1985.*
 Chicago: University of Chicago Press.
Crimp, Douglas
 1981 "The End of Painting." *October* 8:69–86.
 1984 "The Art of Exhibition." *October* 30:49–81.
 1988 *AIDS: Cultural Analysis / Cultural Activism.* Cambridge, Mass.: MIT Press.
Curtis, Cathy
 1991 "Hollywood Collects." *ARTnews,* Nov., 102–107.
Danziger, Charles
 1990 "Where the Buyers Are . . ." *Art in America* 78(July):55–59.

Davies, Jack
 1988 "Yours, Vincent." *ARTnews,* Mar., 19.
De Ferrari, Gabriella
 1992 "The Art of Discord." *Mirabella,* May, 56–61.
Derrida, Jacques
 1967 *L'Ecriture et la différence.* Paris: Editions du Seuil.
 1982 *D'Un Ton apocalyptique adopte naguere en Philosophie.* Paris: Galilee.
Deutsche, Rosalyn, and Cara Gendel Ryan
 1984 "The Fine Art of Gentrification." *October* 31:91–111.
Duncan, Carol, and Alan Wallach
 1978 "The Museum of Modern Art as Late Capitalist Ritual: An Iconographic Analysis." *Marxist Perspectives* 1(winter):28–51.
 1980 "The Universal Survey Museum." *Art History* 3(4):448–469.
Dunn, Jackie
 1990 "L'Art Conceptuel: Une Perspective." *Art & Text* 36:124.
Eco, Umberto
 1975 *A Theory of Semiotics.* Bloomington: Indiana University Press.
Ehrenreich, Barbara, and John Ehrenreich
 1979 "The Professional-Managerial Class." In Pat Walker, ed., *Between Labor and Capital,* pp.5–45. Boston: South End Press.
Esterow, Milton
 1988 "Now Joan, Don't Be Stingy." *ARTnews,* Jan., 22–24.
Fischer, Michael M. J.
 1989 "Museums and Festivals: Notes on the Poetics and Politics of Representation." *Cultural Anthropology* 4(2):204–221.
Flax, Jane
 1990 *Thinking Fragments: Psychoanalysis, Feminism, and Postmodernism in the Contemporary West.* Berkeley: University of California Press.
Foster, Hal
 1985 *Recodings, Art Spectacle, Cultural Politics.* Port Townsend, Wash.: Bay Press.
———, ed.
 1983 *The Anti-Aesthetic, Essays on Postmodern Culture.* Port Townsend, Wash.: Bay Press.
 1987 *Discussions in Contemporary Culture, 1.* Seattle: Bay Press.
Foucault, Michel
 1966 *Les Mots et les choses.* Paris: Gallimard.
 1977 "Nietzsche, Genealogy, History." In *Language, Counter-Memory, Practice,* pp.139–164. Ithaca, N.Y.: Cornell University Press.
 1980 *Power/Knowledge.* New York: Pantheon.
Frascina, Francis, ed.
 1985 *Pollock and After: The Critical Debate.* New York: Harper and Row.
Fried, Michael
 1982 "Three American Painters." In Francis Frascina and Charles Harrison, eds., *Modern Art and Modernism: A Critical Anthology,* pp.115–122. New Yorker: Harper and Row.
Fry, Roger Eliot
 1932 *The Arts of Painting and Sculpture.* London: V. Gollancz, Ltd.

Fry, Tony, and Anne-Marie Willis
 1989 "Aboriginal Art: Symptom or Success?" *Art in America,* 77(July):108–117,
 159–160, 163.

Gablik, Suzi
 1977 *Progress in Art.* New York: Rizzoli International.

Galloway, David
 1991 "The New Berlin: 'I Want My Wall Back.' " *Art in America*
 79(Sept.):98–103, 149.

Geertz, Clifford
 1980 "Blurred Genres." *American Scholar* 49:165–179.
 1991 "The Year of Living Culturally." *New Republic,* Oct. 21, 30–36.

Giddens, Anthony
 1979 *Central Problems in Social Theory: Action, Structure and Contradiction in Social
 Analysis.* Berkeley: University of California Press.

Glueck, Grace
 1983 "A Gallery Scene That Pioneers in New Territories." *New York Times,*
 June 26, 27.

Golub, Leon, et al.
 1991 "On Nationality: 13 Artists." *Art in America* 79(Sept.):124–131.

Gombrich, E. H.
 1963 *Meditations on a Hobby Horse.* New York: Phaidon.

Grampp, William D.
 1989 *Pricing the Priceless: Art, Artists, and Economics.* New York: Basic Books.

Gramsci, Antonio
 1971 *Selections from the Prison Notebooks.* Eds. Quintin Hoare and Gregory
 Nowell-Smith. London: Lawrence Wisehart.

Greenberg, Clement
 [1939] 1961 "Avant-Garde and Kitsch." *Art and Culture: Critical Essays,* pp.3–21.
 Boston: Beacon Press.
 1962 "After Abstract Expressionism." *Art International* 6(8).

Grimes, William
 1990 "Kirk Varnedoe Is in the Hot Seat as MoMA's Boy." *New York Times,*
 Mar. 11, section 6, pp. 61–64.

Gupta, Akhil, and James Ferguson
 1992 "Beyond 'Culture': Space, Identity, and the Politics of Difference." *Cul-
 tural Anthropology* 7(1):6–23.

Habermas, Jurgen
 1983 "Modernity—An Incomplete Project." In Hal Foster, ed., *The Anti-
 Aesthetic, Essays on Postmodern Culture,* pp. 3–15. Port Townsend, Wash.:
 Bay Press.

Hannerz, Ulf
 1989 "Notes on the Global Ecumene." *Public Culture* 1(2):66–75.

Hapgood, Susan
 1990 "Remaking Art History." *Art in America* 78(July):114–123, 181.

Heller, Ben
 1990a "The 'Irises' Affair." *Art in America* 78(July):45–53.
 1990b "Reaching for the Stars." *ARTnews* (summer):138–141.

Henderson, Linda Dalrymple
 1983 *The Fourth Dimension and Non-Euclidean Geometry in Modern Art.* Princeton,
 N.J.: Princeton University Press.

Hirschberg, Lyn
 1987 "The Four Brushmen of the Apocalypse: America, Meet Your Modern
 Masters." *Esquire,* Mar., 70–80.

Horkheimer, Max, and Theodor A. Adorno
 1972 "The Culture Industry: Enlightenment as Mass Deception." In *The*
 Dialectic of Enlightenment, pp. 120–167. Trans. John Cumming. New York:
 Continuum Press.

Hughes, Robert
 1989 "The Patron Saint of New-Pop." *New York Review of Books,* June 1, 29–32.

Hutcheon, Linda
 1989 *The Politics of Postmodernism.* London: Routledge.

Huyssen, Andreas
 1981 *After the Great Divide.* London: Macmillan.

Jaar, Alfredo, et al.
 1989 "The Peripatetic Artist: 14 Statements." *Art in America* 77(July):130–137,
 155.

Jameson, Frederic
 1984 "Postmodernism, or the Cultural Logic of Late Capitalism." *New Left*
 Review 146(July–Aug.):53–92.

Journal of Art, The
 1991 "Government Crackdown Throws Japan's Corporate Art World into
 Turmoil." June/July/August, 8.

Kazanjian, Dodie
 1992 "Emperor Julian." *Vogue,* April, 428–433.

Kelly, Mary
 1984 "Re-Viewing Modernist Criticism." In Brian Wallis, ed., *Art After Mod-*
 ernism: Rethinking Representation, pp. 87–104. New York: New Museum of
 Contemporary Art.

Kirshenblatt-Gimblett, Barbara
 1991 "Objects of Ethnography." In Ivan Karp and Stephen D. Lavine, eds.,
 Exhibiting Cultures: The Poetics and Politics of Museum Display, pp. 386–443.
 Washington, D.C.: Smithsonian Institution Press.

Krauss, Rosalind
 1976 "Notes on the Index: Seventies Art in America." *October* 3:68–81.
 1984 "The Originality of the Avant-Garde: A Postmodern Repetition." In
 Brian Wallis, ed., *Art After Modernism: Rethinking Representation,* pp. 13–29.
 New York: New Museum of Contemporary Art.

Kristeva, Julia
 1989 *The Black Sun, Depression and Melancholy.* Trans. Leon S. Roudiez. New
 York: Columbia University Press.

Kristol, Irving
 1960 "High, Low and Modern." *Encounter* 83:33–41.

Kuspit, Donald B.
1978 "Authoritarian Abstraction." *Journal of Aesthetics and Art Criticism* 36:27–28.
1986 "The Ars Moriendi According to Robert Morris." In Edward F. Fry and
 Donald B. Kuspit, eds., *Robert Morris Works of the Eighties*, pp. 13–21. New
 York: New Museum of Contemporary Art.
Lawson, Thomas
1981 "Last Exit: Painting." *Artforum* 20(Oct.):40–47.
Levin, Kim
1983 "The Neo-Frontier." *Village Voice*, Jan. 4, 80.
Lippard, Lucy
1973 *Six Years: The Dematerialization of the Art Object from 1966 to 1972*. New York:
 Praeger.
1991 *Mixed Blessings: New Art in a Multicultural America*. New York: Pantheon
 Books.
Lyotard, Jean-François
1984 *The Postmodern Condition: A Report on Knowledge*. Trans. Geoff Bennington
 and Brian Massumi. Minneapolis: University of Minnesota Press.
Marcus, George E., and Michael M. J. Fischer
1986 *Anthropology as Cultural Critique: An Experimental Moment in the Human Sciences*.
 Chicago: University of Chicago Press.
Martorella, Rosanne
1990 *Corporate Art*. New Brunswick: Rutgers University Press.
Mascia-Lees, Frances E., Patricia Sharpe, and Colleen Ballerino Cohen
1989 "The Postmodernist Turn in Anthropology: Cautions from a Feminist
 Perspective." *Signs: Journal of Women in Culture and Society* 15(1):7–33.
Mattick, Paul, Jr.
1991 "It's Hammer Time." *ARTS* (summer):21–22.
McEvilley, Thomas
1984 "Doctor, Lawyer, Indian, Chief: 'Primitivism' in 20th Century Art at
 the Museum of Modern Art in 1984." *Artforum* 23(Nov.):54–61.
McGill, Douglas C.
1987a "Art People: Just an Artist's Dream." *New York Times*, Nov. 13, C36.
1987b "Van Gogh Price Shakes Art World." *New York Times*, April 2, C23.
Messenger, Phyllis Mauch, ed.
1989 *The Ethics of Collecting Cultural Property: Whose Culture? Whose Property?* Albu-
 querque, N. Mex.: University of New Mexico Press.
Meyer, James
1992 "AIDS and Postmodernism." *ARTS* magazine, April, 63–68.
Meyrowitz, Joshua
1985 *No Sense of Place: The Impact of Electronic Media on Social Behavior*. New York:
 Oxford University Press.
Michaels, Eric
1988 "Bad Aboriginal Art." *Art and Text* 28:59–73.
Morris, Meaghan
1990 "Metamorphoses at Sydney Tower." *New Formations* 11:5–18.

Myers, Fred
 1991 "Representing Culture: The Production of Discourse(s) for Aboriginal Acrylic Paintings." *Cultural Anthropology* 6(1):26–62.

Newsweek
 1991 "Ashes to Ashes, but Not with Your van Gogh." May 27, 35.

Owens, Craig
 1987 "The Yen for Art." In Hal Foster, ed., *Discussions in Contemporary Culture, 1*, pp.13–16. Port Townsend, Wash.: Bay Press.

Patton, Phil
 1983 "Robert Morris and the Fire Next Time." *ARTnews*, Dec., 85–91.

Pears, Iaian
 1988 "In Sum: Corporate Support for Art." *Art in America* 76(July):55–59.

Pfeil, Fred
 1990 *Another Tale to Tell: Politics and Narrative in Postmodern Culture.* London: Verso.

Plant, Margaret
 1991 "Endisms and Apocalypses in the 1980's." *Art and Text* 39:29–36.

Price, Sally
 1989 *Primitive Art in Civilized Places.* Chicago: University of Chicago Press.

Ratcliff, Carter
 1974 "Art Criticism: Other Eyes, Other Minds (Part 5)." *Art International* 18:53–57.
 1980 "Critical Thought, Magical Language." *Art in America* 68(June):148–152.
 1988 "The Marriage of Art and Money." *Art in America* 76(July):76–84, 145.

Ratcliff, Carter, Hayden Herrera, Sarah McFadden, and Joan Simon
 1982 "Expressionism Today: An Artists' Symposium." *Art in America* 70(Dec.):58–75, 139–141.

Rebay, Hilla
 1937 *Second Enlarged Catalogue of the Solomon R. Guggenheim Collection of Non-objective Paintings, on Exhibition from February 8, 1937 through February 28, 1937.* New York: Bradford Press.

Reddy, William M.
 1992 "Postmodernism and the Public Sphere: Implications for an Historical Ethnography." *Cultural Anthropology* 7(2):135–168.

Robinson, Walter
 1991 "Japanese Art Scandals." *Art in America* 79(July):25–26.

Rorty, Richard
 1979 *Philosophy and the Mirror of Nature.* Princeton, N.J.: Princeton University Press.

Rosler, Martha
 1987 "The Birth and Death of the Viewer: On the Public Function of Art." In Hal Foster, ed., *Discussions in Contemporary Culture, 1*, pp. 9–15. Port Townsend, Wash.: Bay Press.

Rosler, Martha, James Clifford, Boris Groys, Robert Storr, Craig Owens, and Michelle Wallace
 1989 "The Global Issue: A Symposium with Martha Rosler, James Clifford, Boris Groys, Robert Storr, Craig Owens, and Michelle Wallace." *Art in America* 77(July):86–89, 153.

Rubin, William, ed.
 1984 *"Primitivism" in 20th Century Art: Affinity of the Tribal and the Modern.* New York: Museum of Modern Art.
Sahlins, Marshall
 1976 *Culture and Practical Reason.* Chicago: University of Chicago Press.
Sangren, P. Steven
 1988 "Rhetoric and the Authority of Ethnography: 'Postmodernism' and the Social Reproduction of Texts." *Current Anthropology* 29(3):405–435.
Schapiro, Meyer
 [1937] 1978 "Nature of Abstract Art." In *Modern Art: 19th and 20th Centuries.* New York: George Braziller.
 1957 "The Liberating Quality of Avant-Garde Art." *ARTnews* 56(summer): 36–42.
Seabrook, John
 1990 "The Junking of Bond." *Vanity Fair,* June:156–172.
Sondheim, Alan, ed.
 1977 *Individuals: Post-Movement Art in America.* New York: E. P. Dutton and Co.
Tomkins, Calvin
 1971 "Moving with the Flow." *New Yorker,* Nov. 6, 58–113.
Tully, Judd
 1991 "Spring Sales Hint at a Recovery." *Journal of Art* (summer):80.
Tyler, Stephen
 1986 "Post-modern Ethnography: From Document of the Occult to Occult Document." In James Clifford and George E. Marcus, eds., *Writing Culture: The Poetics and Politics of Ethnography.* Berkeley: University of California Press.
Varnedoe, Kirk, and Adam Gopnik
 1990 *High & Low: Modern Art and Popular Culture.* New York: Museum of Modern Art.
Wallis, Brian
 1991 "Selling Nations." *Art in America* 79(Sept.):85–91.
———, ed.
 1984 *Art After Modernism: Rethinking Representation.* New York: New Museum of Contemporary Art.
Washington Post
 1987 Editorial, April 2, A24.
Weiner, Annette
 1992 *Inalienable Possessions: The Paradox of Keeping While Giving.* Berkeley: University of California Press.
Weiss, Philip
 1990 "Selling the Collection." *Art in America* 78(July):124–131.
White, Hayden V.
 1973 *Metahistory: The Historical Imagination in Nineteenth Century Europe.* Baltimore: Johns Hopkins University Press.
Williams, Raymond
 1958 *Culture and Society, 1780–1950.* London: Chatto and Windus.

Wölfflin, Heinrich
 [1932] 1950 *Principles of Art History: The Problem of the Development of Style in Later Art.*
 Trans. M. D. Hottinger. New York: Dover.

Zemel, Carol
 1988 "What Becomes a Legend Most." *Art in America* 76(July):88, 93, 151.

Zorpette, Glenn
 1991 "Star Search." *ARTnews*, Nov., 126–129.

The Artist as Ethnographer?

Hal Foster

My title is meant to evoke "The Author as Producer," the text of which Walter Benjamin first presented at the Institute for the Study of Fascism in Paris in April 1934. There, under the influence of Berthold Brecht and Russian revolutionary culture, Benjamin (1978) called on the artist on the left "to side with the proletariat."[1] In vanguard Paris in April 1934 this call was not radical; the approach, however, was. For Benjamin urged the "advanced" artist to intervene, like the revolutionary worker, in the means of artistic production—to change the "techniques" of traditional media, to transform the "apparatus" of bourgeois culture. A correct "tendency" was not enough; that was to assume a place "beside the proletariat." And "what kind of place is that?" Benjamin asked, in lines that still scathe. "That of a benefactor, of an ideological patron—an impossible place."

Today there is a related paradigm in advanced art on the left: the artist as ethnographer. The object of contestation remains, at least in part, the bourgeois institution of autonomous art, its exclusionary definitions of art, audience, identity. But the subject of association has changed: it is now the cultural and/or ethnic other in whose name the artist often struggles. And yet, despite this shift, basic assumptions with the old productivist model persist in the new quasi-anthropological paradigm. First, there is the assumption that the site of artistic transformation is the site of political transformation, and, more, that this site is always located *elsewhere*, in the field of the other: in the productivist model, with the social other, the exploited proletariat; in the quasi-anthropological model, with the cultural other, the oppressed postcolonial, subaltern, or subcultural. Second, there is the assumption that this other is always *outside*, and, more, that this alterity is the primary point of subversion of dominant culture. Third, there is the assumption that if the invoked artist is *not* perceived as socially and/or culturally other, he or she has but *limited* access to this transformative alterity, and, more, that if he or she *is* perceived as other, he or she has *automatic* access to it. Taken together, these three

assumptions lead to another point of connection with the Benjamin account of the author as producer: the danger, for the artist as ethnographer, of "ideological patronage."[2]

A strict Marxist might question this quasi-anthropological paradigm in art because it tends to displace the problematic of class and capitalist exploitation with that of race and colonialist oppression. A strict poststructuralist would question it for the opposite reason: because it does *not* displace this productivist problematic enough, that is, because it tends to preserve its structure of the political—to retain the notion of a *subject* of history, to define this position in terms of *truth*, and to locate this truth in terms of *alterity*. From this perspective the quasi-anthropological paradigm, like the productivist one, fails to reflect on its *realist assumption:* that the other, here postcolonial, there proletarian, is in the real, not in the ideological, because he or she is socially oppressed, politically transformative, and/or materially productive.[3] Often this realist assumption is compounded by a *primitivist fantasy:* that the other has access to primal psychic and social processes from which the white (petit) bourgeois subject is blocked.[4] Now, I do not dispute that, in certain conjunctures the realist assumption is proper and the primitivist fantasy is subversive. But I do dispute the automatic coding of apparent difference as manifest identity and of otherness as outsideness. This coding has long enabled a cultural politics of *marginality*. Today, however, it may disable a cultural politics of *immanence*, and this politics may well be more pertinent to a postcolonial situation of multinational capitalism in which geopolitical models of center and periphery no longer hold.[5]

The primitivist fantasy was active in two precedents of the quasi-anthropological paradigm in contemporary art: the dissident Surrealism associated with Georges Bataille and Michel Leiris in the late 1920s and early '30s, and the *négritude* movement associated with Leopold Senghor and Aimé Césaire in the late 1940s and early '50s. In different ways both movements connected the transgressive potentiality of the unconscious with the radical alterity of the cultural other. And yet, both movements came to be limited by this very primitivist association. Just as dissident surrealism explored cultural otherness only in part to indulge in a ritual of self-othering, so the *négritude* movement naturalized cultural otherness only in part to be constrained by this second nature. In quasi-anthropological art today this primitivist fantasy is only residual. However, the realist assumption—that the other is *dans le vrai*—remains strong, and often its effect, now as then, is to *detour* the artist. What I mean is simpler than it sounds. Just as the productivist sought to stand in the reality of the proletariat only in part to sit in the place of the patron, so the quasi-anthropological artist today may seek to work with sited communities with the best motives of political engagement and institutional transgression, only in part to have this work recoded by its sponsors as social outreach, economic development, public relations . . . or art.

This is not the facile complaint of personal co-option or institutional recuperation: that the artist is only tactical in a careerist sense, or that the museum and the

media absorb everything in pure malevolence (indeed we know they cannot). Rather my concern is with the *structural effects* of the realist assumption in political, here quasi-anthropological, art, in particular with its siting of political truth in a projected alterity. I mentioned the problem of automatic coding of artists vis-à-vis alterity, but there are additional problems here as well: first, that this projection of politics as other and outside may detract from a politics of here and now. And second, since it is in part a projection, this outside is not other in any simple sense.

Let me take these two problems one at a time. First, the assumption of outside-ness. If it is true that we live today in a near-global economy, then a pure outside can no longer be presupposed. This recognition does not totalize the world system; instead, it specifies resistance to it as an immanent relation rather than a transcendental one. And, again, a strategic sense of complex imbrication is more pertinent to our postcolonial situation than a romantic proposal of simple opposition.[6] Second, the projection of alterity. As this alterity becomes always imbricated with our own unconscious, its effect may be to "other" the self more than to "selve" the other. Now it may be, as many critics claim today, that this self-othering is crucial to a revised understanding of anthropology and politics alike; or, more circumspectly, that in conjunctures such as the surrealist one the troping of anthropology as auto-analysis (as in Leiris) or social critique (as in Bataille) is culturally transgressive, even politically significant. But there are obvious dangers here as well. Then as now such self-othering easily passes into self-absorption, in which the project of "ethnographic self-fashioning" becomes the practice of philosophical narcissism.[7] To be sure, such reflexivity has done much to disturb reflex assumptions about subject positions, but it has also done much to promote a masquerade of the same: a vogue for confessional testimony in theory that is sometimes sensibility criticism come again, and a vogue for pseudoethnographic reports in art that are sometimes disguised travelogues from the world art market. Who in the academy or the art world has not witnessed these new forms of *flânerie?*

What has happened here? What misrecognitions have passed between anthropology and art and other discourses? One can point to a whole circuit of projections and reflections over the last decade at least. First, some critics of anthropology developed a kind of artist-envy (the enthusiasm of James Clifford for the juxtapositions of "ethnographic surrealism" is an influential instance).[8] In this envy the artist becomes a paragon of formal reflexivity, sensitive to difference and open to chance, a self-aware reader of culture understood as text. But is the artist the exemplar here, or is this figure not a projection of a particular ideal ego—of the anthropologist as collagist, semiologist, avant-gardist?[9] In other words, might this artist-envy be a self-idealization? Rarely does this projection stop there, in anthropology and art, or, for that matter, in cultural studies or new historicism. Often it extends to the *object* of these investigations, the cultural other, who also reflects an ideal image of the anthropologist, artist, critic, or historian. To be sure, this pro-

jection is not new to anthropology: some classics of the discipline (e.g., *Patterns of Culture* by Ruth Benedict) presented whole cultures as collective artists or read them as aesthetic "patterns" of symbolic practices. But they did so openly; current critics of anthropology persist in this projection, only they call it demystification.[10]

Today this envy has begun to run the other way too: a kind of ethnographer-envy consumes artists. Here as well they share this envy with critics, especially in cultural studies and new historicism, who assume the role of ethnographer, usually in disguised form—the cultural-studies ethnographer dressed *down* as a fellow fan (for reasons of political solidarity—but with what social anxieties!); the new-historicist ethnographer dressed *up* as a master archivist (for reasons of scholarly respectability—to outhistorian the historians).[11] But why the particular prestige of anthropology in contemporary art? Again, there are precedents of this engagement: in Surrealism, where the other was figured as the unconscious; in *art brut,* where the other represented the anticivilizational; in Abstract Expressionism, where the other stood for the primal artist; and variously in the art of the 1960s and '70s (the Primitivism of earthworks, the art world as anthropological site, and so on). But what is particular about the present turn? First, anthropology is prized as the science of *alterity;* in this regard it is second only to psychoanalysis as a lingua franca in artistic practice and critical discourse alike.[12] Second, it is the discipline that takes *culture* as its object, and it is this expanded field of reference that postmodernist art and criticism have long sought to make their own. Third, ethnography is considered *contextual,* the rote demand for which contemporary artists share with many other practitioners today, some of whom aspire to fieldwork in the everyday. Fourth, anthropology is thought to arbitrate the *interdisciplinary,* another rote value in contemporary art and theory.[13] Finally, fifth, it is the *self-critique* of anthropology that renders it so attractive, for this critical ethnography invites a reflexivity at the center even as it preserves a romanticism of the margins. For all these reasons rogue investigations of anthropology, like queer critiques of psychoanalysis, possess vanguard status today: it is along these lines that the critical edge is felt to cut most incisively.

This turn to the ethnographic, it is important to see, is not only an external seduction; it is also driven by forces immanent to advanced art, at least in Anglo-American metropoles, forces I can only sketch here. Pluralists notwithstanding, this art has a trajectory over the last thirty-five years, which consists of a sequence of investigations: from the objective constituents of the art work first to its spatial conditions of perception, then to the corporeal bases of this perception—shifts remarked in minimalist work in the early 1960s through conceptual art, performance, body art, and site-specific work in the early '70s. Along the way the institution of art could no longer be described simply in terms of physical space (studio, gallery, museum, and so on): it was also a discursive network of other practices and institutions, other subjectivities and communities. Nor could the observer of art be delimited only phenomenologically: he or she was also a social subject defined in various languages and marked by multiple differences (sexual, ethnic,

and so on). Of course these recognitions were not strictly internal to art. Also crucial were different social movements (feminism above all) as well as diverse theoretical developments (the convergence of feminism, psychoanalysis, and film; the recovery of Gramsci; the application of Althusser; the influence of Foucault; and so on). The important point is that art thus passed into the expanded field of culture that anthropology is thought to survey.

And what are the results? One is that the ethnographic mapping of a given institution or a related community is a primary form that site-specific art now assumes. This is all to the good, but it is important to remember that these pseudoethnographic critiques are very often commissioned, indeed franchised. Just as appropriation art became an aesthetic genre, new site-specific work threatens to become a museum category, one in which the institution *imports* critique for purposes of inoculation (against an immanent critique, one undertaken by the institution, within the institution). This is an irony *inside* the institution; other ironies arise as site-specific work is sponsored *outside* the institution, often in collaboration with local groups. Here, values like authenticity, originality, and singularity, banished under critical taboo from postmodernist art, return as properties of the site, neighborhood, or community engaged by the artist. There is nothing intrinsically wrong with this displacement, but here too it is important to remember that the sponsor may regard these "properties" as just that—as sited values to develop.[14] Of course the institution may also exploit such site-specific work in order to expand its operations for reasons noted above (social outreach, public relations, economic development, and art tourism).[15] In this case, the institution may displace the work that it otherwise advances: the show becomes the spectacle where cultural capital collects.

I am not entirely cynical about these developments. Some artists have used these opportunities to collaborate with communities innovatively: for instance, to recover suppressed histories that are sited in particular ways, that are accessed by some more effectively than others. But I am skeptical about the effects of the pseudoethnographic role set up for the artist or assumed by him or her. For this setup can promote a presumption of ethnographic authority as much as a questioning of it, an evasion of institutional critique as often as an elaboration of it.

Consider this scenario, a caricature, I admit. An artist is contacted by a curator about a site-specific work. He or she is flown into town in order to engage the community targeted for collaboration by the institution. However, there is little time or money for much interaction with the community (which tends to be constructed as readymade for representation). Nevertheless, a project is designed, and an installation in the museum and/or a work in the community follows. Few of the principles of the ethnographic participant-observer are observed, let alone critiqued. And despite the best intentions of the artist, only limited engagement of the sited other is effected. Almost naturally the focus wanders from collaborative investigation to "ethnographic self-fashioning," in which the artist is not decentered so much as the other is fashioned in artistic guise.[16]

Again, this projection is at work in other practices that often assume, covertly or

otherwise, an ethnographic model. The other is admired as one who plays with representation, subverts gender, and so on. In all these ways the artist, critic, or historian projects his or her practice onto the field of the other, where it is read not only as authentically indigenous but as innovatively political! Of course, this is an exaggeration, and the application of these methods has illuminated much. But it has also obliterated much in the field of the other, and in its very name. This is the opposite of a critique of ethnographic authority, indeed the opposite of ethnographic method, at least as I understand them. And this "impossible place" has become a common occupation of artists, critics, and historians alike.

NOTES

1. The fact that Stalin had condemned this culture by 1934 is only one of the ironies that twist any reading of "The Author as Producer" (Benjamin [1934] 1978) today (to say nothing of "The Work of Art in the Age of Mechanical Reproduction" [Benjamin 1968]). My title may also evoke "The Artist as Anthropologist" by Joseph Kosuth (1975), but our concerns are quite different.

2. This danger may deepen rather than diminish for the artist perceived to be other, for he or she may be asked to assume the role of native informant as well. Incidentally, the charge of "ideological patronage" should not be conflated with "the indignity of speaking for others." Pronounced by Gilles Deleuze in a 1972 conversation with Michel Foucault, this taboo circulated widely in American criticism of the left in the 1980s, where it produced a censorious silent guilt as much as it did an empowered alternative speech. See Foucault (1977:209).

3. This position is advanced in an early text by the figure who later epitomized the contrary position. In the conclusion of *Mythologies*, Roland Barthes writes:

> There is therefore one language which is not mythical, it is the language of man as a producer: wherever man speaks in order to transform reality and no longer to preserve it as an image, wherever he links his language to the making of things, metalanguage is referred to a language-object, and myth is impossible. This is why revolutionary language proper cannot be mythical. ([1957] 1972:146)

4. This fantasy also operated in the productivist model to the extent that the proletariat was often seen as "primitive" in this sense too.

5. For a related discussion of these problems, see Foster (1993).

6. It is in this sense that critics like Homi Bhabha have developed such notions as "third spaces" and deferred times.

7. James Clifford develops the notion of "ethnographic self-fashioning" in *The Predicament of Culture* (1988), in part from Stephen Greenblatt (1980). This source points to a commonality between the critique of ethnography in new anthropology and the critique of history in new historicism (on which more below).

8. Clifford also develops this notion in *The Predicament of Culture*: "Is not every ethnographer something of a surrealist, a reinventor and reshuffler of realities?" (1988:147). Some have questioned how reciprocal art and anthropology were in

the surrealist milieu. See, for example, Jean Jamin (1986) and Denis Hollier (1992).

9. Is there not, in other words, a poststructuralist projection akin to the structuralist projection critiqued long ago by Pierre Bourdieu in *Esquisse d'une théorie de la pratique* (1972)?

10. Incidentally, this artist-envy is not unique to new anthropology. It was at work, for example, in the rhetorical analysis of historical discourse initiated in the 1960s. "There have been no significant attempts," Hayden White wrote in "The Burden of History" (1966), "at surrealistic, expressionistic, or existentialist historiography in this century (except by novelists and poets themselves), for all of the vaunted 'artistry' of the historians of modern times" (White 1978:43).

11. Obviously there are other dimensions of these crossings-over, such as the curricular wars of the last decade. First some anthropologists adapted textual methods from literary criticism. Now some literary critics respond with pseudoethnographies of literary cultures. In the process some historians feel squeezed on both sides. This is not a petty skirmish at a time when university administrators study enrollments closely—and when some advocate a return to the old disciplines, while others seek to recoup interdisciplinary ventures as cost-effective moves.

12. In a sense, the *critique* of these two human sciences is as fundamental to postmodern discourse as the *elaboration* of them was to modern discourse.

13. Louis Althusser (1990:97) writes of interdisciplinarity as "the *common theoretical ideology* that silently inhabits the 'consciousness' of all these specialists . . . oscillating between a vague spiritualism and a technocratic positivism."

14. I am indebted in these remarks to my fellow participants in "Roundtable on Site-Specificity," *Documents* 4 (1994): Renee Green, Mitchell Kane, Miwon Kwon, John Lindell, and Helen Molesworth. There Kwon suggests that such neighborhood *place* is posed against urban *space* as difference against sameness. She also suggests that artists are associated with places in a way that connects identity politics and site-specific practices—the authenticity of the one being invoked to bolster the authenticity of the other.

15. Some recent examples of each: social outreach in "Culture in Action," a public art program of Sculpture Chicago in which selected artists collaborated with community groups; economic development in "42nd Street Art Project," a show that could not but improve the image of Times Square for its future redevelopment; and recent projects in several European cities (e.g., Antwerp) in which site-specific works were deployed in part for touristic interest and political promotion.

16. Consider, as an example, one project in "Project Unité," a show of site-specific works by some forty artists or artist groups within the Le Corbusier Unité d'Habitation in Firminy, France, in summer 1993. In this project, the neo-conceptual duo Glegg and Guttman asked the Unité inhabitants to contribute favorite cassettes toward the production of a discothèque. The tapes were then edited, compiled, and displayed according to apartment and floor. The sociological condescension in this facilitated self-representation is extraordinary.

REFERENCES

Althusser, Louis

1990 "Philosophy and the Spontaneous Ideology of the Scientists." In *Philosophy and the Spontaneous Ideology of the Scientists and Other Essays*. London: Verso.

Barthes, Roland

[1957] 1972 *Mythologies*. Trans. Annette Lavers. New York: Hill and Wang.

Benedict, Ruth

1934 *Patterns of Culture*. New York: Houghton Mifflin.

Benjamin, Walter

[1934] 1978 "The Author as Producer." In *Reflections*. Ed. Peter Demetz, trans. Edmund Jephcott, pp. 220–238. New York: Harcourt Brace.

1968 "The Work of Art in the Age of Mechanical Reproduction." In *Illuminations: Essays and Reflections*, ed. Hannah Arendt, trans. Harry Zohn, pp. 217–251. New York: Schocken Books.

Bourdieu, Pierre

1972 *Esquisse d'une théorie de la pratique*. Paris: Droz.

Clifford, James

1988 *The Predicament of Culture: Twentieth-Century Ethnography, Literature, and Art*. Cambridge, Mass.: Harvard University Press.

Foster, Hal

1993 "The Politics of the Signifier: A Conversation on the Whitney Biennial." *October* 66(4):3–28.

Foucault, Michel

1977 *Language, Counter-Memory, Practice*. Ithaca: Cornell University Press.

Greenblatt, Stephen

1980 *Renaissance Self-Fashioning*. Chicago: University of Chicago Press.

Hollier, Denis

1992 "The Use-Value of the Impossible." *October* 60(2):3–24.

Jamin, Jean

1986 "L'ethnographie mode d'inemploi. De quelques rapports de l'ethnologie avec la malaise dans la civilisation." In J. Hainard and R. Kaehr, eds., *Le mal et la douleur*. Neuchâtel: Musée d'ethnographie.

Kosuth, Joseph

1975 "The Artist as Anthropologist." Fox 1. 1991. Reprinted in *Art After Philosophy and After, Collected Writings, 1966–1990*, pp. 107–128. London and Cambridge, Mass.: MIT Press.

White, Hayden

1978 "The Burden of History." In *Tropics of Discourse*, pp. 27–50. Baltimore: Johns Hopkins University Press.

ELEVEN

The Female Aesthetic Community

Judith L. Goldstein

The most beautiful face in the world? It's not Elizabeth Taylor's, not Christie Brinkley's, not Brooke Shields's—it's yours. This is not advertising copy—it's what I truly believe. The reason why your face is so beautiful is that it's unique. It has your incredible depth and personality written all over it. It has your creativity and radiance.

LAUDER (1985)

The great modernisms were, as we have said, predicated on the invention of a personal, private style, as unmistakable as your fingerprint, as incomparable as your own body. But this means that the modernist aesthetic is in some way organically linked to the conception of a unique self and private identity, a unique personality and individuality, which can be expected to generate its own unique vision of the world and to forge its own unique, unmistakable style.

JAMESON (1988)

In an influential set of articles, Fredric Jameson has described postmodernism as a new "periodizing concept whose function is to correlate a new type of social life and a new economic order—what is often euphemistically called modernization, postindustrial or consumer society, the society of the media or the spectacle, or multinational capitalism" (Jameson 1988:15). This new type of social life and new economic order would also seem to require a new cultural order, a different set of cultural representations. If, as Jameson says, the modernist aesthetic is linked to the conception of a unique self, then what idea of the individual is associated with the postmodernist aesthetic? The postmodern has come to stand for "new constructions of the self, no longer caught in the mythology of the unified subject, embracing of multiplicity" (Bordo 1991:107), or, more familiarly, the death of the subject, which as Jameson puts it, is the "end of individualism as such" (1988:17).

Jameson and other theorists of modernity have learned from Las Vegas, that is, they have taken much of their evidence for a new order of cultural representations from "that whole landscape of advertising" (ibid.: 14). I want in turn to look at that landscape from a more historical and feminist perspective. My readings challenge certain postmodernist interpretations of the ways in which consumer culture incorporates and names its subjects. I will argue that the rumors of the death of the subject in "postmodern" consumer culture have been greatly exaggerated. In spite of

the claim that "one fundamental feature of all the postmodernisms [is] the efface-
ment in them of the older (essentially high-modernist) frontier between high cul-
ture and so-called mass or commercial culture" (Jameson 1984:54), more analyti-
cal attention has been paid to what we can consider the high culture aspects of
mass culture, such as film and architecture, than to advertising, women's maga-
zines, or fashion.

We need ethnographies, large and small, totalizing and partial, of late capital-
ism. Jameson has quite rightly drawn our attention to the necessity and the diffi-
culty of drawing cultural maps for cultural institutions in which we participate. I
call for ethnographies because I think we need to reinstate the dialectic between
demystification and close readings of cultural forms. Too often it appears as if the
rhetoric of consumer culture is not worth examining in any detail because we think
we already know what it says. We can almost be said to know the demystified form
better than we know the commodified form.

What follows, then, can be considered notes toward an ethnography of late
capitalism. I will examine the world of fashion and advertising through the exam-
ple of makeup—through mass-market makeover videotapes which instruct women
in how to apply makeup. These videotapes are advertised in women's magazines
(in paid ads as well as editorial pages) and on late-night television. They are bought
by mail or in stores such as the Body Shop, which markets a tape demonstrating its
own products, to be viewed at home. The makeover tapes can stand in general
for women's fashion, but I will use them in particular to elucidate what it means to
define an aesthetic in spheres outside those which have the most cultural legiti-
macy.[1] Such finely calibrated readings of beauty product advertising are needed to
show how popular aesthetics defines the female subject and places her in what I
will call the "female aesthetic community." These readings make it hard to prove
that the evidence for the death of the subject can be taken from advertising,
although the presentation of the female subject in the makeover videotapes is cer-
tainly not unproblematic.

The world of makeup advertising (and fashion more generally) is an ideal place
for finding (postmodern) plural selves and free-floating signifiers, but it is also a
place where the modernist self is quite at home. The modernist self is comfortable
in the realm of makeup advertising partly because makeup is a product of moder-
nity.[2] Makeup was part of the apparatus which constructed the modern female
self by enabling proper, bourgeois women to remain proper in public in mid-nine-
teenth-century Paris. According to Charles Baudelaire, who more or less coined
the term modernity, "Woman is quite within her rights, indeed she is even accom-
plishing a kind of duty, when she devotes herself to appearing magical and super-
natural" by wearing makeup in public. Makeup became encoded not as emblem-
atic of the "painted lady" of suspect morals, but as decorous, a second skin indeed,
which enabled proper women to leave the private domain. Makeup protected the
woman, but it can also be said to have protected the public domain by containing

her—makeup was both adornment and constraint, which by creating "an abstract unity in the colour and texture of the skin . . . immediately approximates the human being to the statue" (Baudelaire [1863] 1964:33).

In the late-nineteenth-century United States, the use of makeup by bourgeois women was connected to the moral discussion concerning the relationship between inner character and external appearance. The dissimulation which was increasingly thought to be necessary in urban life was also threatening to the transparency that ideally characterized the honest man. Women, blushing to show true feeling, and increasingly making up that blush to stand for true feeling, mediated between the uncertain moral behavior of public space and the more predictable and controlled morals of the private domain.[3] Thus we can say that makeup was already seen as something proffered to be read, something already understood as constructing a public self which might, or might not, accurately reflect a private self. The middle-class woman, for socially acceptable reasons, might want to manipulate and choose her public face.

Makeup, then, makes possible the visualization of a public face which encoded, and still encodes, class as well as gender and "personality."[4] Makeup advertising, a particularly gendered part of the consumer discourse, constructs women as objects while appealing to them as subjects. The advertising presents women as aesthetic objects of contemplation, on a par with other beautiful things (while also taking advantage of them as social beings educated into and living within the social world of general beauty standards). It also appeals to them as subjects who can choose (images and products) according to their own "personalities."[5]

The makeup discourse assumes that a rupture between self-as-object and self-as-subject, and between the desired self and the socially perceived self, is possible. The world of beauty is one in which an imagined or desired self can be the truer self, the hidden self which has to break through to the visible material body. This legitimization of fantasy would seem to require modes of personalization to support images of standardization. The makeup discourse has to support a woman's desire to legitimate not only "who she is," but also who she would like to be.

Although we might assume that makeup would be particularly amenable to a postmodernist discussion of a play with surfaces, I will argue that it is on the contrary a domain where many of the "fundamental depth models which have generally been repudiated in contemporary theory" (Jameson 1984:61) are very much alive. These include the "hermeneutical model of inside and outside," the "dialectical one of essence and appearance," the "existential model of authenticity and inauthenticity," and "the great semiotic opposition between signifier and signified" (ibid.). The makeup discourse would appear to have retained the rhetoric of modernity in a postmodern world. Perhaps this points to uneven development in the cultural logic of late capitalism—discourses which address women lag behind. Or perhaps the enactment and performance of the notion of gender is too important to give up, so gender remains a still point (or the one still point) in the postmodern flux. Or perhaps, again, if the female consumer as a subject is dead, it may be

because she has been killed off as a subject worthy of attention in postmodern the-
ory and not because of the discourses which address her in consumer culture.

THE WORLD OF THE VIDEOTAPES

The most banal tasks always include actions which owe nothing to the pure and simple quest
for efficiency, and the actions most directly geared towards practical ends may elicit aesthetic
judgments, inasmuch as the means of attaining the desired ends can always be the object of a
specific valuation: there are beautiful ways of ploughing or trimming a hedge, just as there are
beautiful mathematical solutions or beautiful rugby manoeuvres. Thus, most of society can be
excluded from the universe of legitimate culture without being excluded from the universe
of aesthetics.
BOURDIEU (1990)

The makeover videotapes try to mass-market personal attention. One makeup
artist says, "You can't take me home with you and a lot of people wish I was there
with them at 8:00 in the morning to help them get ready for work, but what I can
do is send you home with one of my videotapes." The makeup artists make a point
of directly addressing viewers in an attempt to replicate the individual attention
that female customers get at the makeup counters of department stores. The
makeover tapes, which run for about an hour, show viewers how to apply makeup
to their own faces by performing makeovers on a variety of women who serve as
models. The tapes sell both products and skills. They market specific makeup
products (for example, Victoria Jackson and Linda Mason represent their own
product lines, Barbara Daly that of the Body Shop) and also advertise the skills
and strategies of the makeup artists themselves who are available, off-tape, for pri-
vate, customized, and more expensive makeup lessons. In some cases, as with Vic-
toria Jackson Cosmetics, Inc. (which acquires the customer's phone number and
address when she purchases the tape with a credit card over the phone), the cus-
tomer is regularly contacted after the tape has been ordered. This company sends
out chatty newsletters with photographs of Victoria Jackson and her family as well
as information about new products, and maintains phone contact with customers,
making free offers and follow-up calls after orders have been placed. The
makeover tapes thus sell products, skills, and services. What concerns me here is
the way in which they also construct a public—a community of women who learn
to see themselves and others in culturally particular ways.

From this perspective, the aim of the makeover tapes[6] is a double transforma-
tion: first a transformation of faces from less ideal to more ideal (both the faces in
the video and the face at home), and second, a transformation of the gaze of the
viewer. The gaze must be transformed from innocent (or uninformed/unformed)
vision to critical judgment. The critical judging gaze of the beauty world can be
seen as a unified "scopic regime" that seeks both to limit differences in seeing (and
then differences in what is seen—which is its action in the world) and to incorpo-
rate as much of the world as possible within its gaze. Thus the viewer of the video-

tape, who presumably has some knowledge of her own flaws (or else why buy the tape?), is trained to see others' flaws as much as she is educated in how to correct her own. (She is also trained to spot good features which should be "brought out," but this finding of the good is not emphasized as much as the finding of the bad.)

The viewer's vision is trained to coincide with that of the makeup artist—who asks in various ways throughout the tape, "Do you see what I see?" and announces, "This is what I see." One makeup artist asks the viewer to look at herself carefully in the mirror. "I want you to be able to look in the mirror and to really recognize your strengths and your weaknesses." She says about the woman she is making over, "Now Laurie has eyes that are just a little close set together. . . . What we're going to do is actually reshape her eye. . . . I'm almost going to paint on where the eyebrow should be." Sir Joshua Reynolds could have been speaking from her perspective when he wrote,

> All the objects which are exhibited to our view by nature, upon close examination will be found to have their blemishes and defects. The most beautiful forms have something about them like weakness, minuteness or imperfections. But it is not every eye that perceives these blemishes. It must be any eye long used to the contemplation and comparison of these forms; and which, by a long habit of observing what any set of objects of the same kind have in common, has acquired the power of discerning what each wants in particular. (Reynolds [1769] 1981:44)

It is this discerning eye which the student of makeup learns to acquire. Although she is explicitly learning a procedure—the application of makeup—she is also more implicitly learning to convert the innocent gaze to one of critical judgment. The makeup artists are selling their skills and their makeup products, but they are also selling the discerning eye. That the selling of the discerning eye is not explicit is also the result of its historical origin in the fine arts; it is something situated ideally outside the sphere of commodification.

The viewer is asked to apply a critical aesthetic to her own face, an aesthetic which ranges from simple classifications to more complex distinctions: "Is my face round, oval, square, heart-shaped?" "Do my lips droop?" "Are they clearly defined?" The makeup artist can be very direct. "As I said before," she tells a client, "your lips are very undefined lips." As a woman watches the tape, she is to do what is shown, that is, she becomes both the makeup artist and the client as she does to herself what the makeup artist is doing to the model. She needs to determine which makeup hints apply to her. "This advice is for any face that is especially narrow"; she learns that "blue hues [are] so flattering to dark eyes."

As the makeup artist applies cosmetics, she explains at every step what it is that she is doing. She tells the audience that she is applying foundation or powder and provides hints about technique. "Always apply foundation with a sponge." She also provides insight into the aesthetic choices she makes as a makeup artist. "I love the contrast between Cora's pale skin and her dark hair, so I will use a light-colored foundation." Her suggestions encompass not just facial features, but a total

image which externalizes personality. "Rachel's fashionable personality can be strengthened still more by the application of a blue-red lipstick."

This learning by doing is itself enough to deny makeup the classification of high art, to condemn it to the middle. It partakes of the electronic age's equivalent of the old painting-by-number, the television shows during which viewers at home, in half an hour, reproduce an oil painting a painter produces in the television studio, or a meal following the instructions of a television cook. As Bourdieu points out in his study of amateur photographers, the vocabulary of art which is found in all these domains embodies cultural striving: "It is in this way that members of photographic clubs seek to ennoble themselves culturally by attempting to ennoble photography, a substitute within their range and grasp for the higher arts" (Bourdieu 1990:9).

The transformation of the innocent gaze into one of critical judgment, which occurs upon entry into the world of beauty, is at once social and subjective; it is aimed at other women and at oneself. The standardization of a critical vision is both equalizing and effacing. It applies a universal standard of judgment to women's faces regardless of class, race, or ethnicity. It misrecognizes that the standards of judgment have a particular history and stem from the eighteenth- and nineteenth-century European aesthetic ideal of the proportions in Greek sculpture (i.e., the faces and profiles of Greek statuary). This aesthetic ideal was specifically constructed in opposition to a set of denigrated features, variously presented as animal, African, lower class, or criminal. Superior facial features—which denoted intelligence, morality, and beauty—were those most unlike the features judged animal-like, such as a sloping forehead or a pug nose.

THE FEMALE AESTHETIC COMMUNITY

Feminism tended to forge new solidarities in breaking those partitions proper to femininity which are not the divisions of class, but are those which create the unequal distribution of beauty.
HABIB (1987)

The works of mass culture cannot be ideological without at one and the same time being implicitly or explicitly Utopian as well.
JAMESON (1979)

This combination of equalizing (standardizing) and effacing emphasizes that together women potentially constitute what I call a "female aesthetic community" while it finesses what might otherwise divide or unite them. This community is democratic and, in its erasure of difference, oddly utopian. The male gaze is never introduced as such. Men are safely other and safely heterosexual. In one tape, a male interviewer asks, a little plaintively, "What about men?" and is told that, with the new techniques demonstrated by the makeup artist, men can use makeup to appear more "masculine." In another tape, the makeup artist mentions that men

attended a makeup class she taught at UCLA and expresses her relief that the men said they had no prior experience with makeup. This strategy briefly opens up sexual categories only to close them down again, which is not unique to the world of makeup.[7]

The men in this female aesthetic community can be potentially incorporated as a parallel set of people who can also use makeup to enhance the embodiment of *their* gender. They are not presented as the source of aesthetic surveillance. It is not men who maintain this scopic regime; on the contrary, men themselves can be, and desire to be, encompassed within it. In this way, what I am calling the gaze-as-critical-judgment is naturalized as a universal ideal. It encompasses men and women and is measured in such neutral, almost mathematical, gestures as the makeup brush being laid across the nose to the eyebrow. Other techniques, like this one, share a high-art vocabulary. When a line is filled in under the eye, we are told that it is called "stippling." The critical eye is itself a kind of tool deployed by the philosopher/artist: we are never told exactly what it is that the angle of the makeup brush is measuring, how much is too wide or too narrow, at what point something must be fixed or can be left alone, or what less than perfect attributes can be emphasized for character. Thus this middle art, which pertains to women and decoration and vulgarly reveals its procedures, also refers to such sacred and purer spheres of cultural legitimacy as high art and mathematics. The source of the gaze-as-critical-judgment is thus presented as aesthetic and transcendent; it emanates neither from a historical moment which valorized the appearance of European upper-class whites over everybody else nor from a particular position or social group in contemporary society.

Aesthetic judgments are the only social standards which are applied in the female aesthetic community. In one tape an African-American woman is introduced as having a "perfect oval" face, shape of face being the main differentiating category for the five women who get makeovers on this tape. Her color is referred to—or the category of race misrecognized while being recognized—when it is disclosed that she has had trouble finding a foundation which matches her skin and stays on. This gives the makeup artist a chance to talk about the "darker" skins and about how one needs to choose, according to one's color, whether to emphasize the "red or yellow tones." Because darker than what is never stated, a multiracial universe is elided, and the implication which remains is that women form one group, one race-like category, although they occupy different positions on the color chart.[8]

Major cosmetics companies have only recently (September 1991) responded to what one market researcher has called "the tanning of America" (Kerr 1991:D15) by presenting expanded color palettes "designed for black, Hispanic and Asian women" (ibid.). The new lines offer darker shades of makeup and bear such names as "Shades of You" (Maybelline), "All Skins" (Prescriptives), "Shade Extensions" (Body Shop), and "Darker Tones of Almay" (Revlon/Almay). Although it will be interesting to follow the advertising for these lines, the rhetoric thus far has

remained within the context of color and difference which I analyze here. For example, an article in a women's fashion magazine explains,

> This new trend isn't just about creating ethnic-specific cosmetics: in doing its research, Prescriptives discovered that a Chinese-American woman may have the same coloring as a pale Swede, and an Italian may have a skin tone identical to a light African-American. "Skin is skin," says Sylvia Chantecaille, senior executive of creative marketing for Prescriptives, who was instrumental in developing All Skins. (Scandura 1991:138)

In the discourse of the world of beauty, aesthetic categories exist in uneasy relation to social classifications, and therefore the cosmetics industry at once announces and denies "ethnic-specific cosmetics."

Thus, in the world of beauty, each woman is one in a set of permissible variations of color and feature, a variation on the same basic model. The assembly-line beginning of one tape emphasizes this. Paired "before" and "after" photographs, one set for each woman, follow each other smartly down an invisible conveyor belt as the credits roll. The overriding metaphor here is production and, in particular, the production of variety within standardization.[9]

Makeover tapes always present a series of makeovers, never just the transformation of a single person (whereas the individual woman is the focus of the personal makeovers performed in department stores or beauty salons, see also Goldstein 1990). And, in each of the videos I reviewed, the makeup artist—who, I am arguing, embodies the transcendent viewpoint—appears in different outfits, makeups, and hairdos, like so many variations on the same person. One tape plays on this by having the interviewer ask, "Who really *is* Linda Mason?" while the pictures of the makeup artist in very different looks flash on the screen.

This plurality of women and of one woman as many women helps define a community of women and provides the metaphors of mass production, on one hand, and group conversion or baptism on the other. As I have said, from the point of view of educating the viewing subject, the variety of women's faces helps transform the innocent gaze into one of critical judgment. The two metaphors— those of production and conversion—when taken together guarantee satisfaction as well as standardization: the product will please. There are many points in the videos at which the women who have been made over are expected, in more or less modified forms, to testify. Each of the five women in one tape is asked at the end of the makeover to look at herself in the mirror for the first time. In each case, the still moment of shock is followed by a smile, for three of the women apparently heartfelt, for two far more hesitant—one doesn't trust herself to speak; the other, as far as I can tell, grimaces (although this facial rictus is interpreted as a smile and triumphantly captured in the still photograph which marks the finale of each makeover).

Once the look has been achieved in all the videos, the living person is turned into a still image and even in some cases, a two-dimensional photograph. These

are more or less aestheticized versions of the cartoon person flattened beneath a steamroller (the evil man in "Who Killed Roger Rabbit?," the nose in Woody Allen's "Sleeper"). The three-dimensional quality of the video is made to stand for real life. In contrast, the made-over person, frozen and flattened into two dimensions, becomes her own image (the signifier of her signified?). She is able to reverse the specular field described earlier: instead of modeling her (real) self on the photographed images of others, she becomes the photographed image that others (and she herself) will copy.

We could argue that it is sufficient simply to *have* that photograph, rather than having to *be* that photograph; a studio in Poughkeepsie, where I live, does precisely that—makeovers for a photograph, not for everyday copying in front of the mirror. Ordinary snapshots are treated similarly: we choose the best photographs to copy or to frame, even though we are also, in theory, motivated by a documentary desire to record. In fact, we are just as happy to keep only the best shots of the wedding, the family event, or the yearbook pose. No one asks if twenty years hence we might want to be able to consult the complete range of how we looked then, for better or worse. Even candid shots are usually held to certain minimum aesthetic standards if they are to be preserved. As a food stylist talking about photographs of food put it, "People have definite ideas about what perfection is" (Kleiman 1990:C13).[10]

It is part of the implied doctrine of the world of beauty that differences in attractiveness are the real source of inequality among women. In the female aesthetic community these differences are acknowledged, but then overcome (or rather, ostensibly overcome, as allegiance to the world of beauty is based in part on constant striving). Feminism said that aesthetic surveillance was a source of inequality—that in large part desiring to please was to capitulate to the images of a sexist culture—and advocated social change. The female aesthetic community asks only for cosmetic changes.

THE CRITICAL EYE / THE CLINICAL EYE

The makeup artist's critical eye is female and universal; just as the female aesthetic community excludes the male gaze by universalizing and thereby trying to transcend it, so the female makeup artist's authority is supposedly not "male" but "expert." However, the conflation in popular culture of the expert eye with the male eye makes the assumption of a female critical eye hard to see (and perhaps hard to sustain). Mary Ann Doane contrasts two types of classic film in terms of the way in which they treat the female body. In "mainstream classical cinema" the woman's body is presented as spectacle, "the female body exhausts its signification entirely in its status as an object of male vision" (Doane 1986:154). In contrast, in "films of the medical discourse . . . the female body is not spectacular but symptomatic, and the visible becomes fully a signifier, pointing to an invisible signified" (ibid.). In films of the medical discourse "the illness of the woman is sig-

nalled by the fact that she no longer cares about her appearance" (ibid.:155). However, the distinction between the two types of film breaks down because "the woman's 'cure' consists precisely in a beautification of body/face. The doctor's work is the transformation of the woman into a specular object" (ibid.). The doctor is able to transform the woman because his eye "unveils a previously invisible essence, ultimately the essence of the female character concerned" (ibid.:158).

The makeup artist's critical eye shares much with the clinical eye. Her aesthetics is also conflated with diagnostics. The doctor's diagnosis takes off from aesthetics, while the makeup artist's aesthetics proceeds from diagnosis. She analyzes surface appearance, but she often looks beneath the surface to what she calls "personality," which is also "ultimately the essence of the female character concerned." As makeup artist Linda Mason explained about the women she makes up, she "brings out not only their features, but would also bring out their personalities." She considers her makeovers successful because she often finds that the women "had a personality which they hadn't quite discovered," and she then makes them up in ways which are "a little bit flashier, a little bit stronger." If she sometimes finds "resistance" to her efforts on the part of the women, she thinks this is often because they "haven't gotten to that point in their life or in the development of their personality."

All the makeup artists constantly change their appearances in the tapes, but Mason in particular took those changes to another level when she showed herself in different looks flashed in rapid succession and then, unlike the other makeup artists, went off camera for the rest of the videotape's running time, leaving only her voice behind (and showing only the women being made up). I interpret this as making it impossible for the viewers or clients to read *her* body, to achieve knowledge of her personality. Generally, however, instead of putting themselves off-frame—behind the analyst's couch—the makeup artists put on many disguises to achieve a similar end.

The critical eye, then, enables the makeup artist not only to see flaws which can be corrected for a better appearance, but also to *see through* an appearance, bringing body and soul together to create a more powerful alignment of the inner and outer person.[11] Because the makeup artist is an expert diagnostician, she can discover that which the woman herself may not be able to articulate.

If the clinical and critical eyes are similar, there are nonetheless differences in their approaches to the transformative cure/makeover. Doane points out that "the overwhelming force of the drive to specularize is manifested by the fact that the [impulse to despecularize the female body in the medical discourse films] is not concretized through the representation of 'ugly' or even 'unattractive' women. When a woman is designated as 'plain' within the classical cinema, she is not really 'plain' in relation to any contemporary standards of attractiveness" (Doane 1986:157).

One of the more striking aspects of the videotapes is the degree to which they despecularize the unmade-up women—and in so doing make "spectacles" of

them. The willingness to present women who do appear " 'plain' in relation to . . . contemporary standards of attractiveness" is, of course, connected to the power of the transformation to follow; the more unprepossessing the "before" the more spectacular the "after." Nonetheless, as spectators, we are not used to staring at close-ups of women who do not conform to "contemporary standards of attractiveness." This experience undermines the "natural" association of women and beauty (of women to Woman) and emphasizes the necessity of working for beauty. It emphasizes that the female aesthetic community is a voluntary association. But it is also an effect of the uninformed eye: if we had critical eyes we would no doubt see the bone structure which assures a successful makeover.

THE DEATH OF THE SUBJECT; OR, WHOSE FACE IS IT ANYWAY?

He would see faces in movies, on TV, in magazines, and in books. He thought that some of these faces might be right for him, and that through the years by keeping an ideal facial structure fixed in his mind, or somewhere in the back of his mind, that he might, by force of will, cause his face to approach those of his ideal.
DAVID BYRNE, "SEEN AND NOT SEEN," TALKING HEADS (1980)

The man speaking the words above is not a consumer of cosmetics, apparently, although he certainly is a consumer of popular culture in the form of movies, television, magazines, and books. He would appear to be a believer in an older aesthetic in which external appearance manifests internal character, or in this case, an inner force of will (neatly located spatially "in his mind"). This molding of the face is achieved only through the imagination—without benefit of the technologies of cosmetics and plastic surgery—but it proceeds nonetheless from the contemporary acceptance of seemingly limitless physical transformations of the body, of the body as "cultural plastic" (Bordo 1991:107). The speaker combines a (modern) aesthetic/moral view of the ways in which the internal stamps the external with a (postmodern) vision of the possibilities of wholesale physical change.

The external social world threads in and out of these constructions. The speaker on "Seen and Not Seen" chooses an ideal face from the commercial, public environment in which he is immersed, and he expects his face to be interpreted in his interactions with others as accurately representing his inner state. He believes that others also mold their faces through their wills. "Maybe they imagined a new face, better suited to their personality. Or maybe they imagined that their personality could be forced to change to fit the new appearance. This is why first impressions are often correct" (Byrne: 1980).

Women are also surrounded by faces "in movies, on TV, in magazines, and in books." Although acts of the imagination are not thought to be enough to change one's face, an act of will is needed to "do something about oneself." The reward is the recognition by others that accepted standards of beauty have been achieved. "This is why first impressions are often correct."

In large part, both the man in the song and the women imagined in the makeup tapes respond to what surrounds them as consumers. They try to use what they admire in their environments to shape themselves, to find and create, for example, an "ideal facial structure." Jameson, in his discussion of the Bonaventure Hotel, the most personal and elaborated analysis in his essay "Postmodernism, or the Cultural Logic of Late Capitalism" (1984), has a series of important observations to make about this new space of postmodernism and, in particular, about its aspiration to be a "total space." Jameson visits the Bonaventure Hotel in downtown Los Angeles, finds the physical experience of this new building discomfiting, and theorizes about the ways in which his discomfort must be representative or typical of other people's reactions to postmodern space. Remarkably, however, he does not position himself as a consumer in this space. In consequence, he does not develop the connections that exist between the "landscape" of advertising and that of built consumer space.

Jameson would not appear to be a devotee of department stores. What we see in his experience of the Bonaventure Hotel is familiar as the vertigo of shopping, the planned disorientation and exhilaration of the big store. No wonder Jameson "cannot but feel that here too something of a 'return of the repressed' is involved" (ibid:88). How can he be historically and specifically situated, "to think our present of time in History" (ibid.:85), without recognizing himself as a consumer in this space and without seeing in this space the outlines of the shopping environment of our time?

Shoppers who are used to department stores probably experience a "bewildering immersion" similar to Jameson's—that giddiness which is meant to facilitate unnecessary purchases—but they are also natives here who already have their cognitive maps in place. They have ways of relating to this space which cuts it up into manageable pieces.[12] It is this familiarity which I miss in Jameson's description. It is a familiarity which comes not just from being a frequent visitor, but from being an inhabitant of "that whole landscape of advertising" which includes makeover videos, women's magazines, and television advertisements and which enmeshes them in the kinds of communicative codes I have described in this paper.

David Byrne's persona and the women the makeup discourse addresses want new faces. Their desires are influenced by what they see around them. What does Fredric Jameson, surrounded by a new, "full-blown postmodern building," want?

> I am proposing the motion that we are here in the presence of something like a mutation in built space itself. My implication is that we ourselves, the human subjects who happen into this new space, have not kept pace with that evolution; there has been a mutation in the object, unaccompanied as yet by any equivalent mutation in the subject. . . . The newer architecture therefore—like many of the other cultural products I have evoked in the preceding remarks—stands as something like an imperative to grow new organs to expand our sensorium and our body to some new, as yet unimaginable, perhaps ultimately impossible, dimensions. (Jameson 1988:231)

The building seems to induce organ envy. Jameson, experiencing the building, wants to take up more space—perhaps something like the kind of effect David Byrne achieved with the enormous suit he wore in the movie "Stop Making Sense." (Is the subject dead or just not large enough? Is the subject dead or simply under-dressed?) The idea that the body should refer to a set of stimuli outside of and larger than itself, that it should signify something other than its autobiographical self—other than its lived historical specificity—is not an effect of the postmodern environment. It has been around for a long time, and it is called fashion.[13]

After all, what is proposed above can be considered a designer theory of mutation. The musings brought on by the experience of the Bonaventure Hotel have in fact evoked the rather classic fashion dilemma of "matching": "We do not yet possess the perceptual equipment to match this new hyperspace" (Jameson 1984:80). We will find it easier to buy new outfits to satisfy the inchoate desire stirred by visual changes in the external environment than we will to grow new organs. That is, we will find it easier to consume than to produce.

I find Jameson's delineation of postmodernism as the cultural logic of late capitalism very stimulating and I want to make what troubles me about his analysis as clear as possible. I think that there are changes in the cultural field which can be usefully understood through "a periodizing hypothesis" such as postmodernism. However, I wish to question the motivation for renaming when the names already in place seem to function as well as or even better than the new ones.

We are not, I think, meant to go away from the description of the Bonaventure Hotel with the feeling that we have had an experience with fashion or with "ordinary" consumer culture. Fashion and a too-enthusiastic or uncritical response to advertising are culturally associated with women. Despite statements to the contrary, theorists of postmodernity have, as I have said, been drawn to the high-culture domains of mass culture; these are also domains that are not associated with women. Women have therefore been relegated, once again and however unintentionally, to their place outside a newly legitimated sphere of analysis, in this case the description and critique of postmodernism. If we were to see only the strangeness of the Bonaventure Hotel and not its ordinariness, we would be missing something important about the everyday cultural logic of late capitalism. And we would certainly be imagining a space without (female) consumers, which, at the very least, would be ethnographically incorrect. In short, the Bonaventure Hotel is as close to Bloomingdale's as it is to the Beaubourg.

Jameson—like all advertising targets who purchase—has been successfully hailed as a subject by an object, in this case the Bonaventure Hotel. Others stirred by new visual stimuli in their environment also feel the need to respond in the form of a physical extension of themselves. They buy shoes like the ones they have just seen, or they put on makeup to look more like the woman in an ad in a fashion magazine or to create an aesthetic whole with their new clothes (all of which are, not incidentally, forms of matching). It seems to me that in his reaction to the Bonaventure Hotel, Jameson has responded to the siren call of fashion (of con-

sumer culture), but has viewed this response differently, in a way more befitting a (male) theorist than a (female) consumer.

That the woman of fashion's self is malleable, and that her boundaries as a consumer of fashion are unstable, has long been a proposition of the fashion system. On the other hand, women, even in their role as consumers, and the advertisers who must appeal to these women, have never proceeded as if the subject were dead. The subject is alive, but s/he is not alone. Whereas Fredric Jameson and even David Byrne seem to imagine themselves coming up against the Bonaventure Hotel or facial images as radically isolated heroic individuals seeking new dimensions, consumer culture places women in a female aesthetic community. Women are separated out as individuals by being personally addressed only to be reabsorbed as more fitting members of a larger community.

Put another way, Jameson, while declaring the "unique self" of modernity inadequate for postmodern society, nonetheless responds to the Bonaventure Hotel largely along the familiar lines of the romantic individual undergoing a transcendent aesthetic experience. How this experience specifically constitutes him as a member of a postmodern consumer society is unclear. When he constructs his interaction with the Bonaventure Hotel as this kind of aesthetic experience—that is, as one appropriate to the sphere of legitimate culture—he is also defining his response as that of a theorist and not a consumer; he has not "bought into" consumer culture because his theorizing places him above it, not in it. He may present his "sensorium" as inadequate to the experience, but he is nonetheless in control of it.

By contrast, the makeup discourse both depends on an internalized concept of a unique self and exploits the insecurities that arise when this private self has to acquire an external visible form which others will interpret. This "popular" aesthetic, central to that world of fashion which has helped to define postmodern consumer society, does not deny the subject; on the contrary, it never leaves the subject alone.

The makeover videotapes, as I have argued at length, proceed from the assumption of a female aesthetic community, and recommend not new organs, but trained eyes, eyes which are meant to incorporate others into their field of vision. The female aesthetic community is based on an essential unity—that of gender ("we are all women trying, to greater or lesser extent, to be Woman")—and on a universal set of standards (with all its elisions and misrecognition of race and class) which is considered to be within the grasp of every woman. Although it is generally understood that one is born into a gender, a race, and a class, in the female aesthetic community beauty is considered achievable by all; the community is ascriptive in its procedures. The female aesthetic community does not concern itself with social change, but it imagines an aesthetic utopia nonetheless, one which, it is worth noting, is not entirely unlike that of the feminist critics of the beauty discourse. This utopian world is one in which "Cinderella fraternizes with her stepsisters, and Snow White makes common cause with the wicked witch" (Habib 1987:11, my translation).

The subject has been dislocated to a certain extent from real social systems; it is, in many ways, a shadow of itself, but it is the signified nonetheless of an always proliferating system of signifiers (or looks). The problem, then, is to demonstrate in what ways the subject has been detached from its social ground and to show how to relocate it. The real issue is the web that consumer culture weaves, functioning as both the subject's problem and solution. It participates in the alienation and fragmentation of the subject—making us worry about finding it and expressing it, as if it were some kind of distinct but attached succubus—and it recommends alleviating the pain this causes and reflects by integrating us into a community of like-minded and like-bodied individuals, in this case, the female aesthetic community.

HYPERSPACES/HYPERCROWDS: THE CULTURAL LOGIC OF LATE POSTMODERNISM

The landscape of advertising can be seen as a total space, and the stores in which makeup is bought have much in common with the space of the Bonaventure Hotel. However, it is crucial to understand that these postmodern environments, these spaces of consumer culture (and the Bonaventure Hotel is such a space) are peopled. As I have shown, the makeover videotapes are guides not only to the map of the individual face, but to the faces of others as well. While Jameson is having his transcendent aesthetic experience in a one-on-one interaction with built space, I imagine other people on the escalators and in the elevators, checking each other out. Their activity cannot simply be summed up as the "milling confusion" of a "hyper-crowd" in "hyperspace." According to Jameson, "to this new total space corresponds a new collective practice, a new mode in which individuals move and congregate, something like the practice of a new and historically original kind of hyper-crowd" (Jameson 1984:81). The merging of people and decor, or people into decor, does not necessarily present a more positive vision than do Jameson's unpeopled vistas, but I think it is certainly more accurate.

Jameson, in concluding, points to a homology between "our" inability to orient ourselves both in postmodern space and in the world of multinational capitalism. "This alarming disjunction point between the body and its built environment . . . can itself stand as the symbol and analogue of that even sharper dilemma which is the incapacity of our minds, at least at present, to map the great global multinational and decentered communicational network in which we find ourselves caught as individual subjects" (ibid.:84). But there is another analogy at work here too, and that is the one between the absence of women and consumers both from the built spaces he describes, and from the "cultural products" he chooses to analyze as representative of our moment "in History."

In sum, if postmodern theory[14] knows better than to talk about the *autonomy* of art, it has nonetheless in practice constructed a domain of cultural production which is worthy of analysis, and this domain leaves out much that concerns women's experience or anything that pertains to what I have called the female

aesthetic community. It goes so far in this direction, in fact, that it leaves out the people who inhabit the built spaces of consumer culture. In so doing, postmodern theory produces its own uncritical versions of the "hysterical sublime"—it too transforms "the alienation of daily life in the city" into the experience of "a strange new hallucinatory exhilaration" (ibid.:76).

NOTES

A preliminary short version of this paper was presented in a panel entitled "Feminism/Postmodernism/The Body" at the annual meeting of the American Anthropological Association in November 1990. A later version was read at the conference on "Persons, Passions, Powers" at the University of California at Berkeley in April 1992. Many of the issues addressed in this paper are covered at greater length in my forthcoming book on appearance and identity in consumer culture.

1. Pierre Bourdieu (1990) has described photography as a "middle-brow art." Makeup too can be defined this way because it is a decorative art, a woman's art, and depends largely in the contemporary environment on photography and film. I will have cause to wonder in this paper why postmodern theorists have not produced either deep or feminist readings of advertising. Let me say here that I think it is no accident that postmodern theory, as many have pointed out, has not truly incorporated feminist theory and that a parallel can be drawn between this omission and the status of makeup and beauty advertising. Just as there is a sphere of cultural legitimacy in high art to which makeup and makeover videotapes will never be admitted, so postmodernist theory has in practice carved out for itself a domain of cultural legitimacy in academia where feminist theory seems to occupy a position much like that of makeup and photography in the high arts. It is a middle theory lacking the virile authenticity of the low and the aristocratic cachet of the high. It is, therefore, unforgivably middlebrow, a theory associated with women and (often) with the practical concerns of political engagement. This aura of practicality relates on one hand to women's domestic concerns, such as cooking, and on the other hand, within the university, to such noncanonized programs as African-American or Chicano studies (which can be contrasted to other, possibly small but differently located, programs, such as Victorian or Renaissance studies).

2. For a discussion of the relationship between modernity and makeup in nineteenth-century Paris, see Goldstein (1990).

3. According to Karen Halttunen (1982:160–161), "It was becoming evident in the 1850s that sentimental anxieties about the hypocrisy of fashion were on the wane. In discussions of dress, character was coming to be regarded as a matter of personal style, to be assumed as one donned a particular dress or cloak or hair style. . . . Most important, the sentimental dread of hypocrisy was yielding to a new appreciation for the aesthetic value of personal disguise."

4. Makeup presents a public, gendered self. But it also signifies some notion of group or "class." The U.S. cosmetics industry segmented itself early on into three

markets: "class," "mass," and "ethnic" (Peiss 1990:144). The "class" market tried to replace makeup's lingering negative associations with luxurious European ones, while the "mass" market's customer sometimes preferred obvious makeup which marked "a distinctive and provocative cultural style, if not an oppositional aesthetics" (Peiss 1990:145). Thus it can be said, as Bourdieu (1990) argues is more generally true of the relationship between class and taste, that the "mass" and "ethnic" markets provided aesthetics which were both dominated and alternate and, therefore, needed to be understood as operating with and against the "class" market and each other to maintain distinctions.

5. For more on developing ideas about the "personality" in late-nineteenth-century American culture, see the article by Warren Susman in which he describes the efforts made then to find "modes of externalization" (1979:222) for the personality.

6. E. Ann Kaplan, when delineating certain characteristics of the MTV spectator, notes that she is talking about "the 'model spectator' the [television] apparatus constructs" (Kaplan 1988:44 n. 26). Likewise, I am speaking here of the model consumer constructed by advertising.

7. Its logic is incorporated, for example, in the cover description of an article on "lesbian lifestyles" featured in *Cosmopolitan* magazine: "What Another Woman Taught Me About Love (My Husband Was Grateful)" (Rand 1990).

8. Speaking of an early period in U.S. cosmetics advertising, Peiss (1990:164) likewise suggests that, "the cosmetics industry has historically taken discourses of class, ethnicity, race, and gender—discourses that generate deeply held conscious and unconscious feelings of fear, anxiety, and even self-hatred—and displaced them onto safe rhetorical fields." See also Bordo:199.

9. In her book *The Woman in the Body*, Emily Martin (1987) discusses metaphors of production found in the medical and popular discourses about female sexuality and bodily processes.

10. This quotation is taken from an article on food photography by Dena Kleiman (1990:C1, C13) entitled "Food Styling: The Art of Making the Basil Blush." The title neatly compares looking good in a photograph to makeup and to femininity.

11. The discourse of beauty in this way straddles or encompasses the birth and the death of the clinic. Says Donna Haraway (1990:194), "The clinic's methods required bodies and works; we have texts and surfaces."

12. I discuss how this space is approached at greater length in my "Makeup in the Age of Mechanical Reproduction" (Goldstein 1990). A number of the articles in the Kellner (1989) collection comment, using criteria other than my own, on Jameson's analysis of postmodern architecture. For an important early discussion on the Bonaventure Hotel, see Mike Davis ([1985] 1988).

13. Gail Faurschou (1987) in an interesting article on postmodernism and fashion, in my opinion similarly overdoses the difference made by this thing called "postmodernism." She argues that fashion "constitutes an exemplary site for

examining the cultural dislocations and contradictions of the transition from modernity to the late capitalist, new wave, postmodern era . . . the widely noted tendency towards the abstraction, disembodiment, and even disappearance of the subject is implicit in the very principles of an expanding fashion culture—that if the subject is on the way out, it is going out in style" (Faurschou 1987:69). One reason she sees fashion as so postmodern may be that she does not refer, surprisingly, to central earlier writers on fashion, such as Georg Simmel (1984) and Roland Barthes (1983).

14. I understand that postmodern theory is not one thing; I have been concerned throughout with the arguments of Jameson's "Postmodernism, or, the Cultural Logic of Late Capitalism" (1984). This article can be said to be foundational. Douglas Kellner (1989:2) wrote that it is "probably the most quoted, discussed, and debated article of the last decade." I feel compelled to add at this juncture that, of the fourteen essays in Kellner's book on Jameson's oeuvre (and Jameson's response makes fifteen), none is written by a woman and none poses a feminist critique. This adds a relevance and timeliness to my own critique, in that the next generation, so to speak, seems to be recapitulating a similar set of exclusions to those I describe here.

REFERENCES

Barthes, Roland
 1983 *The Fashion System.* New York: Hill and Wang.
Baudelaire, Charles
 [1863] 1964 *The Painter of Modern Life and Other Essays* London: Phaidon Press.
Bordo, Susan
 1991 " 'Material Girl': The Effacements of Postmodern Culture," in Laurence, Goldstein, ed., *The Female Body,* pp. 199, 106–130. Ann Arbor: University of Michigan Press.
Bourdieu, Pierre
 1990 *Photography: A Middle-brow Art.* Trans. Shaun Whiteside. Stanford: Stanford University Press.
Byrne, David
 1980 "Seen and Not Seen," from *Remain in Light.* New York: Sire Records Company.
Davis, Mike
 [1985] 1988 "Urban Renaissance and the Spirit of Postmodernism," in E. Ann Kaplan, ed., *Postmodernism and its Discontents,* pp. 79–87. New York: Verso.
Doane, Mary Ann
 1986 "The Clinical Eye: Medical Discourses in the 'Woman's Film' of the 1940s," in Susan Suleiman, ed., *The Female Body in Western Culture,* pp. 152–174. Cambridge, Mass.: Harvard University Press.
Faurschou, Gail
 1987 "Fashion and the Cultural Logic of Postmodernity." *Canadian Journal of Political and Social Theory* 11(1–2):68–82.

Goldstein, Judith L.
 1990 "Makeup in the Age of Mechanical Reproduction." Paper presented in abridged form at the annual meeting of the American Society for Aesthetics, New York, Oct. 1989.

Green, Penelope
 1991 "World Hues," *New York Times*, Aug. 18, magazine section, 38.

Habib, Claude
 1987 "Souvenirs du Feminisme," *Esprit*, 3–17.

Halttunen, Karen
 1982 *Confidence Men and Painted Women*. New Haven: Yale University Press.

Haraway, Donna
 1990 "A Manifesto for Cyborgs: Science, Technology, and Socialist Feminism in the 1980s," in L. Nicholson, ed., *Feminism/Postmodernism*, pp. 190–233. New York: Routledge.

Jameson, Fredric
 1984 "Postmodernism, or, the Cultural Logic of Late Capitalism." *New Left Review*, 146:53–92.
 1988 "Postmodernism and Consumer Society," in E. Ann Kaplan, ed., *Postmodernism and its Discontents*, pp. 13–29. New York: Verso.

Kaplan, E. Ann
 1988 "Feminism/Oedipus/Postmodernism: The Case of MTV," in E. Ann Kaplan, ed., *Postmodernism and its Discontents*, pp. 30–44. New York: Verso.

Kellner, Douglas, ed.
 1989 *Postmodernism/Jameson/Critique*. Washington, D.C.: Maisonneuve Press.

Kerr, Peter
 1991 "Cosmetic Makers Read the Census," *New York Times*, Aug. 29, D1, D15.

Kleiman, Dena
 1990 "Food Styling: The Art of Making Basil Blush," *New York Times*, Nov. 7, C1, C13.

Martin, Emily
 1987 *The Woman in the Body*. Boston: Beacon Press.

Peiss, Kathy
 1990 "Making Faces: The Cosmetics Industry and the Cultural Construction of Gender, 1890–1930." *Genders* 7(spring):143–169.

Rand, Erica
 1990 "Boucher and the Heterosexual Presumption." Paper presented at the third annual Feminist Art History Conference, Barnard College, New York.

Reynolds, Joshua
 [1769] 1981 *Discourses on Art*, ed. Robert Wark. London: Collier-Macmillan.

Scandura, Jani
 1991 "True Colors," *Mirabella*, Sept., 138.

Simmel, Georg
 [1904] 1971 "Fashion." In Donald Levine, ed., *On Individuality and Social Forms*, pp. 294–323. Chicago: University of Chicago Press.

Susman, Warren
 1979 " 'Personality' and the Making of Twentieth-Century Culture," in J.
 Higham and P. Conkin, eds., *New Directions in American Intellectual History*,
 pp. 212–226. Baltimore: Johns Hopkins University Press.

Videotapes Discussed

Daly, Barbara
 1988 *Face to Face with Barbara Daly* (London: Colourings Ltd., A Jacaranda Pro-
 duction).
Jackson, Victoria
 1989 *The Victoria Jackson Difference* (1-800-862-5387).
Mason, Linda
 1985 *Linda Mason's Professional Makeover Tape* (29 King Street, New York, New
 York 10014).

TWELVE

Four Essays on Art, Sexuality, and Cultural Politics

Carole S. Vance

OVERVIEW

These articles about visual images, sexuality, and cultural struggle in the United States were written between 1989 and 1993. Beginning in 1989, fundamentalist and moral conservative groups launched an unprecedented and highly successful attack on the National Endowment for the Arts (NEA), a federal arts funding organization. The ensuing controversy saw the meaning and content of visual imagery move center-stage in American political debate, propelled by fundamentalist preachers denouncing allegedly "pornographic" images, fulminating Congressmen who pressed for budget and administrative restrictions, sensationalist media coverage, and well-organized letter-writing campaigns by angry evangelical constituents. Skirmishes and major battles continued for several years, profoundly affecting not just visual imagery but also the shape of political debates about sexuality and gender.

At the outset, the arts community didn't know what hit it, and for good reason. It seemed improbable that the NEA, previously seen as a high-toned, even dull sponsor of worthy cultural activities like symphonies, ballets, and community arts groups—on a relatively minuscule budget—could be recast as a major promoter of "degeneracy" in American life. Indeed, previous attempts by the newly-elected Reagan administration to totally eliminate or drastically cut the NEA, largely for budgetary reasons, had failed, as the agency was vigorously defended by legislators and citizens alike. A decade later and in a period of declining conservative electoral success, what explains the stunning success of this new campaign? The visual and rhetorical strategy of "add sex and stir."

These ethnographic dispatches from the front unpack the cultural dynamics of symbolic mobilizations, in which visual imagery is both the subject of controversy

and the mechanism through which it is initiated and sustained. For at least the past hundred years in English-speaking countries, symbolic mobilizations around sexuality, gender, and family have often taken the form of sexual panics in which representation has played a vital part. In these panics, sensationalism, scandal, and narratives of sexual danger are instrumental in effecting changes in law and policy. "The War on Culture," written at the beginning of the NEA controversy, examines how and why efforts to control sexual imagery—no mere outbursts of irascible Babbitry—are central to the broader fundamentalist program for social reform. "Misunderstanding Obscenity" tracks the rhetorical slippage between "obscenity," "pornography," and "sexual imagery" that proved crucial in advancing fundamentalist arguments and goals among mainstream, even liberal audiences. "Reagan's Revenge: Restructuring the NEA" compares this successful campaign to limit the NEA with previously failed efforts, identifying the advantages of sexual panic as a political technique. "Feminist Fundamentalism—Women Against Images" explores the way in which antipornography feminists, long critical of sexual imagery in commercial pornography, censored an art exhibition for allegedly offensive imagery in the wake of the NEA furor.

Now, as in the previous century, symbolic politics have serious consequences; because images do stand in for and motivate social change, the arena of representation is an important ground for struggle.

THE WAR ON CULTURE

The storm that had been brewing over the National Endowment for the Arts (NEA) funding broke on the Senate floor on May 18, 1989, as Senator Alfonse D'Amato (R-N.Y.) rose to denounce Andres Serrano's photograph *Piss Christ* as "trash." "This so-called piece of art is a deplorable, despicable display of vulgarity," he said. Within minutes over 20 senators rushed to join him in sending a letter to Hugh Southern, acting chair of the NEA, demanding to know what steps the agency would take to change its grant procedures. "This work is shocking, abhorrent and completely undeserving of any recognition whatsoever," the senators wrote.[1] For emphasis, Senator D'Amato dramatically ripped up a copy of the exhibition catalogue containing Serrano's photograph.

Not to be outdone, Senator Jesse Helms (R-N.C.) joined in the denunciation: "The Senator from New York is absolutely correct in his indignation and in his description of the blasphemy of the so-called art work. I do not know Mr. Andres Serrano, and I hope I never meet him. Because he is not an artist, he is a jerk." He continued, "Let him be a jerk on his own time and with his own resources. Do not dishonor our Lord."[2]

The object of their wrath was a 60-by-40-inch Cibachrome print depicting a wood-and-plastic crucifix submerged in yellow liquid—the artist's urine. The photograph had been shown in an uneventful three-city exhibit organized by the

Southeastern Center for Contemporary Art (SECCA), a recipient of NEA funds. A juried panel appointed by SECCA had selected Serrano and nine others from some 500 applicants to win $15,000 fellowships and appear in the show, "Awards in the Visual Arts 7." How the senators came to know and care about this regional show was not accidental.

Although the show had closed by the end of January 1989, throughout the spring the right-wing American Family Association, based in Tupelo, Mississippi, attacked the photo, the exhibition and its sponsors. The association and its executive director, United Methodist minister Rev. Donald Wildmon, were practiced in fomenting public opposition to allegedly "immoral, anti-Christian" images and had led protests against Martin Scorsese's film *The Last Temptation of Christ* the previous summer. The AFA newsletter, with an estimated circulation of 380,000 including 178,000 churches, according to association spokesmen,[3] urged concerned citizens to protest the art work and demand that responsible NEA officials be fired. The newsletter provided the relevant names and addresses, and letters poured in to congressmen, senators and the NEA. A full-fledged moral panic had begun.

Swept up in the mounting hysteria was another photographic exhibit scheduled to open on July 1 at the Corcoran Gallery of Art in Washington, D.C. The 150-work retrospective, "Robert Mapplethorpe: The Perfect Moment," was organized by the University of Pennsylvania's Institute of Contemporary Art (ICA), which had received $30,000 for the show from the NEA. The show included the range of Mapplethorpe's images: formal portraiture, flowers, children and carefully posed erotic scenes—sexually explicit, gay, and sadomasochistic. The show had been well received in Philadelphia and Chicago, but by June 8, Representative Dick Armey (R-Tex) sent Southern a letter signed by over one hundred congressmen denouncing grants for Mapplethorpe as well as Serrano, and threatening to seek cuts in the agency's $170-million budget soon up for approval. Armey wanted the NEA to end its sponsorship of "morally reprehensible trash,"[4] and he wanted new grant guidelines that would "clearly pay respect to public standards of taste and decency."[5] Armey claimed he could "blow their budget out of the water"[6] by circulating the Mapplethorpe catalogue to fellow legislators prior to the House vote on the NEA appropriation. Before long, about 50 senators and 150 representatives had contacted the NEA about its funding.[7]

Amid these continuing attacks on the NEA, rumors circulated that the Corcoran would cancel the show. Director Christina Orr-Cahall staunchly rejected such rumors one week, saying, "This is the work of a major American artist who's well known, so we're not doing anything out of the ordinary."[8] But by the next week she had caved in, saying, "We really felt this exhibit was at the wrong place at the wrong time."[9] The director attempted an ingenious argument in a statement issued through a museum spokesperson: far from being censorship, she claimed, the cancellation actually protected the artist's work. "We decided to err on the side of the artist, who had the right to have his work presented in a non-sensationalized, non-political environment, and who deserves not to be the hostage for larger issues of

relevance to us all," Orr-Cahall stated. "If you think about this for a long time, as we did, this is not censorship; in fact, this is the full artistic freedom which we all support."[10] Astounded by the Corcoran decision, artists and arts groups mounted protests, lobbied and formed anticensorship organizations, while a local alternative space, The Washington Project for the Arts (WPA), hastily arranged to show the Mapplethorpe exhibition.

The Corcoran cancellation scarcely put an end to the controversy, however. Instead, attacks on NEA funding intensified in the House and Senate, focusing on the 1990 budget appropriations and on new regulations that would limit or possibly end NEA subcontracts to arts organizations.[11] Angry representatives wanted to gut the budget, though they were beaten back in the House by more moderate amendments which indicated disapproval of the Serrano and Mapplethorpe grants by deducting their total cost ($45,000) from next year's allocation. By late July, Sen. Jesse Helms introduced a Senate amendment that would forbid the funding of "offensive," "indecent" and otherwise controversial art and transfer monies previously allocated for visual arts to support "folk art" and local projects. The furor is likely to continue throughout the fall, since the NEA will be up for its mandated, five-year reauthorization, and the right-wing campaign against images has apparently been heartened by its success. In Chicago, for example, protestors assailed an Eric Fischl painting of a fully clothed boy looking at a naked man swinging at a baseball on the grounds that it promotes "child molestation" and is, in any case, not "realistic," and therefore, bad art.[12]

The arts community was astounded by this chain of events—artists personally reviled, exhibitions withdrawn and under attack, the NEA budget threatened, all because of a few images. Ironically, those who specialize in producing and interpreting images were surprised that any images could have such power. But what was new to the art community is, in fact, a staple of contemporary right-wing politics.

In the past ten years, conservative and fundamentalist groups have deployed and perfected techniques of grass-roots and mass mobilization around social issues, usually centering on sexuality, gender, and religion. In these campaigns, symbols figure prominently, both as highly condensed statements of moral concern and as powerful spurs to emotion and action. In moral campaigns, fundamentalists select a negative symbol which is highly arousing to their own constituency and which is difficult or problematic for their opponents to defend. The symbol, often taken literally, out of context, and always denying the possibility of irony or multiple interpretations, is waved like a red flag before their constituents. The arousing stimulus could be an "un-Christian" passage from an evolution textbook, explicit information from a high school sex-education curriculum, or "degrading" pornography said to be available in the local adult bookshop. In the antiabortion campaign, activists favor images of late-term fetuses or better yet, dead babies, displayed in

jars. Primed with names and addresses of relevant elected and appointed officials, fundamentalist troops fire off volleys of letters, which cowed politicians take to be the expression of popular sentiment. Right-wing politicians opportunistically ride the ground swell of outrage, while centrists feel anxious and disempowered to stop it—now a familiar sight in the political landscape. But here, in the NEA controversy, there is something new.

Fundamentalists and conservatives are now directing mass-based symbolic mobilizations against "high culture." Previously, their efforts had focused on popular culture—the attack on rock music led by Tipper Gore, the protests against *The Last Temptation of Christ*, and the Meese Commission's war against pornography.[13] Conservative and neoconservative intellectuals have also lamented the allegedly liberal bias of the university and the dilution of the classic literary canon by including "inferior" works by minority, female, and gay authors, but these complaints have been made in books, journals and conferences, and have scarcely generated thousands of letters to Congress. Previous efforts to change the direction of the NEA had been made through institutional and bureaucratic channels—by appointing more conservative members to its governing body, the National Council on the Arts, by selecting a more conservative chair and in some cases by overturning grant decisions made by professional panels. Although antagonism to Eastern elites and upper-class culture has been a thread within fundamentalism, the NEA controversy marks the first time that this emotion has been tapped in mass political action.

Conservative columnist Patrick Buchanan sounded the alarm for this populist attack in a *Washington Times* column last June, calling for "a cultural revolution in the '90s as sweeping as the political revolution in the '80s."[14] Here may lie a clue to this new strategy: the Reagan political revolution has peaked, and with both legislatures under Democratic control, additional conservative gains on social issues through electoral channels seem unlikely. Under these conditions, the slower and more time-consuming—though perhaps more effective—method of changing public opinion and taste may be the best available option. For conservatives and fundamentalists, the arts community plays a significant role in setting standards and shaping public values: Buchanan writes, "The decade has seen an explosion of anti-American, anti-Christian, and nihilist 'art.' . . . [Many museums] now feature exhibits that can best be described as cultural trash,"[15] and "as in public television and public radio, a tiny clique, out of touch with America's traditional values, has wormed its way into control of the arts bureaucracy."[16] In an analogy chillingly reminiscent of Nazi cultural metaphors, Buchanan writes, "As with our rivers and lakes, we need to clean up our culture: for it is a well from which we must all drink. Just as a poisoned land will yield up poisonous fruits, so a polluted culture, left to fester and stink, can destroy a nation's soul."[17] Let the citizens be warned: "We should not subsidize decadence."[18] Amid such archaic language of moral pollution and degeneracy, it was not surprising that Mapplethorpe's gay and erotic images were at the center of controversy.

The second new element in the right's mass mobilization against the NEA and high culture has been its rhetorical disavowal of censorship per se and the cultivation of an artfully crafted distinction between absolute censorship and the denial of public funding. Senator D'Amato, for example, claimed, "This matter does not involve freedom of artistic expression—it does involve the question whether American taxpayers should be forced to support such trash."[19] In the battle for public opinion, "censorship" is a dirty word to mainstream audiences, and hard for conservatives to shake off because their recent battles to control school books, libraries and curricula have earned them reputations as ignorant book-burners. By using this hairsplitting rhetoric, conservatives can now happily disclaim any interest in censorship, and merely suggest that no public funds be used for "offensive" or "indecent" materials.[20] Conservatives had employed the "no public funds" argument before to deny federal funding for Medicaid abortions since 1976 and explicit safe-sex education for AIDS more recently. Fundamentalists have attempted to modernize their rhetoric in other social campaigns, too—antiabortionists borrow civil rights terms to speak about the "human rights" of the fetus, and antiporn zealots experiment with replacing their language of sin and lust with phrases about the "degradation of women" borrowed from antipornography feminism. In all cases, these incompatible languages have an uneasy coexistence. But modernized rhetoric cannot disguise the basic, censorious impulse which strikes out at NEA public funding precisely because it is a significant source of arts money, not a trivial one.

NEA funding permeates countless art institutions, schools, and community groups, often making the difference between survival and going under; it also supports many individual artists. That NEA funds have in recent years been allocated according to formulas designed to achieve more democratic distribution—not limited to elite art centers or well-known artists—makes their impact all the more significant. A requirement that NEA-funded institutions and artists conform to a standard of "public taste," even in the face of available private funds, would have a profound impact. One obvious by-product would be installing the fiction of a singular public with a universally shared taste and the displacement of a diverse public composed of many constituencies with different tastes. In addition, the mingling of NEA and private funds, so typical in many institutions and exhibitions, would mean that NEA standards would spill over to the private sector, which is separate more in theory than in practice. Although NEA might fund only part of a project, its standards would prevail, since noncompliance would result in loss of funds.

No doubt the continuous contemplation of the standards of public taste that should obtain in publicly funded projects—continuous, since these can never be known with certainty—will itself increase self-censorship and caution across the board. There has always been considerable self-censorship in the art world when it comes to sexual images, and the evidence indicates that it is increasing: reports

circulate about curators now examining their collections anew with an eye toward "disturbing" material that might arouse public ire, and increased hesitation to mount new exhibitions that contain unconventional material. In all these ways, artists have recognized the damage done by limiting the types of images that can be funded by public monies.

But more importantly, the very distinction between public and private is a false one, because the boundaries between these spheres are very permeable. Feminist scholarship has shown how the most seemingly personal and private decisions— having a baby, for example—are affected by a host of public laws and policies, ranging from available tax benefits to health services to day care. In the past century in America and England, major changes in family form, sexuality, and gender arrangements have occurred in a complex web spanning public and private domains, which even historians are hard put to separate.[21] In struggles for social change, both reformers and traditionalists know that changes in personal life are intimately linked to changes in public domains—not only through legal regulation, but also through information, images, and even access to physical space available in public arenas.

This is to say that what goes on in the public sphere is of vital importance for both the arts and for political culture. Because American traditions of publicly supported culture are limited by the innate conservatism of corporate sponsors and by the reduction of individual patronage following changes in the tax laws, relegating controversial images and art work to private philanthropy confines them to a frail and easily influenced source of support. Even given the NEA's history of bureaucratic interference, it is paradoxically public funding—insulated from the day-to-day interference of politicians and special-interest groups that the right wing would now impose—that permits the possibility of a heterodox culture. Though we might reject the overly literal connection conservatives like to make between images and action ("When teenagers read sex education, they go out and have sex"), we too know that diversity in images and expression in the public sector nurtures and sustains diversity in private life. When losses are suffered in public arenas, people for whom controversial or minority images are salient and affirming suffer a real defeat. Defending private rights—to behavior, to images, to information—is difficult without a publicly formed and visible community. People deprived of images become demoralized and isolated, and they become increasingly vulnerable to attacks on their private expressions of nonconformity, which are inevitable once sources of public solidarity and resistance have been eliminated.

For these reasons, the desire to eliminate symbols, images, and ideas they do not like from public space is basic to contemporary conservatives' and fundamentalists' politics about sexuality, gender, and the family. On the one hand, this behavior may signal weakness, in that conservatives no longer have the power to

directly control, for example, sexual behavior, and must content themselves with controlling a proxy, images of sexual behavior. The attack on Mapplethorpe's images, some of them gay, some sadomasochistic, can be understood in this light. Indeed, the savage critique of his photographs permitted a temporary revival of a vocabulary—"perverted, filth, trash"—that was customarily used against gays but has become unacceptable in mainstream political discourse, a result of sexual liberalization that conservatives hate. On the other hand, the attack on images, particularly "difficult" images in the public domain, may be the most effective point of cultural intervention now—particularly given the evident difficulty liberals have in mounting a strong and unambivalent response and given the way changes in public climate can be translated back to changes in legal rights—as, for example, in the erosion of support for abortion rights, where the image of the fetus has become central in the debate, erasing the image of the woman.

Because symbolic mobilizations and moral panics often leave in their wake residues of law and policy that remain in force long after the hysteria has subsided,[22] the fundamentalist attack on art and images requires a broad and vigorous response that goes beyond appeals to free speech. Free expression is a necessary principle in these debates, because of the steady protection it offers to all images, but it cannot be the only one. To be effective and not defensive, the art community needs to employ its interpretive skills to unmask the modernized rhetoric conservatives use to justify their traditional agenda, as well as to deconstruct the "difficult" images fundamentalists choose to set their campaigns in motion. Despite their uncanny intuition for culturally disturbing material, their focus on images also contains many sleights of hand (Do photographs of nude children necessarily equal child pornography?), and even displacements,[23] which we need to examine. Images we would allow to remain "disturbing" and unconsidered put us anxiously on the defensive and undermine our own response. In addition to defending free speech, it is essential to address why certain images are being attacked—Serrano's crucifix for mocking the excesses of religious exploitation[24] (a point evidently not lost on the televangelists and syndicated preachers who promptly assailed his "blasphemy") and Mapplethorpe's photographs for making minority sexual subcultures visible. If we are always afraid to offer a public defense of sexual images, then even in our rebuttal we have granted the right wing its most basic premise: sexuality is shameful and discrediting. It is not enough to defend the principle of free speech while joining in denouncing the image, as some in the art world have done.[25]

The fundamentalist attack on images and the art world must be recognized not as an improbable and silly outburst of Yahoo-ism, but as a systematic part of a right-wing political program to restore traditional social arrangements and reduce diversity. The right wing is deeply committed to symbolic politics, both in using symbols to mobilize public sentiment and in understanding that, because images do stand in for and motivate social change, the arena of representation is a real ground for struggle. A vigorous defense of art and images begins from this insight.

Notes

Thanks to Ann Snitow, Daniel Goode, Sharon Thompson and Edna Haber for conversations which helped shape my thoughts (though none of the individuals are responsible for the ideas expressed here).

1. Senator D'Amato's remarks and the text of the letter appear in the *Congressional Record*, vol. 135, no. 64, May 18, 1989, S5594.

2. Senator Helms's remarks appear in the *Congressional Record*, vol. 135, no. 64, May 18, 1989, S 5595.

3. William H. Honan, "Congressional Anger Threatens Arts Endowment's Budget," *New York Times*, June 20, 1989, p. C20.

4. "People: Art, Trash and Funding," *International Herald Tribune*, June 15, 1989, p. 20.

5. Ibid.

6. Honan, "Congressional Anger," p. C20.

7. Elizabeth Kastor, "Funding Art that Offends," *Washington Post*, June 7, 1989, p. C1.

8. Ibid., p. C3.

9. Elizabeth Kastor, "Corcoran Cancels Photo Exhibit," *Washington Post*, June 13, 1989, p. C1.

10. Elizabeth Kastor, "Corcoran Decision Provokes Outcry," *Washington Post*, June 14, 1989, p. B1.

11. Barbara Gamarekian, "Legislation Offered to Limit Grants by Arts Endowment," *New York Times*, June 21, 1989; Carla Hall, "For NEA, an Extra Step," *Washington Post*, June 22, 1989; Elizabeth Kastor, "Art and Accountability," *Washington Post*, June 30, 1989.

12. The Fischl painting *Boys at Bat*, 1979, was part of a traveling exhibition, "Diamonds Are Forever," on view at the Chicago Public Library Cultural Center. Ziff Fistrunk, executive director of the Southside Chicago Sports Council, organized the protest. He objected that "I have trained players in Little League and semi-pro baseball, and at no time did I train them naked." *In These Times*, Aug. 1, 1989, p. 5. Thanks to Carole Tormollan for calling this incident to my attention.

13. Carole S. Vance, "The Meese Commission on the Road: Porn in the U.S.A.," *The Nation*, Aug. 29, 1986, pp. 65–82.

14. Patrick Buchanan, "How Can We Clean Up Our Art Act?" *Washington Post*, June 19, 1989.

15. Ibid.

16. Ibid.

17. Ibid.

18. Ibid.

19. *Congressional Record*, vol. 135, no. 64, May 18, 1989, S 5594.

20. Another ploy is to transmute the basic objection to Serrano's photograph, the unfortunately medieval-sounding "blasphemy," to more modern concerns

with prejudice and civil rights. Donald Wildmon, for example, states, "Religious bigotry should not be supported by tax dollars." *Washington Times*, Apr. 26, 1989, p. A5.

The slippage between these two frameworks, however, appears in a protest letter written to the *Richmond News-Leader* concerning Serrano's work: "The Virginia Museum should not be in the business of promoting and subsidizing hatred and intolerance. Would they pay the KKK to do work defaming blacks? Would they display a Jewish symbol under urine? Has Christianity become fair game in our society for any kind of blasphemy and slander?" (Mar. 18, 1989).

21. For 19th-century American history regarding sex and gender, see John D'Emilio and Estelle Freedman, *Intimate Matters*, New York, Harper and Row, 1988; for British history, see Jeffrey Weeks, *Sex, Politics and Society: The Regulation of Sexuality Since 1800*, New York, Longman, 1981.

22. The 19th-century Comstock Law, for example, passed during a frenzied concern about indecent literature, was used to suppress information about abortion and birth control in the United States well into the 20th century. For accounts of moral panics, see Weeks, *Sex, Politics and Society;* Judith Walkowitz, *Prostitution and Victorian Society: Women, Class, and the State,* Cambridge, Cambridge University Press, 1980; and Gayle Rubin, "Thinking Sex: Notes for a Radical Theory of the Politics of Sexuality," in Carole S. Vance, ed., *Pleasure and Danger: Exploring Female Sexuality*, Boston, Routledge & Kegan Paul, 1984, pp. 267–319.

23. Politically, the crusade against the NEA displaces scandal and charges of dishonesty from the attackers to those attacked. Senator Alfonse D'Amato took on the role of the chief NEA persecutor at a time when he himself was the subject of embarrassing questions, allegations and several inquiries about his role in the misuse of HUD low-income housing funds in his Long Island hometown.

The crusade against "anti-Christian" images performs a similar function of diverting attention and memory from the recent fundamentalist religious scandals involving Jim and Tammy Bakker and Jimmy Swaggart, themselves implicated in numerous presumably "un-Christian" acts. Still unscathed fellow televangelist Pat Robertson called upon followers to join the attack on the NEA during a June 9 telecast on the Christian Broadcasting Network.

24. Andres Serrano described his photograph as "a protest against the commercialization of sacred imagery." See Honan, "Congressional Anger," p. C20.

25. For defenses of free speech that agree with or offer no rebuttal to conservative characterizations of the image, see the comments of Hugh Southern, acting chair of the NEA, who said, "I most certainly can understand that the work in question has offended many people and appreciate the feelings of those who have protested it. . . . I personally found it offensive" (quoted in Kastor, "Funding Art That Offends," p. C3), and artist Helen Frankenthaler, who stated in her op-ed column, "I, for one, would not want to support the two artists mentioned, but once supported, we must allow them to be shown" ("Did We Spawn an Arts Monster?" *New York Times,* July 17, 1989, p. A17).

MISUNDERSTANDING OBSCENITY

On Oct. 7, 1989, arts advocates felt relieved, even elated. They had lobbied against and defeated the censorious bill proposed by Sen. Jesse Helms (R-N.C.), in which he had sought to punish and restrict the National Endowment for the Arts (NEA). Instead, Congress passed a compromise bill which removed most penalties against specific artists and institutions and merely required that the NEA observe legal bans on obscenity. This product of much negotiation was widely hailed as a victory for the arts and for the principle of free expression. The victory, however, now shows every sign of turning into a defeat. The intervening months have been characterized by increasing self-censorship and anxiety in the arts community, spurred by new episodes of formal censorship and McCarthyite witch-hunts. Rather than being a harmless restatement of existing obscenity law, the new NEA regulation now looms as a breathtaking cultural intervention, one which the right wing did not consciously engineer but from which it will surely benefit. How did this happen?

During the summer of 1989, Sen. Helms joined a growing campaign against government support for art, claiming that certain works funded by the NEA were "indecent or obscene." As his principal targets Helms chose photographers Robert Mapplethorpe and Andres Serrano, who both had works in exhibitions supported by the NEA. Helms denounced Mapplethorpe's photographs of homosexual erotica as obscene and railed against one of Serrano's photographs as sacrilegious. As a warning to the NEA (and a gesture which many regarded as the first step toward dismantling the NEA altogether), Helms proposed that Congress cut the NEA's visual arts program by $400,000, that it ban for five years all NEA grants to the two institutions that had sponsored the exhibitions of Mapplethorpe and Serrano, and that it prohibit future grants for art that was deemed "indecent or obscene."[1]

In a climate of intense antisexual hysteria that persisted throughout the summer and early fall, arts supporters and lobbyists worked to defeat the Helms Amendment and to craft a compromise bill which would permit legislators to register the politically requisite disapproval of "offensive" and "blasphemous" art without doing irreparable damage to the endowment and its programs. By early fall these arts advocates were making headway. Led by Rep. Sidney Yates (D-Ill.), they had successfully fought against almost all of the punitive proposals of Helms and other conservative legislators and had engineered a more temperate substitute bill.

When this compromise was passed on Oct. 7, the sting had been reduced. The offending arts institutions, the Institute of Contemporary Art in Philadelphia and the Southeastern Center for Contemporary Art in Winston-Salem, were placed on probation for one year; an outside panel was appointed to study NEA grant procedures; the NEA budget was cut by $45,000 (the exact amount of the grants related to the Mapplethorpe and Serrano exhibitions); and finally, the NEA was prohibited from funding "obscene" art. Although this bill marked the first attempt to control content in the NEA's 25-year history, arts advocates reasoned that the prohibition was meaningless. If obscenity was already illegal, what harm was there

in prohibiting the NEA from funding it? The comment of Anne G. Murphy, executive director of the American Arts Alliance, reflected the dominant view in the art world: she said she could "live with the compromise" because it "only restated the law of the land."[2]

When the House and the Senate voted to prohibit the use of NEA and NEH (National Endowment for the Humanities) money to fund "obscene" art, the intent of Congress was to apply the current legal definition of obscenity, spelled out in Miller v. California, a 1973 Supreme Court case. The Miller ruling provided a narrow definition of obscenity and made clear that only a small portion of sexually explicit material would fall within its boundary. According to what has come to be known as the "three prongs" of the Miller standard, work can be found obscene only when it meets *all three* of the following criteria stated in the ruling:

1) the average person, applying contemporary community standards, would find that the work, taken as a whole, appeals to prurient interest [translation: "prurient interest" here means that the work leads to sexual arousal], and

2) the work depicts or describes, in a patently offensive way, sexual conduct specified by the statute, and

3) the work, taken as a whole, lacks serious literary, artistic, political, or scientific value.[3]

The Miller ruling does not prohibit specific sexual subjects or depictions and takes into account intent and context. And although parts of the definition are problematic and far from crystal clear (what are "contemporary community standards," for example, and how do you assess them?), winning an obscenity conviction under Miller is difficult. The most explicit, prurient, and offensive image, for example, cannot be found obscene if it can be shown to have serious value. As a result, obscenity prosecutions directed at literature and art have virtually disappeared. Even prosecutions against X-rated material found in adult sex shops have dwindled, conservatives and fundamentalists lament, because convictions are so expensive, time-consuming and difficult to obtain.

For all these reasons, the crafters of the compromise legislation believed that the obscenity regulation would have no impact on the NEA and NEH. In practice, nothing that either agency has ever funded, including the photographs of Robert Mapplethorpe, could ultimately be upheld as obscene by a higher court. Indeed, it can be argued that the very choice of an endowment panel to award funds in a competition based on artistic excellence or the decision of an arts institution to show a particular work indicates a priori that the work in question has serious artistic value and thus could not be found obscene.

Despite the protective stringency of the Miller definition, the actual effect of this new regulation has been alarming, chilling, and far from meaningless, even

in these few months since its passage. The regulation has lifted the discussion of obscenity out of the public scrutiny of the courts and landed it in private rooms, where anxious arts administrators, untrained in law, worry about what obscenity *might* mean and perhaps decide to play it safe and fund landscapes this year.

One evident problem with the new regulation is that the procedures used to implement it operate entirely outside the structure of the court system. The determination of obscenity is made by NEA panelists and administrators—not by judges or juries—in private, following procedures that are totally unspecified. Since few arts administrators are attorneys, the "three prongs" of the Miller standard are replaced by gut feelings and vague intuitions. The injunction to avoid funding art that *"may* be considered" obscene, for instance, can suggest that panelists should reject any work that *might* offend any group, no matter how small. The phrase "may be considered" also creates a linguistic elasticity that conservatives exploit, since they already call any act or image that exceeds their notions of propriety "obscene." Moreover, the "may be considered obscene" phrase implicitly acknowledges that definitions of obscenity will not be legally tested. Ultimately, applicants whose work is deemed obscene have no right to defend their work before the persons judging them and no right of appeal. By contrast, in a legal obscenity trial, the prosecutor would have to prove beyond a reasonable doubt that a work or image was obscene; the defendant would be informed of all charges and be able to answer them in open court; expert witnesses could be called if necessary to challenge prosecutorial assertions that a specific work was obscene; and, even if convicted, producers of obscenity have full rights of appeal.

A second problem with the new regulation is the confusion that its language has sowed, even among those most friendly to the NEA. Serious misunderstandings exist about the precise legal definition of obscenity. Despite the rarity and difficulty of Miller-defined convictions, many well-meaning people now seem to believe that obscenity lurks everywhere. Consider two examples. An artist I know, who has already served on NEA panels, recently articulated to me her concern about whether or not she will be able to tell what is obscene when she serves on an upcoming panel, apparently anticipating difficult and wrenching deliberations over what is in fact a null set. (Question: Is there any reason for those who serve on an NEA panel to act any differently given the new obscenity regulation? Answer: A resounding "no," because serious art by definition cannot be obscene.) In another case, a sympathetic article in the liberal *Village Voice* nevertheless expresses some doubt about the legality of recently attacked art works, saying that "Robert Mapplethorpe's homoerotic photographs, and even Andres Serrano's *Piss Christ,* might well pass" the Supreme Court's Miller test.[4] Of course they would pass. Both have serious artistic value, and *Piss Christ* is not even sexually explicit.

The various misreadings of "obscenity" can be traced to the peculiar wording of the compromise regulation, patched together in conference committee. The

compromise bill states: the NEA is prohibited from funding "obscene materials *including but not limited to* depictions of sadomasochism, homoeroticism, the sexual exploitation of children, or individuals engaged in sex acts" (my emphasis). This phrasing derives almost word for word from the Helms amendment introduced by the senator at the height of the furor over the Mapplethorpe show. (Helms originally proposed to prohibit, among other things, the funding of "obscene or indecent material, including but not limited to depictions of sadomasochism, homoeroticism, the sexual exploitation of children, or individuals engaged in sex acts."[5]) The purpose of this sexual laundry list was to provide specific examples of what Sen. Helms and, more generally, conservatives and fundamentalists find indecent. Although in the course of negotiations arts advocates succeeded in removing the term "indecent," the laundry list remained. And many now take this list as an explanation of what obscenity means.

What does the wording of the current compromise legislation really mean? The trick here is to understand that the list of sexual acts simply gives examples of depictions that *might* fall under the legal definition of obscenity, *after* the three prongs of the Miller test are met. But these sexual depictions or acts are not by themselves obscene. (Or, to take another example, more easily understood because it is not about sex, consider the phrase "obscene material including but not limited to black-and-white photographs, color slides and Cibachromes." We grasp immediately that the terms here are not interchangeable: obscenity may include black-and-white photographs, but not all black-and-white photographs are obscene.) Yet when the sexual laundry list is attached to the word "obscenity," many carelessly read the phrase to mean that any depiction of sadomasochism or homoeroticism is in itself obscene. This is no accident, since the original Helms list contains typical right-wing linguistic ploys that play on the readers' own sexual prejudices. It is a list that mixes up acts that are stigmatized (homoeroticism and sadomasochism), illegal (child pornography) and conventional (any individuals engaged in sex acts, the unspecified form of sex here being heterosexuality). Typically the stigmatized acts appear first and are intended to set off the readers' anxiety, their negativity about sex, and homophobia. Critical thinking stops, and the sexual red alert flashes. Although many readers would realize that the mere depiction of (hetero)sexual acts is not necessarily obscene, the placement of the topic so late in the list makes this realization less likely.

The NEA regulation, then, contains a prejudicial sleight of hand, and it comes as no surprise that this language promotes conservative goals. The wide-ranging use of the term obscene has been an important and consistent ploy of conservative and fundamentalist sexual politics, familiar from recent debates over pornography and abortion. Frustrated by their limited ability to attack sexually explicit material through existing obscenity law, conservatives have pioneered new ways of expanding the rhetorical meaning of obscenity. In their own rhetoric, conservatives now routinely equate premarital sex and homosexuality with obscenity. Indeed, the list targets not just homosexual sex but the even broader category of homoeroticism,

thus constituting an attack on all gay and lesbian images. If it were stated explicitly, this viewpoint would not be very convincing to the mainstream public. It is not difficult to imagine the fate of conservative legislation which attempted to define representations of premarital relations or homosexuality as obscene. Yet the almost unnoticed migration of conservative language into the widely circulated compromise legislation plays havoc with people's ability to think critically about obscenity.

How else do we understand the actions of *both* John Frohnmayer, head of the NEA, and Susan Wyatt, executive director of Artists Space, who each believed that the ban on funding obscene art somehow applied to "Against Our Vanishing," a 23-artist exhibition about AIDS that contained images of homosexuality?[6] Or, how do we explain a recent feature in *Art News*, "What Is Pornography?"[7] which responded to the NEA crisis by providing ample evidence of widely differing subjective definitions of pornography, art, and obscenity without ever informing readers that obscenity has a specific legal meaning? Or a recent *New York Times* article about the "loyalty oaths" that NEH grantees are now required to sign? Writers must swear that they will not produce obscene works with endowment funds, but many erroneously believe that the oath prohibits them from *writing* on specific sexual or erotic topics. The *Times* never corrects the error, but compounds it by stating: "grant recipients are now being asked to refrain from producing artworks that include, but are not limited to, 'depictions of sadomasochism, homoeroticism, the sexual exploitation of children, or individuals engaged in sex acts. . . .' "[8] In this morass of confusion, the folk definitions of obscenity—though legally mistaken—are dismayingly compatible with the views and political goals of the right wing, though the vehicle which now endlessly circulates them—the NEA regulation—is no longer identifiably right wing.

The equation between obscenity and sexuality has already achieved wide currency. Consider the distribution of the NEA regulation with no effort to provide guidance about the legal meaning of obscenity or to clarify the relationship between the sex laundry list and that legal definition of obscenity. The unvarnished regulation is now routinely included in all NEA and NEH application packets. Each grant recipient must sign a form agreeing to the terms of the new law, under the threat of not receiving funds. Members of peer-review panels are also instructed to consider in the course of their evaluations whether the art works are obscene. For all concerned, the terms of this regulation are sobering, freighted with a foreboding sense of responsibility and imagined legal penalties for mistaken judgment. What is most fantastic about this regulation, however, is that it covertly circulates and legitimizes conservative definitions of obscenity among liberal, educated people who would, in other circumstances, indignantly reject them.

The past few months have already made clear that the chief effect of the new NEA regulation will be self-censorship by the arts community, both individuals and institutions, encouraged by sporadic episodes of formal censorship and sensa-

tionalized witch-hunts. Last November the *Los Angeles Times* reported that the NEA had held back five literature fellowships because of the sexual or political nature of the projects.[9] In January the *Los Angeles Times* obtained letters written by Sen. Helms to Frohnmayer demanding information about eight arts groups and nine artists over a seven-year period beginning in 1982; the demand seemed motivated by suspicions about the political or sexual biases of the works of those artists and groups.[10] In March, the indefatigable Sen. Helms announced "compelling" evidence that the NEA had violated the ban on funding obscene art: it had awarded grants to "three acknowledged lesbian writers."[11] And most recently, prosecutors in Cincinnati threatened to use the police to remove works that they considered obscene from an exhibition of photographs by Robert Mapplethorpe following unsuccessful conservative attempts to induce the Contemporary Arts Center to censor itself.

From the censor's viewpoint, self-censorship is an ideologue's dream, since it is cheap, self-policing and doesn't require a large bureaucracy to administer. It is more effective than legal regulation, since fearful individuals, trying to stay out of trouble, anxiously elaborate the category of what is likely to be prohibited. Best of all, self-censorship occurs privately, without contentious and unpleasant public struggles.

There is no question that a serious degree of self-censorship is already taking place. Acting on distorted definitions of obscenity, many artists and writers are simply deciding not to apply for NEA grants because they believe their work cannot be funded. Or they expand the scope of the regulation: one writer I know who signed the "loyalty oath" now wonders if her promise to avoid producing obscene work would be in effect forever or just for the duration of her NEH fellowship. Arts administrators and curators face similar decisions: curator Dana Friis-Hansen of MIT's List Gallery (on Helms's investigatory list for suspicion of having exhibited work with sexual content) remarks, "Now we would not consider trying to fund [controversial and difficult art] through the NEA."[12] Others decide that sexual topics are too risky altogether.

Artists and artists' organizations have responded vigorously to attacks on the NEA by lobbying, rallying and protesting these assaults. Artists must mount an equally aggressive effort to educate their own community about what obscenity is and what this new regulation means. A long-term goal, of course, includes defeating any regulation controlling the content of NEA- or NEH-funded work (an effort recently given an unexpected boost by the Bush Administration's support for removal of restrictions of federal grant recipients.)[13] But in the short term, it is imperative to minimize the damage caused by the existing regulation, to publicize and to insist on strict Miller definitions of obscenity and to unveil current loose definitions of obscenity for what they are: right-wing pressure tactics that have no legal status or force.

The NEA must join in this effort, too, by issuing clear guidelines about what is and is not obscene. A simple paragraph of explanation would go far in clarifying the distorted belief that any depiction of specific sexual acts, including homosexuality and homoeroticism, is obscene and therefore prohibited.

Arts organizations can afford to take even more vigorous steps to educate their members. They can start by providing very specific information about obscenity and the new NEA regulation. Groups must take the initiative and prepare NEA panelists with hypothetical scenarios they may encounter in this (art and) sex panic, along with appropriate responses. Basically, organizations must communicate the message that the ban on "obscene art" has no meaning; to act as if it does is a capitulation to Jesse Helms, not any legal requirement. Similar scenarios and instructions need to be given to prospective NEA grant applicants, artists, museum administrators and curators—continue to apply for grants and refuse to be intimidated. Insist on the right to produce and distribute art with erotic and sexual content.

These educational efforts must address not only legal definitions of obscenity, but the way sex panics work, because the assault on the NEA—and its defense—takes place in an emotional and sexual climate. Right-wing concepts and definitions migrate not only because liberals and the arts community are uncertain about the law, but because even they harbor primitive and inchoate ideas that equate sexuality, especially its less conventional varieties, with obscenity. Right-wing politicians acquire power not only through their ability to mobilize votes and constituencies, but through their ability to mobilize sexual anxiety and reduce opponents to silence. In our culture, few people are immune. Sex panics work only because "regular" people, not just zealots, get caught up in their chilling dynamics: self-censorship, caution, and the perception that the domain of sexuality is increasingly marked by penalty and danger. In this battle for the NEA, the legal definition of obscenity is on our side, unless our own residual shame and fear about sexuality immobilize us.

Notes

Thanks to Frances Doughty, Lisa Duggan, Nan Hunter, Gayle Rubin and Ann Snitow for helpful conversations.

1. Martin Tolchin, "Congress Passes Bill Curbing Art Financing," *New York Times*, Oct. 8, 1989, p. 27, and "Congress Bans Funding of Obscene Art," *New Art Examiner*, Dec. 1989, p. 10. For accounts of earlier legislative efforts, see "Congress Votes for New Censorship," *Art in America*, Sept. 1989, p. 33; Carole S. Vance, "The War on Culture," *Art in America*, Sept. 1989, pp. 39–43; Michael Oreskes, "Senate Votes to Bar U.S. Support of 'Obscene or Indecent' Artwork," *New York Times*, July 27, 1989, pp. A1, C18; William H. Honan, "Helms Amendment Is Facing a Major Test in Congress," *New York Times*, Sept. 13, 1989, pp. C17, C19;

William H. Honan, "House Shuns Bill on 'Obscene' Art," *New York Times*, Sept. 14, 1989, pp. A1, C22; Nichols Fox, "Helms Ups the Ante," *New Art Examiner*, Oct. 1989, pp. 20–23; "House Passes Compromise on Federal Arts Financing," *New York Times*, Oct. 4, 1989, p. C19.

2. William H. Honan, "Debate Deepens Over Artistic Costs of Art Subsidies," *New York Times*, Mar. 18, 1990, p. 4E.

3. 413 US 15 at 24 (1973). See also Franklin Feldman, Stephen E. Weil and Susan Duke Biederman, *Art Law: Rights and Liabilities of Creators and Collectors*, New York, Little Brown, 1986, pp. 2–108.

4. Richard Goldstein, "Crackdown on Culture," *Village Voice*, Oct. 10, 1989, p. 29.

5. Oreskes, "Senate Votes to Bar U.S. Support," *New York Times*, July 27, 1989, pp. A1, C18.

6. It is clear that the motivations of Frohnmayer and Wyatt were not identical. Wyatt first alerted the NEA about the show because she did not want the agency to be "blindsided" by a new, suddenly erupting arts controversy. In response, Frohnmayer first expressed concern about the sexual content of the show but then claimed rescinded the NEA grant because its content had become "political." For accounts of the controversy, see William H. Honan, "Arts Endowment Withdraws Grant for AIDS Show," *New York Times*, Nov. 9, 1989, pp. A1, C28; "NEA Recalls, Then Returns Artists Space Grant," *New Art Examiner*, Jan. 1990, p. 11; John Loughery, "Frohnmayer's Folly," *New Art Examiner*, Feb. 1990, pp. 20–25; Carl Baldwin, "NEA Chairman Does Turnabout on AIDS Exhibition," *Art in America*, Jan. 1990, pp. 31–33; Allan Parachini, "Arts Groups Say NEA Future at Risk," *Los Angeles Times*, Nov. 10, 1989, pp. F1, F30.

7. "What Is Pornography," *Art News*, Oct. 1989, pp. 138–43.

8. "Artists, Accepting Federal Grants, Worry About Strings," *New York Times*, Mar. 10, 1990.

9. Allan Parachini, "Ex-NEA Head Requests Session of Arts Advisors," *Los Angeles Times*, Nov. 13, 1989, pp. F1, F6.

10. Allan Parachini, "Helms Letters Add Fuel to the Arts Controversy," *Los Angeles Times*, Jan. 29, 1990, pp. F1, F3.

11. Barbara Gamarekian, "White House Opposes Restrictions on Arts Grants," *New York Times*, Mar. 22, 1990, pp. A1, B4.

12. Parachini, "Helms Letters Add Fuel," p. F3.

13. Gamarekian, White House Opposes Restrictions," pp. A1, B4.

REAGAN'S REVENGE: RESTRUCTURING THE NEA

Controversies surrounding the National Endowment for the Arts (NEA) continued to boil and bubble during the summer and early fall of 1990, drawing increased attention to the way in which the agency might be restructured. Proposals to reform the Endowment have proliferated, offered either by conservatives and fundamentalists to curtail its funding of "offensive," "blasphemous" or "obscene" art or by moderate and liberal supporters in the hope that what they regard as modest concessions will avoid more severe restriction.[1] By the end of September, insiders were predicting a five-year reauthorization without explicit content restrictions, coupled with major changes in the NEA's internal procedures. Over the summer Congress had given up in the face of a glut of competing amendments.[2] "I just can't fit this 200-pound gorilla into this 18-pound cage," grumbled Rep. Pat Williams (D-Mont.), leader of House arts supporters, as he worried over the prospect of a long and acrimonious debate.[3] These proposed amendments, seven of which were already on the floor with perhaps 20 more lurking in the wings, included total abolition of the NEA, channeling the bulk of its funds to state arts agencies or major institutions, and sweeping content controls that would ban the funding of art that "denigrates the cultural heritage of the United States" or "violates prevailing standards of obscenity or indecency."[4] Meanwhile, NEA chairperson John E. Frohnmayer vetoed four performance grants to lesbian, gay and feminist artists on the grounds that they were "too political" and that the mood of the Congress required some agency restraint.[5] As a result of these developments, many arts advocates, both inside and outside Congress, seem to have concluded that some restructuring is inevitable—the only questions are what kind and to what degree.

Only ten years ago, the newly elected Ronald Reagan launched a massive assault on the NEA, part of a larger campaign to privatize government functions and impose a conservative cultural agenda. His initial attempts to abolish the agency or seriously slash its budget failed miserably, however, resisted by a surprisingly vigorous opposition mounted by congressional supporters of the NEA, arts advocates and grass-roots organizers. Subsequent attempts to change the internal functioning of the NEA and influence its cultural agenda were not without effect, but their impact was at best partial, as these onslaughts, too, were resisted.

The Reagan administration's efforts never achieved the political or emotional momentum of the current crusade against the NEA. Indeed, any comparison between Reagan's far-from-successful efforts and the near-complete rout that has been effected during the past year raises a central question: Why are conservatives now winning a cultural campaign to reshape the NEA, something they were unable to achieve during the height of Reagan's power? The answer, I would argue, lies in the power of what are often called sex panics to paralyze moderate and liberal opposition, whether in the political sector or in the art world. Today, we see a surprising number of NEA supporters cowed, terrorized and all too ready to compromise.

Although the connection between the current NEA crisis and the situation 10 years ago may at first seem tenuous, it was in fact during Reagan's administration that the seeds of disaffection with the agency were first sown. By the time of Reagan's election in 1980, the NEA had achieved remarkable success. The Endowment had been established by Congress in 1965 to promote artistic excellence and increase Americans' access to culture.[6] All segments of the arts community (then considerably smaller than it is now) united to obtain federal support for the arts, long routine in Europe but still suspiciously regarded by Congress, to whom cultural sponsorship suggested the beginning of an "arts dictatorship" or, more simply, a waste of money.

The NEA grew spectacularly in the 1970s, in no small part because of the compelling efforts of Nancy Hanks, chairperson from 1970 to 1977, to build bipartisan support for the agency in Congress. Political scientist Edward Arian, author of *The Unfulfilled Promise*, argues that Hanks expanded the agency by favoring what he calls the "performance culture"—traditional, institutionalized and fairly expensive cultural forms, such as major museums, symphonies, operas and ballets.[7] Arian observes that Hanks channeled increasing portions of the NEA budget to these major institutions rather than to individual artists and grassroots community arts; these patrons and board members constituted a powerful and well-connected lobby for steadily increasing budget allocations, which grew from $8.4 million in 1970 to $94 million in 1977.[8] Although artists and community groups still benefited from overall increases in federal subsidies, they complained that their needs were increasingly eclipsed by those of major institutions. The tensions between diverse segments of the arts community had already begun to constitute a fault line, which Reagan-era campaigns to reform the agency would later exploit.

The Reagan administration's antipathy toward the NEA had several sources. Reagan's economic program of privatization and cost-cutting depicted federal support for the arts as an expensive luxury ("The National Endowment for the Frills," as fiscal conservatives joked),[9] better funded by the private sector. More than wasted tax dollars, however, to social conservatives the Endowment represented the populist excesses of the Carter administration, especially NEA chairperson Livingston Biddle's efforts (1977–81) to democratize and regionalize the distribution of cultural subsidies.[10] To conservative critics, programs to bring cultural events to neighborhoods, factories and prisons were "social programs," not art. Reagan denounced the "politicization" of the NEA (referring to Carter's appointments of minority group and union representatives to the Endowment's advisory body, the National Council on the Arts) and promised that "merit and merit alone" would henceforth be the criterion for awarding grants. He even proposed to change the Endowment's structure by giving the power to award grants to the National Council or to arts institutions, though this never happened.[11]

Further anti-NEA rationale was provided by an influential transition document prepared by the Heritage Foundation, the right-wing think tank. The chapter on

arts policy, authored by Michael S. Joyce but noting the prominent contribution of neoconservative cultural critic Samuel Lipman, argued: "The NEA . . . must finally acknowledge that the enduring audience for art is largely self-selecting, a relatively small public marked by the willingness to make sacrifices of other pleasures for the sake of artistic experience."[12]

Reagan's initial efforts to severely cut the NEA were greeted by a storm of protest. That the arts community had not been consulted about the budget cuts only fueled the fire (reportedly, budget director David Stockman spent all of 15 minutes considering whether to abolish the agency entirely or cut its budget by 50 percent).[13] Temporarily ignoring internal tensions, all segments of the arts constituency united in response to the threat and launched an impressive campaign to lobby Congress. Cultural notables, celebrities and directors of major arts institutions appeared at subcommittee hearings and press conferences to extol the NEA's achievements, invoking values such as civilization, creativity and the link between democracy and artistic expression.[14] Their arguments were self-confident and forceful. In addition, philanthropists and donors to cultural institutions testified that federal funding for the arts was essential, rejecting Reagan's contention that private philanthropy could take up the slack.[15] Paradoxically, the boards of many major institutions seemed thick with supporters of supply-side economics who nevertheless wanted continued subsidies for their museums and symphonies. Community arts groups and their supporters, who had benefited from Biddle's program of expanded access, peppered Congress with letters emphasizing the importance of NEA funding in supporting their local cultural organizations. Legislators responded favorably and formed the Congressional Arts Caucus, which soon became the largest legislative interest group, and they led a persistent battle against Reagan's cuts.[16]

Reagan's attempt to halve the budget was soundly defeated. He had proposed an $88-million appropriation for FY1982 compared with $175 million for FY1981. Congress finally appropriated $143 million, $55 million more than Reagan had wanted. Although even this budget reduction was far from trivial and marked the first time in the Endowment's history that its budget had declined, the deflection of the Reagan steamroller constituted a real victory for the arts community. Other Reagan attempts to withhold (through budget recision) already-allocated moneys were also defeated, as was a 1981 plan to abolish both the NEA and the National Endowment for the Humanities (NEH) and to replace them with an independent agency (like the Corporation for Public Broadcasting) that would funnel its money into state arts councils and major institutions.[17] Repeated efforts to impose major budget reductions in 1982 and 1983 were no more successful.

Plans to abolish the agency or impose devastating financial cuts upon it having failed, the administration turned to reshaping the structure of the Endowment and altering its cultural climate. These efforts targeted innovative and experimental mediums, art and art criticism said to have a "political" content and the Expan-

sion Arts program designed to bring art to nontraditional audiences. Grants and fellowships to individual artists were given new scrutiny. Finally, the administration proposed revamping art education programs for children, emphasizing formal instruction in the traditional Western canon.

The administration's next step was to move cultural conservatives into influential positions in the Endowment. In 1981, Reagan nominated a new head for the agency, career bureaucrat and Washington insider Frank Hodsoll.[18] Hodsoll had no previous arts experience but expressed interest in heading the agency after a stint on the administration's transition team. Hodsoll's priorities included more support and better management for major arts institutions, increased partnership with the private sector and more private support for the arts.[19] Hodsoll, in turn, made further conservative appointments within the agency, the most notable of which was his selection for associate deputy chairperson for programs: Ruth Berenson, art critic for William F. Buckley's *National Review*. In an interview in that journal marking her appointment, Berenson had made clear her thoughts on cultural policy, saying, "The conservative part of our culture has not been represented at all" and "the avant-garde, or the so-called avant-garde, has turned into a kind of academy."[20] Hodsoll also took a much more active role than his predecessors in overseeing the selection of members of peer panels, in some cases rejecting staff recommendations when potential panelists struck him as too "radical" or "political."

Reagan also appointed cultural conservatives to the Endowment's National Council on the Arts, a 26-member advisory body established in 1965, which meets four times a year to review Endowment policy and grants. Reagan filled eight openings during his first year in office, but because council members' six-year terms are staggered, the full impact of his appointments was not felt immediately. Within a few years, however, the composition of the National Council had changed radically, with fewer creative and performing artists and more glitterati, Republicans and cultural conservatives. By 1986, the council included such noted conservatives as Samuel Lipman, author Allen Drury, actress Celeste Holm, actor Robert Stack and painter Helen Frankenthaler.[21] Endowment insiders tell of persistent efforts to draw up lists of Republican artists for possible nomination, but the results essentially amounted to a null set. The increasingly conservative composition of the National Council proved important in Hodsoll's efforts to reshape the agency.

Hodsoll plunged into his new job with enthusiasm, though his inexperience led to several embarrassing gaffes. After attending a specially arranged gala to display the range of Endowment-funded art, Hodsoll singled out well-known performance artist and composer Laurie Anderson as an example of precisely what the NEA should *not* be funding.[22] Gentle educational efforts by members of the art world prevented future embarrassments for Hodsoll, but performance art, then as now, tended to remain difficult for political appointees to comprehend.

One of the most significant steps Hodsoll took was his overturning of grants approved by the peer panels or even, in some cases, those already approved by the National Council.[23] In every case, the cause for rejection was the project's subject matter or content rather than artistic merit, since all grants had been evaluated and recommended by a panel composed of art experts in a highly competitive process. These rejections by Hodsoll marked a sharp departure from customary procedure at the NEA, where no previous director had ever rejected a grant. Indeed, the peer panels had been viewed as expert professional bodies, much like the scientific panels at the National Science Foundation; their independent evaluations were seen as central in protecting the Endowment from outside interference and pressure.

Hodsoll claimed that he was simply acting responsibly and following the exact letter of agency procedures, according to which peer panels recommended grants to the National Council, which in turn recommended grants to the chairperson, who finally approved them for funding. Despite his claim to be doing nothing technically new, the art world was outraged and viewed his interference as a direct attack on the integrity of the funding process. Few had anticipated such direct intervention in the internal procedures of the NEA.

Within months of taking office, Hodsoll personally reviewed over 2,000 grants approved by peer panels and the National Council, holding back some grants, particularly those for experimental theater companies, for "additional discussion." In addition, he returned some 500 grants which had been recommended by the National Council, because he had questions about the proposals.[24] Many of these questions were eventually answered and the grants funded, but the queries and delays signaled to both staff and applicants that an unprecedented degree of scrutiny was now taking place. Between November 1981 and April 1983, the chairperson's first period of grant rejections, Hodsoll questioned 316 of 5,727 grants approved by peer panels (5.5 percent), ultimately rejecting 20.[25] In 15 cases, he was able to convince the National Council to disapprove the grants as well, but in five cases he overrode their approval. One of the first grants Hodsoll vetoed included a joint proposal by the Heresies Collective and Political Art Documentation Distribution (PADD) to support forums with artists and critics such as Hans Haacke, Martha Rosler, Lucy Lippard and Suzanne Lacy.[26]

Then grant rejections stopped for a while, possibly because of the negative publicity they engendered and the opposition of many Carter appointees remaining on the Council and the staff. But grants approved by peer panels were still routinely read by Hodsoll or, increasingly, by deputy Ruth Berenson. Berenson also sat in on peer-panel meetings, furiously scribbling notes, in a way that many panelists found intimidating.[27] By 1986, rejections were again on the upswing; targets included Jenny Holzer's *Sign on a Truck*, a project proposed for Lafayette Park in front of the White House (it consisted of a lightboard that would flash the

responses of pedestrians to questions asked by the artist) and *De Peliculas: Archives of Latin American Conflict 1890–1940,* a documentary on the history of American intervention in Latin America, by DeeDee Halleck, Penney Bender and Robert Summers.[28]

The changing composition of the National Council provided the backdrop for what was probably the most blatant attempt to control content—the elimination of the Art Critics' Fellowship Program, designed to provide stipends for low-salaried and independent art critics.[29] The affair started innocently enough: the Endowment staff commissioned an evaluation of the critics program from an independent adviser. This report, though critical, was intended to strengthen the program.[30] The results were presented to a closed Visual Arts Criticism seminar, a group of non-Council advisers convened to evaluate the report. But neoconservative art critic and *New Criterion* editor Hilton Kramer, one of the advisers, was incensed by the goals of the program and he later published in his journal a furiously hostile article called "Criticism Endowed."[31] In that article, Kramer denounced the critics' fellowships for supporting a small clique of bad writers. But his main criticism was that "a great many of them [the fellowships] went as a matter of course to people who were publicly opposed to just about every policy of the United States government except the one that put money in their pockets."[32]

Kramer's attack reflected the overall cultural politics of the *New Criterion.* Founded by publisher and music critic Samuel Lipman in 1982[33] and supported by right-wing money from the Scaife, Olin and Heritage foundations,[34] the journal intended to identify and critique the allegedly pervasive leftist cultural influences in American culture following what Kramer referred to as "the insidious assault on the mind that was one of the most repulsive features of the radical movement of the Sixties."[35] Its editors advocated a return to traditional, elite and supposedly universal cultural forms, though unlike most Reaganites, they did support federal art funding.

Kramer's diatribe might have had little effect, given the small circulation of the journal (5,000–6,000), except that publisher Samuel Lipman was now a member of the National Council and he took up the crusade there. Always bullying and aggressive in arguing his cause, Lipman soon became the Council's enfant terrible and chief ideologue, intimidating more moderate Council members and persistently advancing cultural policies advocated by the *New Criterion* and the Heritage Foundation. At a Council meeting when the fate of the critics' grants hung in the balance, issues of the *New Criterion* containing Kramer's attack were reportedly on the table in front of each Council member. Hodsoll took up Lipman's suggestion to terminate the criticism program beginning with the 1985–86 awards, although this action was opposed by many of Hodsoll's advisers as well as almost all experts in the field. The termination of critics' grants was greeted by protests in the art world, though it proved impossible to reverse the decision.

In terms of overall policy objectives during his tenure, Hodsoll generally favored the interests of major institutions and traditional culture at the expense of

the individual artist and emerging institutions. In addition to more stable and long-term funding for the large cultural institutions, he instituted special grants to encourage better management, planning and technical expertise. The size and scope of the Challenge Grants were increased, while funding for community and expansion arts was cut back. Hodsoll had supreme faith in the private market and the gallery system: he claimed, "Over time, an artist's reputation is made in the market."[36] For the first time, he invited dealers and collectors to sit on visual-arts panels, a situation which in previous years would have been regarded with horror as an egregious conflict of interest. Hodsoll even proposed technical support to encourage alternative spaces to sell artists' work, although these spaces were established by artists precisely to escape the market system. He developed strong partnerships in the private sector, establishing, for instance, the Awards in the Visual Arts Program, a program cosponsored by the NEA, the Rockefeller Foundation and Equitable Life Assurance Society.[37] With the encouragement of Education Secretary William Bennett, Hodsoll also backed efforts by the Getty Foundation to promote an expanded program of formal education for elementary and secondary school students in art history and art criticism (in place of existing programs that "only" encouraged creativity and self-expression).[38]

It is no accident that the administration's efforts to impose a more conservative cultural agenda were directed at the most unpredictable and risk-taking—as well as most vulnerable—groups who received Endowment support: individual artists and community arts organizations. Both produced innovative work, sometimes disturbing and on the edge, reflecting increasingly diverse populations and perspectives. Unlike major cultural institutions, these smaller organizations had fewer obligations to be cautious; they had no need to mount the traditional repertory, to please the subscribers or to expand already gigantic cultural edifices. And as for individual artists, once they received their grants, there was no other force—museum, curator or state arts agency—to monitor or moderate the content of their work.

The arts community had mounted a unified defense against Reagan's initial budget attack, but it did less well when dealing with the administration's efforts to shape cultural content. Hodsoll's strategy of attacking individual artists' fellowships tapped powerful internal divisions: Was it in the interest of major arts institutions to object to sporadic rejections of individual artists' grants, as long as their own establishments were well-funded? Some heads of major institutions accepted the privileging of their more traditional art forms as legitimate parts of "the canon," disparaging more experimental forms as not really "art" and, therefore, dispensable. Others in the mainstream institutional art world (though not enough) saw the censorious impulse for what it was: a threat to the values of democracy and free expression.[39]

If the Reagan administration's attempt to reshape the Endowment could claim

only partial success, it was because art and free expression were legitimate and powerful values in American political culture, and it proved difficult for conservatives to construct an effective line of attack. The cost-cutting rationale proved less than compelling, perhaps because the Endowment budget was in fact quite small. And the arguments of neoconservative ideologues about the elite nature of art did not reach the average citizen and they certainly didn't rouse the larger body politic to action. Frontal attacks on the content of federally funded art simply failed to capture the popular imagination and proved counterproductive when they roused the art community to fight back. Despite the currents of anti-intellectualism and antielitism always endemic in America, art was not such an easy target.

Neither Congress nor a ground swell of public opinion actively supported changes in the Endowment, so pressure for reform came largely from the administration and its top appointed bureaucrats. Hodsoll and his assistants tried to monitor and curb grants and programs that dealt with various types of radical content, but there was a limit to what they could accomplish through internal procedural maneuvers. The NEA's own staff members remained largely moderate and liberal. Constrained, but hardly terrorized, they perceived these interventions as crude political efforts to further Reagan's agenda and felt justified in resisting them. Gross measures, like grant rejection, generated bad publicity and could only be used selectively, not routinely.

The contrast between Reagan's war on culture and the current crusade is striking: the objective is the same—to control artistic content—but this time the means are different and, as it turns out, much more effective. In this case, conservatives and fundamentalists were able to instigate and maintain a full-fledged sex panic.[40] Conservatives have combined the force of two simple cultural phenomena: although it may be difficult to attack art per se, it is easy to attack sex; it follows, therefore, that attacking sex in art will be the most powerful strategy. The initial discovery of this strategy may have been serendipitous (after all, it was a single irate letter to Rev. Donald Wildmon's American Family Association newsletter about Andres Serrano's *Piss Christ* that kicked off the current censorship campaign). As tons of mail began to pour into Congress, fundamentalist and conservative leaders were quick to recognize the political potential of the situation. By attacking the Endowment for funding art with allegedly sexual or obscene content, they have been—and probably will continue to be—able to change the NEA's structure and control the content of art that gets funded in ways that quite eluded them during the Reagan years. Indeed, Hodsoll's efforts can be seen as a blueprint for what is happening now on a much larger scale.[41]

The emotional and political momentum generated by the current sexual panic, however, has led to some stunning new developments, particularly the degree of self-policing now being proposed by the Endowment's own staff. Even stalwart arts supporters, both inside and outside Congress, are urging agency self-restraint

or reform, as if censorship imposed internally and invisibly is superior to and more comfortable than the legal constraints proposed by Sen. Jesse Helms (R-N.C.). Legislators, who have now grown queasy over the idea of antiobscenity oaths and explicit content controls, are suggesting changes in the Endowment's structure, conveniently overlooking the ways in which the new structures are intended to—and will—control content.

The terrified reactions of arts supporters and political moderates are understandable but misguided. Accepting the basic premise of a sex panic—that sex is polluting, shameful and dangerous—arts supporters appear willing to expunge what they imagine to be a limited sphere of sexual content in order to protect the larger project of the Endowment. Their illusion is that sex can be cordoned off, leaving a sex-free artistic domain that can be successfully defended through marshaling the traditional arguments about the value of art, a defense that appeared to work during the Reagan years. Arts advocates don't seem to understand that the creation of a sex panic is a political maneuver designed specifically to bypass these defenses, while increasing public pressure to control *all* content to an unprecedented degree.

But sex, as Jesse Helms's political agenda indeed indicates, is everywhere, and no small thing. Sex weaves into gender arrangements, family, intimate life, desire and pleasure, the relationship between human bodies and state power—in short, the major social and political arenas which the right wing wants to control. For this reason a sex panic such as the one currently swirling around the NEA is a profoundly political event, and an effective political response must take on, even embrace, sexual issues, not flee from them.

Notes

Thanks to Frances Doughty, Jeanne Bergman, Lisa Duggan, Nan Hunter, David Schwartz, Ann Snitow, Sharon Thompson and Gayle Rubin. I am also grateful to the many individuals who talked with me about their experiences with the Endowment during the Reagan years. Thanks to Mary Ann Thompson for research assistance.

1. Allan Parachini, "Congressmen Draw Up New NEA Restructuring Plan," *Los Angeles Times,* July 10, 1990, p. F1; Allan Parachini, "Reauthorization Proposal Offered by Congressmen," *Los Angeles Times,* July 17, 1990, p. F5; Allan Parachini, "House Republicans Seek New Image for NEA," *Los Angeles Times,* July 19, 1990, p. F1.

2. Allan Parachini, "House Delays Vote on NEA Funding Bill," *Los Angeles Times,* July 25, 1990, p. F1.

3. Ibid., p. F4.

4. Parachini, "Reauthorization Proposal," p. F5.

5. Barbara Gamarekian, "Arts Agency Denies 4 Grants Suggested by Advi-

sory Panel," *New York Times*, June 30, 1990, pp. 1, 12; Jan Breslauer, "No Funds, Much Fury," *Los Angeles Times*, July 16, 1990, p. F1.

6. For accounts of the Endowment's history, see Livingston Biddle, *Our Government and the Arts: A Perspective from the Inside*, New York, American Council for the Arts, 1988; and Edward Arian, *The Unfulfilled Promise: Public Subsidy of the Arts in America*, Philadelphia, Temple University Press, 1989.

7. Arian, *The Unfulfilled Promise*, pp. 46–49.

8. C. Richard Swaim, "The National Endowment for the Arts: 1965 to 1988," in Kevin V. Mulcahy and C. Richard Swaim, *Public Policy and the Arts*, Boulder Colo., Westview Press, 1982, p. 181.

9. J. Adler et al., "The Arts Under Reagan's Ax," *Newsweek*, Mar. 16, 1981, pp. 29, 31.

10. A summary of the populist programs of the Biddle years, albeit a hostile one, is provided in John Friedman, "A Populist Shift in Federal Cultural Support," *New York Times*, May 13, 1979, sec. 2, pp. 1, 35.

11. *American Arts*, May 1980, p. 21.

12. Michael S. Joyce, "The National Endowments for the Humanities and the Arts," in Charles L. Heatherly, ed., *Mandate for Leadership*, Washington, D.C., Heritage Foundation, 1981, p. 1056.

13. Adler et al., "The Arts Under Reagan's Ax," pp. 28, 31; "Arts Endowment Slashes Budget," *New York Times*, Apr. 9, 1981, p. C14; Megan Rosenfeld, "NEA Submits Reduced Budget," *Washington Post*, Apr. 10, 1981, p. F7.

14. "Arts Task Force Backs Continued U.S. Support," *New York Times*, Aug. 17, 1981, p. C11.

15. Cynthia Saltzman, "Companies Doubt Their Arts Giving Would Rise to Offset Reagan's Cuts," *Wall Street Journal*, Feb. 26, 1981, sec. 2, pp. 1, 41; Eleanor Blau, "Arts Donors Caution on U.S. Aid Cuts," *New York Times*, Mar. 9, 1981, p. C7.

16. Carla Hall, "Heated Hearings on Cultural Budget Cuts," *Washington Post*, Mar. 5, 1982, p. B8.

17. Grace Glueck, "Independent Corporation Weighed as Arts Agency," *New York Times*, Apr. 14, 1981, p. C9.

18. Irvin Molotsky, "Reagan Fills Arts Post, Is Silent on Humanities," *New York Times*, Oct. 16, 1981, p. C21.

19. Francis S.M. Hodsoll, "Supporting the Arts in the Eighties: The New View from the National Endowment for the Arts," *Annals of the American Academy of Political and Social Sciences* 471 (1984), pp. 84–101.

20. C. H. Simonds, "Amounting to Something," *National Review*, Aug. 20, 1981, pp. 1025–26.

21. David Trend, "The Ministry of Culture," *Afterimage* 14, Oct. 1986, p. 3+.

22. Richard Goldstein, "A James Watt for the Arts?" *Village Voice*, Feb. 10–18, 1982, p. 47.

23. Carla Hall, "Arts Grants Held Back," *Washington Post,* Jan. 28, 1982, pp. C1, C11; Irvin Molotsky, "Arts Chief Delays Grants," *New York Times,* Jan. 29, 1982, p. C5.

24. Hall, "Arts Grants Held Back," pp. C1, C11; Molotsky, "Arts Chief Delays Grants," p. C5.

25. Robert Pear, "Reagan's Arts Chairman Brings Subtle Changes to the Endowment," *New York Times,* Apr. 10, 1983, sec. 2, p. 1.

26. Catherine Lord, "President's Man: The Arts Endowment Under Frank Hodsoll," *Afterimage* 11, Feb. 1983, pp. 3–4.

27. Berenson's unsettling presence at panel meetings was cited by a number of peer panelists I interviewed who served during the Reagan years.

28. "Editorials," *New Art Examiner,* Jan. 1987, p. 5.

29. Niki Coleman, "National Council Roasts Critic's Fellowship," *New Art Examiner,* Dec. 1983, p. 31; Grace Glueck, "Endowment Suspends Grants for Art Critics," *New York Times,* Apr. 5, 1984, p. C16; Martha Gever, "Blowing in the Wind: The Fate of the NEA Critics Fellowships," *Afterimage* 12, Summer 1984, pp. 3+.

30. Ibid.

31. Hilton Kramer, "Criticism Endowed: Reflections on a Debacle," *New Criterion,* Nov. 1983, pp. 1–5.

32. Kramer, "Criticism Endowed," p. 4.

33. Lipman describes the editorial viewpoint of the journal: "We are, in fact, anti-Socialist; we are pro-capitalist; we are very much pro-American." See Derek Guthrie, "Lipman Speaks: The Conservative Voice on the National Endowment," *New Art Examiner,* Oct. 1984, pp. 31–33.

34. Nichols Coleman, "Art Press Review: *The New Criterion,*" *New Art Examiner,* Dec. 1984, pp. 16–19; Connie Samaras, "Sponsorship or Censorship?" [An interview with Hans Haacke], *New Art Examiner,* Nov. 1985, pp. 20–25. As Haacke points out, the *New Criterion*'s contention that artistic and literary excellence should be identified and supported through competition in the free market contrasts sharply with the journal's dependence on generous contribution from tax-exempt foundations, ultimately a form of public subsidy.

35. The Editors, "A Note on *The New Criterion,*" *New Criterion,* Sept. 1984, pp. 1–5.

36. Gerald Marzorati, "The Arts Endowment in Transition," *Art in America,* Mar. 1983, p. 9.

37. Ironically, a touring exhibition of works by Awards in the Visual Arts fellowship winners, which included Andres Serrano's photograph *Piss Christ,* occasioned the opening salvo in the current culture wars.

38. Fred M. Hechinger, "Report Tries to Remedy Neglect of Art in School," *New York Times,* Apr. 2, 1985, p. C6; William H. Honan, "Stringency Is Advised in Training about Arts," *New York Times,* May 4, 1988, p. B10; National Endowment for the Arts, *Toward Civilization: An Overview from a Report on Arts Education,* Washington, D.C., 1988.

39. This view was evoked in the congressional testimony provided in 1981 by Leontyne Price, Toni Morrison, Jean Stapleton, James Earl Jones and others. See Jane Allen, "Federal Arts Report," *New Art Examiner,* May 1981, p. 11; and "Arts Task Force Backs Continued U.S. Support," *New York Times,* Aug. 17, 1981, p. C11.

40. For an elaboration of the mechanics of sex panics, especially this one, see Carole S. Vance, "The War on Culture," *Art in America,* Sept. 1989, pp. 39–45.

41. The tactics of the Reagan-era assaults on the NEA—attacks on individual artists, rejections of grants approved by peer panels, the self-preserving actions of large institutions at the expense of smaller groups and the highly orchestrated cooperation between conservative publications and reactionary members of the National Council—have, in the past year, become depressingly familiar. Only the players have changed. Now joining Hilton Kramer, Samuel Lipman and the *New Criterion* are NEA Council members Jacob Neusner and Joseph Epstein, conservative columnists Evans and Novak and the Moonie-owned newspaper the *Washington Times.* For evidence that confidential Endowment information was leaked to the press, see Jan Breslauer, *Los Angeles Times,* July 16, 1990, p. F1; Rowland Evans and Robert Novak, "New Art Storm Brewing," *New York Post,* May 1, 1990, p. 23.

FEMINIST FUNDAMENTALISM—WOMEN AGAINST IMAGES

The seeming resolution of an art-censorship case at the University of Michigan Law School last spring has done little to quiet artists' fears about the new directions that attacks on sexual imagery are taking. In the midst of a four-year furor over National Endowment for the Arts funding of "offensive" images, antipornography feminists have now stepped into the fray, adopting tactics that strongly parallel those employed by conservatives and fundamentalists. By piggybacking their own views onto notions put into wide circulation by right-wing groups—for example, that virtually any visual imagery about sex is "pornographic"—antipornography feminists managed to shut down an art exhibition focusing on the work of women and feminists and to redefine notions of pornography and free expression.

The flap started in late fall 1992, when critics assailed a multimedia exhibition about prostitution, claiming that the installation was "pornographic" and a "threat." This time, opponents wasted no time in disputes about art funding. Instead, they physically removed the offending art, and ultimately closed down the entire show. The censors were feminists opposed to pornography and law students who claimed they weren't engaging in censorship; their goal was to protect viewers from videos which made people "uncomfortable" and "created feelings of anxiety"[1] and from images "used to get men pumped."[2] The dean of the law school, a specialist in First Amendment law, initially seemed to agree, suggesting that the students were merely exercising their First Amendment rights by removing art from a gallery. The startling incident in Ann Arbor signals the fluidity with which sexual panics move around the culture, here spreading far beyond federal agencies and moral-conservative pressure groups.

What visual images set off such a ruckus? The works were part of an exhibition called "Porn'im'age'ry: Picturing Prostitutes," curated by feminist artist and videographer Carol Jacobsen, and featuring documentary photography and videos by seven artists, five of them women. The show included the work of Paula Allen, Susana Aikin and Carlos Aparicio, Carol Leigh, Veronica Vera, Randy Barbato and Carol Jacobsen. The work was diverse, including Allen's *Angelina Foxy* (1986–), an ongoing phototext essay documenting the life of a Jersey City prostitute; Aikin and Aparicio's *The Salt Mines* (1990), a critically acclaimed documentary about homeless transvestite hustlers in New York City; Jacobsen's *Street Sex* (1989), candid video interviews with Detroit prostitutes just released from jail; and Leigh's *Outlaw Poverty, Not Prostitutes* (1991), an activist video chronicling prostitutes' international organizing to improve working conditions.

The exhibition was commissioned as part of a two-day conference called "Prostitution: From Academia to Activism," held at the University of Michigan Law School Oct. 30–31, 1992. Sponsored by the law school and by its new publication, the *Michigan Journal of Gender and Law,* the conference gave center stage to the views of leading antipornography theorists Andrea Dworkin and Catherine MacKinnon, the latter a professor at the law school; they regard both prostitution and pornography as central—and interrelated—causes of women's inequality. Because feminist opinion on these questions is quite divided,[3] student organizers initially wanted the conference to explore diverse perspectives, and the exhibition was part of this approach. They soon found, however, that antipornography advocates—following a now-familiar maneuver—refused to appear if feminists holding different views were invited.[4] "Some of the key anti-prostitution people accepted on the condition that they wouldn't speak if there were people from the other side there," conference organizer Lisa Lodin told the *New York Times.* "We agonized about it, because we felt we were being manipulated, but we went ahead anyway."[5] The successful attempt to restrict the content of the conference soon spilled over to the art exhibition with more mixed results.[6]

The complete installation was on view for no more than a few hours on Oct. 30 before some conference speakers, objecting to sexual imagery in the show, complained to MacKinnon, who conveyed the complaints to the student organizers.[7] Reports have variously identified those objecting to the show as John Stoltenberg, antipornography activist and close associate of Dworkin, and Evelina Giobbe, director of an antiprostitution group in St. Paul and a longtime member (under the name Evelina Kane) of Women Against Pornography in New York.[8] According to law student and conference organizer Laura Berger, some speakers had "expressed fear for their personal safety. Some speakers had attended prior conferences where pro-pornography groups had shown pornography to incite groups of people to protest alternative views. Such protests had resulted in the harassment of speakers in the past."[9]

Evidently panicked by the charge that some of the art works were pornographic or dangerous, student organizers immediately removed most of the videos from

the installation—sight unseen, and without consulting or even informing the curator. What the students seemed to regard as a minor adjustment ("we agreed to take out a portion [of the show]"[10]) in fact eliminated the work of five of the seven artists.

The next day, curator Carol Jacobsen discovered that the videos were missing; when she learned the reasons for their removal, she objected strongly. "I told them they couldn't just pick out selected artwork and remove it from the exhibit, but they didn't seem to get it," Jacobsen told the *New York Times*. "They said it wasn't censorship; they were just trying to prevent people from getting their feelings upset. I said if they wished to censor any part, they would have to censor the whole thing. They came back and said, 'Take it down.' And that's what happened."[11]

In the ensuing months, Jacobsen waged an uphill battle at considerable personal cost to compel the university to redress the censorship.[12] She demanded reinstallation of the show, as well as a campus forum to address issues of feminism, representation, sexuality and censorship. At first, officials suggested they had no responsibility for the law students' actions, although the university funded the conference which had commissioned the exhibition and the art was removed from a university-owned gallery. In crafting this argument, university administrators attempted to narrow the question to one of strict legal liability: did the university violate the First Amendment rights of the artists? This framing diverted attention from a second, quite separate question: did censorship occur at the university, and did educators have a responsibility to examine the circumstances and speak out about the event?

Controversy raged across the campus, with students, Jacobsen and MacKinnon weighing in; Jacobsen's attorneys, disturbed at unauthorized reproduction and circulation of the artists' videos by school officials and students, threatened to sue the university for copyright violation, while MacKinnon vowed to sue the ACLU for alleged defamation over their press release about the incident.[13] The faculty at Michigan, however, was largely silent about the case, including professors in art, law and women's studies. The threat of legal action by the ACLU Arts Censorship Project, combined with widespread news coverage and a major protest by arts-advocacy, feminist and free-speech groups, led to a March 17, 1993 agreement between the university and the artists to reinstall the exhibition and sponsor an educational forum on sexuality and freedom of expression.[14] Months after the agreement, however, plans for the reinstallation and forum are proceeding at a snail's pace.

The incident suggests several startling similarities to recent fundamentalist campaigns against art and the NEA. Most striking is the use of the term "pornography" to describe any material with a sexual content or theme of which the viewer disapproves. Since "pornography" carries an unmistakably pejorative connotation, the use of this word to describe any visual image involving sex or nudity

serves aggressively to demote the status of the image or art work and, with no overt discussion, to bias the viewer's ability to consider it. This rhetorical sleight of hand, too, suggests that sexuality per se is inherently pornographic, a contention many would question if it were explicitly stated.[15]

Over the past four years, moral conservatives have put into wide circulation terms like "pornographic" and "obscene art" to describe performance art and photography which explores homosexuality, sexism and the body in ways they find threatening. In a similar tactic, antipornography feminists are now hurling the term "pornography" at art videos which dissent from their favored position on prostitution—that prostitution victimizes women and that women can never freely choose to participate in that work. Ironically, antiporn feminists wish to banish these videos specifically because of the *political ideas* they convey, yet their characterization of the videos as pornography—seemingly mindless, masturbatory vehicles—implies that they are devoid of meaning or ideas.

These arguments produced an elision between "porn" and "video" which has fueled the controversy in other ways. As in the NEA episode, this debate centered on newer art forms, here photography and video, which have shorter histories, less prestige and legitimacy, and less cultural protection than more traditional forms of art such as painting or sculpture. The widespread circulation of photography and video in popular and commercial culture renders them vulnerable. For students, removing a painting from a gallery wall might still be unthinkable, or at least clearly understood as an act of censorship, but removing a videotape from a VCR can perhaps conveniently be assimilated into a routine, everyday act of personal preference.

The decontextualized way of viewing images which was prominent in the NEA debates reappeared in the controversy at the University of Michigan. Antipornography feminist critics assailed Veronica Vera's 30-minute video *Portrait of a Sexual Evolutionary* (1987) as "pornography" because it contains—among many other things—short, sexually explicit excerpts from adult films in which she appeared. This makes as much sense as calling the video religious because it incorporates Catholic iconography as it traces her development from obedient daughter to sexually curious porn performer to video maker and sex advocate. Critics ignore the video's many framing devices; the narrative is filled with irony, camp and good girl/bad girl melodrama, interspersed with critiques of censorship, the most winning being Vera's 1984 testimony against MacKinnon-Dworkin-style antiporn ordinances before a U.S. Senate subcommittee and the clearly flabbergasted and uncomfortable Sen. Arlen Specter (R-Pa.). This video, like all others, can be read many ways; it may be that some viewers are discomfited by Vera's shifting, unstable perspective that lurches between seriousness and camp, her largely upbeat account of her experiences in the sex industry or her refusal to work within the genre of earnest documentary. Yet none of these issues—esthetic, intellectual and political—merit dismissal with the reductionistic epithet "pornography."

Antipornography feminists have always favored a single and universal reading

of sexual imagery. They have elaborated a mechanistic theory about the myriad ways in which sexually explicit materials cause enormous harm, from promoting misogynist ideas and male dominance to directly inspiring rape. Just like moral conservatives, they reject interpretive schemes that admit the complexity and ambiguity of images, as well as the diverse responses of viewers. In this incident, the assertion by a few conference participants that the sexual imagery in the videos was pornographic and a menace, coupled with law students' gullible acceptance of such claims, seemed to establish that all viewers, especially women, would read the visual images identically. Yet the extensive debates within feminism over the past decade, focusing on precisely such issues as women's sexuality, subjectivity and interpretive authority, make this particular contention on the part of MacKinnon and her students laughable.

Also comic were the earnest avowals of both law students and antiporn feminists that their actions did not constitute censorship. Here, too, they adopted the rhetorical technique of fundamentalist groups in the NEA controversy, who intuited that an explicit defense, and therefore acknowledgment, of censorship is a liability in public debate. The statements of future lawyers were especially dismaying, as they seemed to reflect the speakers' shallow legal training and hypertrophic credulousness. Bryan Wells, a law student and one of the exhibition's organizers, said, "We really didn't think of it as a censorship issue, but as a safety issue. . . . It wasn't our place to assess that threat. It was our position to trust our speakers."[16] The dean of the law school, Lee Bollinger, also engaged in some creative reasoning over the course of the controversy, though his imaginative explanations perhaps make more sense when seen in light of the ACLU's threatened lawsuit. Against concerns about artists' freedom of speech, Bollinger raised issues of student rights—"that includes the right to be unreasonable as well as the right to be reasonable."[17] Bollinger argued that students, too, were entitled to free expression: "Student organizations can invite or disinvite people to speak at conferences, and it's within their legal and constitutional rights."[18] This spurious analogy between planning conferences and removing art from a gallery is unconvincing, since it would propose a rather Orwellian definition of "free expression"—the right to eliminate any speech or art one doesn't like.[19]

The parallels between the antipornography feminist and fundamentalist attacks on art extend beyond tactics and rhetoric. Both share a powerful desire to reshape cultural attitudes toward sexual imagery as part of a larger program of political, social and legal reform. It is no accident that this incident occurred at the University of Michigan Law School, where Catharine MacKinnon has been elaborating legal theory about the harm of pornography and training enthusiastic students in innovative ways to erode First Amendment protections for sexual images and speech. Though interpretations differ about the degree of MacKinnon's involvement in this episode (she claims that she did not see the videotapes and only con-

veyed to the exhibition organizers various speakers' objections to the tapes), she has publicly supported the students' actions: "It is one thing to talk about trafficking women, and it is another thing to traffic women. There is nothing in the First Amendment to require that this school, or students in it, be forced to traffic women. If these materials are pornography—and I haven't seen them, so I can't say—it is not a question of their offensiveness, but of safety and equality for women. Showing pornography sets women up for harassment and rape."[20]

These parallels should come as no surprise. Like fundamentalists, antipornography feminists have long embraced a two-step strategy that melds cultural and legal activism. Both employ cultural campaigns to enlarge the popularly understood definition of pornography (the pejorative category for bad, harmful or immoral material) to include virtually all sexual imagery. In addition, because current law prohibits only sexual material which is obscene, both are crafting innovative legal strategies to expand the definition of obscenity and, hence, the scope of obscenity law. In their efforts to disable their political opponents, both groups are skilled in deploying demagogic charges of "pornography" and mobilizing sex panics in order to eliminate expression, images and perspectives that counter their own agenda.

The antipornography feminist agenda has been vociferously criticized by other feminists because of its impoverished perspective on both sexual imagery and social change. The single-minded effort to eliminate a broad range of sexual imagery erases the actual diversity in these images, as well as women's complex, sometimes contradictory reactions. The confinement of all sexual imagery to the demonized category "pornography" makes it unlikely that the most intriguing questions about the relationship between sexuality, women and imagery will ever be asked. Moreover, this agenda suggests that sexism and misogyny originate in the sexually explicit, a relatively small domain, rather than being part of the deep cell structure of every institution in our culture.[21]

The solution the antiporn feminists propose is at once too small and too big. It is too small in that it narrows feminism's broad-based response to sexist imagery to an attack on the sexually explicit. This severely limits and misrepresents feminism's wide-ranging critique of all sexist visual conventions, which has historically been coupled with encouragement for women to produce innovative, challenging and subversive alternatives. But the antiporn response is also too big in that it adopts a totalitarian program of physically eliminating objectionable images and symbols as a means to change the culture that produced them, a tactic that would be utterly implausible were it proposed to combat anything but sexually explicit imagery. Behind these polar extremes lies the inability or unwillingness to address the larger theoretical questions: Where does sexual culture come from? And, by implication, how can it be transformed?

Antipornography feminists are entering the public debate about art and sexual imagery after years of their own silence during the NEA controversy, when many feminist, gay and lesbian artists along with innovative work about sex and

gender were attacked. They enter in the wake of serious fundamentalist incursions designed to limit artistic expression, curtail exploration of sexuality and promote self-censorship. The extent to which antipornography feminist campaigns against visual imagery and art will grow remains to be seen; admittedly, they begin with a more modest organizational base than highly funded right-wing groups, and they have acquired vocal opponents within the feminist movement. Yet their stated goal—restricting imagery to allegedly promote equality—can strike a sympathetic nerve in women who would be unmoved by more recognizably protectionist and fundamentalist efforts. The prevailing sexual culture—often hostile and deprecating to women—generates an outrage easily mobilized toward reactionary as well as progressive ends. This case, as well as the landmark 1992 *Butler* decision in Canada (in which traditional obscenity law was upheld and expanded with new, feminist arguments provided by MacKinnon and her allies[22]), shatters the illusion that restricting sexual imagery for feminist purposes is distinguishable from fundamentalist censorship—either in method or consequence.

While conservative campaigns can be easily derided as efforts to punish and restrict women, ironically, antipornography feminist crusades have attacked women, too: in Michigan, feminist and women's art is removed, while in Canada, the first post-Butler obscenity prosecution targeted the lesbian-feminist erotic magazine *Bad Attitude*.[23] The query, "What do women want?" remains a provocative question—in regard to art, imagery and sexual culture. And it is not a question that can be easily answered in a sexist society. Still, these recent skirmishes show that the answer lies in expansion, not closure, and in increasing women's power and autonomy in art as well as sex.

Notes

I am grateful to Frances Doughty, Nan Hunter, Ann Snitow, Gayle Rubin, Robert Glück, Sharon Thompson and Barbara Kerr for helpful conversations. I also benefitted from a writing residency at the MacDowell Colony.

1. Erin Einhorn, "Law Journal Censors Video, Citing Pornographic Content," *Michigan Daily*, Nov. 2, 1992, p. 1.

2. Statement of law student and conference organizer Laura Berger in Reed Johnson, "Sex, Laws and Videotapes," *Detroit News*, Dec. 7, 1992, p. 2E. Berger went on to say that "women such as this speaker [who complained about the videos] have been harassed by people who have watched pornography in the past."

3. For the antipornography feminist analysis, see Laura Lederer, ed., *Take Back the Night*, New York, William Morrow, 1980; Andrea Dworkin, *Pornography: Men Possessing Women*, New York, G.P. Putnam, 1979; Catharine MacKinnon, "Pornography, Civil Rights, and Speech," *Harvard Civil Rights-Civil Liberties Law Review*, vol. 20 (1985), pp. 1–70; Dorchen Leidholdt and Janice G. Raymond, *The Sexual Liberals and the Attack on Feminism*, New York, Pergamon, 1990.

For feminist critiques of the antipornography position, see Kate Ellis et al., eds., *Caught Looking: Feminism, Pornography, and Censorship,* East Haven, Conn., Long River Books, 3rd ed., 1992; Carole S. Vance, ed., *Pleasure and Danger: Exploring Female Sexuality,* London, Pandora, 2nd ed., 1992; Lynne Segal and Mary McIntosh, eds., *Sex Exposed: Sexuality and the Pornography Debate,* New Brunswick, N.J., Rutgers University Press, 1993; Nan Hunter and Sylvia Law, "Brief Amici Curiae of FACT (Feminist Anti-Censorship Taskforce) et al. in American Booksellers Association v. Hudnut," *Michigan Journal of Law Reform,* vol. 21 (Fall 1987-Winter 1988), pp. 69–135.

4. For feminist views favoring decriminalization and efforts to improve the situation of prostitutes, see Gail Pheterson, ed., *A Vindication of the Rights of Whores,* Seattle, Seal Press, 1989; Frederique Delacoste and Priscilla Alexander, eds., *Sex Work: Writings by Women in the Sex Industry,* San Francisco, Cleis Press, 1987.

5. Tamar Lewin, "Furor on Exhibit at Law School Splits Feminists," *New York Times,* Nov. 13, 1992, p. B16; see also comments describing the process by which organizers reluctantly decided to exclude opposing viewpoints in Johnson, "Sex, Laws and Videotape," p. 2E.

6. Local reports and commentary include Ami Walsh, "The World of Prostitutes," *Ann Arbor News,* Oct. 28, 1992, pp. B1–B2; Einhorn, "Law Journal Censors Video," pp. 1–2; Ami Walsh, "Prostitution Exhibit's Artist Removes It After 'Censorship,' " *Ann Arbor News,* Nov. 3, 1992, pp. C1, C3; Carol Jacobsen, "Issues Forum: First Amendment Rights Need to Be Upheld," *Michigan Daily,* Nov. 6, 1992, p. 4; Laura Berger, "Issues Forum: Exhibit Caused People to Fear for Their Safety," *Michigan Daily,* Nov. 6, 1992, p. 4; "Freedom from Speech" (editorial), *Michigan Daily,* Nov. 6, 1992, p. 4; Stephen Jones, "Art Exhibit Ejection Fuels Debate on Speech, Porn," *Detroit Free Press,* Nov. 12, 1992, p. 6B; "Prostituting Feminism" (editorial), *Detroit News,* Nov. 19, 1992, p. 14A; Laura Dermer, "ACLU to Aid Artist in Fighting Censorship," *Michigan Daily,* Nov. 20, 1992, p. 7; Veronica Vera, "Censored Artist, Activist Speaks Out" (open letter by Vera), *Michigan Daily,* Nov. 30, 1992, p. 4; Anne Sharp, "A Look at the Oldest Profession," *Ann Arbor News—Spectator Magazine,* Dec. 3, 1992, p. 26; Johnson, "Sex, Laws and Videotape," pp. 1E–2E, 4E; Andrew Taylor, "Censored Film Presents Scenes of Prostitution," *Michigan Daily,* Dec. 7, 1992, pp. 1–2; Marsha Miro, "Freedom of Expression," *Detroit Free Press,* Dec. 20, 1992, pp. M7, M11.

7. Johnson, "Sex, Laws and Videotape," p. 2E.

8. Ibid. See also Lewin, "Furor on Exhibit at Law School," p. B16. For Giobbe's view of prostitution, authored under the name Sarah Wynter, see "Whisper: Women Hurt in Systems of Prostitution Engaged in Revolt," in Frederique Delacoste and Priscilla Alexander, eds., *Sex Work: Writings by Women in the Sex Industry,* San Francisco, Cleis Press, 1987.

9. Berger, "Exhibit Caused People to Fear," p. 4.

10. Bryn Mickle, " 'U' Avoids Court Case, Settles Disagreement with Local Artists," *Michigan Daily,* Mar. 18, 1993, p. 3.

11. Lewin, "Furor on Exhibit at Law School," p. B16.

12. Reflecting widespread impatience in the arts community with the university's foot-dragging actions in this case, almost two months after the original incident art writer Elizabeth Hess encouraged readers to launch a "fax attack" to "remind Dean Bollinger that it's time to get on with the forum and on with the show," *Village Voice,* Jan. 20, 1993; his rejoinder follows, *Village Voice,* Feb. 23, 1993.

13. See *Arts Censorship Project Newsletter,* vol. 2 (Winter 1993), p. 6.

14. Jacobsen was represented by Marjorie Heins of the ACLU Arts Censorship Project and Robert Carbeck, president of the Washtenaw County (Michigan) branch of the ACLU and cooperating attorney. For press coverage, see Lewin, "Furor on Exhibit at Law School"; Laura Fraser, "Hear No Evil: Anti-porn Feminists Censor Voices of Prostitutes," *San Francisco Weekly,* Nov. 11, 1992, p. 11; Joyce Price, "Feminists in Free-Speech Spat," *Washington Times,* Nov. 13, 1992, pp. A1, A6; "In Box," *Chronicle of Higher Education,* Nov. 25, 1992, p. A11; Laura Fraser, "Pornography—Free Speech or Sex Crime?" *San Francisco Examiner,* Nov. 29, 1992; Catharine MacKinnon, "An Act of Violence Against Women," *San Francisco Examiner,* Nov. 29, 1992; "Porn Fight," *National Law Journal,* Dec. 14, 1993; "University— Ann Arbor, Michigan," *American Library Association Newsletter on Intellectual Freedom,* Jan. 1993; editorial, *New Art Examiner,* Feb. 1993, p. 7; Ami Walsh, "Michigan Law Students Shutter Exhibition on Prostitution," *Independent,* vol. 16, no. 2 (Mar. 1993), pp. 12–13.

Protests were mounted by the National Campaign for Freedom of Expression, College Art Association, National Association of Artists Organization, National Coalition Against Censorship, American Civil Liberties Union, FACT (Feminist Anti-Censorship Task Force), PONY (Prostitutes of New York) and COYOTE (Call Off Your Old Tired Ethics), the prostitutes' rights organization. A petition protesting the closing of the exhibition and requesting reinstallation and an educational forum designed to air issues raised by the incident was signed by over 500 individuals.

For coverage of the "resolution" of the case, see Mickle, " 'U' Avoids Court Case," p. 3; Rosalva Hernandez, "U-M Agrees to Permit Art Exhibit on Prostitution," *Detroit News,* Mar. 18, 1993, p. 3B; Julie Wiernik, "Exhibit on Prostitutes Returning to U-M," *Ann Arbor News,* Mar. 17, 1993, pp. A1, A10.

Almost a year after the original incident and after a great deal of foot-dragging, the University of Michigan reinstalled the exhibition in the Law School on October 15, 1993, accompanying the two-day show with an October 16 debate between Marjorie Heins of the ACLU and Dean Lee Bollinger. The artists independently organized and funded an Artists' Speak-out on October 15.

15. Frances Doughty, personal communication.

16. Lewin, "Furor on Exhibit at Law School," p. B16.

17. "Porn Fight," *National Law Journal,* Dec. 14, 1992.

18. Wiernik, "Exhibit on Prostitutes Returning," p. A10.

19. Bollinger does admit that the students acted "unfortunately" when they removed the videotape, and he is eager to portray himself as a supporter of the reinstallation and educational forum (Wiernik, "Exhibit on Prostitutes Returning," pp. A1, A10); plans for such events remain vague. According to his comments, however, Bollinger envisions this public forum on a considerably smaller scale than the first conference, taking place in a University of Michigan classroom and lasting "just one afternoon" (see Johnson, "Sex, Laws and Videotape," p. 4E).

20. Lewin, "Furor on Exhibit at Law School," p. B16. According to the *Detroit News,* MacKinnon passed on Stoltenberg's complaint to law student Julia Ernst, "without recommending what should be done about the video." MacKinnon herself said, "It was so clearly up to the students to handle it in some kind of way or other. It wasn't something to which I directed my attention because it wasn't up to me" (Johnson, "Sex, Laws and Videotape," p. 2E). In a letter to the *New York Times* on Dec. 12, 1992, MacKinnon stated, "They [the students] acted on their own." See also Jacobsen, "Issues Forum: First Amendment Rights," p. 4; and Lewin, "Furor on Exhibit at Law School," p. B16.

21. In place of the imprecise term "pornography," I am employing the phrase "sexually explicit imagery," a construction that both eliminates the intrinsically pejorative meaning and forces the speaker to define what it is about the imagery that he or she finds offensive.

22. In the Butler case, an adult-bookstore owner convicted under Canadian obscenity statutes challenged the law, claiming restriction of free expression. The court rejected his claims and upheld the obscenity law, citing traditional state interest in preserving morality and, for the first time, in protecting citizens, particularly women, from the violence and degradation allegedly caused by pornography. Key sources which the court used to establish the harms of pornography were the writings of antipornography feminists like MacKinnon and the report of the Reagan-appointed Attorney General's Committee on Pornography, widely criticized for its biased procedures and conservative leanings. See *R. v. Butler,* Supreme Court of Canada, S.C.J. no. 15, 1992. Also, "Law on Pornography Upheld by Supreme Court," *Globe and Mail* (Toronto), Feb. 28, 1992; "Top Court Upholds Law on Obscenity," *Toronto Star,* Feb. 28, 1992.

23. See Camilla Gibb, "Project P Targets Lesbian Porn," *Quota Magazine,* May 1992; and "News in Brief—Canada," *The Advocate,* June 2, 1992, p. 34.

CONTRIBUTORS

Steven Feld is Professor of Anthropology and Music, University of Texas at Austin.

Hal Foster is Professor of Art History and Comparative Literature, Cornell University.

Judith L. Goldstein is William R. Kenan Jr. Professor of Anthropology, Vassar College.

Lynn M. Hart is Professeure Associée de la Psychologie, Université de Montréal.

Barbara Kirshenblatt-Gimblett is Professor of Performance Studies, Tisch School of the Arts, New York University.

George E. Marcus is Professor and Chair of the Department of Anthropology, Rice University.

Molly H. Mullin is Assistant Professor of Sociology and Anthropology, Albion College.

Fred R. Myers is Professor and Chair of the Department of Anthropology, New York University.

Christopher B. Steiner is Assistant Curator of Ethnology, Natural History Museum of Los Angeles County.

Nancy Sullivan is a Ph.D. candidate in the Department of Anthropology, New York University.

Carole S. Vance is Associate Research Scientist in Anthropology and Public Health, Columbia University School of Public Health.

INDEX

Library of Congress Cataloging-in-Publication Data

The traffic in culture : refiguring art and anthropology / edited by George E.
 Marcus and Fred R. Myers.
 p. cm.
 Includes bibliographical references and index.
 ISBN 0-520-08846-8 (alk. paper).—ISBN 0-520-08847-6 (pbk. : alk. paper)
 1. Art and anthropology. 2. Postmodernism. I. Marcus, George E.
II. Myers, Fred R., 1948–
N72.A56T73 1995
701'.03—dc20 94-39487
 CIP